NEW ORLEANS 1867

GARY A. VAN ZANTE

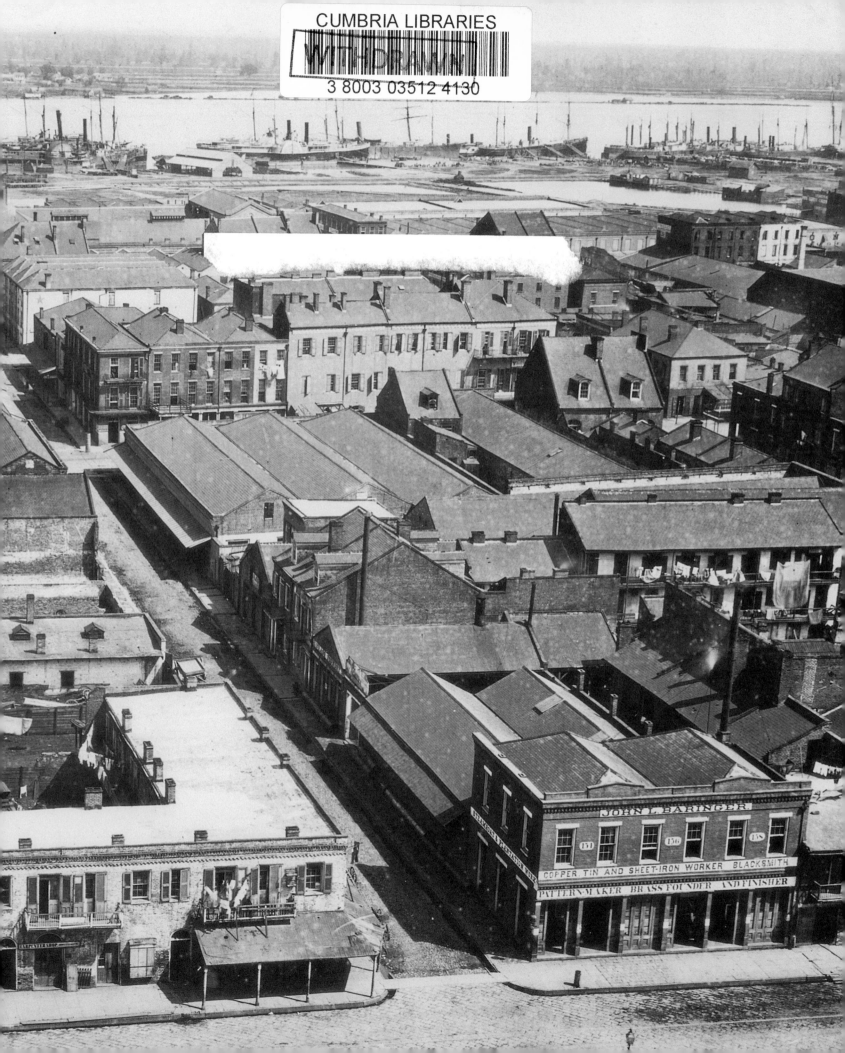

NEW ORLEANS 1867
PHOTOGRAPHS BY THEODORE LILIENTHAL

MISSISSIPPI HOTEL.

MERRELL
LONDON · NEW YORK

First published 2008 by Merrell Publishers Limited

Head office:
81 Southwark Street
London SE1 0HX

New York office:
740 Broadway, Suite 1202
New York, NY 10003

merrellpublishers.com

Catalog records for this book are available from the Library
of Congress and the British Library.

ISBN-13: 978-1-8589-4210-0
ISBN-10: 1-8589-4210-1

Produced by Merrell Publishers
Designed by Tim Harvey
Copy-edited by Diana Loxley
Proof-read by Barbara Roby
Indexed by Hilary Bird

Printed and bound in China

Front jacket: *Steamboat Landing* (cat. 1).
Back jacket, clockwise from top left: *Boiler Maker's Shop*
(cat. 8), *Depot of St Charles St. R. Road* (cat. 93), *Bayou St.
John* (cat. 28), *St. Charles Hotel* (cat. 64).
Pages 2–3: Detail of *St. Louis Hotel* (cat. 14).

This publication was made possible by
generous support from:

The Marjorie and John Geiser Fund of the Southeastern
Architectural Archive, Tulane University, New Orleans

swiss arts council

prohelvetia

LOUISIANA
ENDOWMENT
FOR THE
HUMANITIES

The Grace Slack McNeil Program in the History
of American Art, Wellesley College

Canton of Thurgau/Napoleon Museum

Dedicated, with appreciation, to my parents
and to the memory of an esteemed teacher,
Francis H. Dowley (†2003).

Notes on the text

Frequently cited sources are referred to in the text by
abbreviated titles; their full publication details can be found
on pp. 296–97. NONA (New Orleans Notarial Archives)
and NARA (National Archives and Records Administration)
are abbreviated throughout. Newspapers cited in the text
were published in New Orleans unless another location is
given; see p. 296.

The titles of the catalog entries match those given in
La Nouvelle Orléans et ses environs; errors and inconsistencies
are therefore reproduced. These are discussed on p. 57, n. 10.

The street names of 1867 have been used, with modern
names, if different, given in parentheses. Jackson and
St. Charles streets, both now known as "Avenue," are not
glossed in the text.

Contents

Preface

Conceived "for the purpose of further advertising the city of New Orleans" and to "illustrate the chief center of the Southern and Western trade of the United States," Theodore Lilienthal's photographic campaign for the Paris Exposition of 1867 is a virtually unparalleled visual document of citybuilding and civic boosterism in the Civil War and Reconstruction era. His topography of the city and its faubourgs, the Mississippi River and Lake Pontchartrain, sponsored by the city, produced 150 large (12 × 15-inch/30 × 38-cm) albumen prints gathered in luxurious portfolios bearing the title *La Nouvelle Orléans et ses environs*. At the close of the Exposition, the city presented the photographs to Emperor Napoléon III to commemorate New Orleans's colonial ancestry and the "bonds of commercial interest" that had tethered the city to French markets for most of its history. It was this trade, severed by the war, that boosters hoped to restore, and the entire campaign expressed the aspirations of New Orleans to "retrieve lost fortunes and advantages" and the antebellum commercial supremacy it had so profitably enjoyed.[1]

Only recently discovered, *La Nouvelle Orléans et ses environs* can now be recognized as one of the outstanding achievements in nineteenth-century urban photography, and the first-known municipally sponsored photographic survey of an American city. This accomplishment is all the more remarkable as Lilienthal himself, prominent in the photographic fraternity of his time, is virtually unknown today. Both his career and the photographs that were his greatest achievement follow the trajectory of early recognition, obscurity, and later rediscovery characteristic of Civil War-era commercial photographic practice. The German-born Lilienthal, who was in his late thirties at the time of the Exposition commission, had established a successful portrait practice before the war, and by 1866 was recognized as the city's leading topographic photographer. The Exposition campaign and a Paris prize medal (Lilienthal and Carleton Watkins were among four American photographers honored at the 1867 Exposition) brought Lilienthal commercial success (he published many of the same subjects in the low-cost stereoview format that was rapidly gaining popularity in the late 1860s), and over the next decade he operated an increasingly large studio that

industrialized the production of stereoviews and pioneered, locally, prestige processes in portraiture. By 1880, Lilienthal was "doing the leading photographic business in the city," but during the following decade he was bankrupted and burned out of two studios.[2] He died in 1894, leaving no successor and no negatives. Historic recognition of his work has been confined to scant mention of the portraiture and scenographic stereoviews that were the bread and butter of his commercial practice.

The history of Lilienthal's portfolio follows a similar course. Retained in the imperial household after presentation to Napoléon III, the New Orleans photographs survived with other Second Empire artifacts following the emperor's deposition in 1870 and his death three years later. No negatives and only one duplicate print from the Exposition portfolio are known to have survived in New Orleans, and memory of the portfolio was lost with Lilienthal's death. In 1906, the photographs—126 of the original 150 plates—were inventoried among family heirlooms in the chateau in Arenenberg, Switzerland, that had been the emperor's boyhood home. For nearly another century the photographs remained unseen publicly and unknown outside the Arenenberg estate, which the canton of Thurgau opened as a museum. Identified in the collections of the museum, today known as the Napoleon Museum, in 1994, *La Nouvelle Orléans et ses environs* was exhibited in New Orleans six years later, for the first time since 1867.

How can we account for a work of this significance, and for the photographer himself, being overlooked for so long? Although the luxurious presentation of the photographs (and the patronage referenced in the portfolio's decoration) signaled their importance, the context of their commission was unknown—largely because one of New Orleans's most accomplished photographers remained unrecognized (apart from the stereocards, cartes de visite, and cabinet cards ascribed to him). Documentation of Lilienthal's forty-year commercial practice was scant, and when his only living descendant offered papers and artifacts from his career, including his Exposition medal, to a museum in the 1960s, they were deemed not of sufficient interest.

Lilienthal's obscurity was shared by other commercial photographers of his era, especially in the South, and topographic photography in particular was underappreciated or overlooked

in America for most of the twentieth century, certainly by curators, and even by historians of architecture and the city. Topographic views could be found in the vertical files of libraries, which bulged with unidentified and undated "miscellaneous" prints, their marks of authorship ignored. In their neglect they shared a similar history with architectural drawings, the other visual documents that they often complement and corroborate. The makers of these photographs were often more obscure than their subjects, but the reverse could also be true. City views by New Orleans's best-known photographer, E.J. Bellocq, for example (whose Storyville portraits have received much critical attention), can still be found, unattributed, in library files, his blindstamp clearly visible. Much of the output of the topographic photographers was preserved in card formats, especially stereoviews (often cut in half to enhance their readability as documents), which still occupy the lowest rung of the art-historical ladder of photographic media.

As with architectural drawings, a growing interest in topographic photography arose from the recognition of a loss of urban heritage and the renewed value given to documentation of place at the American Bicentennial. As local historians and preservationists searched for the documents to inform their work, recognition of value and loss stimulated archiving, preservation, and interpretation (for buildings, the interest in preservation extended to the documents as well as the structures of nineteenth-century architecture, for both had been lost in staggering numbers). "The piles of old pictures, boxes of glass negatives, and stacks of tattered photo albums that have been closeted in historical societies, libraries and archives are beginning to be organized," one historian wrote in 1980.[3] Handbooks, dictionaries, and checklists compiled by William Welling, William Darrah, and others established the outlines of commercial photographic practice and admitted the entire range of nineteenth-century studio output including topographic work (referencing Lilienthal's work for the first time since his death).[4]

But historians, as "students of the word," remained uncomfortable with photographs as historical evidence.[5] "We in the 1970s must consider photographs as a historical source," one historian wrote; "Until this decade photographs have been used only as illustrative material."[6] Another writer observed in 1978

7

that although "recently it has been clearly acknowledged that a photograph is a document ... the research potential of historical photographs has not yet been fully realized."[7] Gavin Stamp noted in 1984 that in urban history "comparatively little use was made of [photographs] until recently," and John Kouwenhoven observed that historians were "only beginning to appreciate their documentary value," predicting that the study of photographs would "lead to a new kind of history."[8] Peter Hales, whose book *Silver Cities: The Photography of American Urbanization, 1839–1915* established urban topographic photography as a field of study, prefaced his history, first published in 1984, with the observation that "little research has been done on the iconography of the American city, or on nineteenth-century urban photographs in general."[9] It was at this time that the first history of New Orleans photography appeared, publishing several of Lilienthal's photographs with reference to his early career.[10]

It may be useful in this connection to look back seventy years to Robert Taft's *Photography and the American Scene* (1938), which embarked on a field that the author claimed "had no previous historian."[11] A chemist by training, Taft wrote a broad social history of the first half-century of photography in America, treating portrait, landscape, and topographic work—all the pursuits of commercial photographic practice—equally.[12] "Are photographs historic documents?" he asked. "[T]hat the photograph gives a vivid and valuable supplement to written history cannot be denied," he wrote, "... [but] Whether the photograph truthfully records the past must be determined by actual study."[13] Reviewing Taft's work, the *New York Times* wrote: "Enough has been brought to light by Professor Taft to indicate that the next step must be preservation and classification of these visual historic records," but it was several decades before that step was taken.[14]

"Surely the real value of photography," Gavin Stamp wrote, "is as an accurate and vivid recording device, which has preserved the appearance of streets long altered and buildings long demolished."[15] For New Orleans, Lilienthal's photographs are the primary record of the visual landscape of the city before the war. In 1867, the city's "street-physiognomy," as one writer described it, was antebellum.[16] Five years later, when Lilienthal simulated his Paris Exposition campaign (on a smaller scale) for

the city's first booster book, *Jewell's Crescent City Illustrated*, the city fabric remained primarily prewar; only a scattering of buildings photographed were erected after the war. New Orleans had not experienced the extraordinary entrepreneurial fervor that remade Atlanta and other cities of the New South, which were to surpass the former Queen City of the South in population and commercial influence. As other photographers were busy recording citybuilding south and north—especially new commercial districts and railroad facilities—often as works in progress, Lilienthal recorded in 1872 many of the same structures and streets as they appeared in *La Nouvelle Orléans et ses environs*, and was even able to reprint some of the earlier views.[17] New Orleans's business district was finally updated late in the century, when the city could claim to have at last "resumed its place among the World's ascendant cities."[18] This commercial renascence, and the new construction that accompanied it, was the death knell for many of the buildings represented in the Lilienthal views. But, fortunately, urban renewal as it played out in the second half of the twentieth century in New Orleans did not sweep away the Vieux Carré, and stopped well short of disemboweling the commercial district, as it had in many other cities. We can still experience New Orleans much as a northern journalist saw it in 1865: "the most luxurious, the most unprincipled, the most extravagant, and, to many, the most fascinating city in the Union."[19]

This book is about a city and its aspirations, and a photographer and his ambitions, and how they came together to create a powerful image of citybuilding for a world audience. To place the photographer and the city in what is hoped to be a meaningful juxtaposition, I have taken several directions. Lilienthal is understood as a viewmaker and a "practical photographer" who achieved a work of extraordinary ambition for his time. I look at how he carried out his work, his parallel work in other campaigns and formats, and the sources for his topography of the city. Another context is New Orleans itself, shattered by war, seeking to construct an image in its own memory of an ascendant past. If city boosters generally have consistent aims, the New Orleans case takes on its own form, using photography as a vehicle for expressing municipal aspirations. Finally, through commentaries on the photographs, I have attempted to desediment Lilienthal's city of

1867. To create an understanding of urban change in New Orleans, I have relied on the stories of travelers, journalists, and diarists. Whatever its fate, New Orleans was always liberally observed and recorded by visitors as well as residents, and by photographers—never more successfully than by Lilienthal himself.

Postscript, August 2007

New Orleans has been shaped by disaster more than perhaps any other major American city; certainly few cities in the country have been reconstructed more often. Floods, hurricanes, epidemics, fires, and war have for nearly three centuries imperiled the vulnerable, but resilient, city. In August 2005, a new image of the fated New Orleans emerged, as hurricane Katrina brought devastation on a scale virtually unprecedented in modern America. Photographers left an unforgettable record of flight, desperation, rescue, and ruin—of the destruction of homes, livelihoods, and lives.

New Orleans experienced different half-lives in the catastrophe. The oldest buildings, including those that survived from Lilienthal's city of 1867, remained mostly intact. There were significant exceptions: the Mint, Custom House, and several nineteenth-century churches sustained extensive wind and water damage; Jackson Barracks (adjacent to the Ninth Ward) came under 10 feet (3 m) of water and was heavily damaged; and at City Park, thousands of trees were destroyed in the deluge. Some institutions that had been rebuilt after the Civil War were rebuilt again, but others were lost. Charity Hospital, for example, founded in 1736 and one of the two oldest institutions documented by Lilienthal, was ruined and remains closed as a result of floodwater damage. Much of the twentieth-century city built on reclaimed land was lost. So was much of the population. Forced to flee or evacuate, the diaspora returned weeks and months later, but many fewer than before. The city was expected to reconfigure itself with a population close to that of 1867.[20] Geographer Peirce Lewis predicted that "the shape of the city as drawn on a map will look very much as it did before ... [the] great pumps dried out the backswamp and opened it to what has now proved to be reckless residential development."[21] It was this backswamp that was so vividly pictured by Lilienthal (figs. 1 and 2), nearly a century before it was drained and developed.

In the aftermath of Katrina, New Orleans was awash in the rhetoric of reconstruction and renascence, much as it had been in 1867; a visiting French minister put a spin on the old colonial covenant that recalled Napoléon III's recognition of the city's French ancestry.[22] The challenges of revitalizing and repopulating the city seemed almost insurmountable, but a very resolute citizenry reasserted the city's viability and renewal took hold. The new New Orleans is certainly very different, yet much the same: the city's livelihood depends more than ever on the tourist-historic center, which rebounded quickly after the floodwaters subsided.

The Katrina disaster brought New Orleans into a realm of memory and loss that recalled the historical record of Reconstruction, of Lilienthal's city of 1867. Enveloped for three generations by the tragedy of secession, New Orleans is, once again, struggling to reconcile the city of the past and the reconstructed city, in the shadow of an event that appears to have been even more catastrophic than the Civil War.

1. *Report of Edward Gottheil*, pp. 6–8; New Orleans Public Library, City Archives, Minutes and Proceedings of the Board of Aldermen, X, March 19, 1866–August 28, 1868, Mayor John T. Monroe to the Board of Assistant Aldermen, January 9, 1867.
2. *Louisiana*, XVI, p. 425, R.G. Dun & Co. Collection, Baker Library, Harvard Business School.
3. Renee Friedman, "Photobooks," *Association for Preservation Technology Bulletin*, XII, no. 4, 1980, p. 68.
4. William Welling, *Collector's Guide to Nineteenth-Century Photographs*, New York (Collier Books) 1976; *id.*, *Photography in America: The Formative Years 1839–1900*, New York (Crowell) 1978; William Culp Darrah, *The World of Stereographs*, Gettysburg, Pa. (The Author) 1977 [first published in 1964]; *id.*, *Cartes-de-visites in Nineteenth Century Photography*, Gettysburg, Pa. (The Author) 1981. See also pp. 49–50, n. 4 and 5, for the Lilienthal bibliography.
5. Neil Harris, "Iconography and Intellectual History: The Half-Tone Effect," in *New Directions in American Intellectual History*, ed. John Higham and Paul K. Conkin, Baltimore (Johns Hopkins University Press) 1979, p. 200.
6. Michael Thomason, "The Magic Image Revisited: The Photograph as a Historical Source," *Alabama Review*, XXXI, no. 2, April 1978, p. 84. An exception was the pioneering work of historians Harold M. Mayer and Richard C. Wade, *Chicago: Growth of a Metropolis*, Chicago (University of Chicago Press) 1969, which used photography as evidence for Chicago's physical growth.
7. Joan M. Schwarz, "The Photograph as Historical Record: Early British Columbia," *Journal of American Culture*, IV, no. 1, Spring 1981, p. 65 (originally published in 1977/78).
8. Gavin Stamp, *The Changing Metropolis: Earliest Photographs of London 1839–79*, London (Viking) 1984; edn. used London (Penguin) 1986, p. 10; John Kouwenhoven, *Half a Truth is Better than None: Some Unsystematic Conjectures about Art, Disorder, and American Experience*, Chicago (University of Chicago Press) 1982, pp. 185, 190. Observations on the use of photography as historic documentation were legion in the wake of the Bicentennial; see, for example, Marsha Peters and Bernard Mergen, "'Doing the Rest': The Uses of Photographs in American Studies," *American Quarterly*, XXIX, no. 3, 1977, pp. 280–303; Michael Thomason, "The Magic Image Revisited: The Photograph as a Historical Source," *Alabama Review*, XXXI, no. 2, April 1978, pp. 83–91; Alan Trachtenberg, "Photographs as Symbolic History," in *The American Image: Photographs from the National Archives, 1860–1960*, New York (Pantheon Books) 1979, pp. ix–xxxii; Mark Roskill, "History and the Uses of Photography," *Victorian Studies*, XXII, no. 2, Winter 1979, pp. 335–44; Thomas J. Schlereth, *Artifacts and the American Past*, Nashville, Tenn. (American Association for State and Local History) 1980, pp. 11–47; Justin Kestenbaum, "The Photograph: A 'New Frontier' in Cultural History," *Journal of American Culture*, IV, Spring 1981, pp. 43–46; James Borchert, "Analysis of Historical Photographs: A Method and a Case Study," *Visual Communication*, VII, no. 4, Fall 1981, pp. 30–63; Richard Rudisill, "On Reading Photographs," *Journal of American Culture*, V, Fall 1982, pp. 1–14; Robert Bishop McLaughlin, "The Evaluation of Historical Photographs," *Art Documentation*, VIII, no. 2, Summer 1989, pp. 55–60.
9. Peter Bacon Hales, *Silver Cities: The Photography of American Urbanization, 1839–1915*, Philadelphia (Temple University Press) 1984, p. 5 (revised edition, *Silver Cities: Photographing American Urbanization, 1839–1939*, University of New Mexico Press, 2005).
10. Smith and Tucker, pp. 108–109, 136–38, 163. A Lilienthal portrait had been published as a tipped-in frontispiece in a photography journal in 1882, see below, p. 48. Already in the late 1970s, two exhibition catalogs brought out the work of George Mugnier, the French-born photographer who can be said to have inherited the mantle of the topographic record of New Orleans from Lilienthal: Lester B. Bridaham, ed., *New Orleans and Bayou Country: Photographs 1880–1910 by George François Mugnier*, New York (Weathervane Books) 1972; John R. Kemp and Linda Orr King, eds., *Louisiana Images, 1880–1920: A Photographic Essay*, Baton Rouge (Louisiana State University Press) 1975.
11. Robert Taft, *Photography and the American Scene: A Social History, 1839–1889*, New York (Dover) 1964 [reprint of 1938 edn.], p. viii.
12. Taft's work (he died in 1955) deserves further study; despite the influence of his book, he is not mentioned in either of two recent historiographies of photography: Martin Gasser, "Histories of Photography 1839–1939," *History of Photography*, XVI, no. 1, Spring 1992, pp. 50–60; or Anne McCauley, "Writing Photography's History before Newhall," *History of Photography*, XXI, no. 2, Summer 1997, pp. 87–101. The Taft papers are at the Kansas State Historical Society (Mss. col. 172).
13. Taft, *Photography and the American Scene, op. cit.*, pp. 314, 316, 320.
14. S.T. Williamson, "Early American Photography," *New York Times*, December 25, 1938. The reviewer noted that in local history archives and "unransacked attics" were thousands of photographs that "mirrored the lives and surroundings of inhabitants of the middle quarters of the nineteenth century." But it was not until the pioneering work a year later of John Kouwenhoven, and of Harold M. Mayer and Richard C. Wade, that full use was made of photographs as evidence for urban history (John Kouwenhoven, *The Columbia Historical Portrait of New York*, Doubleday & Company 1953; Harold M. Mayer and Richard C. Wade, *Chicago: Growth of a Metropolis*, University of Chicago Press 1969). Kouwenhoven argued that photographs served as historic documents in two ways: as a "source of factual information on topography, manners, and customs which is available nowhere else," and as "a clue to attitudes and interests, to blind spots and perceptions, of which there may be no other surviving evidence" (Kouwenhoven, *op. cit.*, p. 11).
15. Stamp, *op. cit.*
16. The term was used by the antebellum author Joseph Holt Ingraham, *The South-west, by a Yankee*, New York (Harper & Brothers) 1835, I, p. 159.
17. Apart from two stalled federal projects, cats. 14 and 42, there is only one construction site, cat. 73, recorded in either of Lilienthal's campaigns of 1867 or 1872.
18. *The Resources and Attractions of Progressive New Orleans, the Great Metropolis of the South*, New Orleans (Young Men's Business League) 1895, p. 11.
19. Whitelaw Reid, *After the War: A Tour of the Southern States 1865–1866*, ed. C. Vann Woodward, New York (Harper & Row) 1965 [reprint of 1866 edn.], p. 234.
20. Adam Nossiter, "New Orleans Population is Reduced Nearly 60%," *New York Times*, October 7, 2006. In fact, by the summer of 2007 the city appeared to have recovered nearly sixty-eight percent of the pre-Katrina population, or about 280,000; "New Orleans Population Indicators for July 2007," Greater New Orleans Community Data Center, online at gnoc.org, accessed September 12, 2007.
21. Peirce Lewis, "Learning from the Past and Predicting the Future of a Great American City," *Sitelines*, XI, no. 11, Spring 2007, p. 14.
22. Adam Nossiter, "France Reconnects to an Old Acquaintance, la Nouvelle Orléans," *New York Times*, November 5, 2005.

Introduction

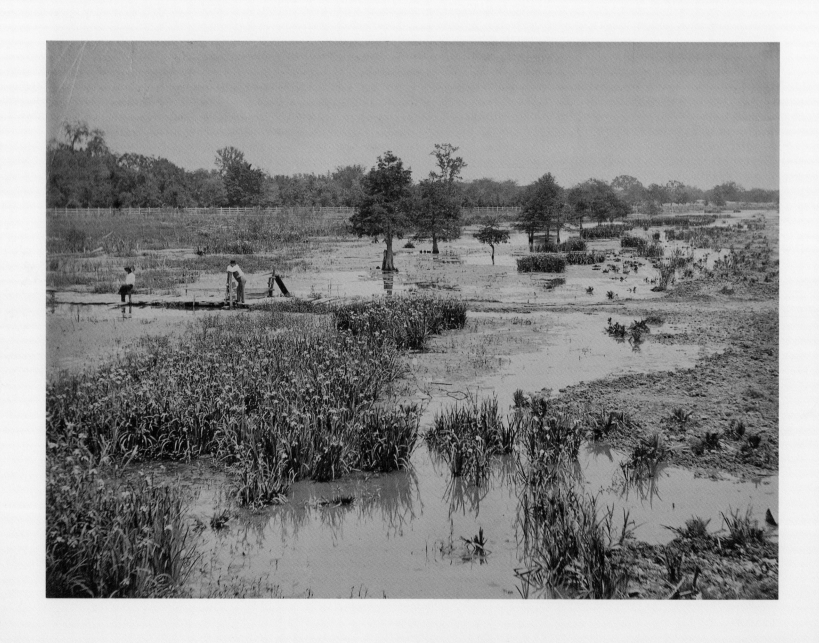

"New Orleans, perhaps with the exception of Charleston and Atlanta, has suffered more from the devastation of the past four years of war than any city in the South," the *True Delta* declared in 1866.[1] The devastation of New Orleans in the Civil War was evident not in charred ruins but in the destitution of what had been the wealthiest city in the South. "The cotton mountains vanished; the sugar acres were cleared, grass grew on the vacant levee," one soldier reported. "The commerce of the city was dead."[2] New Orleans and its great port had fallen faster and farther than any city during the war, from nearly unrivaled commercial supremacy to scarcity. "Who would have believed that prosperous, gay, bragging New Orleans would come to such grief and poverty!" author John W. De Forest wrote. "Business gone, money gone, population gone."[3]

In 1867, two years after the end of the war, the tragedy of New Orleans was the "state of utter hopelessness," as Mayor Edward Heath described it, of a population anguished "not only by recollections of their past misfortunes, and by the pressure of the present difficulties, but by the clouds that lowered over their future prospects."[4] Devastated by the defeat of their way of life and, in one resident's words, "the humiliations heaped upon us" by the conquering army that now occupied their streets, many Orleanians felt little continuity with the ascendant city of the decades before the war, when New Orleans's citybuilding and population growth surpassed those of most other large urban places in America.[5] "Oh! the delicious memories of the city of old!" one writer exclaimed; "... Sad changes the war has wrought since then!"[6]

For the city, recovery and reconstruction were in part a matter of image-building. Regaining antebellum commercial supremacy meant restoring trade to familiar channels, and New Orleans needed to reassure France and other former European trading partners that the city had not been ruined in the war, was getting back on its feet, and remained a good place to invest and do business. Above all, New Orleans looked to Europe for immigrant labor to restore to productivity the war-ruined sugar and cotton plantations that fueled the city's economy. "We must depend largely upon

Fig. 2 Theodore Lilienthal, *Swamp View*, albumen silver print, from *Jewell's Crescent City Illustrated*, prospectus, 1872. Hill Memorial Library Special Collections, Louisiana State University.

foreign immigration to make productive the numberless wasted and devastated fields that supply our markets," the *True Delta* wrote,[7] a call echoed by city boosters: "We want population and must employ every particular mode of attracting it."[8]

"A Laudable Feeling of Pride"

Within months of the end of the war, the U.S. Congress weighed American participation in what promised to be the great globalizing event of the decade, the World Exposition of 1867 in Paris.[9] With a strong presence at Paris, President Andrew Johnson argued, the United States could demonstrate "that, notwithstanding the war which has devastated our land and homes, we can yet show evidences of progress which will surprise ourselves."[10] In the summer of 1866, "amid ... the political troubles and perils" of Reconstruction, Congress appropriated funds for exhibition space at Paris and called on the states to prepare exhibits.[11] Louisiana Governor J. Madison Wells appointed twenty-eight commissioners, largely from New Orleans's business elite, to organize Louisiana's participation in the Exposition, and selected a German-born architect and builder, Edward Gottheil, to head the delegation.[12] Louisiana "heard the invitation," Gottheil wrote,

> and notwithstanding that she had so recently emerged from a protracted war, thought this a fitting opportunity of showing to an intelligent world her unbounded resources, the productiveness of her soil and her commercial facilities. She hoped to show, too, that by an influx of immigrants and capital into her borders she could inaugurate a new system of labor, and thus retrieve lost fortunes and advantages, and finally make New Orleans the great metropolis which nature destined her to be.[13]

Commissioners solicited contributions of rum, chocolate, hats, boots, billiard cushions, saddles, and architectural drawings.[14] But the most competitive exhibits were agricultural—Louisiana cotton, sugar, and tobacco. "A laudable feeling of pride has been stimulated among our people to see our State represented at the great world's exhibition," the governor declared.[15]

La Nouvelle Orléans et ses environs

In January 1867, the Exposition commissioners sent to the New Orleans city council an unusual proposal. The presentation at Paris would be strengthened, commissioners argued, by the use of photography "to convey an idea" of the "internal appearance" of New Orleans, and advertise the city abroad.[16] The commissioners urged that under the council's "authority and supervision, a portfolio be prepared ... illustrating the principal streets, squares, public buildings, levee, river, etc.," with portraits of the mayor and council, for exhibition at Paris and presentation to the Emperor Napoléon III:

> As this work is designed to illustrate the chief center of the Southern and Western trade of the United States, and to be dedicated to the head of a great nation with whose people and associations the State of Louisiana is identified by the bonds of history, language, and commercial interest, we respectfully suggest that it should be designed and executed in the most artistic style, and regardless of the cost.[17]

The proposal originated with Commissioner James Barry Price, one of the city's most successful entrepreneurs, who was reportedly "devoting his large means and abilities to numerous schemes for the advancement and development of New Orleans and the stricken South."[18] From Price's suggestion, Commissioner Gottheil wrote, "the city authorities were induced to send [to Paris] a large number of photographic views of our principal private and public buildings, together with street and levee scenes, the surroundings of the city and Lake Pontchartrain."[19] Presentation of the portfolio to the emperor, proposed for the close of the Exposition, was intended to renew and strengthen "that sympathy which, for the most natural reasons, had always existed between the people of the French Empire and the inhabitants of Louisiana," the commissioners wrote. The campaign would also promote New Orleans as "a residence and place of business for artists, artisans, capitalists, etc.," thereby fulfilling boosters' aims to attract immigrant white labor from Europe.[20]

The council took about a month to endorse the commissioners' proposal. The Board of Aldermen, against some opposition, voted in an appropriation of $2000 for the photographs on February 8.[21]

The measure then required approval by the other chamber of New Orleans's bicameral government, the Board of Assistant Aldermen. Alderman James Prague immediately came out against the expenditure. "Mr. Prague thought $100 would be a more appropriate sum than $2000," the *Crescent* reported. "He could not see the use of honoring the Emperor of the French with either pictures of the city or of the members of the boards." Following a "violent discussion" over the proposition, it failed to gain approval, but was reconsidered ten days later. Prague held firm in his opposition: "What was the good of sending a gilt-edged portfolio to the Emperor Napoleon, who is sitting in purple and fine linen," he argued, "while children and women here at home are crying for bread?" But boosters prevailed after it was brought to a vote, and on February 26 a council majority authorized the campaign.[22]

"We understand that Mr. Lilienthal, the photographer on Poydras street, will be selected as the artist for carrying out this design," the *Crescent* announced.[23] The selection of Theodore Lilienthal, who had recently been awarded a major federal photographic commission and prizes for his city views in local competition (see pp. 44–45), was confirmation of his standing as the city's leading topographic photographer. The *Deutsche Zeitung* also reported, and endorsed, the selection of Lilienthal, well known to the newspaper's German-speaking readers, while also echoing Alderman Prague's earlier objections to the publicly financed campaign. "Although we do not approve the matter from the standpoint of the costs which will thus accrue to the city," the *Deutsche Zeitung* wrote,

the city council has made an excellent choice that we must applaud. In fact, Mr. Lilienthal's studio has gained increasing popularity because in photographing scenery and social events he has acquired a reputation of taking the most naturally accurate views.[24]

A list of subjects supplied by Lilienthal to the *Crescent* provides a partial program for his twelve-week campaign to produce one hundred and fifty 12 × 15-inch (30 × 38-cm) views. "The selections are good ones," the *Crescent* wrote, "and embrace every prominent feature of interest."[25] Many of the subjects were institutional and commercial buildings and the riverfront wharves and landings in the First and

Second districts—the Creole Vieux Carré and Anglo-American commercial quarters. But Lilienthal's view path also took him or his operators downriver beyond the U.S. military barracks and as far as the sugar lands of Plaquemines Parish, 15 miles (24 km) below the city; upriver as far as the suburbs of Greenville and Carrollton; and out along the Bayou St. John and the backswamps to the shore of Lake Pontchartrain and the lakefront villages and resorts. Opposite the city, on the West Bank of the Mississippi River, he photographed the villages of Belleville and Algiers, and at the U.S. Navy anchorage 2 miles (3.2 km) downriver (see pp. 62–63).

In late May, Lilienthal exhibited the finished photographs at his Poydras Street studio. "Mr. Lilienthal has just completed one-hundred and fifty photographic and fifty stereoscopic views of this city and vicinity, which are very creditable to the artist," the *Crescent* reported on May 26. "Our public buildings, squares, statues and our great levee, with its wealth of produce, and fleet of steamers, steamships and sailing craft, have merited prominence, while our handsome residences have not been overlooked."[26] The *Crescent* included a shortlist of subjects that, with the paper's earlier announcement of Lilienthal's commission, is the most complete inventory of the portfolio contents. The prints were mounted on gold-trimmed card stock, captioned in English and French, and ascribed to Lilienthal, and may have already been gathered in portfolios bearing the title *La Nouvelle Orléans et ses environs*.[27] Announcing that "Mr. Lilienthal intends to make duplicates of these views and to exhibit those for sale," the *Deutsche Zeitung* assured its German-born readers that the photographs would "give our friends in Europe a correct idea of the size and importance of New Orleans and the numerous places worth seeing in this city, and will therefore create a very favorable impression concerning our conditions."[28] The *Times*, too, suggested that the Exposition visitor "would at a glimpse of this series of pictures recognize the main features of New Orleans," and added:

The views are all as eloquent as a photograph can be, and are cast in a style of great nicety and finish. Some of them are particularly chaste, in the fact that passers by are taken while in the act of making a step. ... the collection may be pronounced

the most complete of the kind ever arranged in this city.[29]

On June 4, Lilienthal prepared to ship the photographs to Paris.[30] The *Crescent* reported that they would be couriered by Samuel N. Moody, merchant and industrialist and an Exposition commissioner, whose residence and shop Lilienthal photographed for the portfolio (cats. 20 and 21).[31] But Moody's departure was delayed, the *Commercial Bulletin* wrote, "on account of the dilatoriness of the operator who was preparing the photographic views."[32] Moody finally left the city on June 10 bearing the photographs:

The splendid album of views of the city of New Orleans and surrounding area was sent to his Majesty Emperor Napoléon III by Mayor Heath yesterday. On this occasion, Mayor Heath wrote a rather long letter to the Emperor in which he touches on the colonization of Louisiana by the French, the cessation of the French province to the U.S., and the increase, growth, and commercial flowering of the city, and expresses his hope that the ties between the inhabitants of New Orleans and Louisiana and their countrymen in France remain close.[33]

"The Biggest Thing of the Age"

As Lilienthal was carrying out his commission in New Orleans, final preparations were underway in Paris for the opening of the Exposition. Using rhetoric typically associated with world expositions, the New Orleans press saw the fair as the "biggest thing of the age" and "one of the grandest and most perfect displays of the inventions, industrial accomplishments, and the general products of the nations of the earth which has yet occurred."[34] "Thousands of our people expect to visit Paris during the grand Exhibition," the *Picayune* wrote, but even with special Exposition rates for transatlantic steamship passage the lowest fare was $165 in gold— "pretty round sums to be paid in these lean times," and too costly for many Orleanians.[35]

Napoléon III opened the Exposition on April 1. "All [are] hurrying to the neighborhood of the Champ de Mars," the *Picayune*'s Paris correspondent reported, "some climbing the 59 steps to the summit of the Trocadero to catch a bird's-eye view of the whole Palace and park,

and the splendid landscape which lies on either side, that cynosure of the world for six months to come" (fig. 3).[36]

The main exhibition hall, built of iron and glass, covered nearly 7 million square feet (650,000 sq. m; fig. 4).[37] Part of the structure utilized an innovative iron-truss system designed by J.-B. Krantz and engineered by Gustave Eiffel.[38] Some 50,000 exhibits were arranged in seven concentric galleries that covered the Exposition's major themes: the "history of work" (*histoire du travail*), fine arts, liberal arts, furniture and interior decoration, textiles and raw materials, machinery, and, at the outer ring, a food court displaying national cuisines. Intersecting radial avenues segmented the rings into national exhibitions, so the visitor could move through the various classes of exhibits within a single country. But the arrangement was disorienting to many visitors, including novelist Arthur Sketchley's character in *Mrs. Brown's Visit to the Paris Exposition*: "They tells me that Exposishun is arranged in horder, but I'm blessed if I could make 'ead or tail on it, for I kep' a-wanderin' on, and seein' the same things over and over again."[39] Confusing in plan, and "irreclaimably ugly," according to the *New York Times*, the exhibition building was, to most observers, a failure. One of the U.S. commissioners found it "singularly deficient in architectural display and merit,"[40] and a New Orleans visitor saw it as "hideous": "Its flatterers call it a

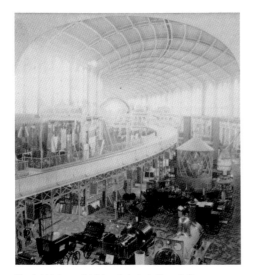

Fig. 4 M. Léon and J. Lévy, *Galerie du Travail, Vue d'Ensemble, Section Amérie* (American section of the exhibition "History of Work" and the adjacent galleries of the fine and applied arts, Machine Hall, Paris Exposition of 1867), stereoview (detail), 1867. Bibliothèque Nationale.

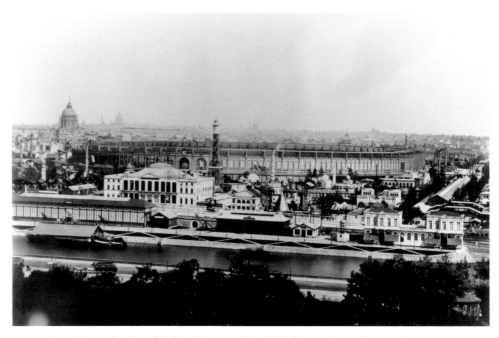

Fig. 3 Unknown photographer, *View of the Exposition grounds, Paris, 1867*, albumen silver print (the American grounds cover the lower right corner of the Champ de Mars). Southeastern Architectural Archive, Tulane University.

gasometer. Spiteful folks liken it to a spittoon. Dub it what name you please. It makes no pretentions to beauty, not even to that beauty of lightness which was predicted would prove iron's beauty."[41]

Surrounding the exhibition hall, the open landscaped park on the Champ de Mars was planned by Adolphe Alphand, Georges Haussmann's park designer and boulevard landscaper, for the national pavilions.[42] It was the first world's fair where countries were invited to contribute their own buildings, and the plan resulted in a hodgepodge of 101 structures in a "magnificent incongruity" of types and styles.[43] A full-sized Gothic cathedral was located in the carnival-like grounds, and a Chinese teahouse, where young Chinese women, exempted from the prohibition on foreign travel, poured tea and painted fans, but served only meals of steak and fries.[44] A sensation was an American restaurant where many Europeans tasted stewed oysters, succotash, and other American foods for the first time.[45]

A workers' housing competition organized by the economist and director of exhibitions Frédéric Le Play issued a call for displays of "cheap and comfortable accommodations for the working classes."[46] In response, U.S. Commissioner General N.M. Beckwith encouraged American exhibitors to contribute "habitations" that would demonstrate to

Europeans "immobilized in poverty" how they could "quickly and easily achieve success in America."[47] Derived from this program, the Louisiana exhibition on the Champ de Mars, the *Maison portative de la Louisiane*, was a prefabricated immigrant cottage that could be erected easily at a plantation or other site where temporary worker housing was needed (figs. 5 and 6; see pp. 57–60).[48] Fabricated in New Orleans under the supervision of Gottheil and fellow commissioner, architect Thomas Murray, the cottage was dismantled and shipped to Paris in late February, but a conflict with Commissioner General Beckwith delayed its installation on the Champ de Mars until mid-June.[49] Other Louisiana exhibits were "scattered through four groups, in fourteen classes," in the American Section of the exhibition building, Gottheil reported.[50]

The American showing at the Exposition was a disappointment. "The American display is limited in extent, late in arrival, and second-rate in opportunity," one visitor observed, and *Harper's Monthly* found it "a failure beyond repair."[51] To the *Picayune* the national galleries were "nearly the worst looking in the whole exhibition ... the whole section looks empty, poor and insignificant to a mortifying degree."[52] Critics saw the United States as ill-prepared for an international exposition and for "advertising itself abroad" at a moment when "one third of its territory was in ruin or

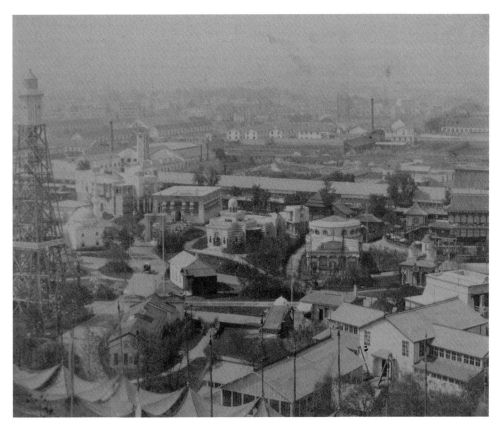

Fig. 5 *Louisiana Cottage in the Champ de Mars, Paris World Exposition of 1867.* M. Léon and J. Lévy, *Panorama du Parc, près du Phare*, stereoview (detail), 1867. Southeastern Architectural Archive, Tulane University.

desolation."[53] Some observers blamed insufficient government funding—what the *New York Times* called "the shabby way Congress has acted ... in refusing to appropriate the small sum required to give our country a fair representation"—and saw a repetition of the humbling United States showings at the fairs of 1855 and 1862.[54] "Our show appears, indeed, humiliating and insignificant when contrasted with the rich display ... of the leading European nations," one journalist remarked.[55]

American photography, underfunded and late, like nearly everything else sent to Paris, was also poorly received, although there were important entries, including Carleton Watkins's views of Yosemite Valley, Lawrence & Houseworth's series of Pacific Coast views, and Alexander Gardner's *Photographic Sketchbook of the Civil War* and views of Washington. German critic Hermann Vogel, writing in the *Philadelphia Photographer*, observed that "Americans do not seem to take much interest in these matters" of photography. Displayed with the state exhibits, the American photographs "seemed lost among the

thousand and one other things," Vogel wrote.[56] Photography jurors, who included Vogel himself and photographic chemist and process inventor Abel Niépce de Saint-Victor, reportedly "called three or four times on the American department" but could not locate even half of the nineteen entries cataloged.[57]

Lilienthal's *La Nouvelle Orléans et ses environs* was among the last American exhibits to reach Paris, in mid-July, fourteen weeks after the opening of the Exposition—so late that many visitors and the jurors missed them altogether.[58] Nevertheless, the photographs were "much admired," according to the *Picayune*: "Every Louisianian recognizes some familiar spot, and all give great credit to Mr. Lilienthal, the artist."[59] In a letter to Lilienthal, "the ladies of New Orleans, now sojourning in Paris," expressed their "admiration for the masterly execution of the Photographic views of New Orleans, destined as a Royal present" and thanked the photographer "for the sweet memories of home."[60]

The Exposition was, above all, an international awards competition, and at the July prize-giving ceremonies the emperor

presided before an audience of 25,000 in the main exhibition hall, arranged to resemble a Roman circus.[61] Juries awarded 17,000 prizes, and, among American states, Louisiana triumphed. After years of "dreariness and gloom," the *Picayune* wrote, "who could have foretold that the city of New Orleans would call forth such a representation of its wealth, its respectability and its loveliness."[62] Although Lilienthal's photographs, late in arrival, were not among the exhibits initially judged, widespread dissatisfaction among exhibitors with the "meteoric" conduct of the juries led to many reclamations, including one by Gottheil on behalf of Lilienthal's portfolio, and in August Lilienthal was awarded a bronze medal (Charles Marville and Carleton Watkins were among the other bronze-medal recipients in photography). The jury recognized the "three volumes of views on New Orleans" in a category of photographs "that impart a knowledge of various countries around the earth."[63] The *Times*, announcing Lilienthal's prize, observed that he had "achieved still another triumph [N]o photographer in this city has received more tokens of appreciation than Mr. Theo. Lilienthal. Wherever he has entered into competition he has been victorious."[64] Exhibiting the combination of

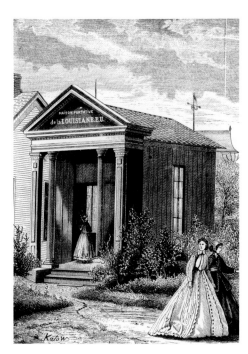

Fig. 6 *Louisiana Cottage in the Champ de Mars, Paris World Exposition of 1867*, wood engraving from Raoul Ferrère, "La maison portative de la Louisiane," in *L'Exposition universelle de 1867 illustrée*, September 23, 1867.

showmanship and salesmanship typical of commercial photographic practice, Lilienthal advertised the Exposition medal and his recognition as a view photographer until the final years of his career (fig. 8).

The ultimate destination of *La Nouvelle Orléans et ses environs* was not public exhibition but the imperial court, for the private viewing of the emperor. The imperial gift was planned for July, but the ceremony was delayed because of the execution of Maximilian, the French-imposed emperor of Mexico (1864–67). "Presentation of the photos to the Emperor is postponed for the present, from necessity," Gottheil wrote, "the court being in mourning for the death of Maximilian."[65] In early August, Gottheil obtained the intervention of Le Play to facilitate his "mission" to present to the emperor "important documents offered by the city of New Orleans."[66] The gift of the portfolio was accompanied by a letter from Mayor Heath acknowledging France as the shaper of the "habits, tastes, and many of the social ideas" of the former colony. Heath, federally appointed, referred to the motivations behind the presentation and the "recent political changes," which would, he predicted, "greatly increase the prosperity" of New Orleans and add "new attractions to our city for the skilled

Fig. 8 "Lilienthal & Burell Photographers, 137 Canal Street," backstamp, cabinet card, 1890. Collection of Mr. and Mrs. Eugene Groves.

Fig. 7 Serge Levitsky, *Portrait of Napoléon III*, carte de visite, *c.* 1867. Napoleon Museum.

labor" of Europe, especially of France. "To promote this purpose we look for great aid to the Exposition," Heath wrote, "and in testimony of our high respect for you as the ruler of the ancient mother of our State and city, we beg your acceptance of [the] accompanying photographic views of notable localities of our city, of our principal public buildings and industrial establishments, with portraits of the members of our municipal government."[67]

Napoléon III, in return, acknowledged the city's gift in a letter to Heath:

I have received the photographic views of New Orleans which you have had the kindness to send me in the name of the City Council. It was with very strong interest that I passed in review the monuments and the various localities of a city which clings to France in so many remembrances and so many sympathies. You have partly retained our laws, our customs, and our language, and I entertain hopes that the links will be made stronger by commercial intercourse. I should be happy, if the Universal exposition, in which you have taken a distinguished part, has contributed to increase our business

relations. Be pleased, sir, together with your honorable colleagues of council, who have sent me their likenesses, and whose acquaintances I am delighted to have made, to accept my sincere thanks, and the assurance of my best wishes. "NAPOLÉON."[68]

Accompanying the letter was a copy of the emperor's two-volume *Histoire de Jules César*, published in Paris the previous year. The gift was evidence, the mayor (now the newly elected John R. Conway) proclaimed, of the "good will entertained by our people for one who has not only trod the soil of New Orleans in the days of his adversity, but sends her this token of his remembrance in the proudest days of his prosperity."[69] The mayor had the *César* ornately bound and exhibited in the City Hall. In a public ceremony in June 1868, the city celebrated the imperial gift and feted Lilienthal and the other Exposition medal-winners.[70]

An Exposition Epilogue: Lilienthal and the *Crescent City Illustrated* of 1872

Five years after the Paris commission, Lilienthal was again hired to produce a large topography of the city in another episode of postwar boosterism, this time under private, not municipal, sponsorship. His client was the former newspaper editor and state senator Edwin L. Jewell, who conceived the city's first commercial booster book, *Jewell's Crescent City Illustrated*, to "demonstrate" New Orleans's "immense resources, advantages and attractions," for the "consideration of the capitalists, immigrants and the commercial world" (fig. 9).[71]

Lilienthal completed at least 108 views for *Jewell's* in the spring of 1872 (figs. 2, 10, 11, 13, and 14). The work did not equal the topographic range of *La Nouvelle Orléans et ses environs*, and, intended not for exhibition or presentation but for the engraver, the views were much smaller in format—4 × 6 to 7 × 9 inches (10 × 15 to 18 × 23 cm)— and were not as carefully executed or finished as the Exposition photographs.[72] Most were of the business houses and residences of the merchants and industrialists who would underwrite publication of *Jewell's* through advertising and subscriptions. Portraits of institutions and civic buildings, lake-front and levee views, and bird's-eye panoramas provided "a comprehensive architectural view of the Crescent City,"

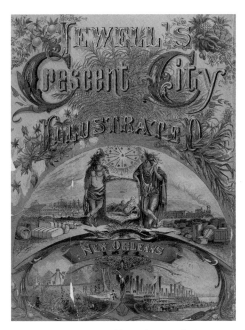

Fig. 9 William Momberger, lithographer, *Jewell's Crescent City Illustrated*, New Orleans (Jewell & Prescott) 1873, frontispiece. Louisiana Collection, Tulane University Library.

narrated with a text lifted from a popular tourist itinerary, *Norman's New Orleans and Environs* of 1845.[73] "Looking over some fifty of the views of prominent buildings, sites and views in and around New Orleans, that have been prepared by Mr. Lilienthal," the *Picayune* wrote in June 1872, "they are admirable photograph pictures."[74]

The New York illustrator John William Orr, operator of the leading engraving house in the country, translated Lilienthal's photographs into print (fig. 12).[75] To emphasize proprietorship and legibility, Orr's tonal wood engravings eliminated detail and even entire buildings in Lilienthal's photographs.[76] *Jewell's* was published in the early spring of 1873 in an edition of 10,000, half of which were distributed free to hotels and steamship lines.[77]

An ebullient expression of postwar optimism, the new boosterism of *Jewell's* appropriated the same imagery of a prosperous marketplace, and the same rhetoric of recovery, as New Orleans's participation at the Paris Exposition of 1867.[78] Although intended to propel commercial revival, *Jewell's* appeared during a deepening economic crisis that gripped the state. Less than one-tenth of Louisiana's productive agricultural land was under cultivation, and the value of plantation property had steadily diminished since the war. The "impoverished, desolated" state of the agricultural region, with which New Orleans was "indissolubly intertwined," was "fatal" to

the city's prosperity, the *Picayune* observed.[79] Thousands of commercial buildings were for sale or rent, a state official reported, and the city, "already in a perilous condition," slipped further into "suffering, poverty and ruin."[80] Later in the year, the Panic of 1873, which closed the stock market and ruined businesses in record numbers across the country, brought on a long depression and doomed any immediate economic recovery for the city.

"Our City Taken": Lilienthal's Topography of New Orleans[81]

The ambitions of Lilienthal's photographic campaign were evident from the outset. As an imperial gift, the portfolio commemorated the "bonds of history and language" with what Mayor Heath called "the ancient mother of our State and city."[82] To many, these bonds with France could be seen everywhere in New Orleans. "Half the inhabitants think of Paris as their home," one visitor commented, "and feel as much interest in the Tuileries as the White House."[83] At least a quarter of the city lived in a cocoon of French culture, especially in the Vieux Carré, where Creole life was, one soldier

wrote, "a miniature, exact to the photograph, of Paris."[84] The English educator Henry Latham attended a Creole party in 1867 where "nothing was spoken but French, the toilettes were Parisian, and the lady of the house was not unlike the Empress Eugénie."[85] Napoléon III himself, in acknowledging the gift of Lilienthal's photographs, referred to New Orleans as a "city which clings to France in so many remembrances and so many sympathies."[86]

Even the streets of New Orleans were more reminiscent of Le Havre or Boulogne-sur-Mer, as one visitor observed, or even Paris, than of other American cities (cats. 14 and 15).[87] The Creole Vieux Carré particularly impressed the visitor with its *magasins*, *boulangeries*, and cafés, where the street names were French and there was "scarcely a signboard in the English language to be seen"—and where, even after the war, the "richest and choicest manufactures of the Parisian market" could be found.[88] "Here you may stroll for hours," a visitor observed, "a straggler from another civilization, hearing no word in your native tongue, seeing no object to remove the impression of an ancient French city."[89] The Baron Salomon de Rothschild, of the Paris banking family, visiting in 1861, wrote that he had "never in all my travels seen

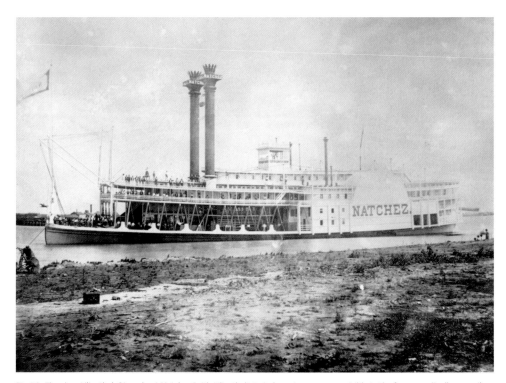

Fig. 10 Theodore Lilienthal, *Steamboat Natchez* (with Lilienthal's twin-lens stereo camera visible in the foreground), albumen silver print, from Jewell and Prescott, *Jewell's Crescent City Illustrated*, prospectus, 1872. Hill Memorial Library Special Collections, Louisiana State University.

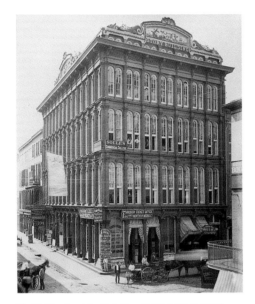

Fig. 11 Theodore Lilienthal, *Story Building, Camp Street*, albumen silver print from Jewell and Prescott, *Jewell's Crescent City Illustrated*, prospectus, 1872. Hill Memorial Library Special Collections, Louisiana State University.

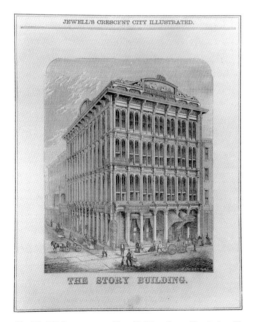

Fig. 12 J.W. Orr, engraver, *Story Building, Camp Street, Jewell's Crescent City Illustrated*, New Orleans (Jewell & Prescott) 1873.

anything which looks as much like Paris."[90] In fact, the surviving colonial fabric was more Spanish than French, a legacy of eighteenth-century fires and nearly forty years of Spanish rule. The persistence of Creole building traditions and the characteristic design concessions to the subtropical climate made New Orleans appear "wholly unlike any other American metropolis."[91]

New Orleans's political aspirations during

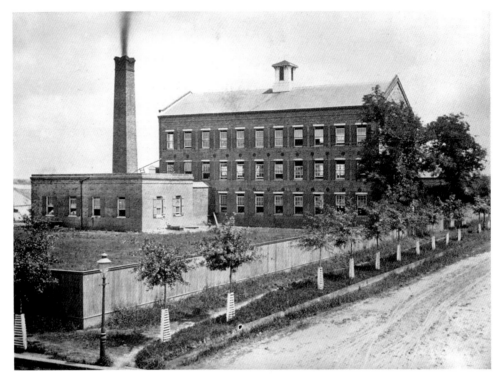

Fig. 13 Theodore Lilienthal, *Lane's Cotton Mills*, albumen silver print, from Jewell and Prescott, *Jewell's Crescent City Illustrated*, prospectus, 1872. Hill Memorial Library Special Collections, Louisiana State University.

the war appeared to harbor the illusion that Napoléon III, who was known to be sympathetic to the Confederate cause, would come to the aid of the former colony.[92] Ten days after the capture of New Orleans by federal troops, the city council, "bearing in grateful remembrance the many ties of amity and good feeling" between France and New Orleans, issued a veiled appeal for "paternal protection," as French warships moved upriver to anchor near the federal fleet.[93] The entreaty alarmed federal officials aware of Napoléon III's imperialistic aims in Mexico, which were better served if America remained divided, but the emperor would not intervene without an allied action by Britain.[94] It was reported that "nothing which has occurred since the commencement of the war has made such an impression on the French as the fall of New-Orleans." While French mill owners sought alignment with the South as a means to restore the cotton trade, and sentiment at Paris ran against the North, France would not recognize the Confederate government and remained neutral throughout the war.[95] Mayor Edward Heath would echo the appeal of 1862 and its affirmation of colonial ancestry with the presentation of Lilienthal's photographs to the emperor five years later.

Beyond the observance of New Orleans's colonial ties with France was the necessity in 1867 to renew the "bonds of commercial interest" with the Second Empire. After England, France had been the city's most important antebellum export market, but war nearly obliterated French trade. "Trade with Bordeaux, France, has been brought to a halt," the *Times* reported in 1866. "What has become of those vessels which traded regularly between France and our port before the war?"[96] The war collapsed 60 percent of the prewar cotton trade and 90 percent of the tobacco trade with French ports.[97]

"The once flourishing city"

The wartime devastation of New Orleans could not be so movingly depicted as in George Barnard's views of the charred ruins of Charleston, Columbia, or Atlanta (where more than 4000 buildings had been torched), or in Andrew Russell's photographs of Richmond's "impassable streets deluged with debris."[98] In fact, as one Union soldier observed, New Orleans "itself showed no traces of war."[99] The Confederacy's largest city (by a substantial margin) had been taken by federal gunboats

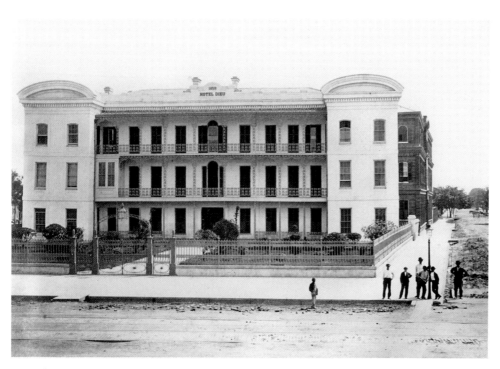

Fig. 14 Theodore Lilienthal, *Hotel Dieu*, albumen silver print, from Jewell and Prescott, *Jewell's Crescent City Illustrated*, prospectus, 1872. Hill Memorial Library Special Collections, Louisiana State University.

only a year into the war—the first major southern city captured—without destruction, except of the steamships, wharves, and warehouses burned by fleeing Confederates and Orleanians themselves.[100] Few probably experienced the fear, even among New Orleans's occupiers, that New Orleans might have been "reduced to a heap of ashes." "The only hope for us," a Union officer in New Orleans wrote in 1862, "is the good sense of the Southerners themselves ... if they attack us they bring on the destruction of their finest City."[101]

Antebellum New Orleans had been the second port city in America, "a commercial depot defying rivalry," as one visitor described it.[102] "What we call the Levee, was then the grand depot for the agricultural products of an immense region," the *Crescent* wrote. "In the busy season the mountains of agricultural wealth which lay heaped along the levee surpassed anything of the kind to be seen elsewhere in the world."[103]

Record cotton and sugar harvests in 1860–61 brought great wealth to the port. "These are certainly ... flush times in this city," the *Delta* declared in 1860. "A plethora of money, an epidemic of extravagance, and a tendency to luxury, prevail among the people. The one hundred millions of dollars worth of cotton received in this city ... [have] diffused through all classes. Our planters are all out of

debt ... [and] our merchants ... are in the easiest sort of circumstances"[104] A northern seaman witnessed "[v]ast sums of money" exchanged in New Orleans in 1860. "[T]he income of planters, factors and others is large, and most of it is expended here." he wrote. "The old proverb of 'easy come and easy go' is exemplified here."[105]

But wartime disruption of agriculture and trade—a Confederate cotton embargo and the Union blockade—brought the great port to a standstill.[106] "What a change!" the *Picayune* observed in 1862:

> the steamers, the forests of masts, the huge piles of produce, the countless variety of manufactured goods, the drays, the carriages, the swarming and eager crowds—where are they? Gone, all gone, and where they once were there is a dreary waste, relieved, here and there, by some solitary wanderer, like one exploring some deserted ruin This is what war does for a land, for a city."[107]

"Now you can hardly recognize the place," a Union soldier wrote in 1863; "it seems as though a plague had fallen upon the doomed city You may pass along the chief business streets; and, on an average, not one store in five will be open: and the few that are open in the daytime close at dusk; for the custom will not warrant the necessary expenditure for gas."[108]

Federal officer John W. De Forest witnessed what he called the "city of desolation" first hand.[109] "The poverty of the once flourishing city is astonishing," he wrote. "The town is fairly and squarely on the point of starvation."[110]

Many Orleanians were unable to pay taxes or refused to pay the Reconstruction government, and with a municipal debt of $14 million the city was bankrupt. "The city is so poor, the treasury is so much depleted, the incomes are so small, the revenue [is] so meagre," the *Times* lamented.[111]

In this context, the large size, luxurious presentation, and high cost of *La Nouvelle Orléans et ses environs* were an expression of the city's postwar aspirations. Although bankrupt, the city ordered that the portfolio should be "designed and executed in the most artistic style, and regardless of the cost."[112] Lilienthal received $2000 in payment for one hundred and fifty 12 × 15-inch (30 × 38-cm) views that retailed at his gallery for $10 each. The total allocation presumably covered bad weather days, spoiled negatives, and the dedicated commitment of Lilienthal and his operators to the three-month project. But Lilienthal's remuneration was costly for the bankrupt city. Two thousand dollars in 1867 would have paid the annual salary of one of the city's highest-ranking policemen or bought a respectable cottage uptown. It might also have subsidized the asylums and orphanages that were so overburdened after the war, as Alderman Prague suggested in his opposition to expending city funds on a photographic campaign "while children and women here at home are crying for bread."[113]

"A refuge from penury and want"

"We want population and must employ every particular mode of attracting it," the Exposition commissioners declared, and it was from the audience of 7 million visitors to the Exposition that the state hoped to attract "the capitalist, the artist, the artisan and the mechanic and laborer of Europe."[114] Lilienthal's photographs visualized a workplace of opportunity for these prospective immigrants, and participated in the powerful propaganda the Exposition would "broad-cast through the Continent" about life in America. "Penetrating the inmost recesses of Europe," Samuel Ruggles, a U.S. Commissioner to the Exposition, asked, "can the intelligence

fail to reach and to animate the overworked, underfed, laboring millions longing for a country offering a refuge from penury and want?"[115]

In the portfolio's many workplace views, Lilienthal posed brewery and kiln workers, pressmen, foundrymen, stevedores, and labor gangs with the skill of a portrait-maker who had arranged sitters under a skylight for thirteen years.[116] They are deftly organized portraits of labor. As in popular occupational portraiture, laborers display tools of their trade and assume conventional studio poses, while owners and foremen stand apart, their bearing and dress signaling authority (cats. 7 and 80).[117] At a Camp Street foundry (cat. 66), the entresol shopfront is opened up, while the sidewalk is claimed for a stage-managed display of merchandise and crates of goods boldly inscribed with their destinations. The foundrymen too are on exhibit—integral to the postwar recovery of the shop—and figured views such as this increased Lilienthal's potential sales, if not for costly large duplicate prints to hang in offices, then for matching stereoviews that most workers could afford. Viewing these labor portraits, the "mechanic and laborer" of Europe might have identified with the assembled workers and seen in a foundry or cooperage an opportunity for higher wages and mobility.

However, the European viewer probably knew nothing like the *Boiler Maker's Shop* (cat. 8)—an image of frontier commercialism that seems out of place in a context of citybuilding. The emphatic letterforms of the signboard advertise American qualities of enterprise and pluck, a place where cheap buildings and availability of land represent opportunities for newcomers. Lilienthal organized the photograph around the activities of the workplace, with sugar boilers arranged in the foreground and two dozen foundrymen and foremen posed for the camera. With its rickety canopy, the shop appears ephemeral, and it was. A short time after the photograph was made the foundry went out of business.

The foundry portraits and the other industrial views represent the largest building type in the portfolio, and create a fiction of New Orleans as a city of industry. Like most other cities of the antebellum South, New Orleans had never developed as a manufacturing center; in 1860, when it was the country's sixth most populous city, it ranked

only seventeenth in manufacturing.[118] A visitor in 1865 found manufacturing in New Orleans "very rudimentary"; in one factory, the owner, machinery, material, and most of the workmen were from the North.[119] Local industry was still dominated by artisanal workshops and old craftsmen—coopers, tinsmiths, carpenters, and cabinet-makers. Small factories made men's clothing, boots, soap, and cigars for a regional market, and with the shipyards and dry docks were the city's largest employers. The city had about a dozen foundries for the manufacture of steam engines, plantation machinery, and sugar boilers, but the largest of these, the Belleville foundry (cat. 105), was out of business in 1867. In the next year, Bennett & Lurges (cat. 80) and Drummond & Doig, the *Boiler Maker's Shop*, would also dissolve or close.

The brickworks of the New Orleans Manufacturing and Building Company (cat. 96), organized in 1867, was the largest industrial start-up since the war. Celebrated for "opening new sources of wealth and prosperity" by releasing the building trades from the dependency on northern suppliers of brick, the new enterprise employed 200 laborers and was the symbolic successor to brickyards that were foundering with the loss of slave labor. But the company (which Lilienthal himself was an investor in and, at one time, president of) failed after seven years.[120]

Lane's Cotton Mills (cat. 100) reopened after the war, but they, too, failed within a few years and were purchased by northern industrialists. The Old Canal Steam Brewery (cat. 24), although a pioneer in brewhouse technology, slid into debt in the years after the war and was finally sold at a sheriff's auction in 1876. The New Orleans Sugar Refinery (cat. 113), one of the largest industrial plants represented in the portfolio, was bankrupt and for sale in 1867. The distance between rhetoric and reality in Lilienthal's portrait of local industry in fact held little real opportunity for the "mechanic and laborer" of Europe.

Lilienthal's photographs suggestive of commercial stability (the banks, for example, and the federal mint, cat. 17) or of civic security (such as the fire companies, cats. 18, 52, 90, and 91) might have found a counterpart in any city booster's imagination. Like many of the portraits of trade, these are pretentious images of citybuilding and the photographer's fiction for a marketplace that had not emerged intact from the war. In reality, most banks had closed during the war, and the Bank of New Orleans

(cat. 65), newly established at the time of Lilienthal's photograph, would fail within the year. The mint was ransacked by Confederates and did not resume minting operations until 1879. The fire companies, predominantly fraternities of ex-Confederates, operated out-of-date and, often, out-of-repair equipment, placing the entire city at risk.

Surprisingly, one photograph in the portfolio addresses the postwar condition of the city and its threats head-on, while also expressing boosters' aspirations. Wartime neglect of levee maintenance put New Orleans at an increased risk of inundation, and in the spring of 1867, when a levee breach forced thousands of residents from their homes, Lilienthal was on hand to record the perilous floodwaters and wrecked steamships (cat. 119). "Instantaneous" stereo photography, with its lighter cameras and faster lenses, was often put to use to record floods, fires, and other disasters, in anticipation of quick sales, and Lilienthal too published flood scenes in stereo format (figs. 71 and 72). It is unusual, however, to find disaster views in an exhibition format made by the toilsome facility of a view camera, normally ill-suited to a quick response to catastrophic events.[121] But a photograph the *Times* declared "would express louder than any tongue the peculiar position of our people" narrated to an overseas audience the specific conditions of New Orleans and its precarious water-bound site.[122] An Orleanian understood, if a European viewer would not, that the peril Lilienthal portrayed was as much a result of war as of nature, and that the city's hope of recovery lay in outside investment to repair the system of ruined levees that the Mississippi River regularly breached, flooding cane fields, plantation homes, and villages, and sometimes New Orleans itself.

The "Networked City"

Engineers failed, as Mark Twain later wrote, to "fetter and handcuff that river and boss him" (the levee-building policy, which disrupted the natural process of the river, was itself flawed). But New Orleans made other key infrastructure improvements necessary to sustain the city's headlong expansion in the decades before the war.[123] Networks of gas delivery; rail, waterway, and turnpike transport; sewerage; telegraph communication; citywide street markets; and granite-paved streets are

recorded in Lilienthal's portfolio, documenting the reach of the city's technology systems across what historian Joel A. Tarr has called the "wired, piped, and tracked city."[124]

The railroad that linked the city with Lake Pontchartrain had been one of the first in the country (cat. 44), and its cribwork spanning the backswamp was a technological marvel (cat. 42). "Almost no one believed that it was possible to build a railroad through the swamp," a German engineer remarked; "this place had always been thought to be impassable."[125] Another early short-line railroad, the New Orleans and Carrollton (cat. 98), played a major role in the growth of the upper wards and suburbs of the city, and introduced an innovative streetcar-propulsion system after the war. But the major urban development of the era was a street-railway system (cats. 28, 40, 47, and 93), which began service in 1861. By the spring of 1867, thirteen horsecar lines carried 60,000 passengers a day, transforming settlement patterns throughout the city.

Not until later in the century were engineers able to prevent the river passes from silting up and obstructing the passage of ships, and until then the best way into New Orleans for commercial traffic was via Lake Pontchartrain and the two waterways that connected the lakefront ports with the center of town. The Carondelet canal had operated since the eighteenth century, linking the Vieux Carré with the Bayou St. John and the lake (cats. 23 and 28), and in the 1830s the New Basin canal (cats. 34 and 74) was cut through the backswamps—a five-year project that claimed thousands of lives. To facilitate canal commerce, engineers built protected harbors, wharves, and lighthouses at the lakefront (cat. 45), a network of toll bridges (cats. 29, 34, and 35), and turnpike shell roads paralleling the towpaths (cat. 34).

New Orleans's gasworks (Lilienthal's portfolio contains more views of this site than of any other) was one of the earliest in the country, and in 1867 it piped illuminating gas to 2570 streetlamps throughout the city.[126] The factory's gasholders, with their graceful guideframes, were highly visible symbols of technological progress and citybuilding, and an object of civic pride. The fire-alarm telegraph (cat. 18) wired the city's firehouses to City Hall in a citywide communications network (which was activated to announce Louisiana secession

in 1861). A ferry network (cat. 4) linked the West Bank of the Mississippi River with New Orleans and Jefferson City long before the river was bridged. Public market sheds (cats. 3, 25, and 60), mostly vanished today, were built across the city before and after the war to deliver fresh food. Ice was important in preserving food, but in New Orleans, the largest city in the country without its own natural ice supply, it had to be brought by ship from northern suppliers. One local outpost of the global ice trade of Frederic Tudor of Boston is documented in Lilienthal's photographs (cat. 61). Efforts to free New Orleans from its dependency on imported ice led to innovations in refrigeration technology, and at the Old Canal Brewery (cat. 24), one of the country's first successful commercial refrigeration systems was put into operation after the war.

Lilienthal's views of dry docks record the technology of the city's shipbuilding and repairing industry (cats. 106–108). The ability of the site to support shipbuilding had been observed before the city was founded. "The oak forests are admirable for the ship-timber they produce," the French explorer Sieur de Rémonville wrote in 1697, "and masts may be obtained equal to those of Norway."[127] Native-growth timber for wooden sailing ships had long been depleted by the war, when a new kind of vessel, the steam-driven ironclad warship, was built at New Orleans for the Confederate navy. Submersible warships were also developed there. In 1867, however, it was the federal monitor ironclads (cat. 111) that best represented the technological future of naval warfare. (Napoléon III in particular recognized the importance of the American monitor warship.)[128]

The Lilienthal views also record buildings that were innovative in construction technology. The U.S. Marine Hospital (cat. 48) was designed as an all-iron building, unique for its time. The hospital's iron frame, walls, and floors were designed to reduce the building load in soil conditions where most large masonry buildings subsided, some perilously. Overcoming subsidence was the greatest construction challenge in New Orleans, and no building sank deeper in the sodden soil than the U.S. Custom House, at one time the largest building in the country after the U.S. Capitol (cat. 19). The weight of the granite ashlar walls kept engineers in Washington anxiously monitoring monthly subsidence reports as the

building gradually gained height, and only the regular injection of federal funds enabled the project to continue over the course of nearly four decades, through one building trial after another. A monument to granite construction, the building in its design reflected a reverence for quarry stone, the use of which had been made economically feasible by advances in quarrying and transport technology.[129]

In a city with no native stone, generally poor building brick (the Custom House used more than 16 million imported bricks), and limited local production of architectural iron, the repeated shortages, delays, and losses at sea of material plagued all large construction projects. The Hoffman Brick Kiln (cat. 96) attempted to profit by this scarcity, as we have seen (p. 19). Constructed on a German patent, it was one of the first annular kilns in the country, and was designed to industrialize kiln production to meet local shortages of brick after the war.

At mid-century, New Orleans began the largest and costliest public-works project of the era: new street surfacing throughout the commercial districts using large granite paving blocks imported from New England, illustrated in so many of Lilienthal's views (cats. 20, 53, 61, 63, and 65).[130] A delight of city boosters, the "square block reform" signaled "streets worthy of a great commercial city," the *Picayune* proclaimed in 1860.[131]

A "Land Between Earth and Sea"

New Orleans was a city "differing from all others in the Union," an observation made by travelers since the early nineteenth century. The unusual topography of river, bayous, and forbidding backswamps, where the "overflowings of the Mississippi creep in black currents," always astonished and fascinated visitors.[132] The Bayou St. John—with associations with the French founding of the city—is the subject of four portfolio views. *Entrance to Bayou St. John* (fig. 1 and cat. 26) is an unusual view of the marshes and trembling prairies skirting the 635-square-mile (1645-sq.-km) Lake Pontchartrain north of New Orleans, and says more about citybuilding in this famously difficult site than many of Lilienthal's street views. "We look in vain for the reasons which prompted the choice of the site" of New Orleans, one antebellum visitor wrote; "were the ground twenty feet higher, the city

might become one of the largest in the world."[133] The site this "impossible but inevitable" city occupied, as geographer Peirce Lewis has written, "guaranteed that the form of the city's physical growth would be shaped by local environment to a far greater degree than in most other American cities." New Orleans's situation as gatekeeper to the interior wealth of the country brought the city prosperity, "but the site [also] guaranteed that the city would be plagued by incessant trouble—yellow fever, floods and unbearable summer heat."[134] Presented to a European audience, Lilienthal's bayou landscape suggests a role for photographers as, in Peter Hales's words, "point-men for an advancing civilization," here the territorial expansion of the city that promised to reclaim vast wetlands and "civilize" them as, perhaps, housing for the prospective immigrant.[135]

Lilienthal's panoramic "bird's-eye" views (cats. 120–24) show a metropolis possessing reclaimed wetlands. The "spirit of the age," a Louisiana engineer wrote before the war, "... [is] that spirit of improvement which would reclaim and cultivate, that would convert every swamp and fen into abodes of wealth."[136] A visitor, the German author Friedrich Gerstäcker, observed the progress of this "spirit of improvement": "[I]n the back of the city the swamp was drained and the remaining primeval forest uprooted, the soil excavated, and street after street built," he wrote. "But the war interrupted all this work, and now there is neither capital nor courage to execute more than is absolutely necessary."[137] Although a feat of antebellum engineering, the swamp drainage, accomplished by a system of steam-driven pumps, was imperfectly carried out, and management of the system between municipal jurisdictions and private contractors was a failure.

This "land between earth and sea," as Mayor Edward Heath observed, "sobbed with water all the year round, verging on a swamp of which it originally formed a part."[138] Rainfall averaged 60 inches (152 cm) a year, and the frequent downpours could turn the city into "an unbroken sheet of water."[139] "After an hour's rain," the *Times* wrote in 1866, "the mud is ankle deep, and in every block ... [there are] immense holes and chasms."[140] A local cartman urged the city council to "invite Mr. Lilienthal to take views ... of some of those beautiful subterranean caverns filled with water" to be found in city streets, and "as the

Emperor takes such a deep interest in the streets and thoroughfares of the City of Paris ... let the Emperor be instructed by seeing the views of our superior thoroughfares, that he may thus improve the streets of Paris."[141]

With no underground sewers to carry runoff, everything—rainwater, refuse, and sewerage—drained into a system of street channels (cats. 22, 48, and 60), "deep troughlike gutters along the curbstones," Mark Twain observed, "half full of reposeful water with a dusty surface" (they were not unlike the *caniveaux* of Paris streets recorded in Charles Marville's photographs of the 1860s).[142] The British traveler Henry Ashworth described this system of draining canals:

> [the] only means of drainage is an outlet at Lake Pontchartrain, six miles distant, and as the surface is nearly on a level, there is great difficulty in providing an adequate means of sewerage. They have not any covered sewers, but wide open drains are formed alongside the parapets of every street ... poisoning the atmosphere, and creating epidemics and fevers, which carry off the inhabitants by the thousands.[143]

Another visitor in the 1860s was surprised by the "incongruities and irreconcilable contrasts" in the Orleanian's accession to these hazards. "You pass over pavements lying deep in mud, and along sidewalks lined with gutters either stagnant, or creeping only with the aid of machinery; and yet you meet ladies taking their morning walks in ermine, and ball dresses."[144]

But if Orleanians accommodated the city's many risks, they also recognized the economic impact of the fouled streets. "There is no need now to talk of stagnant pools," the *Crescent* wrote,

> there [are] enough of them to breed every pestilence that ever decimated a city population. We have all got used to dying in this way, and so we suppose, for a long time to come, that their very appearance alone will frighten away more business men and capital than all other drawbacks the city has to contend with together.[145]

We do not know if European viewers of Lilienthal's photographs were frightened away by the gutters and stagnant pools, mud streets and forbidding backswamps of New Orleans. It was certainly not alone among nineteenth-century cities in having open sewers and other sanitation horrors.[146] Paris had its own

"undrained, fever-haunted purlieus" that Georges Haussmann was making over into "broad and wholesome boulevards," with a vast system of underground drainage (inspired by the Parisian system, underground drains were proposed for New Orleans in 1867, with a price tag of $20 million).[147] But even residents of New Orleans who lived with the peril of the city's many afflictions questioned "whether any city under the sun could vie with ours in the filthy condition of its public thoroughfares."[148] During the federal occupation of New Orleans, U.S. General Benjamin Butler was so dismayed at the filth and so feared an epidemic outbreak that he ordered the city's first thorough cleansing of the century. "In view of this most alarming sanitary condition of the city," he wrote, "I took the most energetic measures to purify the city itself from the possibility of engendering disease."[149] But much of Butler's wartime purgation went into the river, in accordance with the belief that running water purified itself, and dumping of refuse in the streets and on the riverfront continued unabated after the war. "Mountains of stuff and filth have been deposited on the levee, regularly and daily, for the past five years," the *Times* observed in 1866, leaving the river of so many of Lilienthal's views in reality an open sewer.[150] "Between the hours of midnight and daylight, the contents of privies, the refuse of slaughterhouses, and similar accumulating filth, are sunk in the river by means of flatboats constructed for the purpose," the *Republican* reported in April 1867.[151] For the street commissioner, the solution to both the city's collection problems and its impassable streets was to build up the roadways with the most economical fill of all, refuse: "when well rotted [it] makes a much better road than the ordinary mud streets," he asserted.[152]

The Bayou St. John—in Lilienthal's views a tranquil, still stream (cats. 27–29)—fared no better than the river. "The present condition of the bayou ... demands the speedy and serious attention of somebody in authority," the *Times* advised in late 1866.[153] "Sewers containing decomposing matter of all kinds" were centered there, and a "mingling of foul smells of every grade" prevailed. "Who under such circumstances could expect New Orleans to be a healthy city?" the *Times* asked.[154] If the watery "sinks of corruption" that continued to plague the city were not cleaned up, the *Crescent* predicted in 1867, "New Orleans will become unfit for the residence of human beings."[155]

Apart from the aspects of site and topography that formed the identity of New Orleans, and toward which Orleanians had a historic ambivalence, many of Lilienthal's views were of places that shaped public memory of the war.[156] It had been barely two years since General Robert E. Lee had surrendered at Appomattox, Virginia, and only one year since President Andrew Johnson had declared "the insurrection is at an end."[157] Although New Orleans had experienced staggering loss of life brought by frequent yellow-fever epidemics, the casualties of the war exceeded comprehension, and transformed the entire South, as historian Keith F. Davis has written, into "a melancholy realm of memory and loss."[158] The legacy of "grief, blasted hopes, and unanswered progress" was unprecedented in America.[159] The war had taken the lives of a quarter of a million southern men, one of every nineteen whites in the South, and one of every five Louisiana soldiers; only three other Confederate states suffered more casualties.[160] For Orleanians, the *Times* wrote in 1863, "Even an allusion to the ... war now is almost suffocating."[161]

The "countless phantoms of those who fell"—in Walt Whitman's words—surely inhabited the photographs, and in *U S Mint* (cat. 17), no Orleanian could escape an allusion to the war.[162] The spectral flagstaff rising from the courtyard marked the spot where a local gambler named William Mumford defied federal captors and tore down a U.S. flag hoisted in conquest by Union soldiers over reclaimed federal property. Mumford was hunted down by federal troops and hanged from the portico. The execution "converted smouldering discontent into frenzied hatred" among Orleanians, and Mumford into a martyr for the Confederacy.[163]

The "convulsiveness" of the war—as Whitman characterized it—could have lost little of its impact in early 1867, in the presence of the "human wreckage" that was the war's legacy.[164] The "horrible results of the 'real war'" were found in the hospitals, as Whitman himself had discovered. Occupied New Orleans, with some of the best medical institutions in the country (cats. 22, 49, and 69), had been transformed into a "huge war kettle" overflowing with casualties dispatched from distant battlefields and camps, and the city's hotels, factories, and cotton presses were seized for use as military hospitals.[165] "The

wounded have all been brought to this city," a Union officer in New Orleans observed in 1862. "It is a heart-rending sight to see men young and old, mutilated in every form."[166] A feverish federal campaign to establish general military hospitals nationwide could not catch up with the enormity of treating the sick and injured, but in New Orleans the military covered the grounds of an old plantation with the largest building raised in the city during the war years, Sedgwick Hospital (cat. 102). Local asylums—founded to aid widows and children orphaned during antebellum fever epidemics—were now a refuge for victims of war-shattered families. These homes are so well represented in the portfolio (cats. 81, 82, 85, 89, and 101) that it suggests Lilienthal may have known of Napoléon III's, and especially the Empress Eugénie's, patronage of similar institutions in France.[167]

New Orleans had experienced the humiliation of defeat and capture early in the war, and would endure fifteen years of military occupation (a lengthy enemy occupation of a large American city had occurred only once before).[168] "The Queen City of the South," Union soldier Frank Flinn wrote, "lay before us in peacefulness and quiet, and no one would for a moment suppose that two hostile parties occupied it, that it was held by one party only by the sword."[169] The "banner of the conqueror"—the flag that was, the *Crescent* wrote, "uprooted forever from the heart of the citizens of proud Louisiana"—flies over the former seat of the Confederate government at Lafayette Square (cat. 62).[170] Although there were 5000 federal troops stationed in New Orleans in late 1866, few of these soldiers are visible in the photographs (most were garrisoned at Greenville, near the Sedgwick Hospital, or bivouacked in tent camps outside the city). Many buildings, from cotton presses to private residences, recorded in the portfolio had been seized for military use and had only recently been returned to prewar functions. The "eternal enmity" that, as one journalist wrote, "animates our hearts, and the hearts of every citizen of our beloved city, to[ward] those who have invaded and conquered us," surely could be felt on the streets of the occupied city in 1867.[171]

Mechanics' Institute (cat. 68) might have evoked memories of tragic events that came to symbolize the upheaval and violence of "the present fearful situation," as one Orleanian wrote in late 1866, and "the appalling complications and evil events that have resulted from this

period of reconstruction."[172] At this moment of Reconstruction, when enfranchised African Americans were brought to center stage in experiments with bi-racial democracy, blood was shed in the streets of New Orleans. A ghosted flag marks the sepulchre of dozens of African Americans murdered only months before by rioting "unreconstructed rebels" and white supremacists—men, to one observer, "incapable of forgiving and learning."[173] A reaction to an assembly of freedmen attempting to reconvene a constitutional convention, the riot that *Harper's Weekly* called "the massacre of the innocents" is said to have ended "only when there was nothing left to kill or maim."[174] The nation was appalled by the violence in New Orleans—"too brutal," the *New York Times* exclaimed, "for even the imagination of a savage." The Mechanics' Institute, its granite steps "spotted with gouts of blood," now stood as "a monument of disgrace to the city."[175]

There are further clues to the uncertain place of African Americans in Reconstruction, and to the egregious inequalities and widespread vagrancy and mendicity among freedmen.[176] "New Orleans was captured and the whole black population of Louisiana began streaming toward it," W.E.B. DuBois wrote, a migration that nearly doubled the population of what was already the largest urban black community in America.[177] Northern journalist Whitelaw Reid observed after the war that many of New Orleans's blacks "had been educated in Paris" and "conversed in a foreign tongue." But while they "might aspire to the loftiest connections in Europe" and may have been "presented to the Empress Eugénie," they were not, according to Reid, "fit to appear in a white man's house in New Orleans."[178] Every aspect of daily life after emancipation was segregated. In *Depot of St. Charles St. R. Road* (cat. 93), the idle streetcar is marked with a star that designates one of the few cars that blacks were permitted to enter. In the spring of 1867, defiance of this "star car" system was the first major victory against racial inequality in Reconstruction New Orleans.

Everywhere in the city of 1867 were remembrances of a different place for thousands of blacks in prewar New Orleans, the country's "biggest and most notorious market for human flesh."[179] New Orleans was where a young Abraham Lincoln had witnessed a slave auction and "learned the meaning of 'sold down the river.'"[180] At the city's finest hotels, the

St. Louis and St. Charles (cats. 14 and 64), slaves had been sold for decades in the rotundas, two of the most imposing architectural spaces in the city, and in depots nearby. Described by one former slave as "a perfect Bedlam of despair," a depot near the St. Charles was one of twenty-five in the vicinity; one block of Gravier Street alone had seven slave markets.[181] The signboard for a slave mart at the Masonic Hall is just visible in Lilienthal's view (cat. 62).

In 1860, New Orleans's 4200 slaveholders owned 14,000 slaves, who "could be found nearly everywhere there was a task to perform."[182] Bonded laborers worked as domestics and gardeners, cleaned the streets, dug canals and laid rail lines, and operated the gasworks and the sugar refinery (two of the largest workforces of slaves).[183] They competed with wage-earning Irish and German laborers on the Levee, sometimes with violent results. On site at the U.S. Custom House construction project on Canal Street (cat. 19), slave laborers, the "best and most reliable of all workers," owned by Treasury Department foremen, continued to work through fever epidemics, the heat of summer, and pay strikes by white wage workers.[184] Dozens of slaves acquired as collateral on bad debts were owned by a local bank (cat. 65); one local cotton press owned 104 slaves; and even churches owned slaves (only one member of the local clergy had openly championed abolition).[185] The largest slaveholders were, of course, in the rural parishes, where a planter's bonded labor force might number in the hundreds. The sugar plantation photographed by Lilienthal (cat. 118) had been worked by more than 200 slaves in 1860.

Slavery was abolished by military order three years before Lilienthal's photographs were made (southern Louisiana had been exempted from Lincoln's Emancipation Proclamation issued in January 1863).[186] The southern propagandist James D.B. De Bow declared in 1867 that Louisiana had "half the labor power we had before the war." The former slaves were "unwilling to labor as they did formerly," De Bow claimed, a view echoed by a federal Freedmen's Bureau inspector: "they do not work like intelligent white men …. As a rule one white man from the north is worth two freedmen, and will perform as much labor in a day."[187] In the judgment of the *Picayune*, the freedmen "prefer pursuing the chimerical idea of perfect liberty and equality, to anything so

degrading [as labor] … The Negro will not work … [and] it is plain we must have a class who will take their places." Germans and other "intelligent white labor" were needed, the paper wrote, to "supersede the ignorant black labor with which the South has been cursed since the war."[188] The aspiration to "inaugurate a new system of labor" based on racial exclusion was one of the motives for Louisiana's participation in the Exposition, and it was the loss of bonded black labor that boosters sought to replace with the laborers the Exposition campaign might attract.[189]

While many views of places evocative of war and occupation are found in the portfolio, there are other realms of loss the photographs may have summoned. *Odd Fellows' Rest* (cat. 39) is a view of a memorial to victims of the yellow-fever epidemics that, the *Times* observed, "so desolated our city, retarding its growth, and giving it so bad a name abroad."[190] Many Orleanians were survivors of the epidemics that killed thousands in the decade before the war. During three successive epidemic years, 1853–55 (at the time of Lilienthal's arrival in New Orleans), at least 13,000 died (35,000 according to one estimate).[191] The fever at its height brought such destruction of life—250 victims a day— that "[w]hole families were swept away, and almost every house furnished tenants for the cemeteries."[192] Quarantines of shipping, devastating to commerce, were called for to contain outbreaks, but trade-friendly arguments that the "specific poison" of yellow fever was not contagious prevailed, as a legislative study concluded: "a peculiar epidemic atmosphere must and does exist, brought about perhaps by meteorological or electrical influences."[193]

The surge of building projects of the 1850s brought "ever so many strangers of the poorer unacclimated classes" to the city seeking work, the *Picayune* observed, and it was these new arrivals, mostly foreign-born, who "furnished the principal material for the vast mortality" of the epidemics.[194] The fever did take the highest toll in low-lying, "damp and unwholesome places" of the Third District, the swampy back of the city, or the crowded tenement quarters uptown, where it spread quickly among immigrants who resided there. Lilienthal, who emigrated to the city weeks after the end of the epidemic of 1853, was himself an "obscure and unacclimated stranger" who survived the epidemic of the following summer and later

summers, although other recent German immigrants were carried off by the hundreds.

Wealthy "acclimated" Orleanians often outdistanced the epidemics, escaping the fever necropolis every summer (many fled permanently), leaving business to grind to a halt. Foreign trade and immigration were impaired by the quarantines and even more by the image of an imperiled city.[195] "New Orleans, disguise the fact as we may," De Bow declared, "has had abroad the reputation of being a great charnel house."[196]

To some Orleanians, the "Strangers' Disease" was the city's best defense against occupation by "unacclimated" federal soldiers. "Our troops soon learned that the inhabitants of New Orleans … relied with great confidence, as an element to conquer our armies, upon the coming of the yellow fever," General Benjamin Butler wrote.[197] Although no fever outbreaks occurred during the war, when assiduous sanitation measures were taken, New Orleans's reputation abroad as a "wet grave-yard" was sustained when the first postwar epidemic struck the city during the Paris Exposition. "During the whole of our occupation, yellow fever was unknown," a Union soldier wrote. "In 1866 we turned the city over to the civil authorities. That fall there were a few straggling cases, and the following summer the fever was virulent."[198] The epidemic of 1867 was second only to the outbreak of 1853, with a toll of 3300 deaths. In this latest "theater of horrors," mortuary reports recorded an average of fifty deaths a day during September 1867, most of the victims recent immigrants.[199] "There is no disguising the fact that the fever prevails throughout the city," the *Picayune* wrote at the height of the epidemic, "but so far as our observation goes it is of an exceedingly mild type."[200]

"As Eloquent as a Photograph Can Be"

The city council's charge that the Exposition portfolio "should be designed and executed in the most artistic style, and regardless of the cost" expressed a seriousness of purpose and an estimation beyond luxurious mounts and bindings, but we do not know what "artistic style" city boosters sought. Previewing *La Nouvelle Orléans et ses environs* in May 1867, observers found many qualities worthy of praise. Commentators referred to the "neatness of execution" and "admirable finish" of

Lilienthal's work, and its "truthfulness to nature." The *Times* considered the views to be "as eloquent as a photograph can be," and praised their "style of great nicety and finish" and qualities of immediacy and instantaneity, "in the fact that passers by are taken while in the act of making a step." The *Picayune* wrote that Lilienthal, "in exercising his art, always chooses a good subject," and the *Deutsche Zeitung* admired the photographs for the "sharpness and accuracy with which even the least significant object emerges."[201]

The veracity, factuality, and the "insistently concrete" quality of photography had astonished viewers since the medium's invention.[202] The *Bee* had marveled at the earliest daguerreotypes made in New Orleans, reproducing the "minutest object in the original," right down to the "inscriptions on the signs, the divisions between the bricks, the very insect that may have been found upon the wall at the time the impression was taken."[203] Whitman was similarly transfixed by daguerreotypy: "Time, space, both are annihilated, and we identify the semblance with the reality," he wrote, famously, in "A Visit to Plumbe's Gallery."[204] The credibility and immediacy viewers perceived in Civil War-era photographs sometimes horrified, as in the "terrible distinctness"—"by the aid of the magnifying glass"—that viewers saw in Alexander Gardner's battlefield photographs in 1862.[205]

Successful topographic photography, the *Philadelphia Photographer* advised in 1867, had "beautifully soft, and transparent shadows; a careful selection of views ... nice, clear manipulation," and an "elegant sharpness" that would "bear microscopic examination all over."[206] The detail of a kind revealed through close examination made photography especially suited to the multiplicity of the city, and detailed viewing of Lilienthal's photographs yields often beguiling evidence of the urban fabric and its scenographic aspects, or what antebellum author Joseph Holt Ingraham called "street-physiognomy": the paving stones, gaslights, gutters, fences, bollards, streetcars, and horse carriages, and the materials, textures, and tonal qualities of the buildings.[207] As a kind of omnivorous recording device trained on the city, the camera could surprise even its operator, when the "multitude of minute details," as pioneer photographer Fox Talbot wrote, "previously unobserved and unsuspected," were revealed.[208] If Lilienthal was surprised or perhaps delighted at details that emerged from

a close viewing of his photographs, we are often astonished at the results of our own examination, using digital tools that so effectively annihilate space and time. We discover that most of Lilienthal's views, like the daguerreotypes of Whitman's description, are, poignantly, "a peopled world, yet mute as a grave"(fig. 44; cats. 53, 61, and 62).[209]

The *Philadelphia Photographer* observed in 1867 that "not a few photographers have forsaken the vexations and trials of portrait photography and devoted themselves to landscape and architectural work," and as view photography developed an increasingly large practice and patronage in the 1860s the critical capacities of the medium were assessed.[210] Local appraisal of Lilienthal's accomplishment reflected photography's uncertain status, as a product of art or of nature. Lilienthal, at times his own camera operator, was a skilled technician with, as the *Deutsche Zeitung* wrote, "a reputation of taking the most naturally accurate views."[211] At other times, he was praised as a "distinguished artist."[212] From the earliest days of photography, historian Anne McCauley has written, "the rhetorical structure was firmly in place for the entire medium to be dismissed as uncreative, mechanical, mindless and having nothing to do with art."[213] Seen as the reproduction of reality without natural colors but with correct formal values and proportions, photography was typically not judged by the aesthetic criteria of the fine arts.[214] The *Times* wrote in 1866 that photography could not be "lifted into a niche as one of the 'beaux arts'" because it was "more of a mechanism than it is an art ... the photographer has only light and shade for his colors."[215] Boston photographer John Notman argued otherwise. "To consider photography a mere mechanical art is a great mistake," he wrote in 1867. Successful photography required "a practical and artistic knowledge of composition ... and a well educated eye," Notman claimed, as well as the right apparatus and chemicals, and "a skillfully-constructed and well-lighted studio."[216] During Lilienthal's later practice, when he was signing his mounts "Lilienthal, Artist" (fig. 33), photography's status as art was still uncertain.[217] "There is no possibility of changing a photographic impression by any thought or effort of the photographer," a contributor to the *Photographic Times* wrote:

If anybody is entitled to be called an artist in photography, it is the man who can coat or develop well the plate, who dexterously manages to get a good negative where another operator would have failed to get one.[218]

Lilienthal claimed to be this kind of "practical photographer" who produced images for a specific market and whose work was judged on its ability to meet the technical demands of the medium—mastering equipment, chemistry, lighting, framing, posing, and, above all, the quality of the print.[219] "I promise to excel in the beauty and finish of pictures," he advertised, and his photographs, as well as those of his competitors, were admired for their "wonderful clearness and freedom from blemishes."[220] Historian Joel Snyder has argued that a nineteenth-century audience understood photography as unequivocal, utilitarian, and unmediated, and would have expected the image to appear technically unflawed and as finely detailed as reality itself.[221] A uniformity of tone and finish ties many of Lilienthal's images together as a series, and in convention-bound commercial practice, uniformity would have been seen as desirable for photographs assembled for an exhibition portfolio.[222]

An "Uncanny Quality of Presence and Absence"

The consistent tonality of the prints, "as if they were all humming their different melodies in the same key," is a product of Lilienthal's wet-plate collodion process.[223] His forty-year career parallels exactly the commercial use of wet-plate photography from 1853 to the early 1890s, when it was supplanted by the more manageable dry-plate negative process. The ungainly, unpredictable, and very slow collodion chemistry required considerable skill to produce successful prints outdoors, and each exposure of two to three minutes or more had to be prepared and executed with great care.

The photographer James F. Ryder, Lilienthal's contemporary, described early studio practice as "enveloped in a haze of mystery and a smattering of science."[224] Preparation of the plates took place by hand in Lilienthal's rolling darkroom, in a methodical laboratory procedure of dexterity, precision, cleanliness, and a cautious attentiveness to

chemistry, some of it toxic. His glass negatives, larger than 14 × 15 inches (35.5 × 38 cm), were difficult to handle, flow with collodion, and sensitize, even under the best studio conditions. The heat and humidity of New Orleans made the chemistry troublesome, sometimes resulting in foggy negatives, and could also make the environment of the darkroom wagon insufferable (although Lilienthal executed the Paris photographs during early spring, when the local weather was generally at its best). But whatever the conditions, the fiddly process was always unreliable, as one photographer observed:

> You go out on a beautifully clear day, not a breath stirring, chemicals in order, and lights and shadows in perfection; but something in the air is absent, or present, or indolent, or restless, and you return in the evening only to develop a set of blanks. The next day is cloudy and breezy, your chemicals are neglected, yourself disheartened, hope is gone, and with it the needful care; but here again something in the air is favourable, and in the silence and darkness of your chamber pictures are summoned from the vastly deep which at once obliterate all thought of failure.[225]

Not all Lilienthal's prints could have been successful, but the good prints had a desirable definition, clarity, and density. Today the artifacts of his collodion chemistry and the "ineffable, refulgent" qualities of the wet-plate process, as photographer Sally Mann has described it, add mystery and ambiguity—an "uncanny quality of presence and absence"—to our viewing of the photographs.[226]

The destination of the Lilienthal photographs, as an imperial gift and for exhibition to a world audience, gave them an elevated importance from the moment of their commission. The gravity and cost of the work presumably determined the care and attention Lilienthal gave to his compositions and the technical control he imposed, as well as the degree of finish of the prints and their luxurious presentation.

Operating the large view camera raised considerably the cost of materials, and the expeditionary aspect of Lilienthal's campaign—hauling his equipment through backswamps and bayou basins, and on to rooftops and church steeples—increased the likelihood of flawed negatives and unsatisfactory compositions. It is possible that Lilienthal did

not delegate the fieldwork to his operatives. It is not known how many unacceptable negatives he exposed, but to produce at least 150 finished prints in twelve weeks, working six days per week, he had to expose two or three negatives per day, and possibly more to account for rainy or dark days. William England, his contemporary, was reported never to finish more than three landscape views in a day—two too many for photographer and critic Hermann Vogel, writing in 1867:

> I get one good plate a day on an average. Of course, much depends on circumstances. In places that are familiar to me, and where I need not look long for a standpoint, or for proper light effects, or where several fine views are close together, I may succeed in making three or even four views a day ... [but] frequently it happens that the desired light-effect does not return I have visited the same spot half a dozen times before being successful.[227]

The "commercial photographer who has to furnish pictures by the dozen," Vogel continued, "will certainly not agree with me, and for small pictures, at a low price, it would not pay; but, where you want to produce plates of artistic value, the case is different." For Lilienthal, whose output of small view pictures in card formats offered steady income for the studio, the case here *was* different: large hanging prints were more costly to produce and demanded more time. That he added to the portfolio prints from negatives exposed in 1865 and 1866—one of a building no longer standing in 1867 (cat. 9)—may be evidence that he had difficulty in meeting his deadline.[228]

"The Capacities of the Craft"

In such a large series of views, some can be singled out to demonstrate Lilienthal's command of the medium and his compositional strategy: the choice of subject (in the absence of a program from the city), where he placed the camera, when he photographed and in what light, and how he organized the picture and assembled participants in the scene.

Although many photographs are elaborately staged, such as the factory or school portraits (cats. 7, 24, 66, 75, 107, 108, etc.), where the composition is tightly controlled, some views record the city precisely as Lilienthal found it,

where "passers by are taken while in the act of making a step" (cats. 20, 76, and 93).[229] Still other views are without passersby at all, taken in the clear light and stillness of early morning, when there was little movement to ghost the image. New Orleans's relentlessly flat delta landscape did not provide any natural promontory, and Lilienthal often chose an elevated viewpoint (cat. 47 is a striking exception), usually a second-story balcony or a rooftop, giving many of the photographs greater depth and a sense of vastness.

A skillful study in the surfaces and volumes of urban space, *St. Louis Hotel* (cat. 14) is one of the most coherent photographs in the portfolio. The street has a logic and grandeur that makes New Orleans look as stately as Paris, and the high vantage point and deep recession give the photograph a quality of distance and detachment. There is a sense of stillness and melancholy in Lilienthal's view that is chilling, recalling the "air of desertion and loneliness" that architect Thomas K. Wharton found an "almost painful" characteristic of New Orleans streets.[230] *Firemen's Cemetery* (cat. 38) is one of the strongest photographs in this sense of detachment and solemnity.[231]

Meterie Race Course (cat. 37) is a work of startling modernity. The image's minimalism and graphic power, which appeal to the modern viewer, stress formal relationships over narrative (no race is running), but whatever may have led Lilienthal to his choice of subject and moment, the outcome is unlike anything else in nineteenth-century New Orleans photography. With the spaciousness and clear geometry of a perspective study, and in its extreme rigor, it shows better than most of the Exposition views the "capacities of the craft," as Ansel Adams called it.[232] It also exemplifies one of Lilienthal's formal preoccupations, the use of diagonal forms (usually fences and walls) to organize space. In *Charity Hospital* (cat. 69), a brilliant-white wall is a foil for the dark, somber mass of the hospital and shadowy grove of trees that it segregates from a wide road, where the eye is drawn to the sgraffiti of wagon tracks in the mud. The fence in *St. Paul's Church Camp St.* (cat. 76) forms a perimeter around a puzzling trench and separates the viewer from the church as it also echoes the building's Gothic lines. In *Firemen's Cemetery* (cat. 38), a post-and-chain fence distances the viewer, and in *Lafayette Square* (cat. 50), the green space is parapeted by an elaborate cast-

Fig. 15 Theodore Lilienthal, *U. S. Barracks Dispensary*, albumen silver print, 1865. Still Pictures Branch, NARA.

Fig. 16 Theodore Lilienthal, *Odd Fellows' Hall, Lafayette Square*, albumen silver print, 1865. Still Pictures Branch, NARA.

iron railing. In *Lane's Cotton Mills* (cat. 100), a tall plank fence detaches the viewer from the space of the factory. The effect here, however, is one of order, as the fence confines the debris of the milling process and segregates the industrial yard from the public space of the street. Fences that define the street edge and delimit public and private property are so common in Lilienthal's views that the space of the city can be understood as clearly bounded and, with the prevalence of picket fences, domesticated (cats. 33, 48, 93, 112, 113, 118, and 122).

Depot of St. Charles St. R. Road (cat. 93) is a photograph of graceful equilibrium, centered by a luxuriant tree that shrouds the station house (the modest structure is scaled magnificently, but subordinated to nature, like everything in New Orleans). The arc of the railway roadbed, the fences and paving blocks, the boardwalk laid across the drainage channel, and even the wagon rills in the mud street form a dynamic composition of motion and lively rhythms. A gas lamp anchors a long vista down Carondelet Street to a canyon of trees at the perimeter of the view, and the station-house fence, brought into prominence by framing the building obliquely, amplifies the sense of depth. Lilienthal's high viewpoint opens up the space, just as in his batture photographs the elevated perspective emphasizes the expansiveness of the Levee. A station clock, idle workers deferential to the photographer (and one who does not hold his pose), the tree branches

ghosted in the breeze, and the now stationary, horseless rail car—all mark the passage of time in the photograph.

Str. Great Republic (cat. 6) chronicles the departure of a great steamer on its maiden voyage. We are witnessing not the ship's launch but a stage-managed event preceding the historic event to come. There were difficulties in manipulating a ponderously slow medium to respond to a passing incident, and Lilienthal stopped the action and posed the large crowd

of passengers, crew, stevedores, and bystanders to commemorate the episode.[233] He steps back from his subject far enough to include the entire vessel and center it in the frame. We wish for a closer view of the pageantry of the departing passengers and of the crew assembled along the cabin and upper deck, barely perceptible at this distance. Lilienthal could have moved closer to capture the majestic proportions of this "monarch of Western steamboats"—

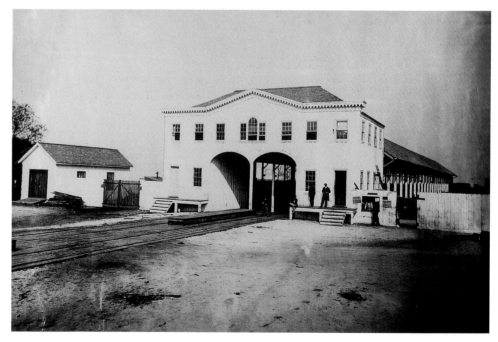

Fig. 17 Theodore Lilienthal, *St. Joseph Street Military Railroad, depot*, albumen silver print, 1865. Still Pictures Branch, NARA.

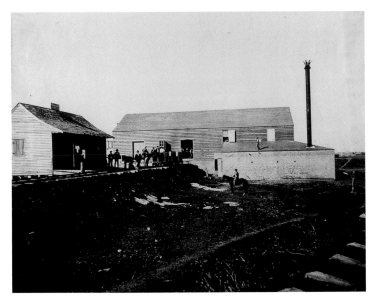

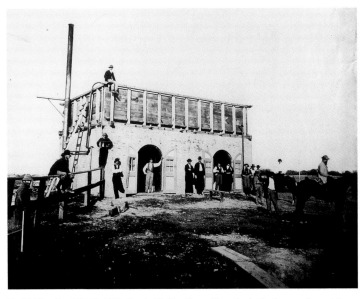

Fig. 18 Theodore Lilienthal, *U.S. Cavalry Stables, Greenville*, albumen print, 1865. Still Pictures Branch, NARA.

Fig. 19 Theodore Lilienthal, *U.S. Cavalry Stables, Greenville, water tank*, albumen silver print, 1865. Still Pictures Branch, NARA.

the largest on the river—but by framing the landing, the activity of the dockworkers, and the arriving and departing carriages seen there, he effectively narrates the anticipation of departure.

As in the *Great Republic* view, Lilienthal often moves his camera well back from the subject, and when photographing on the open, unobstructed levee he moves back still farther. In *Vicksburg Cotton Press* (cat. 10), *Brick yard* (cat. 96), and *Sugar Refinery* (cat. 113), the buildings and the workers assembled for the camera are so distant that little can be made out. The view of the Cotton Press seems almost inept: a deep foreground abyss of mud levee, pools of water, and furrowed road arrests our attention, while the activity of the photograph organized by Lilienthal is almost indiscernible. A close look is rewarded by a fascinating stop-action assembly of pressmen, women and children (some finely dressed), drays and their loads, and a carriage. Examination of the brickworks view reveals men and women (possibly celebrants at the opening of the kiln) posed on an elevated gangway, on the roof, and in the yard, but the exaggerated depth of the view again obscures the organized assembly. In *City Park* (cat. 41), a row of stone bollards parallels the horizon line and partitions the view, but we see more of a foreground of field grass than of the distant group of women posed around the trunk of a great oak tree. Placing human subjects at a distance had the practical advantage of reducing the chance

that movement would spoil the negative. But an "overall, distant view of things," as Joel Snyder has characterized it, typical of Civil War-era photographs, in which "nothing is singled out," is an approach we see here. In this instance, as in many others in Lilienthal's views, "the distance defeats the possibility of gaining useful information from the photographs" (cats. 36 and 107).[234] In the Luling *Private Residence* (cat. 31), the deep forespace results from Lilienthal's centering of the house in the frame and, as in *City Park* and many other views, divides the ground and sky neatly in half; a solution that establishes a consistent horizon line and uniformity of spatial definition throughout the entire portfolio. The centrality of the image is often enhanced by the failure of the sky and landscape to form a unified composition (a shortcoming of emulsions that unavoidably overexposed the sky).[235]

The distant quality that appears odd to a modern viewer can also be a visual artifact of early wide-angle lenses and their exaggerated perspective. A comparison of Lilienthal's earlier topographic work, a series of views of military installations for the U.S. Quartermaster in 1865 (figs. 15–19; see p. 44), or his stereoviews (pp. 260–67), with the greater angle of view of his Exposition photographs reveals the capabilities of different lenses. For the Paris views, he may have used a Globe lens, an inexpensive wide angle for landscape work that became widely available in the South only after the war (one was inventoried in his studio in

the 1870s).[236] The Globe covered a field of 90 degrees, but was slow and required very long exposures, and foregrounds often lost detail and lacked relief.[237] Using it, the photographer had to move well back from his subject, as the photography writer Désiré Van Monckhoven warned in 1867: "in reproducing a landscape or a building, very near foregrounds, which would come out too black, must be avoided."[238]

Evident throughout the portfolio is Lilienthal's sensitivity to the effects of New Orleans's saturated, low-latitude sunlight (on a latitude with Cairo, New Orleans was the southernmost large city in the United States). His bayou landscapes (cats. 27 and 28) are studies in the changing effects of light on water, a vexing subject for wet-plate collodion photography and its long exposures. "Water our art altogether misses, turning it either into congealed mud or to mere chaos or nonentity," a critic wrote in 1857.[239] The mirror-calm water of the bayou provided Lilienthal with ideal conditions for exploration of the pictorial qualities of light. Far less suitable were the headstrong waters of the Mississippi (cat. 109), which produced a leaden effect of "congealed mud" on the plate. Lilienthal's street views are further examples of his mastery of these light effects. In the St. Louis Street view (cat. 14), the low, late-afternoon sun gives relief and mass to the buildings, and Lilienthal has successfully maintained definition and tone in deep shadow while avoiding overexposure of the brightly sunlit walls.

What was Lilienthal's ancestry as a viewmaker,
and what was his model for such an extensive
topography of the city? The idea of a
comprehensive catalog of place images had a
long pre-photographic history.[240] Printmaker
William Birch in Philadelphia was at the
beginning of a tradition of topographic views
that publicized the American city to potential
European immigrants, much as Britain, France,
and other colonial powers had promoted
settlement of their North American dependencies
through maps, prints, and other pictorial
propaganda. *The City of Philadelphia* of 1800
was, in Birch's words, to be "conveyed to Europe
to promote and encourage settlers," and in the
decades before the introduction of photography,
many American cities, including New Orleans,
acquired an iconography.[241] Lithographs after
drawings by a French viewmaker, Achille St.
Aulaire (fig. 21), about 1820, are the earliest
published series of views of New Orleans.[242] A
local convention of building views emerged in the
early 1830s to document the notarial acts of New
Orleans's unusual civil-law process. Publicly
exhibited to advertise property sales, the
colored perspective drawings were often very

large (illustrating placards that were typically
4–6 feet/1.2–1.8 m high) and executed by
architectural renderers (fig. 22).[243] Plans of the
city, notably Charles F. Zimpel's *Topographical
Map of New Orleans* of 1834 and its derivative,
L. Hirt's *Plan of New Orleans* of 1841 (fig. 20),
featured building views in border vignettes.

Guidebooks of the city moved the visitor
through a sequence of views, and determined
what was important to be looked at and even
how it should be viewed. They also provided the
context for the building's significance
architecturally or in local culture and history.[244]
The Gibson *Guide* of 1838, written at least in part
by the engineer Frederick Wilkinson, was the
most authoritative and the progenitor of later
guides. Gibson's lithographed building portraits
were the guide's most successful feature (fig. 23).
Reproduced in business directories and other
publications, the lithographs were widely
circulated models for the new photographic
medium, and even forty years later Lilienthal
reiterated a repertoire of subjects and vantage
points found there (cat. 113).

Wood-engraved and lithographed illustrations
in newspapers and city directories, and
logographs of commercial buildings in the *New-
Orleans Pictorial Advertiser* and other business
directories, established a mercantile iconography

Fig. 20 Jules Manouvrier, lithographer; L. Hirt, publisher,
Plan of New Orleans, 1841. The Historic New Orleans Collection.

and a source for Lilienthal's portraits of labor
and trade (figs. 24 and 25).[245] Lithography,
particularly, was ideally suited to commercial
views, and the impact of color and clarity of
line made lithographs the preferred medium for
advertising well after the introduction of wet-
plate photography.[246] B.W. Thayer & Co. of Boston
produced one of the finest of these lithographed
building views in 1842 to advertise the first St.
Charles Hotel (fig. 28). The effect of the Thayer
image, where the St. Charles is implausibly
isolated from its surrounding buildings, contrasts
with the scenographic view of the hotel in the
St. Charles corridor by local lithographers Jules
Manouvrier and François Chavin (fig. 26).

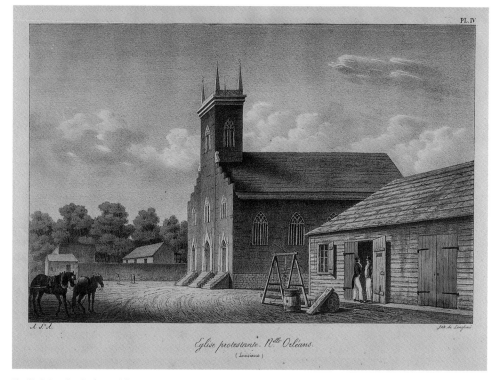

Fig. 21 P. Langlumé, after Achille St. Aulaire, *Protestant Church, New Orleans*, lithograph, *c.* 1820. Southeastern Architectural
Archive, Tulane University.

Fig. 22 Jacques Nicolas Bussiere DePouilly, *Elevation of
124 Dauphine Street, January 23, 1867*, colorwash drawing.
Plan Book 82, fol. 49, NONA.

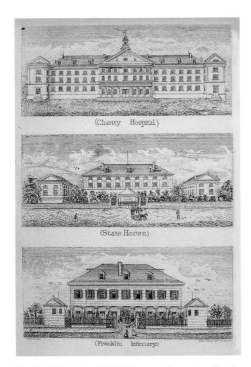

Fig. 23 T.J.R. Clark or R.W. Fishbourne, lithographer, *Charity Hospital and Luzenberg Hospital*, woodcut. J. Gibson, *Gibson's Guide and Directory of the State of Louisiana, and the Cities of New Orleans & Lafayette*, New Orleans (J. Gibson) 1838.

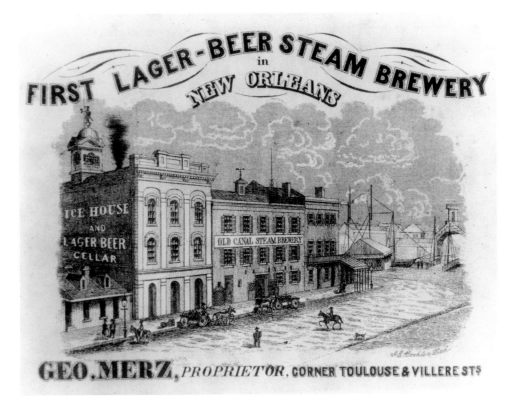

Fig. 24 John E. Boehler, lithographer, logograph of Geo. Merz's Old Canal Steam Brewery, lithograph. *Duncan & Co. New Orleans Business Directory for 1865*, New Orleans (Duncan & Co.) 1865.

In the 1850s, the illustrated press— *Gleason's Pictorial Advertiser, Ballou's Pictorial Drawing-Room Companion,* and *Harper's Weekly* were popular titles—greatly expanded the iconography of New Orleans and other cities through published wood engravings after photographs, some by Lilienthal himself.[247] An important source of income for photographers, the popular press was the best way for their work to reach a national audience, and the reproduction of photographic views in print was so widespread that one photographer concluded that "the viewpoint of early photographers was influenced largely by wood-engraving, because so much of their work had to be interpreted by wood-engravers."[248]

A daguerreotype by St. Louis photographer Thomas Easterly, also of the first St. Charles Hotel, is the earliest existing photograph of the city, and dates about three years after the Thayer view (fig. 27; the daguerreian Jules Lion is known to have exhibited views of the city in 1840, but these are now lost).[249] Easterly's viewpoint from near Canal Street is a perspective taken by nearly all later photographers, including Lilienthal (cat. 64; a second hotel, a near replica, replaced the first St. Charles in 1852). The scale of the St. Charles, its unusual trapezoidal site, the density of building in its vicinity, and the distance required

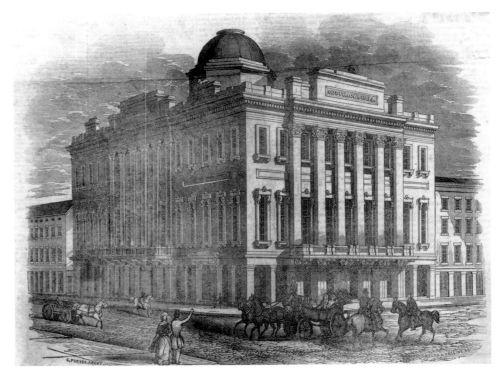

Fig. 25 Shields & Collins, engraver, *Odd Fellows' Hall at Lafayette Square*, wood engraving. *Delta*, December 23, 1849.

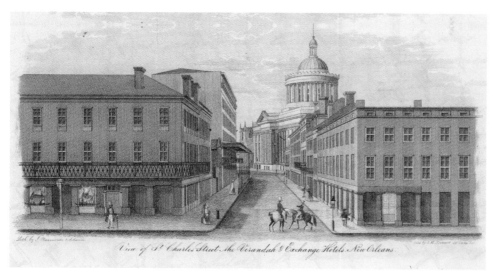

Fig. 26 (above) Jules Manouvrier and François Chavin, lithographers, *View of St. Charles Street, the Verandah & Exchange Hotels, New Orleans*, lithograph, *c.* 1842. Massachusetts Historical Society.

Fig. 27 (right) Thomas Easterly, *St. Charles Hotel*, daguerreotype, *c.* 1845. Missouri Historical Society.

to encompass the massive structure limited photographers' choices in framing the view. Viewmakers working in a print medium, however, could eliminate distracting buildings and achieve a more focused advertising image, as illustrated by the Thayer lithograph.

Many cities acquired photographic inventories at mid-century, and the seemingly limitless possibilities of urban subjects suited the "encyclopedic capacity of the medium."[250] Industrial stereoview publisher–distributors, such as Edward & H.T. Anthony, Frederick and William Langenheim, and the Kilburn Brothers, sold local views to a nationwide audience anxious to acquire the new photography of American sites. Philadelphia photographers John Moran and Frederick DeBourg Richards, Toronto's Octavius Thompson, Cleveland photographer J.M. Greene, Chicago's John Carbutt, and San Francisco's George Fardon all produced topographies of their cities in the 1850s and 1860s.[251] Fardon's *San Francisco Album* of 1855 assembled thirty-three views in a taxonomy comparable to *La Nouvelle Orléans et ses environs,* with equivalent image-building themes of progress and profit, and similar aims of settlement and commercial speculation.[252] Distinguished from the Fardon work and all these collections of city views, Lilienthal's portfolio was more ambitious, larger in the number of views and their size. In scale and in its municipal patronage, *La Nouvelle Orléans et ses environs* is unprecedented in American urban photography.[253]

The promotional value of photography had been recognized by speculators and property

owners, particularly the railroads. In 1862, Cleveland photographer James F. Ryder produced an album of 129 views of the Atlantic & Great Western Railway in New York, Pennsylvania, and Ohio. The railroad sent the views of its equipment and depots, and of towns and land along its right of way, to backers in England, who, in Ryder's words, "could feel a greater sense of actuality from

seeing photographs than from drawings upon white paper."[254]

Western expeditionary photography by Lilienthal's contemporaries Alexander Gardner, Timothy O'Sullivan, Carleton Watkins, and Andrew J. Russell had some similar aims: all described the topography and resources of a place and promoted settlement and commercial investment.[255] The western

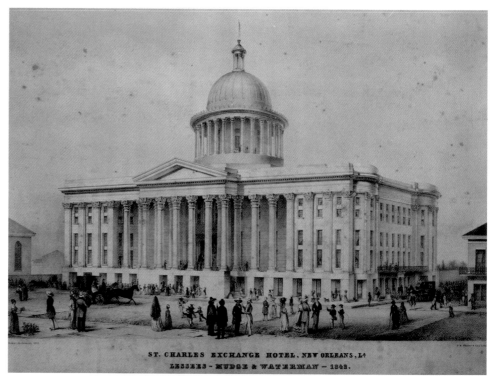

Fig. 28 B.W. Thayer & Co., lithographer, *St. Charles Hotel*, lithograph, 1842. Louisiana State Museum.

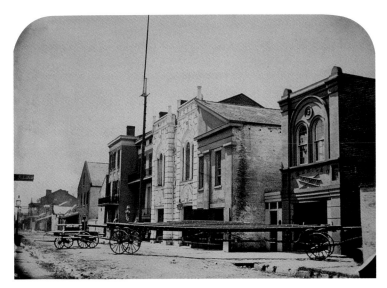

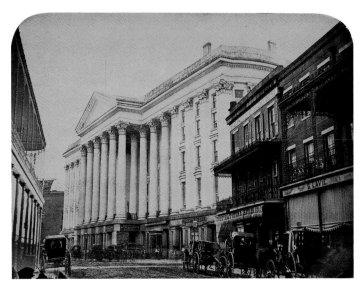

Fig. 29 Jay Dearborn Edwards, *Girod Street Firehouses*, salt print, *c.* 1858. The Historic New Orleans Collection.

Fig. 30 Jay Dearborn Edwards, *St. Charles Hotel*, salt print, *c.* 1858. Southeastern Architectural Archive, Tulane University.

surveys have been published extensively and are now probably the best known of all the photographic work of the decade of the war.[256] Russell's *The Great West Illustrated* (1869) was a leather-bound album of fifty hand-mounted large prints to which the photographer added a printed title page, table of contents, and lengthy descriptive captions.[257] Gardner's photographs of 1867–68 documenting the prospective route of the Kansas Pacific Railroad and O'Sullivan's work for the U.S. Geological Exploration of the Fortieth Parallel under Clarence King—begun in May 1867, as Lilienthal was completing his Exposition portfolio—were captioned and sequenced or presented as narratives, complete with an accompanying text, and intended to be viewed in series. Watkins's photographs of the Columbia River and Oregon were issued in albums, each unique in its contents.[258]

In New Orleans, two photographic series provide direct models for Lilienthal's work. Jay Dearborn Edwards in the late 1850s marketed numbered views of New Orleans, the earliest existing photographic series of the city (figs. 29 and 30).[259] All were salt prints, considerably smaller than Lilienthal's large-plate views, and fewer in number, but many of the subjects and even vantage points of Edwards's series were repeated in *La Nouvelle Orléans et ses environs*. The framing of Edwards's view of the Girod Street firehouses (fig. 29) is strikingly similar to that of Lilienthal's (cat. 52), but with a street-level viewpoint, as in his view of the St. Charles Hotel (fig. 30). The photographers William

McPherson and Oliver developed a specialty of city views in carte-de-visite and stereo formats during the war years, with a topography similar to Edwards's, and which Lilienthal later adopted, but exhibiting the limitations of the smaller formats and lenses (figs. 31 and 32).[260]

Although the views of Edwards and McPherson and Oliver parallel the content of the Exposition portfolio, Lilienthal's use of large format, with its greater technical demands and cost—and greater financial risk for the photographer—was unusual for city views in the Civil War era, and previously unknown for outdoor work in New Orleans. Some of his subjects—*Entrance to Bayou St. John* (cat. 26) or *Crevasse on the Mississippi* (cat. 119)—are inconceivable in earlier topographic photography of New Orleans, and his commercial portraits have no local photographic precedent and few precursors outside the city.[261] His photographs also have much greater range, topographically and thematically, than any earlier work. "[T]he collection may be pronounced the most complete of the kind ever arranged in this city," the *Times* wrote of the Exposition portfolio in May 1867.[262]

La Nouvelle Orléans et ses environs remained the most complete photographic record of the city until late in the century. At the 1884–85 World's Industrial and Cotton Centennial Exposition in New Orleans—where photography exhibitors included Lilienthal, Carleton Watkins, William Notman, and William Henry Jackson—French-born George F. Mugnier, who claimed to be "only an amateur photographer," exhibited highly acclaimed views of the city.[263] A critic

for the *Philadelphia Photographer* praised Mugnier's work as the best collection of southern views he had ever seen.[264] It was a decade before the end of Lilienthal's own career, but as a topographic photographer the thirty-year-old Mugnier was now Lilienthal's successor, crowned by the photographic fraternity at a new world's fair.[265]

Conclusion: "Lost Fortunes and Advantages"

The impact of *La Nouvelle Orléans et ses environs* on potential investors, marketers, or immigrants abroad is difficult to measure. References to the photographs on exhibition are confined to the remarks by Commissioner Gottheil, the jury reclamation and press reports of Lilienthal's prize medal, and the emperor's acknowledgment of the gift. Thereafter the photographs are not recorded again in print until their exhibition in New Orleans in 2000. Perhaps there was some measure of success in the emperor's recognition that New Orleans's participation in the Exposition might contribute to an increase in "business relations" with France; it seemed to be borne out with the announcement that the Paris Chamber of Commerce had initiated discussions with the New Orleans chamber through the Exposition commissioners.[266] In the end the real impact of this image-building campaign was not in bringing home European laborers or trading ships, but in buoying the self-image of Orleanians during Reconstruction. The fair "awakened

ambition and spirit in our people," Governor Baker declared, and a similar rhetoric of revival and renewal was repeated across the state.[267]

And what of "the capitalist, the artisan, mechanic and laborer of Europe" boosters hoped to attract? The *Bee* reported during the Paris Exposition that 25,000 immigrants landed at New York but only twenty-eight headed for Louisiana.[268] "A few emigrants, the cast of whose features was German, were seen yesterday morning taking the air in the vicinity of the Waterworks," the *Times* reported in May 1867. "It is a pity these people cannot be induced to stay here instead of going West."[269] The inauguration in 1867 of a new steamship line that offered, for the first time, direct passage from Germany to New Orleans, was greeted with the hope that it would bring to the city the "intelligent white labor, which we so greatly need."[270] But the first ship from Hamburg arrived during the yellow-fever epidemic of 1867 and eluded quarantine, imperiling its 350 passengers. "It will be almost miraculous if these emigrants ... do not contract the disease," one observer wrote. Faced with this well-known epidemic hazard, an inhospitable climate, and an unfamiliar agricultural system, most immigrants arriving at the port of New Orleans moved west and north, and the campaigns to settle them in Louisiana were a failure. "Attempts were being made to introduce white laborers into Louisiana," the writer J.T. Trowbridge observed. "While I was there, one hundred Germans, who had been hired in New York for a sugar plantation, were landed in New Orleans. Within twenty-four hours thirty of them

deserted ... [and] planters, who had hoped to exchange black for white labor, were very much disgusted."[271] By 1869, despite the availability of 3 million acres (1.2 million ha) of state lands at only twenty-five cents per acre, little had changed.[272] "In regard to labor the present condition is bad," a Louisiana planter wrote. "Labor is more scarce [and] harder to procure at the present time than anytime since the close of the rebellion."[273] In Louisiana and throughout the South, the postwar proportion of foreign-born in the population actually declined. One historian found that by 1910, emigrants made up only eight percent of the population of New Orleans, and there were fewer than half a million foreign-born in the eleven former Confederate states and Kentucky, compared to 13 million in the rest of the country.[274]

Equally, New Orleans failed to attract significant investment through its presence in Paris, and its financial decline worsened, as the *Jewell's* episode demonstrated. While Atlanta, Nashville, and other enterprising cities of the "New South" rebounded from the war as entrepreneurial centers, generating dramatic economic and population expansion, New Orleans, once the fastest-growing city in the country, now lagged behind all southern cities except Charleston.[275] That New Orleans's aspirations "to retrieve lost fortunes and advantages" were not realized was confirmed by Charles Dickens, who visited the city in 1874:

One hears but doleful accounts, now-a-days, of New Orleans. Her glory has departed: on her once bold and brilliant brow is written

Ichabod. What with the disastrous results of the American Civil War ... the once proud and prosperous Crescent City is at a deplorable discount. Excepting Charleston, her pioneer in secession, no Southern metropolis has suffered so much. The whilome opulent and prodigal cotton and sugar-planters, whose business and expenditure constituted two-thirds of the prosperity of the place, are ruined, or struggling ineffectually to accommodate themselves to an entirely new and half-chaotic state of things; the brokers and merchants are impoverished; the people generally discouraged, and all but despairing ... they have paid, and are paying, a terrible price for the folly of secession.[276]

It was nearly another two decades, at the end of Lilienthal's career, before New Orleans could be seen to have shaken the malaise. "The affairs of the city of New Orleans ... have passed their lowest ebb," a fraternal organization proclaimed in 1889. "The signs of prosperity and revival are unmistakably present."[277] A new generation of boosters, most of them born in the 1860s, distanced themselves from the "deplorable discount" that was the war's legacy. The Young Men's Business League acknowledged the "sudden and swift descent" that had been brought on by the war, when the city had "its prestige abated, [and] its whole commercial system deranged." But New Orleans now emerged from this gloom, at least rhetorically, a "reascendant and renaissant" city. The writer of a Chamber of

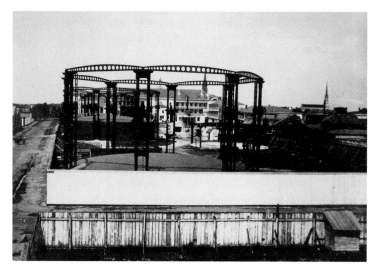

Fig. 31 McPherson and Oliver, *Gas Works*, carte de visite, *c.* 1863–65. Hill Memorial Library Special Collections, Louisiana State University.

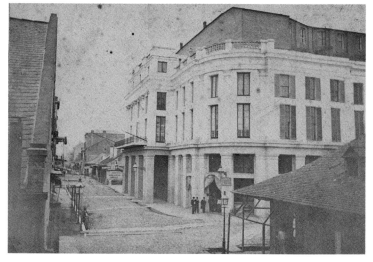

Fig. 32 McPherson and Oliver, *French Opera House*, carte de visite, *c.* 1863–65. Louisiana State Museum.

Commerce booster book observed in 1894 that there was in the city a "home pride, civic spirit and enterprise" not seen since before the war. "After thirty years ... [New Orleans] has resumed its place among the World's ascendant cities," boosters declared.[278]

1. "A City Ornament," *True Delta*, February 11, 1866.
2. James Parton, *General Butler in New Orleans*, New York, 1864, p. 255, cited by Eric Arnesen, *Waterfront Workers of New Orleans: Race, Class, and Politics, 1863–1923*, New York (Oxford University Press) 1991, p. 19.
3. John William De Forest, *Miss Ravenel's Conversion, from Secession to Loyalty*, ed. Gordon S. Haight, New York (Rinehart & Co.) 1955, p. 122.
4. Edward Heath, *Annual Message of the Mayor to the Common Council of New Orleans*, New Orleans (The Republican) 1868, pp. 3–4.
5. An unidentified Orleanian quoted by Giulio Adamoli, 'Letters from America, 1867,' *Louisiana Historical Quarterly*, VI, 1923, p. 274.
6. Thomas Cooper DeLeon, *Four Years in Rebel Capitals: An Inside View of Life in the Southern Confederacy, from Birth to Death*, Mobile, Ala. (Gossip Printing Co.) 1890, p. 64.
7. *True Delta*, November 30, 1865.
8. *Crescent*, January 12, 1867.
9. For sources on the history of the Paris Exposition of 1867, see pp. 294–95.
10. *Message from the President of the United States ... Concerning the Universal Exposition to be Held at Paris in the Year 1867*, Washington, D.C. (Government Printing Office) 1865, p. 56.
11. *Times*, April 11, 1866; *Times*, June 26, 1866; *Crescent*, June 20, 1866; "The Paris Exposition in the House of Representatives," *Bee*, June 27, 1866; *Times*, July 7, 1866; "Resolutions of the United States Passed by the Thirty-ninth Session of Congress," *Bee*, August 20, 1866; *Crescent*, January 17, 1867.
12. "The Paris Industrial Exposition for 1867," *Crescent*, July 4, 1866. Gottheil was appointed by President Andrew Johnson to the international jury of the Exposition in February 1867; *Commercial Bulletin*, February 5, 1867. Gottheil had immigrated to New Orleans in 1849. His reputation as an architect was, the *Crescent* wrote, "well attested by the number of splendid edifices of which he has superintended" (July 4, 1866), but Gottheil had virtually ceased architectural practice by 1854. His only known building after that date, other than his work on the Exposition cottage, was an unusual chalet for Cuthbert Bullitt on St. Charles Street (now moved to 3637 Carondelet), completed upon his return from the Paris Exposition and reportedly designed according to a plan Gottheil obtained in Paris (*Picayune*, September 2, 1868). In the 1870s, Gottheil was active in diplomatic circles on behalf of New Orleans, representing the city at several European expositions (for which he published summary reports), including Altona, Denmark (*Picayune*, May 19, 1872); Vienna (*Picayune*, February 26, 1873); and Hamburg. He died in 1877, "ignored and forgotten by many who pretended to admire and love him whilst he was a prosperous and successful man" (*Picayune*, December 6, 1877, cited by Hilary Irvin, "The Impact of German Immigration on New Orleans Architecture," *Louisiana History*, XXVII, no. 4, Fall 1986, p. 382, n. 20). See also *Picayune*, April 21, 1868; J. Madison Wells, *Message of the Governor of Louisiana to the General Assembly,*

Commencing January 28, 1867, New Orleans (J.O. Nixon) 1867, pp. 10–11; and, on Gottheil's work as architect and builder in the 1850s, *William Cressey Account Book*, 1849–1867, Manuscript Collection, Tulane University Library.
13. *Report of Edward Gottheil*, pp. 3–4.
14. *Crescent*, *Picayune*, and *Commercial Bulletin*, January 3, 1867; *Report of Edward Gottheil*, pp. 4–6.
15. J. Madison Wells, *Message of the Governor of Louisiana to the General Assembly, Commencing January 28, 1867*, New Orleans (J.O. Nixon) 1867, pp. 10–11.
16. *Report of Edward Gottheil*, p. 6.
17. New Orleans Public Library, City Archives, Minutes and Proceedings of the Board of Aldermen, X, March 19, 1866–August 28, 1868, folios unnumbered, entry dated January 9, 1867: "Resolved. That the Board of Aldermen be requested to appoint a committee of four members, to act, in connection with the like committee from this Board, on the communication from the Commission of the Paris Exposition." See also "Stereoscopic Views of New Orleans for the Paris Exposition," *Picayune*, January 11, 1867; *Crescent*, January 12, 1867. (Use of the term "stereoscopic" is apparently a mistaken reference to the popular format that most council members would have known, here confused with the large wet-plate collodion prints that Lilienthal was asked to produce. In no other documentation is the card format mentioned.)
18. "A Suitable Commissioner," *Picayune*, December 16, 1866. Price was a stagecoach entrepreneur; he had operated the Great Overland Mail Line of Stages, which connected St. Louis and Memphis with California, and had controlled all the trans-Mississippi mail routes for the Confederacy. After the war, he partnered in a mercantile firm, Price, Hine & Tupper, and invested in salt mines and petroleum. He later settled in Missouri, where he was reestablished as a major mail contractor in the West. Among his accomplishments, contemporaries noted his participation as an exhibitor at the London Crystal Palace Exhibition of 1851 and his travels worldwide—"more extended than those of any man in the States"—but the documentary record is not specific on the genesis of his pioneering interest in photography for the purpose of municipal boosterism. See *Report of Edward Gottheil*, p. 6; *Jewell's Crescent City Illustrated*.
19. *Report of Edward Gottheil*, p. 6.
20. "Stereoscopic Views," *op. cit.*
21. Minutes and Proceedings of the Board of Aldermen, *op. cit.*, VII, fol. 489, February 8, 1867: "Resolved—that the sum of two thousand dollars ($2000) be, and the sum is hereby appropriated for the purpose of preparing a portfolio of views of the City of New Orleans and under the joint supervision of the Joint Committees on the Universal Exposition in Paris to be sent to the Emperor of the French"; *Picayune*, January 30, 1867.
22. Minutes and Proceedings of the Board of Aldermen, *op. cit.*, X, March 19, 1866–August 28, 1868, fols. 30–31, February 26, 1867; *Picayune*, January 30, 1867; *Bee*, February 13, 1867; *Crescent*, February 16, 1867; *Commercial Bulletin*, February 27, 1867; *Crescent*, February 27, 1867; *Deutsche Zeitung*, February 27, 1867.
23. "The Portfolio of Views for the Paris Exposition," *Crescent*, February 28, 1867.
24. *Deutsche Zeitung*, March 1, 1867.
25. "The Portfolio," *Crescent*, March 1, 1867 (see p. 279).
26. "New Orleans and Vicinity at the Paris Exposition," *Crescent*, May 26, 1867 (see p. 280).
27. It is not known if the photographs were bound in portfolios in New Orleans or in Paris. See n. 62 below and p. 57, n. 11.
28. "Worth Seeing," *Deutsche Zeitung*, May 23, 1867.

29. "The Lilienthal Views," *Times*, May 24, 1867.
30. "Expenditures of City of New Orleans Contingency Fund, June 4, 1867, Warrant No. 850: T. Lilienthal, for Portfolio of Photographic Views of the City, for Paris Exposition," *Controllers Report Embracing a Detailed Statement of Receipts and Expenditures of the City of New Orleans from January 1st, 1867, to June 30th, 1867*, New Orleans (Times Book and Job Office) 1867, p. 90 (I would like to thank Wayne Everard for his assistance in locating this title). Lilienthal apparently applied for payment in late May: Minutes and Proceedings of the Board of Aldermen, *op. cit.*, X, March 19, 1866–August 28, 1868, folios unnumbered, entry dated May 21, 1867: "A communication from Mr. T. Lilienthal, relative to photographs, was received and filed."
31. "Moody on a European Trip," *Crescent*, June 9, 1867.
32. "Col. Moody off for Paris," *Commercial Bulletin*, June 10, 1867. Lilienthal's "dilatoriness" may not have been a delay in mounting and captioning the views, since the photographs were exhibited at his studio on May 22 and reported to be "now ready for the Paris Exposition" on May 24, but an effort to replace unsatisfactory views; "Worth Seeing," *Deutsche Zeitung*, May 23, 1867; "The Lilienthal Views," *Times*, May 24, 1867.
33. "The Album for the Paris World Exhibition," *Deutsche Zeitung*, June 9, 1867 (prematurely reporting the departure).
34. *Crescent*, August 4, 1866; *Picayune*, February 12, 1867.
35. "The Trip to the Paris Exposition: How to Get There the Cheapest and Safest," *Picayune*, April 5, 1867; "The Paris Exposition," *Commercial Bulletin*, April 11, 1867.
36. Opening day was reported in the local press with great fanfare. *Picayune*, April 13, 1867; "Letter from Paris, April 2," *Tribune*, April 23, 1867; "The Paris Exposition," *Picayune*, May 5, 1867. Several New Orleans papers carried frequent reports from Paris during the Exposition, notably the *Crescent*, *Picayune*, and *Bee*. In March, the *Crescent* dispatched its satirical correspondent, A. Head, who reported throughout the year under the title "Letter from Paris" ("A. Head's Appointment as Commissioner to the Paris Exposition," *Crescent*, March 16, 1867). The *Bee* featured regular articles on the Exposition in its French edition, *L'Abeille* (for example, the issues of May 12, 19, and 29, and June 6 and 26). The bilingual French–English weekly *L'Avenir* carried stories on the Exposition in nearly every issue. The *Picayune*'s correspondent using the byline "Gamma" wrote regular columns under the title "Paris Paragraphs." The papers attended to every detail, like colonial subjects, of the emperor and empress, reporting on their movements and every change in their health ("Will He Die?" *Crescent*, January 11, 1867).
37. Pieter van Wesemael, *Architecture of Instruction and Delight: A Socio-Historical Analysis of World Exhibitions as a Didactic Phenomenon*, Rotterdam (010 Publishers) 2001, pp. 250, 262–63.
38. David P. Billington, *The Tower and the Bridge*, New York (Basic Books) 1983, p. 64; Frances H. Steiner, *French Iron Architecture*, Ann Arbor, Mich. (UMI Research Press) 1984, pp. 94–95; Sigfried Giedion, *Building in France, Building in Iron, Building in Ferroconcrete*, trans. J. Duncan Berry, Santa Monica, Calif. (Getty Center) 1995, pp. 124–27.
39. Arthur Sketchley, *Mrs Brown's Visit to the Paris Exposition*, London (G. Routledge and Sons) 1867, p. 94.
40. "The Paris Exposition," *New York Times*, May 7, 1867; Frank Leslie, *Report on the Fine Arts*, Washington, D.C. (Government Printing Office) 1868, p. 6.
41. "The Paris Exposition," *Picayune*, May 5, 1867; "Our Paris Correspondence," *Times*, March 5, 1867, on the demolition material used in its construction.

42. Wesemael, *op. cit.*, p. 742, n. 200.

43. Henry Morford, *Paris in '67 or, the Great Exposition*, New York (G.W. Carleton) 1867, p. 132.

44. Frank Anderson Trapp, "Expo 1867 Revisited," *Apollo*, LXXXIX, 1969, p. 121; Arthur Chandler, "Paris 1867, Exposition Universelle," in *Historical Dictionary of World's Fairs and Expositions, 1851–1988*, ed. John E. Findling, New York (Greenwood) 1990, p. 35.

45. Georges Augustus Sala, *Notes and Sketches of the Paris Exposition*, London (Tinsley Brothers) 1868, p. 372.

46. "Universal Exposition of 1867," *The Land We Love: A Monthly Magazine Devoted to Literature, Military History and Agriculture*, IV, November–April 1867–68, p. 230.

47. W.P. Blake, ed., *Reports of the United States Commissioners to the Paris Universal Exposition, 1867*, Washington, D.C. (Government Printing Office) 1870, I, p. 33; "Universal Exposition of 1867," *op. cit.*, p. 230; Wesemael, *op. cit.*, pp. 218–330. See pp. 57–60.

48. *Report of Edward Gottheil*, p. 8.

49. "Portable Cottage for the Paris Exposition," *Picayune*, February 22, 1867; "Letter from Paris," *Evening Picayune*, April 21, 1868; *Report of Edward Gottheil*, p. 8.

50. *Report of Edward Gottheil*, p. 8.

51. "The Paris Exposition," *Times*, May 21, 1867; M.D. Conway, "The Great Show at Paris," *Harper's New Monthly Magazine*, XXXV, no. 206, July 1867, p. 242.

52. "The Paris Exhibition," *Picayune*, May 30, 1867 (quotation); "The Paris Exposition," *Times*, May 21, 1867.

53. Morford, *op. cit.*, p. 211.

54. "Penny Wise Policy," *New York Times*, February 11, 1867.

55. "The Paris Exposition," *Chicago Tribune*, May 16, 1867.

56. H. Vogel, "Paris Correspondence," *Philadelphia Photographer*, IV, no. 42, June 1867, pp. 172–74; and no. 46, October 1867, p. 327. See also G. Wharton Simpson, "Photography at the International Exhibition in Paris," *Philadelphia Photographer*, IV, no. 43, July 1867, pp. 201–204; and C.T. Thompson, "Photography, Class 9," *Illustrated London News*, LI, no. 1445, September 14, 1867, p. 299. On American art in general, see Carol Troyen, "Innocents Abroad: American Painters at the 1867 Exposition Universelle, Paris," *American Art Journal*, XVI, no. 4, Autumn 1984, pp. 3–29; P. Mainardi, *Arts and Politics of the Second Empire: The Universal Exhibitions of 1855 and 1867*, New Haven, Conn. (Yale University Press) 1987; and Annie Cohen-Solal, *Painting American: The Rise of American Artists, Paris 1867–New York 1948*, New York (Knopf) 2001.

Exhibition of Watkins's and Lawrence & Houseworth's work and their recognition at Paris—both won bronze medals—helped create a world market for landscape views of California and the West; see Peter E. Palmquist and Thomas R. Kailbourn, *Pioneer Photographers of the Far West: A Biographical Dictionary 1840–1865*, Stanford, Calif. (Stanford University Press) 2000, p. 361. Douglas Nickel notes that Watkins's exhibition of his work, framed in redwood and displayed in tight rows on the wall, is a rare documented instance of "large photographs functioning in the nineteenth century as art for the wall" and an indication of Watkins's regard for his own accomplishment as an artist; Douglas R. Nickel, *Carleton Watkins: The Art of Perception*, San Francisco (San Francisco Museum of Modern Art) 1999, pp. 24 and 34, n. 21 (a photograph of Watkins's Paris exhibit is reproduced by Nickel, p. 24, fig. 5).

57. H. Vogel, *op. cit.*, no. 42, pp. 172–73; "The Paris Exposition," *New York Times*, April 18, 1867.

58. Eugene Rimmel, *Recollections of the Paris Exhibition of 1867*, Philadelphia (J.B. Lippincott) 1867, pp. 262–63.

59. "Interesting Letter from Paris," *Picayune*, August 18, 1867.

60. *Times*, December 3, 1867.

61. "The Paris Exposition," *Picayune*, May 5, 1867; "Letter from Paris," *Crescent*, August 4, 1867 (letter dated July 14, 1867); "The Paris Exhibition," *Picayune*, August 5, 1867 (letter dated July 1867). An engraving of the awards presentation is in *Grand Album de Exposition Universelle 1867*, Paris (Michel Lévy Frères) 1868, pp. 100–101. See Cohen-Solal, *op. cit.*, p. 3, and Wesemael, *op. cit.*, pp. 310–15.

62. *Picayune*, June 16, 1868; *Picayune*, July 8, 1867; "Our Paris Correspondence," *Times*, July 26, 1867; "Letter from Paris," *Crescent*, August 4, 1867. In all categories, grand prizes went to Americans Frederick Church for landscape painting, Cyrus Field for the transatlantic cable, C.H. McCormick for his reaper, and D. Hughes for the printing telegraph. Gold-medal winners included the Corliss steam engine, Grant railroad locomotive, Howe sewing machine, Steinway and Chickering pianos, and two Louisiana producers of cotton (Victor Meyer of Concordia parish and L. Trager of Black Hawk Point). Louisiana took silver medals for snuff (Delpit & Co.), electric clocks (S. Fournier of New Orleans), sugar (E. Lawrence), and a special medal to Gottheil for his organizational efforts on behalf of the Louisiana exhibitors. See James M. Usher, *Paris Universal Exposition: 1867*, Boston (Nation Office) 1868, p. 115; *Picayune*, June 12, 1868; *General Survey of the Exhibition with a Report on the Character and Condition of the U.S. Section*, Washington, D.C. (Government Printing Office) 1868, pp. 318–20.

63. "The French Exhibition," *New York Times*, July 8, 1867; "Letter from Paris," *Crescent*, October 10, 1867.

Gottheil's reclamation to the Imperial Commission dated August 2, 1867, is in Paris, Archives Nationales, F12 3095, Class 9, Gottheil to Jurors, annotated by Alphonse Davanne, Chairman of the Imperial Commission (see p. 283; I would like to thank François Brunet for locating this document, and that cited in n. 66 below). Davanne responded that the jury had seen the photographs but "too late to be able to rank them" as they had been "at the binders," probably a reference to fabrication or repair of the portfolios prior to presentation to Napoléon III (see also p. 57, n. 11). Davanne's report on "Class 9: Photographic Proofs and Apparatus," reprinted in *Bulletin de la Société Française de Photographie*, XIV, 1868, pp. 219–20, lists "three volumes of views on New Orleans by Doctor [*sic*] Lilienthal," in this category and not in the category of "landscapes of a purely artistic character." The Imperial Commission's official catalog of the awards does not cite Lilienthal's bronze medal (Michel Chevalier, ed., *Rapports du Jury International*, Paris, P. Dupont, 1868, 13 vols.), nor do Lilienthal's photographs appear in *Official Catalogue of the Products of the United States of America Exhibited at Paris 1867*, Paris (A. Chaix et Cie) 1867, pp. 61–63 (on Class 9), but his medal is listed in *Reports of the United States Commissioners to the Paris Universal Exposition, 1867*, *op. cit.*, I, p. 320 (Lilienthal is cited for "photographic views" but not reported in the photography awards for Class 9, p. 260); and in the following: John Parker Reynolds, *State of Illinois and the Universal Exposition of 1867 at Paris, France*, Springfield, Ill. (State Journal Printing Office) 1868, p. 130; Usher, *op. cit.*; *Report of Edward Gottheil*, p. 10.

64. *Times*, May 3, 1868.

65. "Letter from Paris," *Picayune*, August 18, 1867.

66. Paris, Archives Nationales, F12 3095, Class 9, Edward Gottheil to F.P.G. Le Play, August 7, 1867. Reclamations entered by Gottheil in early August (see n. 63 above) refer to the "photographs presented to Emperor Napoléon III ... made by Mr. Lilienthal" (see p. 283).

67. "The Letter Which Accompanies the Photographic Views," *Times*, June 9, 1867; *Picayune*, June 9, 1868.

68. "An Imperial Letter," *Crescent*, January 21, 1867. The original French text was published in the *Picayune*, January 21, 1868.

69. New Orleans Public Library, City Archives, Office of the Mayor, Messages of the Mayor to the General Council, XXVIII, "Communication from the Mayor in regard to presentation of Life of Caesar by L. Napoleon III, July 7, 1868" (I would like to thank Wayne Everard, New Orleans City Archivist, for locating this document); *Report of Edward Gottheil*, p. 6. The *Histoire de Jules César* (Paris, Imprimerie Impériale, 1865–66) is now in the Louisiana Collection, New Orleans Public Library. The emperor had presented a special edition of the book to European heads of state in early 1865, and to President Lincoln shortly before his assassination; *Bee*, April 14, 1865; *Crescent*, June 16, 1866; William Blanchard Jerrold, *The Life of Napoleon III*, London (Longmans, Green, & Co.) 1874, IV, pp. 556–61.

70. The *Jules César* and the medals that were awarded to the Louisiana exhibitors were displayed in Washington and the New Orleans City Hall before presentation in a public ceremony in New Orleans on June 15, 1868; "The Exhibition in the Governor's Parlor," *Picayune*, June 12, 1868; *Bee*, June 16, 1868; *Picayune*, April 24, May 6, June 5 and 12, 1868; *Times*, May 16, June 7, 11, 14, and 16, 1868. The mayor's message and the resolutions of the city council acknowledging the emperor's gift were "engrossed on parchment" and hung in the mayor's parlor. At the end of the century, the *American Architect and Building News*, in an article on New Orleans (XLIX, no. 10, September 7, 1895), reported that "the chief treasure" at City Hall was "a superb copy of Napoléon III's *History of Julius Caesar* presented by the author and carefully preserved under a glass globe."

71. "The Crescent City Illustrated" (advertisement), *Picayune*, April 14, 1872; *Jewell's Crescent City Illustrated*. Edwin Jewell (1836–1887) was born in Pointe Coupe parish and trained on his father's newspaper, the Pointe Coupe *Echo*, which Jewell edited after attending school in Andover, Massachusetts. In 1862, he began publishing the *Port Hudson News* under Confederate General Franklin Gardner. After the war Jewell settled in New Orleans, where he edited Governor Wells's anti-black-suffrage newspaper, the *Daily Southern Star*, revived the New Orleans *Bulletin*, and was associated with the *City Item*. He served as Democratic state senator from the Fourth District in the 1860s. See Walter M. Lowrey, "The Political Career of James Madison Wells," *Louisiana Historical Quarterly*, XXXI, 1948, p. 1041.

72. Several were made from negatives exposed during the Exposition campaign.

73. "The Crescent City Illustrated" (advertisement), *op. cit.*

74. "The Crescent City Illustrated," *Picayune*, June 23, 1872; *Jewell's Crescent City Illustrated*, prospectus. The prospectus assembled Lilienthal's photographs, specimen engravings from engraver J.W. Orr's workshop, and sample pages of text. The prospectus has 356 numbered leaves with Lilienthal's photographs pasted in, sometimes with Orr's specimen engravings placed opposite. Most of the photographs are captioned in ink, and later nineteenth-century annotations identify some subjects of the photographs. A register of advertisers is partially filled in. The prospectus dates from the late spring of 1872 and includes numerous views of buildings completed or under construction in 1871 and 1872: The Varieties Theatre, which had been finished in March 1872; the Academy of Music, completed the year before; and Henry Howard's New Orleans National Bank, recently

completed on Canal Street. Daniel Edwards foundry store at Front and Gravier was not begun until April 1872 and must have been one of the last photographed, along with the Temple Sinai at Tivoli (Lee) Circle, nearly completed in June 1872 and shown under construction in Lilienthal's photograph (which Orr showed in a finished state for *Jewell's*).

75. Early printings of *Jewell's* (see n. 74 above) reproduced at least forty-six engravings by Orr after Lilienthal's building views; another fourteen *Jewell's* plates were by other engravers or unsigned. Orr was a prolific book and magazine illustrator from the 1830s into the 1870s. His work appeared in New Orleans as logographs for business directory advertisements, and his plates illustrated Louisiana author T.B. Thorpe, "Cotton and Its Cultivation," *Harper's New Monthly Magazine*, March 1860, pp. 447ff, *Affleck's Southern Rural Almanac* for 1854, and *Gardner's New Orleans Directory for 1867*. City views were an Orr specialty. At the beginning of his career, he supplied wood engravings for an early booster book, Henry O'Reilly, *Sketches of Rochester*, Rochester (William Alling) 1838; Howard L. Preston and Dana F. White, "Knickerbocker Illustrator of the Old South: John William Orr," in *Olmsted South*, ed. Dana F. White and Victor A. Kramer, Westport, Conn. (Greenwood Press) 1979, pp. 91–108.

76. Estelle Jussim, "The Syntax of Reality: Photography's Transformation of Nineteenth-Century Wood-Engraving into an Art of Illusionism," *Image*, XVIX, no. 3, September 1976, p. 10; Saul Bass Warner, Jr., "The Management of Multiple Urban Images," in *The Pursuit of Urban History*, ed. Derek Fraser and Anthony Sutcliffe, London (Edward Arnold) 1983, p. 392. On the practice of wood engraving in the 1870s, see Celina Fox, "Wood Engravers and the City," in *Victorian Artists and the City*, ed. Ira Bruce Nadel and F.S. Schwarzbach, New York (Pergamon Press) 1980, pp. 1–12; Sue Rainey, *Creating Picturesque America*, Nashville (Vanderbilt University Press) 1994, pp. 179–86; and Trevor Fawcett, "Graphic Versus Photographic in the Nineteenth-Century Reproduction," *Art History*, IX, no. 2, June 1986, pp. 185–212.

77. *Picayune*, April 14, 1872. *Jewell's* was issued in at least three printings with variant collations before a new edition was published late in 1873; this included additional building views (by Orr and other engravers) and portraits and dropped others, incorporated new advertisements and text, and was paginated and indexed for the first time. Orr's building cuts after Lilienthal's photographs were often reproduced in city directories, such as *Soard's* of 1885, and, with the portrait medallions, in John Smith Kendall, *History of New Orleans*, Chicago (Lewis Publishing Company) 1922.

78. *Jewell's* consisted of illustrated business profiles, paid for by subscribers, with portraits and biographies of commercial and professional men (and one woman), and an accompanying guidebook of tourist-oriented text. In the following two decades this format was used across the country for booster books. Although many of these books were still illustrated with wood engravings, during the next decade most booster books and commercial directories would adopt photo engravings. Possibly stimulated by frequent press announcements of *Jewell's*, the *Picayune* featured a series of articles boosting commercial firms illustrated by wood engravings from the New Orleans Engraving Company; *Picayune*, December 1, 8, 15, 22, and 29, 1872, February 9 and 23, 1873.

79. "Renovation," *Picayune*, September 2, 1865.

80. "An Address on Immigration and the Louisiana Question," *Picayune*, July 20, 1873.

81. *Times*, May 29, 1867.

82. Louisiana Public Library, City Archives, Minutes and

Proceedings of the Board of Assistant Aldermen, X, March 19, 1866–August 28, 1868, folios unnumbered, entry dated January 9, 1867; *Picayune*, January 11, 1867; *Crescent*, January 12, 1867; "The Letter Which Accompanies the Photographic Views," *Times*, June 9, 1867; *Report of Edward Gottheil*, p. 6.

83. Whitelaw Reid, *After the War: A Tour of the Southern States 1865–1866*, ed. C. Vann Woodward, New York (Harper & Row) 1965 [reprint of 1866 edn.], pp. 233–34.

84. Cooper DeLeon, *op. cit.*, p. 63.

85. Henry Latham, *Black and White: A Journal of a Three Months' Tour in the United States*, London (Macmillan) 1867, p. 159.

86. "An Imperial Letter," *op. cit.*

87. Charles Mackay, *Life and Liberty in America: or, Sketches of a Tour in the United States and Canada in 1857–8*, New York (Harper & Brothers) 1859, p. 262.

88. J. Mead, "Memory Types of New Orleans," in *Leaves of Thought*, Cincinnati (Robert Clarke) 1868, p. 19.

89. Albert D. Richardson, *The Secret Service, the Field, the Dungeon, and the Escape*, Hartford, Conn. (American Publishing Co.) 1865, p. 47.

90. Salomon de Rothschild, *A Casual View of America: The Home Letters of Salomon de Rothschild, 1859–1861*, trans. and ed. Sigmund Diamond, Stanford, Calif. (Stanford University Press) 1962, p. 114.

91. Joseph Holt Ingraham, *The Sunny South; Or, The Southerner at Home*, Philadelphia (G.G. Evans) 1860, p. 328.

92. Owen F. Aldis, "Louis Napoleon and the Southern Confederacy," *North American Review*, CXXIX, 1879, pp. 342–60.

93. *Bee*, May 10, 1862; *True Delta*, May 14, 1862; Benjamin F. Butler, *Butler's Book: Autobiography and Personal Reminiscences*, Boston (A.M. Thayer) 1892, I, p. 468; Benjamin F. Butler, *Private and Official Correspondence of Gen. Benjamin F. Butler During the Period of the Civil War*, Norwood, Mass. (Plimpton Press) 1917, I, pp. 496–97; Gerald M. Capers, *Occupied City: New Orleans Under the Federals 1862–1865*, Lexington (University of Kentucky Press) 1965, p. 69, n. 21; Chester G. Hearn, *When the Devil Came Down to Dixie: Ben Butler in New Orleans*, Baton Rouge (Louisiana State University Press) 1997, p. 131. On "wild rumors that their deliverance would soon be at hand," recorded by diarist Julia LeGrand, see Gerald M. Capers, Jr., "Confederates and Yankees in Occupied New Orleans," *Journal of Southern History*, XXX, no. 4, November 1964, p. 416.

94. Lynn M. Case and Warren F. Spencer, *The United States and France: Civil War Diplomacy*, Philadelphia (University of Pennsylvania Press) 1970, pp. 270–75.

95. "American Affairs in France," *New York Times*, June 2, 1862, cited by Case and Spencer, *op. cit.*, pp. 274–75; *Picayune*, January 7, 1862; Kathryn Abbey Hanna, "The Role of the South in the French Intervention in Mexico," *Journal of Southern History*, XX, no. 1, February 1954, pp. 3–21; Louis Martin Sears, "A Confederate Diplomat at the Court of Napoleon III," *American Historical Review*, XXVI, no. 2, January 1921, pp. 255–81.

96. *Times*, June 24 and September 13, 1866.

97. New Orleans shipped 839 hogsheads of tobacco to French ports between 1865 and 1866, compared to 8419 hogsheads between 1859 and 1860. Tobacco trade with Europe overall suffered great declines: 4784 hogsheads compared to 73,241 immediately before the war; *Gardner's New Orleans Directory for 1867*, pp. 13–14.

98. John T. Trowbridge, *The South, a Tour of Its Battlefields and Ruined Cities*, New York (Arno Press) 1969 [reprint of 1866 edn.], pp. 143–44; George Barnard, *Photographic Views of Sherman's Campaign*, New York (Press of Wynkoop &

Hallenbeck) 1866 [reprinted with an introduction by Beaumont Newhall, New York (Dover) 1977]. See Keith F. Davis, *George N. Barnard, Photographer of Sherman's Campaign*, Kansas City, Mo. (Hallmark Cards) 1990. On Russell, see also pp. 51–52, n. 52.

99. Reid, *op. cit.*, p. 234.

100. Lawrence N. Powell, "New Orleans, Louisiana," in *Macmillan Compendium: The Confederacy*, New York (Simon & Schuster) 1993, p. 770. "Major" is a distinction of size: Nashville, at only 17,000 population in 1860, was the first city to fall to Union forces, and was occupied longer than any other city in American history; Don Doyle, *New Men, New Cities, New South: Atlanta, Nashville, Charleston, Mobile, 1860–1910*, Chapel Hill (University of North Carolina Press) 1990, p. 22.

101. Letters from R.P. Davis dated July 20, 1862, to Mary, and August 17, 1862, to Bill, in William H. Gardiner Papers 1852–1863, Massachusetts Historical Society.

102. William Kingsford, *Impressions of the West and South During a Six Weeks' Holiday*, Toronto (A.H. Armour & Co.) 1858, p. 53.

103. "The Levee and the Wharves," *Crescent*, January 15, 1866.

104. "Flush Times," *Delta*, April 15, 1860.

105. Charles R. Schultz, ed., "New Orleans in December 1861," *Louisiana History*, IX, Winter 1968, pp. 53–61 (manuscript journal of a Maine seaman in the Mystic Seaport Library, Mystic, Conn.).

106. Three hundred vessels ran the blockade at New Orleans in the first ten months of the Union blockade, but that number was one-sixth of the prewar port traffic. The port was opened after capture by federal troops in April 1862; David G. Surdam, *Northern Naval Superiority and the Economics of the American Civil War*, Columbia (University of South Carolina Press) 2000, p. 170. See also cat. 107.

107. "The Levee," *Picayune*, October 17, 1862.

108. George H. Hepworth, *The Whip, Hoe, and Sword; or, the Gulf-Department in '63*, Boston (Walker, Wise, and Company) 1864, pp. 87–88.

109. De Forest, *op. cit.*, p. 122.

110. John W. De Forest, *A Volunteer's Adventures: A Union Captain's Record of the Civil War*, ed. James H. Croushore, New Haven, Conn. (Yale University Press) 1946, p. 21.

111. *Times*, November 21, 1865. J. Madison Wells, *Message of the Governor of Louisiana to the General Assembly, Commencing January 28, 1867*, New Orleans (J.O. Nixon) 1867, p. 11; Gilles Vandal, "The Nineteenth-Century Municipal Responses to the Problem of Poverty: New Orleans Free Lodgers, 1850–1880, as a Case Study," *Journal of Urban History*, XIX, no. 1, November 1992, p. 54.

112. *Crescent*, January 12, 1867.

113. In 1867 wages, $2000 was more than a laborer or drayman might earn in three years. On salaries, see *12th Annual Report of the New Orleans and Jackson Railway*, New Orleans 1867, and *De Bow's Review*, II, no. 3, September 1866, p. 283; on police salaries, see New Orleans Public Library, City Archives, Board of Assistant Aldermen, Journal of Receipts and Expenditures 1865–1870, and *Crescent*, April 4, 1866. On housing costs, see sale of Gérard House ($1900), 1532 St. Philip Street, A. Ducatel, April 26, 1867, NONA.

114. Minutes and Proceedings of the Board of Assistant Aldermen, *op. cit.*; *Crescent*, January 12, 1867.

115. "The Paris Exposition," *New York Times*, February 21, 1867.

116. Susan Danly, "The Landscape Photographs of Alexander Gardner and Andrew Joseph Russell," PhD diss., Brown University, 1983, p. 56.

117. On Civil War-era occupational portraiture, see cat. 66, n. 13.

118. *Manufactures of the United States in 1860, Compiled*

from the Original Returns of the Eighth Census, Washington, D.C. (Government Printing Office) 1865, pp. 199–200, 202; Statistics of the United States ... in 1860; Compiled from the ... Eighth Census, Washington, D.C. (Government Printing Office) 1866, p. XVIII. In the 1860 census, the primary industries were boots and shoes (470 establishments), men's clothing (205), cooperages (73), tin, copper, and sheet iron (58), blacksmithing (38), millinery (30), shipbuilding (10), and marble works (10).

119. Albert D. Richardson, The Secret Service, the Field, the Dungeon, and the Escape, Hartford, Conn. (American Publishing Co.) 1865, pp. 61–65.

120. "New Manufacturing Company," Crescent, March 8, 1867 (quotation); "The Environs of New Orleans," Crescent, February 9, 1866; "Vast Brickmaking Establishment," Picayune, March 8, 1867; "Brick Making," Republican, April 26, 1867.

121. The subject matter recalls Édouard Baldus's large-format views of the Rhône Valley floods of 1856, which may have been the first monumental flood pictures. Malcolm Daniel, The Photographs of Édouard Baldus, New York (The Metropolitan Museum of Art) and Montreal (Canadian Centre for Architecture) 1994, pp. 66–70.

122. Times, May 24, 1867.

123. Mark Twain, Life on the Mississippi, 1883, cited by Robert Giegengack and Kenneth R. Foster, "Physical Constraints on Reconstructing New Orleans," in Rebuilding Urban Places After Disaster: Lessons from Hurricane Katrina, ed. Eugenie L. Birch and Susan M. Wachter, Philadelphia (University of Pennsylvania Press) 2006, p. 22. On the levee policy, see George S. Pabis, "Subduing Nature Through Engineering: Caleb G. Forshey and the Levees-only Policy, 1851–1881," in Transforming New Orleans and Its Environs: Centuries of Change, ed. Craig E. Colten, Pittsburgh (University of Pittsburgh Press) 2000, pp. 64–83.

124. Joel A. Tarr, "Building the Urban Infrastructure in the Nineteenth Century: An Introduction," Infrastructure and Urban Growth in the Nineteenth Century: Essays in Public Works History, XIV, December 1985, p. 61. Tarr has developed concept of the "networked city," publishing extensively on urban technology systems during this period; see also id., "Infrastructure and City-Building in the Nineteenth and Twentieth Centuries," in City at the Point: Essays on the Social History of Pittsburgh, ed. Samuel P. Hays, Pittsburgh (University of Pittsburgh Press) 1989, pp. 213–63; Josef W. Konvitz, Mark H. Rose, Joel A. Tarr, "Technology and the City," Technology and Culture, XXI, no. 2, April 1990, pp. 284–94; id., "The Evolution of American Urban Technology," Journal of Urban Technology, I, no. 1, September 1992, pp. 1–18. See also the review of the work of the "infrastructure school" of urban historians during the mid-1990s in Douglas E. Kupel, "Investigating Urban Infrastructure," Journal of Urban History, XXVII, no. 4, May 2001, pp. 520–25. On the rise of the engineering profession, see Terry S. Reynolds, "The Engineer in 19th-Century America," in The Engineer in America, ed. Terry S. Reynolds, Chicago (University of Chicago Press) pp. 7–26.

125. Franz Anton Ritter von Gerstner, Early American Railroads, ed. Frederick C. Gamst, Stanford, Calif. (Stanford University Press) 1997, p. 748 (Gerstner was writing in 1840; see cat. 44).

126. "What it Costs to Light the City," Picayune, April 23, 1867.

127. Sieur de Rémonville, "Letter to Comte de Pontchartrain," in Literary New Orleans, ed. Judy Long, Athens, Ga. (Hill Street Press) 1999, p. 3.

128. Lynn M. Case and Warren F. Spencer, The United States and France: Civil War Diplomacy, Philadelphia (University of Pennsylvania Press) 1970, p. 267; see cat. 111.

129. See Arthur W. Brayley, History of the Granite Industry of New England, Boston (National Association of Granite Industries) 1913, I, pp. 7–66; John M. Bryan, "Boston's Granite Architecture, c. 1810–1860," PhD diss., Boston University, 1972, pp. 11–18; and cat. 19.

130. See discussion at cat. 61. Granite-block streets are illustrated in many other views, including cats. 14, 51, and 85; the old round-stone streets are seen in cats. 16, 25, and 54.

131. "Banquettes," Picayune, March 24, 1860; "Our Streets," Evening Picayune, January 11, 1859; "Local Improvements," Picayune, October 26, 1862.

132. William Howard Russell, My Diary North and South, ed. Fletcher Pratt, New York (Harper & Bros.) 1954 [reprint of 1861 edn.], p. 128.

133. Kingsford, op. cit., p. 60.

134. Peirce F. Lewis, New Orleans: Making of an Urban Landscape, Cambridge, Mass. (Ballinger) 1976, p. 17.

135. Peter Bacon Hales, "American Views and the Romance of Modernization," in Photography in Nineteenth Century America, 1839–1900, ed. Martha A. Sandweiss, Fort Worth, Tex. (Amon Carter Museum) 1991, p. 220.

136. George Willard Reed Bayley, "Overflow of the Delta of the Mississippi," De Bow's Review, XIII, no. 2, August 1852, p. 175, cited by Pabis, op. cit., p. 66.

137. Friedrich Gerstäcker, Gerstäcker's Louisiana: Fiction and Travel Sketches from Antebellum Times Through Reconstruction, trans. and ed. Irene S. Di Maio, Baton Rouge (Louisiana State University Press) 2006, p. 250. The passage was written in 1868.

138. Heath, op. cit., p. 6.

139. Times, April 8, 1866.

140. "Town Talk," Times, January 7, 1866.

141. "Our City Taken," Times, May 29, 1867.

142. Mark Twain, Life on the Mississippi, New York (Harper & Brothers) 1900, p. 297. In 1879, a British newspaper noted that the canals "are open ditches from twelve to fifteen feet wide, full of black stagnant filth, which ferments for eight months of the year under a mean temperature of 80 degrees," Pall Mall Budget, August 8, 1879.

143. Henry Ashworth, A Tour in the United States, Cuba, and Canada, London (A.W. Bennett) 1861, pp. 77–78.

144. Milton Mackie, From Cape Cod to Dixie and the Tropics, New York (G.P. Putnam) 1864, pp. 157–59.

145. "The Streets of the City," Crescent, January 15, 1867.

146. See Lawrence H. Larsen, "Nineteenth-Century Street Sanitation," Wisconsin Magazine of History, LII, no. 3, Spring 1979, pp. 239–42.

147. Blanchard Jerrold, op. cit., IV, pp. 364–65. On the urban interventions of the Second Empire, see Irene Earls, Napoléon III: l'architecte et l'urbaniste de Paris, Levallois, France (Centre d'Études Napoléoniennes) 1991. On the underground drainage system, proposed by engineer John Roy, see "Drainage," Crescent, May 9, 1867.

148. "Filthy Streets," Courier, January 13, 1860.

149. James Parton, General Butler in New Orleans, New York (Mason Brothers) 1864, p. 400.

150. Times, August 31, 1866.

151. "Clean up the City," Republican, April 24, 1867. A physician testified in 1867 that "barrels filled with ... refuse, portions in an advanced state of decomposition, are constantly being thrown into the river ... poisoning the air with offensive smells and necessarily contaminating the water near the bank for miles." Michael A. Ross, "Justice Miller's Reconstruction: The Slaughter-House Cases, Health Codes, and Civil Rights in New Orleans, 1861–1873," Journal of Southern History, LXIV, no. 4, November 1998, p. 654.

152. "Street Commissioner's Report," in Heath, op. cit., p. 15.

153. Times, October 3, 1866.

154. Times, August 31, 1866.

155. "Drainage," Crescent, op. cit.

156. For a recent study of Civil War memory, see David W. Blight, Race and Reunion: The Civil War in American Memory, Cambridge, Mass. (Harvard University Press) 2001.

157. Cited by Herman Hattaway, "The Embattled Continent," in Touched by Fire, ed. William C. Davis, New York (Black Dog & Leventhal) 1997, p. 45.

158. Keith F. Davis, op. cit., p. 176.

159. Michael P. Johnson, "Looking for Lost Kin: Efforts to Reunite Freed Families After Emancipation," in Southern Families at War: Loyalty and Conflict in the Civil War South, ed. Catherine Clinton, New York (Oxford University Press) 2000, p. 15.

160. Approximately 258,000 Confederates died, 94,000 in battle, the larger number from disease, and about 200,000 were wounded. The Union suffered an even greater toll, having mobilized 2.2 million, or half the military-age population in 1860: a total of 360,000 died and 275,000 were wounded; Gary Gallagher, The Confederate War, Cambridge, Mass. (Harvard University Press) 1997, pp. 28–29.

161. "A Sunday Stroll along the Levee," Times, February 4, 1863.

162. Walt Whitman, Memoranda During the War, ed. Peter Coviello, New York (Oxford University Press) 2004, p. 4.

163. Butler, Private and Official Correspondence of Gen. Benjamin F. Butler, op. cit., II, p. 74.

164. Blight, op. cit., pp. 19–20 and 402–403, n. 27.

165. "The Hospital Service," Times, June 12, 1865; "The Military Hospitals of New Orleans," Picayune, March 12, 1863.

166. Major Edward J. Noyes to his mother, August 10, 1862, Noyes Family Papers, 1687–1949, Ms N-607, Massachusetts Historical Society.

167. On Eugénie's pioneering patronage of asylums in France, see Alison McQueen, "Women and Social Innovation during the Second Empire: Empress Eugénie's Patronage of the Fondation Eugène Napoléon," Journal of the Society of Architectural Historians, LXVI, no. 2, June 2007, pp. 176–93.

168. Powell, op. cit.

169. Frank M. Flinn, Campaigning with Banks in Louisiana, '63 and '64 ..., Boston (W.B. Clarke) 1889, p. 12.

170. Crescent, May 2, 1862.

171. "To Our Readers," Crescent, May 3, 1862.

172. Frances Fearn, ed., Diary of a Refugee, New York (Moffat, Yard, & Company) 1919, p. 136.

173. U.S. Justice Samuel Miller, quoted by Eric Foner, Reconstruction: America's Unfinished Revolution 1863–1877, New York (Harper & Row) 1988, p. 263. See p. 60 and cat. 68.

174. "Ampitheatrum Johnsonianum," Harper's Weekly, March 30, 1867, pp. 200–201; "The Riot in New Orleans," New York Times, August 8, 1866.

175. "The Riot in New Orleans," op. cit.; "Riot in the City," Times, July 31, 1866.

176. Dale Somers, "War and Play: The Civil War in New Orleans," Mississippi Quarterly: The Journal of Southern Culture, XXVI, no. 1, Winter 1972–73, pp. 4–28; Vandal, op. cit., pp. 34–35.

177. W.E.B. DuBois, Black Reconstruction in America 1860–1880, New York (Atheneum) 1985 [reprint of 1935 edn.], p. 82, cited by Arnesen, op. cit., p. 262, n. 34; see also David C. Rankin, "The Origins of Black Leadership in New Orleans During Reconstruction," Journal of Southern History, LX, no. 3, August 1974, p. 418.

178. Reid, op. cit., pp. 243–44.

179. Richard C. Wade, *Slavery in the Cities*, New York (Oxford University Press) 1972, p. 198.

180. Louis A. Warren, *Lincoln's Youth: The Indiana Years*, New York (Appleton Century Crofts) 1959, p. 185, cited by Peyton McCrary, *Abraham Lincoln and Reconstruction: The Louisiana Experiment*, Princeton, NJ (Princeton University Press) 1978, p. 25, n. 12.

181. *Picayune*, January 1, 1860; John Brown, *Slave Life in Georgia: a Narrative of the Life, Sufferings, and Escape of John Brown, a Fugitive Slave* [1855], ed. F.N. Boney, Savannah (Library of Georgia) 1991, p. 100; Frederic Bancroft, *Slave Trading in the Old South*, New York (Ungar) 1959, pp. 312, 319; Wade, *op. cit.*, pp. 199–201.

182. Wade, *op. cit.*, p. 38.

183. Peter Kochin, *American Slavery 1619–1877*, New York (Hill & Wang) 2003, p. 257; Katherine Olukemi Bankole, "A Critical Inquiry of Enslaved African Females and the Antebellum Hospital Experience," *Journal of Black Studies*, XXXI, no. 5, May 2001, p. 520.

184. P.G.T. Beauregard to Alexander Bowman, February 5, 1854; P.G.T. Beauregard to Secretary of the Treasury James Guthrie, March 11, 1854; P.G.T. Beauregard to Secretary of the Treasury Howell Cobb, December 26, 1857, New Orleans Custom House, General Correspondence, Letters Received, Records of the Public Buildings Service, RG121, NARA (see cat. 19).

185. Wade, *op. cit.*, p. 37; McCrary, *op. cit.*, pp. 47–48. New York bankers J.P. Morgan Chase disclosed in 2004 that Canal Bank and another of its predecessor banks in New Orleans had taken 13,000 slaves as collateral on loans between 1851 and 1865, and acquired ownership of 1250 slaves when the loans defaulted. Chase publicly apologized and established a $5 million scholarship fund in Louisiana for black college students. See "J.P. Morgan Discloses Past Links to Slavery," *Washington Post*, January 21, 2005; "An Update on Corporate Slavery," *New York Times*, January 31, 2005.

186. Capers, "Confederates and Yankees," *op. cit.*, p. 426, and *id.*, *Occupied City*, *op. cit.*, pp. 55, 94, 222–24.

187. Report of J.D. Rich, Assistant Inspector of the Parish of St. Charles, January 31, 1866, Plantation Inspection Reports, Office of the Assistant Commissioner, Louisiana, Records of the Bureau of Refugees, Freedmen, and Abandoned Lands, RG105, NARA; *De Bow's Review*, IV, no. 3, September 1867, pp. 237–38.

188. *Picayune*, October 26, 1867. Similar statements on immigration filled the pages of *De Bow's Review* throughout 1866 and 1867 and appeared regularly in the *Bee*, *Picayune*, and other newspapers.

189. *Report of Edward Gottheil*.

190. *Times*, July 11, 1866.

191. George E. Waring, Jr., *Report on the Social Statistics of Cities*, Washington, D.C. (Government Printing Office) 1887, II, p. 266; George Augustin, *History of Yellow Fever*, New Orleans (Searcy & Pfaff) 1909.

192. "The Plague in the South-West," *De Bow's Review*, XV, no. 6, December 1853, p. 614; "The Epidemic," *Picayune*, August 14, 1853.

193. *Counter Report of the Joint Committee on Public Health of the Senate and House of Representatives of the State of Louisiana*, New Orleans (Emile La Sere) 1854, p. 1.

194. "The Fever," *Picayune*, July 30, 1853.

195. *Times*, July 30, 1866. The cost of the disease was estimated at more than $45 million for the years 1845 to 1850 alone; David R. Goldfield, "The Business of Health Planning: Disease Prevention in the Old South," *Journal of Southern History*, XLII, no. 4, November 1976, pp. 557–70.

196. Waring, *op. cit.*, p. 265, quoting James D.B. De Bow.

197. Benjamin F. Butler, "Some Experiences with Yellow Fever and Its Prevention," *North American Review*, CXLVII, November 1888, p. 528.

198. Wickham Hoffman, *Camp, Court, and Siege*, New York (Harper & Bros.) 1877, p. 34.

199. *Picayune*, September 6, 12, and 22, 1867; and *Philadelphia Photographer*, IV, no. 47, November 1867, p. 367, on the deaths of photographers William D. McPherson and Charles E. Johnson. John Salvaggio, *New Orleans' Charity Hospital: A Story of Physicians, Politics, and Poverty*, Baton Rouge (Louisiana State University Press) 1992, p. 47. An immigration pamphlet of the period minimized the danger: "Beyond an occasional visitation from yellow fever," *Information for Immigrants into the State of Louisiana* claimed, "New Orleans is the healthiest city on the continent"; J.C. Kathman, *Information for Immigrants into the State of Louisiana*, New Orleans (Republican Office) 1868, pp. 15–16. New Orleans would be plagued by yellow fever for another thirty-eight years: outbreaks occurred again in 1870, 1873, 1878, 1897, and 1905. The epidemic of 1878 was the deadliest of these, with a mortality exceeded only by the epidemics of 1853 and 1858.

200. *Picayune*, September 12, 1867.

201. "The Photographic Aldermanic Album for the Paris Exposition," *Picayune*, May 22, 1867; "The Lilienthal Views," *Times*, May 24, 1867; *Crescent*, November 19, 1866; *Times*, November 28, 1866; *Deutsche Zeitung*, March 1 and 8, 1867; "Worth Seeing," *Deutsche Zeitung*, May 23, 1867; *Crescent*, May 26, 1867; "The Album for the Paris World Exhibition," *Deutsche Zeitung*, June 9, 1867 (see pp. 270–85).

202. Ken Johnson, "Images from the New Deal," *New York Times*, January 9, 2004.

203. "The Daguerreotype," *Bee*, March 14, 1840.

204. Walt Whitman, "A Visit to Plumbe's Gallery," in *The Gathering of the Forces*, ed. C. Rodgers and J. Black, New York (G.P. Putnam's Sons) 1920, p. 116. See Dana Brand, *The Spectator and the City in Nineteenth-Century American Literature*, New York (Cambridge University Press) 1991, pp. 163–67.

205. *New York Times*, October 20, 1862, reprinted in Keith F. Davis, "A Terrible Distinctness: Photography in the Civil War Era," in *Photography in Nineteenth Century America*, *op. cit.*, pp. 150–52.

206. "Architectural Views," *Philadelphia Photographer*, II, 1867, p. 403.

207. Joseph Holt Ingraham, *The South-West, by a Yankee*, New York (Harper & Brothers) 1835, I, p. 159.

208. W.H. Fox Talbot, *The Pencil of Nature*, London (Longman) 1844–46, I, plate XIII, cited by Mark Haworth-Booth, *Photography: An Independent Art, Photographs from the Victoria and Albert Museum 1839–1996*, Princeton, NJ (Princeton University Press) 1997, pp. 21 and 203, n. 16.

209. Whitman, "A Visit to Plumbe's Gallery," *op. cit.*, p. 116.

210. *Philadelphia Photographer*, IV, no. 48, December 1867, p. 403.

211. *Deutsche Zeitung*, March 1, 1867.

212. *Times*, May 29, 1867.

213. Anne McCauley, "Realism and its Detractors", in *Paris in 3D: From Stereoscopy to Virtual Reality 1850–2000*, Paris (Musée Carnavalet) 2000, p. 25.

214. Wolfgang Hesse, "Reproducing the World," in Hermann Krone, *Historisches Lehrmuseum für Photographie: Experiment, Kunst, Massenmedium*, ed. Wolfgang Hesse, Dresden (Verlag der Kunst) 1998, p. 14.

215. *Times*, June 27, 1866.

216. "Cabinet Portraits," *Humphrey's Journal*, XIX, no. 7, August 1, 1867, p. 107.

217. Joel Snyder has suggested that such signatures were as much commercial promotions as claim of authorship, in "Nineteenth-Century Photography of Sculpture and the Rhetoric of Substitution," in *Sculpture and Photography: Envisioning the Third Dimension*, ed. Geraldine A. Johnson, Cambridge (Cambridge University Press) 1998, p. 28.

218. W.J. Stillman, "The Art in It," *Photographic Times and American Photographer*, XVI, 1886, pp. 156, 165. New York photographer B.J. Falk, interviewed in New Orleans in 1893, offered another view: "Formerly the overcoming of technical difficulties was enough to give any photographer a prestige, but now that these have been swept away, the photographer has been placed on the same plane as any other artists, and he must be judged by the same standards"; "Photographic Art," *Times–Democrat*, January 3, 1893. On photography's claim as a fine art during this period, see Neil Harris, "Iconography and Intellectual History: The Half-Tone Effect," in *New Directions in American Intellectual History*, ed. John Higham and Paul K. Conkin, Baltimore (Johns Hopkins University Press) 1979, pp. 202–203; and John Taylor, *The Old Order and the New: P.H. Emerson and Photography, 1885–1895*, New York (Prestel) 2006, pp. 29–33.

219. *Deposition of Theodore Lilienthal*.

220. *Times* (advertisement), May 3, 1868.

221. Joel Snyder, "Photographers and Photographs of the Civil War," in *The Documentary Photograph as a Work of Art: American Photographs, 1860–1876*, Chicago (The David Alfred Smart Gallery, University of Chicago) 1976; *id.*, "Territorial Photography," in *Landscape and Power*, ed. W.J.T. Mitchell, Chicago (University of Chicago Press) 1994, p. 181.

222. William F. Stapp, "To ... Arouse the Conscience, and Affect the Heart," in Brooks Johnson, *An Enduring Interest: The Photographs of Alexander Gardner*, Norfolk, Va. (Chrysler Museum) 1991, p. 21.

223. William Crawford, *The Keepers of Light: A History and Working Guide to Early Photographic Processes*, Dobbs Ferry, NY (Morgan & Morgan) 1979, p. 48. On the collodion process, see John Barnier, ed., *Coming into Focus: A Step-by-Step Guide to Alternative Photographic Printing Processes*, San Francisco (Chronicle Books) 2000, pp. 49–85; Reese V. Jenkins, *Images and Enterprise: Technology and the American Photographic Industry 1839 to 1925*, Baltimore (Johns Hopkins University Press) 1975, pp. 38–39; F.S. Osterman, "How the Collodion Process Was Invented," *Collodion Journal*, VII, no. 23, Winter 2001, pp. 1–8; "Photography in a Nut-shell," *Philadelphia Photographer*, I, no. 6, June 1877, endpages; "Photography Simplified: No. 2, Collodion," *St. Louis Practical Photographer*, II, no. 5, May 1878, p. 141; Robert Taft, "A Photographic History of Early Kansas," *Kansas Historical Quarterly*, III, no. 1, February 1934, pp. 3–4.

224. James F. Ryder, *Voigtländer and I: In Pursuit of Shadow Catching*, Cleveland (Imperial Press) 1902, p. 14.

225. Lady Elizabeth Eastlake, "Photography," *Quarterly Review*, CI, April 1857, pp. 442–68, reprinted in Beaumont Newhall, ed., *Photography: Essays and Images*, New York (Museum of Modern Art) 1980, pp. 81–95.

226. Lyle Rexler, "Marriage Under Glass," *New York Times*, August 20, 2000; *id.*, "Adopting the Itinerant Life of an Old Time Tintypist," *New York Times*, November 19, 2000.

227. Hermann Vogel, "German Correspondence," *Philadelphia Photographer*, IV, no. 47, November 1867, p. 362.

228. Lilienthal made the views for the U.S. Quartermaster (see p. 44) in November 1865 (cats. 9, 102, 103, 116, and 117, and possibly 114) and two firemen's portrait groups in 1866 (cats. 90 and 91).

229. "The Lilienthal Views," *Times*, May 24, 1867.

230. Wharton, "Diary," June 24, 1854.

231. The photograph recalls Charles Marville's view of *c.* 1867 of the Boulevard Saint-Jacques, but the standing figure with his leg up has an insouciance rarely seen on the boulevards of Paris; Maria Morris Hambourg, *Charles Marville: Photographs of Paris at the Time of the Second Empire on Loan from the Musée Carnavalet*, Paris, New York (Alliance Française) 1981, pl. 44.

232. See Sarah Boxer, "Memories Live in Ansel Adams Dreamscapes," *New York Times*, September 1, 2001.

233. On early photography as a record of passing events, see Michael L. Carlebach, *The Origins of Photojournalism in America*, Washington, D.C. (Smithsonian Institution Press) 1992.

234. Snyder, *op. cit.,* p. 22.

235. See the discussion in cat. 46.

236. *Deposition of Theodore Lilienthal.* The Globe lens was introduced by Charles C. Harrison and J. Schnitzer of New York around 1860. On the Globe and other lenses, see Rudolf Kingslake, "Optics Design in Photography," *Image*, XXV, nos. 3–4, September–December 1982, pp. 38–52; Peter Palmquist, "Carleton E. Watkins at Work," *History of Photography*, VI, 1982, p. 292; Taft, *op. cit.,* p. 511, n. 447; Désiré Van Monckhoven, *Photographic Optics*, London (R. Hardwicke) 1867, p. 128; William Welling, *Photography in America: The Formative Years 1839–1900*, New York (Crowell) 1978, pp. 152, 165–67.

237. John Szarkowski, *Atget*, New York (Callaway Editions) 2000, p. 12.

238. Van Monckhoven, *op. cit.,* p. 100. Lilienthal also could not get too close to building subjects in order to avoid convergence of the perpendiculars, and any backward or forward movement of the camera to compensate might risk vignetting.

239. "The Photographic Exhibition," *Journal of the Photographic Society*, III, January 21, 1857, p. 193, cited by Martin Barnes, *Benjamin Brecknell Turner: Rural England Through a Victorian Lens*, London (V&A Publications) 2001, pp. 61 and 76, n. 72.

240. For a concise history of pre-photographic urban iconography, see Eve Blau, "Patterns of Fact: Photography and the Transformation of the Early Industrial City," in *Architecture and Its Image: Four Centuries of Architectural Representation*, Montreal (Canadian Centre for Architecture) 1989, pp. 36–57. On the centuries-old *vedute* tradition of engraved views of cities, see *The Origins of the Italian Veduta*, exh. cat., Providence, RI (Bell Gallery, Brown University Department of Art) 1978.

241. *The City of Philadelphia, in the State of Pennsylvania North America: as it appeared in the Year 1800 consisting of Twenty Eight Plates, by William Russell Birch and Thomas Birch. Engravings, by the artists and Samuel Seymour, 1789–1800 ... Published by W. Birch ... Decr 31st 1800*. There were four published editions of Birch's views in his lifetime; see Martin P. Snyder, "William Birch: His Philadelphia Views," *Pennsylvania Magazine of History and Biography*, LXXIII, 1949, pp. 271–315 (quotation in text from Birch's manuscript *Autobiography*, I, pp. 46–47, cited by Snyder, p. 274); *id.*, "Birch's Philadelphia Views: New Discoveries," *Pennsylvania Magazine of History and Biography*, LXXXVIII, 1964, pp. 164–73; *id., City of Independence: Views of Philadelphia Before 1800*, New York (Praeger) 1975, pp. 224ff. On Birch's influence, see Rodger C. Birt, "Envisioning the City: Photography in the History of San Francisco, 1850–1906," PhD diss., Yale University, 1985, p. 161; and Susan Gross, *Toward an Urban View: The Nineteenth-Century American City in Prints*, New Haven, Conn. (Yale University Art Gallery)

1989. Images of Birch's views in the Free Library of Philadelphia and a plot map of view sites are at brynmawr.edu/iconog/birch.

242. P. Langlumé lithographed the St. Aulaire views, possibly in Paris in the 1820s, or later, in about 1837 in New Orleans. Felix Achille Beaupoil, marquis de St. Aulaire, was author of *Voyage pittoresque à travers le monde*, Brussels, 1843. St. Aulaire is documented in New Orleans in 1820 but by 1827 is back in Paris, where he exhibited in the salon of 1827. Langlumé may have exhibited at the Paris salons of 1822–24, and was working at the *Bee* as a lithographer in 1837. He is later documented as a daguerreian; *Encyclopedia of New Orleans Artists 1718–1918*, New Orleans (The Historic New Orleans Collection) 1987, pp. 225, 335. I thank François Brunet for his research in Paris on St. Aulaire.

243. Many of the auction advertisements, which are typically very large sheets with banner lettering, site plans, and perspective views of sale properties, are preserved in the plan books of the New Orleans Notarial Archives; see Sally K. Reeves, "The Plan Book Drawings of the New Orleans Notarial Archives: Legal Background and Artistic Development," *Proceedings of the American Antiquarian Society*, CV, pt. 1, 1995, pp. 105–25.

244. "Petition de F'k Wilkinson Gibson's Directory 150 Exemplaire $600!!!! S du 27 Janvier 1838," New Orleans City Papers, Manuscripts Collection, Tulane University Library. On the guidebook tradition in general, see M. Christine Boyer, *City of Collective Memory: Its Historical Imagery and Architectural Entertainments*, Cambridge, Mass. (MIT Press) 1994, ch. 5.

245. *The New-Orleans Pictorial Advertiser for 1849*, New Orleans (Cook, Young & Co.) 1849 (the title's frontispiece was a Shields & Collins panorama of the riverfront). Shields was active in New Orleans from about 1836 to 1856 (partnered with both Collins and Hammond). Shields's other work includes the Shields & Co. logographs in *Cohen's New Orleans and Lafayette Directory ... for 1850*, New Orleans (Job Office of the Delta) 1849; *Affleck's Southern Rural Almanac* for 1851 and 1854 (Shields & Collins; Shields & Hammond); Wallace Brice, *New Orleans Merchants' Diary and Guide, for 1857 and 1858*, New Orleans (E.C. Wharton Printer) 1857, and other city-directory engravings from 1841 to 1856. Shields & Collins's wood engraving of Odd Fellows' Hall (fig. 25) appeared on the front page of the *Delta*, December 23, 1849.

246. The highest achievement of the lithographed commercial view for New Orleans occurred about 1868–70, with the publication of a suite of thirty-one colored lithographs of shopfronts and factories by Benedict Simon (a variant of fig. 24). On the use of lithography for city views, see John W. Reps, *Views and Viewmakers of Urban America*, Columbia (University of Missouri Press) 1984; *id., Cities on Stone: Nineteenth Century Lithograph Images of the Urban West*, Fort Worth, Tex. (Amon Carter Museum) 1976.

247. See p. 45. Examples of New Orleans views are found in *Gleason's Pictorial Advertiser*, V, July 16, 1853 (a view of the St. Charles Hotel); and *Ballou's Pictorial Drawing-Room Companion*, XIII, no. 5, August 1, 1857 (a view of Canal Street after James Andrews).

248. Paul Martin, *Victorian Snapshots*, New York (Charles Scribner's Sons) 1939 [reprinted New York (Arno Press) 1973], p. 11.

249. The view is one of Easterly's earliest known images, and his earliest surviving outdoor view; see Dolores A. Kilgo, *Likeness and Landscape: Thomas M. Easterly and the Art of the Daguerreotype*, St. Louis (Missouri Historical Society) 1994, pp. 10–12. Smith and Tucker, p. 10, published a daguerreotype of Canal Street by an unknown photographer, dated to *c.* 1844–46, formerly in the Louisiana State

Museum collection; on Lion, see Smith and Tucker, p. 17, and Peter E. Palmquist and Thomas R. Kailbourn, *Pioneer Photographers from the Mississippi to the Continental Divide: A Biographical Dictionary, 1840–1865*, Stanford, Calif. (Stanford University Press) 2004, p. 400.

250. Mary Warner Marien, "Imaging the Corporate Sublime," in *Carleton Watkins: Selected Texts and Bibliography*, ed. Amy Rule, Oxford (Clio Press) 1993, p. 22.

251. Thompson's view book of forty-eight photographs was bound as *Toronto in the Camera: A Series of Photographic Views of the Principal Buildings in the City of Toronto*, Toronto (Octavius Thompson) 1868 (published in twelve parts). Thompson's prints were much smaller than Lilienthal's, each about 3 × 3 inches (8 × 8 cm), published with accompanying text giving building facts. The book was occasioned by Canadian Confederation in 1867; Toronto was then a city of only 45,000, about a quarter the size of New Orleans. On Thompson, see Elizabeth Hulse, *A Dictionary of Toronto Printers, Publishers, Booksellers and the Allied Trades, 1798–1900*, Toronto (Anson-Cartwright Editions) 1982, p. 256 (I am grateful to Jill Delaney for bringing Thompson's work to my attention). Frederick DeBourg Richards's views of Philadelphia in 1857–60 number 120; John Moran's album of views (1866–67) of Philadelphia, antiquarian in purpose, are in the Library Company of Philadelphia, and number seventy-nine prints; most of these prints are 6 × 9 inches (15 × 23 cm), or smaller. On Moran, see "The Early Work of John Moran, Landscape Photographer," *American Art Journal*, XI, no. 1, January 1979, pp. 65–75; on Philadelphia iconography, see Jeffrey Cohen, "Evidence of Place: Resources Documenting the Philadelphia Area's Architectural Past," *Pennsylvania Magazine of History and Biography*, CXXIV, nos. 1–2, January–April 2000, pp. 145–201. On urban view photography and the motives of boosterism, see Peter Bacon Hales, *Silver Cities: The Photography of American Urbanization, 1839–1915*, Philadelphia (Temple University Press) 1984 (revised edition, *Silver Cities: Photographing American Urbanization, 1839–1939*, University of New Mexico Press, 2005); *id.*, "American Views and the Romance of Modernization," pp. 204–57.

252. On Fardon, see Birt, *op. cit.*, and George Robinson Fardon, *San Francisco Album*, San Francisco (Chronicle Books) 1999.

253. A parallel, but much more modest, episode in municipally sponsored photographic boosterism is recorded in Australia, where in 1866 the town council of Beechworth commissioned Australian photographer Algernon Hall to produce fourteen views of the town (now in the Victoria and Albert Museum, London) for exhibition at the Intercolonial Exposition of 1866 and the Paris Exposition of 1867 (they were not, however, exhibited in Paris). See Haworth-Booth, *op. cit.*, p. 60.

254. James F. Ryder, "Photographing a Railroad," *American Annual of Photography and Photographic Times-Bulletin*, 1904, pp. 144–46.

255. The western surveys had the additional purposes of measuring the land, mapping, collecting samples, and preparing the land for speculators. Robin Earle Kelsey, "Photography in the Field: Timothy O'Sullivan and the Wheeler Survey, 1871–1874," PhD diss., Harvard University, 2000, pp. 216–17.

256. Of the extensive literature on the western surveys, see particularly François Brunet, "'Picture Maker of the Old West': W.H. Jackson and the Birth of Photographic Archives in the United States," *Prospects*, XIX, 1994, pp. 161–87; Susan Danly, "Andrew Joseph Russell's *The Great West Illustrated*," in *The Railroad in American Art*, Cambridge, Mass. (MIT Press) 1988, pp. 93–112; *ead.*, "The Railroad and Western Expansion," in Brooks Johnson, *op. cit.*, pp. 82–95; *ead.*, "The Landscape Photographs of Alexander Gardner and

Andrew Joseph Russell," *op. cit.*; Kelsey, *op. cit.*; David Margolis, *To Delight the Eye: Original Photographic Book Illustrations of the American West*, Dallas (DeGoyler Library, Southern Methodist University) 1995; Martha Sandweiss, "Undecisive Moments: The Narrative Tradition in Western Photography," in *Photography in Nineteenth Century America, op. cit.*, pp. 98–129; *ead., Print the Legend: Photography and the American West*, New Haven, Conn. (Yale University Press) 2002; Joel Snyder, "Aesthetics and Documentation: Remarks Concerning Critical Approaches to the Photographs of Timothy O'Sullivan," in *Perspectives on Photography: Essays in Honor of Beaumont Newhall*, ed. Peter Walch and Thomas F. Barrow, Albuquerque (University of New Mexico Press) 1986, pp. 125–150; *id., American Frontiers: The Photographs of Timothy H. O'Sullivan, 1867–1874*, New York (Aperture) 1981; *id.*, "Territorial Photography," *op. cit.*, pp. 175–201; Robert Sobieszek, "Conquest by Camera: Alexander Gardner's 'Across the Continent on the Kansas Pacific Railroad,'" in *Art in America*, LX, March–April 1972, pp. 80–85; Taft, *op. cit.*, pp. 3–14; *id., Photography and the American Scene*, New York (Dover) 1964 [reprint of 1938 edn.], pp. 248–310; and the essays by William Goetzman, William Kittredge, and Susan Danly in *Perpetual Mirage: Photographic Narratives of the Desert West*, New York (Whitney Museum of American Art) 1996.

257. In Russell's work, the captions, as Martha Sandweiss has shown, draw attention to what is not visible in the photographs, the resources that might be found in the landscape. Sandweiss, *Print the Legend, op. cit.*, pp. 169–73, 184.

258. Rule, *op. cit.*, pp. 165–68.

259. The largest set of Edwards's New Orleans views are in The Historic New Orleans Collection; another set is in the Southeastern Architectural Archive, Tulane University. His construction views of the Custom House (cat. 19), and the Marine Hospital (cat. 48), for the Treasury Department are in the Hill Library, Louisiana State University. Edwards was born in New Hampshire in 1831, worked briefly as a daguerreian in St. Louis, and arrived in New Orleans in 1859. In June 1860 (1860 Census, M653, Roll 421, p. 25, NARA), he is recorded for "Ambrotype Portraits" and a resident of the Fourth Ward, and in 1861 he operated a studio on Royal Street. The *Picayune* of April 9, 1861, announced six "beautiful photographic views of the Park of New Orleans, the Metairie Ridge and the Metairie race course ... from the gallery of photographic art which Mr. Edwards has on Royal street, near Canal street." Edwards's views of Confederate encampments at Pensacola in May 1861 were among the earliest photographs of the war; he advertised them as "Photographic Views from the Seat of War ... superb Views, taken by an artist on the spot" (*Picayune*, May 16 and 19, 1861). By 1865, Edwards was working in Richmond, Virginia, by 1871 in Norfolk, Virginia, and from 1886 in Atlanta, where he died in 1900. See obituaries in the *Atlanta Constitution*, June 7 (with portrait) and 10, 1900; Palmquist and Kailbourn, *Pioneer Photographers from the Mississippi to the Continental Divide, op. cit.*, pp. 230–31; Leslie D. Jensen, "Photographer of the Confederacy: J.D. Edwards," in *Shadows of the Storm: Volume One of The Image of War, 1861–1865*, ed. William C. Davis, Garden City, NY (Doubleday & Company) 1981, pp. 344–46, and William C. Davis, "Photography," in *Encyclopedia of the Confederacy*, ed. Richard N. Current, New York (Simon & Schuster) 1993, III, p. 1205.

260. Most of the surviving McPherson and Oliver views appear to date from 1863 to 1865. Unnumbered and undated, the largest group survives assembled in an indexed carte-de-visite album, the "Dunham Marshall Photo Album," Mss. 3241, in the Hill Library, Louisiana State University, Baton Rouge. McPherson was born around 1833 in Boston. He partnered with Oliver (whose full name is not known) in Baton Rouge from at least 1863, and in 1864 they were established in New Orleans. Between 1866 and 1867 McPherson was working alone at 132 Canal Street; *Louisiana State Gazetteer and Business Man's Guide for 1866 and 1867*, New Orleans (Palmer, Buchanan & Smith) 1867; *Crescent*, January 15 and 20, 1867; *Picayune*, March 10, 1867. See Smith and Tucker for McPherson and Oliver's views of Fort Morgan, Alabama, in 1864, pp. 124–26.

261. The work of Frederick Wenderoth in Philadelphia, N.L. Stebbins in Boston, and Marcus Ormsbee of New York in the 1860s and early 1870s shows a comparable range of commercial portraits.

262. "The Lilienthal Views," *Times*, May 24, 1867.

263. Watkins exhibited 20 × 24-inch (51 × 61-cm) views of the Carmel Mission in Monterey, among other photographs; Jackson exhibited "Scenes along the Line of the Denver and Rio Grande Railway," the Baltimore and Ohio Railroad, and his U.S. Geological Survey work in the west. The New Orleans exhibition has been overlooked in recent photographic literature, but was heavily reported in the contemporary photographic press: "The World's Fair in New Orleans," *Photographic Times and American Photographer*, XIV, October 1884, pp. 543–47, November 1884, pp. 585–87, December 1884, pp. 681–82; XV, January 1885, p. 167; *Philadelphia Photographer*, "Photography at the New Orleans Exhibition," XXI, October 1884, pp. 289–90, 320, December 1884, pp. 321–26, 353–54, XXII, January 1885, pp. 19–21, 31, February 1885, pp. 33–35, March 1885, pp. 65–82, 96, April 1885, pp. 97–101, May 1885, pp. 129–34, 138–40, June 1885, pp. 161–72, 183–85, July 1885, pp. 216–21, September 1885, pp. 280–86, 291, 311–12; "Exposition Jottings," *Anthony's Photographic Bulletin*, XVI, no. 3, February 14, 1885, pp. 84–85, 172, 245–46, 272–73, 324–27, 419–20; "The Photographic Exhibit at New Orleans," *Photographers' Weekly*, XIV, no. 6, March 7, 1885.

264. *Philadelphia Photographer*, XXII, April 1885, p. 98, and "Photography at the New Orleans Exposition," XXII, May 1885, p. 132, June 1885, p. 166.

265. Born in France in 1855, Mugnier lived in Switzerland and London before emigrating to New Orleans shortly after the war. Apprenticed as a watchmaker, he eventually took up photography and by 1884 was operating a gallery at 24 Exchange Alley, where he advertised as a "landscape photographer" specializing in "stereoscopic and graphoscopic views of Louisiana scenery, New Orleans and vicinity," *Soard's New Orleans City Directory*, New Orleans (Soard's) 1884. Mugnier closed the studio a few years later and held a variety of jobs as a photo-engraver and machinist, and in 1901 became foreman of the photo-engraving department of the *Times-Democrat*. Notices of his work appeared in the national photographic press from the mid-1880s and after his presentation at the Cotton Exposition (he was praised as "the first who successfully photographed lightning" by the *Philadelphia Photographer*, XXI, November 1884, p. 349). *Anthony's Photographic Bulletin* (XVI, no. 6, March 28, 1885, p. 172) also reported on Mugnier's display at the Cotton Exposition. Mugnier did not sustain a professional practice, and died in 1936. Large collections of his glass-plate negatives are in the Louisiana State Museum and the Southeastern Architectural Archive, Tulane University. No monograph on him exists, but two exhibition catalogs publish his work with basic biographical notes: Lester B. Bridaham, ed., *New Orleans and Bayou Country: Photographs 1880–1910 by George François Mugnier*, New York (Weathervane Books)

1972; John R. Kemp and Linda Orr King, eds., *Louisiana Images, 1880–1920: A Photographic Essay*, Baton Rouge (Louisiana State University Press) 1975.

266. "Letter from Paris," *Picayune*, April 22, 1868.

267. "Local Intelligence," *Times*, June 16, 1868.

268. "Interesting on the Subject of Immigration," *Bee*, May 9, 1867.

269. *Times*, May 15, 1867.

270. "Arrival of German Emigrants," *Picayune*, October 26, 1867; Gerstäcker, *op. cit.*, p. 253.

271. J.T. Trowbridge, *The South, a Tour of Its Battle-fields and Ruined Cities*, Hartford, Conn. (L. Stebbins) 1866, p. 415.

272. "Emigration to Louisiana," *Harper's Weekly*, XIII, no. 662, September 4, 1869, p. 563; "Ho! For Louisiana," *Harper's Weekly*, XIII, no. 664, September 18, 1869, p. 607.

273. Francis William Loring and C.F. Atkinson, *Cotton Culture and the South Considered with Reference to Emigration*, Boston (A. Williams & Co.) 1869, p. 5.

274. Rowland Berthoff, "Southern Attitudes Toward Immigration, 1865–1914," *Journal of Southern History*, XVII, no. 3, August 1951, p. 342. See also James Bert, "Efforts of the South to Encourage Immigration, 1865–1900," *Southern Atlantic Quarterly*, II, 1932, p. 369; *De Bow's Review*, IV, no. 5, November 1867, pp. 469–71.

275. From 1860 to 1910, New Orleans's population grew by 101 percent, insignificant compared to the cities of the "New South." During the same period, Atlanta grew by 1521 percent, Nashville by 550 percent, Houston by 1526 percent, and Memphis by 480 percent; Doyle, *op. cit.*, p. 15.

276. Quotation in previous paragraph, "Lost fortunes and advantages," *Report of Edward Gottheil*, p. 6; Charles Dickens, "The French Market at New Orleans," *All the Year Round*, XIII, December 26, 1874, p. 257.

277. *Proceedings of the M.W. Grand Lodge of the State of Louisiana ...*, New Orleans (A.W. Hyatt) 1889, p. 15.

278. George W. Engelhardt, *The City of New Orleans: The Book of the Chamber of Commerce and Industry of Louisiana*, New Orleans (George W. Engelhardt) 1894, pp. 1–8; *The Resources and Attractions of Progressive New Orleans, the Great Metropolis of the South*, New Orleans (Young Men's Business League) 1895, pp. 7, 11. The enlistment of photography to bring population to New Orleans did not end with Lilienthal's portfolio. Twenty years later, the New Orleans Camera Club was reported to be "working with the city immigration society by contributing the use of views to be sent out to different sections of the country as a means to attract winter tourists and settlers to Louisiana." *Wilson's Photographic Magazine*, XXVI, January 5, 1889, p. 337.

Theodore Lilienthal (1829–1894): A "Practical Photographer"

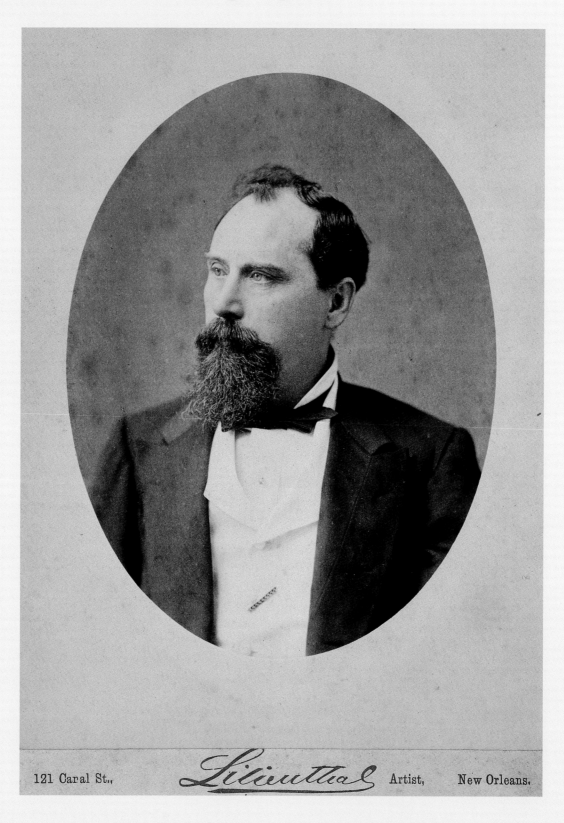

121 Canal St., *Lilienthal* Artist, New Orleans.

Theodore Lilienthal's forty-year career as a commercial photographer in New Orleans spanned the technological development of photography from daguerreotypy to dry plate. Lilienthal began practicing as a daguerreian in 1854, when two dozen photographers were active in New Orleans. At his death in 1894, photography was no longer the pursuit of a small, professional fraternity, but with the introduction of George Eastman's handheld, roll-film camera, a leisure activity open to all, without, a manual advised, "the need of study, experiment, trouble, dark room, chemicals and without even soiling the fingers."[1]

Lilienthal established a successful portrait trade as a daguerreian entrepreneur before the Civil War, and built and maintained a flourishing studio practice in a cut-throat marketplace. As a viewmaker, his practice evolved from a small studio operation with a darkroom wagon and one or two operators in 1867 to the industrialized production of stereoviews and view albums at the beginning of the dry-plate era—when, freed from the impediments of collodion practice, viewmaking was no longer an expeditionary process. The complete integration of photography and typography during the next decade made photographic view books possible and created a new market for photographers, but only at the end of Lilienthal's career.

The essential facts of Lilienthal's life and career can be gathered from a variety of contemporary sources, but nothing, apart from occasional letters to the national photographic press, survives in his own hand—a "disappearance, or resignation, of the authorial voice," as one historian has written, that was characteristic of commercial practice.[2] The most complete record of his career emerges from his professional misfortunes. Intense professional rivalries, competitive practices, and recurring piracy brought many photographers to court, and Lilienthal, too, was beset by lawsuits and bankruptcy. It is through his testimony in these cases that his career and working habits as a "practical photographer" begin to take shape. Newspaper advertisements, business directories, and credit reports provide a chronology of his studio

practice, and newspaper and booster-book profiles supply a biographical framework. Probably the most accurate of these sketches is the four-page profile in J. Curtis Waldo's *Illustrated Visitor's Guide to New Orleans*, published in 1879, for which Lilienthal provided a self-portrait, the only portrait known for his entire career (fig. 33).[3]

According to the Waldo biography, Lilienthal was born in Frankfurt-on-the-Oder, Prussia, in 1829.[4] While in his teens he apprenticed as a merchant in Berlin, but was paroled home to Frankfurt after participating in the labor uprisings of 1848. Drafted for the Prussian–Austrian war, he was wounded and discharged in 1852, and late the following year emigrated to New Orleans with his parents, two sisters, and a brother. The family joined an older brother, Julius, who had emigrated in 1846 and was established in New Orleans as a jeweler.[5]

At mid-century, New Orleans was not a surprising destination for a Brandenburger Jewish family. The city had the largest German population and the largest Jewish community in the South, and Jews appear to have had greater opportunities in commerce and public life there than in most other American cities.[6] In 1853–54, when Lilienthal arrived in New Orleans, more Germans landed at the port than in any other year, 36,000 in all (nearly half of whom remained in Louisiana).[7] One emigrating German found the entrepreneurial opportunities of New Orleans in 1853 liberating:

> In all of Germany there is no city like it ... there is a much greater distribution of wealth ... [and] wages are high ... one can do what one wishes without asking anyone. A person need do no more than hang up his sign. If he has a business which does not please him, he need only change his sign and start something else. A fortune is not necessary for this. An artisan who has no more than his tools can work independently.[8]

Lilienthal did not share in this "greater distribution of wealth," if we are to accept the Waldo sketch of the young immigrant, unemployed and nearly destitute, "whose many experiences of poverty ... might fill a sensational novel."[9]

Soon after his arrival, Lilienthal reportedly enlisted in a militia in support of exiled Cuban patriots formed from the remnants of the filibustering expeditions of Narciso López, whose failed insurrection in Spanish Cuba (López was

Fig. 34 Advertisement for Mealy and Lilienthal Daguerreotype and Ambrotype Saloon, 132 Poydras Street, *Deutsche Zeitung*, October 8, 1856.

captured in 1851 and executed) had recruited many German-born volunteers. But the expedition Lilienthal joined never left the city.[10]

Backed by his brother Julius, Lilienthal began practicing as a daguerreian in 1854.[11] He operated out of a studio on Poydras Street, and he may have trained with a local German photographer; the Bavarian Samuel Moses, for example, who reportedly studied with Daguerre, operated a studio at Poydras and Camp from 1850. In the fifteen years since the artist Jules Lion had introduced daguerreotypy to New Orleans, at least sixty photographers had worked in the city, and some of the established studio operators supplemented their income by instruction in daguerreotypy and the sale of equipment and supplies.[12] The Waldo biography, and the other booster biographies, inevitably portray Lilienthal as the self-made entrepreneur, victorious over "hard fortune" and with the "indomitable persistency usually characteristic of his country."[13] With a trade anchored almost exclusively in the German community, he partnered with E.W. Mealy, Joseph Kaiser, and other German photographers and painters, and in 1856 offered his "esteemed German audience daguerreotypes and *Lichtbilder* of every kind, of the best quality and at the least expensive price."[14] No daguerreotypes or hard images of any kind by Lilienthal are known to exist today, nor any paper photographs made before the war, but he may have begun to adopt paper photography in the mid-1850s, when the new format was beginning to take hold of the market in New Orleans.[15]

The popularity of the inexpensive carte de visite, in widespread use in America by 1860,

Fig. 33 Theodore Lilienthal, *Self-portrait*, cabinet card, 1879 or earlier, for engraving in J. Curtis Waldo, *Illustrated Visitor's Guide to New Orleans*, New Orleans (J.C. Waldo) 1879. Louisiana State Museum.

and the outbreak of war transformed photographic practice in New Orleans, expanding clientele and bringing unforeseen income. "Every young man who goes to war ought, before starting, leave his likeness with his mother, sister, wife or other dear parent" the *Picayune* advised two days after the Confederate bombardment of Fort Sumter.[16] "[When] it came to pass that many of those boys did not return," one photographer wrote, "... those hastily made photographs were valued above price."[17] A staging ground for troops, with 20,000 local men mustered into Confederate army service, New Orleans was a profitable market for military cartes de visite and the war good business for photographers. As one correspondent observed in 1862, "War has developed their business in the same way that it has given an impetus to the manufacturers of metallic air-tight coffins and embalmers of the dead."[18]

Lilienthal's earliest documented photograph is a wartime carte de visite—a "spirited portrait of the lamented Colonel Dreux," the first New Orleans officer killed in the war.[19] Colonel Charles Dreux had been an admired legislator, and was honored in July 1861 with a City Hall funeral and a procession through city streets attended by tens of thousands of mourners.[20] On the occasion of the funeral, Lilienthal distributed the portrait carte of Dreux, "representing him in uniform as he left here," to local newspapers as a sales promotion. Typical of the marketing aplomb that would characterize his entire career, Lilienthal had copies of the portrait ready to "supply to those who desire to obtain a souvenir of the gallant dead."[21]

Lilienthal enlisted as a cannoneer in New Orleans's Washington Artillery militia, one of the elite fighting units of the Confederacy (cat. 52), and was mustered for local defense shortly before federal troops captured the city in late April 1862.[22] His younger brother Edward, who worked in his studio before the war, had enlisted in 1861, saw combat at Shiloh in April 1862, and served in the Confederate army for the remainder of the war.[23] Now thirty-three years old, Lilienthal had been a resident of New Orleans for eight years and was still a Prussian citizen; we can only speculate as to how he responded to secession and the outbreak of war. He may have enlisted in response to a conscription law in the spring of 1862, ordering, in German and English declarations, all males in Louisiana to take an oath of allegiance to the Confederacy.[24]

His association with labor uprisings in Germany suggests that he may have gravitated, as many Germans did, toward abolitionist causes. "Their ideas are sometimes prone to be radical under the influence of revolutionary republicans of the European type," the southern propagandist James D.B. De Bow wrote of German émigrés. "Those who have been red republicans in Germany are black republicans here, only so long as their lager beer is not rashly meddled with."[25] Seven years after the war, Lilienthal would be a Radical Republican party candidate for public office, aligning him with egalitarian objectives.[26]

Following the occupation of New Orleans by federal troops, Lilienthal and other photographers found a new clientele among the thousands of transient northerners. Soon after his arrival in New Orleans, one Union soldier, twenty-four-year-old Lieutenant Lawrence Van Alstyne, "stopped at a picture-taking place" and sat for a portrait. "We hardly expect they will be hung outside with the show pictures," Van Alstyne wrote, "but I have my new clothes on, and that may be an inducement."[27] Union Major Edward Noyes also had his portrait taken at a New Orleans studio in 1862 and promptly sent it home to his mother in Boston. "I suppose you are desirous of seeing how I look after spending a winter on Ship Island, and a summer in New Orleans," he wrote. "I tried to look right and if the picture does not look so, it must have been some fault of nature or the artist that made it wrong."[28]

Lilienthal's studio, one of the most successful locally during the war years, attracted Union sitters from enlisted men to General Ulysses S. Grant. In September 1863, during the Vicksburg campaign, Grant stopped in New Orleans to review troops, and sat for Lilienthal.[29] The resulting vignetted portrait (a popular 1860s portrait style made by masking the sitter's torso) captured Grant's famous resolute expression, looking as if "he had determined to drive his head through a brick wall" (fig. 35).[30] At this time, Lilienthal was also offering for sale a vignetted portrait of Union General Nathaniel Banks (the federal overseer of New Orleans from 1862 to 1865) as well as a full-length portrait of Confederate General Franklin Gardner (fig. 36). Armies commanded by Banks and Gardner had faced off at Port Hudson in 1863 in the only major battle of the war in Louisiana (a Union victory, after the longest siege of the war, that secured

control of the Mississippi River for the North). The potential for brisk sales of these portraits after the surrender of Port Hudson, and of the Grant portrait to Union forces in occupied New Orleans, led Lilienthal to protect his investment and confront the threat of copyists head-on:

> Artists are respectfully informed that Lilienthal has entered his application for the Copyright ... of his photographs of Major Generals BANKS and GRANT, of the Federal Army, and Major General GARDNER, of the Confederate Army, after the full approval of the Generals and their friends. This notice is to warn against trespass upon the author's rights.[31]

Lilienthal's portrait of a man with a long frock coat, top hat, and cane is a conventional full-figure carte-de-visite portrait (fig. 37).[32] The sitter's appearance and apparel—flared sleeves, tubular trousers, square-toe shoes, narrow silk tie, and his mutton chops—date the photograph to the war years. The local press praised Lilienthal's portrait work for its "delicacy and yet distinctiveness of outline," and Lilienthal later characterized himself as a portrait "artist" who "made good likenesses."[33] Dependent on a "complicity between the sitter and camera operator," these portrait sittings combined, as one historian has written, "elements of alchemy and a visit to the dentist."[34] Subjects endured neck clamps, foot rests, eye rests, and other "iron instruments of torture" to compel them to hold their pose, in "operating rooms" with props, painted screens, shades and reflectors, and a smell, one sitter said, "as of a drug and chemical warehouse on fire in the distance."[35] "No wonder old photographs of us look anxious and wistful," another sitter recalled; "that was how we felt."[36]

Lilienthal's studio production during the war may have been curtailed by a shortage of chemicals and supplies, which were scarce in New Orleans and throughout the South.[37] One photographer who had worked in Confederate territory wrote that "in 1862 nearly all kinds of photographic material gave out, the only chance then was to get it through the blockade runners."[38] *Humphrey's Journal* predicted that when the war ended "our Southern Photographic friends will ... be 'let out of jail' as it were. They must be all out of stock and materials, and our dealers will then have their hands full of business."[39] After the trade blockade was lifted in 1862, Samuel Blessing

Fig. 35 Theodore Lilienthal, *Portrait of Gen. Ulysses S. Grant*, carte de visite, 1863. Collection of Joshua Paillet, The Gallery for Fine Photography.

Fig. 36 Theodore Lilienthal, *Portrait of Maj. Gen. Franklin Gardner*, carte de visite, 1863. Louisiana State Museum.

for stereographs) of topographic photography, with the acquisition of a mobile darkroom, which he was operating out of his Poydras Street studio by November 1865.[45] "I am the only photographer in the city who is at any time prepared to do outdoor work, having a travelling apparatus attached to my establishment," he advertised (fig. 112).[46] Traveling darkroom wagons were efficient laboratories, one historian has written, "as carefully planned internally as a Pullman kitchen." They stocked all the materials for wet-plate fieldwork: glass plates, trays, bottles of water, collodion, sensitizing and fixing chemistry, and cameras.[47] "A few years ago, one of the great drawbacks to out-door photography, was the difficulty of obtaining some proper place to develop the plate," the *Philadelphia Photographer* wrote in 1867. "At present, however, there are many devices in use by which the photographer ... may hasten to make a picture of a corpse, a building, a boiler explosion, a parade, or anything else out of doors."[48] The ability to finance a portable darkroom and a horse was a measure of Lilienthal's success. The

and other local photographic dealers were able to restock from New York supply houses. The following year a New Orleans druggist advertised "chemicals for photographists," including "chloride of gold, nitrate of uranium, hyposulphite of soda ... just received."[40]

During the 1860s, Lilienthal operated a studio and gallery in three locations on Poydras Street. His 102 Poydras studio is represented in a logograph he used from 1863 until well after changing location again in 1865 (fig. 39).[41] "Photographic Establishment" suggests more than a lightroom and darkroom for making portraiture, and Lilienthal offered a range of services and merchandise, was well as a degree of comfort, to his customers. On the top, sky-lit floor was the operating or light room, where portraits were taken. Printing was done on the sun ledge (in the logograph, a printer holds a printing frame to catch the light). For clients who ordered painted photographs, Lilienthal operated a studio where "the best German artists ... transferred the photograph to canvas by means of instruments," an activity that elevated the work of the studio to the level of fine art and higher prices.[42] Typical of urban studios, Lilienthal's balconied, second-floor

reception room was lavishly furnished and decorated with art, props, and bric-a-brac for the comfort of clients waiting their turn in the operating room, or for the developed plate in the event that another sitting was necessary.[43] The ground-floor showroom exhibited artwork and a large assortment of frames, a holdover from daguerreian days of cased images (Lilienthal would later open his own frame factory). Fronting on Poydras Street, Lilienthal's display windows announced the output of his studio with specimen photographs, paintings, lithographs, and frames. A street-front display was essential to lure customers, particularly as impulsive portrait sitters had many other studios to choose from in Poydras Street. The *Times* questioned the practice and urged customers not to be deceived by ground-floor advertising by photographers. "[W]hile the pictures exhibited at the entrances and in our fashionable galleries are evidently of a superior style of excellence, the pictures taken by the operators at an actual sitting are far inferior in point of grace, accuracy and finish," the paper warned.[44]

Soon after the war, Lilienthal entered the growing market (fueled by the fashion

Fig. 37 Theodore Lilienthal, *Portrait of unknown man with top hat and cane*, carte de visite, c. 1863–65. Louisiana State Museum.

wagon advertised his aspirations as a view photographer with an elaborately painted sign for his "View Apparatus" (fig. 38).[49]

Lilienthal's earliest documented work as a topographic photographer dates to late 1865, when he was reported to have taken a photograph of the St. James Hotel and to be at work on a series of views of military installations for the U.S. Quartermaster General. In November 1865, the *True Delta* reported that "with his big wagon," Lilienthal was

> endeavoring to "commemorate on paste-board" the appearance of the Chief Quartermaster's office, opposite Lafayette Square. He is ordered, we learn, to take pictures of all the buildings used and occupied by the officers of the Department of Louisiana, and a copy of each is to be forwarded to Washington.[50]

Brigadier General Montgomery Meigs, the Quartermaster General, commissioned Lilienthal in a nationwide photographic survey of military installations undertaken during and immediately after the war.[51] Meigs was probably following the model of photographer Andrew J. Russell,

Fig. 38 Theodore Lilienthal, Lilienthal's "View Apparatus" (darkroom wagon), near his 121 Canal Street studio, stereoview (detail), *c.* 1875. Collection of Joshua Paillet, The Gallery for Fine Photography.

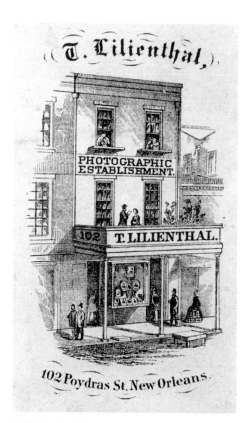

Fig. 39 *T. Lilienthal Photographic Establishment 102 Poydras Street*, backstamp, carte de visite, *c.* 1865. The Historic New Orleans Collection, 1994.100.28.

who as quartermaster for the military railroad service in Virginia used photography to document army facilities (fig. 40). In 1864 Meigs ordered all field quartermasters to document "buildings built or occupied by the Army with which the Quartermaster's Department has any connection or which it pays for or controls."[52] The quartermasters often hired local commercial photographers to complete the work, and for many cities their identities are undocumented. Lilienthal's work comprised at least eighteen views of barracks, hospitals, railroad depots, gasworks, and other buildings constructed or appropriated for use by federal troops in New Orleans (figs. 15–19).[53]

The Quartermaster series was Lilienthal's most important commissioned work as a topographic photographer before the Exposition portfolio, but he was also developing an expanding taxonomy of views of New Orleans in popular card formats (see pp. 260–67). The nationwide stereography craze was announced by the New Orleans *Daily Tropic* in May 1853, less than a year after the stereoscope's introduction into America. But it was not until 1857 or 1858 that the card stereograph entered the market in New Orleans.[54] The card stereoviews of New Orleans made by an itinerant photographer named James Bailey in 1861 appear to be the earliest existing of the city (fig. 62). Five years later, Lilienthal published his earliest known stereograph, a

view of Lafayette Square (fig. 60), and later that year he produced the first stereographic panorama of New Orleans (see pp. 246–59).[55] The periodical press, which increased demand for city views nationwide, also published engravings after his work in 1866. The front page of *Harper's Weekly* in April reproduced a wood engraving after Lilienthal's photograph of the old Medical College of Louisiana (cat. 67), which was then in use by the Freedmen's Bureau as a school for former slaves (fig. 42) The novelty of Lilienthal's "view taking" with his darkroom wagon was itself a newsworthy event: "Lilienthal's 'traveling photographic gallery' was brought into requisition yesterday evening to take a view of the building, now used as a colored school," the *Picayune* wrote.[56]

After the war, the Mechanics' and Agricultural Fair Association organized an annual trade fair, a competitive venue for every conceivable enterprise from "shirt-ironing" to "scientific apparatus," including the first organized competitions for local photographers. Similar industrial fairs, organized around the country, "guaranteed that photographs were visible within a context of the larger mainstream of commerce and industry," as one historian has written.[57] Prize recognition boosted photographers' sales and standing among their peers, and in November 1866 Lilienthal swept the awards of the first New Orleans fair, taking silver medals for "Best series of stereoscopic views," "Best

Fig. 40 Andrew J. Russell, *Government Hay Barns, Alexandria, Virginia, U.S. Military Railroad Photograph Album*, albumen silver print, *c.* 1863–65. Virginia Historical Society.

views of public buildings," and "Best views of landscapes," as well as the highest award, a diploma and gold medal for "Best and largest display of photographs."[58] Critics praised the "admirable finish" and "neatness of execution" of his photographs, and a prize-winning view of a French cabinet-maker's shop is his earliest-known outdoor view in large format.[59] The fair medals brought Lilienthal's topographic photography citywide recognition and put him in line for the most important work of his career, the Paris Exposition portfolio.[60]

The Photographic Industrialist

In the scale of their ambition, accomplishment, and recognition, *La Nouvelle Orléans et ses environs* and its successor, *Jewell's Crescent City Illustrated*, were unlike any other work of Lilienthal's career. With the increasing popularity of stereoviews in the decades after the war, his later topographic work was anchored to the small, versatile, and profitable card formats (fig. 41). His industrialized production of stereoviews in the 1870s and 1880s served the view market with inexpensive and visually animated scenes of the city, far exceeding the limited market for expensive, large, hanging views.

Commercial photographic practice in the second half of the nineteenth century was characterized by a succession of technological advancements and refinements and the development of new business practices.[61] Always quick to secure the "latest success in photography," as his advertisements promised, Lilienthal offered customers a succession of lambertypes, platinotypes, artotypes, and other newly patented prestige processes (at the end of his career a professional journal listed twenty-seven processes in use by photographers, with "a formidable array of almost incomprehensible names").[62] During the 1870s and 1880s, Lilienthal was widely recognized in professional circles for his work with carbon lambertypes (tissue coated with gelatin containing carbon black or other permanent pigment was used to print the image, which was then transferred to paper), a process he vigorously promoted and a patent he defended in court.[63] The instability of albumen silver prints, which caused them to fade, was a vexing problem for portrait photographers. The carbon process, patented in England by Joseph Swan in 1864, promised greater permanence.[64] Swan and the Alsatian photographer Adolphe Braun exhibited carbon prints at the Paris Exposition in 1867, which did much to launch the process worldwide.[65] In late 1876, Lilienthal licensed the carbon patent from brothers Claude Léon and T.S. Lambert, who held the Swan patent for the United States, and began making lambertypes in New Orleans.[66] In a letter to the *St. Louis Practical Photographer* in 1877, T.S. Lambert reported that Lilienthal was successful with the process, even in the unfavorable climate of New Orleans, and *Anthony's Photographic Bulletin* reported that Lilienthal was among the first "practically [to] abandon silver printing" for carbon. "Lilienthal is turning out every day pictures as fine as any that are received from Europe," *Anthony's* wrote.[67] Mastering the carbon process (which was expensive to license) in the New Orleans market was ultimately profitable for Lilienthal, as photography writer Carlo Gentile acknowledged. "No man in the

Fig. 41 Theodore Lilienthal, *Residence, 366 Esplanade Street*, carte de visite, *c.* 1865–67. George Eastman House.

Fig. 42. "School for Freedmen," wood engraving after a photograph by Lilienthal. *Harper's Weekly*, April 21, 1866.

Fig. 43 Logotype illustration of the silver medals awarded to Lilienthal for photographic views at the First Grand Fair of the Mechanics' and Agricultural Fair Association in 1866, carte-de-visite backstamp (detail), *c.* 1866–67. Louisiana State Museum.

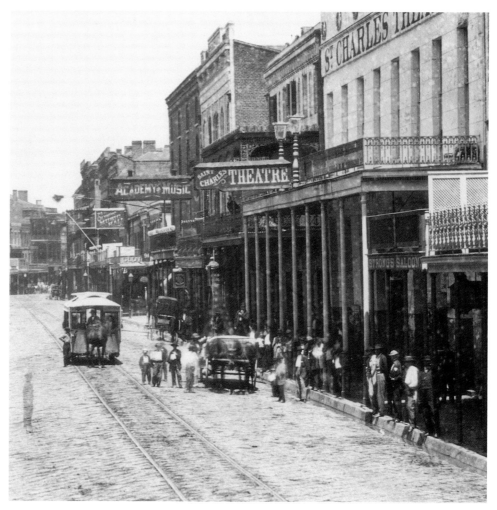

Fig. 44 *St. Charles St. from Cor. Poydras* (cat. 61), detail.

United States has made such a wonderful success with the carbon process as Lilienthal. … [His] business is the leading one among the photographers of New Orleans."[68]

Lilienthal was always an astute self-promoter, and in the 1870s he organized successful marketing schemes that capitalized on the cult of mourning for the Confederate "lost cause." His collage of the White League rebellion of 1874, an insurrection by white supremacists against the federally supported Reconstruction government, was "sold for the benefit of the families of our gallant dead."[69] This work may have led to a 4 × 5-foot (1.2 × 1.5-m) carbon portrait of the elite Pickwick Club, the members of which participated in the street-fighting during the White League's attack on the Custom House in September 1874. A composite of more than one hundred individual

portraits—all "masterpieces, every feature perfect, and all the likenesses lifelike," according to one critic—it was, Lilienthal claimed, the largest composite photograph in the country.[70] His most famous photograph, also a composite portrait, *The Late General Hood's Family* (fig. 45), was sold to thousands of households across the South as a fundraising scheme for the orphaned children of the Confederate hero, General John Bell Hood, who died of yellow fever in New Orleans in 1879.[71] "The groups of Theodore Lilienthal have made him famous," the *St. Louis Practical Photographer* observed in 1879.[72]

During the first two decades of his career, Lilienthal had changed studio locations at least eight times, always orbiting the Poydras Street retail blocks uptown, where many photographic studios were located (see p. 269). But his ascendancy in the profession required a more prestigious location, where his show windows would be visible to a larger public. In late 1875,

he opened a studio and showroom in the Touro Buildings on Canal Street, a "great resort of beauty and fashion" and the city's most recognized retail address (fig. 105).[73] In the late 1870s, he was reported to have "added many improvements to his already fine gallery" and was regarded as "one of the best in his line" in the city.[74]

A challenge to a successful photographic practice in New Orleans was the subtropical climate. All photographers had to "manage a most obstreperous class of chemicals, fickle as the wind," but nowhere in the country was wet-plate chemistry more mercurial than in the extreme humidity and heat of New Orleans.[75] Carlo Gentile, who worked as an operator for Lilienthal in 1879, before founding a photographic journal in Chicago, knew first-hand what Lilienthal faced, in the field and in the studio (on light-filled, and often intensely hot, upper floors):

Mr. Lilienthal is one of the most enterprising and go-a-head photographers we have in the United States. ... A man who has such pluck, living in such an enervating climate as New Orleans, would be a Colossus in such a climate as we have in Chicago.[76]

Lilienthal himself made similar observations. In letters to *Anthony's Photographic Bulletin* and the *St. Louis Practical Photographer*, he claimed that New Orleans was "the most unfavorable of all localities" for photographic work:[77]

I am located in the worst climate of any city in the Union, surrounded by water and swamps, and warmer all the year round than anywhere ... besides numerous other disadvantages I could mention, which I have completely overcome, and with 95° of heat in the shade at present I work without any interruption.[78]

But as his studio prospered, Lilienthal became increasingly removed from the fieldwork and the operating room, tending to the books, defending his entrepreneurial ventures in court, and hiring established operators to do the camera work and printing.[79] By 1880, he employed specialized printers in silver, carbon, and platinum and had little to do himself with darkroom chemistry or even the lightroom camera work, like other successful studio owners.[80] Napoleon Sarony, a leading New York portrait photographer, reported that he "knew nothing and cared less" about the chemistry of photography and no longer operated a camera, confining his role to setting up shots and posing his celebrity sitters.[81] Similarly, New Orleans photographer Gustave Moses claimed, "I don't understand about the different chemical changes ... a great many photographers know nothing about it."[82]

In 1880, Lilienthal was appointed to the executive committee of the newly revived Photographers' Association of America, with Sarony, William Notman, Frederic Gutekunst, and other well-known practitioners.[83] The appointment signaled Lilienthal's arrival at the top of his profession, locally and nationally. His social aspirations, not surprisingly, dovetailed with his professional success, with his election to high honors in the privileged Rex Mardi Gras krewe—an elite New Orleans social club that Mark Twain characterized as "all ... gentlemen of position and consequence."[84] Despite his

professional and social achievements, Lilienthal did not disengage from the German immigrant community where his studio practice originated, although he had emerged from this patronage system with his work in military portraiture during the war, and especially with his Exposition and *Jewell's* commissions after the war. During the 1880s he still advertised heavily in the German press, as he had as a young daguerreian partnered with other German photographers.[85]

In 1880, Lilienthal reported $24,000 in sales: $9500 for carbon portraits, $7900 for silver prints (including stereoviews), and $6600 for paintings, painted photographs, and frames.[86] But the following year, his income from portraiture dropped substantially, a loss he attributed to competition from the photographer William Washburn, whom Lilienthal accused of infringing on his carbon patent rights for the New Orleans market, price-fixing, and stealing his customers through fraudulent advertising. Lilienthal took Washburn to court and eventually won a settlement in what local newspapers headlined "The Battle of the Photographers."[87]

One of the tactics of the competitive photographic marketplace was price-cutting; many photographers attempted to undersell each other, and some made advertising claims they knew were untrue. "We say a great many things in advertisements that were not always carried out," Washburn testified in the patent infringement suit Lilienthal brought against him.[88] Extended price wars often brought rates down to a level at which photographers "could neither deliver good work nor make a living."[89] Lilienthal, for his part, claimed not to compromise quality for competitive prices. "I made good likenesses," he declared, but "I had rivals in the business who sold a great-deal cheaper those things than I was willing or able to furnish them."[90] In 1867, the Photographic Society of New Orleans, a gathering of commercial photographers, set a price structure according to a classification of photographers' work (Lilienthal operated a First Class studio) and agreed "not to deviate from it at the risk of losing our honor and any claim to the trust and respect of brotherhood." Committed to the "beauty and progress of their art," the photographers pledged themselves "not to underbid each other's prices and to deliver poor work."[91] The pact was short-lived, however, amid the realities of a contested marketplace and the extreme competitiveness

Fig. 45 Theodore Lilienthal, *The Late General Hood's Family*, albumen silver print, 1879. Museum of the Confederacy.

that characterized urban photographic practice across the country. "Among ourselves all was strife, ill will, jealousy, concealment, egotism," one northern photographer recalled. "No city was large enough to keep two photographers friendly towards each other."[92]

Lilienthal invested heavily, reportedly "without regard to cost," in a remodeling and expansion of his Touro Buildings studio in 1881.[93] "Lilienthal's Art Emporium" (fig. 105) was "fitted up in splendid style with every modern improvement," the *St. Louis Practical Photographer* reported.[94] The ground-floor showroom sold celebrity portraits, chromolithographs of didactic themes, stereoscopes, graphoscopes, albums, and frames, as well as paintings by Lilienthal's German artists.[95] Lilienthal ushered his clients from the salesroom in a mirrored elevator "of exquisite workmanship," which he claimed was the only elevator in a photography gallery in the entire South.[96] On the second floor were the wholesale rooms and a frame factory, and on the third floor the reception room, dressing rooms, and operating room. The reception room was a carpeted "drawing room" that included a Playel grand piano. There was "no better place in the City to spend a pleasant hour," a Lilienthal advertisement promised.[97]

A few steps off reception, the sky-lit operating room was "supplied with tasteful scenery" for portrait sittings and equipped with "the largest Camera in the South, capable of producing life size and faultless pictures."[98] A flight of stairs led to a children's operating room and the studio where painted photographs were made. On the fourth floor were the developing and finishing rooms. Stored there were the negatives that brought the repeat business of reprinting old portraits.[99] A printing workshop was located on the roof, where direct sunlight was available for printing out.

The opening of the most luxurious and modern studio of his career was a venture that put Lilienthal at financial risk. A correspondent for R.G. Dun & Co. reported that he had "spent considerable money fitting up" the new studio, "which must be regarded as sunk capital, [as the] photography business has been quite dull of late." With Canal Street's high rents—he paid $400 per month on Canal in the 1880s, compared to $60 around the corner on Chartres—a Dun correspondent judged that "it is hardly likely that [Lilienthal] has cleared

expenses for sometime past."[100] Yet he was reportedly "doing the leading photographic business in the city, and apparently getting his full share of the trade going in pictures and works of art of which he carries an elegant stock."[101] The studio, a local booster book reported, represented an investment of "more capital than all the rest of the photographers in New Orleans combined." Lilienthal was carrying on a large trade throughout the South, Mexico, Cuba, and South America, and employed an increasingly large workforce: operatives to expose negatives, negative spotters and retouchers, silver printers, a lambertype printer, stereograph trimmers and mounters, print retouchers and colorists, artists who produced painted photographs and original work on canvas, and clerks and managers who took orders and supervised the sales rooms.[102]

The decade of the 1880s brought the most important changes to the practice of photography since the introduction of the wet-plate collodion process at the beginning of Lilienthal's career. Dry-plate, roll film, daylight-loading, hand-held cameras, and photo finishing were all introduced during this decade, and the practice of photography changed from an exclusive professional fraternity to a field dominated by amateurs. The photographic press, no longer concerned with the vicissitudes of collodion chemistry, now published advice columns for hobbyists and brought news of amateur clubs, including the New Orleans Camera Club, founded in 1888 and one of the first in the country.[103] The evolution of photography from, as historian Sarah Greenough has written, "a messy and complicated process to one so simple that anyone, even a child, could master its technique," was complete.[104]

The Philadelphia Centennial of 1876 had marked the beginning of the transformation to dry-plate practice, which was first described in 1871.[105] Manufactured dry plates appeared on the market by 1879, the same year George Eastman patented a process for gelatin dry plates in England.[106] The *Philadelphia Photographer* published its first gelatin dry plate in November 1880, and the following year Lilienthal was offering "the latest success in photography" at his Canal Street studio. Lilienthal advertised that he had "secured instruments especially constructed for instantaneous photographs" using the "wonderful rapidity of the new Gelatin

Process." Photographs, he claimed, could now be made

> in a fraction of a second, thereby catching any expression, and obtaining pictures in the most difficult positions without the slightest inconvenience to the sitter. Dark or cloudy weather is no longer an obstacle in securing the very best and artistic photographs.[107]

Lilienthal emphasized the ease and rapidity of the new process, "specially adapted for babies, children, and nervous persons," the most troublesome sitters. But early dry-plate work was costly. Rather than prepare the photographic chemistry himself using recycled glass plates, Lilienthal purchased finished plates from commercial vendors (the commercial plates did, however, reduce shop time and labor). In April 1882, the *St. Louis Practical Photographer* published a dry-plate figure study by Lilienthal as the journal's frontispiece (fig. 46).[108] It was the only photograph by Lilienthal to appear in a national publication during his lifetime.

The trajectory of Lilienthal's final decade of practice exemplifies what historian Abigail Solomon-Godeau has described as the "shifting field upon which commercial photographers quite typically could slide from great success to indigence."[109] In 1884, Lilienthal expanded his operations and opened a frame factory and warehouse at 34 Chartres Street, near his Canal Street studio, but in April 1884 the warehouse was destroyed by fire. Lilienthal immediately saw an opportunity to rebuild for the growing market of amateurs who were adopting dry-plate.[110] In November 1884, when the *Philadelphia Photographer* visited his "new stock establishment," which he called the Crescent City Photographic Supply House, Lilienthal was reported to be doing an "immense trade" in photographic supplies, frames, and works of art.[111]

Lilienthal had an adopted son, Louis, who had managed his studio in the 1870s and in 1883 opened his own studio in Galveston, Texas.[112] The following year, the death of Lilienthal's wife, Julia, led to a legal contest between father and son over Julia's succession, a battle that Lilienthal lost.[113] The settlement was one step toward financial disaster, which was further accelerated by overinvestment. In 1886, Lilienthal relocated to 32 Chartres Street, and by early 1887 he was out of business. In September 1887, his estate was

liquidated, and everything except his cameras and lightroom equipment was auctioned to pay his creditors.[114]

In a short time, Lilienthal acquired a partner and rebuilt his practice, returning to the Touro Buildings where he had operated a studio for eleven years. His reemergence was short-lived, however; on February 18, 1890, during Carnival, he was again burned out when a fire destroyed his three-floor studio and most of the Touro block.[115] The *Daily States* reported that "there was nothing left of the establishment ... but a few display photographs and portraits in the outside show cases."[116] Lilienthal's losses were heavy in the blaze, his insurance covering only about half of a $20,000 claim, which included "a large supply of costly portraits and valuable instruments."[117] The greatest part of the loss was a large stock of negatives, probably including the glass plates he had exposed for the Exposition portfolio.

After the second fire Lilienthal reopened at 109 Canal Street, which he leased through 1893. Still active in professional circles, he was appointed to a committee to oversee the photographic congress at the 1892 Columbian Exposition in Chicago.[118] But he was now suffering from Bright's disease, an incurable affliction often linked to chemical exposure in the studio. In early 1894, Lilienthal quit photography, sold out, and moved north to Minnesota with his second wife and two children.[119] He died in Minneapolis on November 29, 1894.[120]

1. *The Kodak Primer*, 1880s, cited by Nancy Martha West, *Kodak and the Lens of Nostalgia*, Charlottesville (University Press of Virginia) 2000, p. 50. Lilienthal began his career in the same year as his contemporaries Carleton Watkins and Andrew Gardner were beginning theirs (Lilienthal was the same age as Watkins, and a year older than Eadweard Muybridge and Andrew Russell). In 1867, when Lilienthal produced the Exposition portfolio, Watkins opened his first public gallery and completed some of the most successful photographs of his career in Oregon's Columbia River Valley; William Henry Jackson opened his first studio; Timothy O'Sullivan was working on the Wheeler survey, the U.S. Geological Exploration of the Fortieth Parallel, under Clarence King; Alexander Gardner was on a photographic campaign in Kansas and along the Thirty-fifth Parallel (Gardner's Kansas views were published in *Across the Continent* in 1867); and George Barnard had just published, in November 1866, his most famous work in sixty-one imperial photographs, *Photographic Views of Sherman's Campaign*.
2. François Brunet, "'Picture Maker of the Old West': W.H. Jackson and the Birth of Photographic Archives in the United States," *Prospects*, XIX, 1994, p. 180.
3. Lilienthal's cabinet-card self-portrait was reproduced in a wood engraving in Waldo, *Visitor's Guide*, p. 134.
4. Waldo, *op. cit.*, p. 133, recorded that Lilienthal was born on September 25, 1829. This date is corroborated by a R.G. Dun & Co. correspondent's report on August 10, 1877; *Louisiana*, III, p. 163, R.G. Dun & Co. Collection, Baker Library, Harvard Business School. Other brief biographies of Lilienthal appear in later booster books: Land, *Pen Illustrations*, p. 165; *The Industries of New Orleans*, pp. 92–93.

References in the literature of the history of photography to Lilienthal's work have been few, and his Paris portfolio unknown. William Darrah listed him as a stereographer in "Stereographs: A Neglected Source of History of Photography," in *One Hundred Years of Photographic History: Essays in Honor of Beaumont Newhall*, ed. Van Deren Coke, Albuquerque (University of New Mexico Press) 1975, p. 46: "His many photographs of the Mississippi River steamboats are among the most beautiful ever produced." William Welling (*Photography in America*, New York, Thomas Crowell, 1978, pp. 247, 249) discussed Lilienthal's copyright

Fig. 46 Theodore Lilienthal, *Two Flowers*, gelatin silver print, from the *St. Louis Practical Photographer*, VI, no. 4, April 1882, frontispiece.

infringement suit against competitor William Washburn in 1880–82, and also referenced Lilienthal in *id.*, *Collectors' Guide to Nineteenth-Century Photographs*, New York (Collier Books) 1976, p. 83. Kathleen Collins published Lilienthal's Hood Family portrait of 1879 in "The Late General Hood's Family," *History of Photography*, VIII, no. 2, April–June 1984, pp. 99–102. References to Lilienthal's early career appear in Smith and Tucker, pp. 108, 109, 136–38, 163, as the authors laid down the broad context of antebellum photography in New Orleans. There is no comparable survey of the postwar period, although Peter E. Palmquist and Thomas R. Kailbourn, in *Pioneer Photographers from the Mississippi to the Continental Divide: A Biographical Dictionary, 1840–1865*, Stanford, Calif. (Stanford University Press) 2004, extend their biographies (including Lilienthal's) through the second half of the nineteenth century, for those photographers who began their careers in the prewar period.

Writing on the history of southern photography has lagged far behind studies for the rest of the country, especially Western expeditionary photography. Compilations of Civil War photography, such as Carl Moneyhon and Bobby Roberts, *Portraits of Conflict: A Photographic History of Louisiana in the Civil War*, Fayetteville (University of Arkansas Press) 1990 (and comparable volumes for Arkansas, Mississippi, North Carolina, Georgia, and Texas under their editorship), publish the work of many little-known southern photographers. Regional and local histories, such as David Haynes, *Catching Shadows: A Directory of Nineteenth-Century Texas Photographers*, Austin (Texas State Historical Association) 1993; Harvey S. Teal, *Partners with the Sun: South Carolina Photographers, 1840–1940*, Columbia (University of South Carolina Press) 2000; and Michael V. Thomason, "Commercial Photography in Mobile, Alabama," *History of Photography*, XIX, no. 1, Spring 1995, pp. 46–50, begin to complete the picture regionally or state by state. A brief overview of the literature, mostly for the twentieth century, is in Robert E. Snyder, "Photography and the American South: A Bibliographical Introduction," *History of Photography*, XIX, no. 1, Spring 1995, pp. 1–3.

5. Lilienthal emigrated with his parents, "M.W." and Clara, younger sisters Johanna and Fanny, and younger brother Edward. Ship registers record the Lilienthal family's arrival in New Orleans from Bremen in December 1853 (William P. Filby and Ira A. Glazier, *Germans to America: Lists of Passengers Arriving at U.S. Ports*, Wilmington, Del., Scholarly Resources, Inc., 1988–96, VI, p. 138). Julius was a successful local jeweler by about 1850 (the earliest directory listing in *Cohen's New Orleans Directory ... for 1853*, New Orleans, Delta, 1852). In April 1866, Julius married the diarist Clara Solomon. He died the following year (*Picayune*, December 20, 1867). On his marriage to Clara Solomon, see Solomon, *The Civil War Diary of Clara Solomon: Growing Up in New Orleans 1861–1862*, ed. Elliott Ashkenazi, Baton Rouge (Louisiana State University Press) 1995, pp. 440, 443.
6. Nearly a quarter of all southern Jews lived in Louisiana, and with a Jewish population seventh in the nation, Louisiana's Jewish representation in political office was the most significant of any other state in the Civil War era. Prominent Jewish officeholders included U.S. Senator Judah Benjamin, Lt. Governor Samuel Hyams, and Speaker of the House Edwin Moise. Lilienthal and other Jews in professional life could participate in major social clubs—Lilienthal was a member of the elite Rex Mardi Gras krewe (see p. 47)—that by the turn of the century, after Lilienthal's death, largely excluded Jews. See I.J. Benjamin, *Three Years in America, 1859–1862*, Philadelphia (Jewish Publication Society of America) 1956, I, p. 76; Walda Katz Fishman and Richard L. Zweigenhaft, "Jews and the New Orleans Economic and Social Elites," *Jewish Social Studies*, XLIV, 1982, p. 291ff; Elliott Ashkenazi, *The Business of Jews in Louisiana, 1840–1875*, Tuscaloosa (The University of Alabama Press) 1988, p. 9; Bruce S. Allardice, "'The Cause a Righteous One': Louisiana Jews and the Confederacy," in *Louisianians in the Civil War*, ed. L.L. Hewitt and A.W. Bergeron, Jr., Columbia (University of Missouri Press) 2002, pp. 72–86. On the political conditions in Germany at this time, the German perception of America, and the motivations to emigrate, see the essays in Alan Lessoff and Christof Mauch, eds., *Adolf Cluss, Architect: From Germany to America*, Washington, D.C. (Historical Society of Washington); Heilbronn (Stadtarchiv Heilbronn) 2005.
7. Robert T. Clark, Jr., "The New Orleans German Colony in the Civil War," *Louisiana Historical Quarterly*, XX, 1937, p. 993.
8. Karl J.R. Arndt, "A Bavarian's Journey to New Orleans and Nacogdoches in 1853–1854," *Louisiana Historical Quarterly*, XXIII, 1940, pp. 492–94. On the broader context of German immigration in the middle of the nineteenth century, see A.E. Zucker, ed., *The Forty-Eighters: Political Refugees of the German Revolution of 1848*, New York (Columbia University Press) 1950.
9. Waldo, *Visitor's Guide*, p. 135.
10. *Ibid.*; Gaspar Betancourt Cisneros, *Addresses Delivered at the Celebration of the Third Anniversary in Honor of the Martyrs for Cuban Freedom*, New Orleans (Sherman, Wharton & Co.) 1854; "The Inquiry After Filibusters," *Picayune*, June 25 and July 2, 1854; Ray F. Broussard, "Governor John A. Quitman and the Lopez Expeditions of 1851–52," *Journal of Mississippi History*, XXVIII, no. 2, May 1966, pp. 103–20; Michael Zeuske, "Deutsche Emigranten in Amerika und das Schicksal Kübas: Eine Geschichte des Schweigens (1848–1852)," *Zeitschrift für Geschichtswissenschaft*, XLII, no. 3, 1994, pp. 217–37.
11. *Report of Edward Gottheil*.
12. See Palmquist and Kailbourn, *op. cit.*
13. Waldo, *Visitor's Guide*, pp. 133–35.
14. *Deutsche Zeitung* (advertisement), July 23, October 8 and 30, 1856 (see p. 271).
15. James Maguire is usually credited with introducing paper photography to New Orleans in 1850, when he and his partner William H. Harrington offered talbotypes. Maguire died in 1851 and paper prints became more popular after John Clarke, Samuel Anderson, and Samuel Blessing began working in New Orleans in 1856. See Palmquist and Kailbourn, *op. cit.*, pp. 74–76, 115–16, 165–66, 411–12; Smith and Tucker, pp. 68–75.
16. *Picayune*, April 14, 1861, cited by Smith and Tucker, pp. 102–103 and 177, n. 5.
17. James F. Ryder, *Voigtländer and I: In Pursuit of Shadow Catching*, Cleveland (Imperial Press) 1902, p. 208.
18. Unattributed quotation from a British reporter cited by William F. Stapp, "Introduction," in *Landscapes of the Civil War: Newly Discovered Photographs from the Medford Historical Society*, ed. Constance Sullivan, New York (Alfred A. Knopf) 1995, p. 18.
19. *Crescent*, July 15, 1861; "Photograph of Col. Dreux," *Bee*, July 15, 1861, on the "photographic full length likeness" of Dreux, who was killed in the battle of Newport News, Virginia on July 5, 1861. No surviving copies of Lilienthal's portrait have been identified, but a Confederate Museum, New Orleans, composite full-length portrait without a backstamp may be Lilienthal's (reproduced in Moneyhon and Roberts, *op. cit.*, p. 37).
20. *Picayune*, July 7, 12, 13, 14, and 15, 1861; *Bee*, July 14 and 15, 1861; Moneyhon and Roberts, *op. cit.*, p. 36. Clara Solomon attended the funeral ceremony and "arrived at the conclusion that the ovation made was too great, and the expenditures, considering the present state of affairs were too great," Solomon, *op. cit.*, pp. 73, 76–77.
21. "Memento of the Departed," *Picayune*, July 14, 1861.
22. Lilienthal's older brother, Julius, was also a 6th Company, Washington Artillery cannoneer, and was recorded, like Lilienthal, in the roll of April 3, 1862; Andrew B. Booth, *Records of Louisiana Confederate Soldiers and Louisiana Confederate Commands*, Spartanburg, SC (The Reprint Company) 1984, III, bk. 1, p. 760; A. W. Bergeron, Jr., *Guide to Louisiana Confederate Military Units 1861–1865*, Baton Rouge (Louisiana State University Press) 1989, p. 14.
23. Edward was later promoted to chief assistant to the Confederate Quartermaster General. After the war, he returned to New Orleans and in 1867, following Julius Lilienthal's death, took over his brother's Canal Street jewelry business. He died in 1888. *The Industries of New Orleans*, p. 83; *Jewish South*, III, no. 4, February 7, 1879, p. 8; "Death of Edward Lilienthal," *Picayune*, May 6, 1888.
24. Lilienthal obtained American citizenship in 1868. On German citizens and the war, see Clark, *op. cit.*; specifically on southern Jews and the war, see Lauren F. Winner, "Taking up the Cross: Conversion among Black and White Jews in the Civil War South," in *Southern Families at War: Loyalty and Conflict in the Civil War South*, ed. Catherine Clinton, New York (Oxford University Press) 2000, pp. 193–209; Allardice, *op. cit.*
25. "German Immigration," *De Bow's Review*, IV, no. 6, December 1867, p. 577.
26. "Our German Citizens," *Republican*, April 25, 1867; *Picayune*, October 22, November 6 and 8, 1872; Clark, *op. cit.*, p. 993; Bruce C. Levine, *The Spirit of 1848: German Immigrants, Labor Conflict, and the Coming of the Civil War*, Urbana (University of Illinois Press) 1992, pp. 8–9. Lilienthal's name was placed before the Radical Republican Convention of Louisiana in November 1872 as a candidate for Administrator of Assessments for the City of New Orleans. "Mr Theodore Lilienthal was placed before the Convention in very complimentary terms," the *Picayune* reported, "as a man respected both by black and white, and by all nationalities." Lilienthal won the nomination unanimously on the first ballot, but ultimately lost in the general election.
27. Lawrence Van Alstyne, *Diary of an Enlisted Man*, New Haven, Conn. (Tuttle, Morehouse & Taylor) 1910, pp. 237–38.
28. Major Edward J. Noyes to his mother, October 12, 1862, Noyes Family Papers, 1687–1949, Ms N-607, Massachusetts Historical Society.
29. *Picayune*, September 3, 6, 1863. The great equestrian was thrown from his horse at Carrollton while reviewing troops and was bedridden at the St. Charles Hotel for more than a week; Ulysses S. Grant, *Personal Memoirs of U.S. Grant*, New York (Webster & Co.) 1885–86, p. 342; John Keegan, *The Mask of Command*, New York (Penguin) 1988, p. 207. Van Alstyne, *op. cit.*, pp. 175–76, narrates an encounter with Grant during his visit to New Orleans. On portrait vignetting, see Robert Taft, *Photography and the American Scene: A Social History, 1839–1889*, New York (Dover) 1964, p. 321.
30. "Photography at the Great Exhibition of the American Institute," *Philadelphia Photographer*, IV, no. 47, November 1867, p. 359; Douglas McGrath, review of Mark Perry, *Grant and Twain*, in the *New York Times Book Review*, June 6, 2004, p. 38. Grant again sat for Lilienthal on a return visit to New Orleans between March and April 1880, a session that

resulted in four portraits that Lilienthal copyrighted on April 26, 1880, and which earned Grant's praise; letter of Charlotte Lilienthal (Lilienthal's daughter) to C.E. Frampton, Louisiana State Museum, October 21, 1964, Correspondence Files, Louisiana State Museum.

31. *Picayune*, September 19, 1863, cited by Smith and Tucker, p. 178, n. 14. Lilienthal applied for copyright for four portraits on September 15, 1863: "U.S. Dist[rict] Court, E[astern] D[istrict] of L[ouisian]a ... 15th day of September 1863, T. Lilienthal of this City hath deposited in this Office, the photographic portraits of Major Genl Banks, Major Genl U.S. Grant[,] Adjutant Genl Thomas of the United States Armies & of Major Genl Gardner of the Confederate States Army." Library of Congress, *Copyright Records, Eastern District, Louisiana, August 1863–June 1870*. In 1865, Lilienthal again applied for copyright of military portraits: "T. Lilienthal hath this day deposited in the Clerk's office of this Court 4 photographs representing Major Genl ERS Canby in 4 different attitudes & 3 photographs representing Major General F Steele in 3 different attitudes ... March 9, 1865" (*ibid.*, fol. 35). Lilienthal's copyright was early for a commercial photographer. Although Alexander Gardner, Mathew Brady, and other war photographers applied for copyright for their battlefield views, it was not until the late 1860s that commercial photographers commonly claimed copyright of portraiture. Barbara McCandless, "The Portrait Studio and the Celebrity: Promoting the Art," in *Photography in Nineteenth Century America, 1839–1900*, ed. Martha A. Sandweiss, Fort Worth, Tex. (Amon Carter Museum) 1991, p. 68. In fact, Lilienthal may not have fulfilled requirements of the law; see the discussion in "Can a Photograph be Copyrighted?," *Philadelphia Photographer*, v, no. 59, November 1868, pp. 379–81.

32. Louisiana State Museum, LSM 9524.23, with a Lilienthal backstamp for 102 Poydras Street.

33. *Crescent*, January 9, 1868; *Deposition of Theodore Lilienthal*, February 24, 1882.

34. Rodger C. Birt, "Envisioning the City: Photography in the History of San Francisco, 1850–1906," PhD diss., Yale University, 1985, p. 161; Tristram Powell, "Fixing the Face," in *From Today Painting is Dead: The Beginnings of Photography*, London (Victoria and Albert Museum) 1972, p. 10.

35. R.G. White, "A Morning at Sarony's," *Galaxy*, March 1870, p. 410, cited by Ben L. Bassham, *The Theatrical Photographs of Napoleon Sarony*, Kent, Oh. (Kent State University Press) 1978, p. 24, n. 60, and Taft, *op. cit.*, p. 345.

36. Powell, *op. cit.* On a contemporary photographer's career as a portrait artist, see H.J. Rodgers, *Twenty-Three Years Under a Sky-Light*, Hartford, Conn. (The Author) 1872 [reprinted New York (Arno Press) 1973].

37. In the interior South, conditions were different, and many photographers had to close up shop. In Mississippi, one historian could find no example of images made by a photographer working in Confederate territory after 1861; Carl Moneyhon and Bobby Roberts, *Portraits of Conflict: A Photographic History of Mississippi in the Civil War*, Fayetteville (University of Arkansas Press) 1993, p. 4.

38. Anne Arundel, "Recollections of Picture Making in the South, the First Two Years of the War," *Eye*, May 16, 1885.

39. "Day Breaking," *Humphrey's Journal*, XIII, no. 20, February 15, 1862, p. 320, cited by Michael L. Carlebach, *The Origins of Photojournalism in America*, Washington, D.C. (Smithsonian Institution Press) 1992, pp. 88 and 178, n. 47.

40. *Picayune*, September 4, 1863.

41. Lilienthal used this backstamp engraving interchangeably, from 1863 to 1875, for two Poydras Street studios at numbers 102 and 131 (*New Orleans Architecture*, II, p. 185). The 131 Poydras Street studio is documented from the spring of 1865. *Harper's Weekly*, IX, no. 433, April 15, 1865, p. 1; *Gardner's New Orleans Directory for 1866*; *Graham's Crescent City Directory for 1867*, New Orleans (L. Graham) 1867; *Deutsche Zeitung*, March 24, 1866; *Almanach de la Louisiane*, New Orleans (F. Bouvain) 1867.

42. *Deutsche Zeitung* (advertisement), February 28, 1861, and January 1, 1867; McCandless, *op. cit.*, p. 58. Lilienthal employed or partnered with painters J.R. Hoening of Düsseldorf and Albert Fahrenberg in the 1860s, among others. He later described the studio process of painted portraits: "I take the negative and allow the artist to make a drawing on canvas according to size ... he then by hand goes to work and finishes this picture [in] water colors or oil, or crayon"; *Deposition of Theodore Lilienthal*. Lilienthal also had large portrait photographs finished as oil paintings, as was common practice in commercial studios. There are several examples of this technique by the Lilienthal studio in the Louisiana State Museum. On painted photographs in New Orleans studio practice, see R.A. Carnden, "New Orleans Photographic Galleries," *Photographic and Fine Art Journal*, XI, August 1858, pp. 244–45; and, on the history of the technique, see Heinz K. and Bridget A. Henisch, *The Painted Photograph 1839–1914*, University Park (Pennsylvania State University Press) 1996, pp. 29, 39.

43. For a discussion of the configuration of photographers' studios at this time, see Eugene Ostrow, "Anatomy of Photographic Darkrooms," in *Pioneers of Photography: Their Achievements in Science and Technology*, Springfield, Va. (The Society for Imaging Science and Technology) 1987, pp. 106–108; Brian Coe, "The Techniques of Victorian Studio Photography," in Bevis Hillier, *Victorian Studio Photographs from the Collections of Studio Bassano and Elliott & Fry*, Boston (David R. Godine) 1975, pp. 25–28; Shirley Teresa Wajda, "The Commercial Photographic Parlor, 1839–1889," in *Shaping Communities: Perspectives in Vernacular Architecture*, VI, ed. Carter L. Hudgins and Elizabeth Collins Cromley, Knoxville (University of Tennessee Press) 1997, pp. 216–30. One of Lilienthal's famous contemporaries, Napoleon Sarony, the New York celebrity photographer, had a famously extravagant reception room, including a stuffed crocodile suspended from the ceiling, sleighs, mummies, armor, and statuary, all used as props. It was called a "dumping ground of the dealers in unsalable idols, tattered tapestry, and indigent crocodiles"; Bassham, *op. cit.*, p. 13; Taft, *op. cit.*, p. 340.

44. The *Times*, November 11, 1866, cited these "deficiencies" of photography in reference to the work of photographers A.A. Turner and Warren Cohen.

45. An engraving by E.M. Law after a photograph by Lilienthal of the back garden of the cathedral, dated to *c.* 1863–64, is the only surviving evidence that Lilienthal was taking outdoor views before his acquisition of a portable darkroom. Law died in March 1864. The engraving is known from a reworked engraving by New York engraver Alf Maurice, published in *Historical Sketch Book and Guide to New Orleans*, New York (Will H. Coleman) 1885.

46. *Times* (advertisement), June 14, 1866.

47. E.F. Bleiler, Introduction to *Gardner's Photographic Sketchbook of the War*, New York (Dover) 1959; "Movable Dark Rooms," *Anthony's Photographic Bulletin*, VII, 1876, p. 181. Lilienthal's mobile darkroom is partially visible in several of the Paris portfolio views, most clearly in *Bank of New Orleans* (cat. 63). Lilienthal's competitor, New Orleans photographer W.H. Leeson, operated a portable darkroom from about 1868, recorded in an S.T. Blessing stereoview of the second Odd Fellows' Hall at Lafayette Square (Louisiana State Museum 1979.120.107). On mobile darkrooms, see Ostrow, *op. cit.*, pp. 115–17.

48. "Goebel's Photoperipatetigraph," *Philadelphia Photographer*, IV, September 1867, p. 277. An alternative to a horse-drawn wagon was a hand-powered cart invented by Lilienthal's contemporary, Missouri photographer Rudolph Goebel, and called a "photoperipatetigraph" (see also Palmquist and Kailbourn, *op. cit.*, p. 33).

49. Lilienthal photographed his wagon opposite his competitor Samuel Anderson's studio at 151 Canal Street (today the 800 block) probably shortly after he moved his studio to 121 Canal Street in the Touro Buildings, visible in the next block. The view painted on the side of the wagon appears to be the fairgrounds' racecourse grandstand, built in 1871.

50. *True Delta*, November 29, 1865. The view of the St. James Hotel was reported earlier, "Photograph of the St. James Hotel," *Times*, November 20, 1865; see p. 272.

51. *Quartermaster Views*, NARA, Still Picture Branch, College Park, MD, 165-ALB. A total of 542 prints, including eighteen photographs of Louisiana installations by Lilienthal, are contained in twenty-seven 12 × 16½-inch (30 × 42-cm) albums, and about the same number of loose prints are filed in related collections. The albums, arranged by state (twenty-two are represented), may have been assembled by the Quartermaster as early as 1867. See U.S. War Department Library, *List of the Photographs and Photographic Negatives Relating to the War for the Union, Now in the War Department Library*, Washington, D.C. (Government Printing Office) 1897, which documents the full extent of the Meigs surveys (including Lilienthal's Louisiana views, inventoried on pp. 22–23) and the very useful finding aid by archivist Nick Natanson, "Joint Finding Aid for Civil War Vintage Prints: 165-ALB, ABC, CO, CS, and CSO," NARA, College Park, MD, Still Picture Branch. I am grateful to Nick Natanson and Ed McCarter, also of the National Archives, for their assistance with my research and in obtaining new photography.

52. Communication from Brigadier General Meigs regarding General Order #3, June 14, 1864, cited in Natanson, *op. cit.*, p. 4. Meigs gave instructions that "on each lot the name be legibly inscribed by a board within field of view of the camera, on which particulars may be chalked". This method was already in use for field reports of construction by Treasury Department superintending architects, for example in J.D. Edwards's views prepared for annual reports of construction at the New Orleans Marine Hospital and U.S. Custom House (examples are in the Hill Library, Louisiana State University, Baton Rouge), but Lilienthal did not himself adopt it. Meigs, an amateur photographer himself, pioneered the use of photography for federal construction documentation and as a publicity tool to obtain appropriations for his projects, notably his work on the Capitol in the 1850s. Meigs may have viewed the series in which Lilienthal participated as documentation of the innovative systems he developed during the war years for the production and distribution of supplies and material. See Dean A. Herrin, "The Eclectic Engineer: Montgomery C. Meigs and His Engineering Projects," in *Montgomery C. Meigs and the Building of the Nation's Capitol*, ed. W.C. Dickinson, D.A. Herrin, and D.R. Kennon, Athens (Ohio University Press) 2001, p. 19; Wayne Firth, "Montgomery C. Meigs and Photography at the Capitol," in *ibid.*, pp. 127–32; Keith F. Davis, "A Terrible Distinctness: Photography in the Civil War Era," in *Photography in Nineteenth Century America, op. cit.*, pp. 164–65. On Russell, see Susan Danly, "Andrew Joseph

Russell's *The Great West Illustrated*," in *The Railroad in American Art*, Cambridge, Mass. (MIT Press) 1988, pp. 93–112; *ead.*, "The Landscape Photographs of Alexander Gardner and Andrew Joseph Russell," PhD diss., Brown University, 1983; Thomas Weston Fels, *Destruction and Destiny. The Photographs of A.J. Russell: Directing American Energy in War and Peace, 1862–1869*, Pittsfield, Mass. (Berkshire Museum) 1987.

53. *Quartermaster Views, op. cit.*, XXXIII, "Louisiana," containing prints numbered 165-C-872 through 889. Print size ranges from about 10 × 14 inches to 11³/₈ × 14³/₈ inches (25.4 × 35.6 cm to 28.9 × 36.5 cm). The inventory of views as indexed in the album, with the NARA negative numbers added, is: "Sedgwick Hospital, Gasworks" (872); "Odd Fellows Hall, used as quarters for troops" (873); "Cavalry stables at Greenville" (874); "Cavalry stables at Greenville" (875); "Depot & Warehouse, St Joseph street R.R., Lakend" (877); "U.S. Barracks" (878); "Sedgwick Hospital, administration build'g & ward" (879); "Jackson R.R. build'g, used for offices, Q.M. Dep't." (880); "Watertank Cavalry stables, Greenville" (876); "Sedgwick Hospital, covered gangway" (881); "Sedgwick Hospital, 'Cistern'" (882); "U.S. Barracks" (883); "U.S. Barracks, dispensary" (884; actually U.S. Hospital); "U.S. Barracks" (885); "U.S. Barracks" (886); "Small pox Hospital, Poydras st, New Orleans" (887); "Small pox Hospital, Poydras st., New Orleans" (888); "Head Qr's, Mil'y. Div. of the Gulf" (889).

The following Quartermaster views are illustrated above: 844, of the U.S. Hospital, a view Lilienthal remade for the Exposition portfolio (fig. 15; cat. 115); 873, of the Odd Fellows' Hall, appropriated as the headquarters of the Army of the Gulf (fig. 16; cat. 120); 875, of the rail line that served the cavalry stables at Greenville (fig. 18); 876, of the watering station at the Greenville post (fig. 19); and 877, fig. 17, of the St. Joseph Street military railway (demolished in 1866; Lilienthal's view of the railroad's downtown terminal was included in the Exposition portfolio [cat. 9], and can be dated to the Quartermaster commission or shortly after).

Lilienthal reprinted four Quartermaster views for the Paris Exposition portfolio: 872 (cat. 103); 878 (cat. 117); 879 (cat. 102); and 886 (cat. 116). Two other photographs in the Exposition portfolio, "U. S. St Joseph St R. Road" (cat. 9) and "Entrance of U. S. Hospital" (cat. 114) may also have been made for Meigs, but are not represented in the surviving Quartermaster views in Washington, D.C. For references to the buildings illustrated, see "Report of Buildings owned by the U.S. Government," 1865, Consolidated Correspondence File, 1794–1915, Office of the Quartermaster General, RG92, NARA; "Report of Buildings Hired, etc, Compiled by Capt. J.B. Dexter, Ass't Quartermaster, U.S. Army at New Orleans, November 1865," Consolidated Correspondence File, 1794–1915, *op. cit.*

54. See the discussion on pp. 260–67.

55. The Bailey stereos are in the collection of Mr. and Mrs. Eugene Groves, Baton Rouge. On Bailey, see George C. Esker, III, "James Bailey: An Obscure Louisiana Photographer and His Confederate Photographic Legacy," *Military Images*, May–June 1998, pp. 12–13.

56. "A Pictur[e]," *Picayune*, January 31, 1866; "A Colored School Photographed," *Daily Southern Star*, February 6, 1866. The *Harper's* wood engraving after Lilienthal's photograph appeared on the front page of the issue of Saturday, April 21, 1866 ("School for Freedmen," X, no. 486, p. 241). Lilienthal also provided the following magazine illustrations: *Harper's Weekly*, VIII, no. 378, March 26, 1864, p. 205 (Hahn portrait); IX, no. 433, April 15, 1865, p. 225 (Canby portrait); X, no. 479, March 3, 1866, p. 132; X, no. 486,

April 14, 1866 (a composite portrait, one of Lilienthal's specialties, of the Mississippi Mission of the Methodist Episcopal Church); and additional Methodist Church portraits, X, no. 496, June 23, 1866, p. 398. Later engravings after Lilienthal's photographs appeared in the issues of January 10, 1874, and February 10, 1877 (a portrait series of American inventors). His work also appeared in *Frank Leslie's Illustrated Newspaper*, XVIII, no. 444, April 2, 1864, p. 21; XIX, no. 478, January 28, 1865, p. 287; and in the issues of September 14, 1874, and March 18, 1876.

57. Julie K. Brown, *Making Culture Visible: The Public Display of Photography at Fairs, Expositions and Exhibitions in the United States, 1847–1900*, Amsterdam (Harwood Academic Publications) 2001, p. 55.

58. *Picayune*, December 2, 1866; *Crescent*, December 9, 1866; Mechanics' and Agricultural Fair Association of Louisiana, *Report of the First Grand Fair of the Mechanics' and Agricultural Fair Association of Louisiana*, New Orleans (Commercial Bulletin) 1867.

59. *Times*, November 28, 1866. The view of the Prudent Mallard workshop and retail store at Royal and Bienville streets referred to here was in the Ray Samuel Collection, New Orleans, when it was photographed in 1978; it is reproduced in Smith and Tucker, p. 139.

60. Lilienthal won awards repeatedly in the annual fairs, taking a silver medal for "Best set of photographic views" and honorable mention for the "Best and largest display of photographs" at the second fair in January 1868, when the *Picayune* wrote that his "views of the city are exceedingly fine" (January 8, 1868). He continued to win medals as a viewmaker at the 1869 ("Best set of photographic views") and 1870 fairs ("Best photographic views"). *Picayune*, May 4, 1870; Mechanics' and Agricultural Fair Association of Louisiana, *Report of the Grand Fair Held in the City of New Orleans*, New Orleans (New Orleans Times Book and Job Office, etc.) 1867–70.

61. See Reese V. Jenkins, *Images and Enterprise: Technology and the American Photographic Industry 1839 to 1925*, Baltimore (Johns Hopkins University Press) 1975.

62. *Picayune*, November 20, 24, and 25, December 25, 1881, January 10, 1882; *St. Louis and Canadian Photographer*, IX, no. 11, November 1891, p. 493.

63. In 1880, Lilienthal brought a suit against local competitor William Washburn for lambertype patent infringement; see what follows on p. 47.

64. On the carbon process, see Audrey Linkman, "The Stigma of Instability: The Carbon Process and Commercial Photography in Britain, 1864 to 1880," *Photographica World*, XCI, Winter 1999/2000, pp. 8–32; and Robert Lansdale, "The Stigma of Instability: The Carbon Process in North America, 1876 to 1880," *Photographic Canadiana*, XXXI, no. 1, May–June 2005.

65. Hugh Diamond, "The Paris International Exposition: Photographic Proofs and Apparatus," and C.T. Thompson, "Photography—Class 9: Permanent Printing," *Illustrated London News*, LI, no. 1445, September 14, 1867, pp. 294–399.

66. "The Albumen Process and Lambertype," *St. Louis Practical Photographer*, I, no. 8, August 1877, pp. 246–48; Claude Léon Lambert, "Improvements in Carbon Printing," *Anthony's Photographic Bulletin*, VII, 1876, pp. 133–34; Welling, *Photography in America, op. cit.*, p. 245.

67. "Dr. Vogel and Lambertypes," *St. Louis Practical Photographer*, I, no. 1, January 1877, pp. 17–19; *Anthony's Photographic Bulletin*, VIII, April 1877, p. 96.

68. Carlo Gentile, "From New Orleans," *St. Louis Practical Photographer*, III, no. 4, April 1879, pp. 571–72. The letter is

dated March 12, 1879. *Anthony's Photographic Bulletin*, X, no. 11, 1879, also reported Gentile's work in New Orleans (p. 182). A local paper reported on Gentile, who "cannot be surpassed for posing with ease and grace," and his association with Lilienthal (*Democrat*, March 2, 1879). Gentile had recently been burned out of his studio in New York, and was working as an itinerant operator, until settling in Chicago in 1880, where he became publisher of the *Eye*. On Gentile, see *St. Louis Practical Photographer*, I, no. 3, March 1877; Cesare Marino, *The Remarkable Carlo Gentile: Pioneer Italian Photographer of the American Frontier*, Nevada City, Calif. (Carl Mautz) 1998 (with no reference to his work with Lilienthal); and Peter E. Palmquist and Thomas R. Kailbourn, *Pioneer Photographers of the Far West: A Biographical Dictionary 1840–1865*, Stanford, Calif. (Stanford University Press) 2000, pp. 258–60.

69. *Picayune*, October 22, 1874.

70. "The Grand Art Emporium of the Crescent City," *New-Orleans Price-Current*, February 19, 1881, reprinted in the *St. Louis Practical Photographer*, V, no. 4, April 1881, pp. 131–32; *The Industries of New Orleans*, p. 92; Augusto P. Miceli, *The Pickwick Club of New Orleans*, New Orleans (Pickwick Press) 1964, pp. 70–71. Miceli states that 113 members participated in the White League insurrection. The portrait still hangs in the Pickwick Club.

71. *St. Louis Practical Photographer*, III, no. 11, November 1879, p. 854; *Philadelphia Photographer*, XVI, no. 191, November 1879, p. 351; Collins, *op. cit.*

72. *St. Louis Practical Photographer*, III, no. 11, November 1879, p. 854. On composite portraiture, see Taft, *op. cit.*, pp. 358–59.

73. *Picayune*, April 17, 1864; J. Curtis Waldo, *Visitor's Guide to New Orleans, November 1875*, New Orleans (J. Curtis Waldo, Southern Publishing and Advertising House) 1876, advertisement, following p. 144, "I have opened my new gallery" (121 Canal Street).

74. *Louisiana*, XII, p. 163, XVI, p. 143, R.G. Dun & Co. Collection, *op. cit.*

75. Edward L. Wilson, *To My Patrons*, Utica, NY (L.B. Williams Photographic Studio), *c.* 1871, p. 2, Pamphlet Collection, Baker Library, Harvard Business School; reprinted in Beaumont Newhall, ed., *Photography: Essays and Images*, New York (Museum of Modern Art) 1980, pp. 129–134.

76. *Photographic Eye*, XV, no. 36, October 3, 1885.

77. *Anthony's Photographic Bulletin*, XI, no. 8, August 1880.

78. *St. Louis Practical Photographer*, I, no. 9, September 1877, pp. 275–76.

79. *Deposition of Theodore Lilienthal.*

80. *Ibid.*

81. Sarony interview in the *Photo-American*, V, September 1894, p. 324, cited by Bassham, *op. cit.*, pp. 14 and 24, n. 67.

82. RG21, U.S. Fifth Circuit Court for the Eastern District of Louisiana, case 8959, *Lilienthal v. Washburn*, Deposition of Gustave Moses, NARA. Bavarian-born Gustave Moses (*c.*1836–1915) was in partnership with his brother Bernard (both were sons of photographer Samuel W. Moses); see Palmquist and Kailbourn, *Pioneer Photographers from the Mississippi to the Continental Divide, op. cit.*, pp. 452–55.

83. "Proceedings of the First Convention of the Photographers' Association of America," *Anthony's Photographic Bulletin*, XI, 1880, p. 148.

84. Letter of Charlotte Lilienthal to C.E. Frampton, *op. cit.*; Mark Twain, *Life on the Mississippi*, New York (Harper & Brothers) 1900, p. 326.

85. *Deposition of Theodore Lilienthal.*

86. *Ibid.*

87. *Ibid.*; *Philadelphia Photographer*, XX, August 1883, p. 256.

The suit dragged on for nearly four years and was eventually settled in Lilienthal's favor.

88. "Deposition of William Washburn" in *Deposition of Theodore Lilienthal*.

89. "Photographic Announcement," *Deutsche Zeitung*, November 6, 1867.

90. *Deposition of Theodore Lilienthal*, February 24, 1882.

91. "Photographic Announcement," *Deutsche Zeitung*, op. cit.

92. Buffalo photographer William J. Baker in "Fifth Annual Meeting and Exhibition of the N.P.A.," *Philadelphia Photographer*, X, August 1873, p. 260, cited by Brown, *op. cit.*, pp. 47 and 57, n. 55.

93. *Louisiana*, XVI, p. 142, R.G. Dun & Co. Collection, *op. cit.*

94. *Philadelphia Photographer*, XVIII, April 1881, p. 128; *St. Louis Practical Photographer*, V, no. 4, April 1881; Lilienthal's Touro Buildings studio is recorded in the illustrated lithograph, and in a photograph by F. Mugnier (The Historic New Orleans Collection, 1980.137.25; and stereograph, Louisiana State Museum 1979.120.182). Five of the original seven Touro buildings survive today on Canal Street.

95. "The Grand Art Emporium," *op. cit.*

96. *The Industries of New Orleans*, pp. 92–93.

97. J. Curtis Waldo, *History of the Carnival of New Orleans* (advertisement), New Orleans (J.C. Waldo) 1882.

98. *The Industries of New Orleans*, p. 93. This was probably the 20 × 24-inch (51 × 61-cm) Success camera with a Dallmeyer rapid rectilinear lens that Lilienthal reported he was using in 1883 (letter to E. & H.T. Anthony & Co., published in *Anthony's Photographic Bulletin*, XIV, December 1883, p. 417).

99. *Deposition of Theodore Lilienthal*.

100. *Louisiana*, XIII, p. 999, R.G. Dun & Co. Collection, *op. cit.* (entry for November 30, 1881). Rent reported by Lilienthal in *Deposition of Theodore Lilienthal*, February 24, 1882.

101. *Louisiana*, XVI, p. 425, R.G. Dun & Co. Collection, *op. cit.*

102. *Deposition of Theodore Lilienthal*; Land, *Pen Illustrations*, p. 165; *The Industries of New Orleans*, p. 92.

103. *Charter and By-Laws of the New Orleans Camera Club, Incorporated May 3d, 1888*, New Orleans (Garcia Stationery) 1890. There is frequent coverage of New Orleans Camera Club meetings from 1888 through the 1890s in *Anthony's Photographic Bulletin, Photographic Times and American Photographer*, and *Wilson's Photographic Magazine*. A club scrapbook of minutes, notes, and articles is in the Manuscript Collection, Howard-Tilton Memorial Library, Tulane University.

104. Sarah Greenough, "Of Charming Glens, Graceful Glades, and Frowning Cliffs," in *Photography in Nineteenth Century America*, op. cit., p. 259.

105. On the history of the process, see Taft, *op. cit.*, ch. 18, and Coe, *op. cit.*, pp. 25–28.

106. Taft, *op. cit.*, pp. 370–71; Welling, *Photography in America*, op. cit., p. 257.

107. "Instantaneous Photographs at Lilienthal's Art Gallery" (advertisement), *Picayune*, November 24, 1881.

108. "Our Picture" *St. Louis Practical Photographer*, VI, no. 4, April 1882, p. 142.

109. Abigail Solomon-Godeau, "Reviewing the View: Carleton E. Watkins Redux," *Print Collector's Newsletter*, XV, May–June 1984, p. 73.

110. *Philadelphia Photographer*, XXI, August 1884, p. 254.

111. *Philadelphia Photographer*, XXI, November 1884, pp. 349–50; "Easel Talk: A Peep into our Artists' Studios," *Daily States*, April 13, 1884.

112. Lilienthal employed Louis (Hitchler Lilienthal, 1846–1898) in his studio from his adoption at the age of nineteen in 1866; he also employed Louis's brother Anthony (1852–1935) before 1870. Both children had been born in Prussia, emigrated to New Orleans with their parents in 1852, and were orphaned within a few years of their arrival, their parents apparently victims of yellow fever. Louis became an operator and later manager of Lilienthal's studio, and in 1883 he left to open his own photographic business on Tremont Street in Galveston, Texas, having bought out the S.T. Blessing family of New Orleans, who had been established there in the 1850s. After only a few years, he moved his studio to Houston, where he practiced until his death. Anthony also worked as a photographer. In 1880, he was employed in the St. Louis branch studio of New Orleans photographer Gustave Moses. By 1894, he was a printer and retoucher for his brother Louis in Houston, where he later succeeded the photographer C.J. Wright. From about 1901, Anthony operated a studio in New Orleans, and attained local prominence for his portraiture, notably as official Carnival photographer (he was awarded a silver medal at the St. Louis Exposition of 1904 for his Mardi Gras portraits). *Anthony's Photographic Bulletin*, XV, January 1884, p. 16; *Houston Daily Post*, April 21, 1898; "A.H. Hitchler," *Times–Picayune States*, August 18, 1935; David Haynes, *Catching Shadows: A Directory of Nineteenth-Century Texas Photographers*, Austin (Texas State Historical Association) 1993, p. 66. I am grateful to Kathleen Colongne and Betty Hendrickson for information on the Hitchler family.

113. *Deposition of Theodore Lilienthal; Succession of Julia F. Hosser; Wife of Theodore Lilienthal*, February 12 and June 20, 1884, Docket No. 10625, Civil District Court for the Parish of Orleans, New Orleans Public Library; *Succession of Julia F. Hosser; Wife of Theodore Lilienthal*, November 1885, Docket No. 9449, Supreme Court of Louisiana, University of New Orleans Special Collections (I would like to thank Doris Ann Gorman for locating this document, and that cited in n. 114 below). Lilienthal's wife's death on January 30, 1884, at the age of fifty-two was reported by the national photographic press; *Anthony's Photographic Bulletin*, XV, February 1884, p. 84; *Photographic Times and American Photographer*, XIV, no. 38, February 1884, p. 72; *Philadelphia Photographer*, XXI, March 1884, p. 96; obituary in *Picayune*, January 31, 1884. The year after her death, Lilienthal married Emma Siemers Weiskopf of Minneapolis. She was a widow at the age of twenty-two; Lilienthal was in his mid-fifties. A cabinet-card portrait of Weiskopf by the Winona, Minnesota, photographer and family friend Robert Morgeneier is in the Louisiana State Museum (1986.55.10; Morgeneier practiced from 1880 to 1887, see *St. Louis and Canadian Photographer*, VI, no. 7, July 1888). The Lilienthal–Siemers Weiskopf wedding was reported in *Anthony's Photographic Bulletin*, XVI, no. 19, October 10, 1885, p. 608, and the *Photographic Eye*, XV, no. 35, September 26, 1885, both citing the *Minneapolis Tribune* of September 23, 1885. A portrait of Lilienthal's first wife is also in the Louisiana State Museum (1986.55.6). Lilienthal had two children with his second wife, both born in New Orleans: Gilbert in 1886, and Charlotte in 1888. A portrait by Lilienthal of the infant Gilbert is in the Louisiana State Museum (1986.55.7).

114. *T. Lilienthal vs. His Creditors*, April 14, 1887, Docket No. 20804, Civil District Court for the Parish of Orleans, New Orleans Public Library.

115. *Daily States*, February 19, 1890; "Large Fire in New Orleans," *New York Times*, February 20, 1890; *Picayune*, February 20, 1890; *Times Democrat*, February 20, 1890; *St. Louis and Canadian Photographer*, VIII, no. 4, April 1890,

p. 152. For a view of the fire ruins, see *New Orleans Architecture*, II, p. 19 (captioned incorrectly to February 1892).

116. *Daily States*, February 19, 1890.

117. *Picayune*, February 20, 1890; *Daily States*, February 19, 1890.

118. "The World's Congress Auxiliary of the World's Columbian Exposition," *Photographic Times*, May 27, 1892, pp. 281–82.

119. Lilienthal's work as an operator with toxic chemicals probably caused or exacerbated his sickness. His early years were spent working with wet-plate chemistry; the collodion itself, ether, alcohol, acetic acid, ammonia, and the quicksilver used for gilding mounts were all volatile, released fumes, or presented other hazards. The inhospitable New Orleans climate contributed further to the hazards of darkroom chemistry "which especially in hot weather produce vapors." The *Philadelphia Photographer* advised the use of opium, ammonia water, or Chinchona wine to obviate various symptoms. The *St. Louis Practical Photographer* (I, no. 5, May 1877, p. 167) suggested "when occasionally you feel sick, in your gallery, from the effects of your chemicals, take a good smell from the ammonia bottle, it won't hurt you; or pour in your hands some acetic acid, rub them together, then inhale the fume, and you will find it very refreshing." See Emil Vaisson, "The Unhealthfulness of Photography," *St. Louis Practical Photographer*, IV, no. 2, February 1880, pp. 50–51; H. Baden Pritchard, "Dark-Room Disease," and "Poisonous Chemicals," in *About Photography and Photographers*, New York (Scovill Manufacturing Co.) 1883, pp. 91–95, 125–29.

120. *Minneapolis Tribune*, December 1, 1894 (reporting the cause of death); "Theodore Lilienthal: Death of a Well Known Citizen," *Daily Item*, December 5, 1894; "The Death of Theodore Lilienthal," *Picayune*, December 5, 1894; *St. Louis and Canadian Photographer*, XIX, January 1895, p. 59; "Death of Mr. Theodore Lilienthal, of New Orleans," *Wilson's Photographic Magazine*, XXXII, January 1895, p. 46. Lilienthal was buried in Lakewood Cemetery, Minneapolis. He was survived by his second wife, Emma (died 1945), and his two children, Charlotte (died 1968) and Gilbert (died 1974). Lilienthal's children died without heirs. (See also n. 113 above.) I am grateful to Alan Lathrop, Dennis E. McGrath, and Zella Mirick for their assistance with the Lilienthal family genealogy in Minneapolis.

New Orleans in 1867:
La Nouvelle Orléans et ses environs

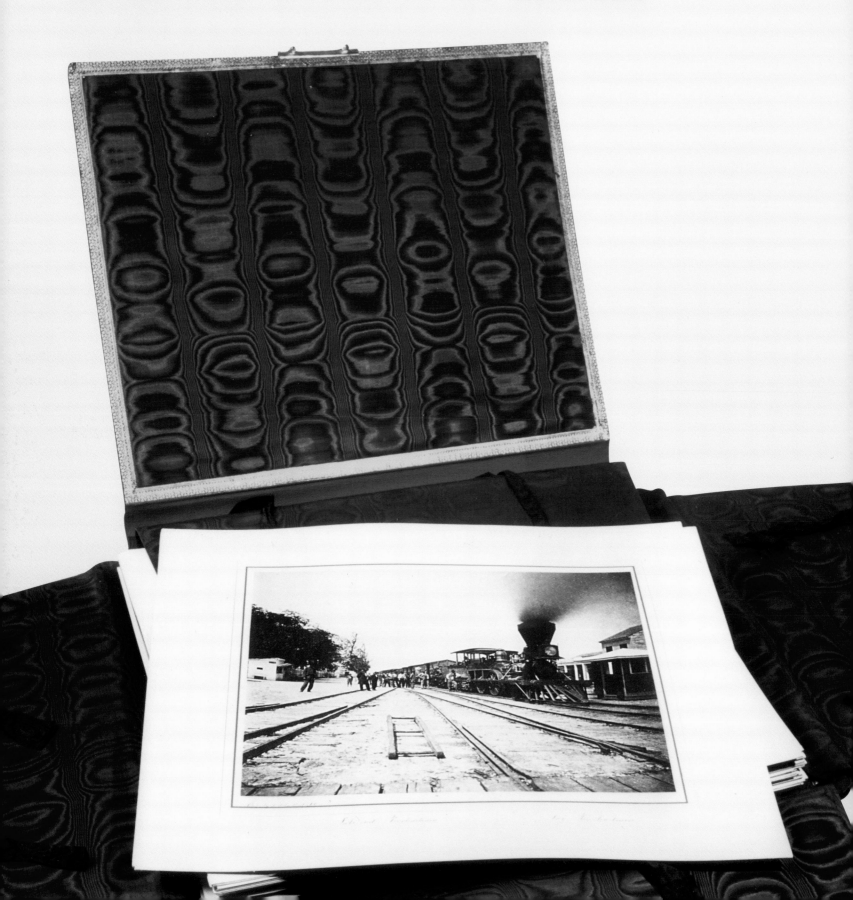

Following the presentation of *La Nouvelle Orléans et ses environs* to the emperor Napoléon III in August 1867, the portfolio is not documented for another forty years. The photographs were evidently retained in the imperial household, but only three-and-a-half years remained of Napoléon's reign and of the Second Empire. In July 1870 he was at war with Prussia and two months later he took up residence at Kassel after the French defeat at the Battle of Sedan, never to return to Paris. In the spring of 1871, the emperor was deposed and, with his release from Kassel, joined the exiled Empress Eugénie at Chislehurst, England, where he died in January 1873. The emperor's property had been scattered among residences in Paris and a family chateau, Schloss Arenenberg, in Thurgau, Switzerland, where he had lived as a child, but most of the contents of the imperial households were seized or destroyed during the Paris Commune fires in 1871.[1] The New Orleans photographs survived destruction or confiscation perhaps because they had been sent to Arenenberg in the late 1860s with other Exposition artifacts, although the transfer is not recorded.[2]

During the summers following the emperor's death, Eugénie sojourned at the Arenenberg estate, which the emperor's mother, Hortense de Beauharnais (the ex-queen of Holland and sister-in-law of Napoléon I) had purchased and remodeled in 1817 (fig. 48).[3] Arenenberg had been "the centre of a little colony of Napoleonists," one visitor wrote, and the setting of the 27-acre (11-ha) estate, on the southern shore of Lake Constance, was idyllic.[4] "No one who has not seen this spot can imagine its beauty," Napoléon III wrote of his boyhood home; "the chateau stands on a high hill, the sides of which are covered with vines and fruit trees. The lake is small, but exquisitely lovely ... a vine-clad slope descends from the house to the water's edge, and the blue mountains of Suabia [Swabia] in the back-ground complete the picture."[5] As emperor, Napoléon III visited Arenenberg officially only once, in 1865, but there is evidence that he may have used the house as a clandestine retreat, and he is known to have intended to take up residence there after his deposition.[6]

Eugénie refurbished the Arenenberg estate in 1873 and "reunited many heirlooms and souvenirs of the First and Second Empires

Fig. 47 *La Nouvelle Orléans et ses environs*, presentation portfolio. Napoleon Museum.

Fig. 48 Emmanuel Labhardt, *Schloss Arenenberg*, watercolor, 1845. Napoleon Museum.

within its walls," turning the house into a mausoleum of the lost empire.[7] Following the death of her son, in 1879, Eugénie lost interest in the estate and returned for short visits only a few times, the last in 1900.[8] In 1906, she donated the chateau and its contents, including the Lilienthal portfolio, to the canton of Thurgau. When the canton opened the chateau as a museum in 1907 (the house had been opened to the public periodically since 1855), the Lilienthal photographs were inventoried as part of Eugénie's bequest.[9]

The Arenenberg portfolio today contains 126 of the 150 views ordered by the City of New Orleans in February 1867. The photographs are albumen prints made from wet-plate collodion negatives, trimmed to an average size of 12 × 15 inches (30.5 × 38 cm) and mounted on 16 × 24-inch (41 × 61-cm) gilt-edged card stock. The mounted prints are framed with one thick and one thin line of gold ink and captioned (not always correctly) in brown ink in English and French.[10] Most of the mounts are signed "Photo by T. Lilienthal. N.O." in brown ink in the lower left corner, inside the framing lines. The photographs are loosely assembled in three gold-tooled portfolios of red morocco, lined with blue moiré silk, secured with blue cotton ties and locking gold clasps. A pattern of black-and-gold bands with the emblems of Napoléon III and the City of New Orleans decorates the front and back

covers. The spines, ornamented with raised bands and gold lines, are inscribed in gold with the volume numbers ("1", "2", "3") and the title, "LA NOUVELLE ORLÉANS ET SES ENVIRONS."[11]

In its luxurious presentation, the portfolio is comparable to other contemporary collections of views gathered in lavish bindings as imperial gifts. Second Empire photographers Roger Fenton, Édouard Baldus, Auguste-Hippolyte Collard, Charles Nègre, and Adolphe Braun prepared presentation albums for Napoléon III (and Empress Eugénie) to commemorate the opening of railway lines or asylums, or to document military installations or the emperor's Arenenberg estate. Fete books of photographs, such as the album Napoléon III presented to Queen Victoria at the London Exposition of 1851, or Baldus's album for her, presented at the Paris Exposition of 1855, were similarly treated in fine bindings. The Lilienthal portfolio is the only documented example of an American photographer's work presented to this emperor, known for his interest in photography.[12]

Albumen prints typically had a fine luster or gloss, and a deep purple-black tone. Although Lilienthal's prints appear to have retained most of their density and contrast, they have developed the deep sepia cast often associated with old photographs, a process due more to chemical impurities in the prints than to the effect of light. Streaking from an uneven

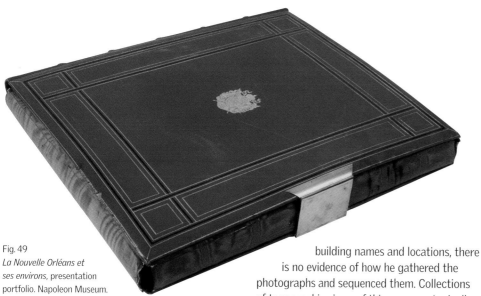

Fig. 49
La Nouvelle Orléans et ses environs, presentation portfolio. Napoleon Museum.

coating of the collodion negative is occasionally visible, a defect traceable to Lilienthal's—or his operator's—fieldwork. But instances of streaking or spotting are infrequent, attesting to his skill and careful habits as a "practical" photographer. Yellow highlights, common in gold-toned albumen prints, and a crackle pattern that develops in albumen over time are pronounced in certain prints, but, overall, the prints are in very good condition.[13]

Although the *Crescent* reported that "Mr. L. retains the negatives of all these views, and will print copies for all who may desire them," only one duplicate print is known.[14] A view of S.N. Moody's residence (cat. 21) survives in an identical presentation mount and was once owned by Moody himself (as Exposition Commissioner, he delivered Lilienthal's portfolio to Paris).[15] The lack of other surviving duplicates suggests that few were sold. At $10 each, the large imperials would have been out of the reach of many buyers. They were less marketable than Lilienthal's stereoviews, which represented many of the same subjects but at a cost of only $3 or $4 per dozen (see pp. 260–67). No Lilienthal negatives are known to have survived two studio fires in 1884 and 1890.

The *Times* wrote in May 1867 that Lilienthal's "collection may be pronounced the most complete of the kind ever arranged in this city." Other newspaper accounts refer to the Exposition photographs assembled in a "portfolio," an "album," or as a "series of views."[16] Because Lilienthal did not index or number the views or provide a table of contents, and supplied only simple captions of

building names and locations, there is no evidence of how he gathered the photographs and sequenced them. Collections of topographic views of this era were typically arranged according to a typology of building functions, or following an unfolding description of the city established in tourist itineraries. In the absence of any instructions to the viewer, the catalog as presented here has been sequenced topographically, following a view path derived from nineteenth-century guidebooks and view books (see pp. 62–63).[17]

How the views were presented at the Exposition is also unknown. Photographs of this size would normally have been intended for wall display but a collection as large as this could probably not have been exhibited in its entirety (certainly not in the Louisiana pavilion). Because they were commissioned as a presentation album for the emperor, it would have been unusual for the prints to have been accessible to visitors, and the frequent thefts of artifacts at the Exposition would have made public viewing of unframed prints impractical.[18] Yet commissioner Edward Gottheil's remarks that the photographs were "much admired," and that "[e]very Louisianian recognizes some familiar spot," suggest that some part of the portfolio was viewed by visitors.[19]

1. A large part of the emperor's collection of photography was also lost in the fires, as were the inventories of the imperial household; see Maurice Fleury, ed., *Memoirs of the Empress Eugénie*, New York (D. Appleton & Co.) 1920, I, p. 472 (see also below); Sanford Kanter, "The Right of Property at the Beginning of the Third French Republic: The Personal Effects of Napoleon III," *Past and Present*, XCIV, no. 92, February 1982, pp. 103–106; Sylvie Aubenas, *Gustave le Gray, 1820–1884*, Los Angeles (The J. Paul Getty Museum) 2002, p. 318.

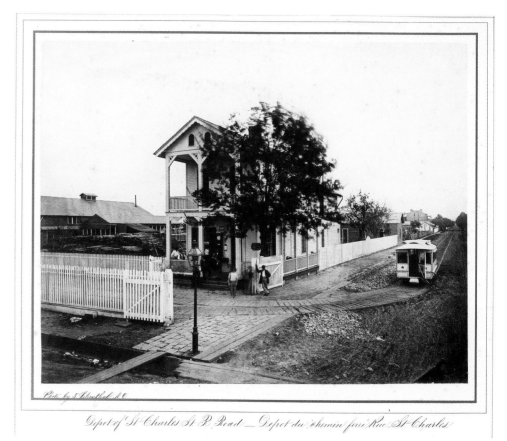

Fig. 50 *Depot of St. Charles St. Rail Road* (cat. 93), showing photographer's mount, caption, and inscription.

2. On the inventories of the artifacts and household goods at Arenenberg, see Dominik Gügel, "Ein Schloss und seine Ausstattung," in *Menschen im Schloss: Lebenswelt um 1900 auf dem Kaiserlichen Gut Arenenberg*, ed. Dominik Gügel and Christina Egli, Frauenfeld (Huber) 2006, pp. 123–67, and note 8, below. It appears most likely that the emperor sent the Lilienthal portfolio to Switzerland late in his reign. Jerrold wrote that "in the first moments of his [Napoléon III's] misfortune, his mind turned to his Swiss home, and he sent everything to this little chateau" (Jerrold, *op. cit.*, I, p. 130). It is also possible that the photographs were deposited at Arenenberg during one of Eugénie's later removals of property. A lawsuit Eugénie initiated in the 1870s over personal property seized in the deposition of Napoléon III was settled in 1880, and more than 500 household articles from the old imperial residences were returned to her. Eugénie sent some of this property to Arenenberg, another possible point of transfer of the portfolios to Switzerland; *Memoirs of the Empress Eugénie, op. cit.*, I, pp. 470–73; Sanford Kanter, *op. cit.* A recent dissertation provides additional research on works of art (with no reference to photographic albums) repatriated to Eugénie: Catherine Granger, *La Liste Civile de Napoléon III*, PhD diss., Paris, University of Paris, 2000. I thank Alison McQueen for this reference.

3. In 1840, Napoléon III was forced to sell the property he had inherited, but he bought it back in 1855 and restored it. On the history of the Arenenberg estate, see Gügel and Egli, *op. cit.*; Dominik Gügel, "Schloss Arenenberg und sein Landschaftspark," in *Arkadien am Bodensee: Europäische Gartenkultur des beginnenden 19. Jahrhunderts*, Frauenfeld (Huber) 2005, pp. 110–65; Michel Guisolan, "Gastlicher Arenenberg," in *Arenenberg: Der Dichter und Maler*, ed. Hans Peter Mathis, Salenstein, Switzerland (Napoleon Museum Arenenberg) 1995, pp. 15–39; Blanchard Jerrold, *The Life of Napoleon III*, London (Longmans, Green & Co.) 1874, I, pp. 127–34; Jean-Claude Lachnitt, "Arenenberg," in *Dictionnaire du Second Empire*, Paris (Fayard) 1995, pp. 68–69; Jasper Ridley, *Napoleon III and Eugénie*, New York (Viking) 1979, pp. 49, 116–17, 193, 496, 595–96. Braun photographed the estate at Arenenberg in the early 1860s; Naomi Rosenblum, "Reproducing Visual Images," in *Image and Enterprise: The Photographs of Adolphe Braun*, ed. Maureen C. O'Brien and Mary Bergstein, New York (Thames & Hudson) 2000, p. 38; several Braun stereoviews from this series are illustrated in Esther Bächer, *et al.*, "Katalog," in *Arenenberg: Der Dichter und Maler, op. cit.*, pp. 312–13.

4. Thomas Murray, *Murray's Handbook for Travellers in Switzerland 1838*, ed. Jack Simmons, New York (Humanities Press) 1970, p. 21. Hortense summered at Arenenberg from 1823 until her death in 1837; Louis, who was educated in Augsburg, often accompanied her.

5. Martha B. Wheaton, *Authentic Memoirs of Prince Napoleon Louis Bonaparte*, Providence (Charles Burnett) 1848, p. 9.

6. That Napoléon III initially intended to take up residence in Arenenberg, not Chislehurst, in the spring of 1871 is documented by a letter in the Paris archives that will be published by the Napoleon Museum, Arenenberg, in a forthcoming exhibition catalog on Napoléon III and the Thurgau estate (communication of Christina Egli, conservator, October 2007).

7. Ellen Barlee, *Life of the Prince Imperial of France*, London (Griffith & Farran) 1880, p. 263. English journalist Blanchard Jerrold wrote in 1874 that at the Arenenberg house he saw "a sad souvenir at every turn"; Jerrold, *op. cit.*, I, p. 127.

8. Guisolan, *op. cit.*, pp. 20–23.

9. The Lilienthal portfolio bears the red-and-green inventory tags "Schloss Arenenberg R29," identifying the donation of 1906. It is recorded in a manuscript inventory of the donation now in the Napoleon Museum archive, *Katalog der Bibliotheken im Schloss Arenenberg, aufgenomen in August 1906*, p. 28: "R29, La Nouvelle Orléans et ses environs Photographies." The photographs are otherwise undocumented at the Napoleon Museum (most canton records of Eugénie's donation were destroyed about 1918). See Esther Bächer, *et al.*, "Katalog," in *Arenenberg: Der Dichter und Maler, op. cit.*, p. 318. Eugénie died in Madrid in 1920 aged ninety-five.

10. Some buildings are misidentified or place names misspelled, in both the English and French captions, and many diacritics are missing. Misidentified subjects include cat. 124, captioned "Birds' eye View of 4th Dist.," actually a view of the Third District downriver. Cat. 87, "St. Joseph's Church Josephine St.," is the Church of St. Mary, and cat. 15, "Louis Phillipe's place of concealment during his stay in New Orleans," is apparently misidentified as a structure associated with Louis-Philippe. Cat. 27, "Bayou St. John & Old Spanish Port," refers to the area of Bayou St. John known as Spanish Fort (the Crescent inventory of March 1 refers to a view of "Fort St. John"). Uncommon usage or misspelled names are found in cat. 1, "Mississipi"; cat. 26, "St. Jhon" for St. John, spelled correctly in the English caption; cat. 37, "Meterie" for Metairie (correctly captioned in cat. 36); cat. 44, "Ponchartrain" for Pontchartrain, in both English and French captions; cat. 77, "Drayades" for Dryades; cat. 82, "St. Ann's" for St. Anna's ("St. Anne's" in the French caption); and cat. 86, "St. Alphonse's" for St. Alphonsus. Two aldermen's names are misspelled in the city council portrait plate, p. 61.

11. Although it is likely that the photographs were bound after their delivery to Paris and before presentation to the emperor, when the portfolios were fabricated is not documented. The title *La Nouvelle Orléans et ses environs* was not referenced in contemporary documents and may be a binder's title. The best evidence may be obtained from the account of Edward Gottheil's reclamation at the Exposition, when he requested a review of exhibitions for prizes after the awards ceremony. The response from the imperial jury was that they had seen the photographs but "too late to be able to rank them" as they had been "at the binders'." This may be a reference to fabrication, repair, or even simply the final decoration of the portfolios. Paris, Archives Nationales, F12 3095, Class 9, Gottheil to Jurors, August 2, 1867 (see p. 34, n. 63, and p. 283).

12. On the Second Empire presentation albums, see Sylvie Aubenas, ed., *Des photographes pour l'empereur, les albums de Napoléon III*, Paris (Bibliothèque Nationale) 2004.

13. Streaking and/or spotting are especially visible on cats. 1, 5, 38, 43, 49, 98, and 109.

14. Excluding the views taken in 1865 for the U.S. Quartermaster General and duplicated for the Exposition portfolio (see p. 52 n. 53).

15. "New Orleans and Vicinity at the Paris Exposition," *Crescent*, May 26, 1867. The Moody duplicate was recently presented to the Southeastern Architectural Archive, Tulane University, by Alicia Rogan Heard, a descendant of S.N. Moody.

16. "The Portfolio of Views for the Paris Exposition," *Crescent*, February 28, 1867; "The Portfolio," *Crescent*, March 1, 1867; "The Lilienthal Views," *Times*, May 24, 1867.

17. See pp. 289–91.

18. The exceptionally clean condition of the photographs today also suggests that the portfolios were not handled. On thefts of artifacts at the Exposition, see "The Universal Exhibition," *Picayune*, May 18, 1867.

19. "Interesting Letter from Paris," *Picayune*, August 18, 1867.

The catalog that follows reproduces the 126 surviving photographs of *La Nouvelle Orleans et ses environs* (see the contents list and map on pp. 62–63). Two photographs, a view of the Louisiana exhibit for the Exposition and a plate of vignetted portraits of the Mayor and City Council of New Orleans, sponsors of the portfolio, precede the topographic catalog.

Cottage House sent to Paris Exh'ion
Pavillon envoyé a l'Exposition de Paris

The Louisiana exhibit at the Paris Exposition, the *Maison portative de la Louisiane*, was a one-room, prefabricated immigrant's cottage designed to house the "artisan, mechanic and laborer" the state hoped to attract through participation in the Exposition.[1] The demountable cabin was an expression of Louisiana's aspirations to "inaugurate a new system of labor" with a plantation economy based on white immigrants.[2]

The Louisiana cottage was entered into competition in response to exhibitions director and social reformist Frédéric Le Play's call for displays of affordable worker housing, an aspect of a broad ethnographic program for the Exposition celebrating "the history of work."[3] Echoing Le Play's call, the U.S. Commissioner General to the Exposition, N.M. Beckwith, challenged American exhibitors to enter into competition "workers' dwellings" that would demonstrate to Europeans "immobilized in poverty" the means "quickly and easily [to] achieve success in America."[4] The Louisiana entry was designed by Edward Gottheil and co-commissioner Thomas Murray, both architects, and fabricated by the Robert Roberts sash factory at Gravier and Howard streets.[5]

The modest cottage was an advertisement for several local industries. It was a product of an export lumbering industry that dated from the French colonial period, when Louisiana cypress, harvested from swamps and resistant to decay in tropical climates, was the preferred building material throughout the southern French colonies.[6] It was also the latest in a long local tradition of manufactured housing.[7] New Orleans builders sent prefabricated houses to the West Indies as early as 1727, and during the first half of the nineteenth century immigration to Louisiana and settlement of the southwest created a steady demand for portable housing.[8] In the 1840s, Samuel Denman marketed prefabs —combining the essential features of "Strength and Comfort, with Cheapness and Portability"—

to the "Texas Emigrant, the Planter, [and] the Proprietors of vacant City Lots," and builder B. Howard on Carondelet Street offered "elegant portable frame houses suitable for California" in the wake of the Gold Rush of 1848 (other local manufacturers also supplied California prefabs).[9] Immigrant handbooks and newspapers advertised ready-made wooden or iron cottages that, like the Exposition prefab, could "in a few hours be taken down and put up." After the war, W.W. Carre at New Basin Canal marketed plantation cabins and immigrant cottages "framed, fitted and each piece ... numbered, so that a common hand can put them up."[10]

Finally, the Exposition cottage was a showpiece of steam-manufactured building materials and the local sash-and-blind industry.[11] Roberts manufactured the double entrance doors and interior floor- and wall boards of different local woods, including oak, red cedar, yellow pine, and cypress. "Some eight or ten kinds of wood have been used in constructing this cottage, which is a very beautiful piece of work," the *Picayune* observed.[12] Roberts made standardized building parts—windows, doors, shutters, cornices, columns—and other components turned on the steam-powered woodworking machines that had come into use in New Orleans in the 1840s. Before the war, Roberts's sash works was "said to be doing the best business in their line in the City and to be making a fortune."[13]

In late February 1867, Roberts completed the cottage and shipped it to New York, from where it was sent by steamer to France.[14] It arrived in Paris soon after the opening of the Exposition on April 1, but Gottheil's attempt to erect it in the American section of the Champ de Mars, the area of the park reserved for national pavilions, was blocked by Commissioner General Beckwith, reportedly because federal funds had not been allocated for its installation. Underwriting the exhibition himself, Gottheil appealed to the Imperial Commission, which permitted the cottage to be erected after opening hours. Finally, on June 15, the installation was completed, ten weeks after the opening of the Exposition (figs. 5 and 6).[15]

The open grounds of the Champ de Mars had been landscaped by Adolphe Alphand, Baron Haussmann's park designer (fig. 5).[16] A "magnificent incongruity" of types and styles of national pavilions were installed there: "Egyptian temples, Christian churches, Moslem mosques, windmills, German, French and Turkish schools,

English cottages, Oriental palaces"—and the Louisiana cottage. The national exhibits were gathered about an immense and much-derided iron-and-glass exposition hall designed by Jean-Baptiste-Sébastien Krantz and engineered by Gustave Eiffel (whose famous iron tower would rise on the Champ de Mars for the exposition of 1889).[17] "In the grounds of the exhibition," the *Crescent* reported, "... is to be seen a pretty, simple cottage It is left in the natural color of the wood, finely polished; and with its little portico, its wide door, its three cheerful windows, it breathes of 'home.'"[18]

Exhibited inside the cottage were the state's agricultural entries: "samples of our great staples," Governor Madison Wells wrote, that

"will attest to Europe, more powerful than language, that Louisiana is the Indies of America."[19] A glass case displayed cotton, perique tobacco, Avery Island salt, and miniature bales of moss, the last of which most impressed French visitors for the "variety of industrial uses to which it can be put."[20] On a sideboard were vases filled with sugar and cane syrup, and suspended from the ceiling was a display of botanical specimens.[21] Decorating the walls were flags, Louisiana paintings by Adrien Persac, and a large view, probably a lithographed bird's-eye, of New Orleans, "with its steamboats, its wharf, its familiar steeples, and a thousand minute objects so well recognized by those who belong to that dear city."[22] The cottage became "a

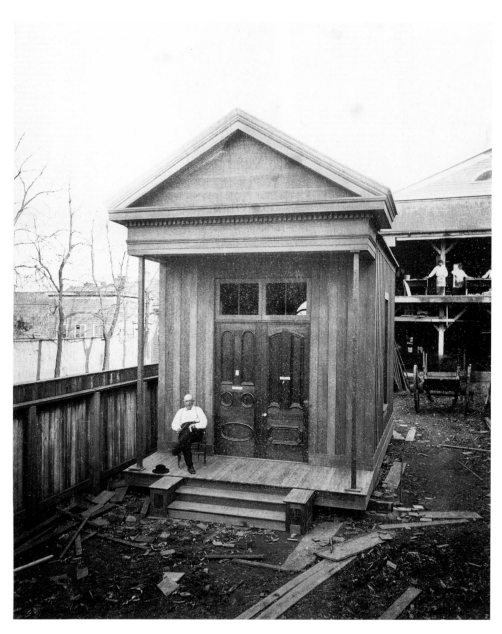

sort of shrine for the Louisiana people in Paris," the *Crescent* reported; "they sit on the little piazza and imagine themselves at home."[23]

The French reaction to the cottage was a mixture of curiosity, measured praise, and some misunderstanding. "Frenchmen and other foreigners appear to be in doubt as to whether the 'Louisiana Cottage' is the private residence of a planter, or his office on a plantation, or a common Louisiana city or country residence, or 'negro quarters'!" the *Crescent* wrote.[24] But the Paris *Moniteur Universel* admired the "originality and usefulness" of the "very beautiful edifice," and, particularly, its demountability: "It takes six hours to raise it and two to take it down. It contains neither nails nor pegs; all the timbers are screwed and jointed with grooves and tongues."[25] The biweekly *L'exposition universelle de 1867 illustrée* found the house "quite lovely" and praised its light weight and practicality for the immigrant: "even if he wants to build a larger house, the cypress house can serve as his lodging during the time required to build another house."[26]

Cited for "excellent workmanship," the cottage was awarded an Exposition bronze medal for the state of Louisiana and, for the United States, a silver medal, as an example of "frame houses for settlers."[27] Louisiana exhibits of cotton, sugar, tobacco, clocks, and shirts, as well as Lilienthal's photographs, also won medals, and altogether, the state carried away more prizes than any of the thirty competing states, except New York. It was an achievement, boosters claimed, all the more remarkable as the state had been "overwhelmed with accumulated disasters such as few countries are ever called upon to struggle with."[28]

Lilienthal's photograph documents the cottage in the yard of Roberts's sash factory. On the shop floor, workers in carpenters' smocks pose beside planing tables, and a bird house, a trophy of the woodworker's craft, is visible on the landing. Seated on the porch is a man who appears to be Edward Gottheil.[29] It is likely that Lilienthal made the photograph shortly before February 23, when the cottage was dismantled and shipped to Paris. This date would place it as one of the earliest photographs, if not the first, that he executed for the Exposition, occurring less than a week after the city council funded the "portfolio of photographic views of the city of New Orleans."[30]

1. "Commissioners to the Paris Exposition—Meeting Last Night," *Crescent*, January 12, 1867.
2. *Report of Edward Gottheil*, p. 4.
3. "Universal Exposition of 1867," *The Land We Love: A Monthly Magazine Devoted to Literature, Military History and Agriculture*, IV, 1867–68, p. 230; James H. Bowen, *Report Upon Buildings, Building Material, and Methods of Building*, Washington, D.C. (Government Printing Office) 1869, in *Reports of the United States Commissioners to the Paris Universal Exposition, 1867*, ed. William P. Blake, Washington, D.C. (Government Printing Office) 1868–70, IV, part 6. Bowen, a U.S. commissioner from Chicago, championed the competing Illinois entries in Exposition Group X, Class 93, "Objects Exhibited with a Special View to the Amelioration of the Moral and Physical Condition of the Population"—"Specimens of Habitations Characterized by Cheapness, Uniting Sanitary Conditions and Comfort." Entries in Class 93 included worker dwellings from France, Algiers, Prussia, Belgium, Württemberg, Switzerland, Italy, Great Britain, and the United States (Illinois and Louisiana). The Illinois "American Farmer's Cottage," a balloon-frame structure intended for settlers in the Western prairies, and a companion exhibition, a country schoolhouse, were designed and built by O.L. Wheelock and Colonel Lyman Bridges of Chicago. Both buildings are illustrated in John Parker Reynolds, *The State of Illinois and the Universal Exposition of 1867 at Paris*, Springfield, Ill. (State Journal) 1868. See Ellen Weiss, "Americans in Paris: Two Buildings," *Journal of the Society of Architectural Historians*, XLV, June 1986, pp. 164–67, and Margaretta Jean Darnall, "Innovations in American Prefabricated Housing," *Journal of the Society of Architectural Historians*, XXXI, March 1972, pp. 51–55. On Le Play and his program, see Pieter van Wesemael, *Architecture of Instruction and Delight: A Socio-Historical Analysis of World Exhibitions as a Didactic Phenomenon*, Rotterdam (010 Publishers) 2001, pp. 224–46.
4. *Reports of the United States Commissioners, op. cit*, I, p. 33.
5. Although Roberts is not mentioned in the Exposition literature or newspaper accounts, references to the cottage appear in Roberts's advertisements in the 1870s and in a business directory profile published in 1879: "At the great Paris Exposition in 1867, this factory furnished all the material for the celebrated 'Louisiana Cottage,'" Waldo, *Visitor's Guide*, pp. 73–74. Based on this reference, the cottage was attributed to Roberts by Bernard Lemann and Samuel Wilson, Jr., "New Orleans Prefab, 1867," *Journal of the Society of Architectural Historians*, XXII, no. 1, March 1963, pp. 38–39 (an article first published in the *New Orleans States*). Waldo reported that Roberts was a native of Liverpool, England, and had emigrated to New Orleans in 1839 and established the sash factory in the 1850s. See also *The Industries of New Orleans*, p. 93; *New Orleans: Her Relations to the New South*, New Orleans (L. Graham) 1888, p. 120; and later records for the firm in the Roberts & Co. Papers, Manuscripts Collection, Tulane University Library.
6. John Hebron Moore, "The Cypress Lumber Industry of the Old Southwest and Public Land Law, 1803–1850," *Journal of Southern History*, XLIX, no. 2, May 1983, pp. 203–207.
7. On early prefabricated housing, see articles by Charles E. Peterson: "Early American Prefabrication," *Gazette des Beaux-Arts*, XXXIII, no. 971, January 1948, pp. 37–46; "Prefabs for the Prairies," *Journal of the Society of Architectural Historians*, XI, March 1952, pp. 28–30; "Prefabs in the California Gold Rush, 1849," *Journal of the Society of Architectural Historians*, XXIV, December 1965, pp. 318–24; "Pioneer Prefabs in Honolulu," *AIA Journal*, LX, September 1973, pp. 42–47; and "Prefabs: An Old Technique," in *Architectural and Engineering News*, June 1967, pp. 63–64. See also Margaretta Jean Darnall, "Innovations in American Prefabricated Housing," *Journal of the Society of Architectural Historians*, XXXI, March 1972, pp. 51–55; and Gilbert Herbert, "The Portable Colonial Cottage," *Journal of the Society of Architectural Historians*, XXXI, December 1972, pp. 261–75.
8. Peterson, "Early American Prefabrication," *op. cit.*, p. 38. Peterson cites sources (p. 38, n. 5) for Louisiana prefabs shipped to the West Indies from 1727 to the 1790s.
9. "Patent Portable Houses" (advertisement), *Delta*, January 25, 1848; "California Houses ... B. Howard" (advertisement), "California Houses ... Wm. A. Miller" (advertisement), "Houses for California ... C.W. Murray" (advertisement), *Crescent*, March 11, 1850. In August 1849, a hotel for California was prefabricated in New Orleans at a cost of $100,000. "Carpenters, upholsterers and other mechanics will be sent from here to San Francisco to put the house together," the *Picayune* reported ("Hotel for San Francisco," *Picayune*, August 22, 1849). On Gold Rush prefabs in general, see Peterson, "Prefabs in the California Gold Rush, 1849," *op. cit.*
10. Advertisement for W.W. Carre & Co., *Picayune*, October 12 and 21, 1872; "Portable Iron Houses," advertisement for Peter Naylor, New York builder, in J.E. Sherwood, *The Pocket Guide to California*, New York, 1849, cited by Peterson, "Prefabs in the California Gold Rush, 1849," *op. cit.*, p. 319, n. 13. The *Washington National Intelligencer*, November 6, 1849, advertised "Portable cottages for Southern markets." In the early 1860s, Boston lumber dealer Skilling & Flint marketed a "cheap, comfortable dwelling" for immigrants; it could be "put up in a few hours where wanted." The firm specialized in houses for hot climates, and during the war supplied prefabs to the Union army; Peterson, "Early American Prefabrication," *op. cit.*, p. 46.
11. Louisiana had been the site of what may have been the first steam-powered sawmill in the country, in operation by 1803. James Marston Fitch, *American Building: The Historical Forces That Shaped It*, New York (Schoken) 1973, p. 50.
12. "Portable Cottage for the Paris Exposition," *Picayune*, February 22, 1867.
13. *Louisiana*, XI, p. 361, R.G. Dun & Co. Collection, Baker Library, Harvard Business School. After the war, Roberts specialized in prefabricated plantation cabins for sharecroppers, and throughout the 1870s and 1880s the company saturated the local housing market with its products. A Roberts Company millwork catalog of 1880 is in the Southeastern Architectural Archive, Tulane University. For an account of the sash industry and building supply trade in New Orleans during the Civil War era, see John Hebron Moore, *Andrew Brown and Cypress Lumbering in the Old Southwest*, Baton Rouge (Louisiana State University Press) 1967; see also Carl R. Lounsbury, "The Wild Melody of Steam: The Mechanization of the Manufacture of Building Materials, 1850–1890," in *Architects and Builders in North Carolina: A History of the Practice of Building*, Chapel Hill (University of North Carolina Press) 1990, pp. 193–239.
14. "Portable Cottage for the Paris Exposition," *op. cit.*
15. "Letter from Paris," *Evening Picayune*, April 21, 1868; *Report of Edward Gottheil*, pp. 8–9.
16. Wesemael, *op. cit.*, p. 742, n. 200.
17. Henry Morford, *Paris in '67 or, the Great Exposition*, New York (G.W. Carleton) 1867, p. 132; "The Paris Exposition," *Picayune*, May 5, 1867; "The Paris Exposition," *New York Times*, May 7, 1867; Wesemael, *op. cit.*, pp. 231, 267–68.
18. "Letter from Paris ... July 14, 1867," *Crescent*, August 4, 1867.
19. J. Madison Wells, *Message of the Governor of Louisiana to the General Assembly, Commencing January 28, 1867*, New Orleans (J.O. Nixon) 1867, pp. 10–11.
20. "A Stroll in the Exposition—The Louisiana Cottage [from the Paris *Moniteur Universel*]," *Crescent*, September 19, 1867.
21. "Letter from Paris ... July 14, 1867," *op. cit.*; "Interesting Letter from Paris," *Picayune*, August 18, 1867 (letter from Edward Gottheil dated August 1867); "A Stroll in the Exposition," *op. cit.*

22. "Letter from Paris … July 14, 1867," *op. cit.*
23. *Ibid*.
24. "A. Head as a Paris-ite. Paris, July 22, 1867," *Crescent*, August 11, 1867.
25. "A Stroll in the Exposition," *op. cit.*
26. Raoul Ferrère, "La maison portative de la Louisiane," *L'exposition universelle de 1867 illustrée*, September 23, 1867, pp. 170–71.
27. *General Survey of the Exhibition with a Report on the Character and Condition of the U.S. Section*, Washington, D.C. (Government Printing Office) 1868, p. 320; Reynolds, *op. cit.*, pp. 129–30; Bowen, *op. cit.*, p. 55.
28. *Times*, August 15, 1867; *Report of Edward Gottheil*, pp. 9–10.
29. Roberts, the builder, would have appeared much younger than this man in 1867 (he was born in 1823). Gottheil did not leave for Paris to oversee erection of the cottage and installation of the state exhibits until April 9; *Crescent*, April 9, 1867.
30. "Portable Cottage for the Paris Exposition," *op. cit.* The Board of Aldermen approved an appropriation for the Paris portfolio on February 8; the Board of Assistant Aldermen on February 16. New Orleans Public Library, City Archives, Minutes and Proceedings of the Board of Aldermen, VII, fol. 489, February 8, 1867; *Crescent*, February 16, 1867.

[Mayor Edward Heath and Members of the Boards of the Common Council]

When federal troops captured New Orleans in April 1862, the mayor of the city was John T. Monroe, a former stevedore and secessionist who reportedly "stood fearlessly at his post … yielding nothing to the victor save what overwhelming force could command."[1] Defiant of one of General Benjamin Butler's "sledge-hammer" edicts, the mayor was removed from office and imprisoned "for aggravated hostility to re-establishment of national authority."[2] He sat out most of the war in an army dungeon, and the occupied city was governed by a quarrelsome mix of military appointees and surviving elected officials.[3]

In March 1866, the Louisiana legislature, backed by a directive from President Andrew Johnson, ordered the first post-bellum municipal election.[4] New Orleans voters (that is, white males over twenty-one) chose the vanquished Monroe, who ran with the "ancient political complexion" of an old Whig and Know-Nothing, and won against accusations that he exerted the same strong-arm tactics that had characterized the antebellum Know-Nothing election mobs he controlled before the war.[5] But New Orleans was still under military domination, and to federals Monroe was a unregenerate rebel unqualified to govern.[6] Petitioning President Johnson, however, he obtained a pardon and took office in May 1866, ushering in a regime of ex-Confederates and what one northerner called a "reign of terror … for conspicuous Union men."[7]

Ten weeks later Monroe helped instigate the Mechanics' Institute massacre, a day of police mayhem that left dozens of African American assemblymen dead (see cat. 68). "Mayor Monroe controlled the element engaged in this riot … giving to those elements an immunity for riot and bloodshed," General Philip Sheridan, the military commander of New Orleans, concluded.[8] On March 27, 1867, seizing the authority to replace elected officials under the Reconstruction acts recently passed by Congress, Sheridan had Monroe again removed from office.

Sheridan's appointee to replace Monroe was Edward Heath, a Maine native who had operated a failing furniture business before the war.[9] "When the Federals occupied the City," a correspondent for R.G. Dun & Co. reported, Heath "became excessively loyal & quite a politician, but did not amount to much."[10] After taking office, Heath was thrown into conflict with the elected city council, mostly holdovers from the Monroe administration, amid evidence that the council had mismanaged the treasury, and over implementation of the Reconstruction acts.[11] Heath—"whose sympathies," one journalist wrote,"… have always been with the cause of the Union, and of late with the Radicals"—supported political equality for African Americans and integrated public schools, which the council opposed.[12] "The political opinions of Mayor Heath differ vastly from those of the majority of the people of this city," the *Crescent* claimed.

> The manner of his accession to office was shocking to their opinions, and to their views of the supremacy of the law. They knew him to be a member of a party which has heaped all manner of contumely and calumny on the people of the South, and especially to the people of New Orleans.[13]

Exasperated by the recalcitrant council, Sheridan in August 1867 intervened in support of Heath by removing twenty-two aldermen, leaving only six in office. He then appointed a council majority of African Americans, the first black aldermen in the city's history.[14] Dismissal of other city officials followed, but Sheridan's manipulations, running against President Johnson's conservative Reconstruction policies, came to an end when Johnson had Sheridan himself removed barely two weeks after his "readjustment" of the council.[15] Sheridan's ouster was denounced by the Republican press for privileging the "unreconstructed element" of Louisiana. "The rebels [in New Orleans] are greatly rejoicing," one northern paper declared.[16]

Heath's fourteen-month mayoralty ended in June 1868 when he was arrested for refusing to surrender his office to mayor-elect John R. Conway, a former Monroe advisor who had been returned by voters in the spring 1868 municipal election (the sixteenth mayor since 1862).[17] Heath alleged that he had been "duly appointed Mayor" by military authority and refused to recognize the legality of Conway's election, or to relinquish the $6000 annual salary that had enabled him to pay off his prewar business debts.[18] Clinging to the "honors and dignities" of the mayoralty "with the vigor of a snapping turtle," according to the *Times*, Heath was escorted from City Hall by police as a waiting crowd "burst into a shrill exultant rebel yell."[19] To some, the "impoverished condition of the people and insolvency of the city" was the legacy of Heath's administration. "He has made the city bankrupt, disgraced the State, and stigmatized the people," one commentator declared.[20]

Lilienthal's vignetted portraits of Heath and the council's bicameral boards of Aldermen and Assistant Aldermen, the sponsors of the Paris photographic campaign, were taken in May 1867, before Sheridan's intervention.[21] They were evidently the final photographs executed for the portfolio. On May 22, 1867, the *Picayune* reported that Lilienthal had "invited the members of both Boards of the Common Council to visit his gallery … to have the *camera lucida* or the *camera obscura*, we don't know which, leveled at them, and thus become immortal—and go to Paris besides."[22] The following day the *Deutsche Zeitung* carried the first announcement of the completed Exposition portfolio.[23]

In the late summer of 1867, Exposition commissioner Edward Gottheil presented the photographs to Napoléon III, including the aldermen's portraits.[24] "New Orleans may now congratulate itself upon a novelty it has discovered—a new use for its Aldermen," the *Times* quipped. "They are no longer to be considered only serviceable in awarding disinterested contracts and legislating unselfishly in relation to city finances. That they are useful in other ways as a source of revenue is now apparent. The very sight of their photographs by Napoleon III revealed … such a constellation of legislative intellect and sublime patriotism that he hastened to honor … the August body [with] a copy of his 'History of the Caesars.'"[25]

1. "The Late Jon. T. Monroe," *Picayune*, February 25, 1871; Gerald M. Capers, *Occupied City: New Orleans Under the Federals 1862–1865*, Lexington (University of Kentucky Press) 1965, p.127.

2. *Beauty and Booty*, p. 87; testimony of Hugh Kennedy, Mayor of New Orleans March 1865–March 1866, in U.S. House of Representatives, *Report of the Select Committee on the New Orleans Riots*, Washington, D.C. (Government Printing Office) 1867 [reprinted New York (Arno Press) 1969], p. 518, cited by James G. Hollandsworth, *An Absolute Massacre: The New Orleans Race Riot of July 30, 1866*, Baton Rouge (Louisiana State University Press) 2001, pp. 65–66. See also Benjamin F. Butler, *Private and Official Correspondence of Gen. Benjamin F. Butler During the Period of the Civil War*, Norwood, Mass. (Plimpton Press) 1917, I, pp. 497–501.

3. Joseph G. Dawson, III, *Army Generals and Reconstruction Louisiana, 1862–1877*, Baton Rouge (Louisiana State University Press) 1982, pp. 31–32.

4. Ted Tunnell, *Crucible of Reconstruction: War, Radicalism and Race in Louisiana, 1862–1877*, Baton Rouge (Louisiana State University Press) 1984, pp. 102–103.

5. "Interference of the Police," *Picayune*, March 7, 1866; "The Election Next Monday," *True Delta*, March 10, 1866; Tunnell, *op. cit.* Monroe ran on the National Union ticket.

6. "Inauguration of the New City Government," *Crescent*, March 20, 1866; "The Mayoralty Question," *Crescent*, March 22, 1866.

7. "Sheridan at Work," *Chicago Tribune*, March 29, 1867 (quotation); Sheridan, *op. cit.*, pp. 250–54; "The Removals Yesterday," *Picayune*, March 28, 1867; "Important Order of Gen. Sheridan," *New York Times*, March 28, 1867; Sheridan, *op. cit.*, II, pp. 253–55; Joe Gray Taylor, *Louisiana Reconstructed, 1863–1877*, Baton Rouge (Louisiana State

University Press) 1974, p. 139; Dawson, *op. cit.*, pp. 46–48; Paul Andrew Hutton, *Phil Sheridan and His Army*, Lincoln (University of Nebraska Press) 1985, p. 24.

8. Philip H. Sheridan, *Personal Memoirs*, New York (Charles L. Webster & Co.) 1888, II, p. 255.

9. *Louisiana*, II, pp. 148, 333, R.G. Dun & Co. Collection, Baker Library, Harvard Business School; "The New Regime Inaugurated," *Bee*, March 29, 1867; "The Transfer of the Mayoralty," *Picayune*, March 29, 1867; "The Distinguished Dead," *Picayune*, January 14, 1892; "Edward Heath," *New York Times*, January 14, 1892; "Edward Heath," *Times-Democrat*, January 14, 1892. Heath ran for alderman in 1866 on the National Union ticket, but finished fifth of five candidates for the seat won by James McCloskey.

10. *Louisiana*, IV, p.178, R.G. Dun & Co. Collection, *op. cit.*

11. Sheridan, *op. cit.*, II, pp. 271–72.

12. "Sheridan at Work," *op. cit.*; Taylor, *op.cit.*, pp. 144–45.

13. "Mayor Heath," *Crescent*, May 18, 1867.

14. "The New Orleans City Council 'Readjusted,'" *Chicago Tribune*, August 2, 1867; "Reconstruction in Louisiana," *New York Times*, August 2, 1867; *Removal of City Council of New Orleans*, 40th Cong., 2d sess., H. Ex. Doc. 209, Washington, D.C., 1868; Sheridan, *op. cit.*, pp. 272–74; John Smith Kendall, *History of New Orleans*, Chicago and New York (Lewis Publishing Company) 1922, pp. 315–16; Dawson, *op. cit*, pp. 56–57; Hutton, *op. cit.*, p. 24.

15. "The Fifth Military District Removal," *New York Times*, August 2, 1867; "Order from Gen. Sheridan," *New York Times*, August 9, 1867; "The Order for General Sheridan's Removal Issued," *New York Times*, August 20, 1867; "The Order Relieving General Sheridan from a Command of the Fifth District," *Chicago Tribune*, August 21, 1867; "The Removal of Sheridan," *New York Times*, August 21, 1867; "Order from General Sheridan,"

New York Times, August 25, 1867; Dawson, *op. cit.*, p. 57.

16. "Feeling in New Orleans Relative to the Removal of General Sheridan," *Chicago Tribune*, August 7, 1867; "General Grant's Letter," *Chicago Tribune*, August 27, 1867.

17. "City Affairs," *Picayune*, June 11, 1868; "Ex-Mayor Conway," *Times-Democrat*, March 11, 1896. Most officeholders during this period were interim military appointees; see *Mayors of New Orleans, 1803–1936*, New Orleans (City Hall Archives) 1940, transcribed by the Louisiana Division, New Orleans Public Library, online at nutrias.org/~nopl/louinfo/admins/ (accessed September 2006).

18. *Louisiana*, IV, p. 178, R.G. Dun & Co. Collection, *op. cit.*; "The Office Holders' Revolt," *Picayune*, June 12, 1868.

19. *Republican*, June 11, 1868; "The Great Battle for the Mayoralty," *Times*, June 11, 1868; "The Mayor's Parlor," *Picayune*, June 11, 1868; "Mayor Heath's 'Taking Off,'" *Times*, June 11, 1868; Kendall, *op. cit.*, p. 325.

20. "Town Talk," *Times*, April 8, 1868; "Citizens to the Polls," *Times*, April 18, 1868; "The Moral of the Election," *Times*, April 21, 1868; "We Must Have Reform," *Times*, June 8, 1868; *Times*, June 11, 1868.

21. Heath is pictured in the top row, third from left. Also included are two former mayors, George Clark and Gerard Stith, whose portraits appear below and to the right of Heath. The Boards of Aldermen and Assistant Aldermen had equal and concurrent powers in city governance. The Aldermen pictured are: Stith, from the 1st District; Clark (captioned as "Clarke," 2d District); Williamson Smith (1st District); Norman Whitney (2d District); E.D. White (3d District); F.A Woolfley (3d District); and Thomas McKnight (4th District). The Assistant Aldermen pictured are: William McCulloch, President (3d Ward); T.H. Higinbotham (captioned as "J.H. Higinbotham;" 1st Ward); P.H. Cummings (1st Ward); James B. Prague (2d Ward); F. Lurges (2d Ward; proprietor of Bennett & Lurges's foundry, cat. 80); J.B. Cunningham (4th Ward); John P. Montamat (captioned as "Montamet," 5th Ward); John Paisley (captioned as "Pasley," 7th Ward); Dr. Edward Goldman (9th Ward); and Peter Kaiser (captioned as "Kieser," 11th Ward). Four aldermen and seven assistant aldermen were not pictured. See "The City Election," *op. cit.*; "The Municipal Election," *op.cit.*; "Our City Council," *Times*, May 2, 1866; *Mayors of New Orleans, 1803–1936, op. cit.*

22. "Photographic Aldermanic Album for the Paris Exposition," *Picayune*, May 22, 1867.

23. "Worth Seeing," *Deutsche Zeitung*, May 23, 1867.

24. *Times*, May 6, 1868.

25. "An Imperial Letter," *Crescent*, January 21, 1868; *Picayune*, January 21, 1868; Napoléon III, *Histoire de Jules César*, Paris (Imprimerie Impériale) 1865–66, 2 vols. The imperial gift is today in the New Orleans Public Library; see p. 34, n. 69.

Map of New Orleans in 1867

For panoramic, landscape, and street corridor views, the direction of the arrow indicates the direction of the view. The following catalog numbers are excluded and correspond to sites beyond the area covered by the map, buildings or locations not identified by Lilienthal, or portraits: 12, 58, 90, 91, 108, 109, 118, 119. The location of cat. 111 is approximate.

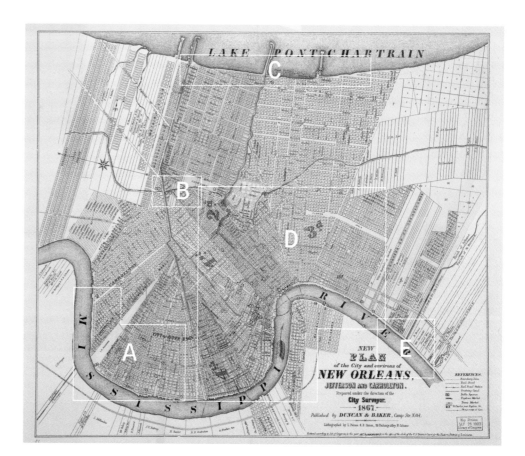

1 Steamboat Landing	63 Bank of New Orleans
2 View of Levee	64 St. Charles Hotel
3 French Market	65 Canal Bank Cor. Camp & Gravier Sts
4 Second Dist. Ferry	66 Stove Manufactory Camp St.
5 Ocean Str. Genl. Meade	67 Medical Colleges Common St.
6 Str. Great Republic	68 Mechanics' Institute
7 McCans Foundry	69 Charity Hospital
8 Boiler Maker's Shop	70 School of Medicine
9 U. S. St Joseph St R. Road	71 Gas Works
10 Vicksburg Cotton Press	72 Interior of Gas Works
11 Interior of Vicksburg Cotton Press	73 Interior of Gas Works
13 Jackson Square	74 Head of New Basin
14 St. Louis Hotel	75 St Simeon's Select School
15 Louis Phillipe's place of concealment ...	76 St. Paul's Church Camp St.
16 French Opera House	77 St. Mary's Convent & Church Drayades St.
17 U S Mint	78 Public Schools Drayades St
18 Fire Engine House N° 9	79 N. O. Jackson & Great N.R.R. Depot
19 Custom House	80 Bennett & Lurges Foundry
20 Canal St.	81 St Vincent Asylum Cor. Magazine and Race Sts.
21 S. N. Moody's Residence	82 St. Ann's Asylum Prytania St.
22 Dr. Stone's Infirmary Canal St.	83 Private Residence
23 Head of Old Basin	84 Trinity Church Jackson St
24 Beer Brewery Old Basin	85 St Elizabeth Asylum Cor. Magazine & Josephine Sts.
25 Parish Prison & Trémé Market	86 St. Alphonse's Church
26 Entrance to Bayou St John	87 St. Joseph's Church Josephine St.
27 Bayou St. John & Old Spanish Port	88 Synagogue Jackson St.
28 Bayou St. John	89 Jewish Widows' & Orphans' Asylum
29 Bayou Bridge	92 Entrance to Lafayette Cemetery Washington Street
30 Private Residence	93 Depot of St Charles St. R. Road
31 Private Residence	94 Private Residence
32 Races 1867 at the Fair Grounds	95 Private Residence
33 Dan Hickock's at Lake end	96 Brick yard
34 Entrance to New Basin	97 St. Vincent's Academy
35 Half way House	98 Carrollton Depot
36 Races of 1867 Metairie Course	99 Residence of J.Q.A. Fellows
37 Meterie Race Course	100 Lane's Cotton Mills
38 Firemen's Cemetery	101 Poydras Asylum Jefferson City
39 Odd Fellows' Rest	102 U. S. Sedgwick's Hospital in Greenville
40 Entrance of City Park	103 Gas works of Sedgwick's Hospital
41 City Park	104 Carrollton
42 Lake Pontchartrain	105 Belleville Iron Works Algiers
43 Lake end Pontchartrain	106 Dry Dock
44 Lake end Ponchartrain	107 Dry Dock
45 Bathing House at Lake Pontchartrain	110 Tow Boat
46 Luzenberg Hospital	111 U. S. Monitors
47 Depot of City Rail Road Canal St.	112 Urselines Convent
48 Marine Hospital	113 Sugar Refinery
49 Hotel Dieu	114 Entrance of U. S. Hospital
50 Lafayette Square	115 Interior of U. S. Hospital
51 City Hall	116 Interior of U. S. Barracks
52 Fire Engine Houses	117 Interior of Entrance to U. S. Barracks
53 Carondelet from Poydras St.	120 Birds eye view of 1st Dist.
54 Synagogue Carondelet St	121 Bird's eye View of 1st Dist.
55 Methodist Church Carondelet St.	122 Birds' eye View of 1st Dist.
56 Synagogue Carondelet St	123 Bird's eye view of 3rd Dist.
57 Private Residence	124 Birds' eye View of 4th Dist.
59 New German Theatre Baronne St	
60 Poydras Market	
61 St. Charles St. from Cor. Poydras	
62 Masonic Hall St. Charles St	

Pessou and Simon, lithographers, *New Plan of the City and Environs of New Orleans, Jefferson and Carrollton*; see p. 286.

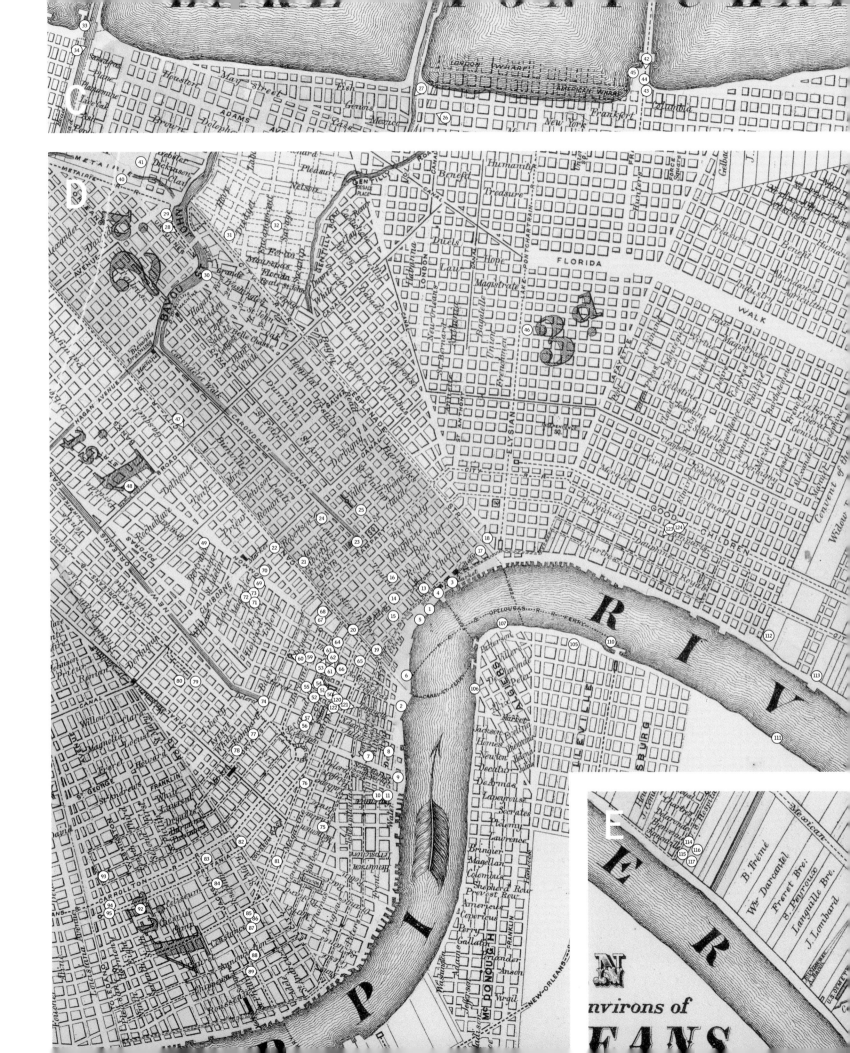

The Batture

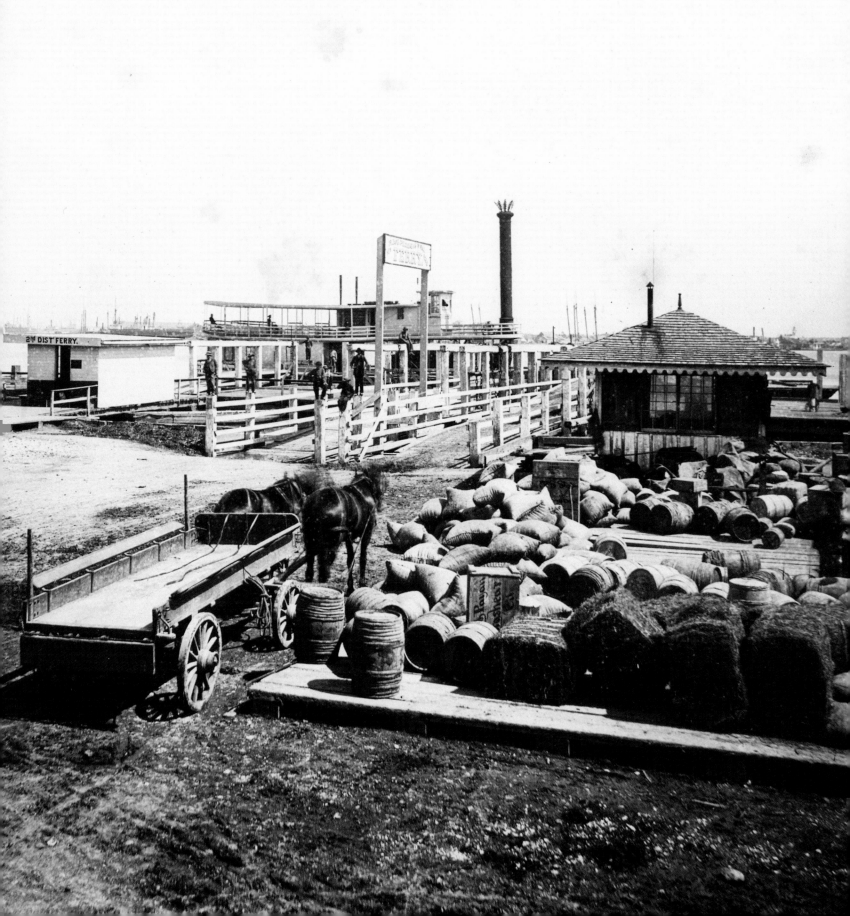

1
Steamboat Landing
Bateaux a vapeur du Mississipi

In 1866, the Boston poet and novelist John T. Trowbridge, visiting New Orleans on a tour through the South, was delighted at the sight of the quay of New Orleans. "The broad levee, lined with wharves on one side and belted by busy streets on the other ... always presents a lively and entertaining spectacle," he observed. "Steam and sailing crafts of every description, arriving, departing, loading, unloading, and fringing the city with their long array of smoke-pipes and masts, give you an idea of the commerce of New Orleans."[1] It was, above all,

this immense, open quay that formed the identity of New Orleans for outsiders. "Picture to your mind's eye an esplanade or open front, a quarter of a mile broad, shaped like a new moon," the antebellum author Joseph Holt Ingraham wrote. "... This magnificent crescent is a grand display of snow white hulls, round-topped wheelhouses, tall, black, iron chimneys."[2]

Before the Civil War, arrivals at the Levee averaged 300 steamboats per month, and about half that many oceangoing sailing ships. "It is quite astounding to see the legions of steamers from the upper country which are congregated here," another visitor wrote in 1857. "For miles and miles the Levee forms one unbroken line of them, all lying with their noses

on shore."[3] The antebellum port, with its continuous arrivals and departures on the water and hundreds of drays loading and unloading vessels, was a "ceaseless maelstrom of motion," Ingraham observed. "Imagine one broad field of such commercial life, four miles in unbroken extent, and you will have some idea of the 'Levee' at New Orleans."[4]

The war brought the great Levee to a standstill. A Union blockade ended soon after the capture of New Orleans in April 1862, but a Confederate embargo severed shipping from the North.[5] In 1863, the English traveler W.C. Corsan noted that "[i]n times of peace, this immense area would have been piled up from end to end ... [but] how different was the

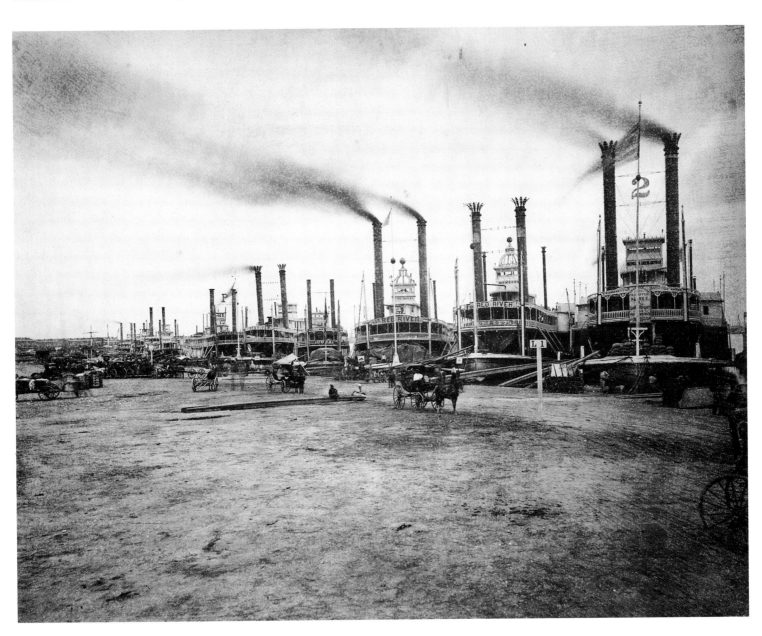

sight that met our eyes. Half a dozen paltry coasters, seeking a freight which was not to be found ... while neither a bale of cotton, a hogshead of sugar, a bushel of corn, a packet of merchandise, [n]or a man at work, could be seen from end to end of that levée."[6] Orleanian Marion Southwood found oatgrass growing on the wharves; "where formerly all was life, bustle and animation, nothing is doing," she wrote. "The place looks as if it had been swept by a plague."[7]

Recovery after the war was slow, hampered by the decay of the wharves. "Five years of war ... reduced our city wharves and landings from an efficient to a most ruinous condition," the *Times* declared in April 1866. The *Crescent* found that "all of the landing from Canal to Washington has gone to ruin."[8] So many wharves were unusable that ships had to land three and four deep, like the tightly berthed Red River packets in Lilienthal's view. "The steamboats hug one another so closely along the whole Levee front that it often seems there is not sufficient space between them to permit another boat to make a landing," the *Picayune* observed.[9] In apportioning the municipal treasury in 1867, the city placed a priority on removing any impediment to the river trade: the largest allocation, around $300,000 of a $3.1 million city budget, was for the repair of wharves and landings.[10] "The Street Commissioner has been to work [on the landings]," the *Picayune* reported in January 1867, "and by means of rocks, brickbats and oyster shells, has given at least the semblance of a surface to this mud puddle."[11]

In Lilienthal's photograph, the Levee is mostly empty of goods, but bales of cotton and other cargo can be seen in the distance. From the landing below St. Peter Street, the Pontalba houses at Jackson Square are visible at the far left. The steamboats that landed here—the *Monsoon*, *B.L. Hodge*, *Cuba* and *St. Nicholas* among them—served the cotton lands of north Louisiana along the Red River, a tributary of the Mississippi. A few steamers are carrying small loads of cotton—hardly the mountains of bales "covering every inch of space, so as to leave nothing but the tops of the reeking chimneys exposed to view" that so captivated antebellum visitors.[12]

With their enormous superstructure, the steamboats were always striking to look at—

Mark Twain compared them to wedding cakes "without the complications"—and were a captivating subject for photography.[13] "One can get a very good notion of the Mississippi steamer from pictures," a Maine sailor wrote in 1861:

> They are simply a rather flat and shoal built hull with an immense house built on it two or three stories high of very light build suitable for river navigation but entirely unfit for sea use Some are fitted up with fine furniture and finished with much of ornament.[14]

Effective at negotiating the shoals and shallows of the river, steamboats were beautifully light on the water, although their tonnage could exceed that of oceangoing sailing ships. But the river steamers were inefficient freight handlers and could not long compete with the railroad, a better carrier (with a rapidly growing web of overland connections) of the bulk goods and grain from the upper Midwest and Ohio River Valley.

1. J.T. Trowbridge, *The South, a Tour of Its Battle-fields and Ruined Cities*, Hartford, Conn. (L. Stebbins) 1866, p. 398.
2. Joseph Holt Ingraham, *The Sunny South; Or, The Southerner at Home*, Philadelphia (G.G. Evans) 1860, pp. 338–42. Ingraham is credited with coining the epithet "Crescent City."
3. Quoted in Henry A. Murray, *Lands of the Slave and the Free*, London (G. Routledge & Co.) 1857, p. 140.
4. Ingraham, *op. cit.*
5. Gerald Mortimer Capers, *Occupied City: New Orleans Under the Federals, 1862–1865*, Lexington (University of Kentucky Press) 1965, p. 146.
6. W.C. Corsan, *Two Months in the Confederate States: An Englishman's Travels Through the South* [London, 1863], Baton Rouge (Louisiana State University Press) 1996, pp. 10–11.
7. *Beauty and Booty*, p. 61.
8. *Times*, April 17, 1866; "The Levee and the Wharves," *Crescent*, January 15, 1866.
9. "A Squeeze In," *Picayune*, July 30, 1867.
10. New Orleans Public Library, City Archives, New Orleans City Council Minute Books, VII, 1867, pp. 507–11.
11. "The Levee," *Picayune*, January 13, 1867.
12. Louis Fitzgerald Tasistro, *Random Shots and Southern Breezes*, New York (Harper & Brothers) 1842, I, p. 57.
13. Lady Emmeline Stuart Wortley, *Travels in the United States, etc., during 1849 and 1850*, New York (Harper & Brothers) 1851, pp. 114–15; Twain quoted by Jonathan Fricker, "Louisiana's Great Steamboat Era," *Preservation in Print*, XVII, no. 10, December 1990, p. 14 (a good brief history of the Mississippi River steamboat).
14. Charles R. Schultz, ed., "New Orleans in December 1861," *Louisiana History*, IX, Winter 1968, pp. 53–61.

Page 64 *Second Dist. Ferry* (cat. 4), detail.

2
View of Levee
Vue de la Levée

At New Orleans the city met the river along a broad, natural levee that was 10–15 feet (3–4.5 m) above sea level and higher than many buildings. Arriving by ship, as one visitor recounted, "You step upon a very dusty landing, and the city is before you, and also below you, the streets running back from the river, at a gentle downward inclination, which brings the pavements of the back streets to the low-water level of the river."[1] For more than a century, the city developed on high and dry land in proximity to the river, until extensive reclamation of low-lying backswamps in the nineteenth and twentieth centuries made virtually all areas available for settlement.

The Mississippi, celebrated in literature, art, and song, held the imagination of the nation, but the Levee was the dusty, brawling workhorse and handler of goods, the economic pump-engine that kept the city alive. "Nowhere is so great an amount of commercial activity presented at a single view as on the levee of the Crescent City," *Harper's Weekly* observed.[2] Charles Dickens also praised the Levee in "the old ante-secession times" as a "spectacle without parallel on the face of the globe," presenting the "whole scene of the city's industry in one view."[3] A French tourist saw the piles of merchandise at the landings and was "seized with admiration" by the activity there: "an area of six hundred feet wide, where half the business of the United States takes place," he wrote.[4]

Visitors were astonished and Orleanians continually dismayed at the accumulation of goods left exposed on the Levee to weather and theft, lacking the protection offered by waterfront terminals typical of other parts. The British educator Henry Latham saw "acres of bales, and acres of barrels" on the open Levee in 1867. "Nobody seems to care about warehousing his goods," he observed.[5] The *Evening Picayune* complained of the vast Levee "without shelter for one single article," and of the urgent necessity of building "vast sheds for the protection of all incoming and outgoing cargoes."[6] Despite the vigilance of watchmen, thievery was common. One visitor observed "a crowd of ragged Irish and German women ... eagerly boring holes into the sugar barrels ... and a similar gang equipped with little handbaskets and pocketknives covertly

cutting into the coffee sacks in order to take a few handfuls."[7]

In Lilienthal's photograph the landings of the Atlantic Mississippi Steamship Company and the St. Louis and Louisville packet line are crowded with stevedored merchandise. Cotton bales, crates of chickens, stacks of lumber, barrels, and sacks of grain partially covered with tarpaulin are staked with pennants to claim ownership. Wagons move in and out with their drayage; one carries hotel baggage to or from berthed steamships. A boardwalk is raised above the Levee, which is a sea of mud below. On the walk, laborers who work without pause leave ghosted images, while

a man leaning against a cotton bale is deferential to the camera.

Lilienthal returned repeatedly to the miles of landings to photograph such scenes as this one, which he published as stereocards for the tourist trade. In this view he uses a perspective device—a long, slanted line into depth (here the plank walk)—that gives the photograph a dramatic spaciousness. The diagonal is an organizing principle that appears frequently in his work (see p. 25). The photographer and writer Henry Peach Robinson advised that "perfect pictorial success" could be obtained by following certain principles of composition derived from landscape painting, including a

dominant diagonal: "It lends itself so admirably to the receding lines of perspective," he explained in his *Pictorial Effect in Photography* of 1869.[8]

1. Thomas Low Nichols, *Forty Years of American Life, 1821–1861*, London (J. Maxwell) 1864, I, p. 182.
2. "More Views in New Orleans," *Harper's Weekly*, v, no. 222, March 30, 1861, p. 196.
3. Charles Dickens, "The French Market at New Orleans," *All the Year Round*, XIII, December 26, 1874, p. 257.
4. Henri Herz, *My Travels in America*, Madison (State Historical Society of Wisconsin) 1963, p. 86 (originally published as *Mes voyages en Amérique*, Paris, Achille Faure, 1866). The Austrian-born Herz was a famous concert pianist and composer.
5. Henry Latham, *Black and White: A Journal of a Three Months' Tour in the United States*, London (Macmillan) 1867, pp. 150–51.
6. "Sheds on the Levee," *Evening Picayune*, November 30, 1866.

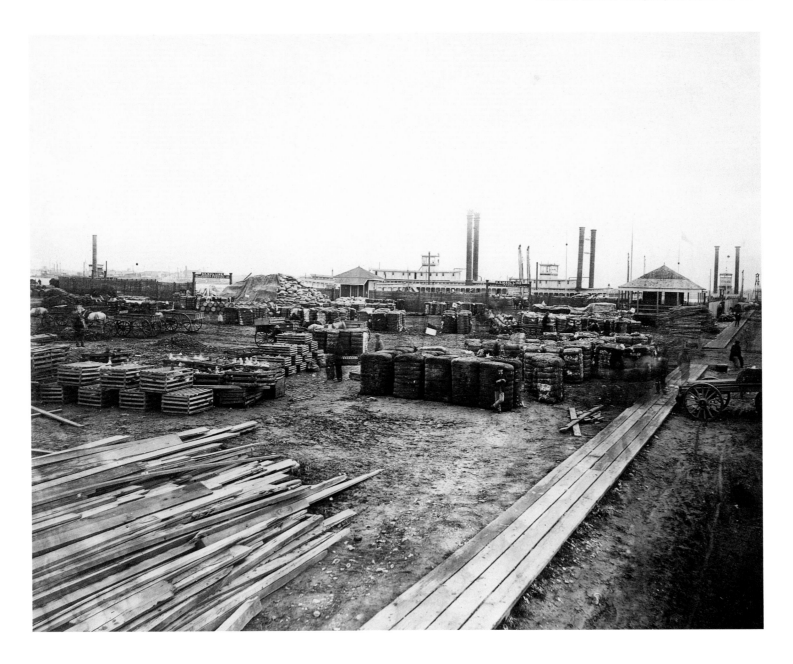

7. Friedrich Gerstäcker, *Gerstäcker's Louisiana: Fiction and Travel Sketches from Antebellum Times Through Reconstruction*, trans. and ed. Irene S. Di Maio, Baton Rouge (Louisiana State University Press) 2006, p. 57.
8. Henry Peach Robinson, *Pictorial Effect in Photography*, Pawlet, Vt. (Helios) 1971 [reprint of 1869 edn.], p. 24.

3
French Market
Marché Français

The riverfront marketplace of the Vieux Carré, which had sold meat, fish, and produce since colonial times, was the largest and oldest in the city. The Meat Market, or Halle des Boucheries, visible in the photograph, extended from St. Ann Street along the waterfront to Dumaine Street. Designed by city surveyor Jacques Tanesse, it was built by Gurlie and Guillot in 1813.[1] The arcaded market had a broad center aisle, with side aisles sheltering vendor stalls, and a floor of slate flagstone. Heavy cypress timbers carried a steeply pitched slate roof, and a wide metal awning supported by slim iron pillars provided protection from the glaring sun. *Norman's New Orleans and Environs* reported that the market, "from its favorable location, and neat simplicity of architecture, is a striking object to those who approach the city by water."[2] Beyond it, at the foot of St. Philip Street, was the Vegetable Market, built in 1822–30.[3]

"The attraction of these markets is not their architectural appearance, nor their history, but the remarkable gatherings that throng them," a local guidebook observed.[4] It was this "living panorama," the *Picayune* wrote, that made "New Orleans the most incomprehensible city in the States."[5] A bazaar of Creole merchants, where "cries and polyglot invitations to buy" greeted the visitor, the market recalled the *halles* of Paris. Gascon butchers, who controlled the meat trade, were "akin to modern Parisians," to one observer, "with the closest cropped heads and the most hursute [*sic*] of beards."[6] Choctaw Indians from north of Lake Pontchartrain sold herbs, medicinal plants, and the famous *filé* powder of sassafras leaves,

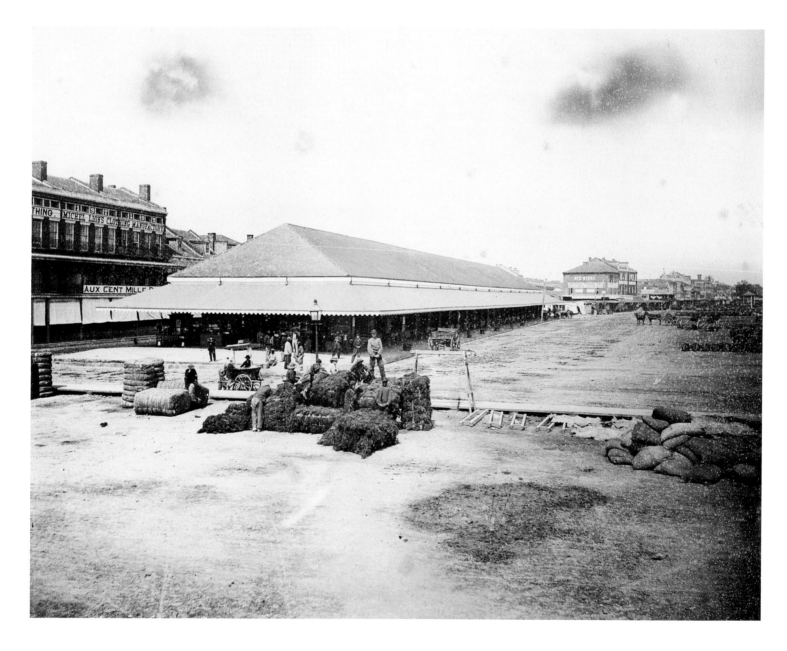

used as seasoning in Creole cooking, at the market. Other vendors sold such specialties as an African American cold pudding made of sweet prunes, a hot spongy rice fritter called *calas*, and *pralines* (sugar cakes made with pecans).[7] Elegant Creole coffee stands (one just visible under the awning in the foreground) with polished mirrors were famous for "steaming Mocha, or Rio, or Java" unsurpassed anywhere in the city.[8] Outside the market a visitor might witness a "learned monkey" or "shows of fat boys, six legged calves and other monstrosities."[9]

Beyond the market were the Red Stores, two three-story brick stores built in 1858. As a result of their proximity to the market and their use of the crowded *banquettes* (sidewalks) for sales of clothing and sundries, they were highly profitable.[10]

Lilienthal's elevated perspective from a ferry landing opens up the space and captures the great expanse of the Levee. Young men sprawled about a pile of moss bales defer to the camera or are oblivious, and customers pause at an ice-cream vendor's cart. Sacks of grain lie in a heap nearby and, on the Levee beyond, barrels in neat rows await drayage.

The open Levee gave way to railroad switching yards in the later nineteenth century, and in the twentieth century to parking lots and green space, while wharf activity moved to container facilities far downriver from the city center. Italian immigrants arriving in New Orleans in great numbers in the 1880s and 1890s, and entering the produce, grocery, and restaurant trades, changed the French character of the market forever. The old Creole coffee stand in the Meat Market was remodeled and expanded in 1894.[11] A Public Works Administration renovation in 1937–38 tidied up the old buildings, installed a sidewalk arcade, and brought refrigeration—"gleaming modern display cases cooled to the proper degree"—as well as rigid sanitary controls.[12] Further renovations in the 1970s removed the open stalls and created a pedestrian mall.[13] As the population of the Vieux Carré declined and shopping patterns changed, the French Market, always a curiosity for visitors, adapted to the tourist trade. No longer a provisions market, it lost all connection to the daily life of the city.

1. The Tanesse building replaced a market hall, only three years old, destroyed in a hurricane in 1812. City Council Proceedings, August 22, 25, September 5, 12, 1812, February 20, April 17, 24, 28, June 26, 1813, New Orleans City Papers, Manuscripts Collection, Tulane University Library; *Gibson's Guide*, pp. 311–12.
2. *Norman's New Orleans and Environs*, p. 137.
3. Building contract, Michel de Armas, XXII, no. 437, November 4, 1822, NONA; *Gibson's Guide*. J. Pilié's specifications for the vegetable market are in the Kuntz Collection, Manuscripts Collection, Tulane University Library.
4. *Griswold's Guide*, p. 17.
5. "The Old French Market," *Picayune*, May 15, 1859.
6. Thomas Butler Gunn, "The French Market of a Sunday Morning," *Era*, February 27, 1863.
7. "French Market," *Picayune*, February 11, 1866; James S. Zacharie, *New Orleans Guide*, New Orleans (New Orleans News Co.) 1885, p. 102.
8. Gunn, *op. cit.*
9. Charles R. Schultz, ed., "New Orleans in December 1861," *Louisiana History*, IX, Winter 1968, p. 57; *Picayune*, April 5, 1862.
10. *Crescent*, September 12, 1859; "The Red Store," *Times*, September 4, 1866.
11. "Proposed Alterations & Additions to the French Meat Market for Mr. F.G. Bautovich, May 1894," plan and elevation by architects Taylor and Burgess, Southeastern Architectural Archive, Tulane University.
12. *Times-Picayune*, September 11, 1932; Emile V. Stier and James B. Keeling, *A Treatise on the Famous French Market ... Rehabilitated in 1937–38*, New Orleans (French Market Corp.) 1938. Drawings for the rehabilitation by architect Sam Stone, Jr., are in the Southeastern Architectural Archive, Tulane University.
13. F. Monroe Labouisse, Jr., "The Death of the Old French Market," *New Orleans Magazine*, June 1975, pp. 72–77.

4 *overleaf*
Second Dist. Ferry
Station et Bateau de passage du 2ᵐᵉ District

In 1867, six steam-ferry lines moved cargo and passengers between New Orleans and the West Bank of the Mississippi River. The Second District ferry began service in October 1866, connecting Bouny Street, Algiers, with the Vieux Carré, or Second District, landing at Dumaine and St. Ann streets, opposite the French Market.[1] The ferry steamer *W.C. Campbell*, seen here, could reportedly "hold at least ten drays and teams all loaded down," and had accommodation for passengers "nicely put up over the engine in a trim though plain manner."[2] Typical of high-pressure steamers, the engine was in the rear and the boilers in front (marked by the tall stack rising above the foredeck). A pilot house sat on the top deck.

With many ferry crossings, and the frequent arrival and departure of steamships and sailing ships at the port, the river could be a logjam of water traffic. One passenger described a ferry "dodging ingeniously ... [the] orange merchants' bateaux, propellers, warships and other strange, nameless and indescribable works, both of art and nature, that haunt the bosom of the old Mississippi."[3]

The Algiers ferry excursion was a popular Sunday-evening outing and "very advantageous to families who cannot afford the expense for what is so essential to their children—a change of air," the *True Delta* wrote. "By the payment of ten cents, persons can remain as long as they please on [the] ferry boats, crossing and re-crossing the river."[4]

The growth of the West Bank was dependent on the development of the ferry services. Although many competing ferry lines worked the river, Algiers residents complained of infrequent connections and service that stopped altogether at 8 pm.[5] During the postwar population boom, when a large in-migration was straining available housing in New Orleans, Algiers offered an alternative, but reliance on ferry service hindered development. "Houses suitable for mechanics and persons of moderate means are almost unobtainable and command exceedingly high rents in the Crescent City," the *True Delta* reported in 1866, "but a partial remedy would be at once provided, if property in Algiers was made easily accessible."[6]

Proposals to bridge the Mississippi River or tunnel underneath it were made as early as 1841, when a tunnel of cast iron was planned, but ferries remained the only means of public transport between New Orleans and Algiers for nearly another hundred years after this photograph was made.[7] Although twin highway bridges, built in 1958 and 1985, now cross the river at Algiers, the old Canal Street ferry link with the Vieux Carré is still maintained.

In Lilienthal's view, bales of cotton, sacks, barrels, and crates—one addressed to "Brashear City" (Morgan City), Louisiana— await transport, and a dray and steamer stand by. The freight landing served the New Orleans, Opelousas, and Great Western Railroad ferry, which connected at Belleville on the West Bank to a rail route reaching northwest toward Texas. Opposite the railroad ferry freight house is a shed for passengers of the Morgan Line steamship ferry, which served points farther downriver, and behind it is a small station house for the Second District ferry. Men who may be stevedores or ferry crew pose like aerialists on the tall fence-posts of the landing.

In this orderly composition of volumes, Lilienthal is in masterly control of the geometry of the view. The eye is led deep into the picture space by means of the converging lines of the plank fences, the signboard, the wagon tracks, and the edge of the distant Levee platform. Deftly composed, the photograph is a work of spatial coherence and structural clarity, and one of the most successful in the Exposition portfolio.[8]

1. "The Canal Street Ferry," *Picayune*, February 8, 1867; Griswold's *Guide*, p. 28; *Jewell's Crescent City Illustrated*.
2. "The New Ferryboat of the Second District and the New Wharves," *Times*, October 18, 1866.
3. "Over the River," *Times*, March 6, 1865.
4. *True Delta*, August 7, 1852.

5. "Our Ferries—The Time to Act," *True Delta*, December 16, 1866.
6. *Ibid.*
7. "Proposal for a Tunnel Under the Mississippi," *Niles Weekly Register*, LIX, February 20, 1841, p. 400. Ferry service between Algiers and New Orleans began in 1827. The river was not bridged at New Orleans until 1935, when what remains one of the longest railroad spans in the world opened about 10 miles (16 km) above the Vieux Carré.
8. Lilienthal also photographed the ferry landing in stereo format; an example is in the Louisiana State Museum, New Orleans (1979.120.65).

5 *opposite*

Ocean Str. Genl. Meade

Navire a Vapeur Gen' Meade

The 900-ton steamer *General Meade* was built in Stockton, England, in 1861 and joined George Cromwell's New York and New Orleans Steamship Line in 1865.[1] Cromwell Line ships—the *Meade* was the fastest—called at its wharf at the foot of Toulouse Street, near Jackson Square.[2] On February 28, 1867, the *Meade* cleared New York harbor en route to New Orleans.[3] Three days later the boat was reported to be "discharging a heavy cargo [of] 900 tons" at the wharf. While 200 tons of coal were hoisted from the hold into the bunkers,

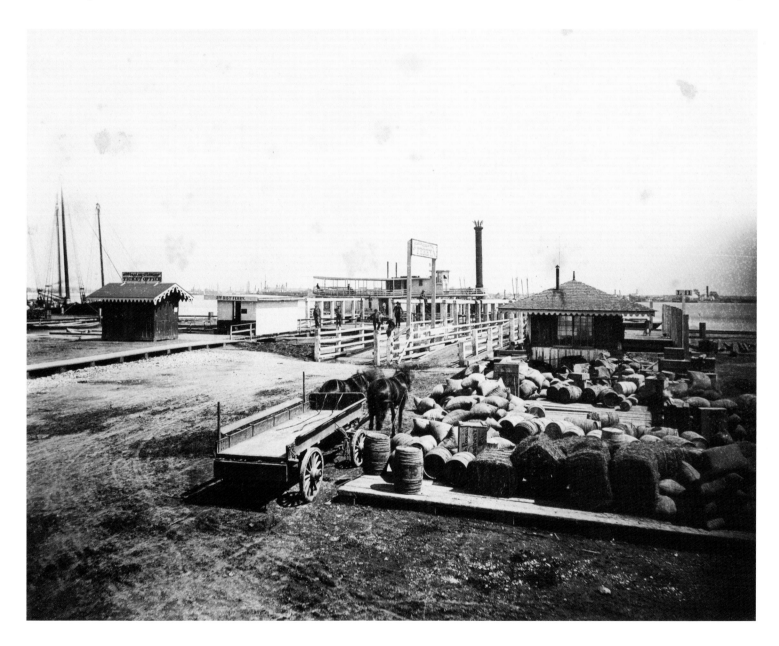

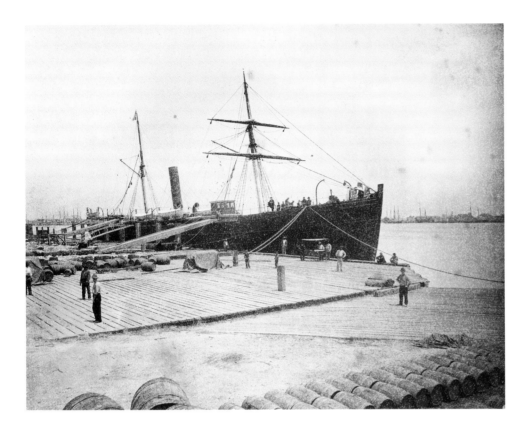

the Advent of Photography in Mid-Continent America, Athens (Ohio University Press) 1983, p. 182. The *Meade* was named for George Gordon Meade, the victor, in 1863, of the Battle of Gettysburg.

2. *Times* (advertisement), December 31, 1866.

3. "Maine Intelligence," *New York Times*, February 28, 1867.

4. "Sailing of the Gen. Meade," *Picayune*, March 3, 1867. The *General Meade* made two return voyages between New York and New Orleans each month. New York departures for March 16 and April 13, 1867, were also posted; *New York Times*, March 6 and April 10, 1867.

5. Franklin E. Coyne, *The Development of the Cooperage Industry in the United States 1620–1940*, Chicago (Lumber Buyers Publishing Company) 1940, p. 7ff.

6. "Statement of Expenditures," June 30, 1858, General Correspondence, Letters Received, New Orleans Custom House, Records of the Public Buildings Service, RG121, NARA.

7. Coyne, *op. cit.*, pp. 17–18.

8. Occupation data from the 1860 Census, *Manufactures of the United States in 1860*, Washington, D.C. (Government Printing Office) 1865, III, pp. 199–200; *Gardner's New Orleans Directory for 1867*.

9. Marshall Meek, "They That Go Down to the Sea in Ships— A Revolution in Container Design," in *RSA: On Design and Innovation*, Brookfield, Vt. (Gower) 1999, pp. 67–86.

6 *overleaf*
Str. Great Republic
Bateau a vapeur Grande République

The *Great Republic*, called the "Queen of the Western Waters," represented the height of steamboat architecture of the nineteenth century.[1] Weighing 1700 tons, with a 335-foot (102-m) deck and a 277-foot (84-m) cabin, she was the largest river steamer of the time and unrivaled in grandeur and luxury. A "faultless" vessel, according to the *Crescent*, she had "the most perfect hull and the most powerful machinery ever put in a steamboat."[2]

Designed by Charles Gearing, the *Great Republic* was built in 1866–67 at the Porter shipyards in Pittsburgh's Shousetown.[3] The steamer accommodated six hundred passengers in "Alladin-like splendor," and the cabin, probably the finest in steamboat history, had a spacious aisled nave of seventy-two columns supporting arches of elaborate Gothic fretwork. The interior was finished in dark wood and trimmed in azure, white, gold, and sky blue.[4] Frescoes and mirrors decorated the walls, the ceilings were hung with ten glittering glass chandeliers, and the floors were carpeted with English floral velvet. Fifty-four staterooms, all with running water, surrounded the main cabin.

The steamer was propelled by two 40-foot (12-m) wheels powered by seven mammoth iron boilers, with chimneys that towered

stevedores took charge of 900 bales of cotton to load aboard for the return voyage.[4]

Lilienthal's photograph of stevedoring the *Meade* illustrates the container that was once so commonplace on New Orleans's wharves and landings, but which has vanished from the modern city. Barrels were ideally suited to transport aboard ship. Although they weighed hundreds of pounds, they could be rolled on and off vessels and wagons easily, and their hand-fitted staves expanded when wet, becoming more watertight.[5] This versatile container carried many of the commodities on which New Orleans's wealth depended: sugar, tobacco, coffee, rice, salt, flour, and pork (stored in dry-tight barrels), and molasses, whiskey, ale, and chemicals (stored in airtight, wet barrels).

Barrels containing building materials often clogged the Levee landings; construction of the U.S. Custom House (cat. 19), for example, required 140,000 barrels of sand, cement, and lime.[6] Oil was also shipped (and measured) in barrels, and petroleum production, which began in 1859, soon outpaced the manufacturing capacity of cooperages nationwide.[7] In New Orleans, barrels were both containers *and* commodities; coopering was one of New Orleans's largest industries, and from the early nineteenth century the city was also a center of the export stave trade. In 1860, there were nearly as many workers employed in making barrels as building ships, and in 1867 no fewer than 110 cooperages operated in the city.[8] Today only a handful of industrial cooperages operate nationwide, supplying distilleries and wineries that still use wooden barrels.

The cargo-handling methods and ship-operating economics represented by the *Meade* did not change significantly until the arrival of container ships one hundred years later. Handling the individual barrels and managing small lots of cargo was labor-intensive and required long layovers in port. It was not unusual for cargo vessels such as the *Meade* to spend half their time at wharves, when it was time at sea that determined their earnings.[9]

In Lilienthal's photograph, the row of barrels is a visual reference point for the construction of space. This method of organizing the picture by introducing a strong foreground element to enhance the illusion of pictorial depth was a common strategy of stereoscopy, and a visual syntax that governed much of Lilienthal's outdoor work.

1. William M. Lytle, *Merchant Steam Vessels of the United States 1807–1868*, ed. Forrest R. Holdcamper, Mystic, Conn. (Steamship Historical Society of America) 1952, p. 72; Frederick Way, Jr., *Way's Packet Directory, 1848–1983: Passenger Steamboats of the Mississippi River System Since*

73 feet (22 m) above the hurricane deck. She drew 4½ feet (1.4 m) of water, and could carry 3500 tons of cargo. All this magnificence and muscle cost more than $1000 a foot.[5]

On March 17, 1867, the *Great Republic* hauled in her planks at Pittsburgh and departed on her maiden voyage for New Orleans. Thousands of spectators lined the wharf in a blizzard for a "last sight of the vessel in which Pittsburgh centres so much pride," one observer reported.[6] Only half her chimneys could be put up until the steamer cleared the bridges on the approach to Cincinnati. As she steamed down the Ohio River with a "glittering passenger list," the magnificent packet "eclipsed all other steamboats on the river."[7] At Wheeling,

West Virginia, her next call, there was a "frantic rush to the wharf" to view the floating palace, and when the gangplank came down the crowd rushed on, according to one witness, "as though salvation depended on getting aboard." Seeing the press of the crowd, the captain hauled in the gangway as visitors scrambled to shore, and the *Great Republic* quickly departed without taking on freight. "She came and was gone so quickly that one had no time to realize her vast proportions," the *Wheeling Daily Intelligencer* remarked. "[But] all the boats at the landing sunk [*sic*] into utter insignificance."[8]

At Cincinnati, where a song was published in the steamer's honor, so many spectators came aboard during her first day in port—

30,000 by one count—that the stevedores could not do their work.[9] At Louisville, a reporter for the *Daily Democrat*, "not very favorably impressed with the general outside appearance" of the *Great Republic*, registered the steamer's first negative review: "There is something about the bow and shape of the *Republic* that ... does not look as if she was built for speed at all. In short, she presents the appearance of a monster freighter, with a fast boat's cabin on her."[10]

On March 25, the *Great Republic* departed Louisville, taking on 125 passengers and 1800 tons of freight. During a stopover in Memphis, one observer described her as a "*tout ensemble* that feasts the eye either by day, or

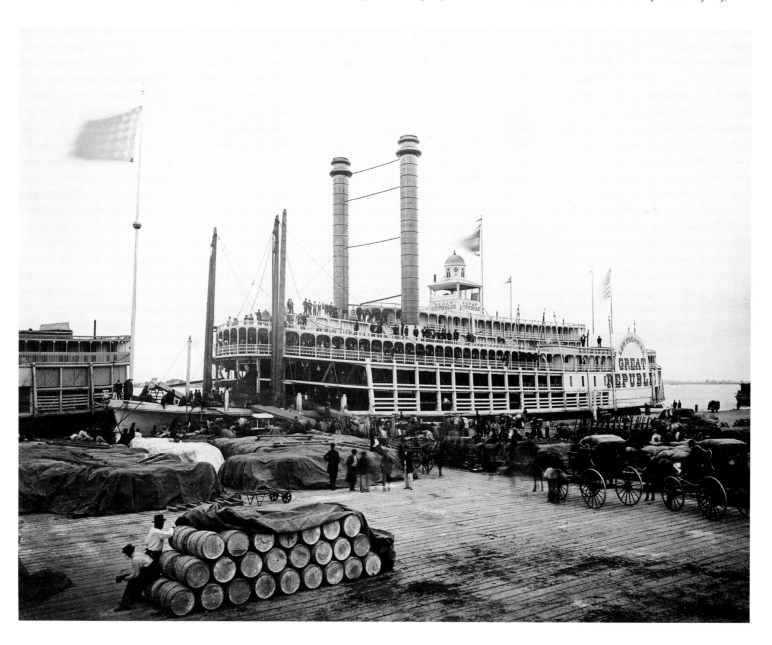

when illuminated by its hundred lights." Passengers declared her "a marvel of American enterprise and American skill."[11]

The *Great Republic*'s arrival in New Orleans was eagerly anticipated, as news of her progress was telegraphed from up-country ports. In the early morning of April 2 the steamer reached the landings. "Her appearance created quite an excitement on the levee and throughout the city," the *Crescent* reported. "Everybody, we believe, is going down to the foot of Poydras street this fine afternoon to see the *Great Republic*."[12]

The Levee was the site of spectacle—a promenade and social space that in 1867 was barely beginning to recover its prewar significance—and Orleanians saw the arrival of this "monarch of Western steamboats" as a "great event of the age," recalling and even rivaling the antebellum celebrations.[13] "We have not in our whole experience as a reporter witnessed such a demonstration as was made on the landing yesterday," a journalist observed:

> Hundreds who rarely visit that dusty margin of town were seen navigating the archipelago that is so intricately studded with boxes and barrels, bags and bales, and steering for the naval monster, with its mazarin blue pilot house and towering smoke stacks … . All pronounced her the grandest specimen of marine architecture that has ever made a landing in this port.[14]

As at her other ports of call, the steamer was "besieged with those anxious to inspect her," the *Crescent* reported, "and during the whole day multitudes of our citizens were … examining her in every detail."[15]

While spectators gawked, the *Great Republic* disgorged her cargo: 3000 chairs, 139 plows, 13,000 sacks of corn, 300 sacks of malt, 2500 washboards, 500 boxes of bitters, 110 boxes of cheese, 700 boxes of candles, 1000 brooms, hundreds of barrels of meat, eggs, and flour, 120 barrels of whiskey, 26 coops of birds, 60 sheep, 73 crates of iron castings and machinery, 32 boilers, 1000 bales of hay—and hundreds more goods, in a seemingly endless inventory of consignments.[16]

On April 4, as the *Great Republic* was preparing to embark on her return voyage up the river to St. Louis, Lilienthal was on hand and completed "excellent pictures of the interior and exterior" of the steamer. "These will be included among the views to be forwarded in the portfolio to the Paris Exposition," the *Crescent* reported, "and will give to those who have never seen our river boats, a thorough idea of the floating palaces which ply upon our inland streams."[17]

The *Great Republic* was a sensation but immensely impractical to operate—she "dragged a hundred-thousand-dollar mortgage up and down the river and burned five thousand dollars worth of fuel on every trip," according to one account.[18] Within two years, the original owners were bankrupt and sold the steamer for just $48,000, a quarter of her construction cost. In 1875, she was reconditioned and rechristened the *Grand Republic*, serving the St. Louis–New Orleans trade for two more years. Then, on September 19, 1877, while docked at St. Louis, she caught fire. "Intensely grand in the raiment of fire," a witness reported, "the steamer burned into a mass of molten magnificence."[19]

1. On steamboat architecture, see Denys P. Myers, "The Architectural Development of the Western Floating Palace," *Journal of the Society of Architectural Historians*, x, no. 4, December 1952, pp. 25–31.
2. "News Items," *Crescent*, March 25, 1867; "Arrival of the Great Republic," *Crescent*, April 3, 1867.
3. *Pittsburgh Gazette*, March 10 and 11, 1867; *Cincinnati Commercial*, March 20, 1867.
4. *Crescent*, April 5, 1867; Myers, *op. cit.*, pp. 30 and 31, n. 28.
5. *Cincinnati Commercial* (advertisement), March 20, 1867; *Crescent*, April 3, 1867; Charles Henry Ambler, *A History of Transportation in the Ohio Valley*, Glendale, Calif. (Arthur H. Clark) 1932, p. 269.
6. *Pittsburgh Gazette*, March 11, 12, 17, 18, 1867.
7. Walter Havighurst, *Voices on the River: The Story of the Mississippi Waterways*, New York (Macmillan) 1964, p. 199.
8. *Wheeling Daily Intelligencer*, March 18, 1867.
9. *Cincinnati Commercial*, March 19, 20, 21, 22, and 23, 1867.
10. *Louisville Daily Democrat*, March 23 and 24, 1867.
11. *Memphis Appeal*, cited by the *Crescent*, April 1, 1867; "Arrival of the Great Republic" and "The Mammoth Steamboat," *Crescent*, April 3, 1867.
12. "The Mammoth Steamboat," *op. cit.*
13. *Ibid.*
14. "River Intelligence," *Crescent*, April 4, 1867.
15. *Ibid.*
16. "Receipts of Produce," *Crescent*, April 3, 1867.
17. "Photographs of the Great Republic," *Crescent*, April 6, 1867. If an interior view was included in the Exposition set, it is one of the twenty-four photographs missing from the portfolio today. No large-format views by Lilienthal of the interior are known to survive, although he did publish both interior and exterior views of the steamboat in stereo format in the late 1860s (fig. 76).
18. Havighurst, *op. cit.*
19. "Burning of the Grand Republic," *Times*, September 23, 1877.

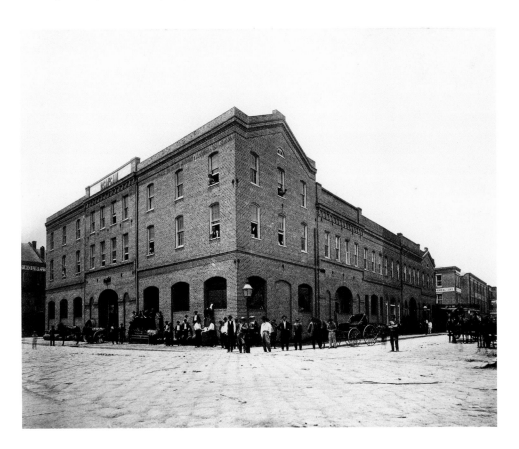

7 *previous page*
McCans Foundry
Fonderie de McCan

McCan's Foundry occupied a square bounded by New Levee (South Peters), Notre Dame, Fulton, and Julia streets. Architects Henry Howard and Albert Diettel designed the 62,000-square-foot (5760-sq.-m) brick ironworks, which were built in 1858 for owners David McCan and Daniel Harrell. The foundry manufactured and repaired steamboat and sugar-mill machinery.

The three-story building was a hollow square in plan, organized around a central yard that was used for coal and scrap storage and materials handling, and which also supplied light and ventilation to the interior shops. Large arched wagon doors at ground level gave access to the casting floor and the yard. Good daylighting for the detailed work of the carpentry and pattern shops was provided by narrowly spaced windows along Fulton Street. One of the city's few modern factory buildings, McCan's was engineered to meet the infrastructure requirements of steam power, and had a higher production capacity than the small artisan workshops typical of the local ironworkers' craft (cat. 8).[1]

The foundry's pattern storeroom contained dozens of furnace patterns for packets and steamships lost to explosions, fire, or the destruction of war. "In looking over the pile of patterns," a visitor wrote, "it was almost sorrowful to think how few of the boats to which these living patterns belonged are now alive and on the levee; it was awful to reflect on the disasters of Mississippi navigation."[2]

Following McCan's death in 1893, the foundry closed, and in 1902 the building was demolished. In the photograph, a wagon emerges from the Fulton Street entrance, bearing a casting of "4950 lbs." Work has come to a halt, and carriages in the street are kept clear as foundrymen and, presumably, their managers pose for the camera, standing on a stack of iron posts, with a leg up on an iron boiler, or in factory windows. Lilienthal's street-level, corner perspective and wide-angle field of view give the building a monumentality that would seem greater than its place in the urban fabric, and equal to some of the city's prominent institutions.

1. On ironworks of this period, see Betsy Hunter Bradley, *The Works: The Industrial Architecture of the United States*, New York (Oxford University Press) 1999, pp. 40–42.
2. "A Glance at New Orleans Manufactures and Arts: Iron Craft," *Times*, January 3, 1865.

8
Boiler Maker's Shop
Manufacture de Bouilloires

Drummond, Doig & Company manufactured railroad, steamboat, and sugar boilers at its foundry on Front Street between Notre Dame and Julia streets, in a district of cotton presses and factories where a sprawling convention center is located today. The foundry prospered during the federal occupation with contract work for the U.S. military, but its business collapsed at the end of the war. Lilienthal's photograph was the foundry's valedictory: it closed soon after this view was made.[1]

In Lilienthal's photograph, foundry workers are posed with the tools and products of their trade. The goods display of boilers is a reminder that the city of the Civil War era ran on steam, and that the machines that powered mills and steamboats and locomotives were themselves the product of a long process of manufacture, the work of laborers and skilled tradesmen. Behind the large boiler two men grasp a long rod, and the man behind them displays a similar tool—a heavy "rabble" that skilled laborers known as "puddlers" used to work out the impurities in raw iron to make it malleable.[2] Puddling was backbreaking work, amid deafening noise, smoke, filth, and intense heat, as one ironworker recalled:

> What time I was not stoking the fire I was stirring the charge with a long iron rabble that weighed some twenty-five pounds. Strap an Oregon boot of that weight to your arm and then do calisthenics ten hours in a room so hot it melts your eyebrows and you will know what it is like to be a puddler.[3]

Other metalworkers assembled in Lilienthal's photograph probably riveted boilerplates and molded oven plates, sugar kettles, anchors, and tools, all products of a typical artisanal smithy and small foundry operation. The picture-taking was undoubtedly a welcome break from the toilsome routines of the foundry floor.[4]

Lilienthal, in his many workshop portraits, appears to have shared a "conscious regard for the dignity of labor" that characterized the best occupational portraiture of the day.[5] His photographs record artisans' pride in craft and a respect for manual labor that was passed from generation to generation, and portraits of labor such as this one were evidence of the "lofty status of the skilled worker in mid-

century America," as historian Michael L. Carlebach has written.[6] But, as workshops and factories became increasingly mechanized, and steam-powered machinery eliminated skilled labor, artisan pride began to erode.[7]

Few of the men Lilienthal photographed would have had their own portraits made, and although inexpensive tintypes and card photographs were within the reach of ordinary wage earners of the 1860s, these laborers probably had money for only bare necessities. Contrasts of relative affluence and poverty are visible in the photograph: a worker wearing badly soiled trousers stands near a respectably dressed man with a top hat, and a servant harnesses a carriage for its owner (a client, perhaps, or a manager).

The striking doll-like, hoop-skirted child on the *banquette* appears quite out of place here, dwarfed by the massive furnace shell and the workers close by. The filthy, hazardous environment of the workshop is one that we would never consider appropriate for children today, but the child's appearance here is a reminder of the omnipresence of children in the nineteenth-century city. "Children were everywhere," one historian has written, "... in factories, in families, schools, churches, prisons, and custodial institutions; they were on ships, on the streets, and even on battlefields. They were, many of them, producers as well as consumers, wanted and unwanted, pampered and abused, cherished and exploited."[8]

Another child in the photograph, the barefoot urchin in the foreground, may have performed small tasks around the foundry. At this time there were no minimum-age laws regulating child labor in manufacturing, and workers often hired young family members as helpers (a way eventually to pass on a trade). Other child laborers were orphaned children, an enormous problem in New Orleans, as one visitor observed in 1866: "Multitudes of them are poor, friendless, homeless [and] excite indescribable pity, when we remember the hopeless poverty and abandonment to which they are heirs."[9]

The foundry's immense signboard with bold egyptian letterforms, like those of the neighboring provisioners, is an advertisement to passing vessels on the river. Small workshops such as this attracted immigrant labor, and Lilienthal's photograph may have been understood by an Exposition audience to illustrate employment opportunities in New Orleans for Europeans. In fact, the foundry's

financial failure appears to be reflected in its shambolic appearance, which is more characteristic of frontier commercialism than the urban center of New Orleans. Surprising in a context of ebullient boosterism, the image appears to conflict with the metropolitan ideal characteristic of most of the portfolio. Here Lilienthal may have recognized pictorial interest in a subject that also carried meaning for the prospective immigrant.

1. *Louisiana*, III, p. 129, R.G. Dun & Co. Collection, Baker Library, Harvard Business School; Drummond, Doig & Company closed before May 4, 1867, when R.G. Dun & Co. recorded its final entry for the company (Lilienthal completed the Paris portfolio commission between February 28 and May 26, 1867). "Drummond, Doig & Co." (advertisement), *Times*, March 18, 1866; *Gardner's New Orleans Directory for 1867*, p. xlviii (advertisement); L. Graham, *Graham's Crescent City Directory for 1867*, New Orleans (L. Graham) 1867, p. iv (advertisement); *Louisiana State Gazetteer and Business Man's Guide for 1866 and 1867*, New Orleans (Palmer, Buchanan & Smith) 1867, p. 108 (advertisement).

2. "The Nail-Makers," *Harper's New Monthly Magazine*, XXI, no. 122, July 1860, pp. 160–61; W.J. Rorabaugh, *The Craft Apprentice: From Franklin to the Machine Age in America*, New York (Oxford University Press) 1986, p. 142.

3. James J. Davis, *The Iron Puddler*, New York (Grosset & Dunlap) 1922, p. 99. On puddling and the skilled iron trades, see David Montgomery, *The Fall of the House of Labor: The Workplace, the State, and American Labor Activism, 1865–1925*, Cambridge (Cambridge University Press) 1987, pp. 14–18.

4. Vernon F. Snow, *A Child of Toil: The Life of Charles Snow, 1831–1889*, Syracuse, NY (Syracuse University Press) 1999, p. 11; Montgomery, *op. cit.*, pp. 196–97.

5. Alan Thomas, *Time in a Frame: Photography and the Nineteenth-Century Mind*, New York (Schocken Books) 1977, pp. 152–54.

6. Michael L. Carlebach, *Working Stiffs: Occupational Portraits in the Age of Tintypes*, Washington, D.C. (Smithsonian Institution Press) 2002, p. 52; Rorabaugh, *op. cit.*, p. 133. See also Henry R. Rubenstein, "With Hammer in Hand: Working-Class Occupational Portraits," in *American Artisans: Crafting Social Identity, 1750–1850*, ed. Howard B. Rock, Paul A. Gilje, and Robert Asher, Baltimore (Johns Hopkins University Press) 1995, pp. 176–98; Brooks Johnson, "The Progress of Civilization: The American Occupational Daguerreotype," in *America and the Daguerreotype*, ed. John Wood, Iowa City (University of Iowa Press) 1991, pp. 109–17.

7. Rorabaugh, *op. cit.*, p. 144.

8. N. Ray Hiner, "Seen But Not Heard: Children in American Photographs," in *Small Worlds: Children & Adolescents in America, 1850–1950*, ed. Elliott West and Paula Petrik, Lawrence (University Press of Kansas) 1992, p. 167.

9. John Chandler Gregg, *Life in the Army, in the Departments of Virginia, and the Gulf, Including Observations in New Orleans*, Philadelphia (Perkinpine & Higgins) 1866, p. 135.

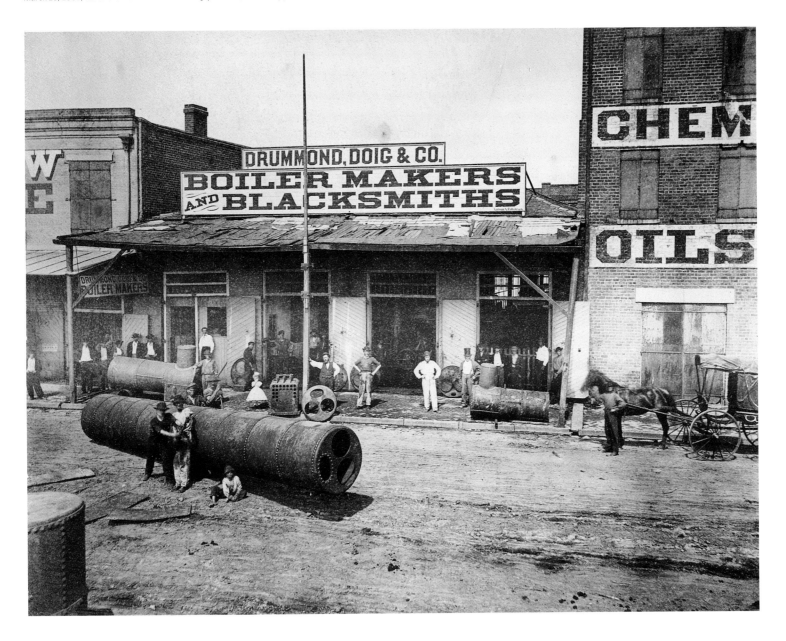

U. S. St Joseph St R. Road
Station Chemin de Fer de la Rue St. Joseph

Late in the war, engineers for the U.S. Military Railroad opened a rail line linking the riverfront wharves and landings with Lake Pontchartrain. Tracks of the new line, called the St. Joseph Street Railroad, crossed the Levee below Canal Street and used St. Joseph Street as a right of way to Triton Walk and the New Basin Canal. The tracks then ran parallel to the canal and the New Basin Shell Road to the lakefront.[1] "The city has suddenly found itself in possession of a railroad which, under the strong and potent impulsion of military power, has been completed in less than ten days," the *Picayune* reported in February 1865.[2] The line put into service elegant carriages for passengers connecting from river to lake steamships, and conveyed passengers to the lakefront resorts, where they dined and drank "mint-juleps and sherry cobblers."[3] "It is a real source of pleasure," a journalist wrote, "to exchange scenes of our city, its brick houses and paved streets and its heat, for the pleasant shores of the lake."[4]

The railroad traversed an area long considered inviolable public space, the Levee.[5] Although a levee railroad serving river wharves had been proposed many times before the war, opponents argued that a rail line would obstruct the landings, disrupt shipping, and threaten the livelihood of draymen and laborers. During the war, however, the levee intervention could be accomplished by "giant Military Necessity" and be welcomed, at least momentarily, as a municipal improvement: "We have so little business now," the *Picayune* lamented in April 1865, "that the rails can do us comparatively little harm."[6]

But the construction was opposed for its interference in one of the great sporting rituals of Orleanians: running horses on the Shell Road. "The spirited and fast horses driven on the Shell Road are frightened by the locomotive," the *Picayune* warned, and in November 1865 Governor Madison Wells presented a petition to military authorities for removal of the railroad that had "greatly injured private property and deprived the citizens of one of the pleasantest drives in the city."[7] Within a few weeks the federal overseer, General Philip Sheridan, issued orders to close the railroad, reportedly earning him "good will and esteem [from Orleanians] for all time to come."[8] "The

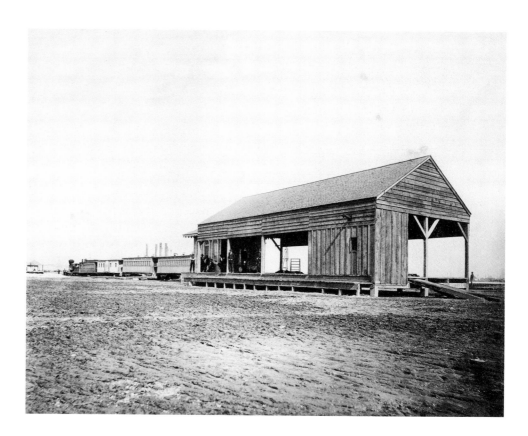

Crescent City's favorite drive—her former pride and boast—is to be restored at once," the *True Delta* announced, "the order, we learn, having already gone forth for the destruction of the 'St. Joseph Street Railroad,' which has so long rendered almost useless 'the Shell' by the side of the New Canal."[9] In early 1866, after barely a year of service, the railroad pulled up tracks and auctioned its equipment, as other lines of the wartime system of the U.S. Military Railroad were also dismantled or returned to private ownership.[10]

In Lilienthal's photograph a small, Gothic station house, with trimmed eaves and tracery windows, is partly obscured by a simple board-and-batten freight shed raised on stilts. The position of the camera makes the depot loom large over the mud Levee, the broad expanse of which is measured by the steamboat stacks and the thin line of the river, visible in the distance. A lake-bound coach-train idles near the station. Lilienthal's photograph probably dates from November 1865, when he also recorded the St. Joseph Street Railroad's lakefront depot at Hickock's Landing (fig. 17) for the U.S. Quartermaster General. Lilienthal apparently reprinted this negative for the Exposition portfolio in early 1867, about a year after the station house and rail line were demolished.[11]

1. "Improvements," *Picayune*, April 14, 1865; "The Lake and Levee Railroad," *Picayune*, April 26, 1865.
2. *Picayune*, February 21, 1865. On the U.S. Military Railroad, see *Reports of Bvt. Brig. Gen. D.C. McCallum ... Appendix to the Report of the Secretary of War Accompanying Message of the President*, 39th Cong., 1st sess., Washington, D.C. (Government Printing Office) 1866; and Erna Risch, *Quartermaster Support of the Army*, Washington, D.C. (Center for Military History, U.S. Army) 1989, pp. 394–405.
3. "The U.S. Military Railroad," *Picayune*, March 22, 1865; *Picayune*, May 30, 1865.
4. "Outside," *Picayune*, May 30, 1865.
5. On public and commercial functions of the waterfront and antebellum perceptions of the Levee as social space, see Dell Upton, "The Master Street of the World: The Levee," in *Streets: Critical Perspectives on Public Space*, ed. Zeynep Çelik, Diane Favro, and Richard Ingersoll, Berkeley (University of California Press) 1994, pp. 277–88.
6. "The Lake and Levee Railroad," *Picayune*, April 26, 1865.
7. "St Joseph Street Railroad," *Picayune*, November 2, 1865.
8. "Good News," *True Delta*, December 2, 1865.
9. *Ibid*.
10. "The Depot and St. Jos. Street R.R. buildings are now advertised for sale in compliance with orders of Quartermaster General," "Report on Buildings Owned by the U.S. Government by Capt. J.B. Dexter, Assistant Quartermaster at New Orleans, January 4, 1866," Consolidated Correspondence File 1794–1915, Records of the Office of the Quartermaster General, RG92, NARA; *Times*, May 3, 17, 1866; *Crescent*, May 14 and 30, 1866; *Picayune*, May 30, 1866; "Sale of the St. Joseph Street Railroad," *Times*, June 14, 1866; *Reports of Bvt. Brig. Gen. D.C. McCallum, op. cit.* A rail line was later reinstated in St. Joseph Street for freight service; see *Picayune*, February 21, 1902.

11. This view is not among those preserved in the
Quartermaster albums in Washington, D.C. (see p. 52, n. 53),
which are all smaller-format prints. Inventoried as military
property in 1865 were the Hickock's Landing, Lake End
buildings of the railroad, including an engine house, depot,
and warehouse, which Lilienthal photographed for the
Quartermaster (NARA 165-C-877). "Report on Buildings
owned by the U.S. Government," *op. cit.*

10
Vicksburg Cotton Press
Presse a Cotton Vicksburg

In New Orleans's cotton market, the world's
largest before the war, cotton presses served
many functions. They cleaned, bleached,
weighed, sampled, and stored cotton before
sale, and steam-powered screw-presses
compressed the cotton lint into dense, 5-foot
(1.5-m) bales weighing 400–500 pounds
(180–225 kg). A "large business is carried on in
the pressing of cotton bales," the British traveler
and mill owner Henry Ashworth wrote in 1861.
"At one of these establishments which we visited,
they were pressing as many as 1500 bales
per day by three presses, employing fourteen
negroes to work each press."[1] Albert Richardson,
a correspondent for the *New York Tribune*
during the war, also visited a New Orleans
press and described the work in the yard:

> The bales are compressed by heavy
> machinery, driven by steam, that they may
> occupy the least space in shipping. They are
> first condensed on the plantations by screw-
> presses; the cotton is compact upon arrival
> here; but this great iron machine, which
> embraces the bales in a hug of two hundred
> tons, diminishes them one-third more. The
> laborers are negroes and Frenchmen, who
> chant a strange, mournful refrain in time
> with their movements. The ropes of the
> bale are cut; it is thrown under the press;
> the great iron jaws of the monster close
> convulsively The ropes are tightened and
> again tied, the cover stitched up, and the
> bale rolled out to make room for another—
> all in about fifty seconds.[2]

The press was a highly specialized
workplace, as one visitor observed, "requiring
a great many hands, powerful steam engines,
and severe labor" (the heaviest labor was often
carried out by slaves).[3] Gangs of rollers moved
bales about the yard, scalemen loaded the
scales, and weighers and reweighers recorded

and checked the weight. After the cotton was
compressed, baled, bored (to detect fraud),
bagged, and banded, samplers took cotton
specimens to factors for grading and sale.[4]
Buyers examined the specimens for length,
fiber (or staple), whiteness, and purity, among
other qualities.[5] The sold cotton was then
drayed from the press to the Levee, where
stevedores supervised the loading of the bales
aboard ship. In the ship's hold, screwmen, the
most skilled tradesmen on the riverfront,
secured the bales in place for the ocean voyage
with large metal screws and wooden posts.

The Vicksburg Cotton Press covered an area
of 96,000 square feet (nearly 9000 sq. m)
near river wharfage on Water Street (bounded
by Calliope, South Front, and Gaienné). During
the war, occupying federal troops seized the
press for use as stables, quartermasters' stores,
and shops for blacksmiths, wheelwrights,
carpenters, painters, and saddlers.[6] In the
decade after this photograph was made, the
railroad industry, with its freight-handling
facilities, came to dominate the old riverfront
districts of cotton commerce. The press
closed around 1873 and was demolished for a
railroad freight depot. Today the New Orleans
Convention Center occupies the site.

1. Henry Ashworth, *A Tour in the United States, Cuba, and
Canada*, London (A.W. Bennett) 1861, p. 82.
2. Albert D. Richardson, *The Secret Service, the Field, the
Dungeon, and the Escape*, Hartford, Conn. (American
Publishing Company) 1865, p. 49.
3. Thomas Low Nichols, *Forty Years of American Life,
1821–1861*, London (J. Maxwell) 1864, I, p. 184. On cotton
presses and baling, see: C.P. Brooks, *Cotton: Its Use, Varieties,
Fibre Structure, Cultivation*, New York (Spon & Chamberlain)
1898; Charles William Burkett, *Cotton: Its Cultivation,
Marketing, Manufacture*, New York (Doubleday, Page &
Company) 1908.
4. "How Cotton Sales are Managed at New Orleans," *Times*,
January 4, 1866.
5. Thomas W. Knox, *Camp-Fire and Cotton-Field: Southern
Adventures in Time of War*, New York (Blelock and Co.)
1865, pp. 395–96; Richardson, *op. cit.*
6. "Plan and Elevation of Buildings Occupied by the U.S.
Government for Warehouse, Stables, and Wagon Yard
Known as the Vicksburg Cotton Press New Orleans. La.
[prepared for] Brig. Gen'l Fred Myers, Deputy Quar. Genl.
U.S.A.," Map 107G, Sheet 2, Post and Reservations, Records
of the Office of the Quartermaster General, RG92, NARA.

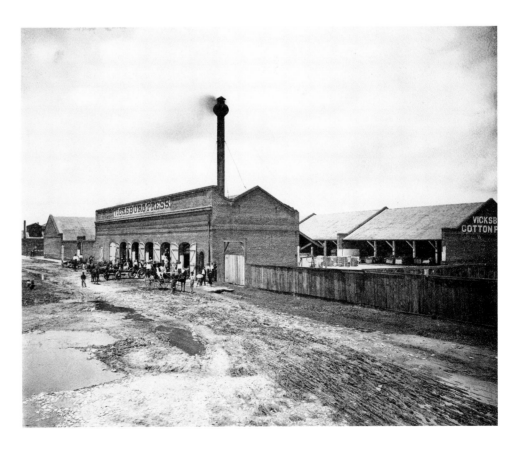

11
Interior of Vicksburg Cotton Press
Interieur de la Presse a Cotton Vicksburg

The large foreground space in Lilienthal's view of the interior of the Vicksburg Press illustrates that most of the area of the press was an open yard for storing cotton bales. "These buildings all front inside," Union soldier Lawrence Van Alstyne wrote in 1863, "with a broad shed ... under which the cotton ... was stored until pressed The great square yard in the center is graded smooth with sea shells."[1]

Although a typical press could store 25,000 bales of cotton at a time, the press yard in this view (and the one shown in cat. 12) is mostly empty. Many presses, like the Vicksburg, had been appropriated during the war for the U.S. military, and made "a capital drill ground large enough for a whole regiment at a time," Van Alstyne observed. "It is the best quarters we have ever had."[2] Other presses were put to use as hospitals or barracks, or for storehouses and wagon yards.[3] The military occupation left many cotton buildings stripped or ruined, as the *Times* noted in 1865: "From the tobacco warehouses up to the levee steam cotton presses [is] nothing but desolation and apparent ruin In our next perambulation in this vicinity we shall expect to find the bricks of buildings in course of being made away with."[4]

There were twenty-seven cotton presses operating in New Orleans in 1867, most, like the Vicksburg Press, in the riverfront district from Calliope Street to Felicity Street. Here, Thomas K. Wharton had observed that the presses were in "almost undisputed possession of this part of town."[5] Many presses reopened in 1866 and 1867, as the cotton market was only "slowly recovering from the effects of the war." The *Commercial Bulletin*, reflecting on an "extremely light" trade in cotton, wrote: "We are not so sanguine as to hope that Cotton will ever again have the regal power

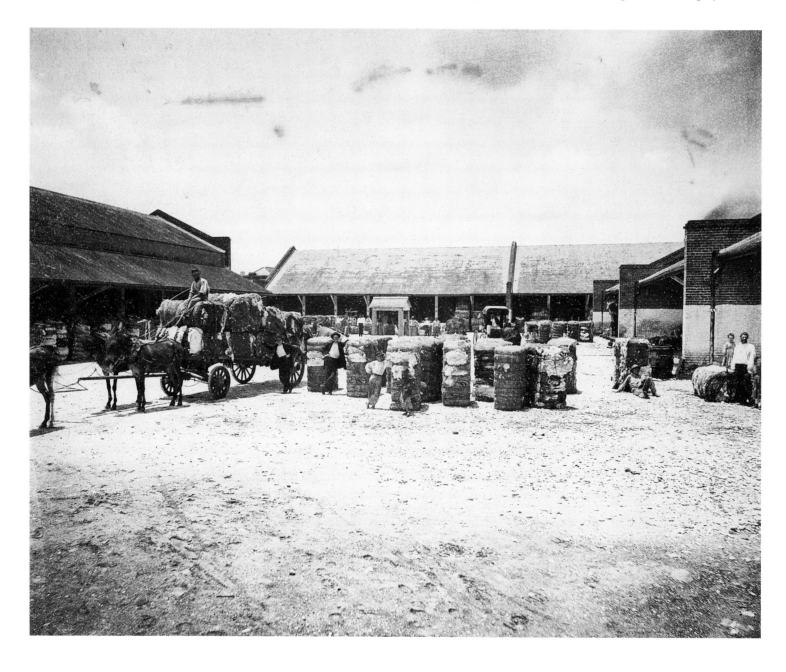

it formerly possessed. Four and a half million crops have vanished, perhaps never to reappear."[6]

1. Lawrence Van Alstyne, *Diary of an Enlisted Man*, New Haven, Conn. (Tuttle, Morehouse & Taylor) 1910, pp. 230–31.
2. *Ibid.*, p. 231.
3. From 1863 to 1865 the Alabama, Tchoupitoulas, Southern, Lower, New Levee, Fassman, Wood, and Picayune presses were used as military hospitals; Registers of Army Hospitals and Their Staffs, 1861–70, Records Related to Hospitals, 1861–1927, Central Office Records, Records of the Surgeon General, RG112, NARA. Other uses are recorded in Captain J.B. Dexter, Assistant Quartermaster, United States Army at New Orleans, "Report of Buildings Hired and in Possession of the United States Government for 1865," November 1865, Consolidated Correspondence File 1794–1915, Records of the Office of the Quartermaster General, RG92, NARA.
4. *Times*, December 28, 1865.
5. Wharton, "Diary," July 8, 1854.
6. "Annual Review of the New Orleans Market For the Year 1867," *Commercial Bulletin*, August 31, 1867.

12
Cotton Press
Interieur d une Presse de Cotton

Cotton was the most important commodity in nineteenth-century world trade, and the American South, before the war, was the largest producer of the world's cotton supply. More than half of the southern cotton crop was shipped through the port of New Orleans. The city's prosperity was dependent on its overseas markets for cotton, but the slave-driven cotton kingdom that flourished in the South before the war was in ruins in 1867.[1] "The mass of the Southern people lost everything in the late revolution but their lands, the larger portion of which they now are unable to cultivate for want of labor," one southern propagandist wrote.[2] New Orleans shipped only 780,000 bales of cotton in 1867, a fraction of the 2.2 million bales exported in 1861.[3]

With the disruption of the production and shipping of southern cotton, European trading partners turned to suppliers in Egypt, Brazil, and India, and retooled their mills for East Indian and other short-staple cotton.[4] The cotton trade with France, second only to England as New Orleans's largest overseas cotton market before the war, had declined by more than half the prewar levels. Observing the disappearance of French ships at the port of New Orleans, the *Times* asked:

What has become of these vessels ... which traded regularly between France and our port before the war, transporting merchandise and passengers? Instead of twenty to thirty vessels loading in the ports of Marseilles, Nantes, Bordeaux and [Le] Havre as during every autumn for the decade ending 1860, we find there were at the last date two vessels in Bordeaux loading for New Orleans, and not one in [Le] Havre.[5]

Louisiana's participation in the Paris Exposition was an effort to regenerate European markets for commodities, examples of which the state entered into competition at Paris and exhibited in the Louisiana Cottage on the Champs de Mars (pp. 57–59). Lilienthal's portfolio of city views played a key role in this boosterism campaign, presenting images of New Orleans as a thriving port and commercial center, as well as a city of culture and architectural display. Lilienthal sent four views to Paris of the local cotton industry, including this one of the sheds, open yard, and firewell of an unidentified press. The views are evidence of the importance of the cotton trade in this image of New Orleans as a world marketplace.

1. "The New Orleans Custom-House Mint, Etc.," *Harper's Weekly*, v, no. 216, February 16, 1861, p. 110.
2. E.C. Cabell, "White Emigration to the South," *De Bow's Review*, i, no. 1, January 1866, p. 93.
3. "Cotton and the Cotton Trade," *De Bow's Review*, iv, no. 3, September 1867, pp. 232–34; *Gardner's New Orleans Directory for 1867*, pp. 10–19.
4. "What the South May Do," *Picayune*, August 28, 1866.
5. "Trade with France," *Times*, September 13, 1866.

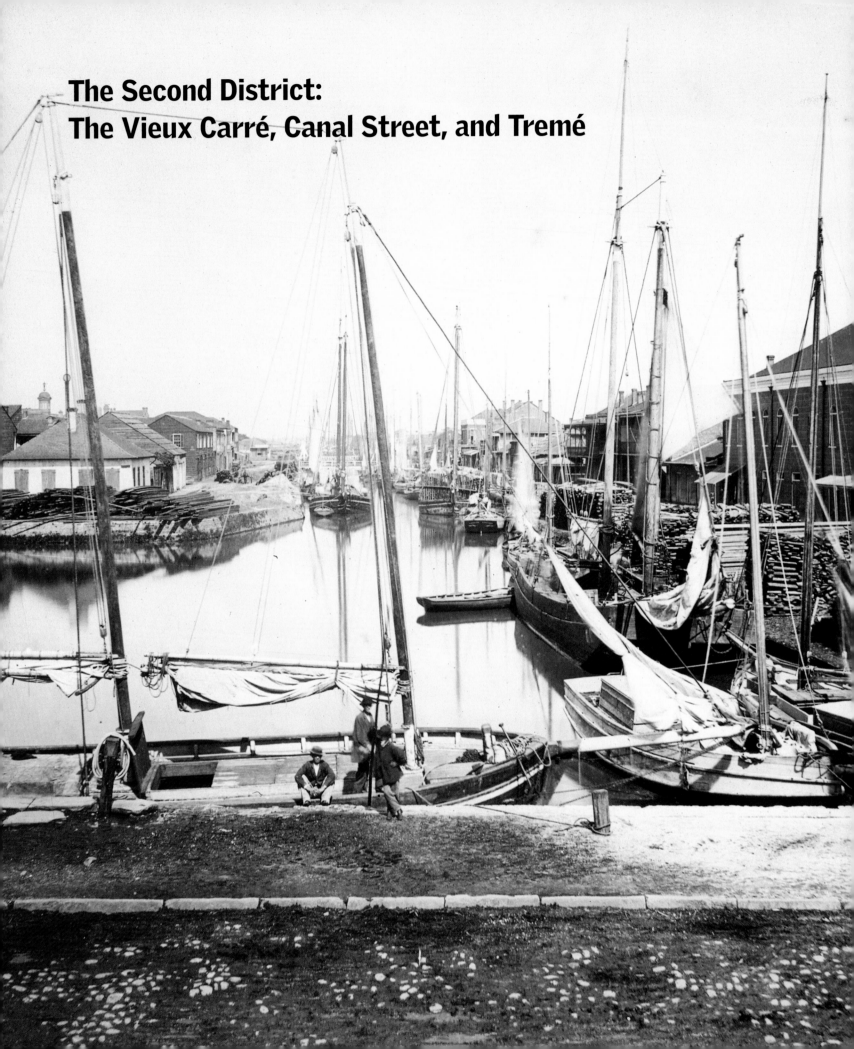

The Second District:
The Vieux Carré, Canal Street, and Tremé

13 *overleaf*
Jackson Square
Place Jackson

Jackson Square, the colonial Place d'Armes, was the heart of the Creole quarter of the Vieux Carré. "[The] nicest scenery in the City is Jackson Square," a federal soldier observed in 1865. "[There are] Evergreens of every kind ... and every kind of shrub that grows in this climate, neat walks paved with shells of the shell fish, and nice Bowers, and seats to accommodate visitors."[1]

Laid out in 1721 by Adrien de Pauger after a plan by Le Blond de la Tour, the square was the focus not only of military display but also of colonial religious and secular authority.[2] Located there were from 1727 the cathedral church of the French colony, dedicated to St. Louis, and from 1799 the council hall (*Cabildo*) of the Spanish colony.

Under American jurisdiction after 1803, the Place d'Armes remained an open, unembellished parade-ground until 1812, when the square was fenced and the first improvements were made. Benjamin Henry Latrobe observed in 1819 that the square, open to the river, gave an "admirable general effect, and is infinitely superior to any-thing in our atlantic cities as a Water view of the city." Despite the square's good situation, Latrobe found it badly neglected—"the fences ragged"—and despoiled by heaps of paving stones and firewood, and "a row of mean booths in which dry goods are sold." An old barracks adjoining the square housed fruit sellers and other vendors. "Thus a square, which might be made the handsomest in America," he wrote, "is really rather a nuisance." Latrobe (who also modified the cathedral) was engaged to redesign the square in 1819 when military drilling functions were removed to another site. His centripetal plan, only partially carried out, was developed with city surveyor Joseph Pilié and provided for a central fountain of Italian marble, with gravel walks, stone gates, an iron fence, and flanking rows of sycamores. Latrobe appears to have conceived of the space as a showpiece for the city waterworks he was designing with his son Henry.[3]

The Place d'Armes was the site of festivities for the Marquis de Lafayette's visit to New Orleans in 1825, when the square was brilliantly illuminated with colored lanterns and decorated with a triumphal arch celebrating the old Revolutionary campaigns. In 1836, a modest fountain was installed, but the space was otherwise little improved, and the grounds had deteriorated badly. "Instead of being a delightful promenade for the recreation of ladies and gentlemen, as squares are in other cities," the *Bee* wrote, "it is permitted to be a thoroughfare for the *canaille*, and is abused by all."[4]

The square was renewed again in 1845–46 and 1851–52, under the direction of surveyor Louis H. Pilié.[5] Improvements included circular beds of roses, acacia, jasmine, and myrtle; evergreens, replacing the "shabby and half-starved" trees; and circular walks paved with red gravel and shells, furnished with benches and illuminated by a double tier of gas lamps. Marble statues of the seasons were added to the four corners, and a magnificent cast-iron-and-granite fence was built enclosing the square, which was now named for Andrew Jackson, hero of the Battle of New Orleans in 1815. A bronze equestrian statue of Jackson, planned from 1851 for a center *rond-point*, was commissioned from Washington sculptor Clark Mills in 1853 and completed two years later, after a subscription drive.[6] Surrounding the square, the "things which nudge it on every side," as one visitor wrote, still included stalls of fruit sellers and other vendors, and "temporary print galleries around the iron railings."[7]

While the landscaping improvements were hailed as a "great attraction for visitors," some residents were not comforted by the transformation of their public square from a "simple, natural grove" into a civic garden, where rare flowers were "cultivated by horticultural *artistes*."[8] In the 1860s, local author J. Mead decried the changes—the "cold, torturing iron benches" and the formerly open, green lawn now "hedged about." "It is not the refreshing meditative place it was," he wrote.[9] With the carefully tended gardens and pruned shrubbery came boundaries on use: "We had our winding pathways," Mead observed, "but were not saluted at every turn ... with despotic little signboards, saucily proclaiming to proprietary inhabitants: '*Ne touchez pas aux fleurs*'; or, as the anglicizing artist literally rendered the prohibiting caution on the same boards: "Touch not *to* the flowers." A similar warning sign, promising a stiff $25 fine for anyone "found injuring the trees, shrubs, flowers &c in this square," can be seen in Lilienthal's photograph.

The mid-century enhancements were reportedly carried out from plans by the Parisian Baroness Michaela Almonester Pontalba as part of a building campaign to gentrify the square.[10] The daughter of Andrés Almonester, at one time the wealthiest man in New Orleans, Michaela married into Parisian aristocracy and became the victim of an unsuccessful murder attempt in 1834 by her father-in-law, the Baron Pontalba.[11] While in Paris the Baroness invested her wealth in property and in 1839 began construction of a residence, the Hotel Pontalba, which became the home of the U.S. Ambassador to France. Ten years later she returned to New Orleans to claim the property she had inherited on Jackson Square. The Baroness demolished the old French colonial buildings flanking the square and built "two rows of elegant and substantial colonnade edifices"—three-and-a-half-story Creole-plan town houses with service wings and courtyards, and cast-iron, colonnaded galleries over ground-floor shops.[12] Iron balconies and galleries had been in use in New Orleans since the 1820s, but the Pontalba galleries were superb examples of pattern making (and may have contributed to the local fashion for cast-iron galleries after the middle of the century).

The Baroness, who was not without design ability herself, consulted architects James Gallier and Henry Howard, and possibly other designers in New York and Paris.[13] The Pontalba group formed, it was said, "the most striking feature of the city," and, with the French and Spanish colonial buildings opposite, "one of the prettiest squares in the Union."[14] Gentrification was now complete: the Baroness was reportedly "careful not to rent any one of her buildings to persons whose character might be disagreeable."[15]

Part of one flank of the Pontalba rowhouses is visible in Lilienthal's photograph. At the time this view was made, the famous buildings, still owned by the Baroness (who died in 1874), were mostly vacant. "We were not a little astonished recently to see that the greater portion of these immense buildings are unoccupied," the *Picayune* noted in December 1866. "'To Let' is posted on nearly every door These fine buildings are scarcely more now than ornaments to the beautiful square which they bound."[16]

Lilienthal's photograph is unusual in its view of the Pontalba block from this vantage point. The eye-level pedestrian perspective places the signboard in the center of the frame, obscures much of the building behind islands of greenery,

Opposite *Head of Old Basin* (cat. 23), detail.

and brings into prominence the shell walks in the foreground. The view re-creates a visitor's experience of a park promenade, but the framing seems odd, especially as Lilienthal could have included the entire Pontalba block with a slight repositioning of the camera. The explanation may lie less with compositional motives than with the limitations of the troublesome and ungainly wet-collodion process: Lilienthal may have trimmed out defects that occurred during his fieldwork. Streaking produced by an uneven coating of collodion is visible on the right-hand side of the image, and the dark patch at the perimeter indicates the limit of the light-gathering power of his lens.[17]

In 2005, the square that for almost three centuries had been at the center of the public ritual and ceremonial life of New Orleans was appropriated for the "imagineering" of an unexpected political mandate, when U.S. President George W. Bush addressed the nation by television amid the devastation that had resulted from hurricane Katrina. As generator-powered lamps illuminated the President and the cathedral front behind him, the rest of the city was cloaked in darkness, desolation, and death. Days before, under a police order, residents had evacuated flooded homes, many probably never to return, leaving the country

to come to grips with the catastrophic destruction of one of its oldest cities.

1. Charles O. Musser, *Soldier Boy: The Civil War Letters of Charles O. Musser, 29th Iowa,* ed. Barry Popcock, Iowa City (University of Iowa Press) 1995, p. 183.
2. On the early history of the Place d'Armes, see *Bee,* April 23, 1836; Samuel Wilson, Jr., *The Cabildo on Jackson Square: The Colonial Period, 1723–1803,* New Orleans (Friends of the Cabildo) 1970; *id., The Presbytere on Jackson Square,* New Orleans (Friends of the Cabildo) 1981; *id.,* "Almonester: Philanthropist and Builder in New Orleans," *The Architecture of Colonial Louisiana: Collected Essays of Samuel Wilson, Jr., F.A.I.A,* Lafayette (Center for Louisiana Studies, University of Southwestern Louisiana) 1987, pp. 301–13.
3. "The Place d'Armes," *Picayune,* February 28, 1850; Benjamin Henry Latrobe, *The Journals of Benjamin Henry Latrobe,* ed. Edward C. Carter, II, New Haven, Conn. (Yale University Press) 1980, III, p. 172; Jeffrey A. Cohen and Charles E. Brownell, *The Architectural Drawings of Benjamin Henry Latrobe,* New Haven, Conn. (Yale University Press) 1994, II, pp. 737–40. A watercolor panorama of New Orleans by George Washington Sully dated 1836 (Southeastern Architectural Archive, Tulane University) shows the square essentially as Latrobe designed it.
4. *Bee,* April 13 and 23, 1836.
5. "Journal of Expenditures for Public Works, 1850–52," fols. 25, 31, 40, 68, March 5, 1851–February 10, 1852, New Orleans Public Library, City Archives, First Municipality Surveyor's Office Records, KG440; "The Place d'Armes," *Picayune,* October 18, 1845, March 30, 1849; *Delta,* November 3, 1850; *Picayune,* March 30, 1851; *Crescent,* April 25, 1851; *Picayune,* April 25, 1851.
6. The Jackson sculpture was a replica of a statue Mills cast for Lafayette Park in Washington in 1851. On the New Orleans statue, see Isaiah Rogers, *Diaries,* February 26, 1851, Avery Library, Columbia University; Mayor A.D. Crossman to the President and Members of the Council of the First Municipality, October 13, 1851, New Orleans City Papers, Manuscripts Department, Tulane University Library; Wharton, "Diary," February 9, 1856; "Jackson Monument Meeting," *Crescent,* January 8 and 13, 1851; "Meeting of the Jackson Monument Committee," *Delta,* May 5 and September 17, 1851; "Statue of Jackson," *Picayune,* August 23, 1853; "The Jackson Monument," *Crescent,* January 25, 1855; "Inauguration of the Jackson Statue," *Crescent,* January 11, 1856; "Inauguration of the Jackson Monument," *Carrollton Star,* February 16, 1856.
7. Abraham Oakey Hall, *The Manhattaner in New Orleans, or, Phases of "Crescent City" Life,* New York (J.S. Redfield); New Orleans (J.C. Morgan) 1851, p. 101.
8. *Crescent,* April 25, 1851; *Picayune,* November 16, 1856.
9. J. Mead, "Memory Types of New Orleans," in *Leaves of Thought,* Cincinnati (Robert Clarke) 1868, pp. 34–35 (and for quotations that follow).
10. *Picayune,* October 13, 1849; "Improvements," *Crescent,* July 2, 1850; "New Orleans Correspondence," *Concordia Intelligencer,* October 11, 1857; Dell Upton, "The Master Street of the World: The Levee," in *Streets: Critical Perspectives on Public Space,* ed. Zeynep Çelik, Diane Favro, and Richard Ingersoll, Berkeley (University of California Press) 1994, pp. 283–84.
11. The Baroness's biography has been written by Christina Vella, *Intimate Enemies: The Two Worlds of the Baroness de Pontalba,* Baton Rouge (Louisiana State University Press) 1997. Her life inspired Thea Musgrave's opera *Pontalba* of 2003.
12. *Picayune,* October 13, 1849; *Crescent,* July 16, 1866.
13. These buildings have traditionally been ascribed to James Gallier, whose 1849 plans for them are now in the New Orleans Public Library. Their attribution has been the subject of debate since the nineteenth century. Vella, *op. cit.,* pp. 277–87, argues for recognition of a greater role on the part of the client, the Baroness, in the design of the buildings.
14. "Improvements," *Crescent, op. cit.; Orleanian,* May 13, 1851.
15. *Delta,* November 3, 1850.
16. "Pontalba Buildings," *Picayune,* December 4, 1866.
17. Print sizes in the portfolio vary within an inch (2.5 cm) in height and width; all were trimmed, some more than others, to fit uniform mounts. The *Crescent* article "New Orleans and Vicinity at the Paris Exposition" (May 26, 1867) listed some of the subjects of the Paris Exposition views, including "Jackson Square and steamship landing from the Cathedral"—not the view shown here, which is taken in a northeasterly direction away from St. Louis Cathedral. The view cited in the *Crescent* inventory is one of twenty-four Paris portfolio views that are missing today. Also missing in the surviving portfolio is any view of the cathedral itself; no topography of the city would have been complete without a view of the cathedral church. A photograph of the building that represented imperial dominion in the former colony of New Orleans would also have made an appropriate gift for a visitor at the French court in Paris, a fact that may explain its loss.

14 *overleaf*
St. Louis Hotel
Hotel St. Louis

Lilienthal's stately view of St. Louis Street—the heart of the Creole district of the Vieux Carré—appears, at first glance, to be a street corridor in a French city. French-born architect J.N.B. DePouilly modeled the St. Louis Hotel, seen here, "after the finest specimens of French metropolitan architecture," and the Girod House, with roof dormers and belvedere in the foreground of the view, exemplified the transmission of French building practice to New Orleans.[1] Rebuilt following two great fires during the Spanish colonial period, the Vieux Carré reflected a dominant Spanish influence after 1794, but French-born architects continued to be active in New Orleans through the early decades of the nineteenth century.

Soon after the commission for the Exposition portfolio was announced in February 1867, the *Times* advised Lilienthal to include

> the old building at the corner of Chartres and St. Louis, which was built by Nicholas [Nicolas] Girod and tendered to Napoleon the first, as his residence, in the event of escape from St. Helena, to effect which escape a plot had been laid in this city, and money subscribed. This old building will attract the attention of no one passing along the street, but in its day it was regarded a grand and palatial edifice.[2]

The residence was built in 1814, when Girod was mayor of the city, probably to the design of Jean Hyacinthe Laclotte of Bordeaux.[3] It had a typical French arrangement of ground-floor shops, with casement doors that opened directly on to the street, and living rooms above, fine wrought-iron balconies, and a flat-tile roof. Girod, a Savoy native, had been a leader of a local scheme to provide refuge for Napoléon in New Orleans following his escape from Elba.[4] After the emperor's death, his physician Francesco Antommarchi reportedly opened an office in the building, which was later renamed Napoleon House in reference to its association with Napoléonic legend.[5] In Lilienthal's photograph, it is in use as a hotel.

Opposite was the most luxurious hotel of the Vieux Carré, the St. Louis Exchange Hotel. The first hotel on this site was built in 1835–38 as the Creole rival to the St. Charles Hotel of 1835–38, the pride of the American quarter

above Canal Street. DePouilly designed the St. Louis as the centerpiece of a master plan that included a mercantile exchange, public bath, banking house, and shopping arcade. A new street of united building fronts, Exchange Place, was to be cut through five city blocks to reach the front entrance of the hotel from Canal Street, but it was never realized (Exchange Alley, cut between Royal and Chartres streets, is a surviving remnant of the plan).[6] The hotel, which occupied nearly an entire square, was completed in the summer of 1838 at a cost of nearly $500,000.[7] Two years later it burned to the ground.[8] "In the destruction of that noble pile and splendid specimen of architecture ... a public calamity has befallen us," the *Picayune* wrote. Within hours of the conflagration a public subscription drive for reconstruction had begun.[9] "This noble building is again rising from its ruins," *Niles Weekly Register* reported in July 1840.[10] The new hotel reopened the following year.

The second St. Louis was a replica of DePouilly's first hotel, with modifications to the interior plan.[11] The hotel fronted a granite arcade of twenty-four bays built by Newton Richards, the city's most accomplished stonemason, with a projecting portico of four cast-iron Corinthian columns.[12] According to the *Picayune*, the St. Louis Street façade of the hotel was "the finest architectural uniform view on which the eye can rest," but it was overscaled for its restricted site in the narrow streets of the Vieux Carré.[13] "It is a great pity that its splendid façade is not more displayed," the *Picayune* added. "Space, however, which is of immense value in this neighborhood, does not permit of its being more exposed." Another observer warned that "one will almost break his neck in the narrow street it fronts endeavoring to catch a glimpse or two of its façade."[14]

The hotel's most admired feature was an 86-foot-high (26 m) copper-sheathed dome, which New Orleans architect and historian Nathaniel Curtis described as "one of the most remarkable structures in the history of American architecture":

> The dome-shell itself was very curiously constructed of hollow earthen pots of different sizes, laid closely together in annular rings These bear evidence of having been turned on a wheel, and are slightly tapered and exceedingly strong and light.[15]

The ceramic pots were set into a plaster-and-wrought-iron framework, a method of fireproofing and load-reduction apparently unprecedented in America and probably derived from Parisian models (the French architect Charles Louis Gustave Eck had published the clay-pot system, a revival of an ancient method of construction, in 1836–41).[16] By reducing the weight of the dome, DePouilly mitigated the problem of settlement of the building in the swampy soil.[17]

The dome sheltered a rotunda, 66 feet (20 m) in diameter, formed by sixteen Corinthian columns, 55 feet (17 m) high, with carved black cypress capitals, themselves nearly 5 feet (1.5 m) in height. A 14-foot (4-m) oculus illuminated the interior, which was stuccoed and colored in imitation of marble. The floor was paved with Italian marble in a geometric pattern. Frescoed panels in the soffit depicted patriotic scenes of the Revolution and niches carried sixteen portrait-heads of Washington, Franklin, Jefferson, and other statesmen.

Considered one of the most imposing interior spaces in the country, the rotunda was as inglorious as it was grand. It was there, below the pantheon of heroes celebrating the American Republic, that auction sales of slaves took place before the war.[18] "A succession of platforms are to be seen, on which human flesh and blood is exposed to public attention," one antebellum visitor wrote, "and the champions of the equal rights of man are thus made to endorse, as it were, the sale of their fellow-creatures."[19] The "privilege of beholding their benevolent countenances," another traveler observed, "was, doubtless, duly valued by the slaves who had the good fortune to be sold in the Rotunda."[20]

The slave market was a meeting point of New Orleans's bilingual culture, where "ranting auctioneers, who cry their sales in alternate French and English," presided.[21] The French traders, known as *encanteurs*, always "formed into little groups," one observer wrote, to review the latest opera or the next fancy ball, anything other than business, which they always conducted with equanimity, their minds "never care-clogged."[22] The Americans at the Exchange, on the other hand, were agitated, "pacing up and down the hall ... watching the revolution of clock-hands, which at noon proclaim the opening of business, with a kind of feverish anxiety. From the rapidity with which they describe swamp cities and advantageous locations for

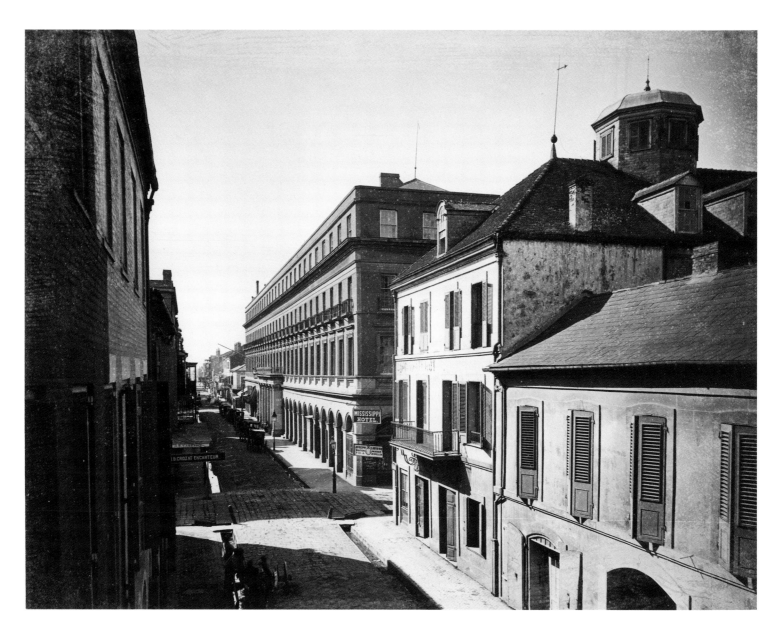

'thriving villages,' you would imagine they were all professional topographers."[23]

In Lilienthal's photograph, an auctioneer who traded at the St. Louis before the war addresses the French community with his signboard over St. Louis Street: "J.B. Crozat Encanteur" (the other side, visible in another photograph [cat. 15], was in English). Creole auctioneers' incomes were among the highest in the community, and in good years commissions could exceed $15,000.[24] It was a time, one Orleanian later recalled, when "the Creoles of Louisiana reigned supreme in society" and "everybody seemed happy, with plenty of money."[25]

A renovation in 1859 introduced gaslight throughout the hotel, private baths on every floor, public baths at street level, and 125 additional rooms.[26] During the occupation of New Orleans, the U.S. military appropriated the hotel as a hospital for both Union and Confederate soldiers. In late 1865, abandoned by the military, it was reported to be "silent and deserted," with "a most forlorn appearance."[27] One visitor found the closed hotel a "story of ruin and desolation."[28]

A renovation in 1866 brought back at least some of the hotel's prewar splendor. "The one thing in New Orleans which no city on the continent could match," the St. Louis was again "the pride of New Orleans below Canal street, as the St. Charles is of New Orleans above Canal," the *Picayune* wrote, referring to the old rivalry between the Creole community of the Vieux Carré and the neighboring Anglo-American district.[29] New Orleans in the 1860s was still a polyglot though segregated city of French- and English-speaking cultures, each with its own hotel, theater, cafés, and law courts. "New York and Paris are not so widely separated as the French and Yankee portions of New Orleans," one antebellum visitor observed."[30] Another traveler found that many Creoles of the Vieux Carré "never crossed to the American town or spoke one word of English."[31]

The postwar reopening of the St. Louis was short-lived, however, and by 1871 the hotel was in the hands of the Citizens' Bank. Its location, "in the French part of the city away from business," was blamed for the failure, but accommodation for less than half the number

of guests as at the rival St. Charles (which could house 1100) was a greater shortcoming.[32] New investors refurbished and reopened the hotel, and added a magnificent cast-iron gallery, but it failed again in the summer of 1873.[33]

The later *fortuna* of the St. Louis was remarkable. In 1874, the building was renovated as the state capitol, and the rotunda that had once been a slave market became a Senate chamber.[34] When Mark Twain visited the building in 1882, after the statehouse had relocated to Baton Rouge, he was reminded of "a vast privy ... [which] hasn't been swept for 40 years."[35] Again restored and reopened for New Orleans's World's Industrial and Cotton Centennial Exposition of 1884–85, and renamed the Royal Hotel, it operated for another twenty years. In 1905, costly renovations of half a million dollars brought new life to the building. But the venture ultimately failed and the hotel was again abandoned.[36]

In 1912, ruined and in use as a stable, the building's "deserted grandeur" inspired the English writer John Galsworthy's essay "That Old Time Place."[37] A hurricane in 1915 came as a deathblow, and despite efforts to save the famous rotunda and incorporate it into a convention center, the ruined building was finally sold to a wrecking company.[38] The finer elements of the building were scavenged, including the portico's cast-iron columns, which were reused for the façade of a psychiatric hospital in Indiana.[39] The site was put to use as a lumber yard and parking lot until in 1956–60 a new hotel, the Royal Orleans, was built there, reproducing design elements of the St. Louis and incorporating granite from the old building.[40]

The destruction of the St. Louis was condemned by historians and architects including Nathaniel Curtis, to whom the hotel was "the most important building erected in New Orleans during the last century, far outranking as architecture any other historic building situated within the old quarter of the city."[41] Talbot Hamlin, a Columbia University historian, mourned the loss of the St. Louis as "one of those architectural tragedies too numerous in American cities."[42]

1. "The St. Louis Hotel," *Picayune*, March 30, 1839.

2. "The Portfolio," *Times*, February 28, 1867.

3. "The Environs of New Orleans," *Crescent*, July 2, 1866; Samuel Wilson, Jr., *The Architecture of Colonial Louisiana*, ed. J.M. Farnsworth and A.M. Masson, Lafayette (Center for Louisiana Studies, University of Southwestern Louisiana)

1987, pp. 358–61.

4. *New Orleans City Guide*, Boston (Houghton Mifflin) 1938, p. 266.

5. Antommarchi came to New Orleans in November 1834. He presented his death mask of Napoléon to the city; it is now in the Louisiana State Museum.

6. Mills Lane, *Architecture of the Old South: Louisiana*, New York (Abbeville Press) 1990, pp. 35–37 (with contributions on DePouilly by Ann Masson). DePouilly's work is documented in an extensive surviving archive of drawings and sketchbooks in The Historic New Orleans Collection and the New Orleans Notarial Archives.

7. Jefferson Williamson, *The American Hotel*, New York (Arno Press) 1975, p. 98.

8. David D. Dana, *The Firemen: The Fire Departments of the United States*, Boston (James French and Co.) 1858, p. 125; Request for Proposals in the *Courier*, June 24, 1835; *Courier*, January 14, 1837. DePouilly's plan was selected from among eight competitors. The building opened three years later; *Courier*, June 10, 1838. See also *Gibson's Guide*, pp. 329–40. The hotel was financed by the New Orleans Improvement and Banking Company, which built a banking house (later the Citizens' Bank) behind the hotel, also designed by DePouilly.

9. "Destructive Conflagration," *Picayune*, February 12, 1840.

10. *Niles Weekly Register*, LVIII, no. 1, July 1840, p. 309.

11. Building contracts, September 23, 1835, F. Grima, VII, no. 500; for carpentry and other work, New Orleans Improvement and Banking Company, September 28, 1835, F. Grima, VII, no. 504; J.N.B. DePouilly and various parties, May 26–June 7, 1838, Joseph Cuvillier, XVIII, nos. 28, 37, 38, 56, 58, all in NONA. Newspaper and guidebook notices documenting the history of the hotel, from the destruction of the first St. Louis, are as follows: "Destructive Conflagration," *Picayune*, February 12, 1840; "Benefit to Aid in the Erection of the St. Louis Exchange," *Picayune*, February 22, 1840; *Picayune*, June 14, 1840; *Courier*, June 11, July 16 and 21, 1841; *Courier*, October 14, 1845; *Picayune*, March 30, 1849; *Norman's New Orleans and Environs*, pp. 157–59; "Alterations to the St. Louis Hotel," *Picayune*, April 1, 1851; "Entire Renovation of the St. Louis Hotel," *Crescent*, September 12, 1859; "Reopening of the St. Louis Hotel," *Times*, January 1, 1866; "St. Louis Hotel," *Picayune*, January 9, 1866; "The St. Louis Hotel," *Times*, October 24, 1866; "Opening of the St. Louis Hotel," *Picayune*, October 24, 1866; "The St. Louis," *Picayune*, November 20, 1866; "The St. Louis Hotel," *Picayune*, December 21, 1866.

12. Newton Richards to John Slidell, May 22, 1856, General Correspondence, Letters Received, New Orleans Marine Hospital, Records of the Public Buildings Service, RG121, NARA, in which Newton cites the hotel as one of his projects. Richard's plan for the original arcade is in Building contract, September 23, 1835, F. Grima, VII, no. 500, NONA.

13. "The St. Louis Hotel," *Picayune*, December 31, 1865.

14. Abraham Oakey Hall, *The Manhattaner in New Orleans, or, Phases of "Crescent City" Life*, New York (J.S. Redfield); New Orleans (J.C. Morgan) 1851, p. 17.

15. N.C. Curtis, "The Work of the Louisiana Chapter in Urging the Preservation of the Historic Architecture of New Orleans," *Journal of the American Institute of Architects*, IV, May 1916, p. 222.

16. Charles Louis Gustave Eck, *Traité de Construction en Poteries et Fer*, Paris (Carilian-Goery) 1836–41, cited by Turpin C. Bannister, "The Roussillon Vault: The Apotheosis of a 'Folk Construction,'" *Journal of the Society of Architectural Historians*, XXVII, no. 3, October 1968, p. 175, n. 84–85. Bannister noted DePouilly's use of the system at the St. Louis, a fact that had been brought to light after hurricane damage to the dome

in 1915 and published by New Orleans architect and preservationist Nathaniel Cortland Curtis in several publications: "Demolition of the St. Louis Hotel Rotunda," *Building Review*, March 18, 1916, p. 5; "Dome of the Old St. Louis Hotel," *Architectural Record*, XXXIX, April 1916, pp. 355–58; "Work of the Louisiana Chapter," *op. cit.*; and later summarized in *New Orleans, Its Old Houses, Shops and Public Buildings*, Philadelphia (J.B. Lippincott) 1933, pp. 174–79. The method was in use in Paris by the 1780s in Victor Louis's theatre at the Palais Royal, and in London in the 1790s, notably in the domed ceiling of Sir John Soane's Bank of England Stock Office, which is discussed in Daniel Abramson, *Building the Bank of England: Money, Architecture, Society, 1694–1942*, New Haven, Conn. (Yale University Press) 2005. A related method of hollow-tile fireproofing was taken up later by Frederick A. Peterson in the Cooper Institute, New York, in 1853–59, and by other American architects. See Cecil D. Elliott, *Technics and Architecture*, Cambridge, Mass. (MIT Press) 1992, pp. 45–46; Sara Wermiel, "The Development of Fireproof Construction in Great Britain and the United States in the Nineteenth Century," *Construction History*, IX, 1993, pp. 7–9; and ead., *The Fireproof Building: Technology and Public Safety in the Nineteenth-Century City*, Baltimore (Johns Hopkins University Press) 2000, p. 85.

17. Curtis estimated that had the dome been constructed by conventional means it would have weighed 800 tons; Curtis, "Dome," *op. cit.*, p. 358.

18. Henry A. Murray, *Lands of the Slave and the Free*, London (G. Routledge & Co.) 1857, pp. 111–12.

19. John S. Kendall, "Shadow over the City," *Louisiana Historical Quarterly*, XXII, January 1939, pp. 150ff.

20. Murray, *op. cit.*

21. Matilda Charlotte Houstoun, *Hesperos: Or, Travels in the West*, London (J.W. Parker) 1850, II, p. 56.

22. Abraham Oakey Hall, *The Manhattaner in New Orleans, or, Phases of "Crescent City" Life*, New York (J.S. Redfield); New Orleans (J.C. Morgan) 1851, p. 17.

23. "City Exchange—St. Louis street," *Picayune*, May 24, 1839.

24. Frederic Bancroft, *Slave Trading in the Old South*, New York (Ungar) 1959, p. 338.

25. Cuthbert Bullitt, "Remembrance of New Orleans and the Old St. Louis Hotel," *Louisiana Historical Quarterly*, IV, no. 1, January 1921, pp. 128–29.

26. *Crescent*, September 12, 1859.

27. "The St. Louis Hotel," *Picayune*, December 31, 1865.

28. Henry Deedes, *Sketches of the South and West; or Ten Months Residence in the United States*, Edinburgh (W. Blackwood and Sons) 1869, p. 112.

29. "Hotel Life," *Picayune*, October 28, 1866.

30. Thomas Low Nichols, *Forty Years of American Life, 1821–1861*, London (J. Maxwell) 1864, I, p. 189.

31. Thomas Cooper DeLeon, *Four Years in Rebel Capitals: An Inside View of Life in the Southern Confederacy, from Birth to Death*, Mobile, Ala. (Gossip Printing Co.) 1890, p. 63.

32. *Louisiana*, vol. II, p. 1, R.G. Dun & Co. Collection, Baker Library, Harvard Business School.

33. On the 1871 renovation, see *Jewell's Crescent City Illustrated*. Lilienthal's photograph of the St. Louis for *Jewell's Crescent City Illustrated* prospectus emphasized the new cast-iron gallery, described as "new in pattern, elegant and unique in design."

34. "The New State House," *Picayune*, April 16, 1874.

35. Mark Twain, *Notebooks & Journals*, ed. F. Anderson, Berkeley (University of California Press) 1975, II, p. 550.

36. *Times-Democrat*, February 20, 1905.

37. John Galsworthy, "That Old Time Place," in *The Inn of Tranquility*, London (Heinemann) 1912.

38. *Times-Picayune*, September 30, 1915; N.C. Curtis, "Demolition of the St. Louis Hotel Rotunda," *op. cit.*, p. 5. Photographs by Charles Franck of the exposed dome construction are in the Southeastern Architectural Archive, Tulane University.

39. The columns were later donated to the Louisiana State Museum when the Indiana Insane Hospital in Richmond was demolished; Robert Glenk, *Handbook and Guide to the Louisiana State Museum*, New Orleans 1934, p. 246.

40. *Item*, September 27, 1916; *Times-Picayune*, November 26, 1916.

41. N.C. Curtis, "Work of the Louisiana Chapter," *op. cit.*

42. Talbot Hamlin, *Greek Revival Architecture in America*, New York (Oxford University Press) 1944, p. 225.

15
Louis Phillipe's place of concealment during his stay in New Orleans

Louis-Philippe, Duc d'Orléans and future King of France (1830–48), arrived in America in late 1796, a refugee of the revolutionary French government. In Philadelphia he joined his younger brothers, Antoine and Louis-Charles, who had been released from imprisonment at Marseilles and exiled to the United States. As Louis-Philippe wrote in his *Memoirs*, from Philadelphia the brothers were "reduced to wandering together over the vast expanse of the United States, always without other resources than the assistance of a few friends."[1] In a long excursion through the western territories, the brothers reportedly "camped for seventy nights in forests," and attempted to settle in the East. In February 1798 they traveled to New Orleans, then a Spanish colony, to seek passage to Havana and eventually to Spain, where they hoped to join their exiled mother.[2]

During a five-week stay in New Orleans, Louis-Philippe and his brothers were feted by the French community.[3] Valcour Aîme, a wealthy planter, hosted opulent dinner parties in the princes' honor, as did Jean Étienne Boré, later mayor of New Orleans, at his plantation near today's Audubon Park.[4] The Convent of the Ursulines received the brothers, "happy to

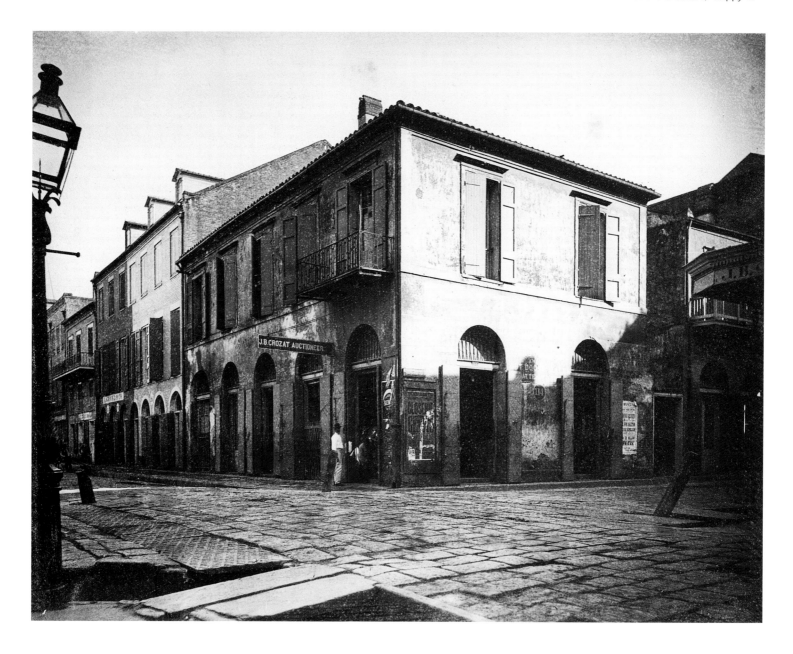

honor, in its own way, the descendants of Kings who had contributed to its foundation as well as to its maintenance."[5]

Local tradition associated Louis-Philippe's visit not with the house Lilienthal photographed, at the corner of Chartres and St. Louis streets, but with the Lalaurie residence on Royal Street, known from the 1840s as the "Haunted House."[6] A visitor to New Orleans in 1850 described the Lalaurie residence:

> [W]e visited the house once occupied by Louis-Philippe, in the early part of his eventful life. It is a detached house, by no means large, and is situated in that quarter of the city still inhabited by the remains of the French *noblesse*[;] it is ... pointed out with great respect to strangers, as the abode of the son of 'Egalité.'[7]

The *entresol* house with a tile roof shown here was built around 1795 for Jean Paillet, a native of Marseilles, possibly by the builder–architects Gurlie and Guillot, who both married into the Paillet family.[8] From the 1830s, when the nearby St. Louis Exchange opened as an auction market for slaves (cat. 14), real estate, and other properties, the Paillet residence housed auctioneers' rooms. The house still stands, and has no known historical connection with Louis-Philippe.

"Years ago Chartres Street had the reputation of being the grand ... promenade of beauty and fashion," the *Picayune* wrote in 1866.[9] It was the main retail street for the French community, and for visitors looking for the latest imports from Paris—"the first place visited by the wealthy planters' wives and daughters on coming to the city," according to local author J. Mead.[10] But after the war the street had not recovered its antebellum luster. "What a change has come over it!" Mead observed. "Proud *Rue de Chartres* now wears a rueful face; it sits disconsolate in its old clothes, looking more like one of the streets of ancient Damascus. Still, it is remembered for its former greatness, and in common with other ruins, deserves to be recorded among the spots of New Orleans."[11]

Lilienthal's low vantage point enhances the viewer's sensation of inhabiting the street. The gaslight that defines the edge of the frame, the foreground geometry of paving blocks, the drainage channel directly underfoot, the bollards and the signboards on the café wall,

all appear to share the viewer's immediate space and contribute to a sense of intimacy with the place of the photograph. The horseless cart and the bilingual sign of auctioneer J.B. Crozat are also seen in cat. 14.

1. Louis-Philippe, *Memoirs, 1773–1793*, trans. John Hardman, New York (Harcourt Brace) 1973, pp. 421–22.
2. Louis-Philippe, *Diary of My Travels in America*, trans. Stephen Becker, New York (Delacorte Press) 1977, p. 166.
3. Local accounts of Louis-Philippe's reception in New Orleans were collected in Helene Robbins, "When a Future King: The Pilgrimage of Louis Philippe to New Orleans," *Times-Picayune*, March 4, 1928.
4. *New Orleans Architecture*, VIII, p. 25.
5. Convent of the Ursuline Nuns, Ursuline Annals, II, ch. 15, p. 9, cited in J. Edgar Bruns, *Archbishop Antoine Blanc Memorial*, New Orleans (Archdiocese of New Orleans) 1981, p. 27.
6. Marie L. Pointe, "The Haunted House," *Picayune*, March 13, 1892, and *States*, January 18, 1920: both discuss the association of the Lalaurie house at the Governor Nichols Street corner with Louis-Philippe, but the house is securely dated to 1831, after Louis-Philippe's visit to New Orleans. The Ursulines owned this property in 1798, and Louis-Philippe is reported to have been hosted by the Ursulines, but there is no record of an Ursuline structure on this lot (*Vieux Carré Survey*, "Square 50, Lot No. 22782–30"). Author George Washington Cable made the Lalaurie house famous in a story published in *Century Magazine* and reprinted in *Strange True Stories of Louisiana*, New York (C. Scribner) 1889. See Christopher Benfey, *Degas in New Orleans: Encounters in the Creole World of Kate Chopin and George Washington Cable*, Berkeley (University of California Press) 1999, pp. 31–46, 214–226; *The Picayune's Guide to New Orleans*, New Orleans (The Picayune) 1904, pp. 24–26.
7. Matilda Charlotte Houstoun, *Hesperos: Or, Travels in the West*, London (J.W. Parker) 1850, p. 152.
8. *Vieux Carré Survey*, "440 Chartres Street." The Paillet house was often mistakenly known as "Maspero's Exchange," which was located between 1814 and 1822 on the opposite corner, where the St. Louis Hotel was later erected. See Samuel Wilson, Jr., "Maspero's Exchange: Its Predecessors and Successors," *Louisiana History*, xxx, no. 2, Spring 1989, pp. 191–220.
9. "Canal vs. Chartres Street," *Picayune*, February 1, 1866.
10. J. Mead, "Memory Types of New Orleans," in *Leaves of Thought*, Cincinnati (Robert Clarke) 1868, p. 44.
11. *Ibid.*, p. 45.

16 *overleaf*
French Opera House
Opera Français

In 1796, New Orleans became the first city in the country to organize a permanent opera company. Dozens of operas had their American premieres in its early theaters, the St. Pierre, the St. Philippe, and Théâtre d'Orléans.[1] By the 1860s, the city's most famous opera venue was the French Opera House at Toulouse and Bourbon streets, designed by James Gallier, Jr., with Richard Esterbrook, for the theater impresario Charles Boudousquié.[2] Work on the stuccoed brick theater began in the fall of 1859. In October the antique structures at the site were "going off piecemeal in carts," the *Crescent* reported, while the architects were completing working drawings.[3] Construction proceeded with "astonishing rapidity" around the clock (at night by torchlight).[4] In only eight months what was called "the finest theater ever built in the South" was open for its first season.[5]

The *Delta* praised the auditorium as "the largest and finest proportioned ever designed in this city."[6] Elliptical in plan, the hall was 56 feet (17 m) from pit to ceiling and 90 feet (27.5 m) wide, and had latticed boxes on each side of the *parquette* and open boxes, or *baignoires*, enclosing the pit. Twelve stage boxes and four tiers of seats seated 1600 spectators (free blacks were admitted only to the highest tiers). Four 32-foot (10-m) Corinthian columns on 10-foot (3-m) pedestals supported the proscenium arch, framing a stage 60 feet (18 m) deep and 85 feet (26 m) wide. In designing the auditorium, Gallier was said to have taken as his model Carl Ferdinand Langhans's Berlin Staatsoper of 1844, a building greatly admired for its acoustics.

The exterior Bourbon Street front rose 161 feet (49 m), towering "like a Colossus over everything in that vicinity," according to the *Delta*.[7] An arcade sheltered a café and shop-fronts of upscale merchants that were geared to opera patrons. The façade was generally admired, particularly the corner angle, which was cut off, "giving the edifice a more graceful form."[8] But Gallier's fellow architect, the reproachful Thomas K. Wharton, found the building deficient and inventoried its defects: "sorry to remark the usual effect of hasty building—evidence of unequal subsidence— bad brickwork—immense mortar

joints—cracks everywhere—and the construction, though bad, was no worse than the design and details of the exterior, which are simply abominable."[9] One of the heavy exterior walls had settled and cracked, and was reportedly "so much glared at and so much talked about" that the architects had it pulled down and rebuilt.[10] Any lingering doubts about the building's construction and safety were addressed in a testimonial from the City Surveyor, who was "fully satisfied" as to the structure's "solidity and strength."[11]

Although war interrupted a brief but acclaimed antebellum opera calendar, performances continued to be staged, for audiences that now included the city's federal occupiers. Union Captain John C. Palfrey, a Bostonian, attended a performance of a sixpenny opera in the spring of 1864 with the wife of General Nathaniel Banks, the federal commander. "Mrs. Banks had made up a party, taken ... four stage boxes, & invited our Boston friends," Palfrey wrote to his family, "& this part of the house really looked very stylish."[12] He thought the Opera House the "loveliest theater" he had ever seen.[13]

After the war Opera House attendance dropped, and in early 1866 the theater and all the "decorations, scenery, wardrobe and library" were up for sale.[14] For some the Opera House was now an exclusively Creole institution that was "full of brilliant reminiscences" but did not reflect contemporary taste in music or architecture, and was located "in a neighborhood too far from the center of the city"—the financial and government center of the Anglo-American quarter above Canal Street.[15] While residents of that quarter pressed for their own theater, new owners acquired the Opera House, had it refurbished, and hired a resident opera company from Paris. Tragedy crushed hope for a revival, however, when all fifty-nine members of the company drowned at sea with the sinking of the steamship *Evening Star*, bound for New Orleans from New York in October 1866.[16] Theater owners were able to bring out productions with itinerant companies for the new season,

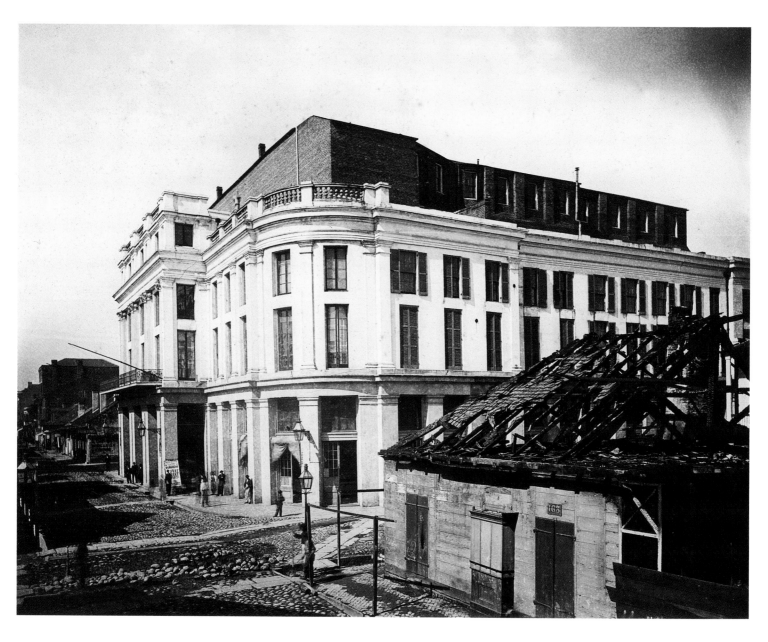

including a dramatization of Eugène Sue's enormously popular *The Wandering Jew*, staged in April 1867, advertised on the signboard in the photograph.[17] Attending performances "without noting or caring for the hours, sometimes until 2 o'clock in the morning," Orleanians again recognized, the *Bee* wrote, how much opera contributed to the "elegant pleasures" of city life and "the fame and luster" of New Orleans.[18] By the end of the century the house had staged operas by Massenet and Saint-Saëns and fifteen other works for their American premieres.[19]

Opposite the Opera House, at 123 Bourbon Street, was the Charles Gayarre house, built in 1777 and destroyed by fire shortly before this photograph was made.[20] Lilienthal's framing emphasizes the fire ruin rather than the architectural form of the Opera House itself. The interest of the photograph lies in its reportorial power—the narrative suggested by the ruin—and in photography's ability to capture a particular moment in time. A stereoview by Lilienthal made at a slightly earlier or later moment also depicts laborers repairing the cobblestone street (fig. 86).

Damaged in a hurricane in 1915, the Opera House was repaired and reopened for a new season in 1919, but a few months later it was destroyed by fire, together with its valuable archive of scores, props, and costumes.[21] Today the site is occupied by a hotel, built in 1959–60 when tourism, especially in the Vieux Carré's Bourbon Street club quarter, was on the rise.[22]

1. John Joyce and Gwynn Spencer McPeek, "New Orleans: Opera," in *Grove Dictionary of Music Online*, ed. L. Macy, grovemusic.com (accessed January 10, 2005).
2. Building contracts, A. Boudousquié, CV, nos. 73, 421, April 19, 1859; "Our New Opera House," *Picayune*, April 17, 1859, NONA.
3. "The New Opera House," *Crescent*, October 17, 1859.
4. "New Opera House," *True Delta*, October 6, 1859.
5. "The New Opera House," *Crescent, op. cit.*
6. "The New Opera House," *Delta*, May 3, 1859 (a description based on the Gallier and Esterbrook drawings).
7. "The New Opera House," *Delta, op. cit.*
8. "The New Opera House," *Picayune*, December 1, 1859.
9. Wharton, "Diary," September 24, 1859.
10. "The New Opera House," *Crescent, op. cit.*
11. *Picayune* (advertisement), December 1, 1859, cited in "The Architecture of James Gallier, Jr.: The French Opera House," *Gallier House Quarterly Bulletin*, IV, Spring 1983.
12. John C. Palfrey to Francis W. Palfrey, New Orleans, April 3, 1864, John Carver Palfrey Papers, Massachusetts Historical Society.
13. Gerald M. Capers, *Occupied City: New Orleans Under the Federals 1862–1865*, Lexington (University of Kentucky Press) 1965, p. 209. Capers quotes from the collection of Palfrey letters in Houghton Library, Harvard University.
14. "A Rare Chance for Investment," *Picayune*, March 3, 1866.
15. "To Build a New Theatre," *Times*, November 15, 1866; *Ancient New Orleans: The French Opera*, New Orleans (Southern Pacific Railroad) c. 1896.
16. James Gallier, father of the Opera House designer and the leading architect in New Orleans before the war, also drowned in the *Evening Star* disaster. "Loss of the Evening Star," *Times*, October 15, 1866; "The Evening Star Disaster," *Times*, October 21, 1866; "The Evening Star Calamity," *Times*, October 22, 1866.
17. Sue published the strongly anticlerical play, based on his serialized novel, in Paris in 1849. "The French Drama," *Picayune*, April 7, 1867; "Eugène Sue," *Dictionary of Literary Biography*, Detroit (The Gale Group) 1992, MXIX, pp. 300–11.
18. "Reopening of the Opera House," *Bee*, November 5, 1866; "The French Drama," *Picayune*, May 4, 1867.
19. Joyce and McPeek, *op. cit.*
20. *Vieux Carré Survey*, V, p. 8. The burned-out structure has been rebuilt and occupied by Jules Himbert's "Charcuterie Parisienne" in Lilienthal's remake of this view for *Jewell's Crescent City Illustrated* in 1872.
21. *Times-Picayune*, December 5, 1919.
22. *States-Item*, April 28, 1959.

17 *overleaf*
U S Mint
La Monnaie

The United States Branch Mint was located at Esplanade Street and the Levee, an area reserved for military and government functions since colonial times. In 1835, Congress established the Mint there in proximity to wharves where shipments of gold could be landed. The architect was William Strickland of Philadelphia. More than any other architect, Strickland was responsible for the nationwide acceptance of Greek forms, and here he applied the style magnificently in a three-story, stuccoed brick building with granite detailing and a stately Ionic portico.[1]

The main vaulting of Strickland's building was supported by piers independent of the walls, a feature designed to compensate for the inevitable settlement of the heavy masonry in New Orleans's marshy soil.[2] When completed in 1838, at a cost of $327,500, the Mint was described by the *Courier* as "a massive pile with center and wings, throwing up the tower of a blast furnace."[3] It was said to be modeled after the U.S. Mint in Philadelphia, attributed to Strickland and begun in 1829.[4]

Structural problems arose after completion, and a succession of architects and engineers, including James Gallier, James Dakin, and P.G.T. Beauregard were called in to oversee modifications. Treasury Supervising Architect

Ammi Young warned in 1854 that unless "prompt measures" were taken to secure the building and make repairs it would "soon be a mass of ruins," and three years later major renovations were carried out.[5] Superintending architect and West Point-trained engineer Beauregard, who found "much bad material and worse workmanship in the structure," addressed seriously bowed walls and unstable foundations, expending nearly another $300,000 on repairs and fireproofing.[6]

The most visible feature of Beauregard's renovation was a 60-foot-tall (18 m) chimney in the rear yard that vented the basement smelting furnace. In 1856, after driving piles to a depth of 34 feet (10.5 m), Beauregard raised a plastered-brick stack, embellished with an Egyptian capital and set on a Doric pedestal, massive enough to carry the immense weight of the shaft. The work was skillfully designed and executed, as would be expected of a West Point-trained military engineer with twenty years' experience on federal building projects, and Beauregard also took care (at considerable cost) to give the chimney an elegance not always found on utilitarian structures.[7] It was an approach to industrial form echoed by the periodical *Building News*, when it advised architects that the "much despised" chimney was "as suitable for the exercise of his talent as any column which he could possibly erect …. [It] affords ample opportunity for the display, not alone of talent, but [also] of genius."[8] For the viewer of the photograph, the prominence of the Mint chimney is a reminder of the ubiquity of the smokestack in the nineteenth-century cityscape, and that, as an element of urban architectural form, it was subject, like church towers and cemetery gates, to measured design considerations and even to pattern-book excess.[9] At the Mint, and everywhere else they appeared in the city, smokestacks were highly visible markers for the common urban environmental hazards of the era.

To an Orleanian in 1867, the U.S. Mint carried symbolic and bitter associations with the federal occupation. The city had been lost to Union control on the morning of April 24, 1862, when U.S. Admiral David Farragut ran his gunboats into New Orleans and cleared the way for General Benjamin Butler's army. Reclaiming the Mint for the United States, Farragut's men raised the U.S. flag (the flagstaff is faintly visible in the photograph),

but a local gambler named William Mumford intervened and, according to the Louisiana governor Thomas Moore, "pulled down the detested symbol with his own hands."[10] A mob of protesters tore the flag apart while a Union gunboat in the river fired volleys from its howitzers to disperse them. Mumford was swiftly apprehended and convicted of sedition by a military court. Butler ordered his execution to be carried out where he had defied the federals, and on June 7, 1862, Mumford was hanged "from a beam adjusted between the two center columns" of the Mint's portico.[11]

Mumford's life "was justly forfeited," Butler's biographer, James Parton, later wrote. "His life was, moreover, not a valuable one ... he was one of those who live by preying upon society not by serving it."[12] But in New Orleans and throughout the South, Mumford was seen as a martyr for the Confederacy, and Butler, his executioner, was reviled. "Everyone is fired with indignation at the atrocious *wonder* of yesterday, the hanging of Mumford," diarist Clara Solomon exclaimed. "God, help us to revenge it."[13] A British newspaper asserted that "the intemperate and seemingly half-crazy soldier," Butler, had "converted smouldering discontent into frenzied hatred."[14] The President of the Confederacy, Jefferson Davis, declared Butler "a felon deserving of capital punishment" for Mumford's death, and in Charleston a reward of $10,000 was offered

for Butler's "capture and delivery, dead or alive, to any proper Confederate authority."[15] According to Butler himself, "[t]hreats of retaliatory vengeance came from the governor of Louisiana, and were circulated by all the cognate rascals south of the Mason and Dixon's line."[16]

After the war, the future of the Mint was uncertain. "Like all old buildings which have been built for business, and whose halls are deserted," the *Crescent* lamented in 1866,

[the Mint] has a melancholy appearance, to which the rank growth of the grass and shrubbery contributes, and the recollection that upon the portico facing Esplanade

street the unfortunate Mumford, the victim of Butler's cruelty, met his sad end. The building is of little use at present, and we much doubt will be soon or ever again devoted to the object for which it was planned.[17]

When Lilienthal made this photograph, the Mint housed offices of the U.S. Lighthouse Service and was reportedly "in much need of repair."[18] In 1869, the Supervising Architect of the U.S. Treasury found the building to be "of very little practical value to the government" and recommended its sale, but it was retained by the Treasury and minting operations resumed in 1879.[19] The Mint issued silver coinage until 1909, when the Treasury closed the New Orleans branch. Thereafter the building served many government bureaus, and in 1931 it was renovated for a federal prison. By 1964, it was vacant and up for sale. The State of Louisiana acquired the building two years later, but not until the late 1970s did major renovation work begin. In 1981, the old Mint reopened as a research center for the Louisiana State Museum, a function it retains.

Lilienthal's view is of the commercial back door of the Mint, an unusual perspective from the corner of Barracks and Levee (North Peters) streets. The viewpoint brings into prominence Beauregard's chimney (demolished in the renovation of 1931) and the foreground construction site for the Barracks line of the City Railroad.[20]

1. Call for proposals is at "Mint at New Orleans: To Architects and Builders," *Bee*, May 11, 1835; Building contract with Strickland's specifications and plans, J. Cuvillier, August 22, 1835, NONA. On the early history of the Mint, see *Gibson's Guide*, p. 328; *Norman's New Orleans and Environs*, p. 88; John L. Riddell, *The Branch Mint at New Orleans*, New Orleans (n.p.) 1847; U.S. Bureau of the Mint, New Orleans, *General Regulations for the United States Branch Mint*, New Orleans (P. Durel) 1854; *Report of the Secretary of the Treasury, on the State of the Finances, for the Year Ending June 30, 1858*, 35th Cong., 2d sess., S. Ex. Doc. 2, Washington, D.C. (William A. Harris) 1858; James Gallier, *The Autobiography of James Gallier, Architect*, Paris (E. Brière) 1864, p. 36; *Letter of the Secretary of the Treasury ... in relation to the present condition of the United States branch mint at New Orleans, Louisiana*, 41st Cong., 2d sess., S. Ex. Doc. 24, Washington, D.C. (Government Printing Office) 1870; *Letter of the Secretary of the Treasury ... in relation to removing the United States branch mint from the city of New Orleans*, 41st Cong., 2d sess., S. Ex. Doc. 55, Washington, D.C. (Government Printing Office) 1870; *Letter of the Secretary of the Treasury ... in relation to the branch mint at New Orleans ...*, 42d Cong., 2d sess., S. Ex. Doc. 7, Washington, D.C. (Government Printing Office) 1872; *Jewell's*

Crescent City Illustrated; *A Brief Description of the U.S. Mint at New Orleans*, New Orleans (I.T. Hinton) 1880; *A History of Public Buildings under the Control of the Treasury Department*, Washington, D.C. (Government Printing Office) 1901, p. 211. *New Orleans Architecture*, IV, pp. 11–17. On minting operations, see "The Mint," *Picayune*, October 31, 1840; Al Wilson, "Minting Memories," *Roosevelt Review*, II, no. 4, March 1939, p. 55.
2. Agnes Addison Gilchrist, *William Strickland, Architect and Engineer, 1788–1854*, New York (Da Capo) 1969, p. 91.
3. "Sketches of New-Orleans," *Courier*, June 1, 1838.
4. The design of 1829 for the Philadelphia Mint is also attributed to John Haviland; see *Drawing Toward Building: Philadelphia Architectural Graphics, 1732–1986*, Philadelphia (Pennsylvania Academy of the Fine Arts; University of Pennsylvania Press) 1986, pp. 72–74.
5. Ammi Young to Treasury Secretary James Guthrie, June 27, 1854, Letters Sent Chiefly by the Supervising Architect and the Engineer in Charge, Records of the Public Buildings Service, RG121, NARA.
6. Capt. J.K. Duncan to Secretary of the Treasury Howell Cobb, "Annual Report for the Fiscal Year Ending June 30, 1857," General Correspondence, Letters Received, 1843–1910, New Orleans Mint, Records of the Public Buildings Service, RG121, NARA.
7. "Chimney Stalk. U.S. Branch Mint N.O.," plan, elevation, and section, 1856. Records of the Public Buildings Service, RG121, Cartographic Division, NARA; J.K. Duncan to Treasury Secretary James Guthrie, September 3, 1856; Duncan, "Annual Report for the Fiscal Year Ending June 30, 1857," *op. cit.*
8. *Building News*, XI, July 15, 1864, p. 535, cited by Edgar Jones, *Industrial Architecture in Britain 1750–1939*, New York (Facts On File) 1985, pp. 142 and 168, n. 16. On nineteenth-century chimney construction, see Robert Wilson, *Boiler and Factory Chimneys*, London (Crosby Lockwood) 1877; "Chimney," in *Appleton's Cyclopaedia of Applied Mechanics*, ed. Park Benjamin, New York (D. Appleton and Company) 1881, I, pp. 345–51; Robert M. Bancroft, *Tall Chimney Construction: A Practical Treatise on the Construction of Tall Chimney Shafts*, Manchester (J. Calvert) 1885.
9. Robert Rawlinson, "Chimney Construction," *Builder*, XV, no. 734, February 28, 1857, p. 120, and no. 742, April 25, 1857, p. 231; *id., Designs for Factory, Furnace, and Other Tall Chimney Shafts*, London (John Weale) 1858.
10. Governor Thomas Moore "to the People of Louisiana," June 18, 1862, in Benjamin F. Butler, *Private and Official Correspondence of Gen. Benjamin F. Butler During the Period of the Civil War*, Norwood, Mass. (Plimpton Press) 1917, I, p. 22.
11. *A History of Public Buildings under the Control of the Treasury Department, op. cit.*; James Parton, *General Butler in New Orleans*, New York (Mason Brothers) 1864, pp. 274–78, 346–54; Benjamin F. Butler, *Butler's Book: Autobiography and Personal Reminiscences*, Boston (A.M. Thayer) 1892, I, pp. 438–49; *id., Private and Official Correspondence, op. cit.*, I, pp. 482–83, 569, 574, 577; II, pp. 22, 72–74, 549, 562, 569.
12. Parton, *op. cit.*, p. 346.
13. Clara Solomon, *The Civil War Diary of Clara Solomon: Growing Up in New Orleans 1861–1862*, ed. Elliott Ashkenazi, Baton Rouge (Louisiana State University Press) 1995, p. 399.
14. Butler, *Private and Official Correspondence, op. cit.*, II, p. 74.
15. *Ibid.*, p. 562.
16. Butler, *Private and Official Correspondence, op. cit.*, I, p. 443.
17. "The U.S. Mint," *Crescent*, September 18, 1866.
18. *Report of the Secretary of the Treasury on the State of the*

Finances, for the Year 1867, 40th Cong., 2d sess., H. Ex. Doc. 2, Washington, D.C. (Government Printing Office) 1868, p. 180.
19. *Report of the Secretary of the Treasury on the State of the Finances, for the Year 1869*, 41st Cong., 2d sess., H. Ex. Doc. 2, Washington, D.C. (Government Printing Office) 1869, p. 203.
20. *Crescent*, October 3, 1866.

18 *overleaf*
Fire Engine House N° 9
Maison de la Pompe a Incendie N° 9

The engine house of Creole volunteer fire company No. 9 was sited on a small triangular block bounded by Esplanade, Victory (Decatur) and Frenchmen streets, opposite the United States Mint (cat. 17). There, the grids of the Vieux Carré and the Marigny faubourg, both aligned with the meandering river, intersected to form the irregular site. Colonial fortifications and a military esplanade dominated this district, known as City Common, in the eighteenth and early nineteenth centuries.[1] Fort St. Charles, garrisoned during the British invasion of New Orleans in 1815, was demolished in 1821 and its square became the site for construction of the new Mint. The firehouse was built facing the Mint between 1850 and 1857, when Creole Engine Company No. 9, organized in 1837, moved there from nearby Elysian Fields.[2] The architect is unknown but the two-story brick structure with classical stone detailing was typical of mid-nineteenth-century firehouses in New Orleans.[3] On the ground floor was an engine room and stable, with keeper's quarters adjacent, and on the second floor was a fraternal space for the volunteers.

Mounted on the front of Creole No. 9 is a Channing Fire Alarm box, one of about one hundred alarms linked to City Hall through a citywide telegraph system.[4] New Orleans was one of the first cities in the country to adopt the system, introduced in Boston in 1845, which centralized control of fire emergencies and quickened the response time of engine and ladder companies.[5] The telegraph was also put to use for other kinds of alerts, as when the fire alarms sounded throughout the city at 12.30 pm on January 26, 1861, signaling Louisiana secession.[6]

Displayed in front of the firehouse is the company's Amoskeag steam fire engine, built in Manchester, New Hampshire, in 1865. The company also owned, according to an inventory

of February 1867, "one two-wheeled hose carriage, in bad order; 500 feet of 2½ inch hemp hose, in bad order; 500 feet of 2½ inch rubber hose, just received; One hand fire engine, built by Jeffers & Co., of Pawtucket, R.I. in 1854, in good order" and two horses.[7] Creole No. 9 was one of the better-equipped companies in 1867. Only seven of twenty-four companies owned steam fire engines, introduced in New Orleans in 1855, and most operated unserviceable equipment. Fire service in New Orleans was clearly at risk in the postwar economy.

Creole No. 9 was replaced in 1888 by a new firehouse, which was, in turn, demolished for a third station on the site built in 1961. The New Orleans Engine Company Number 9 operates at this firehouse today.

1. *New Orleans Architecture*, V, pp. 2–9, 524.
2. Thomas O'Connor, ed., *History of the Fire Department of New Orleans*, New Orleans (New Orleans Fire Department) 1895, p. 131. The first listing for the station appears in *Mygatt & Co. Directory for 1857*, New Orleans (Delta Printing Co.) 1857. The building is documented in a survey drawing of "City Property 3rd District," dating from the 1860s, now in the New Orleans Public Library, Louisiana Division. The firehouse replaced a *Corps de Garde* station dating from the 1820s, possibly designed by Joseph Pilié; drawings for this building are also in the New Orleans Public Library.
3. See cat. 52, the Girod Street fire station. On the architecture of nineteenth-century firehouses, see Rebecca Zurier, *The American Firehouse: An Architectural and Social History*, New York (Abbeville Press) 1982.
4. "Improved Fire Alarm Box," *Picayune*, November 22, 1866; "The Fire Alarms," *Times*, June 18, 1867; Griswold's *Guide*, pp. 39–41; O'Connor, *op. cit.*, p. 524.
5. William F. Channing, "The American Fire-Alarm Telegraph," in *Ninth Annual Report of the Smithsonian Institution*, March 1855, pp. 147–55; Joel A. Tarr, Thomas Finholt, and David Goodman, "The City and the Telegraph: Urban Communications in the Pre-Telephone Era," *Journal of Urban History*, XIV, no. 1, November 1987, pp. 38–80.
6. Wharton, "Diary," January 26, 1861.
7. "For the Firemen," *Times*, February 19, 1867.

19 *page 95*
Custom House
Douane

A rival of the U.S. Capitol as "the most gigantic edifice in the Union," the Custom House on Canal Street, begun in 1848 and under construction for more than thirty years, was the largest public building project of the century in New Orleans and one of the most important federal buildings in the country.[1] Denounced by leading local architects for deficiencies in design, the Custom House became a battleground of professional rivalries and sectional commercial interests, while the building's tabloid designer, Alexander J. Wood, who had recently been imprisoned for killing a fellow architect, was repeatedly censured and

finally dismissed for misconduct. Construction was delayed and costs soared as quarrels raged on in New Orleans and Washington over the plans and as federal overseers fretted over settlement of the massive stonework in New Orleans's marshy soil. To many observers, the Custom House was a failure and a colossal sinkhole of appropriations, "a structure erected merely for the expenditure of money," according to one critic.[2] The federal architect in charge of the project in 1865, Alfred B. Mullett, called the building "the greatest abortion that has been produced on this continent in modern Times."[3] The local press was hardly less contemptuous. "Architectural monstrosities are common all over the United States," the *Times* wrote in 1864, "but there is nothing comparable [to the Custom House] for vast expense and inutility."[4]

Anchoring Canal Street at the batture, the Custom House filled an irregular block near the river landings. A French bastion and marine arsenal, a windmill, a tobacco warehouse, and the Spanish Fort San Luis were all located there before 1794, when a fire destroyed the district.[5] After 1803, two U.S. custom houses occupied part of the site. The first, designed by Benjamin Latrobe and built in 1807–1809, was a structural failure and was replaced after only ten years with an undistinguished building by French-born architect Benjamin Buisson.[6] By 1835, the Buisson building had deteriorated and was obsolete, and the local business community called for a custom house "befitting the immense revenue that flows into the treasury department here": revenue from customs collected over a vast district that at one time included the Ohio as well as the Mississippi rivers, and cities as remote as Wheeling.[7] New Orleans also required a building "of rare architectural beauty, the first for the eye of the approaching mariner to rest upon," local boosters declared.[8] In 1845, Congress authorized a new building for New Orleans and $500 to prepare plans, but another two years passed until $100,000 was appropriated to build it.[9]

The municipal council of the Creole Vieux Carré donated the batture site to the federal government "in order to secure the advantage of having the Custom-House within its limits."[10] After demolition of grog shops, a church, and the old custom house that occupied the site, the new building could fill the square. Across Canal Street was the Anglo-American commercial district, giving the rival Creole and Anglo-American business communities nearly equal access.[11]

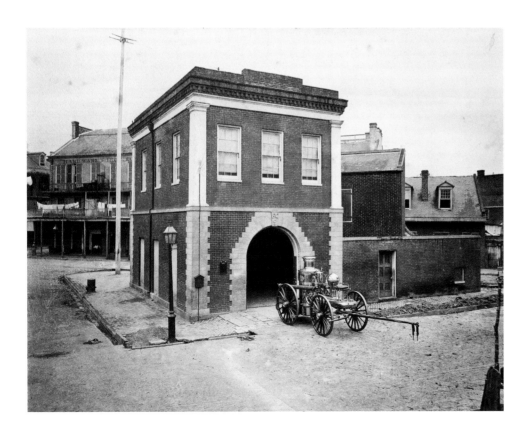

The Custom House project came under the supervision of the Secretary of the Treasury and, before 1853, when the Treasury's Office of Construction was created, under a local commission appointed by the Secretary to hire architects and supervise construction.[12] Treasury Secretary R.J. Walker wrote that the government required a "plain, substantial" building "designed exclusively for the transaction of business ... simple and unostentatious in its character," and avoiding "everything calculated merely for display." He would select a plan that "united good taste with the greatest economy and the largest and best accommodations," one that would not waste space with "courts, steps, porticoes and pillars."[13]

At least twenty architects submitted design proposals before March 1847, when Congress released construction funds.[14] Robert Mills, who had been the salaried "architect of public buildings" until 1842, and had designed many federal custom houses in the 1830s, proposed a domed marble building four times the size of the Boston custom house.[15] James Gallier also supplied a plan, revised twice, for a costly structure of marble and granite crowned by four corner domes and a center dome rising as high "as good taste would admit, for the purpose of having it appear in view at some distance from the City."[16] James H. Dakin, who was "astonished at the bad taste and worse arrangements of Mr. Gallier's Plan"—signalling not only a rivalry between these old associates but the intense and often acrimonious competitiveness that would characterize the entire Custom House project—submitted three proposals. The first was a Gothic building using structural cast iron, the second a showy Greek revival building with twenty-eight Corinthian columns across the front, set on an esplanade facing the river (probably influenced by Robert Smirke's recently completed Ionic colonnade for the British Museum).[17] Dakin's last submittal was a rusticated but otherwise plain palazzo with an open center court.[18]

But it was the English-born architect Alexander J. Wood who was selected in September 1847, in large part because his plan appeared to make maximum use of the site.[19] Walker wrote that Wood's plan was "the only one of the original plans which covers the whole ground ... and more free from unnecessary ornament than any of the other plans."[20]

Wood's four-story building was faced with granite ashlar, backed by brick, and crowned with a cupola. The four similar façades each had a center projecting pavilion of four fluted columns with Egyptian lotus-leaf capitals—described by the *Delta* as "unique in style"—and shallow projecting bays of four pilasters at each end.[21] Above a rusticated base of deeply channeled granite rose unusual tripartite windows and narrow vertical strips of windows; 9-foot (3-m) blind niches, six on each side, framed the entrances.[22]

The most dramatic feature of Wood's plan was a skylit Collector's General Business Room, 125 by 95 feet (38 by 29 m), rising 54 feet (16.5 m) under the cupola. Modeled on the famous Athenian Monument of Lysicrates (see cat. 55), the room was surrounded by fourteen 41-foot (12.5-m) marble Corinthian columns and was approached from the ground floor by marble staircases accessible from three streets. Walls ornamented with pilasters were of marble, and the floor was to be laid in a pattern of black-and-white marble and plates of heavy glass to admit light to rooms below.

"It has been my aim (rather than architectural display) to cover the whole ground," Wood wrote. "I have endeavored to preserve good exterior proportions and an outline that will ... defy the ravages of time or the freaks of fashion."[23] Apart from the Collector's Room, where customs duties were paid, Wood's plan provided for appraisers' offices and a large warehouse for the storage of goods; a post office; offices for other government bureaus; and the U.S. court. The projected construction cost was $800,000. Wood's design (modified in construction) bore some resemblance to Robert Mills's highly praised marble-and-granite General Post Office Building of 1839–41, which had been promoted as a model for federal architecture of the 1840s.[24] Both designs featured a rusticated ground floor and tetrastyle porticoes with engaged columns framing tripartite windows. Wood's repetition of vertical window strips imitating pilasters may have been a response to Mills's composition of pilasters and columns across the façade. His "novel and ingenious" design possessed "a new style in architectural appearance," one observer wrote, and exhibited "a degree of grace and grandeur rarely combined in such vast structures."[25] Wood's innovative design, however, would not be realized in the awkward and ill-proportioned building as it was completed.[26]

Wood's appointment was controversial from the start, as questions arose regarding not only his plan but also his ability to undertake the project. Gallier later wrote that the Treasury Department appointed Wood "to the astonishment of all who knew anything of Wood's previous history"—a reference to his imprisonment for killing architect George Clarkson in a brawl.[27] Gallier accused Wood of appropriating the design ideas of the other proposers, writing that Wood had "free access to all the plans and models that had been sent in, and from them concocted a design in accordance with the taste and ideas of the secretary, who adopted it."[28] As far as Dakin was concerned,

> Mr. Wood's design was a most foolish thing for any man having the least pretension to architectural skill The entire area of the square was covered, having no means of ventilation or air for the interior except by means of a skylight over the General Business Room, which was in the centre of this dense mass of building. His plan would have made a tolerable Mausoleum or Tomb for an Egyptian king.[29]

To superintend construction following Wood's design, the Treasury Department brought in U.S. Army Colonel William Turnbull of the Topographic Engineers.[30] Turnbull had recently supervised construction of the Potomac aqueduct at Georgetown (1832–43), considered one of the great engineering works of its time.[31] Despite his "extraordinary qualifications as an Engineer"—he reportedly found success in work that had "baffled" other eminent engineers—Turnbull appears to have approached the New Orleans project with misgivings.[32] "It was with great reluctance and diffidence," he later wrote, "that I undertook the task of preparing the foundations of so great a building—the very largest, I believe, in the country—in so precarious a formation as that upon which the city of New Orleans stands."[33] Turnbull's primary concern was the stability of the structure during subsidence, which was expected to be considerable owing to the building's great mass (the granite walls were 14 inches [36 cm] thick at the base). Turnbull audited other heavy masonry structures in New Orleans and found most of them unstable. New Orleans architect Lewis E. Reynolds confirmed Turnbull's observations: "Hundreds of buildings are cracked and rent asunder, owing to the unequal subsidence," he wrote. "Take buildings of New Orleans that are of ten years'

standing, there is scarce one out of ten that are not cracked somewhere in the structure."[34]

Site demolition began in June 1848 and excavations the following October. Steam pumps working day and night kept water from flooding the trenches, which were carried to a depth of 12 feet (4 m). Turnbull then laid a grillage of planks and two crosswise courses of 1-foot-square (0.3 m) cypress timbers, covered in a mixture of hydraulic cement, shells, and broken granite. He then raised a foundation of 4-foot-thick (1.2 m) walls of brick, on which rested the granite ashlar of the exterior walls. Groin vaults of brick supported the interior walls.[35]

Meanwhile, contractors lined up to supply the project with 12 million handmade, hard-burnt batture bricks and another 6 million lake bricks; 140,000 barrels of cement, lime, and shells; and 55,000 barrels of white sand.[36] The largest material cost (ultimately $623,000) for the building was 100,000 feet (30,480 m) of blue granite for the outer walls, contracted by Luther Munn of Quincy, Massachusetts.[37] The stone was ordered in three hammered finishes following the model of the new Boston Custom House, completed in 1845, and two other Boston buildings. Weighing up to 20 tons, the cut blocks required ten to twelve weeks to quarry and three or four months aboard ship to reach New Orleans. Industrial quarrying of granite was not yet thirty years old, and the demand for large building blocks often exceeded the quarries' ability to deliver, especially for Quincy granite, which government contractors considered "preferable to other kinds for large public edifices."[38] Delays in the delivery of stone would plague the project year after year.

The cornerstone was laid in February 1849 and work on the superstructure began. Late in the year Turnbull resigned, leaving Wood as both architect and superintendent of construction, and difficulties concerning Wood's "irregularities" reemerged.[39] Local commissioners overseeing the project reported to Treasury Secretary William Meredith that Wood was "totally unworthy of the station he now holds," and had, on several occasions, "drunk to such excess that he was incapable for many days together of attending to his duties."[40] Reported to be defiant and contemptuous of his employers, Wood was repeatedly censured by the Commissioners, as problems at the construction site worsened and further charges, including that of unauthorized

spending, were made against him. "Mr. Wood's arrogance and presumption have been a source of almost perpetual annoyance to us," Commissioners reported to Washington.[41] Finally, in May 1850, Meredith dismissed Wood, and John Roy, foreman of the stonemasons, took charge.[42] For the remainder of the year, the work of raising the interior walls and vaults and setting the exterior granite progressed steadily.[43]

Wood, aggrieved, would not be resigned to watching his design executed by someone else, and launched a protest that resonated from New Orleans to Washington. Feeling "deeply wronged" and "turned adrift," he appealed to Senators Henry Clay and Pierre Soulé (his rhetoric now recalls Ayn Rand's narcissistic architect, Howard Roark):

The Building is my own creation—my name is writ in Granite on its Base—It is my Giant Offspring—even in swaddling Clothes standing defiant to a World—no President, nor Secretary can raise him as his Father ... it is my Plan, to take it from me is Felony.

Wood claimed to have designed a "work without precedent in this Country—immense, yet unostentatious I challenge the World to point to a fault."[44]

Controversy over Wood's design and his dismissal intensified. Dakin—who had appealed to his friend, U.S. President Zachary Taylor, himself from Louisiana, to promote his appointment to the Custom House project—took charge in July 1850.[45] Supporters of Wood, led by the *Delta*, backed Wood's claim that "no man is so able to complete a building as he who designed it."[46] The *Crescent* volleyed back: "[W]e might imagine many ways in which the most skillful architect might render himself incapable of carrying out his own design."[47] Dakin, for his part, printed and distributed a pamphlet promoting his proposed changes to Wood's design. For Dakin, the major shortcoming of Wood's design remained the omission of a center courtyard to supply the interior with light and air.[48]

Dakin's revisions to the plan relocated the Collector's Room from the center of the building to the Canal Street side, allowing a courtyard to be opened in its place. Dakin also called for replacement of Wood's system of groined masonry arches and piers, which were insufficient, in his view, to carry the weight of the structure and its heavily loaded floors of merchandise.[49] Dakin proposed instead an iron-

frame structural system of cast-iron girders and plates supporting a stone floor.[50] Cincinnati architect Isaiah Rogers—who was in New Orleans to consult on the rebuilding of the St. Charles Hotel (cat. 64), and who would later oversee the Custom House project as Supervising Architect of the Treasury—also rejected Wood's plan. "They appear to be in a bad fix with the building," Rogers wrote in January 1851. "It certainly reflects severely on the architects of this country, if we cannot get Public Buildings with more fitness for their use than that of the Custom House of N.O."[51]

While Wood's supporters now seemed to be in the minority, the Creole business community feared the changes Dakin proposed would offer certain commercial advantages to the Anglo-American business quarter by moving the Collector's Room to the uptown side of the building, giving prominence to the Canal Street entrance.[52] The sectional rivalry brought the project to the floor of the U.S. Senate, with a resolution concerning Dakin's appointment. Backed by Senator Soulé, the recipient of Wood's earlier appeal, Wood's supporters succeeded in attaching an amendment to the appropriations bill of 1851–52 that prohibited any change in location of the Collector's Room, and despite President Millard Fillmore's reaffirmation of Dakin, Wood's plan prevailed, and Dakin resigned in disgust. "Circumstances connected with the erection of the said new Custom House are such that were it possible to continue me," Dakin wrote, "I should feel little pride or ambition in the service belonging to my appointment ... [and] I have reason to believe that the authorities in Washington feel some little embarrassment in relation to the affairs of this edifice."[53]

In June 1851, Wood, now recognized by the Treasury Department as the "Architect and Author of the plan of the Building," was reinstated in a consulting role, but in late 1851 his plan again came under scrutiny by a government board of architects and engineers.[54] Chairing the examining panel was P.G.T. Beauregard of the army engineers, a Creole from a family of prosperous sugar planters and a native Louisianian, unlike everyone previously appointed by the Treasury to review the project. "It is to be regretted that this controversy exists," Beauregard wrote. "[It] has already produced much delay in the progress of the work ... and has led to vicious legislation in the premises." Finding the building

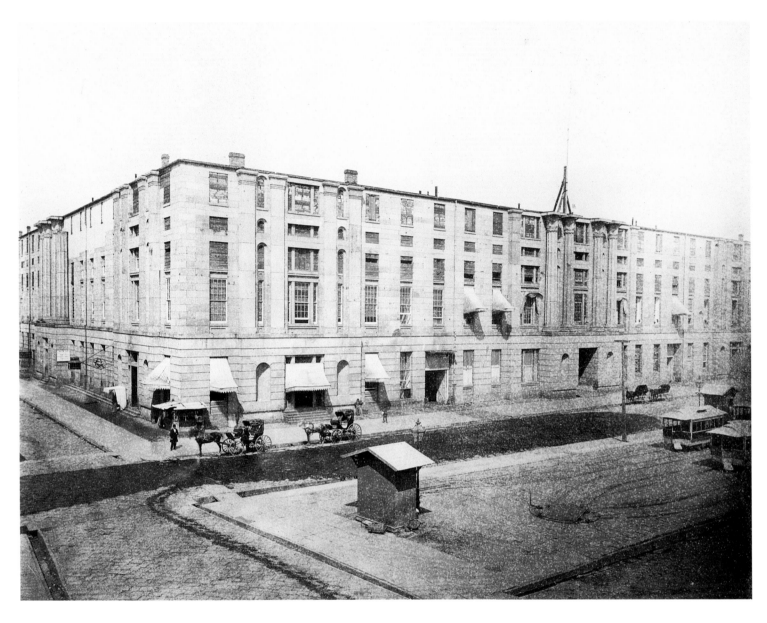

had settled unequally, and that Wood's groined arches were in part the cause, the examiners endorsed some of Dakin's proposed changes, including relocation of the Collector's Room.[55] New construction drawings were executed, following the board's recommendations, in February 1852, including important contributions from one of the examiners, Nashville architect Adolphus Heiman.[56] But in March 1852 Treasury Secretary Thomas Corwin, probably anticipating another confrontation in Congress, rejected the board's report, and proceeded with Wood's original plan.[57]

During the next two years, Wood remained closely involved in the realization of his design, although his "intemperate and irregular habits" put him in conflict with Dakin's successors as

superintending architect, notably Lewis E. Reynolds.[58] Finally, when Beauregard, who already had fifteen years' experience on federal engineering projects, was appointed superintendent in May 1853, real progress was made on construction.[59] During the long controversy over Wood's plan, work had continued on the exterior walls while much of the interior construction was suspended, "a dangerous policy ... tending to disturb the equipoise of the structure," architect Thomas K. Wharton, Beauregard's assistant, wrote.[60] The exterior granite walls had "settled and sprung outwards," and Wood's condemned arches, which had "sunk and cracked badly," Beauregard replaced with iron beams and girders, and segmental arches, similar to those

designed by Dakin.[61] He organized a new program of construction to bring the interior walls up to the level of the outside walls.[62]

In February 1854, Wood died of smallpox. Reporting his death to Washington, Beauregard called Wood a "distinguished architect" and recommended that Louisville architect Adolphus Heiman replace him.[63] "This being a National structure, the Gov't ought ... to select the best Architect in any part of the Union," Beauregard wrote, and as word spread of Wood's death architects from across the country were put forward to succeed him.[64] William Strickland's son Francis applied from Nashville, the New Orleans business elite nominated local architect Henry Howard, and Louisiana Senator John Slidell maneuvered his

candidate Joseph Howell, a carpenter with no apparent qualifications, into position.[65] But the Treasury's Bureau of Construction had already centralized management of public building projects, and Treasury architect Ammi Young was designing custom houses for the government, supplanting the role of outside architects. Young and the newly appointed head of the Bureau of Construction, army engineer Alexander Bowman, would now make most of the design changes executed by Beauregard.[66]

One of the challenges faced in what Beauregard called an "immense and now difficult structure" was a chronic shortage of labor.[67] In a typical month the project employed 160 men, including skilled masons, carpenters, and blacksmiths, and about eighty unskilled laborers. Among these workers, both unskilled and skilled, were slaves (and a small number of free blacks). Beauregard came under criticism in 1854 for putting slaves to work on a public project, "thereby depriving honest democratic Citizens ... from procuring employment," according to petitioners to President Franklin Pierce.[68] The "colored hands employed on this building are the best and most reliable of all kinds employed," Beauregard replied. "They are much preferred in the South, and in Louisiana particularly, to white labor, as is well known to all Builders and Contractors."[69] There were difficulties in recruiting white laborers during the summer season, and a crew of slaves could be made to work through epidemics, when Beauregard's white laborers refused to work or would strike for higher pay. At government pay rates, Custom House work was not competitive, especially for workers who could obtain better wages—$2 to $2.50 per day—unloading ships at the Levee, while Beauregard was authorized to pay only $1.75. Laborers finally petitioned Commissioners for increased pay. "It is impossible for us to gain subsistence at the present Rate of Wages," they wrote. "We can hardly do any thing for our familys, in fact we cannot buy them clothing."[70]

Beauregard, the military engineer who modeled himself after Napoléon and quoted Julius Caesar to his men, had proved his weakness as a tactician in the Mexican campaigns early in his career, and at the Custom House he seemed often overwhelmed by the logistics of deliveries from remote quarries, brickyards, and foundries. He was unable to keep a lid on soaring costs.[71] "It is difficult to predict with anything like accuracy the future progress of so stupendous a work as this," he wrote to Washington, "dependent as it is, on the distant North for all its supplies of heavy materials, and liable to all the delays of slow coast navigation."[72] The millions of bricks required for the project kept industrial kilns north and south turning out product, but not fast enough to keep pace with construction. Cargo losses at sea were common, and delivery of iron was repeatedly delayed by production shortages at the Trenton foundry that supplied the project.[73] Beauregard complained of the "difficulty of getting such large beams and girders as required, when only one foundry in the country was prepared to make even the small ones."[74]

Granite, marble, and other materials were unloaded at the federal wharf and carried from the Levee by an elevated railway.[75] A lofty scaffold, requiring 6 million feet (1.8 million m) of lumber, was raised from September 1855 to encompass the building, and a 153-foot-high (47 m) steam-driven crane hoisted stone and iron into place. "Three or four of our riggers were running up and down it all day as nimbly as squirrels, fixing the blocks and cordage &c. to raise the other pieces," Wharton wrote.[76] Designed to lift up to 20 tons, the steam hoist more than once gave way, and in one instance a load of stone fell, killing several laborers.[77] The scale of the Custom House required experimentation in construction methods and turned the project into a proving ground for materials-handling technology, comparable only to Montgomery Meigs's contemporary work on the dome of the U.S. Capitol.[78]

The Collector's Room took shape in 1856–57. Marble for the column capitals was quarried in Vermont and the 4-foot-diameter (1.2 m) column shafts in East Chester, New York, near Tuckahoe, where much of the stone for New York building projects originated. Meigs, inspecting his own marble works at Tuckahoe for the Capitol project, observed the stone brought out for the Custom House: "Much of it is marked with seams of a dull grey, and they get white ashlar by splitting the blocks between these seams so as to give a layer of an inch or half an inch of white upon the face of the ashlar."[79] Wharton reported in March 1855, when setting began on site, that the East Chester marble was given a fine finish: "[T]ho' strongly laminated in texture, and clouded in many places with blue veins, [it] will generally have a fine effect. The rubbed surface would, to my fancy, have been preferable but the Department has expressed a strong opinion in favor of fine droving."[80] Beauregard considered the capitals to be "probably the finest specimens of ornamentation in Marble ever executed in this country, both from the superior elegance of the design, and the exquisite delicacy of the finish."[81]

By 1859, expenditures had risen to nearly $3 million, exhausting the Congressional appropriation. The *New York Times* wrote that the Custom House "would cost more alone than all the expenditures of the [Treasury] Department for building purposes from the commencement of the Government to the year 1850."[82] In what was called the "Custom House swindle," criticism of the excesses of the New Orleans project resounded across the country. The *Chicago Daily Tribune* called the building "a specimen of the profligate squandering" of public funds.

> The structure is palatial, and a description of it reminds one of the extravagances of the ancient Kings and Emperors in buildings when millions of dollars was spent to gratify a whimsical caprice Special pains seem to have been taken to make it as expensive as possible.[83]

Alexander Bowman echoed this view, while hoping to bring expenditures under some measure of control in a new centralized project-management system. "Expensive custom houses have been erected by the government, the joint revenue of which does not pay the expense of construction," Bowman wrote.[84] In 1860, Congress made no further appropriation to continue the work in New Orleans, and construction came to a halt. At the end of June 1860, Beauregard had $23,000 remaining in his budget, and estimates offered to Congress of the funds needed to complete the building ranged from $350,000 to more than $1 million.[85]

Beauregard resigned in December 1860 to head the Military Academy at West Point. After only five days he left the Academy to take up a commission as Brigadier General in the Confederate Army (in April 1861 he would lead the bombardment of Fort Sumter, South Carolina, the first military engagement of the war).[86] At the end of January 1861, following Louisiana's secession, Wharton, Beauregard's successor, closed the Custom House books with

a zero balance, dismissed a work crew of fifty men—"the most delicate and painful tissue of official duties I ever went thro'," he wrote—and resigned his federal post.[87]

The Confederacy appropriated the building for customs collection, and resumed construction with funds sent from Richmond. In May 1861, Wharton, retained by the Confederacy, prepared plans for completion of the courtrooms and for a new roof.[88] The war effort, however, soon trumped construction. "The New Custom House is a mine of wealth to the New War Department, and I, by the blessing of Providence, am the miner," Wharton declared in October 1861.[89] The Confederate army mounted cannon on the exterior walls and set up a factory for shot, gun carriages, and artillery in the building, but they did not remain in possession for long.[90] Wharton himself watched from the roof as federal gunships approached the city on April 26, 1862. "In these dangerous times I shall adhere to my post of duty to the last," he wrote, and after federal troops entered the city he reported as usual to the building site, "but as it has been taken possession of by the Federal officers" he could transact no business. Wharton gazed at the nearly 1000 federal troops quartered there—"to whom," he wrote, "I had nothing to say."[91]

Occupying the building, federal troops found hundreds of Confederate gun carriages and cannon, and a large quantity of scavenged plantation bells and iron rails for smelting, plus "a thousand other things belonging to the officers, left behind in the hasty retreat."[92] Soldiers barracked in the building built campfires in the Collector's Room, and "fell picturesquely asleep in the ruined door-ways."[93] Political prisoners, as many as 600 at a time, were confined in unfinished rooms.[94]

At the end of the war the interior was in shambles. Covered with debris, many of the floors were half-laid or destroyed, and window openings were covered. The roofless Collector's Room was squalid and, for the grandeur of its conception, a particular disgrace. Much of the structure was still open to the outside and some occupants worked through rainstorms with umbrellas over their heads.[95] Isaiah Rogers, now Supervising Architect of the Treasury, hired architects Gallier and Esterbrook to complete work on the federal court and ordered a temporary roof for the building, which Boston suppliers delivered, reluctantly, to the "rebels at New Orleans."[96]

In September 1865, Alfred B. Mullett took charge of the building for the Treasury. Frequently censorious of his predecessors, he found much to denounce in the New Orleans project.[97] "The building is neither beautiful inside or outside [and] seems to combine the greatest amount of waste room, inconvenience and discomfort, with the greatest possible expenditure of money," he wrote.[98] Following his appointment as Supervising Architect in 1866, Mullett felt free to unleash his full scorn for the "unfinished monstrosity" passed on to him. Reporting on work needed to make even the occupied portion of the building fully functional, he found it "difficult to devise a remedy, so radical are the defects."[99] He added another temporary roof, and fussed with other changes, but finally threw up his hands to Congress over the project, which he claimed was "a disgrace to the government, as well as its designers and builders." Mullett could not advise completion of the building as designed but was "reluctant to recommend that the immense mass of material now piled on the foundations be used as a quarry," and proposed not its demolition, but its reconfiguration as a two-story structure.[100]

Congress, however, stirred to action by the Louisiana delegation and an audit of the structure by Boston architect Gridley J.F. Bryant, resolved to bring an end to the project by releasing even more money to complete it, and Mullett was ordered to draw up new plans.[101] The best Mullett could say of his effort, when construction resumed in 1871, was that the building would, "though devoid of beauty, be a permanent and substantial structure."[102] Still under construction in 1875, the building was said to "have a fair chance of completion at the beginning of the millennium."[103] Four years later the second story was finished, and in 1881 the third. By the time the building was finally topped off with an incongruous cornice of cast iron, designed by Mullett, nearly $5 million had been expended. The fourth story and the cupola that Wood planned over the Collector's Room were never built because of the fear that the additional weight would sink the building further. As late as 1926 completion of the fourth floor was considered but abandoned after load tests confirmed the lingering fears about settlement.[104]

Plagued by design quarrels, conflicted appointments, construction suspensions, high

material costs, federal ignorance of local conditions, and the upheaval of war, the Custom House was not a project of elegant solutions, and the building was never well received. Its *fortuna* suffered most memorably in the words of one of the nineteenth century's best observers of the local scene, author Lafcadio Hearn:

> That vast gray building on Canal Street, upon which princely sums have vainly been expended in the foolish hope of completing it, has long troubled us with a strange impression difficult to analyze. A sense of weight and antiquity oppresses the beholder when he gazes upon it.

Even the glittering Collector's Room in Hearn's "shadowy and dusty sarcophagus of granite," was all gloom, "like the Pharaonic burial-chamber in the heart of the granite monument of Cheops."[105]

With the distance of time, perhaps the right measure of criticism of this eventful building was reached in the estimation of architect–historian Talbot Hamlin. Illustrating the Collector's Room as the frontispiece of his influential *Greek Revival Architecture in America*, published in 1944, he wrote of the building:

> It is a huge, rather gaunt, granite mass, with exterior detail unlike any ancient work whatsoever, although it probably represents a rather uneducated person's idea of Egyptian [Its] history from the beginning was clouded with scandal and incompetence, its designer an architect only by courtesy. Yet somehow the whole, even in its awkwardness, perhaps even in its occasional downright ugliness, has a kind of power, a sort of forthright arrogance, that is impressive if only as an expression of the bold pride of New Orleans in the cotton-boom days.[106]

In 1978–80, after considering demolition, the federal government carried out renovations amounting to almost $7 million, restoring some of the original interior spaces swept away by early twentieth-century renovations.[107] By the 1990s, the building was underutilized and new uses were proposed to capitalize on its heavily touristed location in the Vieux Carré. Plans for an insectarium on the ground floor (opened in 2007) alarmed preservationists, and the building, along with others in its historic district, landed on the National Trust of Historic Preservation's list of the "11 Most Endangered

Places in America." In 2005, the U.S. Custom Service, occupants since 1856, vacated it after the roof failed during hurricane Katrina. Since the catastrophe, the building has been closed and undergoing renovation.

In Lilienthal's photograph the enormity of the building is evident, as his lens, from a vantage point over 200 yards (183 m) across Canal Street, fails to encompass all of what Hearn called the "dismal immensity of its exterior." With the granite walls carried to their full height, concealing the unfinished interior, and after removal of the exterior scaffolding in 1860, the building looked little different from one decade to the next, from the 1860s to its completion in 1881. As Hearn wrote, "Rivers of gold have been poured into it; yet it remaineth as before."[108]

1. "The New Custom House," *Bee*, October 18, 1850. In 1850, the Custom House was projected at about 87,000 square feet (8083 sq. m), 30,000 square feet (2787 sq. m) more than the U.S. Capitol (although construction that had just begun on Thomas U. Walter's Capitol Extension would considerably enlarge it); Alexander J. Wood to Pierre Soulé, July 26, 1850, New Orleans Custom House, General Correspondence, Letters Received, 1843–1910, Records of the Public Buildings Service, RG121, NARA (this correspondence file is hereafter cited by reference to its record group, as "RG121"). Sources for the history of the project are found in RG121 (including also correspondence in "Letters Sent" and other files of this record group) and the Secretary of the Treasury's annual reports to Congress, which summarize the superintending architects' field reports of construction. A chronology based on a partial study of the Public Buildings Service records is in Stanley C. Arthur, *A History of the U.S. Custom House New Orleans*, New Orleans (Works Projects Administration of Louisiana, Survey of Federal Archives in Louisiana) 1940 (edited and with an appendix by Samuel Wilson, Jr., New Orleans, U.S. Custom Service, 1984). See also *A History of Public Buildings under the Control of the Treasury Department*, Washington, D.C. (Government Printing Office) 1901, pp. 213–15; Charles A. Favrot, "An Historical Sketch on the Construction of the Custom House in the City of New Orleans," *Louisiana Historical Quarterly*, III, no. 4, October 1920, pp. 467–74; and Bates Lowry, *Building a National Image: Architectural Drawings for the American Democracy, 1789–1912*, Washington, D.C. (National Building Museum) 1985, pp. 50–51, 214–15. The best brief account of the project, and of architect James H. Dakin's role, is in Arthur Scully, Jr., *James Dakin, Architect: His Career in New York and the South*, Baton Rouge (Louisiana State University Press) 1973, pp. 162–84. On the Treasury Department Office of Construction and the organization of federal building projects during this period, with reference to the Custom House project, see Daniel Bluestone, "Civic and Aesthetic Reserve: Ammi Burnham Young's 1850s Federal Customhouse Designs," *Winterthur Portfolio*, XXV, nos. 2–3, Summer–Autumn 1990, pp. 131–56. The history of the Custom House will be treated in greater detail in my forthcoming study, "Federal Architecture for the Port of New Orleans, 1803–1880."
2. "New Orleans Custom-House," *Times*, March 18, 1864.

3. A.B. Mullett to W.E. Chandler, Assistant Secretary of the Treasury, November 10, 1865, RG121.
4. "New Orleans Custom-House," *op. cit.*
5. Arthur, *op. cit.*, pp. 1–3.
6. Samuel Wilson, Jr., "American Notes: Latrobe's Custom House, New Orleans, 1807–09," *Journal of the Society of Architectural Historians*, XIV, no. 3, October 1955, pp. 30–31. The building appears in a vignette engraving on Jacques Tanesse, *Plan of the City and Suburbs of New Orleans from an actual Survey made in 1815*, New York (Ch. del Vecchio), New Orleans (P. Maspero), 1817.
7. *Norman's New Orleans and Environs*, pp. 89–90; "Customhouse Square," *Bee*, May 11, 1835. The *Bee*, May 20, 1835, called the Buisson building a "public nuisance." See also Anne Saba, "The United States Customhouse at New Orleans, Louisiana," *U.S. Customs Today*, June 2000.
8. *New Orleans Directory for 1842*, New Orleans (Pitts & Clarke) 1842.
9. Appropriation of March 3, 1847. "Custom-House New Orleans," 28th Cong., 2d sess., H. Rep. 55, Washington, D.C. (Government Printing Office) 1845; *Reports of the Secretary of the Treasury*, VI, Washington, D.C. (John C. Rives) 1851, pp. 135–37, 233–37.
10. "The New Custom-House," *Picayune*, October 6, 1850.
11. *Ibid.*; *Reports of the Secretary of the Treasury*, VI, *op. cit.*; Scully, *op. cit.*, p. 172.
12. On the role of local commissioners in federal construction projects of this period, see Bluestone, *op. cit.*
13. *Reports of the Secretary of the Treasury*, VI, *op. cit.*, p. 234.
14. Alcee LaBranche to R.J. Walker, July 21, 1847, submitting a plan of a custom house by DePouilly and Goudchaux; paste-up of newspaper clippings dated July 22, 1847, in RG121. Dakin records in his diary that he "saw a number of designs by various architects" in the Collector's office at the Custom House on June 26, 1847, all of which he thought "a lot of rubbish, to speak plain"; Scully, *op. cit.*, p. 167. The Congressional appropriation of $100,000 for foundation excavation was passed on March 3, 1847.
15. Robert Mills to R.J. Walker, January 11 and 29, 1846, RG121. On Mills as federal architect, John M. Bryan, *Robert Mills: America's First Architect*, New York (Princeton Architectural Press) 2001, pp. 257–87.
16. James Gallier to Thomas Barrett, Collector, July 15, 1845, RG121; James Gallier to Denis Prieur, Collector, December 26, 1845, RG121; John Turpin to the Commissioners (earlier plans modified, domes dispensed with, center dome only), June 14, 1847, RG121; James Gallier to R.J. Walker, November 10, 1847 (model transmitted), RG121. In 1845, before the project was funded by Congress, Gallier was asked to submit a proposal, which he revised over a two-year period; one of these submittals is in the Southeastern Architectural Archive, Tulane University. Gallier wrote (*Autobiography*, pp. 39–40) that when requested to submit a design for the new Custom House he was "fully occupied at the time" and refused "without positive assurance of being paid for my trouble." But with the assurance of the Collector of Customs that the Treasury would "undoubtedly cause a liberal compensation to be paid to me for any trouble or labour I might bestow upon it," Gallier submitted drawings and a model. His model was never returned and the drawings were so "much soiled and torn as to be unfit to be looked at," he wrote. "I have never received the slightest compensation for the time and labour expended upon those plans nor for the expenses in travelling to and from Washington on that business." *Norman's New Orleans and Environs*, published at this time, promoted Gallier's design (p. 90) calling it "a

durable ornament to the city, and an honor to the nation."
17. Dakin, *Diary*, June 26, 1847, cited by Scully, *op. cit.* Dakin modified his Gothic plan of 1846 for the Louisiana State Capitol the following year. His Custom House drawings are in the New Orleans Public Library. See Scully, *op. cit.*, pp. 162–67.
18. Scully, *op. cit.*, pp. 170–71.
19. Wood's original elevation is in RG121, Cartographic Div., NARA; see Lowry, *op. cit.*, pp. 214–15 and Plate 31. Writing when Wood's submittal of 1847 was unknown, Scully believed that Wood had based his design on Dakin's third proposal. Following modifications, Wood's design was engraved by Sarony & Major, New York, and published in "The New Customhouse," *Delta*, February 13, 1848, and five months later Wood publicly exhibited a model of his design at Hewlett's Exchange; *Orleanian*, July 22, 1848. The Sarony & Major engraving is in RG121. Wood (1799–1854) had worked in London, France, and New York before settling in New Orleans about 1833. Gallier wrote that Wood was a former builder who "had only recently returned from the state prison at Baton Rouge, where he had passed five years in confinement for the murder of his foreman"—a reference to the death by stabbing of his partner, architect George Clarkson, in a street brawl in 1835; Gallier, *Autobiography*, p. 39; see "Architectural Academy," advertising handbill, New York, September 14, 1831, Southeastern Architectural Archive, Tulane University; Scully, *op. cit.*, p. 201, n. 14.
20. *Reports of the Secretary of the Treasury*, VI, *op. cit.*, p. 23.
21. "The New Customhouse," *Delta*, *op. cit.*
22. A.J. Wood to Commissioners, July 10, 1847, RG121.
23. *Ibid.*
24. Bryan, *op. cit.*, pp. 276–81; Pamela Scott and Antoinette J. Lee, *Buildings of the District of Columbia*, New York (Oxford University Press) 1993, pp. 191–93.
25. Unidentified newspaper clippings dated July 1847 in RG121.
26. Lowry, *op. cit.*, pp. 214–15, publishing Wood's rediscovered 1847 elevation, offers a reassessment of Wood's "exceptionally powerful" design and his historical position.
27. Gallier, *op. cit.*, p. 40; *Courier*, July 28, 1835.
28. Gallier, *op. cit.*
29. Dakin, *Diary*, cited by Scully, *op. cit.*, p. 170 (date not given).
30. R.J. Walker to William Turnbull, August 18, 1848, RG121; *Reports of the Secretary of the Treasury*, VI, *op. cit.*, p. 135.
31. On Turnbull, *Biographical Register*, I, pp. 211–12.
32. Colonel J.J. Abert to Secretary of War William Wilkins, March 5, 1844, RG121.
33. William Turnbull, "Appendix C: New Orleans Custom House," *Report of the Chief of Topographical Engineers*, 31st Cong., 1st sess., 1849, S. Ex. Doc. 1, pp. 309–12 (republished as W. Trumbell [*sic*], "The Foundations of the New Orleans Customhouse," *Architectural Art and Its Allies*, V, no. 11, May 1910, pp. 5, 24); see also *Crescent*, October 2, 1848, and *Picayune*, October 13, 1848. For later accounts of the foundation, see King H. Pullen, "Early Building Methods in New Orleans," *Building Age*, August 1917, pp. 425–26, and James S. Janssen, *Building in New Orleans: The Engineer's Role*, New Orleans (Waldemar S. Nelson) 1987, p. 69.
34. Lewis E. Reynolds, *Remarks on the Compressibility and Motion of the Soil of New Orleans* (pamphlet, n.p., n.d.), p. 7, in RG121.
35. *Picayune*, July 20, 1849; Arthur, *op. cit.*, pp. 26–27.
36. J.W. McCulloch and William Collins to J.L. Adams, February 26, 1848, RG121; *Delta*, January 25 and February 20, 1848.
37. Contract with Luther Munn of Quincy, December 4, 1848, RG121; *Delta*, February 20, 1848. Architect Thomas K. Wharton sketched the Quincy quarries and described the

quarrying in his *Diary*, August 25, 1853.

38. Adolphus Davis to R.J. Walker, May 29, 1848, RG121; George P. Merrill, *Stones for Building and Decoration*, New York (John Wiley & Sons) 1891, pp. 194–95.

39. "Letters from the Department relative to the construction of a Custom House Building at New Orleans," November 28 and December 4, 1849, RG121; *Picayune*, February 23, 1849.

40. Commissioners to Treasury Secretary William Meredith, December 14, 1849, RG121.

41. Commissioners to William Meredith, May 16, 1850, RG121.

42. *Ibid.*; "The Custom-House Architect," *Delta*, June 14, 21, and 22, 1850; "The New Custom-House Architect," *Crescent*, June 15, 1850.

43. Commissioners to Treasury Secretary Thomas Corwin, November 15, 1850, RG121.

44. A.J. Wood to Pierre Soulé, July 26, 1850; A.J. Wood to Henry Clay, July 31, 1850, RG121.

45. *Delta*, June 13 and 14, 1850; *Picayune*, June 30, 1850.

46. *Crescent*, August 1, 1850, quoting the *Delta*.

47. "The New Custom-House Architect," *op. cit.*

48. James H. Dakin, *To the Commissioners for the Erection of a New Custom House in New Orleans*, New Orleans, *September 21, 1850* (pamphlet), reprinted in the *Bee*, October 11, 1850; Scully, *op. cit.*, pp. 174–75.

49. Commissioners to Treasury Secretary Thomas Corwin, August 29, 1851, RG121; "The New Custom House," *Bee*, October 11, 1850; "The New Custom House," *Crescent*, March 26, 1851; Dakin, *op. cit.*, p. 37; Scully, *op. cit.*, p. 174.

50. Had Dakin's iron framing system been built, as his biographer Arthur Scully has pointed out, it would have been an early instance of the use of structural cast iron in America; Scully, *op. cit.*, p. 174. See p. 143, n. 1 for a discussion of early iron construction.

51. Isaiah Rogers, *Diaries*, January 14, 1851, Avery Library, Columbia University; Letter of Isaiah Rogers to Commissioners, January 25, 1851, reprinted in "The New Custom House," *Crescent*, *op. cit.* Rogers served as supervising architect for the Treasury's Bureau of Construction from 1862 to 1865.

52. The *Bee*, October 5, 1850, claimed Dakin's proposed changes were instrumental in "materially injuring the interests of the Municipality," while the *Picayune*, October 6, 1850, found the interests of the business community "not injured by the alterations," and supported Dakin's proposed changes. The quarrel raged on.

53. *Picayune*, September 3, 1851, cited by Scully, *op. cit.*, p. 181, n. 55.

54. "Letters from the Department relative to the construction of a Custom House Building at New Orleans," June 21, 1851, RG121; panel members, in addition to Beauregard, included architects Adolphus Heiman, Lewis E. Reynolds, and Ammi Young (who would later be appointed Supervising Architect of the Treasury), and Major William H. Chase of the Corps of Engineers.

55. "Report of the Commissioners appointed to investigate the plan and material of the new Custom House at New Orleans," December 15, 1851, RG121.

56. Fourteen drawings executed under Heiman's supervision were completed on February 14, 1852 (in NARA), and follow a sketch dated November 20, 1851, prepared by the board showing the location of the Collector's Room as Dakin proposed. On Heiman, see James Patrick, "The Architecture of Adolphus Heiman," *Tennessee Historical Quarterly*, XXXVIII, 1979, pp. 167–87, 277–95 (for his work at the Custom House, see pp. 179–83); John G. Frank, "Adolphus Heiman: Architect and Soldier," *Tennessee Historical Quarterly*, V, 1946, pp. 35–57.

57. Commissioners to Thomas Corwin, March 22, 1852, RG121.

58. In January 1852, Wood was reported to have turned up at the site "so intoxicated that he could not walk straight"; Commissioners to A.J. Wood, January 6, 1852, RG121; "Letters from the Department relative to the construction of a Custom House Building at New Orleans," July 24 and August 24, 1852, RG121.

59. Beauregard was also put in charge of construction of the U.S. Marine Hospital (cat. 48). On Beauregard's superintendency of the Custom House, see T. Harry Williams, *P.G.T. Beauregard: Napoleon in Gray*, Baton Rouge (Louisiana State University Press) 1995, pp. 39–45.

60. "The New Custom-House," *Picayune*, July 30, 1854; Wharton, "Diary," July 29, 1854. Wharton, who would succeed Beauregard, had clerked on the project since 1848.

61. Alexander H. Bowman to Treasury Secretary James Guthrie, January 23, 1854; *Report of the Secretary of the Treasury, on the State of the Finances, for the Year Ending June 30, 1854*, 33d Cong., 2d sess., H. Ex. Doc. 3, Washington, D.C. (A.O.P. Nicholson) 1854, pp. 353–54.

62. Wharton, "Diary," January 20, 1855.

63. Alexander H. Bowman to James Guthrie, February 10, 1854; P.G.T. Beauregard to James Guthrie, October 10, 1854, RG121.

64. P.G.T. Beauregard to Ammi Young, November 17, 1854, RG121.

65. F.W. Strickland to James Guthrie, October 30, 1854; John Slidell to James Guthrie, October 15, 1854; and numerous other letters of application and nomination, October 1854, RG121.

66. Lee, *op. cit.*, pp. 37–47.

67. P.G.T. Beauregard to Ammi Young, November 17, 1854, RG121.

68. P.G.T. Beauregard to Alexander H. Bowman, February 5, 1854, RG121.

69. P.G.T. Beauregard to Howell Cobb, December 26, 1857, RG121.

70. "Laborers" to Commissioners, July 28, 1854, RG121. Beauregard was echoing the view expressed fifteen years earlier by the Quartermaster General of the U.S. Army; see "Colored Persons in the Army," *Letter from the Secretary of War*, 27th Cong., 2d sess., H. Ex. Doc. 286, Washington, D.C. (Government Printing Office) 1842, p. 2.

71. Williams, *op. cit.*, pp. 5, 28, 33, on Beauregard's early career and leadership style.

72. P.G.T. Beauregard to Howell Cobb, "Annual Report for the Year Ending June 30, 1857," June 30, 1857, RG121.

73. J.W. Crary, *Sixty Years a Brickmaker*, Indianapolis (T.A. Randall & Co.) 1890, pp. 13–14.

74. P.G.T. Beauregard to Howell Cobb, August 6, 1857, RG121.

75. The railway began operation in 1851; A.J. Wood to Commissioners, July 10, 1851, RG121.

76. Wharton, "Diary," November 15, 1854. Wharton recorded the engineering works in sketches dated March 1 and July 25, 1855, and in Jay Dearborn Edwards's salt print of the building (*c.* 1858–59) the full-height scaffolding covers the building (copy in the Southeastern Architectural Archive, Tulane University).

77. P.G.T. Beauregard to Howell Cobb, December 26, 1857, RG121; "Statement of Expenditures to June 30, 1858," P.G.T. Beauregard to Howell Cobb, June 30, 1858, and March 20, 1859, RG121; Wharton, "Diary," March 12 and 15, 1859 (the steam hoist and railroad are visible in Wharton's diary sketches).

78. On Meigs's innovations in hoisting technology at the Capitol, see Dean A. Herrin, "The Eclectic Engineer: Montgomery C. Meigs and His Engineering Projects," in *Montgomery C. Meigs and the Building of the Nation's Capitol*, ed. W.C. Dickinson, D.A. Herrin, and D.R. Kennon,

Athens (Ohio University Press) 2001, p. 13.

79. Montgomery C. Meigs, *Capitol Builder: The Shorthand Journals of Montgomery C. Meigs, 1853–1859, 1861*, ed. Wendy Wolff, Washington, D.C. (Government Printing Office) 2001, p. 283.

80. Wharton, "Diary," March 17, 1855.

81. P.G.T. Beauregard, "Annual Report for the Year Ending June 30, 1856," RG121. Marble for the floor came from additional quarries in New York and Vermont; *Republican*, May 30, 1875.

82. "United States Treasury Buildings," *New York Times*, January 28, 1858.

83. "The New Orleans Custom House Swindle," *Chicago Daily Tribune*, December 21, 1857.

84. "Report of the Engineer in Charge of the Office of Construction," *Report of the Secretary of the Treasury, on the State of the Finances, for the Fiscal Year Ending June 30, 1857*, 35th Cong., 1st sess., H. Ex. Doc. 3, Washington, D.C. (Cornelius Wendell) 1857, pp. 93–94, cited by Lee, *op. cit.*, pp. 46 and 301, n. 19.

85. Federal building projects were reviewed and continued (or not) by Congress annually. "Memorial of Merchants and Others, Citizens of New Orleans, to the Louisiana Delegation in Congress," January 12, 1860; P.G.T. Beauregard, "Statement of Estimates, Appropriations, Expenditures ... in relation to the New Custom House, New Orleans, from the Commencement of the Work to June 30th 1860," RG121. P.G.T. Beauregard to Howell Cobb, "Annual Report," June 30, 1860, RG121; P.G.T. Beauregard to Treasury Department (Secretary Philip F. Thomas), December 16, 1860, RG121; *Report of the Secretary of the Treasury, on the State of the Finances, for the Year Ending June 30, 1860*, 36th Cong., 2d sess., S. Ex. Doc. (number not given), Washington, D.C. (Thomas H. Ford) 1860, pp. 92–94.

86. Williams, *op. cit.*, pp. 45–47, 51–62.

87. "Report of operations ... for the month of January 1861," Thomas K. Wharton to Treasury Department, January 31, 1861, RG121; Thomas K. Wharton to Treasury Secretary John Dix, January 31, 1861, RG121; Wharton, "Diary," January 31, 1861.

88. Wharton, "Diary," May 4, 1861.

89. *Ibid.*, October 19, 1861.

90. John Roy, *Diary*, cited by Arthur, *op. cit.*, pp. 43–44; *Report of the Secretary of the Treasury, on the State of the Finances, for the Year Ending June 30, 1864*, 38th Cong., 2d sess., H. Ex. Doc. 3, Washington, D.C. (Government Printing Office) 1864, p. 156.

91. Wharton, "Diary," April 27 and May 1, 2 and 3, 1861.

92. *New York Times*, July 25, 1862.

93. *Ibid.*

94. *Report of the Secretary of the Treasury ... 1864, op. cit.*, p. 156; Arthur, *op. cit.*, p. 26.

95. *Report of the Secretary of the Treasury ... 1864, op. cit.*

96. New England Roofing & Mfg. Company, Boston, to Isaiah Rogers, November 14, 1863, RG121; Levi Willcutt to Isaiah Rogers, December 10, 1863, RG121; "Roofing the Custom House," *Times*, February 6, 1864; Isaiah Rogers to Treasury Secretary Hugh McCulloch, July 6, 1865, RG121.

97. Mullett's own work, the granite State, War & Navy Building in Washington, D.C., the largest public building in the country when it opened in 1883, would later be called the "greatest monstrosity in America" by President Harry Truman; Benjamin Forgery, "Cityscape: Opening Up the EOS," *Washington Post*, June 8, 1985.

98. A.B. Mullett to W.E. Chandler, Assistant Secretary of the Treasury, November 10, 1865, RG121; "Looker-On," *Times*,

March 15, 1866.

99. *Report of the Secretary of the Treasury on the State of the Finances, for the Year 1866*, 39th Cong., 2d sess., H. Ex. Doc. 4, Washington, D.C. (Government Printing Office) 1866, p. 196, reprinted in *Bee*, February 20, 1867, and *Picayune*, February 20, 1867.

100. *Report of the Secretary of the Treasury on the State of the Finances, for the Year 1869*, Washington, D.C. (Government Printing Office) 1869, p. 8.

101. Report of Gridley J.F. Bryant, March 1, 1870, RG121. According to the *Republican*, the report was written by Gridley's associate architect, Lewis F. Rogers; "The Customhouse," *Republican*, May 30, 1875.

102. *Report of the Supervising Architect of the Treasury, on the State of the Finances, for the Year 1870*, Washington, D.C. (Government Printing Office) 1871, p. 6.

103. "The Customhouse," *Republican*, May 30, 1875.

104. "The Custom-House Roof," *Picayune*, August 17, 1889; Arthur, *op. cit.*

105. Lafcadio Hearn, "La Douane," *Item*, December 2, 1878, reprinted in *Creole Sketches*, Boston, New York (Houghton Mifflin) 1924, p. 6.

106. Talbot Hamlin, *Greek Revival Architecture in America*, London (Oxford University Press) 1944, p. 230.

107. Samuel Wilson, addendum to Stanley C. Arthur, *A History of the U.S. Custom House New Orleans*, New Orleans (U.S. Custom Service) 1984, pp. 72–78. A major renovation was completed in 1916, when the Post Office moved to a new building on Lafayette Square.

108. Hearn, *op. cit.* The exterior complete, construction of an interior staircase and internal modifications were carried out throughout the decade.

20
Canal St.
Rue du Canal

Said to be the widest main street in America, and a "leviathan of a causeway," Canal Street was the remnant of an old colonial common planned for a canal that was never built.[1] As late as the mid-nineteenth century there was, according to a local guidebook, "little of architectural display" along its full length, and only "an irregular front of unpretending structures" between Bourbon and Royal streets.[2] But with the great Touro Block of commercial structures and a fine group of cast-iron buildings raised after 1850, Canal developed into what one Union soldier called "probably the prettiest street in America."[3] Now the retail center of the city and the hub of the street-railway system, Canal was, according to the *Picayune*, the "heart of New Orleans":

the broad footwalks, the double, wide and well-paved carriage ways, the green "neutral ground," with its refreshing vista of trees, the brilliantly colored railway cars, which

are constantly moving in the midst of them, the lofty stores, with their rich displays of silks and diamonds ... all that is elegant and beautiful, rich and rare, seeks "the grand Boulevard" for its display.[4]

Lilienthal's view of the corner of Canal and Royal streets at the Henry Clay statue was a vista recommended for every visitor in 1866: "No one has seen New Orleans who has not taken his stand, first near the Custom House, then near the Clay Statue ... and looked at the panorama of Canal street."[5] Many of the city's most successful merchants were located there, although after the war the "extortionate rents" were reported to "compel many dealers and traders to seek other localities."[6] At the corner of Royal Street was the S.N. Moody store, the most famous of all local manufacturers and retailers, whose shirts won a bronze medal at the Paris Exposition. Moody couriered Lilienthal's photographs to Paris, and among them was a view of Moody's own residence a few blocks farther up Canal (cat. 21).[7] As an effective merchandiser and marketer, Moody understood the potential of the city's busiest street for the display of goods. "There are a great many beautiful show windows on Canal street," the *Picayune* wrote in 1866, but none, reportedly, could compare with Moody's "elegantly arranged window ... piled up with a clever eye to scenic effect."[8]

Moody himself may be standing on the balcony of his shirt emporium in Lilienthal's view, below the advertising banners that covered much of the façade of his building.[9] The Moody building was built in 1825 by Germain Musson, grandfather of the painter Edgar Degas (Degas's mother was born in New Orleans).[10] The storefront, made of Massachusetts granite, still stands, and is one of the oldest buildings on Canal. In 1867, one of the building's tenants was photographer William Washburn, Lilienthal's chief competitor, whose studio is visible just below the outstretched hand of the Clay statue.

Next door to Moody's, at the corner of Exchange Place, is the three-story Bank of America, designed by Charles Zimpel and built in 1832. Later, in 1896, this was the location of Vitascope Hall, which has been identified as the first motion-picture theater in America.[11]

At the north corner of Royal and Canal streets is part of the Touro Block with its fine iron galleries. After Touro's death in 1854 his

estate funded street enhancements (the street was briefly renamed in his honor).[12] Designed by Thomas Murray, the group of twelve stores, called the "finest bazaar in the city," was the most prestigious retail address in New Orleans.[13] Lilienthal later operated a studio there, at the height of his commercial success (1875–86), next door to A.B. Griswold Jewelers (fig. 105).

The Henry Clay monument, completed a year before the war, honored the most famous man in America—the popular Kentucky senator and three-time presidential candidate of the Whig party.[14] "There is about him a remarkable air of dignity and high breeding," a British traveler observed of Clay; "his counte-nance is full of benevolence and intellect, and his conversational powers are of the highest order."[15] Clay championed open commerce on the Mississippi River and tariffs on imported sugar, causes that benefited the port of New Orleans and raised his prestige locally to heroic status. "He was a supporter and friend of the industry of Louisiana," the *Carrollton Star* wrote, "and [he] contributed all the immense resources of his intellect to the maintenance of a policy which has tended to her prosperity and advancement."[16] Clay had close family ties to New Orleans—two daughters and a brother lived in the city—and his visits were celebrated with artillery salutes, closed shops, and welcoming assemblies of thousands.[17] When a clock tower was planned for Canal in 1850, promoters chose a statue of Clay to crown it, and other monument proposals gained momentum after his death in June 1852. In one scheme, statues of Clay and other luminaries lined Canal, renamed "Monument Street," in what would have been New Orleans's largest antebellum beautification project.[18]

These proposals were never carried out, but the Clay Monumental Association, promoted by financier James Robb and other "liberal and patriotic citizens," mostly Whigs, set out in November 1852 to raise $50,000 for "a colossal statue of our departed statesman."[19] The drive resulted in a design by William P. Freret that placed a 12-foot (4-m) bronze statue of Clay by Kentucky sculptor Joel Tanner Hart on a 22-foot (7-m) pedestal of Massachusetts granite.[20] Hart's statue represented Clay in "a graceful attitude ... as if he was in the act of addressing the Speaker in Congress."[21] But in commissioning the work, backers in New Orleans were divided on how "the Great Commoner" should appear. To some,

only the "classic toga" of the Roman Tribune was appropriate, while others reasoned that it would be "far more republican, democratic, [and] American" to represent Clay dressed "in his [Senate] habit, as ... men were used to seeing him." Hart's New Orleans statue was one of three versions he executed from 1846 to 1860; all represented Clay in modern rather than antique costume.[22]

Dedication of the Canal Street monument on April 12, 1860, Clay's birthday, was reported to be the "grandest celebration ever seen in the South." Mayor Stith declared that the city would "consecrate the day," and proclaimed all business suspended, while inaugural medals were struck on Chartres Street and the Jackson Railroad

ran free return-trip excursions to accommodate spectators. "We have seen many gatherings in New Orleans, but never did the city present such a scene," the *Picayune* reported that day. "The whole population seemed to have concentrated itself in the immediate vicinity of the monument and in the streets through which the procession was to pass." The 3-mile-long (5 km) parade featured a fully rigged three-masted warship, firing its cannons as it was wheeled up Canal Street by teams of horses. Storefronts along the parade route carried "tasteful contrivances" honoring Clay, and "splendid banners of rich coloured silk" filled the air with kaleidoscopic tints of incomparable beauty."[23] Moody, who "quaffed champagne"

on his balcony with guests as the procession passed, was not to be overshadowed by the event, and immediately published notices that the Clay Monument could be found "opposite S.N. Moody's Shirt Emporium."[24]

The procession of more than 5000 participants took hours to pass Moody's corner. Finally, the Washington Artillery fired a thirty-three-gun salute, the bands struck up "Hail Columbia," and the bunting was pulled, unveiling the statue.

The bright sun glittered on the unvarnished bronze and made it look almost like a statue of gold, revealing all its artistic beauty and faithful likeness. The figure is twelve feet six

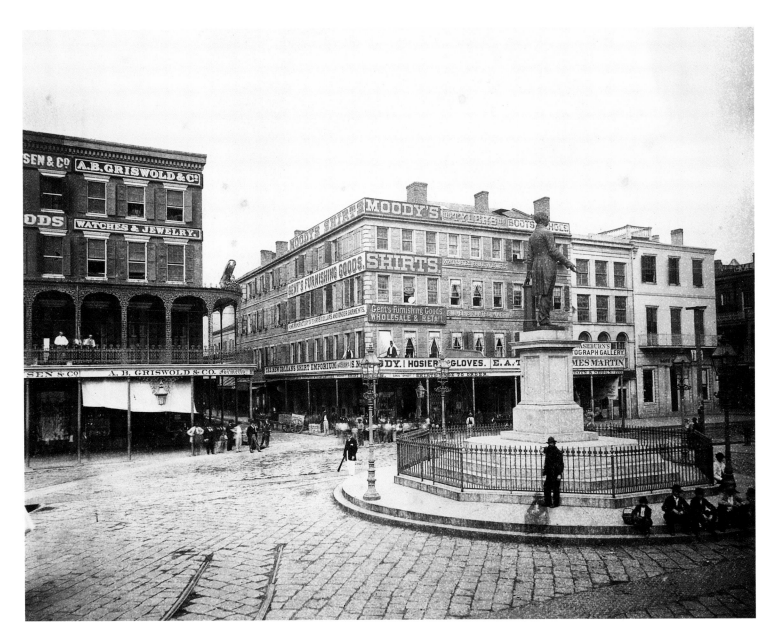

inches in height, standing in a graceful attitude, with the left foot forward, the left hand resting on a shaft, and the right slightly extended as if he was in the act of addressing the Speaker in Congress.[25]

The "air was rent with cheers" for Clay and for Hart, whose work was celebrated "most vociferously." Following orations so lengthy that the newspapers could not print them in full, the crowds gradually dispersed. Calcium light illuminated the statue throughout the night.[26]

A decade later, the war brought unexpected significance to the Clay monument. To Orleanians Clay "represented the southern mind, and reflected its highest and noblest qualities;" he had also opposed slavery and championed the Union, and had been an important influence for reconciliation, notably during an early nullification challenge from South Carolina.[27] When Union General Nathaniel Banks was in possession of the city he gave the symbol of southern nobility a distinctly abolitionist cast. "For some time past the sharp click of the stone-cutter's chisel has been heard around the base of the colossal bronze statue of Henry Clay," the *True Delta* reported in April 1864.[28] Banks "ransacked the speeches of Clay," the *New York Times* later wrote, for eloquent words against slavery, and had them inscribed into the pedestal:

> If I could be instrumental in eradicating this deepest stain, slavery, from the character of our country, I would not exchange the proud satisfaction which I should enjoy, for the honor of all the triumphs ever decreed to the most successful conqueror.[29]

Clay's words now possessed "a significancy in these evil times that never were attached to them before," the *True Delta* wrote, and to many Orleanians, the incident was an act of desecration and yet another humiliation of the federal occupation. Even the *True Delta*, although now owned by the Unionist governor of Louisiana, disapproved:

> [A]fter the close of this war the paragraph will read somewhat oddly to people who well know that the cause of the declaration has passed forever away from among us, and they will wonder at the inappropriateness of the inscription in such a place. Perhaps it would be well to leave the surface uncut until the present struggle has ceased.[30]

Adulation for Clay himself seemed diminished by the episode, and, before long, removal of the desecrated monument was called for under veiled objections that the pedestal was "not pleasing to the artistic eye."[31] Twenty years later the incident remained vivid, as one journalist recalled: "After the federals had defiled the statue by cutting upon the granite pedestal words garbled from a speech by Mr. Clay, our people felt no longer an interest in the thing ... the statue still stands there insulting every good taste."[32] In the early 1890s the monument became an obstacle to expansion of electric streetcar service at the city's busiest traffic corner, and in 1901 it was finally removed to Lafayette Square.[33]

1. Abraham Oakey Hall, *The Manhattaner in New Orleans, or, Phases of "Crescent City" Life*, New York (J.S. Redfield); New Orleans (J.C. Morgan) 1851, p. 45; "Destiny of Canal Street," *Picayune*, February 24, 1867; Ralph Keeler and Alfred R. Waud, "New Orleans I: The Heart of the City," *Every Saturday*, III, July 1, 1871, p. 6. On the history of Canal Street, see Samuel Wilson, Jr., "Early History of Faubourg St. Mary," in *New Orleans Architecture*, II, pp. 3–48, esp. pp. 10–20. Broadway, New York, was 80 feet (24 m) wide; Canal Street was 171 feet (52 m).

2. Griswold's *Guide*, p. 19.

3. Thomas W. Knox, *Camp-Fire and Cotton-Field: Southern Adventures in Time of War*, New York (Blelock and Co.) 1865, p. 392; "Building Improvements," *Crescent*, September 12, 1859.

4. "Canal Street on Saturday," *Picayune*, January 9, 1866.

5. *Ibid.*

6. *Times*, September 14, 1866. Canal street shop rent ranged from $600 to $1200 per year in 1866; *Times*, August 27, 1866.

7. Not including the Moody residence and other building views taken on Canal Street, Lilienthal sent at least two street-corridor views of Canal Street to Paris. The *Crescent* reported in May 1867 that among the 150 views in the Paris portfolio was a view of "Canal street from Bourbon to the river." Another photograph by Lilienthal of the Clay statue from the opposite corner is recorded in stereograph, *c.* 1867 (fig. 96).

8. *Picayune*, October 26, 1866. On retail spectacle and consumption in the mid-nineteenth-century city, see Dell Upton, "Inventing the Metropolis: Civilization and Urbanity in Antebellum New York," in *Art and the Empire City: New York, 1825–1861*, ed. Catherine Hoover Voorsanger and John K. Howat, New York (The Metropolitan Museum of Art), New Haven, Conn. (Yale University Press) 2000, pp. 23–24.

9. Moody moved to the Canal and Royal streets building in July 1857; *Sunday Delta*, July 26, 1857.

10. *New Orleans Architecture*, II, p. 137; Jean Sutherland Boggs, *Degas and New Orleans: A French Impressionist in America*, New Orleans (New Orleans Museum of Art) 1999, p. 106.

11. Sylvester Quinn Breard, "A History of the Motion Pictures in New Orleans, 1896–1908," *Historical Journal of Film, Radio and Television*, XV, no. 4, 1995, supplement. The historic site is today a McDonald's restaurant.

12. John Magill, "Canal Street is 150 Years Old," *Preservation in Print*, XII, no. 10, December 1985, pp. 8–9.

13. "Architecture in New Orleans," *True Delta*, September 10, 1852; "City Improvements," *Crescent*, October 21, 1856.

14. *Constitution, Officers, and Address of the Clay Monumental Association of New Orleans*, New Orleans (Crescent Office) 1852, p. 7.

15. Matilda Charlotte Houstoun, *Hesperos: Or, Travels in the West*, London (J.W. Parker) 1850, II, p. 79.

16. *Carrollton Star*, April 5, 1856.

17. "Reception of Mr. Clay," *Picayune*, December 22, 1842.

18. *Crescent*, January 15, 1851; "The Union Column," *Crescent*, June 24, 1851; "The Union Monument," *Picayune*, April 27, 1852; "A Glimpse at Canal Street," *Times*, October 28, 1866. William P. Freret was the author of the first proposal, a "Union Column" where Clay stood above inscriptions of the names of "Union Senators," recorded in an undated lithograph by Jules Manouvrier and Perez Snell in the James Dakin Collection at the New Orleans Public Library. An undated drawing by James Gallier, Jr., for the clock tower in the form of a Corinthian column, referenced in the article of January 1851 cited above, is in the Southeastern Architectural Archive, Tulane University.

19. *Constitution, Officers, and Address, op. cit.*; "Monument to Henry Clay," [mss. invitation], Clay Monument Association Papers, Col. M184, Manuscripts Collection, Tulane University Library; "Clay Monument Meeting," *True Delta*, August 7, 1852; "Address of the Clay Monument Association," *Courier*, November 13, 1852; "Monument to Henry Clay," *Courier*, January 16, 1853; "Clay Monument Association," *Delta*, January 18, 1853; "The Clay Monument," *Picayune*, February 27, 1856.

20. Clay was reportedly "one of the first to discover the genius [of Hart]," and promoted his early career; "Clay and Hart," *Delta*, April 16, 1860; *Courier*, May 21, 1859, cited by Francis P. Burns, "Henry Clay Visits New Orleans," *Louisiana Historical Quarterly*, XXVII, no. 3, July 1944, p. 59, n. 130; "The Clay Statue," *Picayune*, March 4, 1860.

21. "The Celebration Yesterday," *Bee*, April 13, 1860.

22. Hart's statue was modeled in plaster in Florence and cast in bronze in Munich (by M. Müller). The first executed version of the statue, in marble, was installed at the Virginia State Capitol in Richmond and unveiled a short time after the New Orleans work, on April 17, 1860. See "The Clay Statue," *Picayune*, March 24, 1856; "Statue of Henry Clay," *Picayune*, September 19, 1858; *Picayune*, April 11, 1860; Samuel Woodson Price, *The Old Masters of the Bluegrass*, Louisville, Ky. (John P. Morgan & Co.) 1902, pp. 161–62; William H. Gerdts, "Celebrities of the Grand Tour: The American Sculptors in Florence and Rome," in Theodore E. Stebbins, Jr., *The Lure of Italy: American Artists and the Italian Experience 1760–1914*, Boston (Museum of Fine Arts), New York (Harry N. Abrams) 1992, pp. 82–83.

23. Wharton, "Diary," April 12, 1860, apparently with reference to Camp Street.

24. "The Clay Statue," *Evening Picayune*, March 23, 1860; *Picayune*, April 11, 1860; "The Celebration Yesterday," *Bee*, April 13, 1860; "The Statue of Henry Clay," *Picayune*, April 13, 1860.

25. "The Celebration Yesterday," *Bee, op. cit.*

26. "The Clay Statue," *Bee*, April 12, 1860; *Bee*, April 13, 1860; *Delta*, April 12 and 13, 1860; "Statue of Henry Clay: The Inauguration," *Picayune*, April 13, 1860.

27. "A Monument to Henry Clay," *Carrollton Star*, March 29, 1856; Robert V. Rimini, *Henry Clay: Statesman for the Union*, New York (W.W. Norton) 1991, pp. 411–35.

28. "The Inscription on Clay Statue," *True Delta*, April 12, 1864.

29. *Ibid.*; John Chandler Gregg, *Life in the Army, in the Departments of Virginia, and the Gulf, Including Observations*

in New Orleans, Philadelphia (Perkinpine & Higgins) 1866, p. 146; "New-Orleans Statue Inscriptions," New York Times, November 25, 1887. On Clay's views on slavery, see Rimini, op. cit., pp. 26–27, 526, 670, 740.

30. Rimini, op. cit.

31. "Removal of the Clay Statue," Daily States, January 17, 1894. Critics of the monument design had raised objections to the size and height of the pedestal from its unveiling in 1860. Thomas K. Wharton wrote that the pedestal, though "beautiful," was in "no proportion whatever to the mass of the figure … too scant in every dimension and at least 25 feet too low" (Wharton, "Diary," April 12, 1860). The Delta offered the epigram: "[Clay] stands, by architectural doom, like a huge giant on a young mushroom" ("The Elevation of the Clay Statue," Sunday Delta, April 15, 1860).

32. "Clay's Statue," Daily States, January 23, 1884. Suggesting the depth of the resentment regarding the incident, many accounts, including Gregg and the Daily States in 1884, associated the event not with General Banks but with "the ruthless Butler," who had, however, been relieved of command in early 1863. That Butler was thought to have committed the deed only intensified the disgrace. Hatred of Butler, as historian Joe Gray Taylor has written, "has been assiduously cultivated in New Orleans since his departure." Joe Gray Taylor, Louisiana Reconstructed 1863–1877, Baton Rouge (Louisiana State University Press) 1974, p. 18.

33. "Removal of Clay Statue," Daily States, January 17, 1894; "Notice Served on Henry Clay," Picayune, January 6, 1900. The removal was not without public opposition, and one counter-proposal put forward a plan for a monumental arch spanning Canal Street and the streetcar tracks, crowned by the Clay statue.

21 *overleaf*

S. N. Moody's Residence
Residence de S. N. Moody

This Italianate town house on Canal Street between Tremé and Marais streets was built for Samuel Nadin Moody and was one of New Orleans's finest antebellum residences.[1] Moody was an entrepreneur of the clothing trade, a local celebrity who was reported to be "perhaps as widely known as any resident of the southwest."[2] His retail and wholesale store, located seven blocks away at the corner of Canal and Royal streets (cat. 20), was a local landmark.

Designed by Henry Howard and Albert Diettel in 1858, the Moody house was ornamented with cast-iron galleries, cast-iron hood molds, and marble steps. A carriage entrance led to a coach house and stable. A neighboring house built about the same time was nearly identical in plan and elevation but was more plainly executed.[3] Within a decade, Canal Street's blooming retail trade, which Moody had anchored, was encroaching on the residential life of the street. "He who builds a dwelling on Canal Street," the Picayune observed in 1866, "is likely to be driven out of it by the demands of traffic."[4]

Moody was a native of Manchester, England.[5] He became secretary of the Manchester Stock Exchange and head of an investment firm before the age of twenty, but the Railway Panic of 1846–47 ruined him. He soon immigrated to New Orleans, where he began clerking in an uncle's clothing store, although he was said "not [to] know linen from cotton."[6] Within three years he had opened his own store at Canal and Exchange Alley, retailing linen shirts and other garments. By 1857, he was successful enough to lease a large shop in the granite Musson building at Canal and Royal streets, reportedly the "best location in town for business."[7]

With 500 laborers employed locally and in a factory he operated in New York's garment district, Moody was New Orleans's largest manufacturer in the 1860s and the "biggest shirt tailor of the Southern States."[8] He was also the city's exemplary entrepreneur, legendary in the Civil War era for his marketing and retailing skills, and known throughout the South as the "shirt king" of Canal Street. Even during the war years he appeared to be "doing very well and making money."[9] As early as the 1850s he had perfected his promotional strategy: skillfully arranged display windows on the city's busiest street were never shuttered, night or day, and a continuous blitz of display advertising and column notices appeared in local newspapers. Most effective of all was his pioneering use of outdoor advertising: "talismanic words," the Times wrote, "conspicuously posted in every section of the country."[10] In New Orleans, Moody's placards seemed to be everywhere, in nearly every street, nailed to telegraph poles or staked in the ground. "Who in the city of New Orleans is ignorant of the whereabouts of Moody's shirt repository?" the Orleanian asked in 1857. "Moody is fully cognizant of the mode whereby to make himself known."[11]

But Moody's forceful publicity campaigns were not always condoned. In Carrollton, where his ubiquitous signage disturbed the gentility of suburban streets, the town council gave instructions to remove the telegraph placards. He met the opposition head-on in print, inviting the council of the "pleasant and umbrageous little village" to his shop to sample his "luxurious shirts."[12]

It was most of all Moody's "extensive and persistent manner of [print] advertising"— often droll notices astutely timed to events—that contributed significantly to his success as a retailer.[13] On the day of Louisiana secession, he seized the moment to promote a sale of shirts "at war prices," and soon offered military shirts ready-made in twelve patterns.[14] During the war, he mimicked battlefield reportage and placed advertising narratives in columns adjacent to accounts of battle, adopting similar rhetoric. "Another fierce but very unsanguinary series of engagements has been raging for several days, culminating in the desperate storming of the granite fort, corner of Canal and Royal streets," his advertising copy read in March 1864, while an adjacent column reported on bloody engagements in the battlefields of Mississippi.[15] He published poems, satirical dialogues, and sarcastic letters in local papers addressed to "other monarchs" and the "starchy bosoms" of "fellow aristocrats," including Emperor Napoléon III.[16]

In December 1866 the Governor of Louisiana appointed Moody Commissioner to the Paris Exposition. He was also an exhibitor, and the courier of Lilienthal's photographs to Paris in June 1867. The Crescent reported on June 7 that Moody "departs to-morrow from among us to mingle a while with other

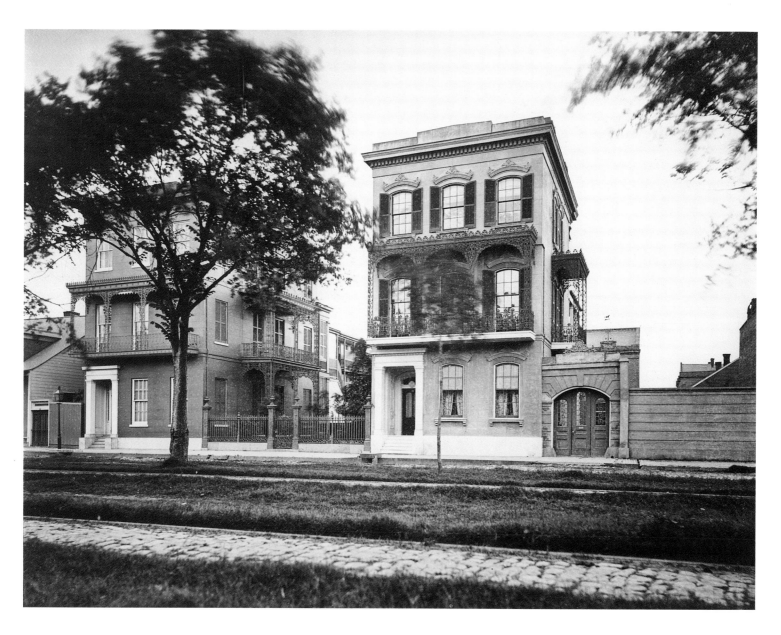

potentates [in Paris], accredited with a letter from Mayor Heath, presenting him to the illustrious Louis Napoleon as the greatest shirt maker and the most appreciative admirer of art on the American continent."[17] Later in the year, Moody received an Exposition medal for "the best shirts in America," which were reported to have "elicited the wonder and delight of the saturnine and sartorial French emperor himself."[18] Never missing a marketing cue, Moody immediately offered a new line of shirts at his Canal Street shop, priced at six for $9, to celebrate his Paris prize.[19]

1. The Moody house stands today at 1411 Canal Street, much altered as a retail storefront.
2. *Picayune*, January 3, 1872.
3. Building contract, G. Rareshide, XII, no. 2227, April 5, 1858, NONA; *Crescent*, July 8 and September 12, 1859; *New Orleans Architecture*, VI, pp. 79–80.
4. *Picayune*, April 15, 1866.
5. Moody was born in Manchester in 1826 and died in New Orleans on New Year's Eve, December 31, 1874, a suicide (he had been incapacitated by a spinal injury suffered in a carriage accident). His biographies, presumably self-written, are in *Jewell's Crescent City Illustrated* and in "Col. S.N. Moody," *Picayune*, February 23, 1873. His obituary is in the *Picayune*, January 3, 1875.
6. "Col. S.N. Moody," *op. cit*. His uncle, Charles Leighton, was a shirt manufacturer and clothing retailer.
7. "Removal of S.N. Moody," *Sunday Delta*, July 26, 1857; *Crescent*, March 1, 1866.
8. Archives Nationales, Paris, F12 3095, Class 9, Letter of Edward Gottheil to Frédéric Le Play, President of the Imperial Commission, Paris Exposition, dated August 7, 1867; I am grateful to François Brunet for this reference. Moody's shirt factory was located at 315 Broadway, New York, in 1857; *Sunday Delta*, July 26, 1857.
9. *Louisiana*, XI, p. 195, R.G. Dun & Co. Collection, Baker Library, Harvard Business School.
10. *Times*, September 1, 1866.
11. "Moody's," *Orleanian*, February 1, 1857.
12. "The Common Council of Carrollton versus S.N. Moody's Placards," *Sunday Delta*, May 17, 1857.
13. "Death of SN Moody," *Picayune*, January 3, 1875.
14. "Volunteers, Take Notice" (advertisement), *True Delta*, June 10, 1861; *True Delta*, January 26, 1861.
15. *True Delta*, January 26, 1861; "S.N. Moody, Besieged and Almost Defeated" and "The March in Mississippi," *Picayune*, March 27, 1864; *Crescent*, November 19, 1866; "Moody's Shirts," *Crescent*, March 17, 1867. Moody was keenly sympathetic to the Confederacy and was reported to have contributed substantially to its treasury. His brother-in-law was Confederate general Charles Labuzan, whom he served as

aide-de-camp. It was the policy of the occupying Union forces to confiscate and occupy Confederate property, but Moody retained British citizenship, which may have dissuaded the federals from seizing his assets.

16. "A Good Deed," *Times*, May 4, 1867.

17. "Moody on a European Trip," *Crescent*, June 7, 1867. On Moody's appointment, "Commission to the Paris Exhibition," *Picayune*, December 24, 1866, and more on his Paris trip: "New Orleans and Vicinity at the Paris Exposition," *Crescent*, May 26, 1867; "Col. Moody Off for Paris," *Commercial Bulletin*, June 10, 1867; *Times*, June 9, 1867.

18. "The Paris Prize Medal," *Crescent*, December 1, 1867.

19. A duplicate of Lilienthal's view of the Moody house exists and is the only known duplicate, in presentation format, of the Paris portfolio views (see p. 56). It is in the collection of the Southeastern Architectural Archive, Tulane University, a recent gift of Moody descendant Alicia Rogan Heard, whom I thank for her contribution of Moody family material to my research.

22
Dr. Stone's Infirmary Canal St.
Infirmerie du Dr. Stone Rue du Canal

Known as the Maison de Santé (House of Health), Dr. Stone's Infirmary was located at a secluded site on Canal Street near Claiborne. Dr. Warren Stone was a Boston-trained physician who arrived in New Orleans in 1832, and within a few years was appointed professor of surgery at Charity Hospital (cat. 69), the leading medical position in the city.

Stone purchased the hospital site in 1838 from descendants of the Marquis de Lafayette, who had been granted the land by the U.S. government.[1] With his partner, Dr. William Kennedy, Stone hired architect James H. Dakin to design the infirmary.[2] Dakin—whom contemporaries James Gallier and Minard Lafever praised as "a young man of genius,"— had trained in New York, and in 1832–33 formed a partnership with one of the most successful architects in the country, Alexander Jackson Davis.[3] In 1835, Dakin came to New Orleans, where his brother Charles had established a practice, for a time with James Gallier (see cat. 64). Dakin designed many admired buildings, alone and in partnership with Charles, but Stone's Infirmary, completed in 1839, was only a routine example of the Greek style that Dakin and James Gallier brought into fashion locally during the 1830s. Awkwardly proportioned, the infirmary's massive pedimented Doric porch seems to explode from a modest, fenestrated box.

One of the founders of the Medical College of Louisiana (cat. 67), Stone pioneered the use of ether as a surgical anesthetic in New Orleans, only a year after its first use at Massachusetts General Hospital.[4] The introduction of anesthesia made possible many new surgical procedures for Stone and other surgeons, as one historian has noted: "For the first time doctors found themselves able to achieve significant results," results that led to recognition and even fame. Physicians began to attach greater importance to clinical work, using hospitals, and often their own clinics, to advance their professional and social standing. Stone himself was propelled by his clinical success to national recognition in the profession, as well as local celebrity as a surgeon.[5]

For most of the 1850s the Sisters of Charity managed the Stone clinic, while Stone himself served as chief surgeon, but in 1859 the sisters left to open their own hospital, Hotel Dieu (cat. 49). In the year before the war, Stone's infirmary admitted 264 whites and 428 blacks (many of them slaves), and treated many others, often indigent, as outpatients. Stone's policy was "never to refuse professional services on the score of poverty of the applicant."[6] Other private hospitals—the new Hotel Dieu and the Circus Street, Touro, and Luzenberg (cat. 46) hospitals—also had wards for slaves (who accounted for nearly half of all admissions at Touro).[7] The disproportionate number of slaves admitted is a reflection of the slaveholders' stake in the fitness of their charges, and the missed work or loss of investment that might result from their illness or death.[8]

Stone's Infirmary closed during the war, while Stone, appointed state surgeon, supervised surgery at Bull Run, Shiloh, and other Confederate field hospitals. He returned to New Orleans after the war and reopened the infirmary, then one of only two private hospitals operating in the city, but in late 1867 the hospital closed permanently. Following Stone's death in 1872 the building was put up for sale, "at a great bargain," according to an advertisement, for a property that "could at a small outlay be converted into a first class hotel, college, or other public edifice."[9] A few years later a visitor observed that the "Maison de Santé, long one of the most noted infirmaries of New Orleans, is now deserted, and ... is rapidly falling into decay."[10] By the early 1880s the building was gone.

1 A biography of Stone is in *Jewell's Crescent City Illustrated*.

2. *Picayune*, August 8, 1839; Arthur Scully, Jr., *James Dakin, Architect: His Career in New York and the South*, Baton Rouge (Louisiana State University Press) 1973, p. 85. Building contract, H.B. Cenes, February 8, 1839, NONA, cited by Scully, *op. cit.*, p. 196, n. 2.

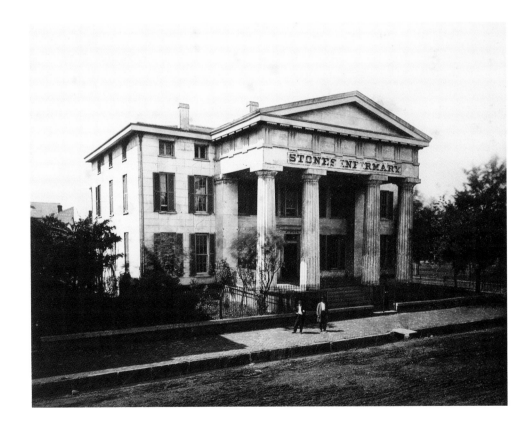

3. Gallier, *Autobiography*, pp. 18–19; Scully, *op. cit.*, pp. 3–22; Jacob Landy, *The Architecture of Minard Lafever*, New York (Columbia University Press) 1970, p. 45; Jane B. Davies, "Alexander J. Davis, Creative American Architect," in *Alexander Jackson Davis, American Architect 1803–1892*, ed. Amelia Peck, New York (The Metropolitan Museum of Art) 1992, pp. 18–19.

4. John Salvaggio, *New Orleans' Charity Hospital: A Story of Physicians, Politics, and Poverty*, Baton Rouge (Louisiana State University Press) 1992, p. 74. The Boston operation, or its reenactment, is recorded in a famous daguerreotype by Southworth and Hawes.

5. Adrian Forty, "The Modern Hospital in England and France; The Social and Medical Uses of Architecture," in *Buildings and Society*, ed. Anthony D. King, London (Routledge & Kegan Paul) 1980, p. 81.

6. "Report of Stone's Infirmary for the Year ending August 31st, 1860," *New Orleans Medical and Surgical Journal*, XVIII, no. 2, March 1861, pp. 201–202.

7. Forty-three percent of Touro's admissions between 1855 and 1860 were registered as slaves. Katherine Olukemi Bankole, "A Critical Inquiry of Enslaved African Females and the Antebellum Hospital Experience," *Journal of Black Studies*, XXXI, no. 5, May 2001, pp. 518–19.

8. Peter Kochin, *American Slavery 1619–1877*, New York (Hill and Wang) 2003, p. 114.

9. "A Valuable Canal Street, College, Hotel, Theatre or Church Site for Sale," *Picayune*, June 30, 1872.

10. Edward King, *The Southern States of North America: A Record of Journeys*, London (Blackie & Son) 1875, p. 64.

23
Head of Old Basin
Quai du Vieux Bassin

Commerce in nineteenth-century New Orleans was heavily dependent on two internal waterways, the Old and New Basin canals. The Old Basin, or Carondelet, Canal was cut through cypress swamp at the rear of the city in 1793–96 under Baron Carondelet, then the Spanish Governor of Louisiana.[1] Carondelet "commenced a work from the head waters of the Bayou ... St John, in nearly a direct line with Orleans street, the center street of the city, for the express purpose of draining the city," according to one account.

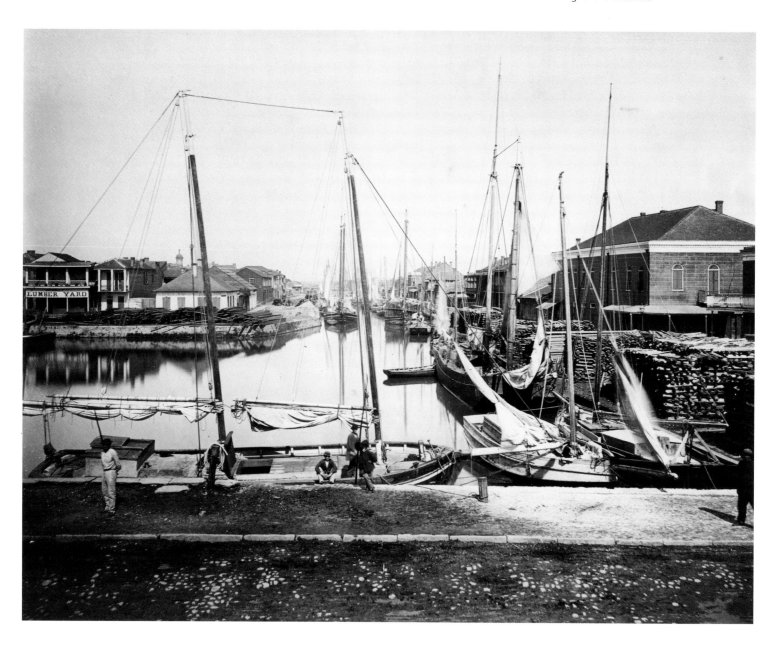

After digging a ditch about two miles in length, he then stopped and commenced what is now the Basin, which was a large shallow pond intended as a reservoir. To carry on this work, the citizens were generally taxed, and those who owned slaves obligated to give their labor a part of each week.[2]

In 1810, the *Louisiana Gazette* reported that the canal was an "unwholesome morass, from which pestilential emanations are continually evaporating."[3] A company formed in 1815 improved the waterway for navigation and levied tolls on shipping. "Where there was formerly a filthy ditch and noisy frog pond," according to Paxton's *Directory*, "we find a beautiful canal, with a good road and walks on each side, with gutters to drain off the water, and a large and secure basin where vessels can lie in perfect safety at all seasons."[4]

The 2-mile (3.2-km), 30-foot-wide (9 m) waterway required constant dredging and could not accommodate heavy cargo boats with a draft that exceeded the canal's shallow depth of 3½–6½ feet (1–2 m). Typical of canal traffic were flat-bottomed scows, luggers, sloops, and schooners, such as the double-masted schooner seen in the photograph.

In 1866, the Old Basin was revitalized, when steam dredges cleared the waterway for large lake steamers.[5] "The amount of business being done now by this canal," the *Crescent* reported in July 1866, "is much larger than ever before at this season, judging from the immense piles of lumber, wood, and bricks on the sides of the canal, and the large quantities of merchandise on the wharf around the basin."[6] In Lilienthal's view of the turning basin of the canal (at Basin Street), the banks are lined with woodpiles and tidy cordwood stacks awaiting drayage. Planing mills and lumber dealers—the Jouet Lumber Yard at Toulouse Street is visible on the opposite bank—were located along the canal to receive timber from sawmills in Mississippi and northern Louisiana.

By World War I the canal was obsolete for larger and faster water craft and was again so clogged with sediment that it was considered a menace to public health, but it remained open until the late 1920s. The waterway was finally covered over in 1937. The turning basin site is now a highway interchange.

1. The best account of the canals and waterways of New Orleans is in Peirce Lewis, *New Orleans: The Making of an Urban Landscape*, Cambridge, Mass. (Ballinger) 1976, pp. 17–30.
2. *New-Orleans Directory & Register*, New Orleans (J.A. Paxton) 1822, cited by *De Bow's Review*, VII (new series I), no. 5, November 1849, pp. 417–19.
3. "The Canal of Carondelet," *Louisiana Gazette*, July 9, 1810.
4. *De Bow's Review, op. cit.*, p. 418.
5. "A Visit to the Carondelet Canal," *Crescent*, July 5, 1866.
6. *Ibid.*

24 *overleaf*
Beer Brewery Old Basin
Manufacture de Biere Vieux Bassin

The Old Canal Steam Brewery at Toulouse and Villere streets was one of nine breweries operating in New Orleans in 1867, and one of four that predated the war. Established in 1858 by George Merz, a native of Württemberg, Germany, the Old Canal was an important innovator in brewhouse technology.[1]

The introduction of German-style *Lagerbier* in the mid-nineteenth century, with the immigration of large numbers of Germans, and German brewers, created a strong market for beer in New Orleans and the rest of the country.[2] The pale, light-bodied, sparkling lager proved enormously popular, and to meet demand, brewery construction in America quadrupled in the decade before the war. Lager from industrial breweries in Cincinnati, St. Louis, Chicago, and Milwaukee—cities with large German populations—was sold in New Orleans, and by 1860 George Merz was brewing lager locally. Marketed as a "pleasant, healthful drink," of social benefit to the community, lager was low in alcohol, so the drinker would, it was claimed, experience "no maddening impulses that stir the mind to deeds nefarious," but only a "hearty full feeling." The *Picayune* applauded Merz's new beverage: "As men must drink something, we hail [lager] as a moral institution."[3]

The lager-brewing process at the Old Canal began on the malt floor, where barley malt was soaked in water, kiln-dried, and mill-ground. In two large mash tanks the ground malt was steam-heated, mixed with water, and mashed. From there a malt liquor was extracted, blended with hops in brew kettles, and boiled into wort. The wort was then cooled down in iron chambers and piped through ice water, and finally fed into fermenting vats, where it remained for four or five days. Transferred to barrels, the brew was aged, or "lagered," in ice-cooled cellars, and carbonic acid was added to give the desired effervescence.[4]

Lager beer production was dependent on a ready supply of ice. New Orleans was the largest city in the country without its own source of natural ice, and the largest domestic market for ice imports (see cat. 61). The need for a continuous supply of ice in the brewing process and the high cost of imported ice fueled innovation in mechanical refrigeration, and New Orleans, notably Merz's brewery, took a lead in development of both refrigeration technology and ice manufacture.[5]

In 1858–59, a French engineer, Ferdinand P.E. Carré, developed a refrigeration machine that was the first to become available commercially in America.[6] Carré machines, manufactured in Paris by Mignon & Rouart, were smuggled into New Orleans during the war, and a local ice company was organized under the Carré patent, but the machines were expensive ($25,000 each in Paris), unreliable, and produced a poor-quality ice.[7] Daniel Holden of New Orleans improved the Carré patent in 1866 for industrial use and the machines were later installed in the Louisiana Ice Works, the largest commercial ice plant in the country when it opened in 1867.[8]

In 1867 or 1868, Merz imported a small refrigeration machine built in London and had it installed in the Old Canal by his engineer, F.V. DeCoppet. It was the first refrigeration machine operated in an American brewery, but it failed. Merz encouraged DeCoppet to design his own machine, which was put into use at the brewery in 1869 and operated successfully for two years.[9] In 1872, Merz installed another experimental refrigerating machine, designed by Charles Tellier, to cool his 5000-barrel cellar.[10]

Artificial refrigeration brought greater stability, more consistent quality, and increased production and profits to brewing, revolutionizing the industry. "Brewery fever" took hold in New Orleans in the 1880s when ten new breweries opened and a large exporting market developed in Latin America.[11] By the end of the century, brewing was one of the largest industries in the country. Today, there is one industrial brewery operating in New Orleans.[12]

The Old Canal was a jumble of disparate structures, and typical of the undeveloped state of brewery architecture in 1867. The gravity flow organization of the brewing process (which eliminated the use of costly pumps) resulted in

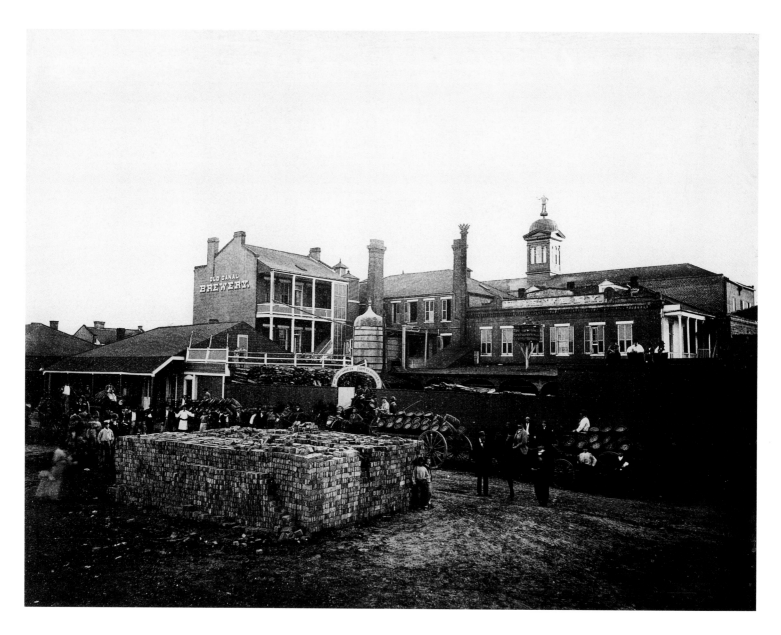

a vertical arrangement of building functions. The brewhouse, with the ventilator roof tower, contained the brew kettle, mash tank, cooling tank, and malt mill. A three-story icehouse with a cold-storage cellar faced Villere Street, and a tall iron chimney capped by a coronet marked the boiler house and its 16-horsepower steam engine. Above the open barley shed was a large purple martin house, a traditional feature on southern plantations (martins were known to keep crows from grain supplies). The brewery yard fronted on the Old Basin Canal, giving easy access to cargoes of grain and coal.[13]

In Lilienthal's elaborately staged photograph, taken from the canal landing, workers pose on rooftops and balconies, and gather around a brickpile outside the brewery compound. Bricks

were another product marketed by Merz, whose investments included a lumberyard, planing mill, and building supply company, all located at the Old Basin Canal.[14] Draymen pose with a fleet of delivery wagons, heavily laden with barrels of beer, which are arranged about the landing. Distinguished from the large assembly is a man on horseback, possibly Merz himself. He would seem to dominate the scene but for the two boys who have secured a corner of the brickpile closer to the camera.

The Old Canal brewery closed a year after Merz's death in 1876 and the property, heavily encumbered by debt, was sold by the parish sheriff. In 1881, the Southern Brewing Company built a plant on the site.[15] This brewery, too, had gone by 1900 when a railroad switching

yard covered the precinct. Today, the site is an open block adjacent to the Iberville Housing Project, and Lafitte Avenue and a municipal playground cover the old canal bed and landing.

1. City Brewery, opened in 1851 and still operating in 1867, had been the first commercial brewery in the city. See *Bee*, September 8, 1876; Dale P. Van Wieren, *American Breweries II*, West Point, Pa. (Eastern Coast Brewiana Association) 1995, pp. 125–27.
2. John E. Siebel and Anton Schwarz, *History of the Brewing Industry and Brewing Science in America*, Chicago (n.p.) 1933, pp. 56–57; Stanley W. Baron, *Brewed in America: A History of Beer and Ale in the United States*, Boston (Little, Brown) 1962, pp. 189, 211.
3. Merz laid claim to be the first local lager brewer in *Louisiana State Gazetteer and Business Man's Directory*, New Orleans 1860, p. 24. See also *Era*, December 2, 1864; "Inauguration of the First Lager Beer Establishment in New

Orleans," *Picayune*, December 4, 1864.

4. "A Glance at New Orleans Manufactures and Arts II: Merz's Old Canal Brewery," *Times*, December 29, 1865; Auguste J. Rossi, "Artificial Refrigeration in Breweries," *Western Brewer*, XX, no. 1, January 15, 1895, pp. 127–28.

5. "Historical Review of the Rise of Mechanical Refrigeration," *Ice and Refrigeration*, XXI, no. 2, August 1901, pp. 45–59, no. 3, September 1901, pp. 89–102, no. 4, October 1901, pp. 125–29; J.F. Nickerson, "The Development of Refrigeration in the United States," *Ice and Refrigeration*, XLIX, October 1915, pp. 170–75; Oscar Edward Anderson, Jr., *Refrigeration in America: A History of a New Technology and Its Impact*, Princeton, NJ (Princeton University Press) 1953, pp. 90ff; Susan K. Appel, "Artificial Refrigeration and the Architecture of 19th-Century American Breweries," *IA: The Journal of the Society for Industrial Archeology*, XVI, no. 1, 1990, pp. 21–38; Barry Donaldson and Bernard Nagengast, *Heat and Cold: Mastering the Great Indoors*, Atlanta (American Society of Heating, Refrigerating and Air-Conditioning Engineers) 1994, p. 134; *Picayune*, June 3, 1868; "Louisiana Ice Works," (advertisement) *Times*, November 21, 1865.

6. "Manufacture of Ice," *American Artisan*, X, February 9, 1870, pp. 89–90; Donaldson and Nagengast, *op. cit.*, pp. 127–28 and 317, n. 45.

7. "Machine Ice," *Atlanta Constitution*, February 27, 1870; "Artificial Ice," *New York Times*, October 23, 1870. The Parisian industrialist Henri Rouart, a patentee of Carré's apparatus in America, was a co-founder of the Louisiana Ice Works. See *Ice and Refrigeration.*, XXI, no. 2, August 1901, pp. 49–52; Marilyn Brown, *Degas and the Business of Art*, University Park (Pennsylvania State University Press) 1994, pp. 122–26. See also cat. 61.

8. The first U.S. patent for the mechanical manufacture of ice was issued in 1851 to a Florida inventor, John Gorrie, backed by New Orleans investors. On ice manufacture in New Orleans, see *Bee*, October 10, 1865; "A Sight from the Attic: Construction of the Louisiana Ice Works," *Sunday Times*, April 7, 1867; "Making Ice By Machinery," *Manufacturer and Builder*, I, December 1869, p. 353; "Historical Review," *op. cit.*, XXI, no. 2, August 1901, pp. 49–51; Nickerson, *op. cit.*; Anderson, *op. cit.*, pp. 86–87; Donaldson and Nagengast, *op. cit.*, p. 130. Lilienthal photographed the Louisiana Ice Works in 1872 for *Jewell's*; see *Jewell's Crescent City Illustrated*, prospectus.

9. "Historical Review," *op. cit.*, p. 52. Few sources agree on the date of the machine installed by Merz and DeCoppet. According to some accounts, it was a machine designed by Charles Tellier of Passy, France, patented in 1869, and modified by DeCoppet. In 1872, DeCoppet demonstrated a Tellier machine built by the W.H. Smith foundry, Front Street (*Picayune*, May 16, 1872). See J.E. Siebel, "Refrigeration in its Relation to the Fermenting (Brewing) Industry of the United States," *Western Brewer*, XXXVII, no. 5, May 15, 1912, p. 223; Nickerson, *op. cit.*

10. "Refrigeration by Means of Ammonia," *Scientific American*, XXVI, no. 24, June 8, 1872, p. 380.

11. "Beer Breweries," *Picayune*, September 2, 1889.

12. The Dixie brewery was established by Valentine Merz in 1907.

13. "An Improvement in Beer Making," *Picayune*, May 16, 1872. For a lithograph view of the Merz brewery (showing the icehouse and other buildings fronting on Villere Street) by John E. Boehler, see L. Graham, *Graham's Crescent City Directory for 1867*, New Orleans (L. Graham) 1867 (advertisement). On brewery architecture, see F. Widmann, "The Development of the Buildings and Equipments of Breweries from Pioneer Times to the Present Day," *Western*

Brewer, XXXVII, no. 1, January 1912, pp. 29–32; Susan K. Appel, "The German Impact on Nineteenth-Century Brewery Architecture in Cincinnati and St. Louis," in *The German Forty-Eighters in the United States*, ed. Charlotte L. Brancaforte, New York (Peter Lang) 1989, p. 252, and *ead.*, "Brewery Architecture in America from the Civil War to Prohibition," in *The Midwest in American Architecture*, ed. John S. Garner, Urbana (University of Illinois Press) 1991, pp. 185–214.

14. "A Glance," *op. cit.*

15. "Beer Breweries," *op. cit.*; "Brewing in New Orleans," *Southern Brewer and Bottler*, I, no. 1, April 10, 1897, pp. 14–16.

25 *overleaf*
Parish Prison & Trémé Market
Prison de Parish et Marchè de Trémé

For most of the nineteenth century, New Orleans had a reputation as one of the most violent, crime-ridden cities in the country.[1] "There is no city in the Union, or perhaps the world," the *True Delta* declared in 1853, "where notorious thieves and penitentiary graduates can strut about unmolested with the same impunity [as] they can in New Orleans."[2] A turbulent port city of violent ethnic politics and "lawless and vicious men," as one young arrival from the North observed, New Orleans was "a perfect hell on earth" of criminality.[3]

An attribute of this lawlessness was the prevalence of side-arms. "The only security for life in this cut-throat town, is the belief that everyone is armed and ready to use his weapons in an instant," one antebellum visitor wrote.[4] Another traveler, astonished at the "great number and variety of deadly weapons" for sale in the city, was informed that seven out of ten men carried concealed weapons.[5] In a demonstration of the American egalitarianism that shocked many travelers from abroad, all classes of society in New Orleans were observed to be armed. At a fancy-dress ball, the British visitor Edward Sullivan discovered, guests were admonished to leave their revolvers "as you would your overcoat on going to the opera." The consequence of so many firearms in circulation was not a peaceful one: "There are more murders here than in any other city in the Union," Sullivan wrote.[6] Another Briton, educator Henry Latham, who also found weapons prevalent on city streets in 1867, endorsed gun control: "The argument is strong for carrying arms in a country where the majority go armed, but stronger still for putting a forcible end to the custom altogether," he wrote.[7] Even the parish sheriff observed that nothing could put an end to the slaughter, "till it was made penal to carry arms."[8]

Before 1837, those convicted of crimes were sentenced to confinement in an old police jail in the Vieux Carré—as infamous for its severity as New Orleans was for its disregard of the law. Referred to as a "horrible residence for any human being, no matter what his guilt may be," the old jail was replaced by a new parish prison on Orleans Street, between Marais and Trémé streets, built in 1832–36.[9] The architects Joseph H. Pilié and A. Voilquin worked in a local vocabulary drawn from colonial building traditions, and rejected the imagery of an impregnable, castellated fortress that was typical of contemporary prison design.[10] Twin three-story buildings of plastered brick featured ground-level arcades and interior courtyards enclosed by porticoes and tiers of galleries. Separate hipped roofs with distinctive belvederes for alarm bells may have derived from colonial guardhouses. Separate yards or wards segregated prisoners by color and sex, and debtors from all the rest.

A grand-jury audit of 1837 found the building "airy, commodious, well distributed and sufficiently capacious," and concluded: "we cannot help looking upon the complexion of the new prison as auspicious to humanity."[11] But prison life there was far from auspicious. The wing for condemned prisoners was a horror, and flogging was customary for slaves sent there by their owners to be "tied on a ladder the usual way" and given twenty-five lashes—punishment that was considered too "unseemly" to be meted out by the slaveholder.[12] "Every day there are many whipped," a visitor wrote.[13]

Early in the war, Union soldiers were held at the prison in appalling conditions: one captive reported sixteen men to a 10-by-12-foot (3-by-3.6-m) cell.[14] The civilian cellblocks were hardly less barbarous, as the British journalist William Howard Russell discovered. In what was later called "one of the most damning and terrible arraignments against New Orleans," Russell described a "disgraceful institution" where prisoners, condemned to death or merely awaiting trial, were confined in "wretched cells." In the women's wing, he saw "criminals of all classes" huddled together. "The prisoners have no beds to sleep upon, not even a blanket, and are thrust in to lie as they please, five in each small cell," he wrote. "It may be imagined what the tropical heat produces under such conditions as these." In one cell he was shown a "desperate character" wearing only a shirt

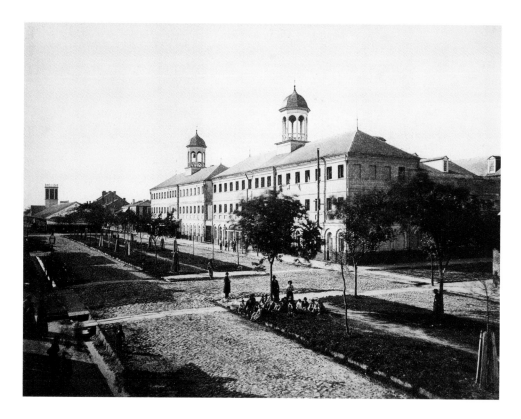

and bloodied by heavy leg irons. He reported that frequent hangings took place in the courtyard, as prisoners watched from cells open to the veranda.[15]

Further horrors evolved at the prison after the war, when the city moved psychiatric patients under municipal care into the building. The outcome was "a disgrace to civilization and humanity," according to one physician. Patients were "locked by tens and twenties into cells whose heat, filth and noisome smells in the morning cannot be described."[16] In 1872, Grand Jury inspectors could report only that "Words fail us when we think to describe this hell on earth; so we refrain." Six months later the insane were transferred to the unfinished Marine Hospital (cat. 48).[17]

Although Parish Prison at the time of Lilienthal's photograph was reported to be "old and in a very dilapidated condition," the buildings remained in use for almost another thirty years.[18] In 1891, rioting citizens overtook the prison and lynched eleven prisoners, all Italian nationals or Italian–Americans, accused of the murder of the city's chief of police, which, allegedly, had been carried out by local *mafiosi*.[19] The appalling murders brought attention to the decayed buildings as well as to conditions at the prison, which was closed two years later and demolished. In 1906, a city water pumping station was built on the site, in what is Louis Armstrong Park today.[20]

Lilienthal's view of the prison encompasses Orleans Street with its wide, grassy median or "neutral ground," freshly planted with sycamore trees. A group of boys is gathered there, possibly to await omnibus service. The low, colonnaded structure in the distance, shaded by wide awnings and crowned by a cupola, is the Tremé market, built from 1839.

1. The best account of crime and public safety in nineteenth-century New Orleans is Dennis C. Rousey, *Policing the Southern City: New Orleans, 1805–1889*, Baton Rouge (Louisiana State University Press) 1996.
2. "A Practice More Honored," *True Delta*, May 5, 1853. In 1850, Louisiana had the largest penitentiary population in the country after the more populous states of New York and Massachusetts; *Seventh Census of the United States*, Washington, D.C. (Robert Armstrong) 1850, IV, p. 165.
3. Walter B. Foster, *Journal*, December 26, 1841, Missouri Historical Society, cited by Lewis O. Saum, *The Popular Mood of Pre-Civil War America*, Westport, Conn. (Greenwood Press) 1980, p. 171; William Howard Russell, *My Diary North and South*, Boston (T.O.H.P. Burnham) 1863, p. 244, cited by Rousey, *op. cit.*, p. 66, n. 1.
4. James Logan, *Notes of a Journey through Canada, the United States of America, and the West Indies*, Edinburgh (Fraser & Co.) 1838, p. 179. Logan was a Scottish lawyer.
5. Henry Ashworth, *A Tour in the United States, Cuba, and Canada*, London (A.W. Bennett) 1861, p. 80.
6. Edward Sullivan, *Rambles and Scrambles in North and South America*, London (R. Bentley) 1852, pp. 223–25, cited by Rousey, *op. cit.*, p. 81, n. 26.

7. Henry Latham, *Black and White: A Journal of a Three Months' Tour in the United States*, London (Macmillan) 1867, p. 161.
8. Russell, *op. cit.*
9. Albert Fossier, *New Orleans: The Glamour Period, 1800–1840*, New Orleans (Pelican) 1957, p. 171.
10. Pilié's elevation for the prison is in the Louisiana Collection of the New Orleans Public Library. Pilié resigned from the project after completion of the second story. A. Voilquin designed the third story; Samuel S. Slack (as builder), François Correjolles, Jean Chaigneau, and Colonel C. Crozat were also involved in the execution of the building. Building contract, Felix de Armas, L, no. 603, October 17, 1836, NONA; *Gibson's Guide*, pp. 328–29; *New Orleans Architecture*, VI, p. 63. For the history of the prison as a building type, see Iona Spens, ed., *The Architecture of Incarceration*, New York (St. Martin's Press) 1994.
11. Fossier, *op. cit.*, p. 171.
12. Barbara Leigh Smith Bodichon, *An American Diary, 1857–8*, ed. Joseph W. Reed, Jr., London (Routledge & Kegan Paul) 1972, pp. 100–101; James S. Zacharie, *New Orleans Guide*, New Orleans (New Orleans News Co.) 1885, p. 113.
13. Bodichon, *op. cit.*, p. 101.
14. "New Orleans," *Street Railway Journal*, x, no. 4, April 1894, p. 245.
15. Henry C. Castellanos, *New Orleans as it Was: Episodes of Louisiana Life*, New Orleans (L. Graham) 1895, p. 133; Russell, *op. cit.*, pp. 245–48; *id., William Howard Russell's Civil War: Private Diary and Letters, 1861–1862*, ed. Martin Crawford, Athens (University of Georgia Press) 1992, pp. 63–64.
16. Board of Health physician C.B. White to George S. Pontrell, Secretary of the Treasury, January 4, 1873 (reporting on conditions in the later 1860s). General Correspondence, Letters Received, New Orleans Marine Hospital, Records of the Public Buildings Service, RG121, NARA. On use of this building and others as psychiatric asylums, see Gilles Vandal, "Curing the Insane in New Orleans: the Failure of the 'Temporary Insane Asylum,' 1852–1882," *Louisiana History*, XLVI, no. 2, Spring 2005, pp. 155–84.
17. "Report of the Grand Jury," *Crescent*, January 3 and March 31, 1867.
18. *Ibid.*
19. "New Orleans' War on the Mafia," *Illustrated American*, April 4, 1891, pp. 319–23. For a popular account of the incident, see Richard Gambino, *Vendetta: A True Story of the Worst Lynching in America, the Mass Murder of Italian–Americans in New Orleans in 1891*, Garden City, NY (Doubleday) 1977.
20. *New Orleans Architecture*, VI, p. 63.

Opposite *Half way House* (cat. 35), detail.

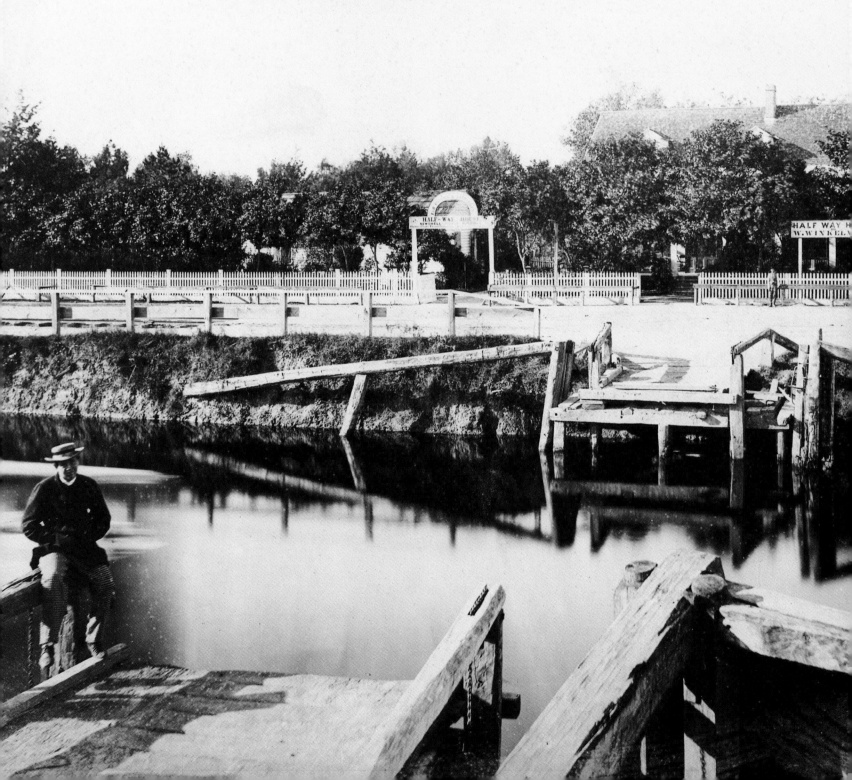

Lake Pontchartrain, the Bayou St. John, and Metairie Ridge

Entrance to Bayou St John

Entreé du Canal St. Jhon

"There are some very pleasant plantations, gardens, and orange groves, on the Bayou St. John," a visitor wrote in the late eighteenth century, "and where it enters the lake, there are thirty or forty houses, occupied by fishermen who ... supply the city with fish."[1] For another century, only scattered houses could be found at the entrance to the bayou, which was surrounded by "nothing but dreary cypress forests, morass prairies and reed brakes."[2] This region was the natural marsh buffer between the city and the 630-square-mile (1630-sq.-km) Lake Pontchartrain to the north, as one Union

soldier observed: "the country between the Lake and the City of New Orleans is nothing but one great Cypress swamp, and nine tenths of the land is under water, and the water looks almost as black as Ink I cannot see how the people live there [They] live in water, work in water, and are a kind of water animal."[3]

In Lilienthal's view of this boggy terrain at land's end, earth, water, and sky seem to merge. In the distance is a watermen's tavern and restaurant, and at the horizon the thin line of the bayou and a plantation house are visible. The plantation's orchard skirts the shore of the lake, which enters the view at the far right. A cabriolet rider, gesturing toward the camera, has paused here with a companion or servant; their shadows are dark forms on the glassy

surface of the still lagoon. The men and horses are diminished by this vast, disintegrating landscape, and in this desolate, melancholy scene there is little sense of the civilizing presence of the city only 5 miles (8 km) away.

As the oldest area of European settlement in New Orleans, the bayou carried particular meaning for an Exposition audience, especially for French viewers who understood the association of this site with French colonization. In 1699, Jean Baptiste Lemoyne de Bienville claimed this territory for France and gave French names to the islands, lakes, and streams in the region, including this bayou, named for Bienville's patron saint. It was this waterway, referred to by early settlers as a "very sluggy sort of water straight," that determined where

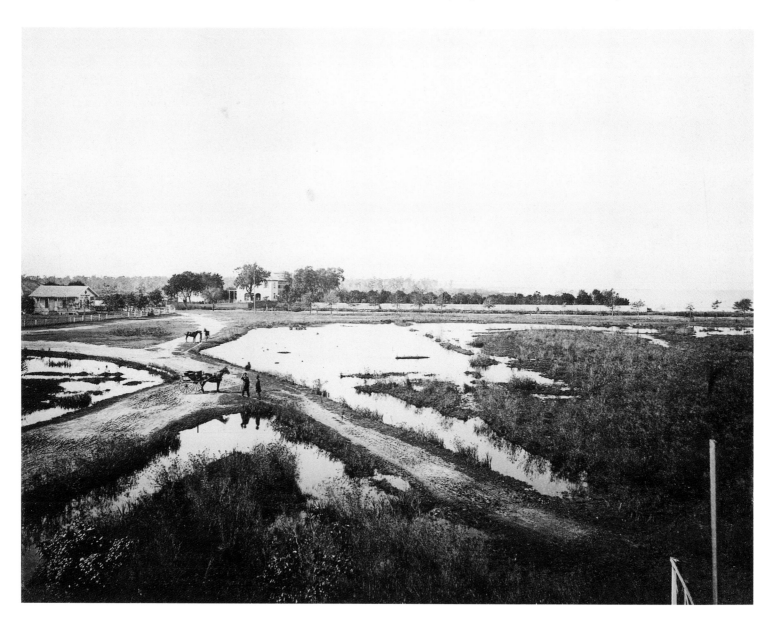

the new colony would be located.[4] The easiest access to the Mississippi River from the Gulf of Mexico was via Lake Pontchartrain, the Bayou St. John, and an old Indian portage from bayou headwaters to the river, and the site selected for New Orleans commanded this portage.

One of the most accomplished of Lilienthal's photographs, this landscape view extends the limit of the Exposition portfolio's subject matter. The photograph's elevated perspective (it may have been one segment of a multiview panorama) has been achieved by mounting the tripod on a rooftop or scaffold, which Lilienthal allowed to enter the frame—a traditional painterly technique to give scale and depth to a landscape composition.[5] Here Lilienthal worked with an altogether different scale compared to his building and street views in the confined spaces of the city. The interest lies in the wider visual field possible in the flat, open swampland and in the pictorial qualities of this waterworld, a subject introduced to the photographic iconography of the city with Lilienthal's work.

During the early twentieth century, the bayou swamplands were drained and developed, with disastrous results: it was the loss of these protective wetlands that exposed the city to flooding during hurricane Katrina in 2005. The area of Lilienthal's view, today the Lake Vista and Lake Terrace subdivisions, was heavily inundated during the catastrophe.

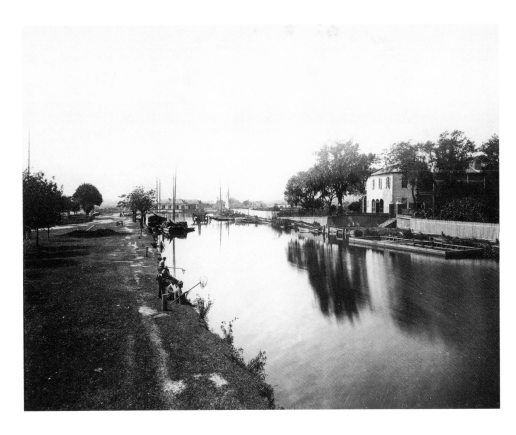

1. Francis Baily, *Journal of a Tour in Unsettled Parts of North America in 1796 & 1797*, ed. Jack D.L. Holmes, Carbondale (Southern Illinois University) 1969, p. 314.
2. "Environs of New Orleans," *Crescent*, May 12, 1866.
3. Charles O. Musser, *Soldier Boy: The Civil War Letters of Charles O. Musser, 29th Iowa*, ed. Barry Popchock, Iowa City (University of Iowa Press) 1995, p. 185.
4. "Environs of New Orleans," *op. cit.*
5. Lilienthal published stereoviews taken from this vantage point, including one made only a short time before or after this Exposition view (figs. 63 and 65). He may have completed a stereo panorama of the mouth of the Bayou St. John, but only two stereoviews taken from this position are known today.

27
Bayou St. John & Old Spanish Port
Canal St Jean et Vieux port Espagnol

The village of Spanish Fort, referenced in Lilienthal's caption, took its name from Fort San Juan, which was built near the mouth of the Bayou St. John on the site of an old French stockade, following the Spanish Crown's acquisition of Louisiana in 1769. By 1800, the fort was reported to be "so ruinous, that a discharge of one of the guns would probably shatter the walls."[1] After the Louisiana Purchase in 1803, Americans restored the old Spanish outpost and garrisoned it for the war of 1812. But the fort was too far inland and lost its strategic importance after forts Pike and Macomb were built to protect the passes into Lake Pontchartrain to the east. In 1823, the land was sold and a hotel was built within the walls of the old fort—early tourist development for an area that in the later nineteenth century became the city's largest lakefront resort.[2]

Facing the bayou was an elegant house reportedly dating from the early American settlement of the area.[3] The residence also appears in Lilienthal's photograph *Entrance to Bayou St John* (cat. 26), where its orchard is clearly visible. The cypress-frame structure had front and rear galleries, a marble-finished entrance hall, and twenty rooms "finely lighted and ventilated," according to a contemporary account, "affording one of the prettiest marine views of the Lake imaginable."[4] The orchard of 300 fruit trees included orange, Japanese plum, pear, and banana.

Lilienthal's photograph creates a powerful impression of light and atmosphere on the bayou, and has pictorial qualities and a compositional structure evocative of Dutch landscape painting—not an unusual parallel for a nineteenth-century American photographer. The *Philadelphia Photographer* and other photographic journals published lessons in composition, lighting, and perspective based on the principles of seventeenth-century Dutch landscapes, illustrated with engravings after Ruisdael, Rembrandt, and Cuyp. As historian Susan Danly has shown, some nineteenth-century photographers may have followed the conventions of critically admired seventeenth-century painting in an attempt to "ally themselves with established artistic practice."[5] We can only speculate as to whether or not Lilienthal, who referred to himself as a "practical photographer," consciously embraced these principles and sought to create artistic effects in his work.[6] But throughout his career he promoted an identification with artistic practice in his advertising and in the studio exhibitions at his "Art Emporium," where his photographs were displayed alongside paintings attributed to Salvador Rosa, Giorgione, and other masters.[7]

1. Francis Baily, *Journal of a Tour in Unsettled Parts of North America in 1796 & 1797*, ed. Jack D.L. Holmes, Carbondale (Southern Illinois University) 1969, p. 314.

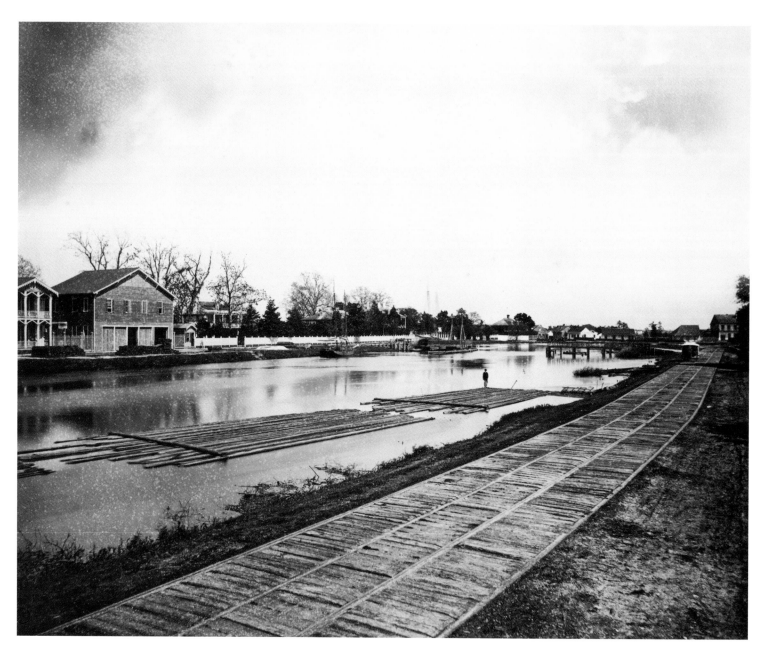

2. A site plan of 1828 in the National Archives is reproduced in Leonard Huber, *New Orleans: A Pictorial History*, New York (Crown) 1971, p. 232.

3. "Jackson in New Orleans," *Delta*, December 17, 1854, with a wood engraving of the house.

4. Auction sale notice in *Picayune*, May 17, 1868. The property can be seen on the survey by William Bell, City Surveyor, *Plan of Proposed Improvements for the Lake Shore Front of the City of New Orleans, April, 1873*, New Orleans (D. Simon, lithographer) 1873.

5. Susan Danly, "The Landscape Photographs of Alexander Gardner and Andrew Joseph Russell," PhD diss., Brown University, 1983, p. 124. See her discussion of the pictorial basis of nineteenth-century photographic practice, pp. 93–127.

6. Lilienthal used this common reference to commercial practice in court testimony later in his career. See pp. 47–48.

7. *Collection of Paintings by Leading New Orleans Artists and others of the United States and Europe, on Free Exhibition and Sale* (brochure), Lilienthal's Art Emporium, 121 Canal Street, 1883.

28
Bayou St. John
Canal St. Jean

The Bayou St. John cut a winding course through cypress swamps at the rear of the city and along the base of the Metairie Ridge, a geologic rise that marked the ancient course of the Mississippi River north and west of the level plain on which New Orleans was built. Periodic flooding of this low-lying plain led to the formation of the bayou as a drainage channel into the lake.[1] About 2 miles (3 km) from the center of the city the bayou joined the Old Basin, or Carondelet, Canal (cat. 23), which was opened in 1796 for sanitary drainage and later developed as a commercial waterway connecting the lake to the center of town at Basin Street. For nearly a century this waterway was the preferred shipping route into the city. The calm waters of the bayou were safer for navigation than the Mississippi River, with its swift currents, constant silting, and other hazards.

The high ground created by the bayou's natural levees was the site of early settlements by Native Americans, who used the bayou as a

lake-to-river portage. In 1699, explorers recognized the strategic significance of the bayou, and by 1708, colonists had settled there. The new colony of New Orleans, however, took shape after 1718 farther southeast, at the great crescent bend of the river.

The opening of drainage canals in this region at the end of the war turned the tranquil bayou into a cesspool. "The air upon its banks had been balmy and salubrious," the *True Delta* observed in 1866, "but we have found it different since."[2] The bayou waters were now a "villainous compound" of "decomposing matter of every kind," and, the *Delta* added, "the aroma arising from these waters, too, is—whew!—abominable."[3] The *Times* warned, for those who had reason to visit the bayou, "a cast-iron inside lining is the only thing which will enable you to stand it."[4] Finally, in the winter of 1867, the "not very aromatic stream" was dredged and cleaned to facilitate boat traffic and "lessen the noisome odors with which residents along its banks are afflicted."[5]

In 1867, a City Railroad line opened tracking the bayou; its roadbed and a horsecar are visible in Lilienthal's view.[6] On the left bank of the bayou are offices and stables for the new railroad. Next door is the Tissot residence, built about 1799 by the Spaniard Andrés Fernández. Farther along the bank, all partially hidden by foliage, are three early houses that still exist today at this site: the James Pitot House, built about 1800 and home of the second mayor of New Orleans; the Evariste Blanc House of about 1834 (cat. 30); and the Roux residence (known as the Spanish Custom House), built or remodelled after 1807.[7] The cypress swing bridge, here shown rotated to allow boat traffic to pass, is on a site still bridged today for pedestrians.[8]

The bayou was an important channel for timber from Mississippi and the pine forests north of Lake Pontchartrain, and rafting was the most economical means of moving sawlogs and lumber via the waterway.[9] The timber float in the photograph was possibly moored there until oarsmen could guide it to a sash factory or lumber yard in the city. The man who appears poised gracefully at the very edge of the crib may be the logman of this raft, which seems weightless and suspended in perfect equilibrium on the bayou's glassy surface.

Lilienthal's carefully calibrated photograph appears to be a study more in light and atmosphere than in topography: its main concern is ultimately with the passing effects of light on the bayou. In the stillness and silent tranquility of the view, a sense of melancholy pervades the scene, a mood intensified by the enveloping darkness of early evening.

1. Craig E. Colten, *An Unnatural Metropolis: Wresting New Orleans from Nature*, Baton Rouge (Louisiana State University Press) 2005, pp. 2–4, 38–39. See also Peirce Lewis, *New Orleans: The Making of an Urban Landscape*, Cambridge, Mass. (Ballinger) 1976, pp. 17–30.
2. "Out on a Lark," *True Delta*, February 1, 1866.
3. *Ibid.*; "Town Talk," *Times*, October 3, 1866.
4. "Town Talk," *op. cit.*
5. *Times*, February 4, 1867.
6. "Petition of John Pemberton *et al.* to the Board of Aldermen, City of New Orleans, New Orleans, October 23, 1866," Pontchartrain Railroad Series, Manuscripts Collection, Tulane University Library; "The Bayou St. John Railroad," *Crescent*, July 11, 12, 17, 1866; "Project for a New Railroad," *Times*, October 23, 1866; "The Basin and Bienville Streets and Carrollton Avenue City Railroad," *Picayune*, November 15, 1866.
7. Samuel Wilson, Jr., "A Country House on Bayou St. John," in *The Architecture of Colonial Louisiana*, Lafayette (Center for Louisiana Studies) 1987, pp. 374–77; *id.*, *The Pitot House on Bayou St. John*, New Orleans (Louisiana Landmarks Society) 1992.
8. Building contract, Joseph Brown, IV, no. 2386, December 3, 1866, NONA, for the pedestrian bridge that replaced the old Bayou Bridge at this site; drawings are in the Southeastern Architectural Archive, Tulane University. The crossing at Harding Drive is today spanned by a steel Pratt Truss swing bridge dating from 1908 and now maintained as a footbridge. I am grateful to Dan Brown for his research on the bridge of 1908. (See also cat. 29.)
9. John Hebron Moore, *Andrew Brown and Cypress Lumbering in the Old Southwest*, Baton Rouge (Louisiana State University Press) 1967, pp. 73–78; Charles Edward Russell, *A-Rafting on the Mississip'*, Minneapolis (University of Minnesota Press) 2001, pp. 92–93, 282–83.

29
Bayou Bridge
Pont Tournant du Canal St Jean

The site of the Bayou St. John Bridge was an historic crossing. A Native American footbridge spanning the bayou predated the first colonial settlement there in 1708. The opening of the Carondelet Canal (cat. 23) provided water access from Lake Pontchartrain via the bayou and the canal to the ramparts of the Vieux Carré. The growth of commercial boat traffic soon required a drawbridge across the bayou and, by 1810, a toll bridge.[1] In 1866, a visitor still found an "almost uninterrupted wilderness" at the bridge crossing—the only notable settlements on high ground were reportedly on the site of ancient native encampments.[2] But as plantations and cypress swamps were subdivided for villages and suburbs along the banks of the bayou, new streets and the expansion of omnibus service and, later,

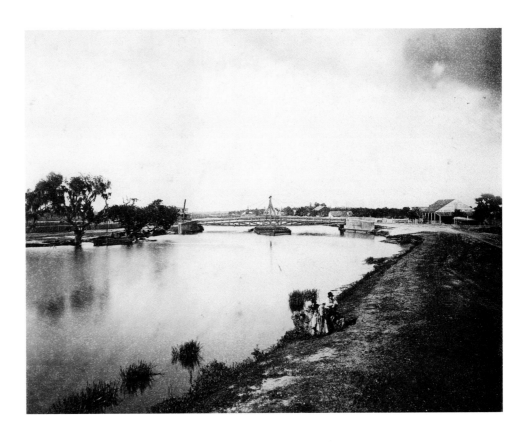

streetcar lines required new bayou crossings. By the 1860s, several turreted toll bridges spanned the waterway.

At the end of the war the old Bayou Bridge at Magnolia Gardens had become so deteriorated that it was no longer operable, and pedestrians had to ferry the bayou in "a filthy little flatboat."[3] Construction of a new bridge at Esplanade Street was one of many public-works projects implemented during federal occupation. Opened in early 1866, the bridge was a revolving truss with a cypress superstructure and a cast-iron turret erected on a brick foundation in the middle of the bayou.[4] Called "one of the largest and best constituted works of the kind in or near the city," the new bridge was painted brown with a special paint formulated to withstand "the exhalations" of the polluted bayou.[5] The bridge replaced, for carriage traffic, the old Bayou Bridge nearby, which was rebuilt in early 1867 as a footbridge.[6]

Turreted bridges like these, and the tenders who kept them, became obsolete on the bayou when the waterway was closed to navigation in 1936. A bridge crossing is still maintained at this site today.[7]

1. "Contract of adjudication for the rebuilding of the Bridge over the Bayou St. John," June 25, 1808; Contract, signed by Jacob F. Woods, John Steward, and Michael M. Kensey, July 2, 1808; "Agreement passed between the hon[ora]ble. Jas. Mather, Mayor of New Orleans, and Jacob F. Woods, Esqre. Contractor for the building of a Draw bridge at the Bayou St. John," August 31, 1808, New Orleans City Papers, Manuscripts Department, Tulane University Library; *Courier*, July 16, 1810; Edna B. Freiberg, *Bayou St. John in Colonial Louisiana 1699–1803*, New Orleans (Harvey Press) 1980, p. 303.
2. "The Environs of New Orleans," *Crescent*, May 12, 1866.
3. "The Bayou St. John Bridge," *Times*, August 29, 1865.
4. "Esplanade Street," *Times*, June 15, 1865; "Bayou Bridge," *Picayune*, March 10, 1866; *Crescent*, May 12, 1866.
5. "Municipal Items," *True Delta*, February 11, 1866; "Esplanade Street," *Times, op. cit.*; "Bayou Bridge," *Picayune, op. cit.*; *Times*, August 11, 1866. A Lilienthal stereoview of the bridge made before 1875 is in the collection of Joshua Paillet, The Gallery for Fine Photography, New Orleans.
6. Building contract, Joseph Brown, IV, no. 2386, December 3, 1866, NONA; *Times*, May 16, June 2, 22, and 23, and October 24, 1866, and February 4, 1867; *Picayune*, February 4, 1867.
7. The Esplanade Street bridge is a concrete structure built in 1985. M.L. Guerriero, "Existing Orleans Parish Bridges," New Orleans Streets Department, 1958. The old Bayou Bridge crossing is maintained as a footbridge (see cat. 28).

30
Private Residence
Maison Particuliere

Evariste Blanc, a Creole real-estate developer, built this house around 1834 on the east bank of the Bayou St. John.[1] Lilienthal posed the Blanc family and several servants on the upper gallery off the private parlors and bedrooms of the second floor. The Blanc home had the open, airy aspect of a colonial plantation house, appropriate to its semi-rural site. The wide, open galleries took advantage of the bayou breezes, provided shade, and allowed windows and doors to remain open in wet weather. Entrance doors on both levels had arched heads, flanking Ionic columns, sidelights, and radial transoms. Triple-hung windows with granite sills, tall dormers with an arched upper sash, and curved muntins gave distinction to the house and combined elements of both Creole and American house design.

Interior furnishings featured cabinetry from Paris and bronze fixtures purchased from a French chateau.[2] The house was crowned with an open belvedere that gave a panorama of the bayou and surrounding country. From this vista the family could observe the mule-drawn schooners and sloops with their cargoes of vegetables, lumber, and other goods glide past on the bayou, only a stone's throw from the front gate of the house.

A terraced garden was decorated with statues and urns and planted with flowering magnolias and massive japonica bushes. The enclosing wall of tall, stuccoed brick posts and open ironwork was unusual in New Orleans and provided an equal measure of seclusion and visibility.

After Madame Blanc's death in 1875, the house was leased until the Blancs's daughter, Sylvanie Blanc Denegre, acquired it. In 1905, she donated the property for the foundation of Our Lady of the Most Holy Rosary Church. In use as a rectory, the house exists today much as it appears in Lilienthal's photograph.

1. Property sale, F. Grima, III, no. 350, November 24, 1834, NONA. Details of Blanc's acquisition of bayou properties is discussed in *New Orleans Architecture*, VI, p. 56.
2. "Blanc Mansion Survival," *Times-Picayune*, August 20, 1922.

31
Private Residence
Maison Privée

When Lilienthal photographed this suburban villa on Esplanade Street for the Paris Exposition, it had only recently been completed and was one of the most elegant of elite residences in New Orleans. The owner was Florence Luling, a native of Bremen, Germany, who settled in New Orleans in 1850 and acquired great wealth in the antebellum tobacco and cotton markets.[1] During the war, Luling purchased 80 acres (32 ha) of land on the Metairie Ridge near the Bayou St. John and hired architect James Gallier, Jr., and his partner Richard Esterbrook to design a residence.[2]

The undeveloped site allowed for construction on a large scale, and Gallier provided a design for a twenty-two-room mansion (housing a family of four and servants) in a plain but bold Tuscan Renaissance vocabulary. The design had much in common with the Italianate villa form popularized and commodified by architects and style-book authors such as Samuel Sloan, Andrew Jackson Downing, and Lewis F. Allen. The work of these mid-nineteenth-century authors was the latest of the model books on villa design that had, as James Ackerman has written, "pour[ed] from the presses in astonishing profusion" since the 1750s.[3] Allen praised the Italianate style in 1852 for its openness and freedom of plan, and the "wide range of choice" it offered the architect. "Its wings, verandas, and terraces, stretching off in any and almost every direction desired from the main building made it exceedingly appropriate for general use," he wrote.[4] Suited to a suburban site, the Italianate villa was appropriate architectural imagery for a man of business. Andrew Jackson Downing suggested that the style expressed "the elegant culture and variety of accomplishment of the ... man of the world ... [and] not wholly the spirit of country life nor of town life, but something between both, and which is a mingling of both."[5] Philadelphia architect Samuel Sloan's popular *Model Architect*, issued in five editions from 1852, also probed the Italianate villa form, and Sloan's own villa for Joseph Harrison in Philadelphia (1855–57) has been suggested as a model for the Luling house.[6]

Construction of the house got under way during the war, but it was still unfinished in 1865, when Gallier had to explain a doubling of construction costs to his client—increases the architect attributed to the "extraordinary rise in price not only of all Building materials, but of Gold, cotton and every other marketable commodity" during the war.[7] The house was finally completed in 1866 for a total cost of $140,000.

Built of plastered brick trimmed with granite, the house had a Palladian entry that was approached by massive granite steps and a promenade raised on a rusticated basement arcade. Projecting beyond the galleries was a deeply recessed cornice braced by great scrolled brackets. Symmetrical pavilions, housing a conservatory and bowling alley, were bridged to the main block. Crowning the house was a lofty belvedere, which gave panoramic views of the bayou and swamps at the rear of the city, and of the adjacent Fair Grounds racecourse (cat. 32). In the interior, a wide entrance hall led to five parlors with 16-foot (5-m) frescoed ceilings, marble mantels, bronze chandeliers, rich Italian carpeting, and furnishings of carved rosewood and oak. The attic story housed the servants.

The vast estate was ornamented with a lake and island, orchards of peach, apple, and orange trees, and an extensive garden, said to be among the finest in the South. In Lilienthal's photograph, the earliest known view of the villa, gardeners can be seen at work, their spades standing upright in the ground, with watering crocks nearby. Lilienthal's ground-level perspective and distant lens suggest the detached grandeur of the house and emphasize its connection to the land it dominated.[8] Although separated from the city and suggestive of seclusion and solitude, the house was also an imposing showpiece, an expression of both pompous display and private retreat. To the prospective immigrant the photograph declares the opportunity to achieve prosperity in New Orleans and to express that wealth by building on a large scale in the expanding territory of the city.

Luling occupied the mansion for only a few years. In 1868, he purchased a plantation in St. Charles Parish (near a town later named after him), and three years later he sold the Esplanade Street villa to the Louisiana Jockey Club (associated with the Fair Grounds racecourse), which renovated it for a clubhouse and added a battery of stables to the grounds. Luling relocated in the 1880s to Mobile, Alabama, and later to London, where he died in 1906. The selling price of the Luling villa in 1871 was $60,000, less than half the construction cost five years earlier.[9]

Although the main block of the house still stands today, both wings were removed soon after the estate was subdivided in 1915. All trace of the once-magnificent interior was wiped away in 1934 when it was renovated for apartments. Now enclosed in a block of housing on Leda Court, the house is detached from the grand esplanade and vast estate it once commanded.[10]

1. On Luling, see obituaries in *Picayune*, May 22, 1906; *Mobile Register*, May 22, 1906. On the Luling villa, see J.P. Coleman, "One of the City's Fine Landmarks," *States*, June 8, 1924; *New Orleans Architecture*, V, pp. 134–35.
2. Building contracts, S. Magner, February 24, 1864, and XVII, no. 583, May 19, 1865, NONA, to which are attached letters from F.A. Luling to James Gallier, Jr., March 13, 1865, and James Gallier, Jr., to F.A. Luling, March 17, 1865. Gallier and Esterbrook's drawings are in the Southeastern Architectural Archive, Tulane University. The house was one of Gallier's last projects; he died in 1868.
3. James S. Ackerman, *The Villa: Form and Ideology of Country Houses*, Princeton, NJ (Princeton University Press) 1990, p. 158.
4. Lewis F. Allen, *Rural Architecture*, New York (C.M. Saxton) 1852, p. 285.
5. Andrew Jackson Downing, *The Architecture of Country Houses*, New York (D. Appleton and Company) 1850, p. 285, cited by Amelia Peck, "'Being Sensible of the Value of Professional Services': Alexander Jackson Davis's Designs for the Interiors of Lyndhurst and Grace Hill," in *Alexander Jackson Davis American Architect, 1803–1892*, ed. Amelia Peck, New York (The Metropolitan Museum of Art) 1992, pp. 94 and 127, n. 28. See the discussion of Downing and the villa in Ackerman, *op. cit.*, pp. 229–51.
6. Joan Caldwell, "Urban Growth, 1815–1880: Diverse Tastes—Greek, Gothic, and Italianate," in *Louisiana Buildings 1720–1940: The Historic American Buildings Survey*, ed. Jessie Poesch and Barbara S. Bacot, Baton Rouge (Louisiana State University Press) 1997, pp. 234–35.
7. James Gallier, Jr., to F.A. Luling, March 17, 1865, *op. cit.*
8. Lilienthal's view recalls another house portrait, the photograph, *c.* 1853–54, by Victor Prevost of the suburban New York estate of Dr. Valentine Mott, reproduced in Mary Black, *Old New York in Early Photographs 1853–1901 ... from the Collection of the New-York Historical Society*, New York (Dover) 1976, plate 171.
9. *Jewell's Crescent City Illustrated*.
10. I would like to thank Clyde Welcher, current owner of the house, and Marianne Weiss Kim for assisting my research.

32
Races 1867 at the Fair Grounds
Courses de 1867 a l'Hypodrome

"What is most characteristic of society here is horse racing," observed the Parisian Baron Salomon de Rothschild during a visit to New Orleans in 1861.[1] Like Paris, New Orleans—especially the local Creole community—had great affection for the track, and it is not surprising to find this affinity explored by Lilienthal in three photographs presented for public exhibition in Paris.[2]

Horses had been run at the fairground site since 1852, when the Creole Race Course opened here at Gentilly Ridge on what had been the Johns Hopkins plantation, about 3 miles (5 km) from the city center. Renamed the Union Race Course, it operated until the war. In 1866, the Mechanics' and Agricultural Fair Association inaugurated annual fairs on the grounds, including charity races (James Gallier, Jr., designed for the Association a pair of Gothic brick gatehouses that still stands on Gentilly Boulevard).[3] In November 1866, Lilienthal produced a series of stereoviews of the fairground, including bird's-eye views from the belvedere of the newly completed Luling House on Esplanade Street (cat. 31).[4]

Thoroughbred racing in New Orleans, as Baron Rothschild affirmed, was the domain of the elite, and the track "the property of a special group—something like the Jockey Club of Paris." Women occupied their own grandstand in this male domain, and Rothschild observed the female spectators "decked out in their finest clothes ... two or three hundred of them, each more beautiful than the other, and all of them in society." Entranced by the women of New Orleans, whom he found "extraordinarily beautiful and exceedingly lovely," Rothschild, who would soon marry the niece of former Senator John Slidell of Louisiana, paid little mind to the horses: "It isn't the four-legged creatures who are the heroes of the day," he wrote, "it is rather the two-legged ones with whom one is much more concerned."

The covered stand for women is visible in Lilienthal's photograph. "The ladies' stand in particular has been fitted up with a view to secure to them every facility in seeing the race and enjoying themselves to their heart's content," the *Crescent* reported at the inauguration of the 1867 season.[5] Other spectators watch from carriages in the infield, and parked carriages crowd the grounds near the stands. The horses can be seen at the paddock. Lilienthal made this photograph on the opening day, April 23, 1867, or at one of the daily races of the short, week-long season.

In 1871, the architect Henry Howard designed a 120-acre (49-ha) campus of fairground exhibition buildings and a new grandstand for the Louisiana Jockey Club, which took over the course.[6] Lilienthal photographed the Howard buildings for *Jewell's Crescent City Illustrated* in 1872 and for *Leslie's Illustrated* in 1876.[7] The Fair

Grounds track is still active today, and is one of the oldest sites for thoroughbred racing in America.[8]

1. Salomon de Rothschild, *A Casual View of America: The Home Letters of Salomon de Rothschild, 1859–1861*, trans. and ed. Sigmund Diamond, Stanford, Calif. (Stanford University Press) 1962, p. 114. Citations that follow are taken from pp. 110–11, 115. Rothschild was the grandson of the founder of the famous Parisian banking firm of the same name.
2. Horse racing was a common subject in nineteenth-century French painting—Degas and Manet, in particular, were fascinated by the sport that captivated so many spectators in Paris. The subject was also explored by early photographers from New Orleans other than Lilienthal. In 1861, Jay Dearborn Edwards published views of the Metairie races (cats. 36 and 37), "taken on Saturday, when Lightning surprised so many sportsmen by beating Planet," *Picayune*, April 9, 1861, cited by Smith and Tucker, p. 92. Degas may have attended races at the Fair Grounds, a short distance from his local residence; for speculations on Degas and horse racing in New Orleans, see Christopher Benfey, *Degas in New Orleans: Encounters in the Creole World of Kate Chopin and George Washington Cable*, Berkeley (University of California Press) 1997, pp. 85 and 273–74, n. 9.
3. "Mechanics' and Agricultural Fair," *Crescent*, June 6, 1866; "A Visit to the Fair Grounds," *Picayune*, November 9, 1866.
4. Additional stereoviews of the fairgrounds in 1866 are in The Historic New Orleans Collection, 1997.7.1 and 1997.7.2. Lilienthal published other stereoviews of the fairgrounds in the 1870s and 1880s.
5. "The Races," *Crescent*, April 23, 1867.
6 Building contracts, E. Barnett, XCII, no. 18, July 1, 1871, NONA; M.T. Ducros for E. Barnett, XCII, no. 49, July 29, 1871; and XCII, no. 89, August 11, 1871. *Picayune*, December 22, 1873; J.C. Waldo, *Visitor's Guide to New Orleans*, New Orleans (J. Curtis Waldo) 1875, pp. 40–41; "Old Race Tracks," *Times-Democrat*, December 11, 1883.
7. Frank Leslie's *Illustrated Newspaper*, March 18, 1876, p. 29.
8. Nancy Stout, *Great American Thoroughbred Racetracks*, New York (Rizzoli) 1991, pp. 71–80. The present grandstand replaced a structure of 1905 (reerected in 1919) that was destroyed by fire in 1993.

33
Dan Hickock's at Lake end
Dan Hickock's au Lac

Dan Hickock's hotel, restaurant, and pleasure garden, located at Lake Pontchartrain on the west bank of the New Basin Canal (cat. 34), had been a popular resort since 1852, when the Jefferson and Lake Pontchartrain Railroad built the hotel near the terminus of its line from Carrollton to the lake shore.[1] Visitors arriving on lake steamers disembarked at a pier, later called Hickock's Landing, for passage into the city or to pass the time at the resort.[2]

Hickock's featured encircling galleries and a rooftop belvedere designed to make the most of the vistas and cool breezes that attracted visitors to the lakefront. Although many of the lakefront amusements were predominantly male activities—gambling, billiards, shooting, drinking, and smoking—the restaurant made an effort to attract women and families to their dining rooms. The "ladies' entrance" seen in the photograph brought women directly into the parlors and dining rooms without having to pass through the barrooms.

The restaurant was celebrated for *pompano*, a prized lake fish. A diner there would, as one lakefront visitor observed, "gorge himself with pompanos, like a pike with frogs. He will also eat croakers, or *courtbouillon* of redfish, or tenderloin trout."[3] Architect Thomas K. Wharton, visiting the restaurant in 1861, enjoyed "a basketful of the finest fish for supper, fresh from the lake," while taking in the "perfectly delicious" lake air.[4]

1. Building contract, Robert Crozier and Frederick Wing, builders, Jefferson Parish Mortgage Book, XVI, fol. 382, cited by Betsy Swanson, *Historic Jefferson Parish: From Shore to Shore*, Gretna, La. (Pelican) 1975, p. 133. The railroad, completed in 1853, was abandoned in 1865.
2. *True Delta*, February 3, 1866. Hickock's Landing is illustrated in "Affairs in New Orleans," *Harper's Weekly*, VII, no. 323, March 7, 1863.
3. J. Milton Mackie, *From Cape Cod to Dixie and the Tropics*, New York (G.P. Putnam) 1864, p. 170 (record of a visit before the war).
4. Wharton, "Diary," September 23, 1861. Wharton provided a sketch of Hickock's.

34 *overleaf*
Entrance to New Basin
Entreé du Bassin Neuf

Running along the west side of the New Basin Canal from above Tivoli (Lee) Circle to Lake Pontchartrain was a 25-foot-wide (7.5 m) turnpike known as the Shell Road, seen in the foreground of Lilienthal's view.[1] Built on piles and surfaced with crushed lake shells, the toll road was "hard and smooth as a floor of cement," a Union soldier wrote, "[and] after a shower it glistens like snow, for it slopes each way so the water runs off and leaves it as clean as you please."[2] The road was an admired carriage drive—"one of the most delightful drives in the world," *Harper's Weekly* declared—and a "drive on the Shell" was one of the city's great entertainments.[3] "It is the great resort for every species of pleasure vehicle that the city furnishes," an early guidebook observed, "and here may be seen, on an afternoon, all grades of society, from the gay sportsman, mounted on his fast trotter, to the sober citizen, who sallies forth on his ambling pony."[4] At the lake terminus of the road excursionists often concluded their

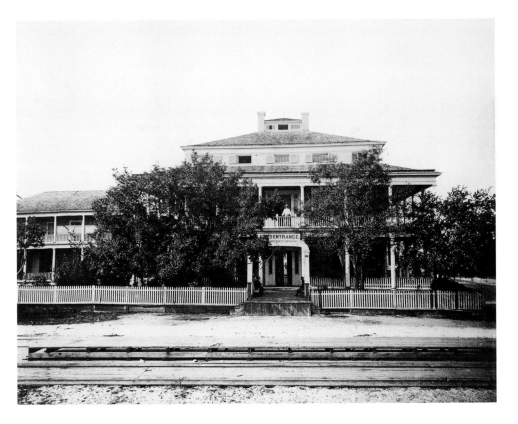

drive with "champagne carousals" at lakefront barrooms, restaurants, and resort hotels.[5] One traveler recounted the "fashionable drive" of the fast men and their fast horses: "they drive out, smoke and drink at hotels on the lake, and then they drive back, smoke and drink, sometimes racing all the way."[6]

For much of its distance the Shell Road traversed the vast, mostly unreclaimed swamp at the rear of the city. The "dazzling white surface of the road," one visitor remarked, "formed a strong contrast with the vegetation of the adjoining swamps."[7] The strange, tropical landscape astonished, fascinated, and even frightened travelers. A correspondent for the *Illustrated London News*, Charles Mackay, visiting a few years before the war, found a "melancholy beauty" in the swamps' "dangerous solitudes," where he witnessed

> luxuriant forest-growth, festooned with the graceful ribbons of the wild vine, the funereal streamers of the tillandsia, or Spanish moss (sure sign of a district subject to yellow fever), drooping from the branches of pine, cottonwood, cypress, and evergreen oaks—weird-like all, as witches weeping in the moonlight.[8]

The celebrated "Shell" and a similar road skirting the Bayou St. John were important highways for military transport during the war, with destructive consequences. "The movement of large army wagons, batteries of artillery soon cut through the surface crust of shells," the *Times* wrote in 1866, "and then followed, as a matter of course, deep ruts and deeper holes, which are positively dangerous to light vehicles, especially after nightfall."[9] What before the war had been called the "best road in America" was ruined.[10] The Shell Road's owners, Canal Bank, abandoned it in 1865 as "useless and of no value," but improvements followed federal appropriation of the turnpike during Reconstruction.[11] "General Sheridan has furnished four thousand barrels of shells" for repaving, the *True Delta* reported in early 1866, and the road was soon said to be "in fine order."[12] In March 1867, the *Picayune* again anticipated the spring outings on the "Shell": "The rattle and clatter on our famous shell road, along the New Canal, will be as great as ever, and fast men, fast women and fast horses will, at break neck speed, go whirring to the Lake."[13]

In Lilienthal's photograph several lakefront destinations can be seen: the Lake House Restaurant and Hotel, Canal Exchange Restaurant and Ten Pin Alleys, with a "Ladies' Entrance," and, beyond the bridge-tender's house, the Gem Oyster Saloon. Tourists reached these resorts not only by the Shell Road but also by covered passage-boats towed by mules along the canal, or by omnibuses from the Halfway House (cat. 35). In 1867, the Lake House, opened before the war, was reported to be "one of the most attractive places of resort on the Lake shore," and featured a luxurious pleasure garden with "rare and magnificent" blooming century plants.[14] The restaurant offered "all the luxuries of a First Class *Table d'Hote*," featuring the specialties of Lake Pontchartrain: soft-shell crabs, eels, oysters, frogs, croakers, and *pompano*.[15] The Canal Exchange also offered diners lake fish and crabs, and an adjacent ten-pin alley was open late into the night.[16] But diners were not always favorably impressed with the lakefront fare, as one visitor to the Canal Exchange revealed in 1867:

> We found the bill of fare at this "shebang" very limited, indeed, and modestly contented ourself with six consumptive looking croakers and a bottle of a decoction called claret, … usually sold for a dime anywhere below Canal street, but which, on the present occasion, was ostentatiously labeled "Vin Seville, 1849." Think of it, ye diners at the Lake, Two dollars and a half for six sickly croakers and a dime's worth of liquid extract of log wood.[17]

From 1880, this district was known as West End and remained a popular destination for day-trippers.[18] Vulnerable to destructive lake storms, the lakefront buildings were damaged and rebuilt many times. In 1909, a railroad opened an amusement park at West End and in the late 1930s the Works Progress Administration built a yacht harbor there. The district, which had attracted visitors to seafood restaurants and oyster houses for decades, was deluged by the floodwaters following hurricane Katrina in 2005.

1. Franz Anton Ritter von Gerstner, *Early American Railroads*, ed. Frederick C. Gamst, Stanford, Calif. (Stanford University Press) 1997, p. 746.
2. Major Edward J. Noyes to his mother, June 30, 1862, Noyes Family Papers, 1687–1949, Ms N-607, Massachusetts Historical Society; "More Views in New Orleans," *Harper's Weekly*, v, no. 222, March 30, 1861, p. 196. Lawrence Van Alstyne, *Diary of an Enlisted Man*, New Haven, Conn. (Tuttle, Morehouse & Taylor) 1910, p. 184.
3. "More Views in New Orleans," *op. cit.*
4. *Norman's New Orleans and Environs*, p. 192.
5. "Rides on a Summer Sunday," *Picayune*, March 25, 1867.
6. John W. Oldmixon, *Transatlantic Wanderings: Or, A Last Look at the United States*, London and New York (G. Routledge & Co.) 1855, p. 145.
7. Charles Lyell, *A Second Visit to the United States of North America*, London (J. Murray) 1849, II, p. 134.

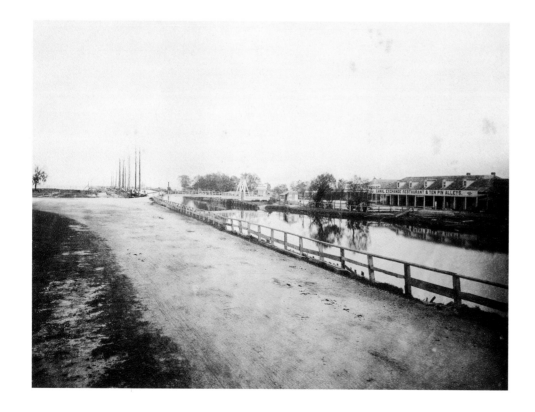

8. Charles Mackay, "Transatlantic Sketches: The Swamps of Louisiana," *Illustrated London News*, XXIII, no. 942, Sunday, October 23, 1858, p. 389; reprinted in *id.*, *Life and Liberty in America: or, Sketches of a Tour in the United States and Canada in 1857–8*, New York (Harper & Brothers) 1859, pp. 271–72.

9. "The Bayou Road," *Times*, May 8, 1866. The military also built a rail line along the Shell Road at the end of the war, disrupting the placid drive (see cat. 9).

10. *Times*, August 16, 1865.

11. *Ibid.*; *Specifications of Improvements of the Shell Road*, New Orleans, *c.* 1865–66, p. 7.

12. *True Delta*, February 3, 1866.

13. "Rides on Summer Sunday," *Picayune*, March 25, 1867.

14. "Great American Aloe at Lake House," *Crescent*, June 18, 1867; "Lake House, New Canal," *Picayune*, July 7, 1867. The Lake House was featured in *Harper's Weekly*, VII, no. 323, March 7, 1863.

15. *Times*, "The Lake House" (advertisement), March 15, 1864. Although sources differ in recording the early history of the Lake House, the Bruning family may have opened the resort in 1859, making it a predecessor to a West End restaurant by the same name. See Betsy Swanson, *Historic Jefferson Parish from Shore to Shore*, Gretna, La. (Pelican) 1975, p. 132.

16. "Canal Exchange" (advertisement), *Picayune*, April 19, 1853.

17. "The Lake—The Regatta," *Picayune*, October 4, 1867.

18. *Times*, June 6, 1880.

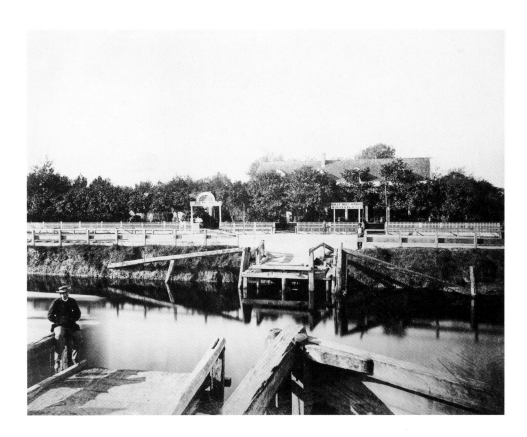

35
Half way House
Café de l'Hypodrome

William Winkelmann's Halfway House restaurant, pleasure garden, and retail nursery was located on the west bank of the New Basin Canal (cat. 74), about halfway between New Orleans and Lake Pontchartrain. Lilienthal's French caption refers to the restaurant's proximity to the Metairie Race Course (cat. 37). There, passengers on the City Railroad changed to omnibuses or mule-drawn barges for the lakefront resorts, and carriages or horseback riders using the Shell Road waited at a drawbridge crossing the canal. The Halfway House was a favorite stopover, where "cocktails and sherry-cobblers are dispensed to thirsty souls."[1] A 3-acre (1.2-ha) "Garden of Eden," the restaurant's chief attraction, featured a floral collection unrivaled in a city with many private pleasure gardens. "Seldom have we seen a more beautiful sight," a visitor wrote in April 1867.

> The garden was a perfect wilderness of beauty. Only about three acres in extent, it yet contains nearly every floral specimen to be found in the country … . Thousands of roses were blooming on every side. Exquisite flowers of every type gave forth their fragrance and overhead noble trees … gave shade to all. The very air was rich with perfume.[2]

The Halfway House was a traditional site of pistol duels, and in the 1860s deadly confrontations with arms still took place on this "classically bloody ground."[3] The locality was called the Bois de Boulogne, and there, as in the Paris park, "matters of chivalric combat would be conducted according to the rules of the duello."[4] The nearby grave of the casualty of such a duel, one traveler observed, was marked with a tablet inscribed: "Mort, victime de l'honneur!"[5]

Duelists fought "with the sword, with double-barreled shotguns, and sometimes with bowie knives," the Italian tourist Giulio Adamoli discovered, "usually to the death."[6] In 1866, *Harper's Weekly* reported on a duel between the jealous husband of a French Opera diva and a young actor named Hippolyte, her lover. Hippolyte's pistol shot glanced the husband, but believing he had killed him, the actor fainted, and the seconds declared a conciliation.[7]

Another encounter at the Halfway House, in 1867, brought together two duelists, both writers, one a local Creole and the other a columnist for a French weekly. Although their quarrel was "very slight and entirely of a personal nature," it was "found impractical to conciliate matters" and the two men faced off with dueling pistols. With "cool placidity," the *Crescent* reported, the combatants approached each other and fired, but missed their targets. Reprieved, they celebrated the harrowing encounter in "the best terms of friendship and esteem."[8]

In March 1867, "two German gentlemen," a writer for the German *Gazette* and a local theatrical luminary, also faced off there. The "difficulty had arisen," the *Evening Crescent* reported,

> with a reference to the German theater which the journalist refused to retract … . The weapons used were navy revolvers, and at a distance of five paces. Shots were exchanged three times, resulting in a severe wound, in the breast, to the writer of the paragraphs in question. The other gentleman was unharmed. We are informed that both parties displayed great presence of mind and the strictest observance of the rules of the code.[9]

In the 1880s, Mark Twain found dueling, with "the French immunity from danger," still

commonplace in New Orleans. "It is still the romantic dark ages here," Twain wrote. "They fight duels for the merest trifles"[10]

In Lilienthal's photograph the Halfway House is obscured by a screen of trees and enclosed by a picket fence. The carriage entrance to the garden from the Shell Road is visible to the left. In the foreground of the view is a bridge crossing over the canal, with a bridge-tender posed on the approach. After the war, the bridge was badly in need of repair, and overlooked in the city's appropriations, as the *Times* observed satirically:

Antique in style, its venerable timbers inspire involuntary respect. The dry rot of years of neglect adds greatly to this effect, and in passing over it the fear of falling through it, or it crumbling beneath its own weight, gives a glow of exhilarating excitement to the frame. It is a noble structure, that New Canal bridge, illustrating the enterprise and progressive spirit which so eminently distinguish all the departments of the city government.[11]

The Halfway House relocated in the late nineteenth century to the east bank of the canal, opposite its site in the photograph, and reopened as a club that played a role in the early development of jazz. The canal was closed in the 1930s and, after World War II, an interstate highway was built up along its bed. The area of the photograph is now part of a cemetery precinct, where the Greenwood, St. Patrick's, and Metairie cemeteries are located.

1. Robert Somers, *The Southern States Since the War*, New York (Macmillan) 1871, p. 193.
2. "A Very Garden of Eden," *Times*, April 16, 1867.
3. "Environs of New Orleans," *Crescent*, May 8, 1866.
4. *Ibid.*
5. Charles Lyell, *A Second Visit to the United States of North America*, London (J. Murray) 1849, II, p. 118.
6. Giulio Adamoli, "New Orleans in 1867," *Louisiana Historical Quarterly*, VI, 1923, p. 272.
7. Alfred R. Waud, "Sunday Amusements at New Orleans," *Harper's Weekly*, X, no. 498, July 14, 1866, pp. 442–45.
8. "Affair of Honor," *Crescent*, August 27, 1867.
9. "Duel at Metairie Ridge," *Evening Crescent*, March 29, 1867.
10. Mark Twain, *Notebooks & Journals*, ed. F. Anderson, Berkeley (University of California Press), 1975, II, p. 553.
11. "A Noble Structure," *Times*, June 5, 1868.

36
Races of 1867 Metairie Course
Courses de 1867 a l'Hypodrome

The mile-long (1.5 km) Metairie course was laid out in an ellipse with a grandstand parallel to Metairie Road on the south, and to the east the course adjoined the Shell Road and New Basin Canal (cat. 34). Visitors to the track could ride the City Railroad out along Canal Street to the Halfway House (cat. 35), which was a short walk from the grandstand.

The Metairie held its inaugural meet in 1838. During the 1840s and 1850s, it secured its place in turf history by recording some of the fastest races in the country; at least one record was broken nearly every year.

The war put an abrupt end to the Metairie's distinction. The Confederate army used the track for mustering troops early in the war, and with federal occupation Union forces also appropriated the track for encampments. The troops, according to the *Times*, reduced the grounds to "a mere waste field ... everything in the way of woodwork having been taken away or destroyed ... leaving nothing standing but the brick and ironwork of the stands."[1] Obliterated was "all trace of the famous oval," and "the grounds were an unbroken wilderness of weeds

and coco," the *Crescent* wrote. "The ruthlessness of war had made a dilapidated wreck, an unsightly ruin, of the grand stand from which such triumphs of speed and endurance ... had been witnessed."[2]

In November 1866 the Metairie Jockey Club was reorganized.[3] "We hail with pleasure the revival of this famous institution of the days of our prosperity," the *Times* proclaimed, "and sincerely trust that it may mark the dawning of happier times."[4] Racing resumed on December 22, 1866, and the following spring the course opened for its first full season with a rebuilt track and grandstand. "The view of the elegant grand stand from the course was beautiful," a visitor remarked on opening day, April 6, 1867. "In the flush times before the war the Metairie, in its accommodations and appointments, was far from being equal to what it is now."[5]

The thirteen-day meet featured a 3-mile (5-km) heat between Fannie Brown, a filly, and General Rousseau, a five-year-old that was described as "one of those most worthy to be remembered in the annals of American racing."[6] But attendance in 1867 was far below expectations, and although "more ladies were present than ever before," on some days "not a dozen men could be counted in the stand."[7] The

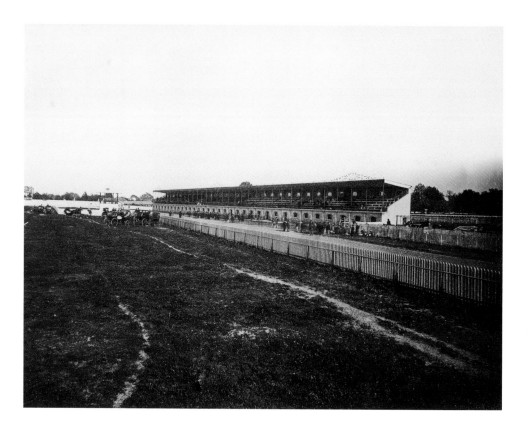

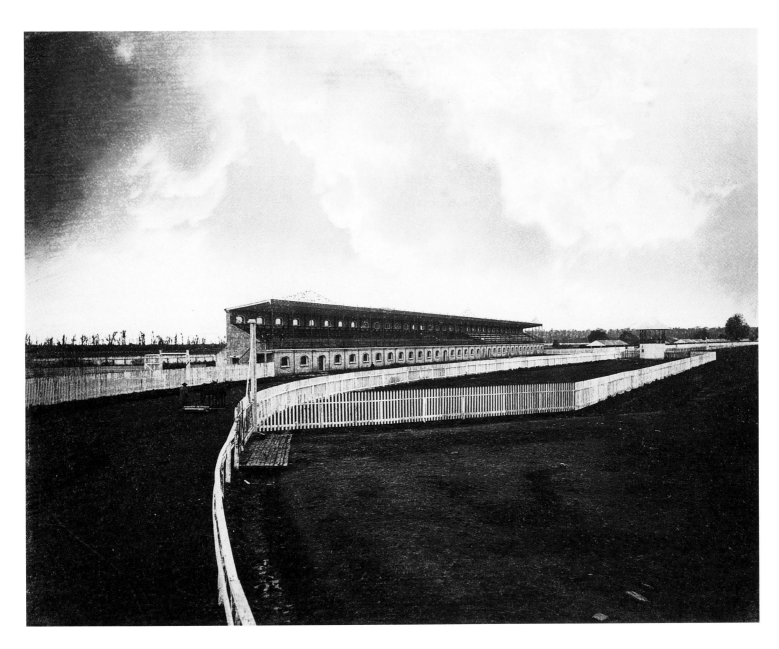

Crescent deplored the decline of one of the city's important visitor attractions and sources of income, especially at a moment when "so much is lost to the city by an interrupted commerce."[8] Although Lilienthal's photograph proclaims the pleasure and luxury of sport in lean times, the Metairie never recaptured its prewar distinction. In 1872, the track was sold for redevelopment as a cemetery.[9]

Other photographers published views of the race tracks of New Orleans, but Lilienthal's preeminence with this popular local imagery is confirmed by his association with the most celebrated view of the Metairie course, the 1867–68 painting *Life on the Metairie* by Victor Pierson and Theodore Moise—a composite of forty-four portraits of prominent members of the Metairie Jockey Club after photographs by Lilienthal's commercial rivals Bernard and Gustave Moses. Although not the photographer, Lilienthal was called in, the *Crescent* reported, to "assist in the success of this work," and "drove his apparatus to the race-track, with the artists, to select some point of sight from which a pleasing effect could be produced."[10] The episode is evidence of Lilienthal's preeminence in the local artistic community of the 1860s.[11]

1. "The Metairie Races," *Times*, April 21, 1867.
2. "The Metairie," *Crescent*, December 20, 1866; "The Metairie Races," *Crescent*, April 21, 1867.
3. "The Old Metairie Course," *Times*, August 16, 1866.
4. "Metairie Jockey Club," *Times*, November 16, 1866.
5. "A Trip to the Metairie," *Picayune*, April 7, 1867.
6. "Metairie Jockey Club Races—Spring Meeting, 1867," *Crescent*, April 14, 18, 1867.
7. *Ibid.*; "Metairie Races," *Crescent*, April 17, 1867.
8. *Ibid.*
9. *Times*, May 5, 1872; Henri Gandolfo, *Metairie Cemetery: An Historical Memoir*, New Orleans (Stewart Enterprises) 1981, p. 15.
10. "Life on the Metairie," *Crescent*, January 5, 1868. The Pierson–Moise painting was exhibited in the Fair Grounds Race Course (cat. 32) clubhouse when that building was destroyed by fire in 1993.
11. Photographer Jay Dearborn Edwards published views of the Metairie races six years before Lilienthal; see *Picayune*, April 9, 1861, cited by Smith and Tucker, p. 92.

37 (previous page)
Meterie Race Course
Intérieur de l'Hypodrôme

Meterie Race Course is a work of striking graphic power and formal clarity. Unlike Lilienthal's other racecourse views (cats. 32 and 36), the interest here is not in the spectacle of the race but in what the *Crescent* called the "symmetry and scenic beauty" of the track, which he photographed when no race was running.[1] Only a groundskeeper and his plow horse animate the view, and the emptiness contributes to a quality of detachment that is amplified by the mottled sky and the spindly cypress trees of the nearby swamp silhouetted on the horizon.

The geometry of the view—the arc of the plank fence intersecting the picket fence, and the grandstand receding off-axis into depth—gives the photograph a sense of abstract order. With this deftly structured perspective Lilienthal demonstrates that he was not only a skilled practical photographer in command of his medium, but also an artist who could exceed the conventions of his subject matter.

1. "The Metairie Races," *Crescent*, December 31, 1867.

38
Firemen's Cemetery
Cimetiere de Pompiers

The main necropolis of New Orleans was located 4 miles (6.5 km) from the Vieux Carré, where Canal Street met the Metairie Ridge. The Firemen's and Odd Fellows' (cat. 39) cemeteries were located there, near other large burial grounds. The Metairie Ridge was the highest ground in the region, and the garden setting, among the "mourning cypress and the drooping willow," was appropriate to meditation and memorial.[1] In contrast, the older city cemeteries, once located at the perimeter of the Vieux Carré, had been absorbed into the developing city, as the *Picayune* noted in 1840:

> the rapid growth of our city has already encroached upon the tombs of its fathers, and the sacred relics of the dead have been compelled to give way to the cold and selfish policy of speculators, and the intrusion.[2]

In the marshy soil of New Orleans, most burials took place above ground. "In New Orleans a different method of sepulchre prevails," the physician Bennet Dowler explained in 1850. "A grave in any of the cemeteries, is lower than the level of the river, so that it fills speedily with water, requiring it to be bailed out before it is fit to receive the coffin."[3] Subterranean burial, when practiced, could have ghoulish consequences if gravesites flooded, as one journalist observed after a heavy rain: "A great number of coffins were seen floating, and being agitated by the wind were driven in different directions, knocking against each other, and forming a deadly representation of a sham sea-fight."[4]

The Firemen's Charitable Association organized Firemen's, or Cypress Grove, Cemetery in 1840. The designer was Frederick Wilkinson, who supplied the plans for the U.S. Barracks campus downriver (cats. 116 and 117) and Poydras Market (cat. 60). Wilkinson worked in a "pure Egyptian style," and laid out the grounds in avenues that were 18–20 feet (5.5–6 m) wide, named Live Oak, Cedar, Magnolia, Cypress, and Willow after the trees that could be found growing there.[5] Specifications called for a "large Gateway, fronting on the Metairie Road, with two side gates; also a Porter's Lodge and Dead House, all to be of brick, plastered and painted to imitate Egyptian Marble."[6] At the perimeter was a 280-foot (85-m) range of brick vaults in four tiers, and enclosing the grounds was a whitewashed cypress picket fence.

Wilkinson's imposing gateway—"remarkable in its bold outlines"—was an early example of the Egyptianizing cemetery gate that came into fashion in America in the late 1830s.[7] He appears to have modeled his entrance on James Bigelow's portal and porters' lodges at Mount Auburn Cemetery, Cambridge, Massachusetts. Built in 1832 (and rebuilt in 1842–43), Bigelow's work is credited with launching the Egyptian style in funerary architecture.[8]

The suitability of Egyptian models for cemetery architecture—nearly all the surviving examples were funerary—was debated. In 1836, the critic Henry Russell Cleveland stated that he was "very doubtful" that the style was appropriate to any Christian burial place:

> In its characteristics, it is anterior to civilization; and, therefore, is not beautiful in itself …. Egyptian architecture reminds us of the religion which called it into being, the most degraded and revolting paganism which ever existed. It is the architecture of embalmed cats and deified crocodiles: solid, stupendous, and time-defying, we allow; but associated in our minds with all that is disgusting and absurd in superstition.[9]

New York architect Robert G. Hatfield, however, in his *American House Carpenter* of 1845, disagreed: "The general appearance of the Egyptian style of architecture is that of solemn grandeur—amounting sometimes to sepulchral gloom. For this reason it is appropriate for cemeteries."[10] The Egyptian fashion grew out of widespread interest in the French archaeological discoveries in Egypt in the early nineteenth century. James Dakin was probably the first to use the Egyptian style in New Orleans, for a church steeple he designed in 1836, and James Gallier worked with Egyptianizing motives for several structures, including a tomb, before 1841.[11]

Wilkinson's gateway at Cypress Grove served a dual purpose, as a deterrent to grave theft and as a symbolic passageway from the world of the living to the hallowed "last resting place of those who slept in consecrated ground."[12] In Lilienthal's view, a column of trees cloaks the gate, and in his choice of framing, the trees are as important in establishing the

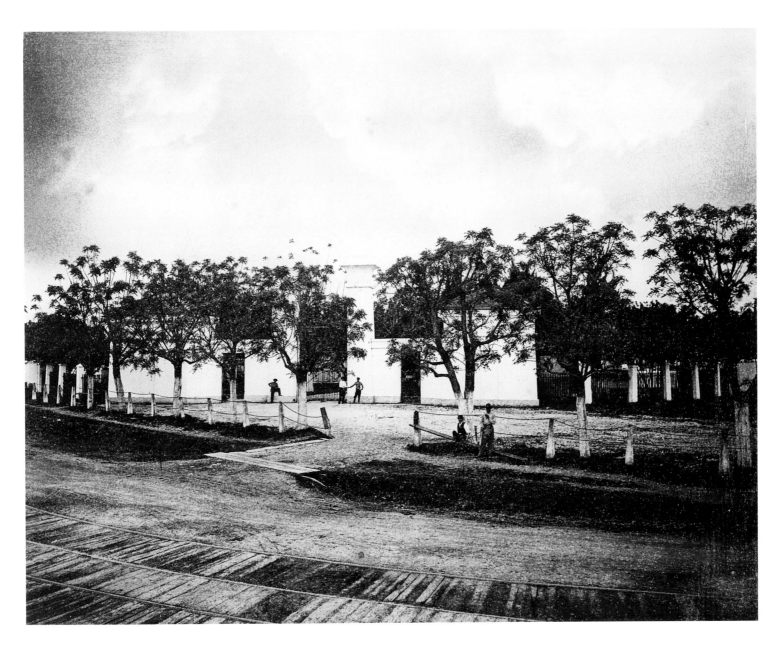

rural tranquility and solemnity of the cemetery as its monumental architecture.

As in many of his views, Lilienthal seems to be composing stereographically, locating the main subject in depth and bringing strong foreground elements—here the railroad tracks, shell road, and drainage canal—into the frame. This stepping back and composing in depth is a characteristic that historian Joel Snyder has observed in the work of other Civil War-era photographers, in which subjects are often taken in their entirety and "nothing is singled out, no one thing given greater visual weight than another."[13] Many of Lilienthal's views appear to have this distance and detachment from their subject, which can also be a result of the sometimes exaggerated perspective characteristic of early wide-angle lenses.

1. "A Rural Cemetery," *Orleanian*, May 20, 1851.
2. "Cypress Grove Cemetery," *Picayune*, October 3, 1840.
3. Bennet Dowler, *Researches upon the Necropolis of New Orleans*, New Orleans (Bills & Clark) 1850, p. 7.
4. *Niles Weekly Register*, XXVII, November 20, 1824, p. 192.
5. *Norman's New Orleans and Environs*, pp. 105–106; "Cypress Grove Cemetery," *op. cit.* On Wilkinson, *Biographical Register*, I, pp. 494–95.
6. "Notice to Contractors," *Picayune*, February 27, 1841.
7. "All Saints' Day in New Orleans," *Times*, November 2, 1866.
8. On the Mount Auburn gateway, see Jacob Bigelow, *A History of the Cemetery of Mount Auburn*, Boston (James Munroe & Co.) 1860, and Blanche Linden-Ward, *Silent City on a Hill*, Columbus (Ohio State University Press) 1989, pp. 261–66. Maximilian Godefroy's gateway to Westminster Cemetery, Baltimore, of 1815 was probably the first Egyptian

Revival cemetery gate in the country, but it was not until Mount Auburn that the style came to be more widely adopted. Egyptian gateways were proposed for Philadelphia's Laurel Hill Cemetery in 1836, Mount Hope Cemetery in Rochester in 1838, and New Haven's Grove Street Cemetery in 1839. In 1840, Isaiah Rogers designed Egyptian entryways for Boston's Old Granary Burying Ground (which he reused at Touro Cemetery in Newport, Rhode Island in 1843). Historian Richard Carrott has cataloged at least fifteen Egyptian cemetery entrances that were built or designed between 1830 and 1850, including Cypress Grove. See Richard G. Carrott, *The Egyptian Revival: Its Sources, Monuments, and Meaning*, Berkeley (University of California Press) 1978, pp. 82–97. See also James Stevens Curl, *Egyptomania: The Egyptian Revival: A Recurring Theme in the History of Taste*, New York (St. Martin's Press) 1994, pp. 166, 180–81. In New Orleans, later in the century, Thomas Sully designed what was the most exuberant local expression of the Egyptian funerary style, in the Brunswig

pyramid for Metairie Cemetery (Sully's drawings are in the Southeastern Architectural Archive, Tulane University).

9. Henry Russell Cleveland, "On the Rise, Progress and Present State of Architecture in North America," *Architectural Magazine*, IV, no. 35, 1837, p. 16, reprinted from the *North American Review*, XLIII, October 1836, pp. 356–84. The article, ostensibly a review of James Gallier's work, is unsigned, but Russell's original manuscript is in the *North American Review* Papers, Houghton Library, Harvard University. See William H. Pierson, Jr., *American Buildings and their Architects*, New York (Oxford University Press) 1986, II, p. 169; and Phoebe B. Stanton, *The Gothic Revival & American Church Architecture: An Episode in Taste, 1840–1856*, Baltimore (Johns Hopkins University Press) 1997, p. 163, n. 12.

10. Robert G. Hatfield, *American House Carpenter*, New York and London (Wiley & Putnam) 1845, p. 89, cited by Samuel Wilson, Jr., "Influences on 19th Century Funerary Architecture," in *New Orleans Architecture*, III, p. 97. Hatfield was among the most prominent architects of his time, and an innovator in iron construction; see David G. Wright, "The Sun Iron Building," in *Baltimore's Cast-Iron Buildings and Architectural Ironwork*, ed. James D. Dilts and Catherine F. Black, Centreville, Md. (Tidewater) 1991, p. 24.

11. On Dakin's First Methodist Church steeple, see Arthur Scully, Jr., *James Dakin, Architect: His Career in New York and the South*, Baton Rouge (Louisiana State University Press) 1973, pp. 59–62. Another example of the style in New Orleans was the Jefferson Parish Courthouse Annex on Rousseau Street, *c.* 1840, often attributed to James Gallier. But the culmination of the application of Egyptian Revival motives was the Custom House, designed with prominent lotus-leaf capitals by A.J. Wood in 1847 (cat. 19). See Carrott, *op. cit.*, pp. 119, 128–29.

12. "A Rural Cemetery," *Orleanian*, May 20, 1851.

13. Joel Snyder, "Photographers and Photographs of the Civil War," in Joel Snyder and Doug Munson, *The Documentary Photograph as a Work of Art: American Photographs, 1860–1876*, Chicago (The David and Alfred Smart Gallery; The University of Chicago) 1976, pp. 21–22.

39
Odd Fellows' Rest
Cimetiere des Odd Fellows

The Odd Fellows, a fraternal society that originated in eighteenth-century England, was established in New Orleans in 1831 and dedicated this cemetery, the society's first in America, in 1849.[1] It was one of a cluster of cemeteries located in the necropolis at Canal Street and Metairie Road (City Park Avenue). The burial ground, and a major building campaign in Lafayette Square begun at the same time, signaled the height of wealth and influence of the fraternity, which had twenty-two lodges and 2000 members in New Orleans.[2]

"'Odd Fellows' Rest is one of the most attractive of all the homes of the dead," the *Crescent* wrote in 1866.

> ... Passing through its gates one is impressed, however great the human throng may be, with an idea that it is a place of repose. The spacious avenues leading through it are lined with monuments to good and charitable men, and the horticultural embellishments, in some inexplicable way, tend to abstraction from thoughts of the world and its vanities, and solemn contemplation of the eternal.[3]

The Odd Fellows held an important place in the ceremonial life of the city, as demonstrated by the dedication of their cemetery in February 1849, described as one of the most "imposing sights that has ever been witnessed in this city."[4] More than 1000 Odd Fellows, "clad in their superb regalia, with their magnificent banners," formed a procession through the city streets. A black funeral car drawn by six white horses carried the ashes of lodge members collected at other cemeteries for interment at the new site.

Nearly two years after dedication, the cemetery remained unfinished: "those who expect the 'Rest' to spring up as if by magic, perfect in all its parts, will be sadly disappointed," the fraternity advised.[5] During the 1850s, surveyor M. Harrison laid out the shell walks in the form of a triangle with a central circular pathway, "thereby carrying out the symbolic language of our order," a reference to the Order's triangular seal with the "All-seeing Eye of the Almighty."[6] The circle at the center of this symbolic landscape plan can be seen in Lilienthal's photograph.

In the far distance is a series of wall vaults of Massachusetts marble, some with their tablets removed. One prewar visitor to the cemetery took note of these vaults, common to nearly all local cemeteries: "New Orleans has several peculiarities of its own The dead are buried in sepulchral houses, which are termed here 'ovens.' These often contain three or four tiers. Those belonging to the wealthy are frequently very handsome, and built with marble walls."[7] Handsome or not, there was "something very doleful" about the "oven" vaults, the *Republican* wrote in 1867, "in the idea of being thus put away on a shelf, broiling in the heat, generating poisonous gases, and filling the air with odors. But if you don't like that, you had better not die in New Orleans."[8]

In the center of the photograph is a burial mound marked by an obelisk with a portrait of John Howard, the eighteenth-century English hospital and prison reformer.[9] This was the tomb of the Howard Association, a relief

organization founded in 1837 by survivors of yellow fever to care for victims of epidemics. An "early Red Cross," the Association was active in at least four southern cities and was a successful model for charitable medical and social-service organizations in other parts of the country.[10] The fame of the Association spread nationwide after its work in the yellow-fever epidemic of 1853, when it took charge of more than 10,000 victims.[11] During the epidemic, the Association acted as a "*quasi* board of health," receiving thousands of dollars of municipal funds.[12] "Yellow fever was a specialty with us," a member in New Orleans recalled. "The citizens ... looked to us alone to avert or mitigate the suffering reported in every quarter. Proud of our selection in a forlorn hope, we set about it without thought of personal risk."[13]

1. On Odd Fellowship, see Henry Stillson, *The History and Literature of Odd Fellowship*, Boston (Fraternity Publishing Co.) 1897; Brian Greenberg, "Worker and Community: Fraternal Orders in Albany, New York, 1845–1885," *Maryland Historian*, VIII, no. 2, 1977, pp. 38–53; Mary Ann Clawson, *Constructing Brotherhood: Class, Gender, and Fraternalism*, Princeton, NJ (Princeton University Press) 1989, pp. 119–23.
2. *Journal of the Proceedings of the Right Worthy Grand Lodge of the Independent Order of Odd Fellows*, New York (McGowan & Treadwell) 1852, p. 1226; *Historical Synopsis and Reports of Officers of Board of Directors of Odd Fellows' Rest*, New Orleans (Bulletin Book and Job Office) 1859, p. 19.
3. "The Graveyards Yesterday," *Crescent*, November 2, 1866.
4. "Consecration of the Odd-Fellows Rest," *Bee*, February 27, 1849; "Consecration of Odd Fellows' Rest," *Crescent*, February 27, 1849.
5. *Historical Synopsis, op. cit.*, p. 29.
6. *Ibid.*, p. 106. The Odd Fellows referred to this symbol as the "eye of omnipotence ever upon us; that all our work, thoughts, and actions are open to his view," Noel P. Gist, "Secret Societies: A Cultural Study of Fraternalism in the United States," *University of Missouri Studies*, XV, no. 4, October 1940, p. 119.
7. Lady Emmeline Stuart Wortley, *Travels in the United States, etc., during 1849 and 1850*, New York (Harper & Brothers) 1851, p. 126.
8. "New Orleans Grave Yards," *Republican*, July 25, 1867.
9. Howard's major work was *An Account of the Principal Lazarettos in Europe*, Warrington (W. Eyres) 1789.
10. The Howard Association was active in Galveston, Memphis, and Houston, as well as New Orleans. *Constitution and By Laws of the Howard Association ... Organized August 1, 1837*, New Orleans (Stetson & Armstrong) 1867; Elizabeth Wisner, "The Howard Association of New Orleans," *Social Service Review*, XLI, no. 4, 1967, pp. 411–18; Peggy Bassett Hildreth, "Early Red Cross: The Howard Association of New Orleans, 1837–1878," *Louisiana History*, XX, no. 1, 1979, pp. 77–92.
11. "The Howard Association," *Picayune*, December 13, 1853; *Report of the Howard Association of New Orleans: Epidemic of 1853*, New Orleans (Sherman & Wharton) 1853. *History of the Yellow Fever in New Orleans ... to which is added the names of all persons who contributed to the funds of the Howard Association, in all parts of the United States*, Philadelphia (C.W. Kenworthy) 1854. One source reported 11,000 interments. George E. Waring, Jr., *Report on the Social Statistics of Cities*, Washington, D.C. (Government Printing Office) 1887, II, p. 266; see also John Duffy, *Sword of Pestilence: The New Orleans Yellow Fever Epidemic of 1853*, Baton Rouge (Louisiana State University Press) 1966.
12. "The Plague in the South-West," *De Bow's Review*, XV, no. 6, December 1853, p. 611.
13. William L. Robinson, *Diary of a Samaritan*, New York (Harper & Brothers) 1860, pp. 70–71.

40
Entrance of City Park
Entreé du Parc

There were two entrances to City Park on Metairie Road, both ornamented by gates built in 1858, when the park was fenced.[1] Access to the park was by the City Railroad —its plank roadbed is visible here—which ran horsecars between Bayou Bridge and the Halfway House. The vanishing lines of the railroad, drainage canal, and fence give the photograph a sense of deep space, a distance measured by the magnificent mushrooming oaks outside the perimeter of the park.

1. Building contract, James Lindsey, builder, to the specifications of Louis H. Pilié, E. Bouny, April 14, 1858, II, no. LXVII, NONA.

41
City Park
Parc de la Nouvelle Orleans

City Park developed on swampy pasturage of the old Allard Plantation, situated along Bayou Metairie and Metairie Road and adjacent to the Bayou St. John. The philanthropist John McDonough purchased the Allard property and in 1851 endowed the land to the city, which took steps to improve it. In 1854, the 180-acre (73-ha) tract was designated as the City Park.[1]

The City Railroad extended service to the district in 1861, opening public access to the park, but it remained undeveloped throughout the war. In 1866, the park was described as a "wild, desolate and entangled waste" and "an eyesore to the city." Although it had the potential to become the city's "noblest ornament," the *Times* wrote, "everything that Art can do toward it has yet to be done."[2] City Park's assets, however, included stands of Louisiana cypress and "magnificent groves of some of the largest live oak trees in the State."[3] "If properly improved," the *Picayune* advised, it "would be one of the handsomest parks in America ... but few cities would long permit a park like this to remain in so unimproved a condition."[4]

New Orleans looked to New York's Central Park, designed by Frederick Law Olmsted and Calvert Vaux and the first large-scale public park in the country, as the model for improvements: "The example of the New York City Fathers in laying out Central Park and beautifying it so that it is now one of the boasts of the Empire City, ought to inspire us to transform the Park gradually into a place in which our citizens would take pride, and where they could pass their time agreeably," the *Picayune* wrote in 1866. But the newspaper also acknowledged that, in the postwar economy, "little, comparatively, can be done for some time to come in the way of expending money for the adornment of New Orleans and its environs."[5]

In 1867, the city council did take steps to improve the park, with $10,000 appropriated from the municipal budget. A private developer proposed to build two lakes and miles of serpentine shell walks and roads in the park in return for a beer garden concession.[6] Opposition to private use of the public space, although it was called a "filthy, disgraceful cattle pen," was vigorous, however, and the proposal was another opportunity to denounce the measures of the Reconstruction council. "We are forever cursed with a set of so-called 'public servants,' who do not represent the people, their wants or requirements, and who most unworthily squander the taxes wrung from them," the *Evening Picayune* proclaimed.[7]

Apart from Central Park, few landscaped urban parks were developed in America before the war; most were not opened until the 1870s or later. Brooklyn's Prospect Park, also by Olmsted and Vaux and generally considered their masterpiece, was designed in 1865 and completed in 1873. Chicago passed a parks bill in 1869 designating 1800 acres (730 ha) of public parkland, and Philadelphia's Fairmount Park, although dedicated before the war, received its greatest development with the Centennial Exposition of 1876. Boston appointed a parks commission in 1875 and began building Olmsted's Emerald Necklace three years later.

Real improvements to City Park were still decades away. Closely tied to an agrarian plantation culture, New Orleans came less under the spell of the parks movement and its ideals of cosmopolitan refinement, and the city had long been domesticated by private pleasure gardens that were operated by hotel and restaurant promoters (cats. 33–35, 43, 46, and 104). The site in uptown New Orleans of the World's Industrial and Cotton Centennial Exposition of 1884–85 (today's Audubon Park) was developed from 1897 as a public park designed by Olmsted's successors. But not until the intervention of a citizens' association in 1891 did City Park begin to take shape. Acquisitions of land in 1897 and 1926–27 enlarged the park to 1300 acres (526 ha) extending from City Park Avenue to Lake Pontchartrain. Public-works projects of the 1930s finally created the park as it is today, the fifth largest municipal park in the country. Following hurricane Katrina in 2005, floodwaters from the 17th Street Canal and Lake Pontchartrain deluged the park and destroyed nearly one thousand trees. Today, some unrestored areas have returned to native growth.[8]

In Lilienthal's photograph, an orderly row of stone bollards defines the boundary of the park and prevents carriages from entering the grounds, as it also delimits the foreground space of the photograph. The deep foreground distances the gathering of women, who are dwarfed by the massive, spreading oak tree overhead. The luxurious, ancient oaks were the beauty of the park, and Lilienthal has captured the effects of light on their gnarled branches. Hanging moss, caught in the breeze, creates a fine blur everywhere in the image, and the whitewashed tree trunks are a reminder of the ever-present threat from the stinging buck-moth caterpillar.

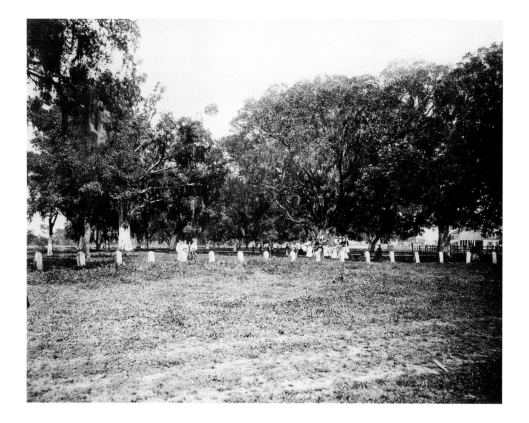

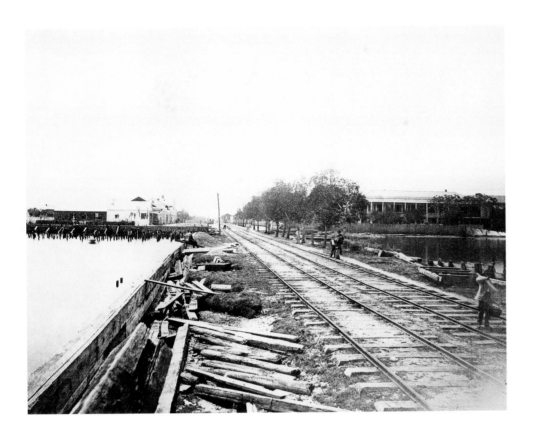

1. On the history of City Park, see Sally K.E. Reeves and W.D. Reeves, *Historic City Park, New Orleans*, New Orleans (Friends of City Park) 1982.
2. *Times*, September 20, 1866; *Picayune*, October 31, 1866; "The Park," *Times*, November 11, 1866.
3. "The Park," *op. cit.*
4. "City Park," *Picayune*, October 16, 1867.
5. "Adornment of the City and Environs," *Picayune*, January 7, 1866.
6. New Orleans Public Library, City Archives, Minutes and Proceedings of the Board of Assistant Aldermen, VII, pp. 507–11.
7. "Our City Park," *Evening Picayune*, October 22, 1867.
8. Lake Douglas, "Landscape Challenges for Post-Katrina New Orleans: '*Il faut cultiver notre jardin*,'" *Sitelines*, XI, no. 11, Spring 2007, p. 13.

42
Lake Pontchartrain
Lac Pontchartrain

Part of a vast basin of slow-moving bayous, cypress swamps, and hardwood forests, Lake Pontchartrain is a shallow, brackish, usually placid estuary of 635 square miles (1645 sq. km), connected to the Gulf of Mexico through the Rigolets and Chef Menteur passes. The lake played an important role in the history of New Orleans. In 1698, Pierre Lemoyne, the Sieur d'Iberville, obtained permission from the French naval minister, the Comte de

Pontchartrain, for the settlement of Louisiana.[1] In an expedition the following year Iberville explored the Mississippi River as far as Baton Rouge and returned by way of the lake that he named Pontchartrain. At the narrowest point between the lake and the Mississippi River, a distance of about 5 miles (8 km), where a portage linked the two waters, Iberville founded the colony of New Orleans.

"Lake Pontchartrain gives to the city one of its chief attractions," a Union soldier wrote; "this is a beautiful sheet of water."[2] To another visitor, the cool breezes off the lake were "redolent of piny woods and scrub oaks, telling of cotton-fields and sawmills," a reference to the hardwood forests and cropland of north Louisiana.[3] The lake was the city's recreational shoreline, attracting bathers and other excursionists, and especially fishermen, in large numbers. "The daylight car of the Pontchartrain Railway is loaded with those who are fond of the sport," the *Times* reported in 1866. "Sunday morning it is jammed, [with] hooks, lines, baits, corks, reels, poles, and all the little accompaniments by which the fish is lured."[4]

Lilienthal's view is of the pier that was the terminus of the Pontchartrain Railroad at Milneburg. "Everything [in Milneburg] has a clean and fresh appearance," a visitor observed

in 1867. The various houses of refreshment are open and ready for the crowds which will be there when the days become warmer."[5] Milneburg's plantation-style hotel, with wide verandas and a garden of palm and live oak trees, is visible in the photograph. A plank floodwall, which carries a painted sign advertising a respiratory remedy, is evidence of the constant threat of inundation at the lakefront. Because of its shallow waters, the normally calm lake could kick up powerful swells in a gale, with surges that frequently destroyed lakefront structures. The suddenness of these storms, especially in winter, could catch visitors unawares, as one antebellum traveler, John Oldmixon, discovered. Surprised at the suddenness of a "violent freezing gale," he took shelter in the Milneburg hotel, but found little protection there against the "howling of the winds and lashing of the waves." "I could be eloquent on the intense sufferings of that wretched night," Oldmixon wrote, "to be frozen to death on the hot Gulf, amidst the odoriferous pines and magnolias, and milk-white sands; where nobody can complain of anything but intolerable heat and mosquitos."[6]

Lilienthal's view illustrates a great engineering achievement of the nineteenth century in New Orleans. To reach the lakefront, the Pontchartrain Railroad had to span several miles of backswamp and floating prairie with cribwork and new roadbed on infill, seen here with its lakefront revetment. Lilienthal's photograph celebrates the railroad's intervention in the landscape, a typical promotional motive of railroad photography that expressed a widespread belief in technological progress and, as one historian has written, "man's ability to overcome the obstacles of nature by dramatic feats of engineering."[7]

1. Louis Phélypeaux, Comte de Pontchartrain (1643–1727) was minister of the French navy until September 1699, when his son, Jérôme, Comte de Pontchartrain (1674–1747), took office. The Phélypeaux ministers promoted the Gulf Coast colonies as part of a strategy to develop maritime trading zones and as outposts to prevent settlement of the Gulf Coast by Britain and other rivals. See Dale Miquelon, "Envisioning the French Empire: Utrecht, 1711–1713," *French Historical Studies*, XXIV, no. 4, 2001, pp. 653–77; and David Farrell, "Reluctant Imperialism: Pontchartrain, Vauban and the Expansion of New France, 1699–1702," *Proceedings of the Annual Meeting of the French Colonial Historical Society*, XII, 1988, pp. 35–45.
2. John Chandler Gregg, *Life in the Army, in the Departments of Virginia, and the Gulf, Including Observations in New Orleans*, Philadelphia (Perkinpine & Higgins) 1866, p. 129.
3 "Looker-On," *Times*, May 8, 1866.

4. *Ibid.*
5. "Trip to the Lake," *Picayune*, April 12, 1867.
6. John W. Oldmixon, *Transatlantic Wanderings: Or, A Last Look at the United States*, London and New York (G. Routledge & Co.) 1855, pp. 150–51.
7. Susan Danly, "Andrew Joseph Russell's *The Great West Illustrated*," in *The Railroad in American Art*, Cambridge, Mass. (MIT Press) 1988, p. 94.

43
Lake end Pontchartrain
Lac Pontchartrain

Among the celebrated resorts on the shore of Lake Pontchartrain, the most famous was Boudro's Restaurant and gardens, pictured here, at the terminus of the Pontchartrain Railroad in Milneburg. Frederick Law Olmsted visited the resort in 1856:

The first house from the wharf had a garden about it, with complex alleys, and tables and arbors, and rustic seats, and cut shrubs, and shells, and statues, and vases ... a lamp was feebly burning in a large lantern over the entrance-gate. I was thinking how like it was to a rural restaurant in France or Germany.[1]

Lucien Boudro, a native of Brittany, opened the restaurant in the 1830s. He employed

French chefs, often the best in the city. The writer William Thackeray, a visitor to Boudro's before the war, praised the *bouillabaisse* he ate there: "better was never eaten at Marseilles."[2] Architect Thomas K. Wharton also "fared sumptuously at Boudro's," noting in his diary "the red snapper and everything from 'soup' to 'beignets' admirably cooked. Then we took the fresh breeze from the Lake and rambled among the flowers."[3] Boudro's chefs, Philippe and François, were "*artistes*," the *Crescent* noted, whose accomplishments would make them the envy of the cooks of Paris, or of the White House.[4] "We are certain that if Lincoln had a knowledge of the good things to be had at Boudro's, he would eschew abolitionism and move Mrs. L. and Bobby out *tout-de-suite*."[5]

Another attraction at Boudro's was a menagerie. During federal occupation, one Union soldier—who was also "much pleased with the manner [in which the] trees were trimmed" in the garden—enjoyed a collection of wild animals that included bears and alligators, an anteater, a "Mexican Hog," and "birds of various kinds."[6]

In June 1865 Boudro's burned to the ground in a fire that also destroyed twenty other buildings in Milneburg.[7] "Fortunately, there was a calm on the Lake," the *Picayune* wrote, "or

there would not have remained a single building in the village."[8] Boudro's new restaurant, built immediately after the fire, and recorded in Lilienthal's view, was a frame building with a slate roof, center hall, two small and two large parlors, and a "rear gallery, enclosed with Venetian blinds, used as a dining saloon."[9] Fronting on the lake was a garden with shelled walks ornamented by a "splendid cast iron fountain." Outbuildings included a pistol gallery and gasworks. In Lilienthal's ground-level perspective over the tracks of the Pontchartrain Railroad, the lake and its breakwater and jetties are visible beyond the restaurant, and the houses of Milneburg behind the neatly trimmed fence. After Lucien Boudro's death in 1867 the property was sold, but his descendants continued to operate a lakefront restaurant until 1911.[10]

1. Frederick Law Olmsted, *A Journey in the Seaboard Slave States, with Remarks on their Economy*, New York (Dix & Edwards) 1856, p. 581., p. 578.
2. William Makepeace Thackeray, "A Mississippi Bubble," in *Roundabout Papers*, New York (Harcourt Brace) 1925, p. 187. Thackeray's visit has also been associated with Miguel's restaurant, at one time operated by Boudro.
3. Wharton, "Diary," June 3, 1857. Wharton's diary entry for May 28th also describes a visit to the gardens.
4. "Boudro's Restaurant," *Crescent*, April 1, 1861.
5. *Ibid.*
6. James Miller, *Diary*, February 13, 1863, Mss. S-14, Massachusetts Historical Society.
7. "Boudro's Burnt," *Picayune*, June 3, 1865. The restaurant had been "completely refitted and furnished" three years earlier; *Delta*, April 17, 1862.
8. "The Fire at Milneburg," *Picayune*, June 3, 1865.
9. Building contract, E.G. Gottschalk, XV, no. 137, March 3, 1866, NONA; "The Popular and Far-Famed Boudro Restaurant and Pistol Gallery" (property sale advertisement), *Crescent*, March 3, 1868.
10. A well-known restaurant by the same name operated at West End for many years until 1997, when it was destroyed by hurricane Jacques.

44
Lake end Ponchartrain
Lac Ponchartrain

The Pontchartrain Railroad, linking the city with Lake Pontchartrain, was one of the first railroads in the country.[1] Only 23 miles (37 km) of track had been laid in the United States when construction on the Pontchartrain began in 1830, but railroad fever and competition with canal builders to open the lakefront to resort and residential development boosted backers' confidence. "It would be surprising,"

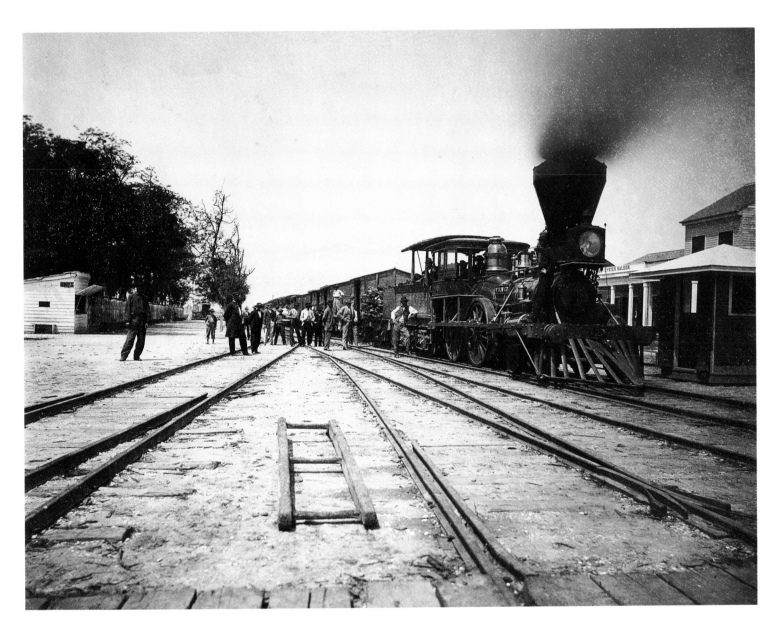

the company's founders wrote, "if a short road from New Orleans (visited by so many strangers) to the Lake, a place of great resort for pleasure, and on which so much business is transacted, should not afford a profitable investment."[2]

The work of building the road began at the narrowest point—"possessing the highest ground and the least swamp"—between the river and the lake, a distance of about 5 miles (8 km). "Almost no one believed that it was possible to build a railroad through the swamp," the German engineer Franz Anton Ritter von Gerstner wrote; "this place had always been thought to be impassable."[3] Builders marshalled gangs of laborers to clear cypress trees and underbrush and build up the roadbed by hand, and mortality was high,

especially during a yellow-fever outbreak, when hundreds of workers died.[4] Fill for the roadbed and cribwork foundations was difficult to obtain: "the greatest difficulty and expense of the road has been the filling of the swamps, for which purpose there is in Lower Louisiana, a great scarcity of any kind of material," the *United States Weekly Telegraph* reported.[5] The line was opened to passengers in April 1831.

The high death rate of white workers during construction led the railroad in 1833 to invest heavily in slave labor, which owners calculated would be a means of "reducing the heavy expenses that have weighed upon the company from its origin."[6] The railroad bought thirty slaves and hired eighty-four others (largely from area plantations), giving it the largest

bonded workforce in the city. Antebellum railroads were typically dependent on bonded labor—the New Orleans, Jackson and Great Northern Railroad (cat. 79) at one time owned 106 slaves—and southern railroads altogether have been estimated to have employed more than 20,000 slaves.[7]

A second track was laid in 1838 using a steam pile driver. At the lakefront, engineers built a lighthouse, harbor, and pier where passengers and cargo could be transferred from lake ships for carriage into the city, and by 1840 the railroad operated two hotels and bathhouses there. Construction costs topped $300,000, exceeding the original capitalization, but soon the railroad fulfilled its promise to investors as "one of the most

lucrative public enterprises in the United States," and generous dividends were paid to shareholders.[8] In the summer, trains departed every hour from both the lakefront terminal and the city station near Esplanade Street. Early trains were drawn by horse traction, reaching the lake in about half an hour. A lakefront trip cost thirty-seven cents in 1838, when the railroad's annual costs were $60,000, including $5500 for the food, clothing, and medical expenses of its slaves, and $22,000 for the wages of officers and train crews.[9]

Writer Joseph Holt Ingraham traveled the Pontchartrain in the 1830s:

> A mile from the Levée we had left the city and all dwellings behind us and were flying through the fenceless, uninhabited marshes. ... [At] the lake ... a quiet village of handsome, white painted hotels, cafés, dwellings, store-houses, and bathing rooms, burst at once upon our view; running past them, we gradually lessened our speed, and finally came to a full stop on the pier, where the rail-road terminates.[10]

The settlement Ingraham found at the lakefront terminus was named Milneburg after area land speculator Alexander Milne, who profiteered on the great rise in property values brought by the railroad. "A village has grown up around the terminus," a visitor reported, "all the names of the owners, the notices and sign boards being French."[11] Restaurants, oyster houses, and saloons were located there, followed by housing construction, while recreational bathing, fishing, and rowing attracted excursionists from the city.

The Pontchartrain was the first railroad in the South to replace the mule- or horse-drawn trains with faster steam traction.[12] "Over this road you are 'ricketed' to the lake," one passenger remarked in 1851, and the steam trains with their "hard-backed, harder-seated cars" could be not only uncomfortable but also dangerous.[13] The wood-burning engines were a pyrotechnics show along the rails, casting off a red-hot hail of sparks that frequently ignited passengers' clothing and "rendered rail road travelling disagreeable ... particularly to ladies," the Bee declared.[14] The city council intervened, ordering the railroad to "take immediate measures" to address the hazard, and leading the Pontchartrain to offer a $500 prize to the inventor of a spark arrester.[15] A local engineer

took the prize but his arrester was as ineffective as the many baffles, screens, and other smokestack modifications that preceded it. The funnel-shaped stack seen on the M.W. Baldwin "American" locomotive of the 1850s in the photograph was yet another of a thousand patents awarded during the century for devices to reduce the spray of sparks, none truly successful.[16]

During the war, many lakefront resorts closed and rail service was often suspended. In 1866, the Pontchartrain resumed regular runs, but ridership never reached prewar levels.[17] There was "no attraction for local travel to the lake end of the road," the Crescent observed in early 1867, "no inducement for families to spend their holidays there."[18] Wartime neglect left the tracks in disrepair and the ride, although "good for dyspeptic persons," was more uncomfortable than ever.[19] To boost ridership the railroad proposed to develop 30 acres (12 ha.) at the terminus of the rail line as a pleasure garden to attract "those of our citizens who remain in the city during the summer season," and to encourage construction of summer houses.[20] But the extensive landfill required was too costly without the slave labor that had been available before the war.

In 1871, the Pontchartrain Railroad was absorbed into the New Orleans, Mobile, and Texas Railroad, and in 1890 the Louisville and Nashville acquired the line, which carried passengers to the lakefront until 1932.[21] Most of the track was dismantled by 1935.[22] Milneburg was important for the early development of jazz and inspired Jelly Roll Morton's "Milenberg Joys" and other compositions, but residential subdivisions and the Pontchartrain Beach amusement park displaced the village in the first half of the twentieth century.[23] Eventually, the University of New Orleans came to dominate lakefront development with a sprawling campus. The location of Lilienthal's photograph is now part of the Lake Oaks subdivision, which was devastated by the floodwaters of hurricane Katrina in 2005.

One of many portraits of labor in the portfolio, Lilienthal's photograph illustrates the large complement of specialized workers necessary to operate the trains. The uniformed conductor—his crew typically worked without uniforms—stands forward of the assembly, expressing his authority as the man in charge

of the train.[24] The locomotive driver leans out of his cab, and we almost sense his pride in operating the great engine. Until the 1870s each locomotive was usually operated by an assigned crew, and the other workers posed here may have included the locomotive's fireman, brakeman, and brake crew. Trackmen, yardmen, shop workers, and station hands from the lakefront terminal may also have joined the assembly.[25] The soda stand and the oyster saloon at the terminus were undoubtedly attractions for railroad workers and passengers alike.

Lilienthal's low, track-level perspective of the idling locomotive suggests the size and muscle of the iron horse. With their enormous drive wheels and exposed pistons, and their glittering brightwork, the locomotives were a spectacle to all. The complex mechanical workings of the engine and, to a great extent, the work of the crew were highly visible, communicating "a sense of purpose and controlled power" to the observer.[26] The architect Viollet-le-Duc expressed this fascination for the "special physiognomy" of the locomotive, in a lecture published in the 1860s:

> Nothing can better express force under control than these ponderous rolling machines; their motions are gentle or terrible; they advance with terrific impetuosity, or seem to pant impatiently under the restraining hand of the diminutive creature who starts or stops them at will. The locomotive is almost a living being, and its external form is the simple expression of its strength. A locomotive therefore has style.[27]

Early photographers sought to capture the locomotive's gleam and power.[28] Many writers on nineteenth-century photography have seen a parallel between these great machines and photography as the transforming inventions of their age (in New Orleans, they arrived during the same decade, at the beginning and end of the 1830s).[29] The imagery of the locomotive and the camera was linked by such contemporary writers as Emerson, who described the daguerreotype as a "great engine."[30] Both machines played a crucial role in the war, as historian Thomas Fels has pointed out, one facilitating and one recording the conflict, and, similarly, in the opening of the West for the settlement and documentation of the territory.[31] As icons of progress that dominated the popular imagination, railroads would be

expected to be represented in contexts of boosterism, such as Lilienthal's portfolio.[32] Railroad imagery would also be appropriate subject matter in a presentation portfolio commissioned for Napoléon III, a great railroad builder himself.[33] We do not know if Lilienthal was aware of the emperor's interest in railroads when preparing these views, or whether he was motivated by the importance of the railroad in the daily life of the city and its dramatic presence in the landscape.

1. On the history of the Pontchartrain Railroad, see Merl E. Reed, *New Orleans and the Railroads: The Struggle for Commercial Empire, 1830–1860*, Baton Rouge (Louisiana State University Press) 1966, pp. 33–38; G.W.R. Bayley, "History of the Railroads of Louisiana [1873]," *Louisiana Historical Quarterly*, XXX, 1973, pp. 1117–22.
2. *Minute Book of the President and Board of Directors of the Pontchartrain Railroad Company*, December 6, 1830, Pontchartrain Railroad Series, Manuscripts Collection, Tulane University Library.
3. Franz Anton Ritter von Gerstner, *Early American Railroads*, ed. Frederick C. Gamst, Stanford, Calif. (Stanford University Press) 1997, p. 748. Gerstner was writing in 1840.
4. Reed, *op. cit.*, pp. 33–38.
5. *United States Weekly Telegraph*, May 1831.
6. *Niles Weekly Register*, XL, May 21, 1831, p. 196.
7. Robert S. Starobin, *Industrial Slavery in the Old South*, New York (Oxford University Press) 1970, pp. 28, 122–23.
8. *Minute Book of the … Pontchartrain Railroad Company, op. cit.; Norman's New Orleans and Environs*, pp. 192–93; *Times*, August 7, 1864; Hinton, *History and Topography of the United States of North America*, Boston (S. Walker) 1857, II, p. 471. The railroad beacon was replaced in 1834–35 by a federal lighthouse; S. Pleasanton, Fifth Auditor and Acting Commissioner of the Revenue, to Levi Woodbury, Secretary of the Treasury, February 11, 1836, Committee on Commerce, Records of the U.S. Senate, RG46, NARA. The breakwater and about twenty other structures on pilings are documented in a lithographed plan published by Wagner and McGuigan, Philadelphia, *Sketch of the Pontchartrain Harbour & Breakwater, New Orleans*, October 30, 1853. A copy is in the Louisiana Collection, Tulane University Library.
9. Gerstner, *op. cit.*, pp. 749–50; W. Bogart and S.W. Oakey, Pontchartrain Rail Road Company, to James A Breedlove, Collector of Customs, August 1, 1835, NARA.
10. Joseph Holt Ingraham, *The South-West, by a Yankee*, New York (Harper & Brothers) 1835, I, p. 173.
11. William Howard Russell, *My Diary North and South*, ed. Fletcher Pratt, New York (Harper & Brothers) 1954, p. 128.
12. Anthony J. Bianculli, *Trains and Technology: The American Railroad in the Nineteenth Century*, Newark (University of Delaware Press) 2001, I, p. 47.
13. Abraham Oakey Hall, *The Manhattaner in New Orleans; or, Phases of "Crescent City" Life*, New York (J.S. Redfield); New Orleans (J.C. Morgan) 1851, p. 113.
14. "Important Invention to Rail Roads," *Bee*, September 7, 1836; John H. White, *A History of the American Locomotive: Its Development, 1830–1880*, New York (Dover) 1979, p. 114.
15. *A Digest of the Ordinances, Resolutions, By-Laws and Regulations of the Corporation of New-Orleans*, New Orleans (Gaston Brusle) 1836, p. 51; *Bee* (advertisement), May 26, 1836.
16. White, *op. cit.*, pp. 114–16.

17. *Times*, May 5, 1866.
18. "Present Condition of the Pontchartrain Railroad," *Crescent*, January 16, 1867.
19. "A Trip to the Lake," *Picayune*, April 12, 1867.
20. "Proposed Park and Garden at the Lake End," *Crescent*, February 16, 1867.
21. "Smokey Mary Makes Last Run to Milneburg," *Times-Picayune*, March 10, 1932.
22. Bayley, *op. cit*, p. 1120; "Smokey Mary," *op. cit.*; E. Harper Charlton, "Pontchartrain," *Railway and Locomotive Historical Society Bulletin*, CIII, October 1960, p. 78.
23. *Times-Picayune*, November 16, 1938.
24. Robert B. Gordon and Patrick M. Malone, *The Texture of Industry: An Archeological View of the Industrialization of North America*, New York (Oxford University Press) 1994, p. 271.
25. Gordon and Malone, *op. cit.*, p. 270.
26. *Ibid.*
27. Eugène-Emmanuel Viollet-le-Duc, *Lectures on Architecture*, New York (Dover) 1987, I, p. 184, cited by Antoine Picon, "Anxious Landscapes: From Ruin to Rust," *Grey Room*, I, Fall 2000, pp. 77 and 83, n. 29.
28. See John H. White, "The Steam Engine in Prints and Photographs," *Railroad History*, CLII, Spring 1985, pp. 29–41.
29. On the railroad as a subject for photography, see several works by Susan Danly: "Andrew Russell's The Great West Illustrated," in *The Railroad in American Art: Representations of Technological Change*, ed. S. Danly and L. Marx, Cambridge, Mass. (MIT Press) 1988; "Photography, Railroads, and Natural Resources in the Arid West: Photographs by Alexander Gardner and A.J. Russell," in *Perpetual Mirage: Photographic Narratives of the Desert West*, New York (Whitney Museum of American Art; Harry N. Abrams) 1996, pp. 48–55; and "The Landscape Photographs of Alexander Gardner and Andrew Joseph Russell," PhD diss., Brown University, 1983. See also Deborah Bright, "The Machine in the Garden Revisited: American Environmentalism and Photographic Aesthetics," *Art Journal*, LI, no. 2, Summer 1992, pp. 60–71; and Anne M. Lyden, *Railroad Vision: Photography, Travel, and Perception*, Los Angeles (J. Paul Getty Museum) 2003.
30. Alan Trachtenberg, "Likeness as Identity: Reflections on the Daguerreian Mystique," in *The Portrait in Photography*, ed. G. Clarke, London (Reaktion) 1992, pp. 184–85, cited by Karen Burns, "Topographies of Tourism: 'Documentary' Photography and the Stones of Venice," *Assemblage*, XXXII, 1997, p. 25.
31. Thomas Fels, *Destruction and Destiny. The Photographs of A.J. Russell: Directing American Energy in War and Peace, 1862–1869*, Pittsfield, Mass. (Berkshire Museum) 1987, p. 8. On photography and the railroad in the transformation of the West, see Martha A. Sandweiss, *Print the Legend: Photography and the American West*, New Haven, Conn. (Yale University Press) 2002, especially pp. 158–80.
32. "New Orleans as a Railroad Center," *Times*, January 18, 1867.
33. On the photographers producing railroad imagery for Napoléon III, see: on Baldus, Malcolm Daniel, *The Photographs of Édouard Baldus*, New York (The Metropolitan Museum of Art) and Montreal (Canadian Centre for Architecture) 1994, pp. 78–93, and Sylvie Aubenas, ed., *Des photographes pour l'empereur, les albums de Napoléon III*, Paris (Bibliothèque Nationale) 2004, pp. 68–83; on Braun, Deborah Bright, "Souvenirs of Progress: The Second Empire Landscapes," in *Image and Enterprise: The Photographs of Adolphe Braun*, New York (Thames and Hudson) 2000, pp. 98, 106–107; on Collard, Elizabeth Anne McCauley, *Industrial Madness: Commercial Photography in Paris, 1848–1871*, New Haven, Conn. (Yale University Press) 1994, pp. 195–97, 206–15.

45 *overleaf*
Bathing House at Lake Pontchartrain
Maisons de Bains Lac Pontchartrain

At its terminus in Milneburg the Pontchartrain Railroad created the first artificial harbor on Lake Pontchartrain, called Port Pontchartrain, and built a complex of bathhouses on jetties there.[1] The first bathhouse was raised on the hull of a sunken steamer in 1831. Two years later the railroad added bathing facilities for free people of color.[2] Bathhouses were segregated by both race and gender, although mixed bathing was common.[3] The shallow water of the lake made fine bathing, although it was not without apparent hazards, as a Wisconsin soldier observed in 1864:

> The lake is shallow, but the water is clear. The banks are muddy and stumpy, and as compared with our beautiful Northern lakes [it] is very unsightly, but down here where decent water is scarce, Lake Pontchartrain is one of the watery pearls of the South. The bathing is good, as the bottom is sandy and pleasant to the feet; but, as a lady informed me, now and then an alligator makes his appearance and bites off somebody's leg.[4]

Another bather found it "delightful … to plunge into the exhilarating element" of the lake. "It puts your body in a perfect glow, and just prepares you for enjoyment amidst the charming society you will meet on your return to the Hotel."[5]

 Although normally placid, Lake Pontchartrain held perils for navigation. "If lashed by tempestuous weather," the *Picayune* wrote, the Lake's shallow waters could be whipped into "furious waves and surges" in a very short time.[6] Recognizing this danger and the rising commercial importance of schooner traffic at Port Pontchartrain, the federal government established a navigation beacon in 1838, replacing a 50-foot (15-m) light that had been erected in 1832 by the Pontchartrain Railroad.[7] In 1855, the U.S. Lighthouse Service built a new conical light-tower with a cast-iron lantern, visible in Lilienthal's photograph beyond the light-keeper's frame house.[8] Designed by army engineer Danville Leadbetter, the tower stood about 2000 feet (610 m) offshore on a submarine foundation of concrete supported by wood pilings, and was built of brick at a time when iron skeleton lighthouses were increasingly specified for federal construction.[9] Heavy masonry towers had

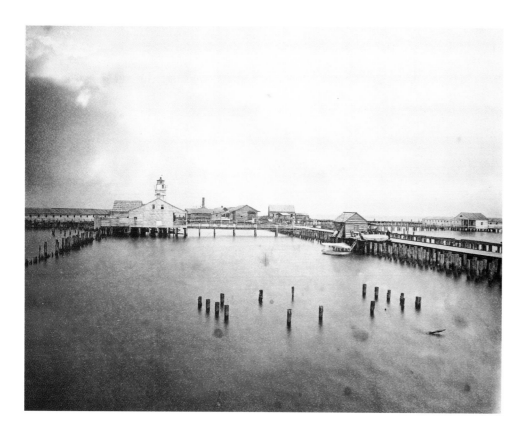

proved unsuitable for the sandbanks of the Gulf Coast, where more than half of the early brick towers eventually settled precariously or collapsed. Screwpile lights with their open framework of iron were found easier to anchor in soft ground.[10]

Lake Pontchartrain and Gulf Coast lighthouses were important military assets, and targets, during the war. The Bayou St. John light, site of the oldest U.S. lighthouse outside the original thirteen colonies, had "withstood the gales and all the changes of the channel and shifting shores of the Lake," army engineer Richard Delafield reported, but it could not withstand the federal troops, who "effected the complete destruction" of the light when occupying the village of Milneburg.[11] The Port Pontchartrain light was blacked out only briefly and its light-keeper served through Confederate control, the only federal keeper to remain at his post in the South. In 1866, the Lighthouse Board ordered all the lights in New Orleans reestablished "in such a manner as to make each equal to its condition before the war."[12] The Port Pontchartrain light survives today, although long dark and no longer offshore. Now located on landfill created in the 1930s, the lighthouse stands among buildings of the University of New Orleans technology center.[13]

1. *Minute Book of the President and Board of Directors of the Pontchartrain Railroad Company*, Pontchartrain Railroad Series, Manuscripts Collection, Tulane University Library, I, pp. 146, 165, 182, 184, 255–58, 278; *Courier*, April 27, 1833; *Advertiser*, April 5, 1832; James P. Baughman, "A Southern Spa: Ante-Bellum Lake Pontchartrain," *Louisiana History*, III, Winter 1962, pp. 5–32.
2. "Notice to Carpenters & Bricklayers," *Courier*, April 26, 1833.
3. *A Digest of the Ordinances, Resolutions, By-Laws and Regulations of the Corporation of New-Orleans*, New Orleans (Gaston Brusle) 1836, p. 11.
4. "West-Views of the South [Editorial Correspondence of the *Daily Wisconsin*]," *Picayune*, March 6, 1864.
5. *Crescent*, July 24, 1850, cited by Baughman, *op. cit.*, p. 16, n. 48.
6. "Pontchartrain Lake Shore," *Picayune*, September 1, 1867; *Times*, April 1, 1867.
7. W. Bogart and S.W. Oakey, Pontchartrain Rail Road, to James A Breedlove, Collector of Customs, August 1, 1835; S. Pleasanton, Fifth Auditor and Acting Commissioner of the Revenue, to Levi Woodbury, Secretary of the Treasury, February 11, 1836, Committee on Commerce, Records of the U.S. Senate, RG46, NARA.
8. *Annual Report of the Secretary of the Treasury*, 34th Cong., 3d sess., H. Ex. Doc. 2, Washington, D.C. (Cornelius Wendell) 1856, p. 612; "Report on the Condition of the Light Houses under the Superintendence of the Collector of the Customs, the District of New Orleans," December 21, 1846, Records of the U.S. Lighthouse Service, Records of the U.S. Coast Guard, RG26, NARA; "Port Pontchartrain Light-Station, La.," Clippings Files, Records of the U.S. Lighthouse Service, *op. cit.*; Eighth Lighthouse District, Department of Commerce, Lighthouse Service, "Description of Port Pontchartrain Light Station," May 16, 1927, Records of the

U.S. Lighthouse Service, *op. cit.*; David L. Cipra, *Lighthouses, Lightships, and the Gulf of Mexico*, Alexandria, Va. (Cypress Communications) 1997, pp. 118–21; J. Candace Clifford and Mary Louise Clifford, *Nineteenth Century Lights*, Alexandria, Va. (Cypress Communications) 2000, p. 113, reproduces a nineteenth-century view of the lighthouse from the direction opposite Lilienthal's vantage point. The keeper's house was severely damaged in a gale in 1869 and demolished sometime later. *Annual Report of the Secretary of the Treasury*, 42d Cong., 3d sess., H. Ex. Doc. 2, Washington, D.C. (Government Printing Office) 1870, p. 373.
9. Leadbetter proposed the new light, the existing tower being "utterly worthless," for Port Pontchartrain in 1853, while he was superintendent of the Eighth District, Gulf Coast, of the Lighthouse Service, a post he held from December 1852 to May 1857; *Report of the Secretary of the Treasury, on the State of the Finances, for the Year Ending June 30, 1854*, 33d Cong., 2d sess., H. Ex. Doc. 3, Washington, D.C. (A.O.P. Nicholson) 1854, p. 262; *Biographical Register*, I, p. 630.
10. A 65-foot (19.8-m) iron lighthouse had been erected in the Mississippi River in 1851, and an iron-screw pile light was ordered for Ship Shoal, Louisiana. Before 1860 iron lighthouses were specified for other sites along the Gulf Coast. "Proposals for Building and Putting up an Iron Lighthouse," *Crescent*, April 5, 1851; Clifford and Clifford, *op. cit.*, p. 23; Sara E. Wermiel, *Army Engineers' Contributions to the Development of Iron Construction in the Nineteenth Century, Essays in Public Works History*, XXI, Kansas City, Mo. (Public Works Historical Society) 2002, pp. 6–27.
11. Richard Delafield, Chairman of the Committee on Engineering, to Admiral Shulrick, Chairman of the Lighthouse Board, December 17, 1867; "Report of the Lighthouses," Letters to the Lighthouse Board, July 24, 1866–February 15, 1869, fol. 73. Records of the Seventh and Eighth Lighthouse Districts, Records of the Lighthouse Board and Bureau, Records of the U.S. Lighthouse Service, *op. cit.* In 1870, an iron-screw pile light was put into operation at the entrance to the Bayou St. John.
12. Letter from O.M. Poe to M.F. Bonzano, September 13, 1866, Records of the Seventh and Eighth Lighthouse Districts, *op. cit.*
13. The Lighthouse Service extinguished the Port Pontchartrain light in 1929. From the 1930s to the 1980s the light stood in the Pontchartrain Beach Amusement Park. Although this area of New Orleans was heavily flooded following hurricane Katrina, the lighthouse was not seriously damaged. The other surviving nineteenth-century lighthouse on the south shore of Lake Pontchartrain, the New Canal Light, was badly damaged by Katrina and by hurricane Rita a short time later; it collapsed in November 2005.

46
Luzenberg Hospital
Hopital du Luzenberg

Luzenberg Hospital was a private infirmary operated by Dr. Charles A. Luzenberg, a native of Verona, whose interest in tropical diseases brought him to New Orleans in 1829.[1] Luzenberg introduced a treatment for fever involving a regimen of bleeding and purging that was even more drastic than typically administered at the time, and his bold surgical methods challenged local medical practice. He had attained the highest medical position in the city—Dean and Chair of Anatomy at the new Medical College of Louisiana—when charges of malpractice were brought against him. Fellow practitioners reproached Luzenberg for "mendacity, ignorance, presumption and ill-breeding," and one challenger alleged that he used cadavers for pistol practice.[2] When Luzenberg's adversaries refused to take up his challenge to a duel, he took out newspaper advertisements admonishing their cowardice.

In 1835, Luzenberg opened an infirmary on a salubrious site in the faubourg Franklin of the Third District, facing Champs Elysees (Elysian Fields) Street and served by the Pontchartrain Railroad. Known as the Franklin Infirmary, the hospital was "a beautiful building," according to *Gibson's Guide*, "with an imposing portico in front, surrounded by very handsome shrubbery, and having attached to it a variety of out buildings."[3] In a luxurious garden Luzenberg assembled a menagerie of "living specimens of natural history," including bears, reptiles, and birds.[4] There, the English traveler James S. Buckingham saw "a fierce-looking wolf, recently caught in the mountains of Tennessee," and in a natural history exhibition on the grounds he found many interesting specimens, "all lifeless and preserved," including a rattlesnake, a "water-turkey," and a rare grasshopper, "glossy jet-black on the exterior, and bright scarlet under the wings."[5]

Reportedly "the best hospital for invalids in the vicinity of the city," Luzenberg's was organized according to a patient's ability to pay.

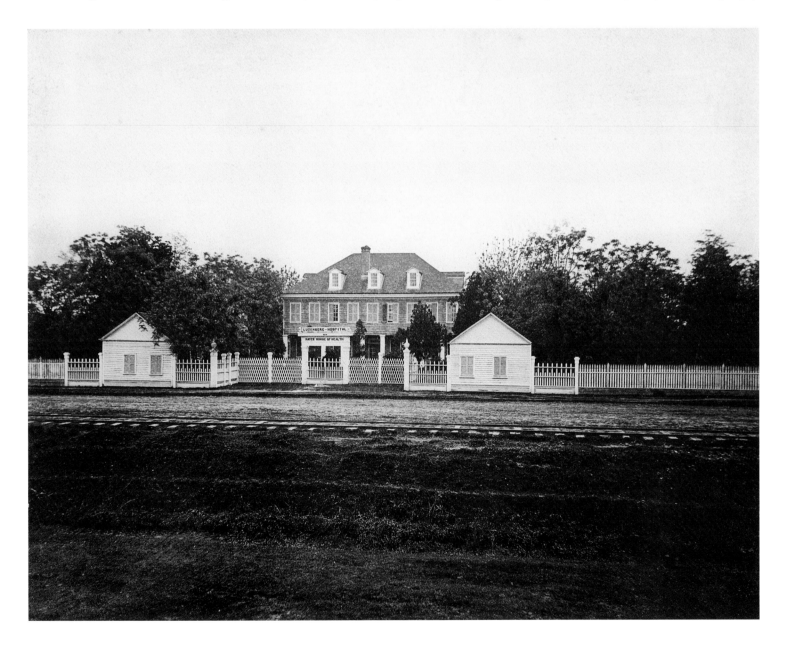

The ground floor was given over to private rooms "for the better order of patients" who could afford $3 a day to have "the utmost care and attention paid to all their wants and wishes."[6] Slaves and free blacks were admitted to a segregated open ward on the third floor. Away from the main wards Luzenberg opened buildings for smallpox patients and "for those afflicted with insanity."[7]

After Luzenberg's death in 1848 the infirmary continued operation under other physicians, including Dr. John Hayes, who purchased the buildings in 1859 and announced that he was fitting them out as Hayes House of Health, following Parisian clinical models (the name survives on the sign in Lilienthal's photograph).[8] Hayes continued to promote the hospital's healthy site, "exposed to the river and lake air," and with "all the advantages of a country retreat."[9]

At the end of the war the hospital was again put up for sale, advertised as "a large two story and attic frame house, having about twenty rooms ... and some five out-houses, etc ... well adapted and located for any Institution, retired Hotel, or Beer Garden."[10] The building was returned to use as a hospital and in the 1870s and 1880s served as the municipal smallpox infirmary. Expanding residential development brought subdivision of the property and demolition of the hospital in the 1890s.[11]

Lilienthal's orderly composition is a skillful arrangement of tonal values. The vacant foreground is a succession of lighter and darker patches of ground, broken by the rail line and shell road, and the light-colored fence and gatehouses contrast with the dark screen of trees flanking the house. Flattening the perspective of the view is the featureless, pale sky, characteristic throughout Lilienthal's work and typical of wet-plate collodion practice. "The sky, that principal point of the landscape painter's selection and care, in the photograph has no existence, but remains a blank," photographer Lake Price explained in a popular manual.[12] The intense luminosity of the sky made recording subtle lights and darks difficult, if the exposure was correct for a building or other prominent feature in the view.[13] The result was often a pale or mottled sky that some photographers opaqued by stopping out, an approach not without its critics. "A spotted or stained sky," one critic later wrote, "is not half so grave a defect as the glaring white,

hard, painted-out sky which cuts the edge of the subject like tin, and destroys the space and atmosphere, while it leaves the mind in doubt whether part of the view is not cut out as well."[14]

For sky features, photographers would sometimes superimpose a separate negative for clouds, sandwiching the negatives during the slow printing-out process, or they would create effects through dodges in the negative using smoke, cotton-wool, or brushed-in color.[15] Printing a desirable cloud image from a separate negative was the only means, according to the pictorialist photographer Henry Peach Robinson, "by which the fullest value can be obtained, and the utmost amount of pictorial effect can be produced." For Robinson, a pioneer of combination printing (for which Lilienthal was also recognized during his career), a conjured sky was only one of many techniques in a photographer's legitimate bag of tricks. "Any dodge, trick and conjuration of any kind is open to the photographer's use," he wrote in the 1860s. "A great deal can be done and very beautiful pictures made, by a mixture of the real and the artificial in a picture."[16]

1. On Luzenberg's infirmary, see *Crescent*, September 6, 1849; *Orleanian*, January 26, 1857; *Bee*, May 17, 1861. On Luzenberg, see Thomas M. Logan, *Memoir of C.A. Luzenberg, M.D.*, New Orleans (J.B. Steel) 1849; Henry W. Sawtelle, "Historical Notes of the Marine-Hospital Service at New Orleans, La.," in *Annual Report of the Supervising Surgeon-General of the Marine-Hospital Service of the United States for the Fiscal Year Ending 1897*, Washington, D.C. (Government Printing Office) 1899, p. 300; Gayle Aiken, "The Medical History of New Orleans," in *Standard History of New Orleans*, ed. Henry Rightor, Chicago (Lewis Publishing Co.) 1900, pp. 215–16; Matas, *History of Medicine*, I, pp. 216–17, 229; Glenn Conrad, ed., *Dictionary of Louisiana Biography*, New Orleans (Louisiana Historical Association) 1988, pp. 527–28; John Salvaggio, *New Orleans' Charity Hospital*, Baton Rouge (Louisiana State University Press) 1992, pp. 31, 65, 70–71.
2. Salvaggio, *op. cit.*, p. 70.
3. *Gibson's Guide*, p. 326, with view on p. 324. See also *Norman's New Orleans and Environs*, p. 124.
4. Logan, *Memoir, op. cit.*, cited by Matas, *History of Medicine*, p. 216.
5. J.S. Buckingham, *The Slave States of America*, London (Fisher, Son & Co.) 1842, I, pp. 384–86.
6. "Luzenberg's Infirmary," *Bee*, September 4, 1835; "Franklin Infirmary," *Bee*, November 21, 1835.
7. "Luzenberg Hospital," *Crescent*, September 6, 1849.
8. "The Luzenberg Hospital, now Dr. Hayes's" (advertisement), *Bee*, March 15, 1860.
9. *Ibid.*
10. "The Luzenberg Hospital" (advertisement), *True Delta*, December 2, 1865.
11. "Sale of Real Estate," *True Delta*, December 10, 1865; J.J. Hayes, *Board of Health Interference: Baneful Interference*

of the Old Board Small Pox Hospital, New Orleans 1876; *Small Pox and Small Pox Hospital of New Orleans*, New Orleans (E.A. Brandao & Co.) 1883.
12. Lake Price, *A Manual of Photographic Manipulation*, London (John Churchill & Sons) 1868 [reprinted New York (Arno Press) 1973], p. 183. Price's pioneering technical manual was written in 1858.
13. On the challenge of skies for wet-plate photographers, see Joel Snyder, *American Frontiers: The Photographs of Timothy O'Sullivan, 1867–1874*, New York (Aperture) 1981, p. 111, and Peter E. Palmquist and Thomas R. Kailbourn, *Pioneer Photographers of the Far West: A Biographical Dictionary 1840–1865*, Stanford, Calif. (Stanford University Press) 2000, p. 47, n. 46.
14. "Photography for Amateurs No. III," *Photographic Times*, 1885.
15. Walter Woodbury, "Cloud Negatives and their Use," *Philadelphia Photographer*, V, 1868, pp. 388–89; "Pellicular Negatives," *Anthony's Photographic Bulletin*, VIII, 1877, pp. 382–83; "The Rationale of Cloudy Skies in Photographs," *Anthony's Photographic Bulletin*, VIII, 1877, pp. 8–9.
16. Henry Peach Robinson, *Pictorial Effect in Photography*, Pawlet, Vt. (Helios) 1971 [reprint of 1869 edn.], p. 56 (Robinson discusses cloud negatives at length, pp. 54–62).

47
Depot of City Rail Road Canal St.
Dépot du Chemin ferré Rue du Canal

Development of a citywide street railroad network was the most important urban infrastructure improvement in New Orleans during the Civil War era. Chartered in 1860, only six months before Louisiana seceded from the Union, the City Railroad began mule-car service in June 1861, "to the great delight of all uptowners."[1] Neither a public service nor entirely a privately held corporation, the railroad was granted a government franchise to operate on public streets, and was vigorously opposed in court and council by New Orleans's omnibus lines, which had run on city streets for three decades.

Opening of the City Railroad paralleled the construction of urban railroads in other American cities. Street railroads were already operating in New York, Philadelphia, Boston, Baltimore, Cincinnati, and Chicago.[2] The phenomenal success of the new public transport networks, as Joel Tarr has written, "altered the basic patterns of work and residence from those of the pedestrian city," shifting populations away from old urban centers.[3] In New Orleans, too, the introduction of rail service throughout the city "greatly changed the mode of every day travel," as the *Picayune* observed in 1864, and propelled commercial and residential development.

"No improvement in modern days has been more beneficial to our city; none, in such a brief time, has been so lucrative,' the *Picayune* wrote. "They have largely increased the value of property in their vicinity [and] ... afford opportunities of pleasant recreation for the toil-worn."[4]

City Railroad cars were powered by a fleet of 650 mules working three hours at a stretch. With steel wheels running on iron rails, the cars were much easier for the mules to move than the old omnibuses, which had to be pulled over mud-rough streets.[5] "The quiet, smooth, easy running of the cars," the *Picayune* observed, was "in great contrast to the noisy, rattling omnibuses" and "more soothing to our ... nerves."[6] The railroad promoted an image of

efficiency and neatness to win over riders. Drivers were forbidden to report to work "slovenly dressed" or even in shirtsleeves, the *Times* reported, so that "a lady can at all times approach them for change without fear of having her modesty shocked."[7]

Riders entered cars with tickets—cards with a vignette of a mule car—or deposited five cents in a fare box.[8] Passengers were warned that they should have the correct fare "or be wearied beyond endurance with the changing of money."[9] Once aboard, they enjoyed the "soft luxurious seats, the easy, regular motion of the cars, and the ease with which a book or newspaper can be read whilst the cars are in motion."[10] The "ladies especially

seemed delighted with the cars," the *Crescent* remarked, "their width permitting persons to pass through without jostling their knees or damaging their crinoline."[11]

But "troubles and evils" were introduced as, according to the *Picayune*, "traveling on city railroads becomes part of our daily life."[12] The "impracticalities" of female fashion left some male riders imposed upon by the "whalebone and wire superfluities" of crinoline and the "vexatious monopoly, by the lady-travelers, of all the seats in the cars:"

No allowance is made in the law for indefinite crinolines, and hence it follows, that a lady cannot claim two, three or four

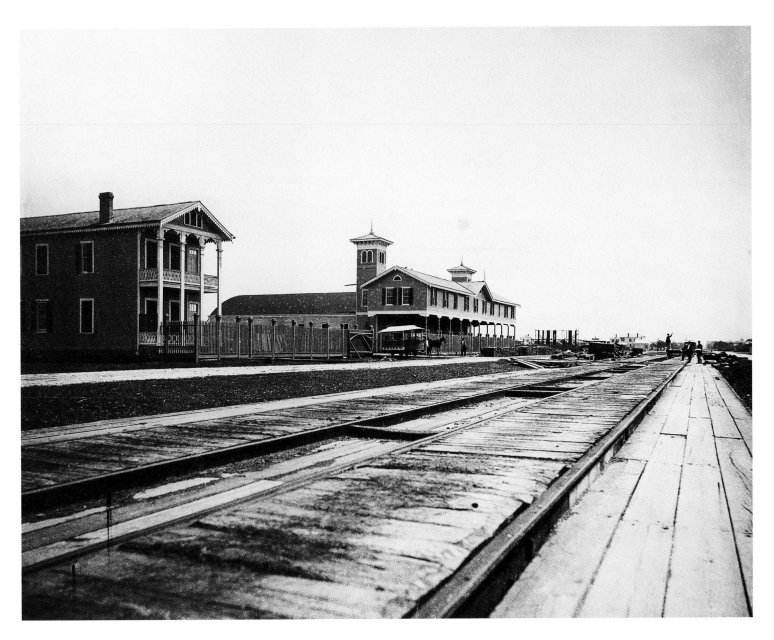

seats as due to her muslin and wire attachments. She must either arrange some contrivance to contract them within the limits prescribed by the law of the road, or she must smilingly and contentedly, and not with such annihilating and crushing expressions of disgust, acquiesce in the necessity and right of some wearied masculine depositing himself upon that portion of her voluminous skirts which exceeds the legal limits.

It was on the new streetcars, during the federal occupation, that residents came unavoidably face to face with the Union soldiers who held the city. For many Orleanians, such encounters were a reminder of the "bitter humiliation" they had endured as residents of the first large Confederate city captured during the war.[13] Author John W. De Forest, who served as a federal officer in occupied New Orleans, portrayed a streetcar confrontation in his popular novel *Miss Ravenel's Conversion* of 1867. His protagonist, Captain Colburne, riding a streetcar, rose to offer his seat as several women entered.

They no more took it than if they knew that I had scalped their relatives. They surveyed me from head to foot with a lofty scorn which made them seem fifty feet high and fifty years old to my terrified optics. They hissed out, "We accept nothing from Yankees," and remained standing.[14]

In the spring of 1867, thirteen rail lines operated 225 cars over 100 miles (160 km) of track, with a capacity of 60,000 passengers a day.[15] Several lines converged on Canal Street at the Clay statue (cat. 20), a bustling hub of brightly painted cars with multicolored lamps.[16] At peak times, cars ran every minute on the Magazine Street line, the busiest in the city. A grid of lines served the markets and business quarters in Carondelet, Baronne, and Dryades streets, and other lines served Prytania Street and the riverfront. The Canal Street and Bayou Road lines ran out to Metairie Ridge, City Park, and the Bayou St. John, and the Levee and Delery Street lines ran downriver, one as far as the U.S. Hospital and Barracks.[17] Successful beyond the expectations of its managers, the City Railroad was able to pay a substantial dividend to stockholders after the war. The recipients of this windfall were mostly widows and children,

a reflection of the devastating human toll of the war years.[18]

The depot Lilienthal photographed on Canal Street between North White and North Dupre streets was one of seven citywide. The complex—trimmed with a paling fence and marked by twin Italianate towers—included stables, car sheds, dormitories for workers, blacksmith shops, and other buildings, designed by company engineer S.L. James in the "most approved wooden style" for railroad buildings.[19]

In Lilienthal's ground-level perspective the rail lines converge on a distant vanishing point in Canal Street (tracks vanishing into depth was a common motif in railroad photography).[20] The low viewpoint places the depot in clear juxtaposition to the rail line it served. Down the line a work crew turns toward the camera, as one worker on a flatbed gestures to the photographer, and in the distance, the frame of a water cistern, under construction, is visible. The slats between the rails were placed there to give good footing for the mules.

Conversion to electric tramcars began in New Orleans in 1889, when the City Railroad opened a coal-fired electric generating plant.[21] As in most cities, diesel buses eventually replaced the electric trams, and by 1950 only six streetcar lines were still in service.[22] The last of these, the Canal Street Cemeteries route, operated until 1964, when the tracks were pulled up. Streetcar service on Canal was reintroduced, at enormous cost, in 2004, linking the Vieux Carré with the Metairie Ridge, and with the St. Charles Avenue streetcar, the surviving line of the New Orleans and Carrollton Railroad (cat. 98). Part of the Canal Street depot complex seen in Lilienthal's photograph, a car barn of 1861, survived fires in 1887 and 1893, a hurricane in 1915, and conversion to bus service in 1960, only to be demolished for a new maintenance facility in the early 1990s. Preservationists succeeded in disassembling and saving part of the structure, a fine example of nineteenth-century timber-frame and iron-truss construction.[23]

1. "Inauguration of the Camp Street Cars," *Picayune*, June 8, 1861; *Crescent*, June 1, 1861. For observations on the arrival of the streetcars, see John Blandin, "English Composition Copy-Book ... Begun on the 13th of March 1861," p. 50 (mss.), Archdiocese of New Orleans. On the history of the City Railroad, see E. Harper Charlton, *Street Railways of New Orleans: Interurbans Special No. 17*, Los Angeles (I.L. Swett) 1955; and Louis C. Hennick and E. Harper Charlton, *The*

Streetcars of New Orleans, New Orleans (A.F. Laborde and Son) 1965, pp. 159–72.
2. George Rogers Taylor, "The Beginnings of Mass Transportation in Urban America," *Smithsonian Journal of History*, I, nos. 2–3, Summer–Autumn 1966, pp. 39–50.
3. Joel A. Tarr, "Infrastructure and City Building in the Nineteenth and Twentieth Centuries," in *City at the Point: Essays on the Social History of Pittsburgh*, ed. Samuel P. Hays, Pittsburgh (University of Pittsburgh Press) 1989, p. 227.
4. Quotation: "City Travel," *Picayune*, August 18, 1864; "Supreme Court: The Street Railroad Question," *Picayune*, December 14, 1859; "The Omnibus Interest," *Picayune*, January 8, 1860; "Progress in New Orleans," *Times*, October 7, 1866.
5. "The New Orleans City Railroad," *Crescent*, December 20, 1866.
6. "Inauguration of the Camp Street Cars," *op. cit.*; *Picayune*, June 10, 1861.
7. *Times*, October 3, 1866.
8. Lawrence Van Alstyne, *Diary of an Enlisted Man*, New Haven, Conn. (Tuttle, Morehouse & Taylor) 1910, p. 184.
9. "City Railroad Statistics," *Crescent*, April 14, 1867; John Chandler Gregg, *Life in the Army, in the Departments of Virginia, and the Gulf, Including Observations in New Orleans*, Philadelphia (Perkinpine & Higgins) 1866, p. 132.
10. *Ibid.*
11. "City Railroad Statistics," *op. cit.*
12. "Car Rights," *Picayune*, June 1, 1866, and for the quotations that follow.
13. Benjamin F. Butler, *Private and Official Correspondence of Gen. Benjamin F. Butler During the Period of the Civil War*, Norwood, Mass. (Plimpton Press) 1917, I, p. 23.
14. John William De Forest, *Miss Ravenel's Conversion, from Secession to Loyalty*, ed. Gordon S. Haight, New York (Rinehart & Co.) 1955, p. 139.
15. "City Railroad Statistics," *op. cit.*
16. Griswold's *Guide*, pp. 23–24.
17. "City Railroads," *Crescent*, October 3, 1866; "City Railroad Statistics," *op. cit.*; *Seventh Annual Report of the President and Stockholders of the New Orleans City Railroad Company, December 1867*, New Orleans (Price-Current Office) 1867, pp. 1–2.
18. *Crescent*, December 20, 1866.
19. *Crescent*, March 29, 1861.
20. Anne M. Lyden, *Railroad Vision: Photography, Travel, and Perception*, Los Angeles (J. Paul Getty Museum) 2003, p. 85.
21. "New Orleans Railway and Light Company," in William H. Deacon, *Martin Behrman Administration Biography 1904–1916*, New Orleans (John J. Weihing) 1916, pp. 61–62.
22. Charlton, *op. cit.*, p. 27.
23. "Oldest U.S. Carbarn," *Society for Industrial Archeology Newsletter*, xx, no. 3, Fall 1991, p. 1; Edwin D. Weber, Jr., "The Canal Street Car Barn," *Preservation in Print*, XVIII, no. 6, August 1991, p. 15.

Marine Hospital
Hospital de la Marine

The United States Marine Hospital at Common (Tulane Avenue) and Broad streets, begun in 1857, was a pioneering federal project and structurally one of the most advanced buildings of its time. Designed by architect Ammi B. Young almost entirely of iron, at a time when no building with an iron frame, roof, walls, and floors is known to have been built, the hospital was praised by the *New-York Daily Times* as a model structure that would "initiate the use of iron in the construction of the public architecture of the country."[1] The project engineer, Benjamin Severson of Washington claimed the New Orleans Iron Building, as it was called, would be "probably the only completely fireproof specimen of architecture, so far as the external walls and floors are concerned, ever erected on the continent."[2]

The building's modernity was, however, its failure, as experimental construction methods proved unsuccessful. Ultimately, costly imported iron, failed fabrication attempts, and construction suspensions made it the most expensive federal building project of its kind. Unfinished at the beginning of the war, the building was never completed or occupied as a Marine Hospital, and was ultimately demolished. The ambitions of the project were quickly forgotten, and the building is today unknown to the history of architecture and building technology.[3]

The Marine Hospital Service was the oldest federal institution in New Orleans, established in 1802 to provide medical care for American seamen in what was then a foreign port.[4] In 1837, after several decades without facilities of its own, the Service began construction of a hospital according to the plans of Antonio Mondelli and John Reynolds, based on a design by Robert Mills, on the west bank of the river.[5] It was not completed until 1848. Inhospitably located near slaughterhouses and shipyards on a flood-prone site, the building was called "utterly unfit for any purpose" and, the *True Delta* wrote, furnished "the strongest proof with which public money can be squandered."[6] The hospital was abandoned in 1856 and destroyed by fire five years later.[7]

In August 1854, Congress authorized $248,000 for construction of a new marine hospital at New Orleans, one of sixteen new public buildings projects across the country.[8] Overseeing the construction campaign were the Secretary of the Treasury and, under him, the newly created Office of Construction, which centralized federal projects and ended an ineffective practice of supervision by local commissioners.[9] Appointed to this office were architect Ammi B. Young and, to head the department, army engineer Alexander H. Bowman. In the 1850s this office would supervise an enormous volume of federal construction—eighty-eight public buildings in all—and Young would design many of them, including the new hospital for New Orleans.[10]

Bowman directed local superintendents, who contracted for materials, hired laborers, and supervised construction.[11] While often standardizing building designs to minimize costs, Bowman and Young introduced innovative building technologies, particularly in iron construction, and made the Office of Construction, as one historian has written, "a place for encouraging innovation and disseminating information about new technologies to the public."[12] By proving the versatility and practicality of iron as a building material, and promoting fireproof construction, Young and Bowman supported the fledgling industry of American ironmakers with beneficial federal contracts.[13] "By these contracts was inaugurated the system of discrimination in favor of the purchase of iron as a building material in the construction of public edifices," while sustaining "the iron interest of this country, an interest in urgent need of a fostering hand," the contractor for the Marine Hospital, Emanuel Harmon, later wrote.[14] For the Office of Construction, the "advantages of using iron for all purposes to which it is applicable in our public buildings" were "fully demonstrated," Bowman claimed. "Every new trial suggests new uses, and the opportunity thus given to stimulate the production of this great national staple ... will not be neglected."[15] The New Orleans project was one of those trials and, although ultimately a failure, probably the Office of Construction's most important experiment in non-traditional building practice.

After surveying at least five proposed locations for the new hospital, in August 1855 Bowman selected a 5-acre (2-ha) site, bordering on Common Street and the New Basin Canal, in an unbuilt, swampy precinct known as the "draining district" for the steam-powered draining machines located there. The site was at least 2 miles (3.2 km) from the river landings where patients would disembark, but it was in close proximity to the canal for easy delivery of construction supplies, and Common Street, one of the best shell-paved thoroughfares in the city, led directly to Charity Hospital (cat. 69) where the Marine Hospital Service was admitting patients in leased beds.

Young's plan for the new Marine Hospital, developed in the fall of 1855 and published in April 1856, described an H-shaped structure of 47,000 square feet (4370 sq. m), with a domed, three-story center building and symmetrical two-story, semi-detached wings, also domed.[16] The two wings were connected to the main building by open corridors and the entire structure was encircled by columned galleries on two floors. A roof piazza was accessible from the center building. The first floor housed physicians' quarters and offices, a pharmacy and dispensary, staff kitchens and dining rooms, and wards to the rear. The second floor housed eight large wards, all with at least two exterior walls. Two passenger elevators to transport bed-bound patients between floors—an innovation in the design of the Marine Hospital and one of the earliest passenger elevators installed in a federal building—flanked the center wards.[17] Under the domes on the third floor were dissecting rooms, connected to the wards by narrow corridors.

It was the extensive encircling gallery that was the distinguishing feature of Young's plan. His many federal buildings of the 1850s were typically compact, rusticated, Italianate palazzo forms built of granite, maximizing the use of dense urban sites.[18] In his hospital designs the masonry block was relieved by open ironwork galleries off the center wards, taking into account the prevailing belief that well-ventilated wards kept disease-causing "miasmas" at bay. In several projects for the South, Young developed open galleries encircling a core structure, but it was at New Orleans that the concept was most fully developed.[19] Use of encircling galleries was current in hospital and barracks designs for tropical sites, especially in the work of British military engineers, as published in building and engineering periodicals.[20]

All-iron construction had not previously been adopted for a federal project, and specifying an iron building, industry boosters argued in 1854, would be "of immense benefit

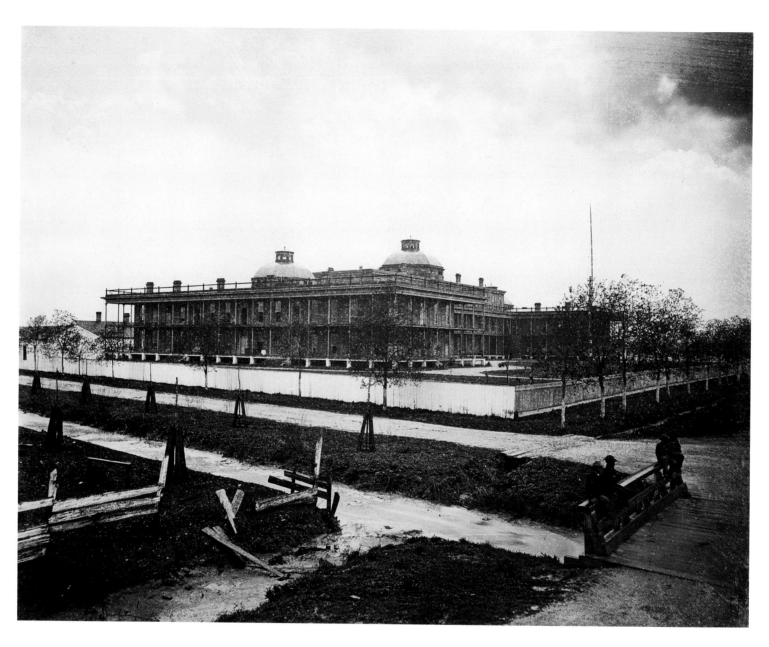

to the iron interests of the country."[21] "Inasmuch as the Treasury Department has been urgently solicited to construct the external walls of this building, and its appendages of iron," Bowman wrote, "the Department [is] favorably disposed to test ... the feasibility and the comparative economy of such construction, as compared with brick and stonework."[22] For the Office of Construction building the hospital in iron also appeared to quiet misgivings about New Orleans's swampy ground conditions, after the subsidence problems that plagued the Custom House project (cat. 19)—conditions that encouraged development of innovative construction methods to lighten foundation loads. A trade

organization, the Iron Manufacturers of New England, lobbied Bowman to build the New Orleans hospital in iron, arguing that the "superior lightness" of iron construction would be suitable for the "badness of the ground" there.[23] It was a view Bowman endorsed: an "iron structure by its lightness is better suited to the character of the foundation, which like all soil in the vicinity of New Orleans is compressible," he wrote in 1856.[24]

While promoting iron construction for the New Orleans project, Bowman was uncertain of the costs of building in iron and concerned that those costs might exceed the Congressional allocation. In an unusual move, the department allowed contractors to bid simultaneously for a

brick building according to the same design. Although bids came in too high for both iron and brick construction, the department successfully sought an increased allocation, and the final bids, in December 1856, were close enough to justify the experiment in iron.[25] Adding substance to the proposal to build in iron was the source of the low bid, the Washington partnership of Harmon and Severson (who outbid prominent iron founders Daniel Badger, Marshall Lefferts, and John Armstrong). Severson was one of the most innovative structural engineers of the time, and among the most experienced in iron construction, and he supplemented his proposal with detailed specifications on the assembly of

the iron plates and girders.[26] Although Harmon later assigned the construction contract to the Trenton Locomotive and Machine Manufacturing Company of New Jersey, which agreed to build the hospital according to the Harmon and Severson proposal, Severson was retained to provide engineering drawings. The foundry of Cooper & Hewitt in Trenton was contracted to supply the iron.[27] The contract construction cost was $360,000.

In the bid specifications issued in 1856, the Office of Construction ordered that the hospital's "main or exterior walls will be constructed of an iron veneering, upon iron frames, filled with some non-conducting substance, thus making the structure fire-proof."[28] What was called a "proper inside filling" was a substance not yet specified. Marshall Lefferts, in his bid for construction, proposed a backing of unburnt clay that was, the Treasury Department calculated, far less costly than a backing of brick.[29] Similarly, Severson proposed that fireproofing and insulating the building could be achieved

> by constructing the external walls of iron columns and veneering insulated ... with a filling in of common earth or pise from 9 to 12 inches deep By this simple arrangement the inconveniences and dangers resulting from the great conducting and expansive qualities of iron are completely obviated.

The *pisé* would be "non conducting, incombustible and cheap," and structurally superior, Severson reasoned, to brick or concrete, which could expand in the intense heat of summer and collapse the iron walls. But the *pisé*, "contracting at all the points of contact with the iron," would leave sufficient room for the expansion of the metal "without endangering the structure." The combination of iron and *pisé* construction, Severson argued, would be "compatible with the soil and climate of New Orleans."[30] Taking up these ideas, Bowman called for the space between the exterior iron plates and interior plastering to be filled with unfired clay blocks, made by ramming earth into formwork with a steam-powered pneumatic tamper.

Rammed-earth construction was centuries-old: Pliny described its use in Spain and it had been widespread in the ancient Near East. The method was common in the Rhône River valley in France, where it was documented and

published in the late eighteenth century by agriculturalist and architect François Cointereaux.[31] Translated into English, Cointereaux's discoveries were publicized in the *American Farmer*, the *Prairie Farmer*, and in builders' manuals including *The Economical Builder*, published in Washington in 1839.[32] But *pisé* construction was not widely understood in America and had been applied almost exclusively to modest agricultural structures; it had not been put to use in a major federal building project or a large urban structure. In 1850, Robert Mills proposed *pisé* construction for the U.S. Custom House in San Francisco, but the Treasury Department was not ready to adopt it.[33] When *pisé* construction was attempted at New Orleans, this ancient technology was used in conjunction with the latest advances in all-iron construction, also previously untested in a major public building project.

The Treasury Department's ambitions at New Orleans were applauded across the country. The *New-York Daily Times* hailed the building as a "model fire- and heat-proof structure" and "the most important measure, for the interest of iron manufacturers, ever adopted by the National Government."[34] *Scientific American* published Severson's design intent and noted that the Marine Hospital proposal finally addressed the problem of all-iron construction for habitable buildings:

> The great fault with iron, and that which has prevented the adoption of this material still more rapidly for building purposes, is its too ready transmission of heat, making iron buildings insufferably hot on summer days and intensely cold ... in winter The new Marine Hospital at New Orleans ... [will be] constructed on a plan which bids fair to obviate this difficulty.[35]

The New Orleans project was an early example of the "American genius" to build in iron, the *United States Magazine* wrote, attributable to the foresight of Bowman and the Treasury Department: "They chose iron, and ... a new invention, which is being successfully applied in the construction of the Marine Hospital This invention is known as the 'Pise Iron Building.'"[36] The New Orleans method of iron construction could "be applied with extreme economy in the whole system of domestic architecture," the *Magazine* suggested, while heralding "the age ... when great cities will

spring out of iron mines, and flash forth every classic form of architecture in enduring iron!" It was an optimistic projection, for there was resistance to iron construction among architects and builders, especially to the use of iron for hospitals and homes. But while the debate over the suitability of iron for building raged on in professional circles, "ferromania" was taking hold in cities across the country, and public attitudes toward iron construction were changing.[37]

Further objections to iron were raised by the New Orleans delegation in Congress, who argued that the use of iron for the Marine Hospital would be unsuitable to the local climate and "unhealthy" for occupants of the building. Harmon called the charges "fanciful." Iron building had already been successfully tested in New Orleans, Harmon claimed (although nothing approaching the scale of the Marine Hospital had been attempted anywhere in the country). The building would be "hailed as a new era in the architecture of the South," Harmon argued confidently putting aside all objections to his proposed building and assuring Treasury Secretary James Guthrie that his legacy would be well served:

> The iron building in the abstract is not an experiment. The fire-proof and heat-proof iron structure proposed to be erected at New Orleans is an experiment, without, however, the possibility of a failure. And it will preserve among men a more enduring memorial of your administration than would monuments of marble or of brass.[38]

Site work for the hospital began in the spring of 1856, and late in the year superintendent Captain Gustavus Smith and his successor Captain Johnson Duncan completed excavation of the foundation trenches.[39] Work on the pilings began in May 1857 using two steam pile drivers. "The system pursued is, we believe, entirely new, or at least one which has never before been adopted in this city," the *Picayune* wrote.

> Twelve inch square pilings are sunk to a depth of nearly thirty feet, in a trench four feet deep, and are then sawed off three feet six inches below the surface of the ground. The piling is then capped by twelve inch square timbers, firmly secured by oak pins, the whole being then covered by a two inch planking.[40]

Contractors devised a carriage-mounted,

steam-driven circular saw and hoist to trim the heavy foundation timbers and position them in the trench.[41] In the winter and early spring of 1857, an average of sixty laborers were laying 800 piles per month, while constantly pumping out the trench as it flooded with 1 foot (0.3 m) or more of groundwater.[42] To complete the foundation, the trenches were filled with earth and concrete was poured over the entire assembly.[43]

In April 1858, the first-story beams and girders were set in place and work began on the exterior iron veneering. Then trouble arose with the clay backing.[44] Superintendent Duncan could find no satisfactory clay beds in the vicinity of New Orleans, and the steam tamper built in the North was lost at sea.[45] But the real difficulty came in applying the rammed earth to the iron frame. Contractors laid no damp course and the *pisé*, which wicked moisture from the marshy ground, weakened and destabilized, causing the iron posts to fracture or break loose from their fastenings.[46] "There are many and great objections to the entire system of this clay filling between iron columns," Duncan reported to Washington. "I consider it a hazardous experiment."[47]

As Duncan carried out the *pisé* trials, he had also to contend with chronic delivery delays and shortages of iron and brick. The building's "peculiar construction," Bowman wrote, "requires almost the entire of its material to be transported from the north, involving more or less of delay from shipwreck and other uncontrollable causes."[48] Cooper & Hewitt, the iron contractor, was a pioneer American foundry and one of the few in the country capable of rolling the 7-inch (18-cm) beams for the project. But the company, reliant on federal contracts, was on shaky financial ground in the late 1850s. During one of Cooper & Hewitt's many disputes with debtors, shipments of iron for the Marine Hospital sat on the Levee for several weeks with claims against it. As a result the company's credit was ruined in New Orleans and work on the building was delayed.[49]

In June 1859, Duncan was dismissed for refusing patronage appointments maneuvered by Louisiana senators John Slidell and Judah Benjamin (at a time when political patronage was the primary criterion for hiring and promotion). "I could not be made a tool of for party purposes," Duncan informed superiors in Washington.[50] His replacement was P.G.T. Beauregard, who had served as the federal

superintendent at the Custom House since 1853. In early 1860, with the iron of the third story set in place, and the external walls veneered, Beauregard stopped application of the rammed earth. "Finished portions of the walls of the 1st story have tumbled down, and parts of the remainder threaten to do likewise," Beauregard reported in February, attributing the failure to the *pisé* backing.[51] Bowman, still confident that the method he had specified was sound, approved Beauregard's appeals to remove the *pisé* and substitute a backing of brick—but only after several more months of trials.[52] The construction failures and suspensions brought pressures at the job site to the surface—Beauregard complained of the "grasping and illiberal spirit of the Contractors" —and on one occasion a contractor's foreman pulled a gun on Beauregard's assistant. "They have given me more trouble than any set of contractors I have ever had to deal with and I should consider it a special favor to be relieved from the charge of that building," Beauregard wrote to Treasury Secretary Howell Cobb.[53] In the summer of 1860, expenditure for the *pisé* removal and other work left $2.55 in Beauregard's construction budget, and with the building barely roofed over, staircases incomplete, and the interior unfinished, work stopped.

Construction costs now exceeded $520,000, Congressional appropriations were exhausted, and no new funds were approved.[54] The project had failed to win the local constituency required for renewed Congressional support—the Treasury's poor choice of site and the almost exclusive use of northern contractors and suppliers left Orleanians largely indifferent to the project— and the building failures and fabrication trials the Treasury Secretaries reported to Congress gave little evidence to legislators that their appropriation was well spent.[55] The Treasury Department officially attributed the cost overruns to "the nature of the work being entirely novel." The building was "experimental," the department reported, "and, upon trial, the original design was found impracticable in many of its details."[56] Congress would continue to pay out to fund the experiments at New Orleans, as more than one hundred claims brought by the contractors for losses exceeding $100,000 would not be settled for another twenty years.[57] In its inquiries the Treasury Department held

everyone to task. Architect Thomas K. Wharton, clerk of the works under Beauregard, was troubled by "the 'jealous' eye of the Department" during investigations into the project accounts in the spring of 1860. "All the valuable time of our Office is consumed in turning over the charred bones, withered skeletons, and refuse ashes of the defunct 'Duncan administration,'" he wrote.[58]

After the outbreak of war in April 1861 (Beauregard was now commanding Confederate armies at the eastern front), the Confederate military appropriated the building for use as a hospital and armory.[59] "The sick were in one wing of the house," the *Picayune* reported, "and in the main building men were for weeks making cartridges for cannon and small arms, and altering and repairing muskets."[60] Following federal occupation of New Orleans the hospital, unfinished, was fitted out with wards to admit the sick and wounded of both armies, including hundreds of Union casualties from the battle of Port Hudson in May 1863.[61]

At the end of the war the unfinished building was turned over to the Freedmen's Bureau, a branch of the U.S. military established to oversee the welfare and education of more than 4 million newly freed slaves.[62] While occupied by the bureau as a hospital, the building was reported to have "a very damp, unhealthy and shabby appearance"—it was rusting badly, with large areas of the roof open to the outside, galleries breaking away, foundations out of level and the grounds flooded.[63] After the Freedmen's Bureau hospital vacated in 1869, Surgeon-General John Woodworth recommended sale of the building. "The U.S. Marine Hospital at New Orleans is a marvel of stupidity and extravagance," he proclaimed:

> ... the building has never been occupied as a marine hospital and it is to be hoped that it never will be. The site for this hospital was selected in a swamp, and ... during the seventeen years that have elapsed since the purchase of the site, it is still an improper and unhealthful locality for a hospital.[64]

Architect Henry Howard, hired to do an audit of the building in 1869, reported that "the great portion of the backing of iron" was unfinished and "the whole interior left in the rough without any finish whatever." Windows and doors were missing, there was no workable

plumbing, the privies were deteriorated, and "no provision [had been] made for lighting the building with gas or heating it." Howard, one of the most successful architects in the city, offered to complete the building for $175,000—an offer the Treasury Department rejected.[65]

The city took over the hospital in the fall of 1872, sending committed psychiatric patients to be confined there (for years they had been kept in cells at Parish Prison [cat. 25]). In the unfinished hospital, and the swampy environment, most of the patients contracted malaria.[66] While the federal government attempted to sell the building, the insane remained. In 1879, a total of 160 patients were confined to the wards, some in "frightful" conditions; a surgeon found one ward "worse than a foul menagerie of animals." Homeless families occupied other rooms and cultivated vegetable gardens on the grounds.[67]

In 1880, twenty years after work stopped at the Marine Hospital, Congress finally abandoned the project and approved funds for construction of a "properly-located" new facility at New Orleans.[68] A 22-acre (8.9-ha.) site was chosen at the head of Clay Street and the river, where a three-story masonry hospital was constructed in 1883–85.[69] In another four years that hospital, too, was reported to be deteriorating and "unsatisfactory in every way."[70] Meanwhile the old Marine Hospital was ordered to be dismantled, and plans were made to reassemble it at Pensacola, Florida, where customs offices were needed. The ironwork was "susceptible of being easily taken down, numbered and bolted, and taken aboard a vessel" to its new site, the government reported, but the work was not carried out.[71] The building was put up for auction in 1881 but the high bid came in so low—$19,000—that the Treasury Department cancelled the sale.[72] It was finally purchased by the city in 1896.[73] "After an expenditure of over half a million dollars," a local historian wrote at the time of the sale, "the authorities discovered what the townspeople had known from the beginning, [that] ... the swampy nature of the ground made the location entirely unsuitable for a hospital of any kind."[74] A year later the building was torn down. On the site the city erected a prison and courthouse, which was itself demolished for the Criminal District Courts, designed by Diboll and Owen and completed in 1929.

Lilienthal's view establishes the context of the hospital, occupied by the Freedmen's

Bureau, on reclaimed cypress swamp at the rear of the city. In the foreground is the Broad Street sanitary canal, which drained into the nearby New Basin.[75] The whitewashed plank-and-picket fence that enclosed the newly landscaped grounds replaced a costly Wood & Perot iron fence erected in 1859, which had been allowed to deteriorate—the iron fence alone had cost as much as the building's sale price in 1896. The small iron obelisk at the fence corner was placed there in 1856 to mark the perimeter of federal property.[76]

1. "Iron Buildings for Government Purposes," *New-York Daily Times*, December 8, 1856. By 1856, the fashion for iron construction was well established in America. Apart from columns (sometimes weight-bearing), ties, and decorative elements, iron was not commonly used in American building until the 1840s. Iron fronts were in use as early as 1825 but were not in great demand until the early 1850s, when the federal government also specified iron for structural use in new buildings. Although James Bogardus in 1849–50 published and patented an all-iron factory in New York, with iron frame, walls, floors, and roof—which he claimed was the "first complete cast-iron edifice ever erected in America, or in the world"—it has not been proven to have been built as designed, and appears not to have influenced the design of other all-iron buildings (it was disassembled in 1859). No other proposals for an all-iron building are known until the New Orleans Marine Hospital. Daniel Badger's all-iron warehouse at Watervliet (NY) Arsenal, planned from late 1857, built in 1859 (and still standing), was probably the first successful all-iron building in America. Lois Craig, *The Federal Presence: Architecture, Politics, and Symbols in U.S. Government Buildings*, Cambridge, Mass. (MIT Press) 1978, pp. 91–92, 99; Carol Gayle and Margot Gayle, "The Emergence of Cast-Iron Architecture in the United States: Defining the Role of James Bogardus," *APT Bulletin*, XXIX, no. 2, 1998, pp. 5–12; ead., *Cast-Iron Architecture in America: The Significance of James Bogardus*, New York (W.W. Norton & Co.) 1998, pp. 34–37, 84–94, 244; Diana S. Waite, *Ornamental Ironwork: Two Centuries of Craftsmanship in Albany and Troy*, New York, Albany, NY (Mount Ida Press) 1990, pp. 67–70.
2. Benjamin Severson, "Iron Marine Hospital at New Orleans" (n.d.), accompanying specifications of E. Harmon & Co., November 23, 1856, General Correspondence, Letters Received, New Orleans Marine Hospital, Records of the Public Buildings Service, RG121, NARA (in further citations this correspondence file in this record group is referred to only as RG121). Severson's manuscript proposal was excerpted in *Scientific American*, which identified the author only as "one of our Washington correspondents" (Severson contributed many signed articles to the magazine from 1849–60); "Iron and Earth Walls for Buildings," *Scientific American*, XII, no. 27, March 14, 1857, p. 214. On Severson, see n. 26 below.
3. The New Orleans project has been overlooked even in the extensive literature on nineteenth-century iron construction. It will be treated in further detail in my forthcoming study "Federal Architecture for the Port of New Orleans, 1803–1885."
4. From 1798 Congress taxed merchant seamen to provide funding for marine hospitals at major ports, but few were

built before 1820; the Marine Hospital Service contracted with local hospitals to care for sailors (in New Orleans Charity and Hotel Dieu); Thomas O. Edwards and George B. Loring, "Report upon the Subject of Marine Hospitals," *Report of the Secretary of the Treasury*, 31st Cong., 2d sess., S. Ex. Doc. 14, 1849, Washington, D.C. (Government Printing Office) 1850; Henry W. Sawtelle, "History of the Marine Hospital at New Orleans," *New Orleans Medical and Surgical Journal*, LIX, no. 8, February 1897, pp. 437–42; Matas, *History of Medicine*, I, pp. 449–56, II, pp. 214–20; William E. Rooney, "The New Orleans Marine Hospital, 1802–1861," MA diss., Tulane University, 1950; John Jensen, "Before the Surgeon-General: Marine Hospitals in Mid-19th-Century America," *Public Health Reports*, CXII, no. 6, November/December 1997, pp. 525–28; John L. Parascandola, "Public Health Service," in *Historical Guide to the U.S. Government*, ed. G.T. Kurian, New York (Oxford University Press) 1998, pp. 487–93.
5. Contract and specifications for "Marine Hospital Opposite New Orleans, Louisiana," May 15, 1838, RG121. See "The United States Marine Hospital," *Ballou's Pictorial Drawing-Room Companion*, XV, no. 4, July 24, 1858, p. 49; "United States Marine Hospital," *Ballou's Monthly Magazine*, XXV, no. 4, April 1867, pp. 260–62. The building was photographed about 1863 by William McPherson and Oliver ("Dunham Marshall Photo Album," Mss. 3241, Hill Library, Louisiana State University, Baton Rouge), and illustrated in a woodcut in *Norman's New Orleans and Environs*, p. 125, and also in a contemporary lithographed bird's-eye view, reproduced in Betsy Swanson, *Historic Jefferson Parish from Shore to Shore*, Gretna, La. (Pelican) 1972, p. 112; and in "The United States Marine Hospital," *op. cit.* Years after the hospital was built Mills applied for "professional compensation" from the government alleging the theft of his design by Mondelli and Reynolds; Mills to Treasury Department, October 20, 1852, RG121. In his journal (now in the Library of Congress) Mills recorded the submittals of competing architects and sketched the plans. See Rhodri Windsor-Liscombe, *Altogether American: Robert Mills, Architect and Engineer, 1781–1855*, Oxford (Oxford University Press) 1994, pp. 201–204, and John M. Bryan, *Robert Mills: America's First Architect*, New York (Princeton Architectural Press) 2001, pp. 230–32. Dakin, Bell, and Dakin also submitted a design proposal for the hospital in 1837; see Arthur Scully, Jr., *James Dakin, Architect: His Career in New York and the South*, Baton Rouge (Louisiana State University Press) 1973, pp. 62–63.
6. Ross Browne to Treasury Secretary James Guthrie, May 18, 1854, RG121; *True Delta*, May 25, 1854. An 1849 Congressional report by Drs. George Loring and T.O. Edwards described the first marine hospital as one of the worst in the service, "Report upon the Subject of Marine Hospitals," *Report of the Secretary of the Treasury*, 1849, *op. cit.* Also on the failures of the building, see *Crescent*, October 29, 1850, and John M. Woodworth, *Annual Report of the Supervising Surgeon, of the Marine-Hospital Service of the United States*, Washington, D.C. (Government Printing Office) 1873, p. 10.
7. "New Marine Hospital," *True Delta*, May 25, 1854. The building was destroyed by an explosion and fire in December 1861 while in use as a powder mill, and in 1866 the river inundated the ruins.
8. *Report of the Secretary of the Treasury, on the State of the Finances, for the Year Ending June 30, 1855*, 34th Cong., 1st sess., H. Ex. Doc. 10, Washington, D.C. (C. Wendell) 1856, p. 229.
9. Ellis L. Armstrong, ed., *History of Public Works in the United States 1776–1976*, Chicago (American Public Works

Association) 1976, pp. 460–61.

10. On Bowman, *Biographical Register*, I, pp. 341–42. Young served as Supervising Architect for ten years, from 1852 to 1862; he designed more than fifteen marine hospitals during this period. On Young, see Lawrence Wodehouse, "Ammi Burnham Young, 1798–1874," *Journal of the Society of Architectural Historians*, XXV, December 1966, pp. 268–80; *id.*, "Architectural Projects in the Greek Revival Style by Ammi Burnham Young," *Old-Time New England*, LX, no. 3, January–March 1970, pp. 73–85; Osmund Overby, "Ammi B. Young," in *Macmillan Encyclopedia of Architecture*, New York (Free Press) 1982, IV, pp. 463–64; Bates Lowry, *Building a National Image: Architectural Drawings for the American Democracy, 1789–1912*, Washington, D.C. (National Building Museum) 1985, pp. 51–57; Antoinette J. Lee, *Architects to the Nation: The Rise and Decline of the Supervising Architect's Office*, New York and Oxford (Oxford University Press) 2000, pp. 19–22.

11. On the history of the Treasury Department building program, see Darrell Hevenor Smith, *The Office of the Supervising Architect of the Treasury: Its History, Activities, and Organization*, Baltimore (Johns Hopkins University Press) 1923; Truman Strobridge, "Archives of the Supervising Architect, Treasury Department," *Journal of the Society of Architectural Historians*, XX, no. 4, December 1961, pp. 198–99; Lee, *op. cit.*

12. Sara E. Wermiel, *Army Engineers' Contributions to the Development of Iron Construction in the Nineteenth Century, Essays in Public Works History*, XXI, Kansas City, Mo. (Public Works Historical Society) 2002, p. 49. On standardization of design in the Office of Construction, see Daniel Bluestone, "Civic and Aesthetic Reserve: Ammi Burnham Young's 1850s Federal Customhouse Designs," *Winterthur Portfolio*, XXV, nos. 2–3, Summer–Autumn 1990, pp. 131–56.

13. Osmund R. Overby, "Ammi B. Young in the Connecticut Valley," *Journal of the Society of Architectural Historians*, XIX, no. 3, October 1960, p. 122; Craig, *op. cit.*

14. E. Harmon to President James Buchanan, October 1857, RG121.

15. Overby, *op. cit.*, n. 19.

16. G.W. Smith to E. Harmon, September 13, 1855, with A.B. Young's "outline idea of what will probably be required at the New Marine Hospital in New Orleans," RG121; August Köllner to Treasury Secretary James Guthrie, April 21 and 29, October 4, 1856, RG121. The Marine Hospital plans were lithographed in Philadelphia by Köllner, assembled with plates of other federal buildings under construction (some from other lithographers), and supplied with a title page that read *Plans of Public Buildings in the Course of Construction for the United States of America Under the Direction of the Secretary of the Treasury*. The sets were distributed to libraries, legislators, and others to promote the Office of Construction's building program (a practice followed by the office since 1852). Thirty-six projects were issued between 1855 and 1856; twelve more between 1856 and 1861. A.B. Young to Köllner, October 4, 1852, and October 28, 1859, RG121; Lee, *op. cit.*, pp. 49–52. Today, in surviving copies of *Plans of Public Buildings*, the Marine Hospital plates are among the rarest of all project sets. They are found in a copy at the University of Kentucky Library (I would like to thank Faith Harders, special collections librarian, for her assistance at the University of Kentucky).

17. The Otis steam-powered passenger elevator installed the same year, 1857, in the five-story E.V. Haughwout & Co. Building at Broadway and Broome in New York is generally credited as the first practical application of a passenger

elevator in the U.S.; Sarah Bradford Landau and Carl Condit, *Rise of the New York Skyscraper 1865–1913*, New Haven, Conn. (Yale University Press) 1996, p. 36; Cecil D. Elliott, *Technics and Architecture: The Development of Materials and Systems for Buildings*, Cambridge, Mass. (MIT Press) 1992, pp. 330–31.

18. For example, the Mobile, Alabama, Custom House, built in 1852–56; Daniel Bluestone, *op. cit.*, pp. 131–56; Lee, *op. cit.*, pp. 48–49.

19. The Detroit, Chelsea, Massachusetts, and Vicksburg, Mississippi, marine hospitals had galleries off the main wards, and the Galveston Custom House (1855–56) and the Burlington, Vermont, Marine Hospital also had extensive galleries on at least two elevations. Projects with encircling galleries were two Florida buildings, the Pensacola Custom House and St. Mark's Marine Hospital. See *Plans of Public Buildings in the Course of Construction, op. cit.* The design for encircling galleries at the Marine Hospital may have originated with a proposal by New Orleans Custom House foreman John Roy in 1855; John Roy to Bowman, July 27, 1855, RG121. Roy's plan was recorded in the antiquarian trade in the 1920s and subsequently lost; *Sunday Item-Tribune*, May 19, 1929, cited by Rooney, *op. cit.*, p. 95.

20. An example of a prefab iron custom house for a tropical site, with encompassing galleries and two prominent cupolas, was published in the *Civil Engineer and Architect's Journal* in May 1854. "Iron Custom-house and Store, for Peru," *Civil Engineer and Architect's Journal*, XVII, no. 242, May 1854, pp. 184–85. The architect was E. Salamons and the fabricator E.T. Bellhouse & Co. of Manchester, England. Published in London and New York, the *Journal* would have been accessible to Young. For British engineers' use of this feature in plans for military installations in the West Indies, see John Weiler, "Colonial Connections: Royal Engineers and Building Technology Transfer in the Nineteenth Century," *Construction History*, XII, 1996, pp. 11–16.

21. John Lord Hayes to James Guthrie, September 14, 1854, RG121.

22. Office of the Construction of Buildings, Treasury Department, *Specifications for Building the New Marine Hospital at New Orleans, Louisiana*, Washington, D.C. (A.O.P. Nicholson, Public Printer) 1856.

23. John Lord Hayes to James Guthrie, RG121, *op. cit.*

24. A.H. Bowman to James Guthrie, December 5, 1856, RG121.

25. After first-round bids came in uniformly over-budget, Congress increased the original allocation to $436,459, during fiscal year 1856. In the second round of proposals the lowest bid for brick construction came in at $309,000 (from J. Mulligan), compared to Harmon's bid in iron of $360,000. John Cochrane to A.H. Bowman, November 24, 1856, RG121; Alexander Bowman to P.G. Washington, Assistant Treasury Secretary, "Synopsis of proposals rec'd for construction," November 26, 1856, RG121; *Delta*, April 2, 1856; *Courier*, April 16 and May 11, 1856; *Philadelphia Evening Argus*, October 3, 1856; *Letter from the Secretary of the Treasury Transmitting Additional Estimates for the Erection of a Marine Hospital at New Orleans*, 34th Cong, 1st sess., H. Ex. Doc. 136, Washington, D.C. (C. Wendell) 1856; *Report of the Secretary of the Treasury, on the State of the Finances, for the Year Ending June 30, 1856*, 34th Cong., 3d sess., H. Ex. Doc. 2, Washington, D.C. (C. Wendell) 1856, p. 566.

26. Severson, *op. cit.* In the early 1850s Severson (*c.*1813–1883) was a superintendent at the Philadelphia iron foundry, J.A. Gendell's & Co. Architectural Iron Works. When developing the Marine Hospital proposal, he had been

recently discharged from work at the U.S. Capitol, where he was the foreman (under Montgomery C. Meigs) responsible for erecting the iron roof of the new extension. He published many articles on iron construction in *Scientific American* and other journals during the period of construction of the Marine Hospital. His later projects included the iron roof of the Smithsonian (after 1865), proposed canal improvements in Washington, D.C., and hydraulics in Florida; *Washington Post-Union*, April 23, 1883. Severson's innovative use, in the 1850s, of wire cables in place of iron bars in trusses (producing girders of greater strength-to-weight ratio) for a Philadelphia bank and the Peabody Institute in Baltimore (called a "wonder of mid-nineteenth-century American engineering") are recent discoveries; see Sara Wermiel, "An Unusual Application of Wire Cables from the 1850s: Benjamin Severson's Wire-tied Iron Girders," *Construction History*, XVII, 2001, pp. 43–54 (see Montgomery C. Meigs, *Capitol Builder: The Shorthand Journals of Montgomery C. Meigs, 1853–1859, 1861*, ed. Wendy Wolff, Washington, D.C., Government Printing Office, 2001, pp. 312, 331–32, 339, 414–15).

27. Building Contract, January 12, 1857, Misc. Operating and Fiscal Records, Construction Contracts, 1854–60, Records of the Public Buildings Service, RG121, NARA; Building Contract, A.H. Van Cleve for Trenton Locomotive and Machine Manufacturing Company, January 14, 1857, RG121; "An Extensive Iron Government Building," *American Railway Times*, IX, no. 42, October 15, 1857.

28. "Request for Proposals for Erecting a Marine Hospital at New Orleans, LA," March 22, 1856, RG121.

29. Marshall Lefferts, "Proposal for an Iron Building," September 17, 1856, RG121; J.K. Duncan to Treasury Secretary Howell Cobb, August 8, 1857, citing contract computations of 1856. Lefferts was working with James Bogardus (from 1855) on the Tomkins Market and Seventh Regiment Armory, one of New York's largest iron buildings; Carol Gayle and Margot Gayle, "The Emergence," *op. cit.*, pp. 154–55, 188–92.

30. Severson, *op. cit.*

31. François Cointereaux, *École d'architecture rurale*, Paris (Niodet) 1791. Cointereaux's research was taken up in Paris by Jean-Baptiste Rondelet and widely disseminated in his *Traité théorique et pratique de l'art de bâtir* (1802–17). See Abraham Rees, "Pisé," in *The Cyclopaedia*, London (Longman, Hurst, Rees, Orme & Brown) 1819–20, XXVII, p. 59; Louis Cellauro and Gilbert Richaud, "Thomas Jefferson and François Cointereaux, Professor of Rural Architecture in Revolutionary Paris," *Architectural History*, XCVIII, 2005, pp. 173–206. It is not unlikely that Cointereaux and Rondelet's contributions would have been known in the engineering program at West Point, where, as Todd Shallat has shown, the curriculum relied on Parisian works; Todd Shallat, "Science and the Grand Design: Origins of the U.S. Army Corps of Engineers," *Construction History*, X, 1994, p. 18. For a brief history of rammed-earth construction, see David Easton, *The Rammed Earth House*, White River Junction, Vt. (Chelsea Green Publishing Co.) 1996, pp. 10–16.

32. E. Gilman, *The Economical Builder: A Treatise on Tapia and Pisé Walls*, Washington, D.C. (J. Gideon, Jr.) 1839. See Jeffrey W. Cody, "Earthen Walls from France and England for North American Farmers, 1806–1870," in *International Conference on the Conservation of Earthen Architecture, VI, October 14–19, 1990*, Los Angeles (The Getty Conservation Institute) 1990, pp. 35–43. The *American Farmer*, edited by John Stuart Skinner, gave coverage of *pisé* building from 1819 to 1830, and published a translation of Cointereaux's

work. The Chicago periodical *Prairie Farmer* published articles on *pisé* from 1843 to 1855 (see III, pp. 126–27; IX, p. 171; XI, p. 452). A common American application of *pisé* was for plantation buildings in the South, especially the Carolinas, where examples survive today (e.g. Church of the Holy Cross in Statesboro, South Carolina, of 1850). Earthen wall construction was revived after 1914 especially in Britain through the efforts of architect Clough William-Ellis as a solution to wartime housing shortages; see Clough William-Ellis, *Cottage Building in Cob, Pisé, Chalk & Clay: A Renaissance*, New York (C. Scribner's Sons) 1919; and Mark Swenarton, "Rammed Earth Revival: Technological Innovation and Government Policy in Britain, 1905–1925," *Construction History*, XIX, 2003, pp. 107–26. Recent interest in sustainable construction has brought a renewed focus on the technique.

33. John M. Bryan, *Robert Mills: America's First Architect*, New York (Princeton Architectural Press) 2001, p. 308.

34. "Iron Buildings for Government Purposes," *op. cit.*

35. "Iron and Earth Walls for Buildings," *op. cit.*

36. "The Civilizer," *United States Magazine*, IV, no. 5, May 1857, p. 520.

37. The controversy over iron construction during the 1850s is summarized in Carol Gayle and Margot Gayle, *Cast-Iron Architecture in America, op. cit.*, pp. 192–94.

38. E. Harmon to Treasury Secretary James Guthrie, August 29, 1856, RG121.

39. "Report of Operations on the New Marine Hospital New Orleans," September and October 1856, RG121; "The New Marine Hospital," *Picayune*, October 2, 1856; *Crescent*, October 21, 1856. Smith was appointed superintendent in January 1856 (G.W. Smith to Guthrie, January 23, 1856, RG121). Duncan was appointed assistant superintendent in May 1856 and superintendent in April 1857. For biographies of these men, both West Point-trained Army engineers, see *Biographical Register*, II, pp. 45, 374.

40. "The New Marine Hospital," *Picayune, op. cit.*

41. Davis, McLanahan & Co., Joseph Moorehouse subcontractor for Trenton Locomotive Machine Manufacturing Company, H.B. Cenas, LXVIII, no. 448, May 16, 1857, NONA; "The New United States Marine Hospital," *Picayune*, May 17, 1857.

42. Wharton, "Diary," February 20, 1857; J.K. Duncan to Howell Cobb, monthly reports, January to May 1857, RG121.

43. "The New United States Marine Hospital," *Picayune, op. cit.*

44. *Report of the Secretary of the Treasury, on the State of the Finances, for the Year Ending June 30, 1858*, 35th Cong., 2d sess., S. Ex. Doc. 2, Washington, D.C. (Wm. A. Harris) 1858, p. 108.

45. J.K. Duncan to Howell Cobb, December 3, 1858, RG121.

46. Trenton Locomotive Machine Manufacturing Co. to Howell Cobb, April 14, 1859, RG121.

47. J.K. Duncan to Howell Cobb, May 7, 1857, RG121.

48. *Report of the Secretary of the Treasury, on the State of the Finances, for the Year Ending June 30, 1860*, 36th Cong., 1st sess., S. Ex. Doc. 3, Washington, D.C. (Geo. W. Bowman) 1860, pp. 112–13.

49. Cooper & Hewitt to Bowman, June 22, 1857, RG121; President James Buchanan to James Cooper, October 13, 1857, RG121.

50. J.K. Duncan to S.M. Clark, June 4, 1859, RG121; A.H. Vancleve to S.M. Clark, July 17, 1859, RG121.

51. P.G.T. Beauregard to A.H. Bowman, February 25, 1860, RG121.

52. "Report of Operations on the New Marine Hospital New Orleans," April 1860, RG121; *Report of the Secretary of the Treasury ... for the Year Ending June 30, 1860, op. cit.*

53. P.G.T. Beauregard to Howell Cobb, March 28, 1860; P.G.T. Beauregard to S.M. Clark, telegram, May 10, 1860; J.F. Houdayer to Jos. Potts, Trenton Locomotive and Machine Manufacturing Company, May 10, 1860; J.F. Houdayer to A.H. Vancleve, May 10, 1860; "Deposition of J.M. Reid," *State of Louisiana vs. John F. Houdayer, 1st District Court, Henry M. Summers*, May 10, 1860, all in RG121.

54. P.G.T. Beauregard to Howell Cobb, "Monthly Report," August 13, 1860, RG121; *Report of the Secretary of the Treasury ... for the Year Ending June 30, 1860, op. cit.*, pp. 112–13.

55. "New-Orleans Marine-Hospital, October 15th 1862, Claim No. 66: Loss from suspension of pise-work," RG121.

56. "Report of Acting Engineer in Charge, S.M. Clark," in *Report of the Secretary of the Treasury ... for the Year Ending June 30, 1860, op. cit.*, pp. 103–104. Photographer Jay Dearborn Edwards completed a series of record photographs of the hospital under construction dated June 30, 1860; six prints are now in the Hill Library, Louisiana State University. Photographs were requested by Washington to accompany annual reports of supervising architects from September 1857. In 1859, Beauregard sent twelve views of the Marine Hospital and twenty-three of the Custom House to Washington, and construction photographs are also documented for 1857; Wharton to Cobb, September 17, 1859, RG121; "Official Architecture: Importance of the Photographic Branch," *Anthony's Photographic Bulletin*, VII, no. 1, January 1876, pp. 13–14; Lee, *op. cit.*, p. 55.

57. William B. Franklin, Engineer in Charge, Treasury Department, to Treasury Secretary S.P. Chase, March 29, 1864, RG121; Trenton Locomotive and Machine Manufacturing Company, claim, May 15, 1876, RG121.

58. Wharton, "Diary," April 14, 18, 19, and 21.

59. Architect Thomas K. Wharton took charge briefly after Beauregard's resignation; Wharton, "Diary," January 2, 7, and 17, 1861. Wharton was also in charge of the Custom House construction and he had worked at the Marine Hospital as clerk since Beauregard's appointment in 1859; P.G.T. Beauregard to Howell Cobb, June 1, 1859, RG121; Wharton, "Diary," May 31, 1859.

60. "The Military Hospitals of New Orleans," *Picayune*, March 12, 1863. Nearly seventy years later excavations unearthed a large munitions mine at the site, *Sunday Item-Tribune*, May 19, 1929.

61. "The Maritime Hospital," *Times*, December 24, 1863.

62. "Report on the present condition of the Marine Hospital at New Orleans La," John F. Morse to Isaiah Rogers, Supervising Architect of the Treasury, July 7, 1864, Miscellaneous Letters, January to December 1864, General Records of the Department of the Treasury, RG56, NARA; Treasury Secretary Hugh McCulloch to Major General Oliver O. Howard, Commissioner of Freedmen's Bureau, December 2, 1865, RG121; "The Marine Hospital," *True Delta*, January 25, 1866. On the Bureau, see Howard A. White, *The Freedmen's Bureau in Louisiana*, Baton Rouge (Louisiana State University Press) 1970.

63. Edwin Stevens and Robert Ream to E.J. Parker, Surveyor of Customs, November 6, 1868, RG121.

64. John M. Woodworth to Treasury Secretary George S. Boutwell, February 6, 1872, RG121.

65. Henry Howard and J.M. Reid to W.D. Stewart, Treasury Department Special Agent, February 18, 1869, RG121.

66. Gilles Vandal, "Curing the Insane in New Orleans: The Failure of the 'Temporary Insane Asylum,' 1852–1882," *Louisiana History*, XLVI, no. 2, Spring 2005, p. 164; Griswold's *Guide*, p. 48.

67. W.H.H. Hutton, Surgeon, U.S. Marine Hospital Service (USMHS), to John B. Hamilton, Surgeon-General, USMHS, June 23, 1879, RG121; Edward King, *The Southern States of North America: A Record of Journeys*, London (Blackie & Son) 1875, p. 64 (with a wood engraving of the building).

68. John Hamilton to John Sherman, May 4, 1880, RG121; *Report of Committee on Commerce*, 46th Cong., 2d sess., H. Rep. 1450, Washington, D.C. (Government Printing Office) 1880. Congress was, in part, bowing to pressure from the City of New Orleans, which had adapted a measure in July 1879 demanding that the hospital be turned over to the city for charitable use. Vandal, *op. cit.*, p. 165, n. 43.

69. John Godfrey, Surgeon, USMHS, to the Surgeon-General, April 20, 1885, RG91. "Correspondence of the Marine Hospital Service," Letters Received from Marine Hospitals, 1884–85, New Orleans, Records of the Public Health Service, RG90, NARA.

70. *Annual Report of the Supervising Surgeon-General ...*, Washington, D.C. (Government Printing Office) 1882, p. 13, 1883, pp. 28–30, 1889, p. 118; *Picayune*, September 23, 1882; *New York Times*, September 24, 1882; *Picayune*, September 1, 1883. One structure from the 1880s complex survives today; see *New Orleans Architecture*, VIII, pp. 181–82.

71. A.W.W. Wrotowski to A.S. Badger, Collector of Customs at New Orleans, February 17, 1881, RG121.

72. *Picayune*, January 16, 1881; "The Marine Hospital for Sale" (advertisement), February 16, 1881.

73. *Daily States*, June 5, 1896; Sawtelle, *op. cit.*

74. A.G. Durno, "Public Buildings and Charities," in *Standard History of New Orleans, Louisiana*, ed. Henry Rightor, Chicago (Lewis Publishing Co.) 1900, p. 447.

75. Lilienthal also published a stereoview of the hospital about this time; an example is in The Historic New Orleans Collection, 1988.134.17.

76. "Report of Operations on the New Marine Hospital New Orleans," August 1856, RG121; "Statement Exhibiting the Amount of Funds Expended, June 30, 1857–June 30, 1858," RG121; Ass't Supervising Architect A.B. Mullett to Wm. E Chandler, Ass't Secr. of the Treasury, November 9, 1865, RG121.

49
Hotel Dieu
Hopial Hotel Dieu

The Sisters of Charity of St. Vincent De Paul established the Hotel Dieu infirmary in 1859 and named it after the municipal hospital of Paris.[1] It was one of twelve institutions in the city that were operated by the sisters, whose local community, founded in 1830, was one of the largest in the country.[2]

Thomas Mulligan, an Irish-born architect and builder who came to New Orleans in 1847, designed the three-story brick building on Common Street (Tulane Avenue), between Bertrand and Johnson streets.[3] Mulligan's building was an H-shaped block with exterior galleries, richly decorated with ironwork and "thoroughly ventilated and open to the winds from all quarters"—reflecting the fear of stale air as an agent of disease characteristic of the age. The "spacious and handsomely ornamented grounds" were enclosed by a magnificent iron fence.[4] The *New York Times* observed in 1867 that the "beautiful little hospital" was "a model of excellence in its nursing and repose."[5]

The first patient admitted to Hotel Dieu was reportedly a slave, and the hospital continued to admit slaves as well as those with means, who might be charged up to $7 a day for a private room.[6] In treating white patients, the infirmary went against a local tradition of long-term home care, especially for women, when concern for family privacy often prevailed over the medical needs of patients. The sisters cared for war casualties there, including many federal officers, following battles in northern Louisiana early in the war. A sister related in 1862 that the hospital was

> full of wounded federals …. These poor creatures are generally protestants, and only know Catholicity to despise it. Many of them have not even received baptism. There are a good number of Irishmen among them, all of whom ask for a priest. ... Nothing is so distressing as a war of this kind; we find the son armed against the father, and brother against brother. A poor young man told one of our Sisters that he had a twin brother on the other side.[7]

In 1863, the hospital was under the supervision of ten sisters, who were reportedly treating seventy soldiers in conditions so "absolutely perfect" that it was doubted "if the Sanitary Commission could suggest an improvement."[8]

From 1871 to 1882 the Hotel Dieu received patients under contract from the Marine Hospital Service, which had suspended construction of the immense iron building on Common Street (cat. 48) before the war.[9] Hotel Dieu was enlarged several times in the 1880s and replaced by new facilities in 1924 and again in 1972, still under the management of the Sisters of Charity. In 1993, the sisters transferred ownership of their hospital to the State of Louisiana.

Lilienthal's view of the Hotel Dieu frames the building in its cover of shade trees and places it deep in the picture space, recording its secluded setting near the edge of the city. The hospital, if ideal for the isolation of invalids, was not easily accessible, especially after a rainstorm, when the entire district was often "an unbroken sheet of water."[10] In the foreground, Common Street, which was the commercial hub of the city near the river, is here only a muddy track scattered with oyster shells and lined by a deep drainage canal, bridged to the entrance of the hospital by a heavy stone slab. The photographic print appears scored where the uneven application of collodion emulsion, an artifact of Lilienthal's fieldwork, has marred the negative.

1. *Crescent*, September 12, 1859; *Delta*, August 7, 1857; *Picayune*, March 12, 1863; Matas, *History of Medicine*, II, p. 233.
2. "Order of the Sisters of Charity in New Orleans," *Times*, September 10, 1866. In addition to Hotel Dieu, the Sisters of Charity operated three other institutions photographed by Lilienthal: St. Simeon's Select School (cat. 75); St. Vincent's Asylum (cat. 81); and St. Elizabeth's Asylum (cat. 85). The sisters also administered wards of Charity Hospital (cat. 69) and, in the 1850s, operated Dr. Stone's Infirmary (cat. 22). St. Vincent's Academy (cat. 97) came under their care in the 1870s.
3. Building contract, O. de Armas, LXVIII, no. 449, December 21, 1857, NONA. Mulligan also designed St. Vincent's Asylum; *Jewell's Crescent City Illustrated*; *Picayune*, May 13, 1874. Mulligan also designed the St. Elizabeth Children's Home on Napoleon Avenue in 1865, also for the Sisters of Charity, and the Dominican convent of St. Mary's (cat. 77).
4. "A Visit to the Hotel Dieu," *Crescent*, August 4, 1867.
5. "Relief for the Sufferers from Yellow Fever in the South," *New York Times*, September 16, 1867.
6. "Infirmary of the Sisters of Charity" (advertisement), *Times*, July 7, 1866.
7. Daniel Hennefin, *Daughters of the Church: A Popular History of the Daughters of Charity in the United States, 1809–1987*, Brooklyn (New City Press) 1989, p. 134.
8. "The Military Hospitals of New Orleans," *Picayune*, March 12, 1863.
9. National Library of Medicine, *Register of Permits to Enter the Marine Hospital at New Orleans, 1870–1887* [ms.].
10. *Times*, April 8, 1866.

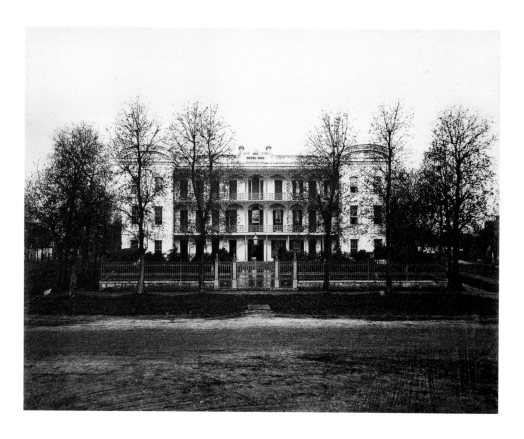

Opposite *Masonic Hall, St. Charles Street* (cat. 62), detail.

The First District:
The Colonial Faubourg St. Mary

Although the greensward had deteriorated, in the late 1860s the ensemble of buildings facing the square was perhaps the finest architectural grouping in the city. Lilienthal included four views of buildings there in the Exposition portfolio, including City Hall (cat. 51) and James Freret's Moresque Building, the largest cast-iron building in the city, completed just after the war.[7] His panorama of the square from St. Patrick's Church (cats. 120–22) includes the Moresque and Henry Howard's First Presbyterian Church, partially visible here through the foliage.

Facing Camp Street, opposite the City Hall, were the ruins of George Purves's Odd Fellows' Hall, which had been destroyed by fire the previous summer (see cat. 120). A collapsing wall of the hall wrecked a section of the magnificent wrought-iron fence enclosing the square, and delay in its restitution, "suggestive of a bankrupt community," was a continuing scandal.[8] Removed sections of fence can be seen in the photograph.[9] Lilienthal's view from the corner of Camp and South streets focuses our attention on the shaded promenade created by the double row of sycamores, a prominent feature of the original colonial plan of the square.

50
Lafayette Square
Place Lafayette

Lafayette Square, laid out in 1788 as a public plaza for the faubourg St. Mary, was named in honor of Marquis de Lafayette after his visit to New Orleans in 1825. By the 1830s, the square was a popular promenade and centerpiece of a prosperous Anglo-American commercial and residential district, and a counterpart to the French community's Jackson Square in the Vieux Carré. Construction of James Gallier's Municipal Hall in 1844–51 assured the dominance of Lafayette Square in the civic and ritual life of the city, as a stage for inaugurations, funeral processions, carnival celebrations, and other public ceremonies. The most consequential of these events was on February 12, 1861, when the secessionist convention raised the flag of the sovereign state of Louisiana over the square. Four years of war and another nine of military intervention followed.[1]

During the war, the square was used as an encampment for both the Confederate and Union armies. With the departure of Confederate companies for the front, New Orleans was left to the protection of a "home

guard" stationed in the square—a battalion of "old gentlemen," described by a New York journalist as "deaf, knock-kneed, and spavined, etc., and older than the everlasting hills."[2] But to Orleanian Marion Southwood, the home guard was a source of pride. The battalion's tents in the square "were beautiful to behold," she wrote. "They dined and toasted there. The ladies visited them, and they went through the drill with great eclat."[3]

Following the capture of New Orleans in late April 1862, an encampment of federal troops took over the square. "Tents are pitched and camp fires lighted in the heart of the city," the *Delta* wrote.[4] By the end of the war the military maneuvers had ruined the square, once the most privileged green space in the city. "They have trodden up the lawn and made one of our most beautiful promenades a desert and a waste," the *Picayune* protested in 1866, referring to the tent city of federal troops still located there.[5] The square was now an "eyesore to citizens," according to the *Crescent*:

time was when it could be pointed out to the visitor as one of the loveliest spots in the city, but now look at the trodden grass, [and] the forlorn seedy appearance pervading the whole square.[6]

1. New Orleans was occupied by federal troops from May 1, 1862, until April 1869, and again from late 1872 until the end of Reconstruction in early 1877.
2. *Beauty and Booty*, pp. 18–19.
3. *Ibid*.
4. "Paraphernalia of War," *True Delta*, March 25, 1864.
5. "Gone and Thanks," *Picayune*, December 6, 1866.
6. "Lafayette Square," *Crescent*, March 14, 1867; "Lafayette Square," *Crescent*, August 2, 1867.
7. The Moresque view, reported in the press accounts of the portfolio, is one of the lost photographs; see cat. 120.
8. "Too Long Neglected," *Picayune*, January 6, 1867; "Why Don't They Do It?," *Crescent*, February 9, 1867; "Absurd Proposition," *Picayune*, February 27, 1867; "On Entering Lafayette Square," *Picayune*, September 25, 1867.
9. "Improvement," *Crescent*, February 22, 1867; "Railing Around Lafayette Square," *Crescent*, April 7, 1867; "Lafayette Square," *Picayune*, May 9, 1867.

51
City Hall
Hotel de Ville

City Hall at Lafayette Square, designed by James Gallier, was built in 1847–53 as the town hall for the Second Municipality (the Anglo-American quarter above Canal Street), when the city was divided into three municipalities, each with its own governing council.[1] The building became the New Orleans City Hall when the municipality form of government was abolished in 1852. A century later a municipal office park was built several blocks away on Loyola Avenue, relegating the old city hall to largely ceremonial functions.

Construction of the City Hall began in 1847, but after completing the basement in Quincy granite the municipality found itself short of funds, and work ground to a halt.[2] When building resumed, the costly marble Gallier had specified for the exterior walls was replaced with brick—plastered, scored, and painted brown to resemble stone—but construction costs still topped $340,000, about three times over-budget.[3] In April 1851, builders installed the pediment relief, *Liberty Supporting Justice and Commerce*, by the New York sculptor Robert Launitz, completing the exterior, but the building was not finished and dedicated until May 1853. The protracted building campaign marked the end of Gallier's fifteen-year career in New

Orleans. In 1850, before the City Hall was completed, his eyesight failing, he retired and turned his practice over to his son, James, Jr.

The monumental Grecian Ionic front of New York marble, modeled on the north porch of the Erechtheum, was "a very chaste and highly finished example of that style," Gallier himself wrote, and the use of Greek forms was, the *Crescent* contended, "another proof of the architectural taste of James Gallier."[4] It was Gallier, more than any other architect in the city, who spread the Greek style locally; New Orleans is said to have had "more monumental Grecian specimens than ancient Athens in its prime."[5] But the "chaste" Greek forms did not have universal appeal. "There is such an all-holy

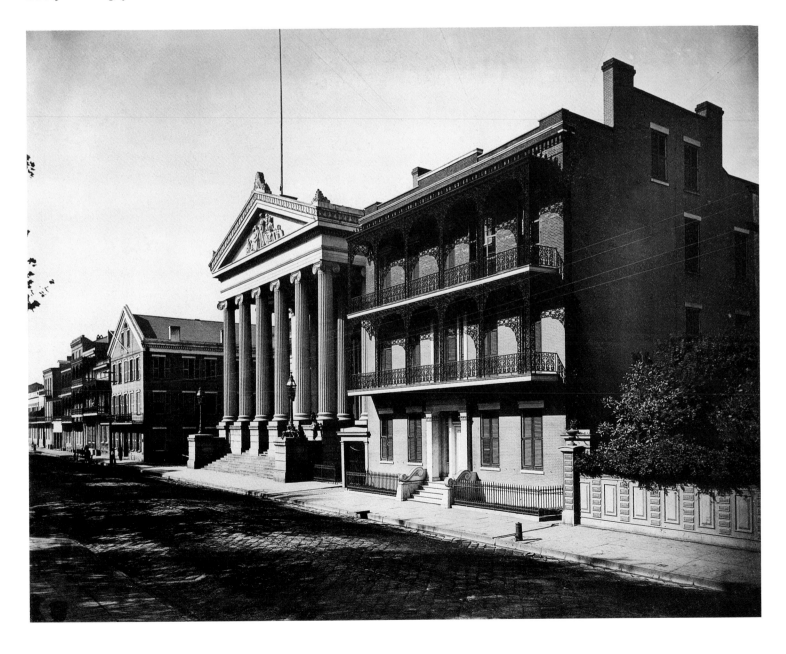

sanctity that lingers about," the *Times* concluded about the building; "it makes it too unfamiliar with the public."[6] For the next decade or more, it was generally considered the "standard of American taste" in the city, and its modernity was made to contrast with the architecture of the old Creole Vieux Carré.[7] In later decades, the building's *fortuna* rose and fell with the regard for the Greek style, but it was never more admired in print than when Talbot Hamlin, in 1944, praised it as "one of the most beautiful examples of the smaller Greek Revival public buildings to be found anywhere."[8]

The City Hall housed municipal offices, council chambers, courtrooms, the city's first public library, and the Lyceum—a public lecture hall, 85 by 76 feet (26 by 23 m), with galleries—which was the most imposing space in the building.[9] "[The Lyceum] contains extensive galleries on three sides, besides having a row of fluted columns in front, beneath which is a broad, elevated platform or stage, with retiring rooms on each side," the *Picayune* wrote.[10] The library, said to be modeled on William Thornton's Library Company of Philadelphia of 1788, was designed for 40,000 volumes and fitted with red-cedar shelving, reading alcoves, and a hanging gallery.[11] Luxurious decorative finishes of Egyptian marble, brass, and fine woods were used throughout. No expense was said to have been spared in rooms "for the people."[12]

During the Civil War era, the City Hall had important associations with secession, federal occupation, and Reconstruction. In February 1861, secessionists raised the Louisiana flag above the building to signal withdrawal from the Union, and it was there that the first company of the Washington Artillery assembled, prior to their departure for the eastern battlefields. The Reverend Benjamin Morgan Palmer, pastor of the First Presbyterian Church at Lafayette Square, and the most celebrated orator in New Orleans, stirred the volunteers into sectional fervor:

> It is fitting that here, in the heart of this great city—here, beneath the shadow of this hall, over which floats the flag of Louisiana's sovereignty and independence—you should receive a public and tender farewell … . Soldiers! history reads to us of wars which have been baptized as holy; but she enters upon her records none that is holier than this in which you have embarked.

It is a war of defense against wicked and cruel aggression; a war of civilization against a ruthless barbarism which would dishonor the dark ages; a war of rebellion against a blind and bloody fanaticism. It is a war for your homes and your firesides—for your wives and your children—for the land which the Lord has given us for a heritage. It is a war for the maintenance of the broadest principle for which a free people can contend—the right of self-government.[13]

The tide of war turned quickly for New Orleans, however, and on May 1, 1862, federal troops entered the city and seized the City Hall, as a local diarist recounted:

> The Yankee soldiers in number about five thousand have entered the City and taken possession of the Mint, the Custom House, and other public buildings. Their entrance was so quiet—no demonstrations of delight, or cheering for the Union, for they felt they were coming amongst a hostile and unwilling people. I am told they are the dirtiest, meanest looking set that were ever seen—nothing at all of the soldier in their appearance … . They have completely surrounded Mr. Slocomb's, having encamped in Lafayette square and having taken possession of Lyceum [City] Hall as a hospital for their sick.[14]

The galleried house in the foreground of Lilienthal's view, fronting on the square, is the Slocomb residence, built in 1834 for hardware merchant Samuel Slocomb. With the outbreak of war, Slocomb's widow, Cora, applied the family's considerable wealth to financing the Washington Artillery and other Confederate causes. During federal occupation, the Union commander General Benjamin Butler attempted to confiscate the residence for his personal quarters. Cora Slocomb appealed to the General not to take from her the house "endeared to her by a thousand tender associations," and Butler, impressed by the "courage and ladylike propriety" of her entreaty, relented.[15] The Slocomb house was annexed to City Hall in 1914 and demolished after 1940 for construction of a Federal Reserve bank.

Lilienthal photographed the City Hall from a balcony facing Lafayette Square, framing the building's narrow but imposing front in the ensemble of buildings on St. Charles Street.[16] The scale of the City Hall podium is diminished by the Slocomb residence in the foreground but its grandeur is heightened by the brilliant morning sun that gives strong relief to the columns. The sun casts long shadows on St. Charles Street from the arbor of sycamores in the square, and the detail of the paving stones revealed in shadow is evidence of Lilienthal's mastery of the technical demands of his medium.

1. "Memorial of the Citizens of the Second Municipality," *Picayune*, January 16, 1841.
2. Gallier, *Autobiography*, pp. 40–41; *Bee*, April 11, 1847; *Delta*, February 20, 1848.
3. "Journal of Receipts and Expenditures, 1836–1852," IV, fol. 683, May 31, 1850, fol. 703, July 31, 1850, V, November 30, 1850, January 31, 1851, New Orleans Public Library, City Archives, Second Municipality Comptroller's Office Records, CB440. "City Improvements," *Picayune*, September 19, 1850; *Picayune*, March 25, 1851; "Cost of the Municipal Hall," *Picayune*, March 27, 1851; *Crescent*, April 3, 1851.
4. Gallier, *op. cit.*; "The New Municipal Hall," *Crescent*, October 14, 1849. Gallier's drawings are in the Southeastern Architectural Archive, Tulane University.
5. "The New Municipal Hall," *op. cit.*; *New Orleans Architecture*, II, p. 204.
6. "Looker-On," *Times*, March 15, 1866.
7. *Picayune*, March 30, 1849; Gallier, *op. cit.*; "City Intelligence: Fifth District Court," *Bee*, April 11, 1847; and the letter of Robert Seaton in *True Delta*, February 20, 1848.
8. Talbot Hamlin, *Greek Revival Architecture in America*, New York (Oxford University Press) 1944, p. 226.
9. The Lyceum and Library Society, established in 1844, was a subscription library for public-school students. See p. 182, n. 19.
10. *Picayune*, October 13, 1849.
11. "The New Municipal Hall," *Crescent*, October 14, 1849.
12. *Ibid.*
13. *Beauty and Booty*, p. 15.
14. *Diary of Mrs. Robert Dow Urquhart*, May 2, 1862, Urquhart Collection, Manuscripts Collection, Tulane University Library, cited in *New Orleans Architecture*, V, p. 16.
15. Benjamin F. Butler, *Butler's Book: Autobiography and Personal Reminiscences*, Boston (A.M. Thayer) 1892, pp. 423–24.
16. Lilienthal also made a stereoview of this building; see fig. 83.

52
Fire Engine Houses
Maisons des Pompes a Incendies

Lilienthal's *Fire Engine Houses* is a view of the downtown side of Girod Street between St. Charles and Carondelet streets, directly behind City Hall. In the foreground is the firehouse of American Hook & Ladder No. 2, built at mid-century, its company symbol in relief on the façade. Next door is the Columbia No. 5 Steam Engine Company station house, built about 1837.[1] At mid-block is the castellated façade of the abandoned Washington Artillery Armory. Beyond, in the direction of Carondelet Street, are several houses dating from before 1850.[2]

Exhibited outside the Columbia No. 5 station house is a hand-pulled J. Smith steam engine built in New York in 1859.[3] Also on display at the American Hook & Ladder firehouse is that company's ten-year-old hand-pulled ladder truck. Columbia No. 5 moved to Julia Street in 1885, and the Girod Street firehouse was later demolished. Fire companies occupied the American Hook & Ladder building until 1960, when the building was renovated for commercial use.[4] It is still standing today.

The most notable building in this view had significant associations with the war. The "military gothic" façade of the Washington Artillery Armory was designed by Will Freret in 1858 and built in plastered brick, scored to resemble a rusticated fortress.[5] It was one of the earliest examples in the U.S. of an armory in the castellated style (derived from medieval military architecture) that came into common use for armory buildings in the 1880s.[6] The arsenal's massing, the twin towers flanking a narrow receding block, the tall, arched windows, and the martial iconography of cannons and cannonballs made a bold statement in the street. Its occupant, the Washington Artillery, was a private military company dating from the early 1830s; it held assemblies, paraded, enacted ritual battles, and served as auxiliary police. At the outbreak of the war the Artillery and other militia in the

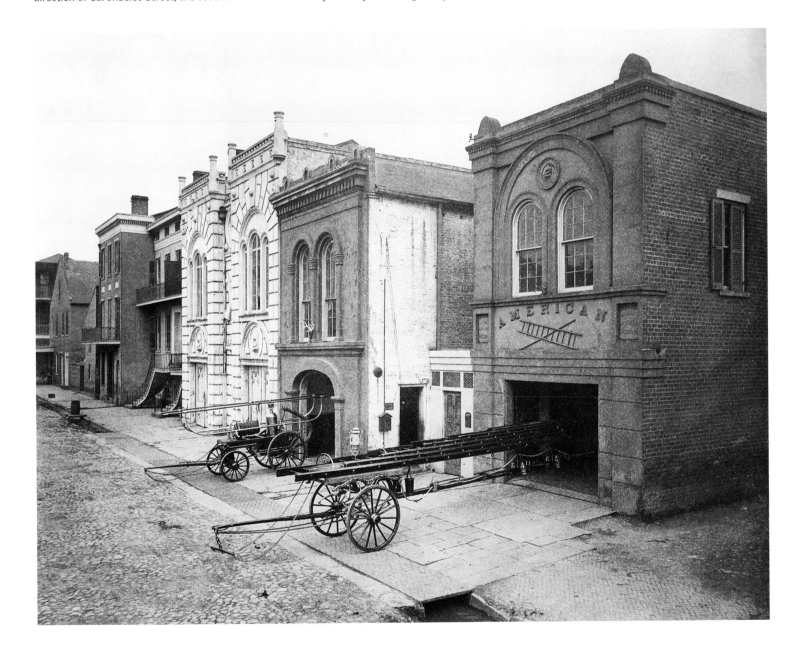

South formed the core of the Confederate forces, since the South had no standing army. The company participated in more than sixty battles and was one of the most distinguished fighting units of the Confederacy.[7] Lilienthal himself (with his brother Julius) had joined the Artillery as a cannoneer and was mustered shortly before the capture of New Orleans in the spring of 1862 (see p. 42).

During the federal occupation, as Washington Artillery companies were engaged on the eastern front, Union troops seized the armory. A short time later a fire, reported to be the work of an "incendiary fiend," severely damaged the building.[8] At the time of Lilienthal's view the armory was abandoned. Artillery members who survived the war reorganized and built a new hall nearby on Carondelet Street in 1872.[9] The old armory building was restored for other uses and eventually, in 1938, demolished.[10] The façade, however, was saved and reassembled opposite Jackson Square in Washington Artillery Park.[11] This relic of the old armory, having finally lost its hallowed associations with the war, was pulled down in 1972.[12]

Lilienthal's view is strikingly similar in composition to a photograph by Jay Dearborn Edwards, published in 1858–59 (fig. 29), but differs in the use of an elevated, not street-level, perspective. Edwards's series of New Orleans views and a slightly later cartes-de-visite series by McPherson and Oliver are local photographic precedents for Lilienthal's topography of the city.

1. In 1832, the city prepared plans for a guardhouse—possibly for the militia, which later formed the Washington Artillery—and an engine house on this site (Building contract, F. de Armas, January 26, 1832, NONA). By 1837, the firehouse was completed, and in 1841 the American Hook & Ladder Company moved there (*Gibson's Guide*, 1838, p. 369). Columbia No. 5, organized in 1835, apparently rejected a design of 1836 by Frederick Wilkinson for a station house with a bell tower (an elevation and plan are in Louisiana Collection, New Orleans Public Library) and built this firehouse by 1838. In 1850, builder Benjamin Howard made repairs to the No. 5 firehouse to the design of George Dunbar (Building contract, William Monaghan, July 12, 1850, NONA). In 1854, the American Hook & Ladder firehouse was reported to be "new & in the best condition," while No. 5 was reported to be "in bad condition & in great need of repairs;" L.H. Pilié to the Board of Assistant Aldermen, June 13, 1854, "Outgoing Correspondence, 1853–1863," II, fol. 99–102, New Orleans Public Library, City Archives, Surveyor's Office Records, 1833–90, KG511. No. 5 was altered again in 1879, and No. 2 in 1884 (Building contracts, Gustave Le Gardeur, 22/141, March 10, 1879; Joseph D. Taylor, 8/1302, March 18, 1884, NONA). The narrow, two-story, double-window-over-

single-door elevation of both buildings was a common firehouse design of the 1850s, easily recognizable and associated with fire protection companies; see Rebecca Zurier, *The American Firehouse: An Architectural and Social History*, New York (Abbeville Press) 1982. On the history of the fire companies, see Thomas O'Connor, ed., *History of the Fire Department of New Orleans*, New Orleans (New Orleans Fire Department) 1895, pp. 127, 139.

2. The three-story brick duplex with a second-floor balcony dates from about 1847, and the neighboring residence, built for Andrew Hodge, a bank president, from about 1839; see *New Orleans Architecture*, II, p. 165. Both buildings survive today at 727–31 Girod Street. The gabled store and residence with an awning at the Carondelet Street corner may also date from the 1830s, but was demolished soon after Lilienthal's photograph.

3. "For the Firemen," *Times*, February 19, 1867; see William T. King, *History of the American Steam Fire Engine*, Chicago (Davies) 1960.

4. *Times-Picayune*, January 17, 1960.

5. "The Washington Artillery," *Courier*, November 6, 1858. In 1858–59, Freret was engaged in building projects all over the city: the Touro Alms House, Levee at Piety Street (see cat. 123); three cast-iron fronts on Canal Street, for Theodore Frois, the Merchant's Insurance Company, and C.H. Slocomb Hardware; houses for H.M. Wright and A. Barbly, both on Esplanade Street; the Semmes residence at Edward and Annunciation streets; a house for E. Davis at Second and Prytania streets and another for E.W. Briggs at First and Coliseum streets; his own house at Third and Prytania streets; a residence for Louis Rose on St. Charles Street; cotton sheds and other buildings ("City Improvements for 1859," *Crescent*, September 12, 1859). He had recently completed the Carondelet Street synagogue (cat. 56). For other Freret projects, see cats. 70 and 89. After the war, Freret served as the state engineer of Louisiana (1866–68); architect of the Orleans Parish Schools (1874–84); and architect for the University of Alabama at Tuscaloosa (1880s). In 1885, President Chester Arthur appointed Freret Supervising Architect of the U.S. Treasury. He was a cousin of architect James Freret (see cats. 50 and 120).

6. The castellated armory style remained fashionable until about 1910. See Robert M. Fogelson, *America's Armories: Architecture, Society, and Public Order*, Cambridge, Mass. (Harvard University Press) 1989, pp. 118–219.

7. The Artillery battalion's cenotaph in Metairie Cemetery, 1880, records sixty-six military engagements of the company from the Mexican War through World War II. On the Artillery, see "Washington Regiment," *Weekly Delta*, November 17, 1845; *Courier*, November 6, 1858; "The Washington Artillery," *Picayune*, April 22, 1866; Napier Bartlett, *A Soldier's Story of the War, Including the Marches and Battles of the Washington Artillery*, New Orleans (Clark & Hofeline) 1874; William Miller Owen, *In Camp and Battle with the Washington Artillery of New Orleans*, Boston (Ticknor and Co.) 1885; Nathaniel Hughes, *The Pride of the Confederate Artillery: The Washington Artillery in the Army of Tennessee*, Baton Rouge (Louisiana State University Press) 1997.

8. "Armory Destroyed," *Picayune*, June 29, 1862.

9. Albert Diettel designed the new Artillery hall, the Southwestern Exposition Building. In 1872, Lilienthal photographed the building under construction for *Jewell's Crescent City Illustrated*, which was the basis for a wood engraving by J.W. Orr; see *Jewell's Crescent City Illustrated*, prospectus. The Washington Artillery survives in name as a

unit of the Louisiana National Guard.

10. *True Delta*, January 30, 1866; *Crescent*, December 28, 1867. The armory sold at auction in January 1868; *Crescent*, January 21, 1868. The survey for the sale, with an elevation, dated December 7, 1867, is in the Louisiana Collection, Tulane University Library. *Drawings of the Armory*, unsigned and undated, in the New Orleans Public Library may document a renovation or sale in the late 1860s.

11. "Historic Armory Edifice Spared from Wrecking," *Times-Picayune*, November 11, 1938; the façade was dedicated in the fall of 1939. "Bienville Plaza," *Times-Picayune*, December 13, 1938; "Transfer of Historic Façade Completed," *Times-Picayune*, August 13, 1939.

12. The façade was demolished during reconstruction of Bienville Plaza and riverfront park that included installation of a small amphitheater, which faces Decatur Street today; "People Place Seen for River," *Times-Picayune*, September 27, 1972; "Jackson Square: Anxiety Behind the Scenes," *Times-Picayune*, April 6, 1975.

53
Carondelet from Poydras St.
Rues Carondelet du coin de Poydras

Among the Exposition portfolio's many building and water views, Lilienthal included two street-corridor views made near his Poydras Street studio: this view of Carondelet and a view, one block away, of St. Charles (cat. 61). These streets, with nearby Camp and Magazine streets, formed the financial heart of the city, and Carondelet Street in particular was the center of the cotton trade. In reporting on Lilienthal's portfolio for the Paris Exposition in May 1867, the *Crescent* identified this view as the "Cotton Region of Carondelet street, where the bulls and bears most do congregate."[1] It was there that the brokers of cotton bought and sold New Orleans's most valuable commodity and charted the commercial fortunes of the greatest cotton market in the world.

Originally known as Apollo Street, Carondelet was named at the end of the eighteenth century for the governor of Louisiana. The street developed as a major commercial corridor in the mid-nineteenth century. "Carondelet street has received at last the impetus which will make it one of our most desirable promenades," the *Crescent* wrote in 1850.[2] In the decade before the war, the street was improved as "building after building, with palatial proportions and finish, gradually sprung up side by side."[3] Several of the best cast-iron buildings in the city were located there, rivaling nearby Camp and Canal streets, including the Wood Stores designed by Henry Howard and Albert Diettel in 1859—the

four-story iron front on the left-hand side of the street.[4] Beyond this was a white masonry building with cast-iron detailing, designed by Lewis Reynolds in 1858 and known as Factor's Row after the cotton factors who traded in the building. Factor Michel Musson, uncle of the painter Edgar Degas, moved his office to this building not long after this photograph was made. Degas produced two paintings of Musson's office there in 1873, among at least a dozen works he made during a five-month stay in New Orleans.[5]

The war brought commerce on Carondelet Street to a standstill. "Wholesale houses do no business; for the country trade is entirely shut off," Marion Southwood wrote, "and the city business amounts to almost nothing ... the stores are mostly shut." On Carondelet, she reported:

> the observing pedestrian could not fail to notice the great number of stores and offices that had black squares painted on the granite columns where formerly there were gilded letters Men mounted on ladders were every day taking down those signs, which were once the symbols of commercial activity.[6]

Early in the federal occupation, Carondelet Street was stirred to life, according to Southwood, by one of the "diableries" of General Benjamin Butler, whose "despotism," she wrote, "knew no bounds." Butler was dismayed at the "deplorable state of destitution and hunger of the mechanics and working classes" of the city, whose requests for sustenance strained the resources of his office.[7] He was particularly vengeful toward the "leaders of the rebellion, who have gotten up this war, and are now endeavoring to prosecute it, without regard to the starving poor." The Confederate merchants, he wrote, "have brought upon the city this stagnation of business, this desolation of the hearthstone, this starvation of the poor and helpless." In order to "relieve the suffering poor," Butler enacted a tax, assessed at up to $76,000, to be paid in one week, which hit the cotton factors

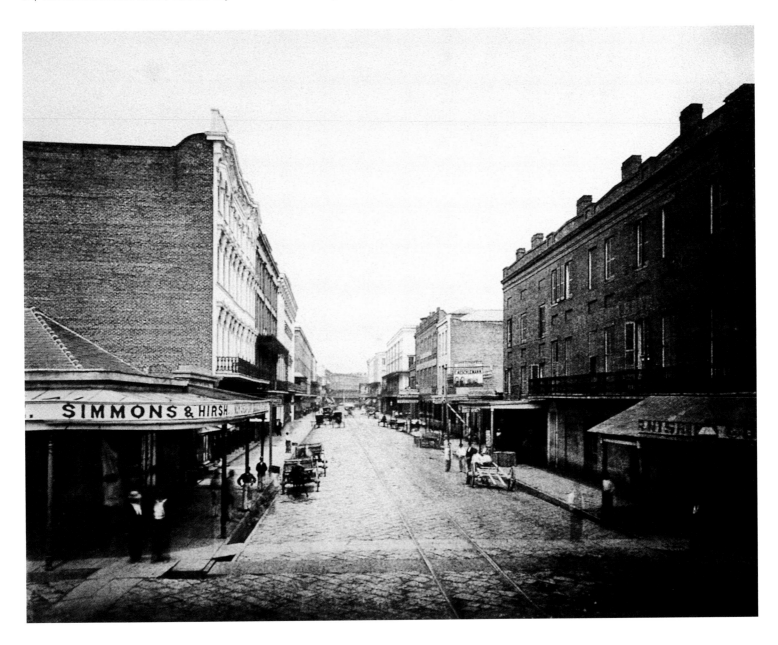

hard. The Union-controlled *Delta* observed sardonically the "scene of unwanted agitation" on Carondelet Street after Butler's order became known:

> For the first time those many months, the habitues of la Grande Rue were awakened from their ancient, snake-like lethargy. Sleek old gentlemen, whose stomachs are extended with turtle, and who sport ivory-headed canes, and wear on their noses two-eyed glasses rimmed with gold, came out from their umbrageous seclusions ... for the purpose of discussing the merits of the order ... [that was] destined to disturb the equilibrium of many a cash balance But gentlemen, ... the poor must be employed and fed, and you must disgorge. It will never do to be said that while you lay back in cushioned divans, tasting turtle and sipping the wine-cup, dressed in fine linen and rolling in lordly carriages—that gaunt hunger stalked in the once busy streets, and poverty flouted its rags under your aristocratic noses for the want of the privilege to work.[8]

In four months, Butler expended $340,000 that he had extracted from the factors and others, and soon called for more. A second tax was assessed of the same parties. The income financed federal public-works projects that put hundreds of unemployed, largely Irish and German immigrants, to work cleaning up the city.[9] In February 1864, the streets commissioner reluctantly admitted that after Butler's zealous scrub-down the city was "clean generally," a modest appraisal quickly overshadowed by the U.S. Surgeon General's declaration that New Orleans was now "the cleanest city in the Union." The *Times* was compelled to agree: "the streets are positively in better condition now in every respect than for years past."[10]

In 1867, Carondelet Street, freshly paved with square blocks of Massachusetts granite, was "one of the handsomest, most commodious, and pleasant thoroughfares in the city."[11] The street was served by the St. Charles Street Railroad; its tracks and a distant horsecar are visible in the photograph. Among the commercial businesses located there were the Simmons and Hirsh dry-goods store and, next door, a tobacconist—one of 165 retail tobacco dealers in New Orleans in 1867, when only grocers, dry-goods dealers, and bakers were more plentiful.[12] Anyone in the market for a new carriage or

wagon might come to the Carondelet Street showrooms of the Philadelphia Wagon Works or the depot of F. Aeschlemann Company (at mid-block), but sales of horse-drawn vehicles were in a slump in the 1860s. The wagon and carriage trade was dominated by northern manufacturers who had enjoyed a large and profitable southern plantation market, but the wartime collapse of sales throughout the South sent the industry into a dive from which it never recovered. One southern carriage dealer remarked after the war that "not one in a hundred" southerners could afford a carriage, and by the early 1870s the supply of new carriages in the South was at a thirty-year low.[13]

1. *Crescent*, May 1, 1867.
2. "Improvements," *Crescent*, July 2, 1850.
3. "Carondelet Street," *Picayune*, November 4, 1866.
4. Building contract, P.C. Cuvillier, April 26, 1859, NONA; *New Orleans Architecture*, II, p. 150.
5. Degas's *A Cotton Office in New Orleans* (Musée des Beaux Arts, Pau) and *Cotton Merchants in New Orleans* (Fogg Art Museum, Harvard University). Marilyn R. Brown, "Degas and *A Cotton Office in New Orleans*," *Burlington Magazine*, CXXX, March 1988, pp. 216–21; *ead., Degas and the Business of Art: A Cotton Office in New Orleans*, University Park (Pennsylvania State University Press) 1994; *Degas In New Orleans: A French Impressionist in America*, New Orleans (New Orleans Museum of Art) 1999, pp. 222–35, 243.
6. *Beauty and Booty*, pp. 60–63.
7. *Ibid.*, p. 75; Benjamin F. Butler, *Private and Official Correspondence of Gen. Benjamin F. Butler During the Period of the Civil War*, Norwood, Mass. (Plimpton Press) 1917, I, pp. 457–58.
8. *Delta*, July 20, 1862.
9. Lawrence Powell, "New Orleans, Louisiana," in *Macmillan Compendium: The Confederacy*, New York (Simon & Schuster) 1993, p. 770.
10. *Times*, February 23, 1864; "The Streets," *Times*, February 26, 1864.
11. Repaving of the commercial district began before the war (cat. 61); "Square Block Paving," *Picayune*, January 27, 1867.
12. *Gardner's New Orleans Directory for 1867*.
13. Thomas A. Kinney, *The Carriage Trade: Making Horse-Drawn Vehicles in America*, Baltimore (Johns Hopkins University Press) 2004, p. 17.

54
Synagogue Carondelet St
Cinagogue Rue Carondelet

New Orleans, with the largest Jewish community in the South, had four Jewish congregations in the 1860s. Temime Derech, or "Way of Righteousness," organized in 1857, was a small congregation composed mainly of Polish immigrants.[1] The earlier congregations of the Gates of Mercy (1828) and Gates of Prayers (1850) were predominantly German, and the Dispersed of Judah (1845) was initially a Spanish and Portuguese foundation. Lilienthal photographed three of these congregations for the Exposition portfolio, omitting only Gates of Mercy (cats. 56 and 88). The Temime Derech and Gates of Prayers congregations erected new synagogues after the war, both designed by the German-born architect William Thiel.[2]

The site of Temime Derech's new synagogue was the corner of Carondelet and Lafayette streets, behind City Hall.[3] In January 1866, workmen were "busily engaged in removing frame buildings" that filled the site.[4] Thiel supplied a "chaste and neat design" for a "Norman" building, which was erected quickly.[5] In a few weeks, with one floor completed, the cornerstone was laid, and on August 30, only a couple of hours after builder Peter Middlemiss "performed the last touches" to the structure, the synagogue was consecrated.[6]

Thiel designed Temime Derech with crenellated projecting towers—"like the turrets of a feudal castle"—with corbeling, round-headed windows, and trefoil friezes, and a rusticated raised basement.[7] A massive flight of steps led to a round-arched double entry, and a decorated round window illuminated the nave. The Romanesque style adopted by Thiel was often used in synagogues from the mid-1840s. The Jewish monthly the *Occident* praised the Romanesque as "best adapted" for synagogues: "the spectator will at once receive the impression that the building is intended for a place of worship, not of the poetical deities of the Greeks, nor the pompous trinity of the Christians, but of the mighty God of the Jews."[8]

The Temime Derech congregation dissolved after the turn of the nineteenth century, and in 1905 the synagogue was demolished and replaced by an annex to City Hall.[9] In Lilienthal's photograph, the tracks of the New Orleans and Carrollton Railroad (which ran a line on Carondelet Street) can be seen in the

York," *Occident*, IV, no. 5, August 1846, pp. 239–40, cited by Rachel Wischnitzer, *Synagogue Architecture in the United States: History and Interpretation*, Philadelphia (Jewish Publication Society of America) 1955, p. 44.
9. "The Polish Synagogue," *Jewish Ledger*, May 12, 1905.

55 *overleaf*

Methodist Church Carondelet St.

Eglise Methodiste Rue Carondelet

Built in 1851–53, the Methodist Episcopal Church on Carondelet Street, between Girod and Lafayette streets, was the third building of the oldest Methodist congregation in New Orleans. The designer of the church is unknown, but during construction the building collapsed and architect George Purves completed the work.[1]

The church was built of brick, plastered and scored to resemble stone. "Its front is unique," one observer wrote,

> "consisting simply of a massive Grecian portico, seventy-five feet wide and fifty feet high, of solid masonry, covered with white stucco, and crowned with a cupola reaching to a height of some eighty or ninety feet. Both outer and inner planes are broken by a central recess, producing the effect of three porticoes rather than one. Six pillars, five feet in diameter and some twenty-five feet high, support a massive entablature. A flight of eighteen white freestone steps ... a large central Grecian door and a large window on each side of the recess complete the façade."[2]

The interior sanctuary was frescoed and illuminated by an enormous chandelier, and two spiral staircases led down to a basement-level lecture room, assembly hall, and classrooms.

The building's most distinguishing feature was the lofty lantern venting the sanctuary, modeled on the ancient Greek monument of Lysicrates in Athens.[3] One of the most fruitful inventions in the history of architecture, this small Corinthian temple was widely admired and copied by nineteenth-century architects.[4] The most famous adaptations in America were by William Strickland, first for the Philadelphia Merchants' Exchange in 1832–34, and later in his Tennessee State Capitol.[5] In New Orleans, Alexander T. Wood modeled the Collector's Room of the Custom House (often regarded as the finest interior space in the city; cat. 19) on the monument, and it was also the source for several projects by James Dakin, including the Merchants' Exchange trading room and the

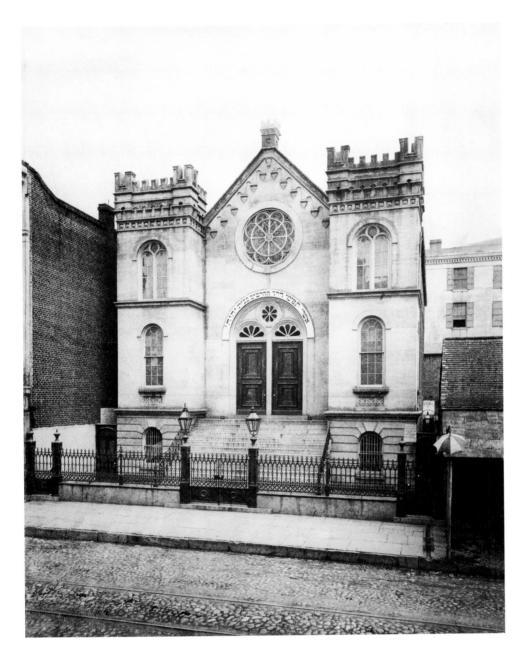

foreground and part of the side elevation of the City Hall is visible in the rear.

1. *Occident*, XV, no. 2, May 1857, pp. 202–203; XV, no. 8, November 1857, p. 408.
2. Thiel, one of the most active architects after the war, was the designer of the Gates of Prayers Synagogue (cat. 88) and the German National Theater (cat. 59), also completed in 1866–67. On Thiel, see Hilary S. Irvin, "The Impact of German Immigration on New Orleans Architecture," *Louisiana History*, XXVII, no. 4, Fall 1986, pp. 402–406. The commerce and institutions of the Jewish community during this period are surveyed in Walda Katz Fishman and Richard L. Zweigenhaft, "Jews and the New Orleans Economic and Social Elites," *Jewish Social Studies*, XLIV, 1982, p. 292; Elliott Ashkenazi, *The Business of Jews in Louisiana 1840–1875*, Tuscaloosa (University of Alabama Press) 1988.

For an overview of Jews in the South, see Robert N. Rosen, *The Jewish Confederates*, Columbia (University of South Carolina Press) 2000.
3. Building contract, H. Madden, XIV, no. 1668, January 9, 1866, NONA; Sources for the construction history of the synagogue include: *Crescent*, February 23, 1866; *Bee*, February 24, 1866; *True Delta*, February 28, 1866; *Picayune*, February 28, 1866; *Times*, August 29, 1866; *Bee*, August 30, 1866; *Crescent*, August 30, 1866; *Inventory of the Church and Synagogue Archives of Louisiana: Jewish Congregations and Organizations*, Baton Rouge (Louisiana State University, Department of Archives) 1941, pp. 27–8.
4. "A Synagogue," *Times*, January 23, 1866.
5. *Ibid.*; *Gardner's New Orleans Directory for 1867*, p. 6.
6. "Association Temime Derech, Consecration of the Synagogue," *Times*, August 30, 1866.
7. "A Synagogue," *op. cit.*
8. S.M. Isaacs, "Of the New Synagogue, Now Building at New

lantern of the first St. Charles Hotel (attributed, see cat. 64).[6] Dakin was especially skillful in his adaptation of Greek forms and may have been the designer of the Methodist Church.[7] There the ancient source was followed with precision: the lantern was close to the original scale of the monument, with the correct number of engaged columns (six) and a replica of the crowning finial of acanthus leaves.[8]

In carrying out his views of the city, Lilienthal organized the work according to the limitations of his medium. With one portable darkroom, he and his operatives were restricted in the physical range of subjects available to them on any one day. Exposures would have been planned according to the quality and direction of light (and the light-gathering power of the lenses), and Lilienthal would have exercised some choice in the selection of the most appropriate time of day at which to photograph. Commercial views with group portraits of proprietors and workers were made during business hours, but views of street corridors and building portraits were often taken in the stillness and clear light of early morning or in the late afternoon, when long shadows gave added relief to pavements and building façades.

Lilienthal selected a position for his bulky camera and tripod that would best frame each subject. The fiddly collodion chemistry, prepared in the confines of the photography wagon, was difficult to manage and materials were expensive, so alternative exposures were not common practice. "Under these conditions photography was a conceptual art," John Szarkowski has written; Lilienthal and other wet-plate photographers often determined the content of the picture long before the exposure was made, and would not know the success, or failure, of their work until they returned to the studio with the exposed negative.[9]

Lilienthal's oblique, elevated perspective of the church places the building firmly in its street context and gives it depth and mass. But this perspective also diminishes the effect of monumentality. The adjacent buildings give scale to what is, in reality, a modest structure, and the sharp angle of view reveals how shallow the portico is. Lilienthal rarely chose a ground-level frontal perspective, which in this instance would have produced a very different effect of a building with its grand orders and lofty cupola possessing the street.

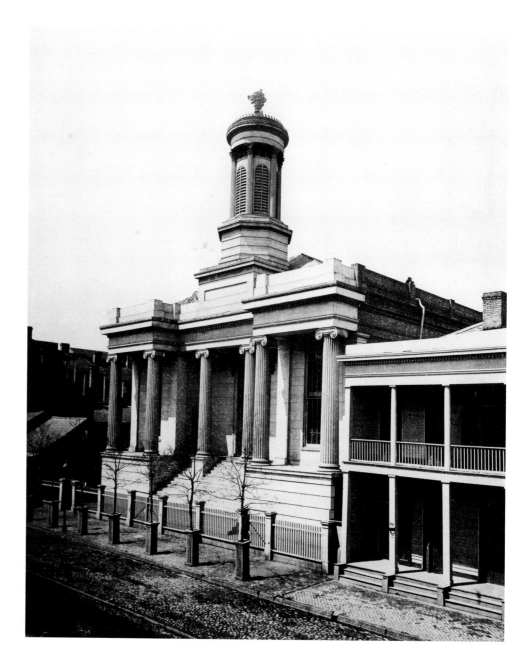

1. "Methodist Church," *True Delta*, March 30, 1851; *Picayune*, August 8, 1852; "Building Improvements: New Churches," *Picayune*, September 19, 1852.
2. "W.T.G.," "Letter from New Orleans," *Christian Advocate and Journal*, XXXIX, no. 36, September 8, 1864, p. 281.
3. The Greek source for the church was first identified in the *The Picayune's Guide to New Orleans*, New Orleans (The Picayune) 1897, p. 72. The church was also known as the McGehee Church, for Edward McGehee, a Mississippi plantation owner and the major contributor toward its construction costs.
4. The Choragic Monument of Lysicrates (335/334 BC) is located at the foot of the Athenian Acropolis. The monument originally supported a bronze trophy awarded to Lysicrates in a choral competition and is said to be the earliest surviving use of the Corinthian Order. Renewed interest in the monument from the 1840s led to its restoration in the 1870s and 1880s. Adaptations of this inventive form persisted well into the twentieth century and can be found in, for example,

Chicago's Wrigley Building by Graham, Anderson, Probst & White (1919–21). On the many eighteenth- and nineteenth-century adaptations of the monument, see Dora Wiebenson, *Sources of Greek Revival Architecture*, London (A. Zwemmer) 1969, pp. 61–65.
5. Agnes Addison Gilchrist, "The Philadelphia Exchange," in *William Strickland, Architect and Engineer 1788–1854*, New York (Da Capo) 1969, pp. 86–95. The Nashville capitol was built in 1845–59.
6. Stanley C. Arthur, *A History of the U.S. Custom House New Orleans*, New Orleans (Works Projects Administration of Louisiana, Survey of Federal Archives in Louisiana) 1940, p. 18 (see cat. 19). Dakin also based designs for a monument to George Washington (c. 1834) and a firehouse (1841) on the Lysicrates monument; Arthur Scully, Jr., *James Dakin, Architect: His Career in New York and the South*, Baton Rouge (Louisiana State University Press) 1973, pp. 26–27, 103–104. Another contemporary derivation is a firehouse by

James Gallier at Levee (North Peters) and Bienville streets, 1836; see D. Augustin, XCII, no. 10, NONA. See also the discussion of the Lysicrates monument as a model in Mills Lane, *Architecture of the Old South: Louisiana*, New York (Abbeville Press) 1990, pp. 96–99.

7. Mills Lane, *op. cit.* (Lane reproduces a half-stereo of the church by Samuel Blessing).

8. In 1905, a Masonic lodge acquired the church, removed the cupola, and remodeled it as the Scottish Rite Temple. The temple is still in use. (I would like to thank Phil J. Walker, Jr., Secretary of the Scottish Rite Bodies, for his assistance.)

9. John Szarkowski, *Looking at Photographs*, New York (Museum of Modern Art) 1973, p. 28.

56
Synagogue Carondelet St
Cinagogue rue Carondelet

The Dispersed of Judah, the second Jewish congregation established in New Orleans, built this synagogue on Carondelet Street, between Julia and St. Joseph streets, in 1857.[1] Designed by Will Freret, the Dispersed of Judah was "conspicuous among the recently erected edifices in this city," the Jewish weekly the *Asmonean* reported in 1857.[2] "It stands out, bold and classic in its outlines, and challenges the imagination of every passerby. Its beauty is of that kind which is derived from its simplicity of style and massiveness of structure, and which is always a pleasure to the eye."[3] Constructed for $70,000, the building was said to be "probably the most costly Jewish place of worship in the country."[4] It was described as the "phoenix" of the congregation's first synagogue—Christ Church on Canal Street— which had been remodeled by Judah Touro in 1850 from an original building by James Gallier and James Dakin.[5] When Christ Church was demolished in 1856, its colossal, 40-foot (12-m) Ionic columns were reused in the pedimented portico of the new Carondelet Street synagogue. "The building in appearance is the exact counterpart of the old Synagogue," the *Picayune* wrote. The basilican plan, "eminently neat and classic" on the interior, had front and side galleries supported by Corinthian columns.

One-third of the way up the central space stands the *tebah*, or reader's desk; and midway between that and the ark, which occupies a recess in the rear extremity, is erected a pulpit, of peculiar formation, entirely of mahogany. The floor, the *tebah*, and the steps in front of the ark are covered with rich carpeting; and suspended from the ceiling is a costly and elegant chandelier. The recess for the ark and a portion of the space above it is decorated with fresco painting; while on either side it is supported and ornamented with columns and capitals of elaborate finish.[6]

Architect Thomas K. Wharton, witnessing the consecration of the synagogue in April 1857, wrote that "[t]he arrangement of the interior [is] similar to that of the great & ancient Synagogue at Amsterdam."[7] Freret's project included residences at the rear of the luxuriant grounds for the rabbi and the sexton and, along the street front, a high, ornamental iron-and-granite fence.

Although by the 1850s the Jewish population of New Orleans was the largest in the South, early Jewish settlement had been impeded by an erratically enforced "Code Noir" of the French colony that regulated the slave trade and also prohibited all forms of worship other than Roman Catholicism. After annexation to the United States in 1803, New Orleans was legally open to Jewish settlement, but growth of a local community was slow. Portuguese and German immigrants organized the first congregation, the Gates of Mercy, in 1828.[8] In 1845, Portuguese members of this congregation, who practiced the Sephardic rite, separated to form the Dispersed of Judah.

During the war, most of, if not all, the rabbis of New Orleans largely supported the Confederacy and continued to hold services as long as federal authorities permitted. James K. Gutheim, the rabbi of the Dispersed of Judah, was forced to leave the city for refusing to take the oath of allegiance demanded by the U.S. military. "We have nothing to advance one way or the other respecting the mandate which condemns Mr. G. with many of his congregation to exile and poverty," the northern Jewish monthly the *Occident* declared.[9] One of the Dispersed of Judah congregation, the diarist Clara Solomon, recalled that Gutheim's prayers were offered "earnestly for the S. Confederacy," while Solomon herself displayed contempt for the "Northern Vandals" who occupied the city more confrontationally. She could not bear to "breathe the air tainted by the breath of 3000 Federals," and when passing a Union soldier in the street, she wrote, "I lifted up my dress, [and] put my kerchief to my nose."[10] In a place that was historically more tolerant of difference and diversity than many American cities, Solomon's antagonism toward those she saw as "conquerors" was not surprising in light of the anti-Semitism some northerners

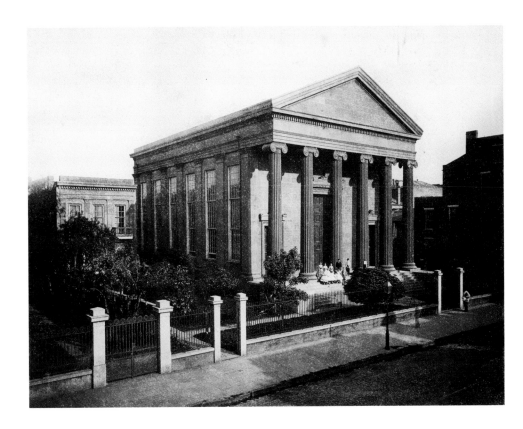

expressed openly. One northern journalist, quoted by the Jewish periodical *The Israelite* in 1863, asserted that "The Jews in New Orleans and all the South ought to be exterminated. They run the blockade, and are always to be found at the bottom of every new villainy."[11]

With congregations scattered, religious leaders in exile, treasuries empty, and sanctuary doors sometimes locked down, public worship and religious life in the South was endangered during the war. "There is a great scarcity [in the South] of ministers and religious functionaries," the *Occident* wrote in 1864, "and the observances therefore are few and very much neglected."[12] While some congregations in New Orleans rebounded from the war and even embraced new building campaigns (cats. 54 and 88), the Dispersed of Judah never regained its antebellum stability. For nearly two decades, "[t]he disasters of the war rested upon the congregation," according to one report, and in 1881 it reunited with the Gates of Mercy to form a new congregation named for Judah Touro.[13]

The architect William Fitzner rebuilt the Carondelet Street synagogue for the Touro congregation in 1888, leaving only the original façade and foundation.[14] Over the next two decades the congregation became less closely tied to the older immigrant neighborhoods downtown and, in 1907, it abandoned Carondelet Street for an uptown location. Two years later the Touro congregation dedicated a new synagogue, designed by Emile Weil, on St. Charles Avenue, where it remains today. Remodeled by the Knights of Columbus as a fraternal hall, and before 1950 by a trade union, the old Carondelet Street building, once highly admired, was razed and replaced by an automobile dealership.

1. On Dispersed of Judah and the Carondelet Street synagogue, see *Occident*, III, no. 8, November 1845, p. 416; V, no. 4, July 1847, p. 275; VIII, no. 1, April 1850, pp. 57–58; VIII, no. 3, June 1850, pp. 108–34; *Picayune*, May 6, 1856; *Picayune*, March 8, 1857; *Crescent*, March 16, 1857; *Constitution and By-Laws of the Hebrew Congregation of the Dispersed of Judah*, New Orleans (Clark & Brisbin) 1860; *Times-Democrat*, August 21, 1882, and December 13, 1885; *Picayune*, April 6, 1889; *Inventory of the Church and Synagogue Archives of Louisiana: Jewish Congregations and Organizations*, Baton Rouge (Louisiana State University, Department of Archives) 1941, pp. 1–3, 9–10, 19–22.
2. The architect Thomas K. Wharton also submitted plans for the synagogue in March 1855; Wharton, "Diary," March 14, 1855, and February 8, 1856; *Asmonean*, XV, no. 23, March 20, 1857, pp. 180–81, reprinting an article in the *Picayune*, uncited.
3. *Asmonean*, XV, no. 23, March 20, 1857, pp. 180–81.
4. *Occident*, VII, no. 4, July 1849, p. 224; XV, no. 1, April 1857, pp. 47–48.
5. *Delta*, February 29, 1852; "City Improvements," *Crescent*, October 21, 1856.
6. "Dedication of the New Synagogue Nefutzoth Yehudah, in New Orleans," *Occident*, XV, no. 1, April 1857, pp. 79–93, reprinting an article in the *Picayune*, April 2, 1857.
7. Wharton, "Diary," April 1, 1857. The reference here is to Amsterdam's seventeenth-century Sephardic synagogue, also a galleried basilican building, which was renovated in 1852–53. See Carol Herselle Krinsky, *Synagogues of Europe: Architecture, History, Meaning*, Cambridge, Mass. (MIT Press) 1985, pp. 391–95.
8. *Courier*, April 11, 1828.
9. *Occident*, XXI, no. 3, June 1863, p. 140.
10. Clara Solomon, *The Civil War Diary of Clara Solomon: Growing Up in New Orleans 1861–1862*, ed. Elliott Ashkenazi, Baton Rouge (Louisiana State University Press) 1995, pp. 354, 425. Solomon married Lilienthal's elder brother, Julius, in 1866.
11. *Israelite*, IX, no. 33, February 20, 1863, p. 258, cited in Bertram W. Korn, *American Jewry and the Civil War*, New York (Meridian Books) 1961, p. 163, and by Robert N. Rosen, *The Jewish Confederates*, Columbia (University of South Carolina Press) 2000, p. 275, n. 175.
12. *Occident*, XXII, no. 2, May 1864, p. 95.
13. *Picayune*, June 3, 1881; "The Jews," *Times-Democrat*, August 21, 1882.
14. Building contract, Abel Dreyfus, XL, no. 61, November 30, 1888, NONA.

57
Private Residence
Maison Privée

The residence of Dr. George Washington Campbell at St. Charles and Julia streets was "one of the finest in the city" when it was completed in late 1859.[1] Campbell was a physician who had settled in New Orleans in 1822, and accumulated great wealth operating two sugar plantations. The house was "erected in flush times before the war," the *Times* later reported, and "finished in the finest style," including frescoed walls and a magnificent spiral staircase of rosewood.[2] The designer was Lewis E. Reynolds, a New York-trained architect whose work included the Poydras Asylum (cat. 101), Canal Bank (cat. 65), and the cast-iron-fronted Story Building (fig. 11), which was completed in the same year as the Campbell house.[3] Reynolds's interest in decorative iron casting is evident here in his use of iron columns and railings and the elaborate fence patterned after corn stalks and morning-glory vines, supplied by the local outlet of Philadelphia's Wood & Perot foundry, the country's leading ornamental ironworks. The

same fence pattern was ordered for other residences in New Orleans, Galveston (Texas), and Philadelphia, as well as for the New York Custom House.[4]

During the war, when federal troops took possession of residences belonging to "absent Rebels" for use as officers' quarters, General Benjamin Butler appropriated the Campbell house.[5] Butler was "very fastidious about locating his family, it must live in style," Marion Southwood remarked in *Beauty and Booty*; "he and his wife visited many mansions before making up their minds which to choose." Butler reportedly had the owner, Mrs Campbell, "suddenly, just before dark, turned into the street; her horses and carriage taken from her, and some of her servants." As Union soldiers prepared the house for Butler's family, someone made off with the Campbell silver. "It is almost impossible to give an inkling of what our people have suffered," Southwood wrote, "in insult, wrongs, deprivation of rights, confiscation of property, seizing of private dwellings, and turning into the street the families occupying them."[6] The General became known in New Orleans as "Spoons" Butler for the alleged plundering.

Among the occupiers, Union Captain John W. De Forest might have agreed, in principle, with Southwood. "Now all this looting and foraging is a disorder and a shame," he declared. "Of course it is General Butler who is chiefly at fault for it."[7] De Forest took exception to the comforts enjoyed by his fellow officers who were "grandly lodged and abounding in foraged claret" in confiscated dwellings, while his field regiment had been, he wrote "so vilely lodged that I would have been grateful for a stable to sleep in." But the city's private wine-cellars left unattended were too great a temptation, even for De Forest. While another officer and his party consumed dozens of bottles of burgundy from the well-stocked cellar of an absent owner, De Forest declared the wine "soured and corky" and his comrade a "barbarian" for his bad taste. "But the sauterne [sic] ... served iced for breakfast, was in good condition and superior quality," he reported.

The allegations of looting by federal soldiers, and by Butler himself, followed Butler everywhere, even in the northern states. In Boston it was reported that "[t]hree ships, two steamers and one bark" had arrived at Long Wharf carrying "the immense wealth accumulated by General Butler and his staff while stationed at New Orleans." The booty

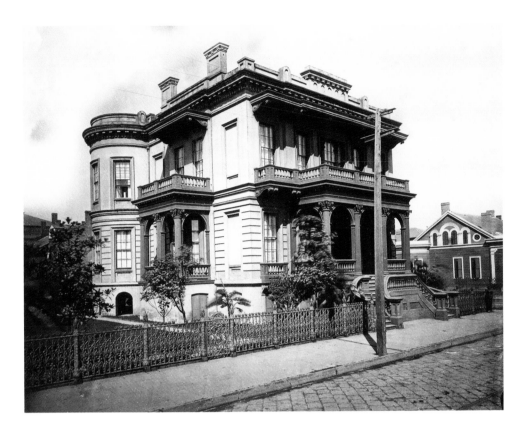

included gold rings allegedly "stolen from the ladies while walking in the streets," silver doorknobs, gold pens, silver pencil cases, "two boots full of diamonds," twenty-one pianos—"one for each of the staff"—two church organs, and five poodles.[8] "Don't think that you have so easily gone to New Orleans and robbed," a "New Yorker" wrote on the occasion of a dinner Butler attended there in 1863. "No; you are to answer to the people of the North for your thieving."[9] Butler, for his part, claimed to have suppressed the looting by apprehending and executing a gang of thieves he accused of impersonating federal soldiers. After his return to the North, he took up the mournful appeal of the destitute widow of one of the men he had executed. "I directed that a sewing machine ... should be purchased and given to her," he wrote in his memoirs.[10]

Campbell died in 1874.[11] The house was eventually divided into rental units and shops as the district became increasingly commercial after World War II. In 1965, the house was demolished to make way for a parking lot, although the carriage house was spared for use by parking attendants.[12]

Across Julia Street from the Campbell house, at the far right of the photograph, is the former residence of planter, factor, and legislator Maunsel White, who died in 1863. One of the most prominent residents of New Orleans before the war, White was widely known for marketing a pepper sauce made from tabasco chilies, which he claimed was a preventative for cholera.[13] In the foreground of Lilienthal's photograph, telegraph lines follow the tracks of the New Orleans and Carrollton Railroad, just visible entering the picture frame in the lower right-hand corner. Several of the Exposition photographs document telegraph service in the commercial district of New Orleans, which had been linked to the East by the second oldest telegraph company in the country, the Washington and New Orleans Telegraph, organized a decade before the war.[14]

1. "Building Improvements," *Crescent*, September 12, 1859.
2. *Times*, April 18, 1878.
3. Another Reynolds project remarkable for the use of cast-iron detailing was Factor's Row on Carondelet Street of 1858 (cat. 53). On Reynolds, see *Picayune*, February 6, March 25, and July 13, 1850; and *Commercial Bulletin*, January 19, 1854. Reynolds's biography is in *Jewell's Crescent City Illustrated*. For an account of his career, see S. Frederick Starr, *Southern Comfort: The Garden District of New Orleans*, New York (Princeton Architectural Press) 1998, pp. 126–47.
4. Robert Wood & Co., *Portfolio of Original Designs of Ornamental Iron Work*, Philadelphia, *c.*1866–70, pattern no. 115. I would like to thank Ann Howell, who is preparing a study of Wood & Perot, for this reference. Also in 1859,

architect Henry Howard used the corn-stalk railing for the Colonel R.H. Short residence on Fourth Street, still extant (a second example survives on Royal Street in the Vieux Carré). Wood & Perot's New Orleans agent was Miltenberger C.A., a major supplier of ironwork in the city. See Frances Lichten, "Philadelphia's Ornamental Cast Iron," *Antiques*, LXXII, August 1952, p. 113; Julia Nash, "Lacy Iron: Nineteenth-century American Ornamental Castings and Robert Wood of Philadelphia," *Pennsylvania History*, XXXIV, July 1967, pp. 236–37; Ann M. Masson and Lydia H. Schmalz, *Cast Iron and the Crescent City*, New Orleans (Gallier House) 1975, p. 19. For a mid-century account of the Philadelphia foundry, see C.T. Hinckley, "A Day at the Ornamental Iron Works of Robert Wood," *Godey's Lady's Book*, XLVII, July 1853, pp. 7–8.
5. "List of Officers assigned by the Qr. Mr. Department" and "Houses Assigned to Officers as Quarters," 1865, Consolidated Correspondence File 1794–1915, Records of the Office of the Quartermaster General, RG92, NARA.
6. *Beauty and Booty*, pp. 64–67.
7. John William De Forest, *A Volunteer's Adventures: A Union Captain's Record of the Civil War*, ed. James H. Croushore, New Haven, Conn. (Yale University Press) 1946, pp. 48–50, and for the quotations that follow in this paragraph.
8. *Beauty and Booty*, pp. 265–66.
9. Benjamin F. Butler, *Private and Official Correspondence of Gen. Benjamin F. Butler During the Period of the Civil War*, Norwood, Mass. (Plimpton Press) 1917, II, p. 569.
10. Benjamin F. Butler, *Butler's Book: Autobiography and Personal Reminiscences*, Boston (A.M. Thayer) 1892, I, p. 449.
11. *Picayune*, December 9, 1874; "Death of an Old and Influential Citizen," *Picayune*, December 13, 1874.
12. Mary Cable, *Lost New Orleans*, Boston (Houghton Mifflin) 1980, pp. 89–90.
13. *Delta*, January 26, 1850. White's daughter and son-in-law occupied the house from 1870, remodeling it extensively. It was later demolished (communication of Maunsel White, III, July 31, 2004, and March 2006). See also Arthur Scully, Jr., *James Dakin, Architect: His Career in New York and the South*, Baton Rouge (Louisiana State University Press) 1973, pp. 126–27 and 199, n. 7. On White, see Clement Eaton, *The Mind of the Old South*, Baton Rouge (Louisiana State University Press) 1967, pp. 69–89.
14. See J. Cutler Andrews, "The Southern Telegraph Company, 1861–1865: A Chapter in the History of Wartime Communication," *Journal of Southern History*, XXX, no. 3, August 1964, pp. 319–20. Telegraph lines can be seen in cats. 17–19, 53, and 62–64. Even today, an unusual aspect of the New Orleans cityscape is the presence of utility poles and wires, which have been removed from many urban streets across the country—evidence of the difficulty and expense of laying lines below ground in the city's marshy soil.

Private Residence
Résidence Particulière

The unidentified house in this view is a two-and-a-half-story, side-hall American town house, with a semidetached service wing.[1] Similar houses could be found on many streets of the First and Fourth districts uptown where Anglo-Americans settled in the late 1840s and 1850s. It is set close to the sidewalk in town-house style, on a wide lot with a side carriage entrance, and is probably built of brick, with a covering of scored plaster. The shutters have been pulled open to reveal mullioned windows. The stepped, double-chimneyed gable end was typical of mid-century houses, and the liberal use of cast iron would also suggest an 1850s date. The lavish, two-story, cast-iron gallery distinguishes this house from the relatively plain brick front of its neighbor (with only a modest iron railing), and the netted ironwork in a floriated pattern, with anthemion cresting, was a fine example of the output of the ornamental ironworks that supplied New Orleans and other cities with castings at mid-century. Many of these foundries were located in Philadelphia and New York, and maintained showrooms or distributors in New Orleans, although several local ironworks, including Bennett & Lurges (cat. 80), also marketed architectural iron. (See also cat. 57.)

The women of the family pose on the gallery near the private rooms of the second floor. The gallery was a suitable adaptation to the sultry climate of New Orleans, but even in the late 1850s, the decade that brought galleried house fronts into fashion, an argument had to be put forward for their greater use. The *True Delta* complained:

> We still are deficient [in] the adaptability of our private residences to the climate … . New Orleans, of all other American cities, can boast of its balconies and verandas. But we should like to see them come into universal use. Give us a city of balconies, verandas, and terraces—a city of airy and graceful architecture, of material and colors adapted to a semi-tropical country."[2]

The town-house lot is enclosed by a tall, plank fence for privacy and a boxed post-and-picket fence on a more domestic scale, giving some visibility into the property while bounding it, like the masonry and open ironwork fences of European estates.[3] This was a more refined version of the common paling fence that was distinctly out of fashion in 1867. The *Picayune* found "something rural and particularly Louisianan about a picket fence," but also "odd and out of place" in the city.[4] Ornamental cast iron was a more suitable and stylish railing, especially for a building with any design pretensions. State lawmakers expressed this sentiment most explicitly when debating a proper enclosure for the state capitol before the war: "we have here a magnificent building, grand in design, elegant in architecture [that] no one would be willing to see … surrounded by a miserable picket fence."[5]

The former slave quarters are located adjacent to the main house, with a narrow gallery facing them, and fenced in their own enclosure. At the rear of the house is a large cistern to collect rainwater, "an unfailing adjunct to every structure," as *Harper's Weekly* observed, in a city where rainfall was plentiful and wellwater was unfit for drinking or washing. "These cisterns are occasionally quite elegant, rising out of a shrubbery of palms, bananas, pomegranates, and crape myrtles, and draped with honey-suckles," *Harper's* wrote.[6] Some visitors had to become reconciled to this unusual "mighty cask … propped against the house-corner on stilts," just as Mark Twain had; he found something of a "mansion-and-brewery suggestion about the combination which seems very incongruous at first."[7] Cisterns were usually built of cypress on a brick foundation, and might hold 5000 gallons (23,000 litres) or more of water, although this one appears to be of a more conventional size. Rainwater was fed from the cistern to an attic storage tank or directly to the kitchen and bathrooms, where occupants filled buckets as needed. Piped water systems and such plumbing fixtures as bathroom sinks, bathing tubs, and water closets came into more frequent domestic use by the 1860s.[8]

The saplings seen here were probably planted during the spring of 1867, when the city gardener distributed two thousand 10-foot (3-m) oak trees throughout the city. The beautification project was an effort to relieve the barrenness of city streets. "There are at present no remarkable fine avenues of trees," the *Crescent* wrote. "Should those that are at present being planted ever attain the size of those in the City Park and other places, they will form a sight well worth seeing."[9] Today, New Orleans is a city much admired for its canopies of old oak trees that shade many of its residential streets.

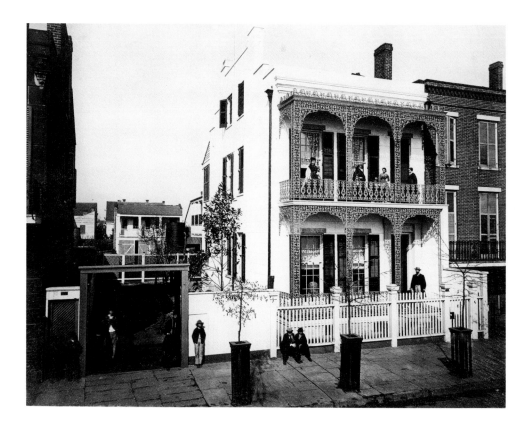

1. The house-number of the neighboring residence, barely legible, places the building in the 500 block of what may be Camp Street, bounded by St. Andrew and Josephine streets, a densely built block with similar town-house construction. For discussion of the American town house, see "Types and Styles," in *New Orleans Architecture*, IV, pp. 63–66. I thank Sally Reeves for her assistance with research on the location of this house.

2. "Architecture in New Orleans," *True Delta*, July 14, 1859.

3. Philip Dole, "The Picket Fence at Home," in *Between Fences*, ed. Gregory K. Dreicer, New York (Princeton Architectural Press) 1996, pp. 27–35. See cat. 30 for an example in New Orleans of the European estate fence.

4. "Out of Place," *Picayune*, August 6, 1867.

5. Legislature of the State of Louisiana, *Debates in the Senate, Session of 1853. Appendix. Report of the Joint Committee on the ... New Orleans, Jackson and Great Northern Railroad*, New Orleans (Emile La Sere) 1854, p. 172.

6. "Sketches of New Orleans," *Harper's Weekly*, XI, no. 532, March 9, 1867, p. 158. "The Former and Present Times ...," *De Bow's Review*, VII, no. 5, November 1849, p. 419.

7. Mark Twain, "Life on the Mississippi," in *Mississippi Writings*, Berkeley (University of California Press) 1982, p. 472.

8. Maureen Ogle, "Domestic Reform and American Household Plumbing, 1840–1870," *Winterthur Portfolio*, XXVIII, no. 1, Spring 1993, pp. 33–58; Merrett Ierley, *The Comforts of Home: The American House and the Evolution of Modern Convenience*, New York (Three Rivers Press) 1999, p. 102. Architect James Gallier, Jr., engineered both cold and hot running water in his residence on Royal Street (today a house museum) in 1857; see Ogle, *op. cit.*, pp. 97–103.

9. Minutes and Proceedings of the Board of Assistant Aldermen, VII, 1867, pp. 507–11, City Archives, New Orleans Public Library; "An Improvement in the City," *Crescent*, March 1, 1867; *Wheeling Daily Intelligencer*, March 18, 1867.

59

New German Theatre Baronne St

Nouveau Theatre Almand Rue Baronne

The audience for Lilienthal's portfolio was European, some part of the 7 million visitors who attended the Paris Exposition of 1867 (as well as the Emperor Napoléon III himself). Many of Lilienthal's photographs, like the one shown here of the German Theater, document institutions that were established by European émigrés serving a foreign-born constituency, underscoring the strong cultural traditions of Europe in mid-nineteenth-century New Orleans. Such traditions were nowhere more clearly expressed than in the architecture of these institutions, often the work of foreign-born architects using an architectural language derived from European models, and designed for clients who remained tied to their European origins.

In 1866, a partnership of three "enterprising capitalists and ardent Germans," Christian and Louis Schneider and Herman Zurberbier, hired German-born William Thiel, architect of the

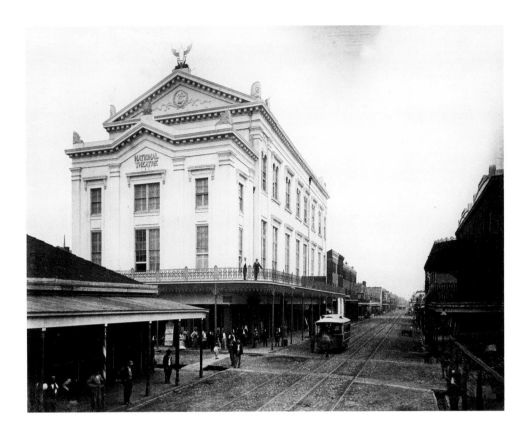

Temime Derech and Gates of Prayers synagogues (cats. 54 and 88), to design a national theater.[1] New Orleans had the largest German community in the South and in 1839 had established one of the earliest German-language theaters in the country—a demonstration, *Niles Weekly Register* wrote, that the Germans of New Orleans "must be men of taste and refinement."[2] Three German theaters were built between 1839 and 1862, all destroyed by fire.

The site of the new theater was Perdido and Baronne streets, the location of an old railroad depot of the Carrollton, Jefferson, and Lake Pontchartrain Railroad. Built in less than five months, at a cost of $200,000, the theater opened in November 1866 (one of the few important buildings illustrated in Lilienthal's portfolio erected after the war). With the expansion of the Poydras Market nearby (cat. 60), the theater helped revitalize the old Baronne Street railroad corridor as a commercial district. "A better class of business houses are seeking locations near the new Theatre," the *Bee* observed; "rents are higher, stores are in greater demand, and the small retail tradesmen and second-hand clothiers are being pushed on another block toward the suburbs It has also made the street a

favorable promenade with those who never trod its pavement before." The *Bee* compared construction of the theater to the urban interventions of Napoléon III, who had "increased the value of property [in Paris] more than five hundred percent," the *Bee* stated, by projects and public works, and by "the encouragement given to popular entertainments," including new theaters.[3]

The stuccoed-brick exterior of the theater was ornamented with Doric and Ionic pilasters, masks at the blocking courses, and, crowning the upper gable, a winged lyre flanked by dolphins. Across the lower gable "National Theatre" was written in gilded letters. For the interior plan Thiel borrowed elements from Carl Ferdinand Langhans's Berlin Staatsoper and James Gallier, Jr.'s French Opera House in New Orleans (cat. 16), itself influenced by Langhans's famous work. In response to the tragic history of the earlier German theaters, which were all destroyed by fire, Thiel attempted to fireproof the building with a structural system of iron pillars, iron plates, and brick arches, and a ventilation system that utilized eighty gas chandeliers, some arranged in the form of an enormous lyre, to light the auditorium and vent inside air through exhaust stacks. The ceiling was frescoed and the proscenium, decorated

with the Muses, was hung with a painted curtain. The acoustics were "astonishing," the *Crescent* exclaimed. "What strikes you upon first entering are the spacious qualities of the building, [and] the ease with which sound is heard in its every part."[4]

During the winter of 1867, the German Theater staged now-forgotten works by Errico Petrella and Friedrich Flotow, and the once enormously popular romance *Das Donauweibchen* by the Austrian composer Ferdinand Krauer, announced on the signboard in the photograph. The new theater momentarily revived local interest in German opera and drama, but the audience that had supported hundreds of German-language performances before the war was eroding. The theater was able to sustain a German repertoire only until 1873, when it closed.[5] Variety shows then took over the stage. In 1880, the building was renamed Werlein Hall for a new owner and given over to amateur productions and an organ factory. A fire in July 1887 destroyed the building, and since 1906 the site has been occupied by a hotel.[6]

For this view, Lilienthal selected an elevated vantage point that places the theater squarely in the confines of its Baronne Street corridor. The deep perspective toward Poydras Street reveals how imposing the 100-foot (30-m) building actually appeared in the street, where no other structures come close to its height and mass. The men, who are probably the proprietors, posing on the gallery complete the portrait of the new business enterprise.[7]

1. "Building," *Times*, June 22, 1866. The following newspaper accounts chronicle the project from July through December 1866: *Deutsche Zeitung*, July 12, 1866; "The City," *Picayune*, July 18, 1866; *Deutsche Zeitung*, August 28, 1866; *Deutsche Zeitung*, September 13, 1866; "The National Theater," *Crescent*, September 17, 1866; "The German Theatre," *Times*, September 17, 1866; *Deutsche Zeitung*, October 4, 1866; "The New German Theatre," *Times*, October 9, 1866; "National Theater—Grand Opening," *Picayune*, November 21, 1866; "The National Theater," *Crescent*, November 22, 1866; "The National (German) Theatre," *Picayune*, November 22, 1866; "The National Theater," *Picayune*, November 23, 1866; "German Theatricals," *Picayune*, November 28, 1866; "The New German Theater," *Crescent*, December 1, 1866; "Wanted: A New Public Hall," *Bee*, December 12, 1866; *Gardner's New Orleans Directory for 1867*, pp. 6–7; *Bee*, February 21, 1867. On Thiel, see Irvin, *op. cit.*, p. 151, n. 2.
2. *Niles Weekly Register*, LVII, November 2, 1839, p. 160.
3. "Wanted: A New Public Hall," *op. cit.*
4. "The New German Theater," *Crescent*, *op. cit.*
5. William Robinson Konrad, "The Diminishing Influences of German Culture in New Orleans Life Since 1865," *Louisiana Historical Quarterly*, XXIV, no. 1, January 1941, pp. 156–57;

Arthur Henry Moehlenbrock, "The German Drama on the New Orleans Stage," *Louisiana Historical Quarterly*, XXVI, no. 2, April 1943, pp. 361–627.
6. *Times-Picayune*, May 9, 1920.
7. The photograph was a success, even if the theater itself was not; Lilienthal later reprinted it for an engraving by J.W Orr in *Jewell's Crescent City Illustrated* of 1873.

60
Poydras Market
Marché Poydras

Poydras Market, viewed here from the corner of Baronne Street, was built in 1837–38 on land that was once part of the Julien Poydras plantation. The property was ceded to the city by the New Orleans and Carrollton Railroad to stimulate commercial development of the district (the Baronne Street line of the railroad can be seen entering the frame in the lower right). Designed by City Surveyor Frederick Wilkinson, the market shed was the fifth in a citywide network of open-air public markets, and supplied the Anglo-American community uptown with fresh food.[1] The skeletal canopy of cast-iron posts, wood trusses, and slate roof allowed easy access to market stalls along its 400-foot (122-m) length, minimizing traffic congestion caused by parked drays unloading their goods.[2] A distinctive gable end with segmental arches, fanlight windows, and a cornucopia relief gave the simple building a more ornamental appearance than most market sheds. Crowning the building was a 35-foot-tall (11 m) ventilating cupola with an onion dome, marking the passage of Dryades Street through the structure.

After the war, as the city looked for ways to replenish the depleted municipal treasury, a plan to expand the public market projected a $25,000 annual revenue from market leases. The expansion launched a frenzy of speculative commercial building, revitalizing the neighborhood. The *Times* reported "at least twenty" brick retail stores and warehouses, and the German Theater (cat. 59), under construction within a block of the market in 1866. "There is no neighborhood that has so rapidly improved in as short a space of time as the vicinity of Poydras Market," it observed.[3] The new iron extension of the market shed, fabricated by the Bennett & Lurges foundry (cat. 80), opened in February 1867, expanding market stalls as far as Basin Street. The "beautiful, airy and graceful" shed was named

Pilié Market for city surveyor Louis H. Pilié, who designed it.[4]

Public markets like this were major interventions in the street grid of New Orleans and generated development that can still be detected today. Existing streets were widened or new streets cut to accommodate the expansive market sheds or to service them. Old market sites can be read in the urban plan as voids and are marked by streets that terminate unexpectedly. The Poydras, Tremé, St. Mary, Sorapuru, and a dozen other markets were prominent features of the nineteenth-century city, but by the late 1920s the street markets were victims of residential settlement away from the city center, the reconfiguration of streets to accommodate the automobile, and changing shopping patterns.[5] The Poydras Market was especially vulnerable as the Poydras Street corridor evolved from a mixed residential and retail neighborhood into one of the city's major commercial office districts.

The widespread implementation of mechanical refrigeration in the 1920s also had an impact on the life and death of the public markets. A century earlier, the availability of natural ice from northern suppliers ended the monopoly of the public markets by extending the life of fresh food and allowing corner retail grocers to flourish.[6] Commercial refrigeration—which few open-air markets in New Orleans successfully integrated—again allowed retail stores to obtain an edge on the consumer market. Shoppers increasingly turned away from the old street markets in favor of grocery stores, which were often perceived as more sanitary and efficient food handlers, and more convenient, providing one-stop shopping in locations more accessible to the automobile. The economics of the distribution of supply also changed with the rise of national food chains, and well before World War II public markets were disappearing across the country.[7] After almost a century of operation, the Poydras Market closed in early 1932, and was soon demolished.[8]

Lilienthal's view from a second-floor balcony is a record of market-day incident. Peddlers have set up chairs and covered small patches of pavement with their goods, and a vegetable vendor awaits customers. A trio of men wearing homburg hats, one gesturing and cradling a purchase, pause in front of Czarnowski's "Pharmacie Francaise," signboarded below the apothecary's mortar and pestle. Beyond, a seated vendor is

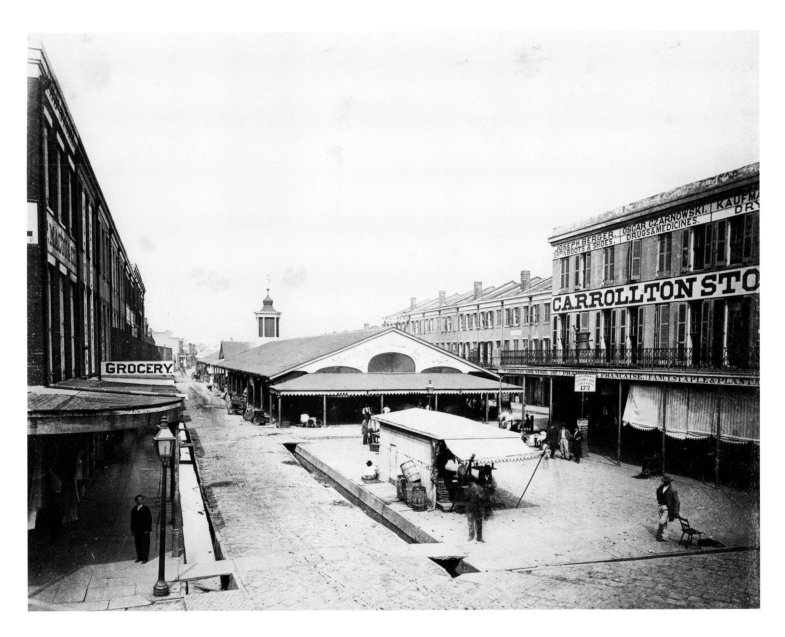

silhouetted in the shadow of the Carrollton Shoe Store gallery. On the *banquette*, at Macou's corner grocery, a well-groomed (although hatless) man, dwarfed by a gaslight, makes a striking appearance, with a gaze so direct he appears to look past the camera directly at us. Opposite, a man wearing a frock coat and wide-brim hat has stood up from tending to his small goods display on the pavement, perhaps to watch Lilienthal at work. Bracing himself on the chair-back, he may have grown impatient with the photographer, and seems unaware of being observed.

1. Wilkinson was also architect for Jackson Barracks downriver (cats. 116 and 117) and Cypress Grove Cemetery (cat. 38). In December 1837, a call for proposals from the Surveyor of the Second Municipality resulted in at least nine submittals, including one from architects James Dakin and Charles Dakin. See New Orleans City Papers, Box 7, Folder 13, Manuscripts Collection, Tulane University Library. A plan for the market dated December 12, 1837, is in the City Archives Map Collection, New Orleans Public Library.
2. The specifications called originally for a fireproof, all-metal structure with an iron frame and zinc roof, but as iron was expensive and difficult to obtain only the posts were fabricated in iron; *Gibson's Guide*, pp. 310–11 (where the lithographed view shows an infill of glass).
3. *Times*, September 21, 1866.
4. *Times*, November 21 and 22, 1865; *Picayune*, February 9, 1866; *Picayune*, March 12, 1866; "Poydras Market Extension," *Times*, May 10, 1866; "Market Improvements," *Times*, June 7, 1866; *Times*, September 21, 1866; "Extension of Poydras Market," *Picayune*, December 14, 1866; "An Ovation," *Picayune*, February 1, 1867; "The Pilié Market," *Times*, February 1, 1867; "Poydras Market," *Bee*, February 14, 1867.
5. James H. Mayo, *The American Grocery Store: The Business Evolution of an Architectural Space*, Westport, Conn. (Greenwood Press) 1993, pp. 12–13.
6. On the ice trade, see cat. 61. Sally Reeves is preparing a study of the life-cycle of the early public markets and corner stores in New Orleans. On the history of public markets, see James H. Mayo, "The American Public Market," *Journal of Architectural Education*, XLV, no. 1, November 1991, pp. 41–57; id., *The American Grocery Store, op. cit.*; and Helen Tangires, *Public Markets and Civic Culture in Nineteenth-Century America*, Baltimore (Johns Hopkins University Press) 2003.
7. Mayo, *The American Grocery Store, op. cit.*
8. "95-Year-Life of Poydras Market is Closing," *Times-Picayune*, February 21, 1932. *Harper's Bazaar* published a wood engraving of the building (February 7, 1885) and William Henry Jackson photographed it about 1890 for the Detroit Publishing Company (Library of Congress Collection), before a remodeling in 1898 removed the decorated gable end and cupola.

61
St. Charles St. from Cor. Poydras
Rue St. Charles du coin de Poydras

"St. Charles is one of our finest thoroughfares," the *Picayune* declared in 1860. "Covered with granite, with broad flags over the banquettes, it will become one of the most fashionable promenades in the city."[1] Beginning in 1858, St. Charles from Canal to Julia streets was improved with granite block paving and flagged sidewalks as part of the "square block reform" of city streets.[2] The granite resurfacing signaled not only a street "worthy of a great commercial city," but also another stage in the most ambitious public-works project of the decade before the war.[3]

Before mid-century, New Orleans streets were surfaced with wood planks, cobblestone, or crushed lake shells, if they were paved at all. A pedestrian crossing Camp Street in 1845 had to "jockey a line of flatboat gunwales" to avoid "becoming swamped in the mire," and many of the busiest streets were "impassable" in wet weather.[4] The city's turnpike roads were surfaced with crushed oyster shells, ideal for horseback riders (cat. 74), but the best-paved commercial streets were surfaced with cobblestone—"sea shore" or "bank" stones laid on a bed of sand and covered with gravel or shells.[5] Cobblestone was difficult to maintain: it bedded unevenly, broke up easily, and was rough on horses and vehicles, as well as

passengers, "jolting them horribly at every step."[6] It was a "very inferior pavement," the engineer W.M. Gillespie charged, "which disgraces the streets of nearly all our cities."[7]

In 1839, St. Charles from Poydras to Lafayette streets was paved with small blocks of Belgian granite.[8] "[W]ho would have believed that in our day the stones for the streets of New Orleans would be imported from Flanders?" the *Scientific American* asked.[9] It was a pioneering trial, and although Belgian block paving was not immediately adopted, within a decade New Orleans and other cities were laying square-cut granite blocks supplied by northeastern quarries.[10] Boston, New York, and Philadelphia laid large

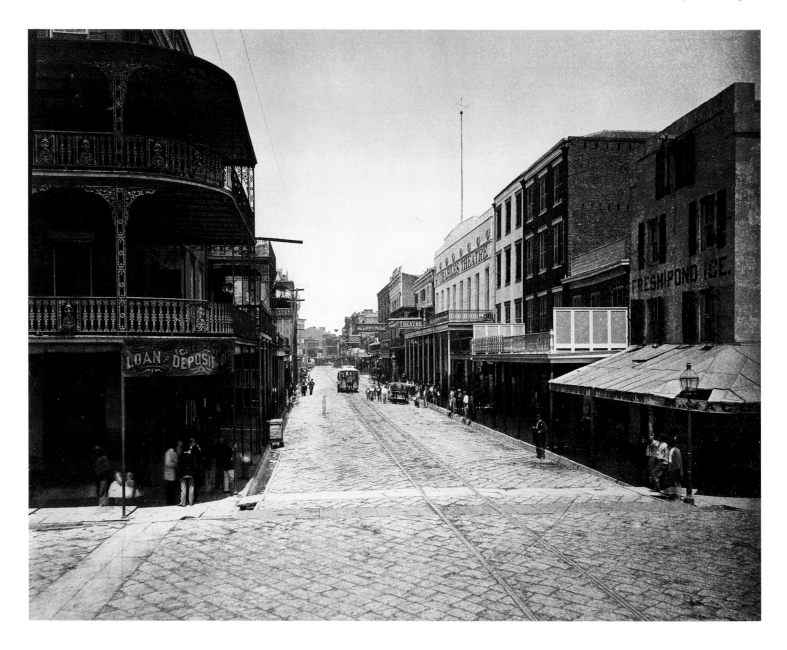

stone blocks in the early 1840s, much of it Palisades trap stone up to 18 inches (46 cm) square, following the example of some European cities where stone paving blocks more than 2 feet (60 cm) square had been used since antiquity.[11] New York adopted granite Belgian block paving in 1850: "street after street of the old cobble stones are being lifted, and the beautiful little oblong blocks laid in their place," the *Scientific American* announced.[12]

New Orleans surveyor George Dunbar, and his successor Louis H. Pilié, campaigned from 1846 for granite pavements to replace cobble on the city's busiest streets.[13] Only granite was durable enough to carry the heavy traffic that accompanied the rise of the commercial port. Three- and four-horse drays with narrow wheels and enormous loads tore up the old cobblestone quickly, especially on batture streets such as Tchoupitoulas, where the "amount of hauling," Pilié argued, was "larger than over any other commercial street, either in this Country or in Europe."[14] In 1849, Pilié ordered 20,000 yards of granite pavers from Boston for Tchoupitoulas and New Levee (South Peters) streets, and within a year other heavily trafficked streets had been "granitized."[15] As supplied by Cape Ann and other New England quarriers, the granite pavers laid in New Orleans were larger than Belgian blocks: oblong and typically about 2 feet long, 1 foot wide and up to 10 inches deep (60 × 30 × 25 cm).[16] Bedded on compressed sand or gravel, the blocks were elevated toward the center of the street for drainage and laid in a crosswise pattern to reduce edge wear, a modification (clearly visible in the photograph) instituted by Pilié.[17] "From the manner in which the Blocks are at present laid; being at right angles with the line of the street," Pilié wrote in 1853, "the stone is much cut up into ruts & the edges worn. If the stone be taken up & relaid diagonally this evil will be remedied & the pavement will not only last much longer, but will be more commodious & easier for draughts & less destructive to vehicles."[18] From 1854, the older granite streets were taken up and the blocks relaid at a 45-degree angle to the street edge.[19]

"It is difficult to conceive of a finer system of paving than by square stones," the *Bee* wrote in 1859. "They are particularly advantageous for a soil like that of New Orleans. They prevent the accumulation of mud, and offer a firm even surface for the thousands of vehicles which traverse our streets."[20] For city boosters, the

"square block reform" was a potent image, and granite was the only modern choice: the new pavement offered "more advantage to business and health than any other works which have been projected for many years," the *Picayune* wrote in 1860.[21] While the old cobblestone streets were "an eyesore" and "a relic of a past day," the modern granite streets complemented the new granite and cast-iron architecture of the 1850s— "substantial modern constructions," architect Thomas K. Wharton observed, which replaced the "dilapidated relics of ancient times."[22] Granite paving was necessary to complete the *tout ensemble* of the modern street, as one municipal engineer later observed: "Where would the beauty of architecture be without streets to display it? ... A handsome building with a disgraceful pavement about it is like a beautiful picture with a broken and soiled frame."[23]

But granite paving had drawbacks.[24] The blocks were difficult to bed in place, and underlaid with gas and water mains they were costly to remove for utility maintenance. They were also a poor foothold for horses, and when worn smooth were like "a field of ice."[25] To roughen the surface for better traction, the blocks were picked with a hammer every few months, but the rutted and uneven surface increased the "thundering, deafening, rattling clatter" of iron hoofs and wheels striking the hard stone.[26] Granite, imported from distant quarries, was also expensive. Ten city blocks of granite paving on Levee (North Peters) Street cost $76,000 in 1855; by comparison, shell cost only $900 per block.[27] In 1855, the city spent more on granite street paving than on any other category of public works except port construction, and by 1861 the expenditure on granite alone was estimated at $757,000, outdistancing all municipal engineering projects.[28] Abutters, who from 1852 were free to select pavements, paid from one-third to two-thirds of the construction cost (although nothing for street maintenance).[29]

Granite block was the most successful of many pavements adopted by American cities during the 1850s, when the search for improved street paving became a kind of national obsession. "It is astonishing to see the numerous plans that are advanced almost day by day, for the better paving of our streets," the *Scientific American* observed at the beginning of the decade.[30] By 1858, "everything in the shape of a pavement" had been tried, the *New York Times* declared. "In one street we find a pavement of iron; in

another, cobblestones; in another the small, loosely-laid Belgian blocks, and in another, huge, square blocks of granite."[31]

After the war, although granite paving remained in common use, another new pavement became fashionable. New Orleans "joined the rush for the Nicolson pavement" and in 1867 resurfaced nine blocks of St. Charles Street with a wood block paver invented and tirelessly promoted by Samuel Nicolson of Boston.[32] Wood block for paving was not in itself new—thirty years earlier, St. Charles had been the site of an unsuccessful trial with an apparently untreated wood block—but the patented Nicolson blocks were sealed with creosote, laid on end on a plank foundation, grouted, and covered with tar and sand.[33] Marketed nationally with a volley of claims against street paving evils that had plagued cities for decades, the "noiseless" pavement freed passengers from the din of stone streets, which was not only "disagreeable," the inventor argued, but also "a great hindrance to the transaction of business."[34] The slippery-smooth surface reduced the cost of street cleaning to "almost nothing," backers claimed, and cleaner meant healthier: sanitarians found in the composition of the wood blocks a life-saving antiseptic for cholera and yellow fever that would "turn unhealthy neighborhoods in to healthy ones."[35] For Orleanians who had experienced the city's first postwar yellow-fever epidemic in 1867, nothing could be more compelling proof of the superior qualities of wood paving over stone than a published report that not a single case of fever had occurred in the vicinity of the Nicolson pavement.[36]

For nearly two decades, municipalities found the "charm" of the Nicolson pavement "almost overpowering," and endorsements were legion.[37] "This is an age of progress," the *Scientific American* remarked in 1869, "but it is an age which favors smooth and rapid progress, and is intolerant of jolting and jarring. It has sickened of the intolerable nuisance of stone blocks and cobbles, and now demands something that will exact less of man and beast and vehicle"[38] *Harper's New Monthly Magazine* called it "the most perfect pavement that has yet been constructed," and in New Orleans the *Times* led a drive "to have all of our streets paved with this most excellent pavement."[39] P.G.T. Beauregard, probably the most respected public figure in postwar New Orleans, promoted its use, sponsoring specimen pavements on Canal and

Jackson streets in early 1867. But Louis Pilié, the city surveyor who had championed granite paving for nearly two decades, doubted that the Nicolson pavement would survive sustained use in the wet climate.[40] His opposition led the federal overseer, General Philip Sheridan, who endorsed the new pavement, to remove him from office, but Pilié was soon proved correct.[41] The wood blocks decayed quickly and, although grouted, they dislodged when the streets filled with water.[42] The failure in New Orleans was repeated in Memphis and Boston, and in Chicago, where more streets had been "Nicolsonized" than in any other city (the wood block was thought to have helped spread the great Chicago fire of 1871).[43] In Washington, a scandal that erupted over the wasted expenditure of the Nicolson pavement led directly to the loss of District home rule in 1878.[44] In St. Louis, taxpayers revolted against the Nicolson "blunder," and in New York, too, abutters filed suit against the city for imposing a "fancy pavement ... unfit for the use designed."[45] The "very costly experiment" bankrupted at least one municipality (the town of Elizabeth, New Jersey), and other city treasuries were depleted by extortionist contractors, who charged ten times more for the wood block than for granite, and by the Nicolson Company itself, which reportedly profiteered shamelessly on its patent.[46] "[T]he wooden block was to astonish the world by its superiority over cobble stone, granite block, and every other block," one municipal engineer wrote. "Well, it had its day, and at last paved the way of its own extermination."[47] New Orleans, like other cities, eventually tore up the Nicolson pavers and resurfaced many streets, including St. Charles, with asphalt, which was by the 1880s the preferred smooth pavement.[48]

Through all these paving trials, and the enormous expenditure of public funds, the city that had been an antebellum innovator in street construction by 1886 had paved only 94 of its 566 miles (14.5 of 910 km) of streets. More than half the paved streets remained no better than shell or cobblestone. It was a record that retarded the city's progress, the engineer George Waring, Jr., warned, and another sign of the postwar malaise that earned New Orleans a position as the least progressive of the nation's fourteen largest cities.[49] A decade later, after years of asphalt street construction, more than 400 miles (640 km) of city streets remained unpaved.[50] "A city without pavements can not maintain its economic existence," the municipal

engineer J.W. Howard explained in 1896. "Goods can not be moved. Progress even on foot is impeded, street cleaning [is] impossible, [and the] health of all [is] in danger."[51]

In Lilienthal's photograph, at the corner of St. Charles and Poydras streets is an ice depot that was operated before the war by the Tudor Ice Company of Boston. "Fresh Pond Ice" advertises the global enterprise of Frederic Tudor, based on natural ice harvested from Fresh Pond and Spy Pond in Cambridge, and from Wenham Pond near Salem.[52]

For Tudor—the first-made millionaire in America after the Revolution—profits lay in substituting square-cut blocks of ice for the rock ballast required by cargo-less sailing ships.[53] From his first shipload of ice to Martinique in 1806, Tudor built a trade in the West Indies, but he operated at little profit until he began shipping ice to the southern United States: first to Charleston, then, by 1818, to Savannah. In 1806, he had proposed a collaboration with merchant Judah Touro to bring ice to New Orleans, but regular cargoes did not begin until 1820, when Tudor built his first icehouse in the city.[54] "Thus it appears that the sweltering inhabitants of Charleston and New Orleans ... drink at my well," Henry David Thoreau wrote, having witnessed ice harvested from his famous pond in 1847.[55]

Capturing the ice trade in the largest market in the South made Tudor's fortune, and before mid-century he had consolidated an ice empire that reached from London to Bombay.[56] The Tudor Ice Company operated five icehouses in New Orleans and at the peak of its prewar trade in 1858 shipped 14,000 tons of ice in eighteen ships to its largest outlet.[57] Tudor and, before long, his competitors had "succeeded in converting a rapidly-wasting, and ordinarily valueless substance, into a production of large commercial importance," one journalist observed.[58]

However, war and the blockade of southern trade in 1862 reversed the company's fortunes. To offset the loss of its lucrative southern markets, the Tudor Company increased cargoes to Cuba and India and developed new markets in China and South America.[59] When Tudor died in 1864, his icehouses had not reopened in New Orleans. In 1866, the Tudor Company resumed ice shipments, but cargoes were far below prewar levels.

After the war, sales of natural ice faced a new threat: commercial ice manufacture, in

which New Orleans took an early lead. French ice-making machines were brought into the city during the blockade and New Orleans engineers pioneered mechanical refrigeration technology for the brewing industry in the 1860s.[60] The first commercial ice plant in New Orleans, the Louisiana Ice Works, opened in 1867 to the "utter dismay and confusion of the Northern ice importers."[61] "The city of New Orleans, amidst all its wants, has now got one thing which suits it exactly—an ice factory," a British visitor remarked.[62] It was reportedly the largest ice factory in the world, and undersold imported ice, but the quality of the manufactured product was inferior to natural pond ice, and it did not immediately dominate local markets. The twenty-seven ice dealers in New Orleans in 1867 represented a diversified trade that now brought ice from the Great Lakes and other regions, as well as Boston. The Tudor Ice Company, its market share diminished, sold the depot at St. Charles Street to another importer in 1867, but the company continued to ship ice to New Orleans until 1886. By 1890, the natural ice trade had virtually disappeared from the city.[63]

1. "St. Charles Street," *Picayune*, January 13, 1860.
2. "Specification Books, 1855–1865," II, March 14 and July 28, 1859, KG630, "Petitions for Sidewalk and Street Paving, 1857–1874," fols. 51–52, December 8, 1858, KG320, "Bills for Street and Sidewalk Paving, 1852–1877," III, fols. 235, 249, 289, 348, KG540, New Orleans Public Library, City Archives, Surveyor's Office Records, 1833–90; "Record of Paving Bills Turned Over to Contractors, 1852–1870," New Orleans Public Library, City Archives, Records of the New Orleans Comptroller's Office, I, fol. 100, 1860, CB540p; "Square Block Pavements," *Bee*, December 2, 1859.
3. "Our Streets," *Evening Picayune*, January 11, 1859; see also n. 27 and 28 below.
4. Surveyor George Dunbar to the Recorder and Council, Second Municipality, October 1844 and December 11, 1844, "Letter Books, 1836–1851," fols. 15, 18, KG511, New Orleans Public Library, City Archives, Second Municipality Surveyor's Office Records; "Specification Books, 1855–1865," III, May 14, 1860, and April 17, 1861, KG630, Surveyor's Office Records, *op. cit.*; "New Orleans," *Picayune*, March 16, 1845.
5. "Specification Books, 1855–1865," I, fol. 50, May 4, 1860, KG630, Surveyor's Office Records, *op. cit.*; "The Former and Present Times ...," *De Bow's Review*, VII, no. 5, November 1849, p. 415; "The City Pavements," *Picayune*, April 14, 1875. Cat. 93, for example, shows the texture of New Orleans's cobblestone streets.
6. "Our Streets," *Evening Picayune*, *op. cit.*; "Square Block Pavements," *Bee*, *op. cit.*
7. W.M. Gillespie, *A Manual of Road-Making*, New York and Chicago (A.S. Barnes & Company) 1871 [10th edition; first published in 1855], p. 216.
8. "Tchoupitoulas Street," *Picayune*, September 12, 1852; *Times*, October 17, 1866; "The City Pavements," *Picayune*, *op. cit.* On Belgian block paving, see "The Construction of Roads," *Scientific American*, VI, no. 16, January 4, 1851,

p. 122; Q.A. Gillmore, *A Practical Treatise on Roads, Streets, and Pavements*, New York (D. Van Nostrand) 1885, pp. 160–62; George W. Tillson, *Street Pavements and Paving Materials*, New York (John Wiley & Sons) 1900, pp. 12, 184–88; Ira Osborn Baker, *A Treatise on Roads and Pavements*, New York (John Wiley & Sons) 1908, pp. 529–30.

9. "Square Stone," *Scientific American*, V, no. 21, February 9, 1850, p. 164.

10. "Granite Paving," *Picayune*, June 25, 1893.

11. "Report on the Best Modes of Paving Highways," *Journal of the Franklin Institute*, VI, ser. 3, no. 3, September 1843, p. 166; "Street Paving," *Scientific American*, V, no. 32, April 27, 1850, p. 253; "The Paving of Streets," *Scientific American*, V, no. 37, June 1, 1850, p. 293; "Roman and Modern Roads," *Scientific American*, X, no. 20, January 27, 1855, p. 153; Baker, *op. cit.*, p. 529; George W. Tillson, "The Development of Street Pavements," *Journal of the Franklin Institute*, CLXIII, no. 6, June 1907, p. 439; Harwood Frost, *The Art of Roadmaking*, New York (McGraw-Hill) 1910, pp. 314–22; Arthur W. Brayley, *History of the Granite Industry of New England*, Boston (National Association of Granite Industries) 1913, I, pp. 167–70.

12. Cited in "Street Pavements," *Chicago Daily Tribune*, August 18, 1855.

13. "Letter Books, 1836–1851," fol. 52, June 19, 1846, KG511, Second Municipality Surveyor's Office Records, *op. cit.*; "Death of Louis H. Pilié," *Picayune*, April 24, 1886.

14. L.H. Pilié to Isidore O. Starke, September 21, 1853, "Outgoing Correspondence, 1853–1863," fol. 54, Surveyor's Office Records, *op. cit.*

15. "Letter Books, 1836–1851," fol. 207, August 6, 1849, KG511, Second Municipality Surveyor's Office Records, *op. cit.*; "Description of Properties Fronting on Streets Paved, 1844–1846," fol. 162, October 11, 1849, KG543p, Second Municipality Surveyor's Office Records, *op. cit.*

16. "Specifications for furnishing all materials and laying the Square Block paving of Common Street from Carondelet to Baronne Street," "Specification Books, 1855–1865," I, fols. 66–68, November 15, 1856, KG630, Surveyor's Office Records, *op. cit.*; Gillespie, *op. cit.*, p. 222; Brayley, *op. cit.*, p. 169; Barbara H. Erkkila, *Hammers on Stone: A History of Cape Ann Granite*, Woolwich, Me. (TBW Books) 1980, pp. 19, 23.

17. "Petitions for Sidewalk and Street Paving, 1857–1874," fol. 84, 1857, KG320, Surveyor's Office Records, *op. cit.*; "Specifications for the contract for taking up and relaying diagonally the Square block paving of Julia Street from Baronne to Rampart Streets," "Specification Books, 1855–1865," I, fols. 281–82, July 29, 1858, Surveyor's Office Records, *op. cit.*; "Camp Street," *Evening Picayune*, December 3, 1858.

18. L.H. Pilié to Isidore O. Starke, September 21, 1853, "Outgoing Correspondence, 1853–1863," fols. 54, 89–90, KG511, Surveyor's Office Records, *op. cit.*

19. "Report on the Best Modes of Paving Highways," *op. cit.*, pp. 164–68; "Square Stone Pavement," *Picayune*, May 8, 1854; *Picayune*, July 30, 1854 (advertisement); Gillespie, *op. cit.*, p. 3.

20. "Square Block Pavements," *Bee*, December 2, 1859.

21. "Paving of Rampart Street," *Picayune*, January 11, 1860; "Local Improvements," *Picayune*, October 26, 1862; "St. Joseph Street Railroad," *Picayune*, February 21, 1865; Ellen Day Hale, "The Cape Ann Quarries," *Harper's New Monthly Magazine*, LXX, no. 418, March 1885, p. 560.

22. Wharton, "Diary," July 21, 1854; "Camp Street," *Evening Picayune*, December 3, 1858.

23. J.W. Howard, "Why Good Paving is Essential to the Success of A City," *Paving and Municipal Engineering*, X, 1896, p. 305.

24. "Street Paving," *Scientific American*, V, no. 32, April 27, 1850, p. 253; "The Best City Pavements," *New York Times*,

February 25, 1860; Frost, *op. cit.*, pp. 314–16.

25. "Street Paving," *Chicago Press and Tribune*, February 14, 1859; "Street Pavements," *Harper's New Monthly Magazine*, XXVII, no. 218, July 1868, p. 226.

26. Frank G. Johnson, *The Nicolson Pavement, and Pavements Generally*, New York (W.C. Rogers & Co.) 1867, p. 81.

27. "Estimate of Amount of money required to carry on the Public Works under the Superintendence of the Surveyor from the 13th of April to the 1st of July 1855," "Outgoing Correspondence, 1853–1863," fols. 146, 151, Surveyor's Office Records, *op. cit.*; "Statement of Indispensable Expenditures for works to be carried on during the year 1855 in the Department of the Surveyor," "Outgoing Correspondence, 1853–1863," fols. 130–31, Surveyor's Office Records, *op. cit.*

28. "Statement of Probable Expenditures of the Surveyor's Department for the year 1861," "Outgoing Correspondence, 1853–1863," II, KG511, Surveyor's Office Records, *op. cit.*

29. "Bills for Street and Sidewalk Paving, 1852–1877," III, fols. 235, 291, KG540, Surveyor's Office Records, *op. cit.*; "Description of Properties Fronting on Streets Paved, 1844–1846," fol. 162, October 11, 1849, KG543p, Second Municipality Surveyor's Office Records, *op. cit.*; "The City Pavements," *Picayune*, *op. cit.*

30. "Paving for Streets of Cities," *Scientific American*, V, no. 29, April 6, 1850, p. 229; "Pavement Appropriations," *New-York Daily Times*, January 21, 1857.

31. "Our Street Pavements," *New York Times*, February 5, 1858.

32. "Square Block Paving," *Picayune*, January 27, 1867. The first sections of Nicolson pavement laid were at Canal and Baronne, the foot of Jackson, part of Race, and on St. Charles, which was to be paved with wood block from Tivoli (Lee) Circle to Carrollton; *Crescent*, August 23, 1866; "City Roads and Railroads," *Times*, September 20, 1866; "City Pavements," *Scientific American*, XVI, no. 15, January 15, 1867, p. 237; "The Nicolson Pavement," *Picayune*, January 27 and February 8, 1867; "The Nicolson Pavement," *Times*, June 22, 1867; "Improvements," *Picayune*, August 24, 1867; "The Nicolson Pavement," *Picayune*, March 1, 1868.

33. On the New Orleans experiment, see "Wood Pavements," *Commercial Bulletin*, May 17, 1838, "Wooden Pavements," *Picayune*, November 16, 1839. The *Picayune*, promoting the new wood-block paving, called the round-stone pavements they were to replace "semi-barbarous" and "about a century behind the other improvements of the age." Nicolson experimented with the new paving method near his mill on Western Avenue, Boston, in 1848, and used the process on other Boston streets during the next decade. Chicago adopted the pavement in 1856, and by 1867, New York, St. Louis, Milwaukee, Detroit, Cleveland, Memphis, and San Francisco were using it; in 1869, Washington resurfaced Pennsylvania Avenue with it. See Samuel Nicolson, *The Nicolson Pavement*, Boston (Dutton & Wentworth) 1855; "The 'Nicolson Pavement,'" *Ballou's Pictorial Drawing-Room Companion*, XVII, no. 16, October 15, 1859; "The Nicolson Pavement," *Chicago Tribune*, November 21, 1861; "The Nicolson Pavement," *Chicago Tribune*, October 10, 1866; Johnson, *op. cit.*; "Wooden Pavement," *New York Times*, March 2, 1868; "Street Pavements," *Scientific American*, XXVII, no. 16, October 19, 1872, p. 242; Gillmore, *op. cit.*, pp. 163–70; Tillson, *op. cit.*, pp. 293, 308–309; Baker, *op. cit.*, pp. 557–62.

34. Johnson, *op. cit.*, p. 81.

35. "City Pavements," *Scientific American*, *op. cit.*

36. *Gardner's New Orleans Directory for 1868*, New Orleans (Charles Gardner) 1868, p. 12. The Nicolson contractor, Jonathan Taylor, made a similar claim for Cincinnati; "Nicolson Pavement" (advertisement), *Picayune*, February 14, 1867.

37. "City Pavements," *Scientific American*, *op. cit.*

38. "Wood and Concrete Pavements," *Scientific American*, XXI, no. 12, September 18, 1869, p. 185.

39. "The Nicolson Pavement," *Times*, *op. cit.*; "Nicolson Pavement on Jackson Street," *Picayune*, April 9, 1867; "Street Pavements," *Harper's New Monthly Magazine*, XXVII, no. 218, July 1868, p. 227.

40. "The City Pavements," *Picayune*, *op. cit.*

41. "Nicolson Pavement" (advertisement), *op. cit.*; *Chicago Tribune*, March 18, 1867; "The Nicolson Pavement," *Picayune*, *op. cit.*; *New Orleans Architecture*, VII, p. 56.

42. James Jansson, *Building in New Orleans: The Engineer's Role*, New Orleans (Waldemar Nelson & Company) 1984, p. 9.

43. *Id.*, "Transforming the Use of Urban Space: A Look at the Revolution in Street Pavements, 1880–1924," *Journal of Urban History*, V, no. 1, May 1979, pp. 282, 288–89.

44. "The Construction and Maintenance of Roads," *Discussion on Paper CLXXX, Transactions of the American Society of Civil Engineers*, VIII, December 1879, pp. 353–54; *American Architect and Building News*, IV, no. 144, September 28, 1878, p. 110; "Street Paving," *Chicago Daily Tribune*, October 14, 1883; Clay McShane, *Down the Asphalt Path: The American Automobile and the American City*, New York (Columbia University Press) 1994, pp. 60–61.

45. "The Nicolson Pavement," *New York Times*, November 14, 1868; "The Sixth Avenue Nicolson Pavement," *New York Times*, January 4, 1870.

46. "The Nicolson Pavement and the Objections to it," *New York Times*, May 7, 1868; "Costly Street Pavement," *New York Times*, May 15, 1879.

47. "Paving for Streets of Cities," *Scientific American*, *op. cit.*

48. On asphalt pavements in New Orleans, see "Asphaltum Pavements," *Niles Weekly Register*, LVI, April 27, 1839 (on an early, unsuccessful trial on Bourbon Street); "The City Pavements," *Picayune*, April 14, 1875; James S. Zacharie, "New Orleans, its Old Streets and Places," *Publications of the Louisiana Historical Society*, II, pt. III, February 1900, p. 68; "St. Charles Avenue," *Times–Democrat*, January 30, 1891, February 3, 5, and 15, 1892.

49. George E. Waring, Jr., *Report on the Social Statistics of Cities*, Washington, D.C. (Government Printing Office) 1887, II, p. 272; N.P. Lewis, "From Cobbles to Asphalt and Brick," *Paving and Municipal Engineering*, March 10, 1896, p. 235. See McShane, "Transforming the Use of Urban Space," *op. cit.*, p. 279.

50. George W. Engelhardt, *The City of New Orleans: The Book of the Chamber of Commerce and Industry of Louisiana*, New Orleans (L. Graham) 1894, p. 19; Zacharie, *op. cit.*

51. Howard, *op. cit.*, p. 305.

52. On Tudor and the ice trade, see Tudor Ice Company Collection, Baker Library, Harvard Business School; N.J. Wyeth, "Ice Trade," in *Annual Report of the Commissioner of Patents*, 30th Cong., 2d sess., H. Ex. Doc. 59, Washington, D.C. (Wendell & Van Benthuysen) 1849, pp. 696–703; "Ice—How Much of it is Used and Where it Comes from," *New-York Daily Times*, August 21, 1855; "Ice and the Ice Trade," *Hunt's Merchants' Magazine*, XXXIII, 1855, pp. 169–79; "Ice," *Scribner's Monthly*, X, no. 4, August 1875, pp. 462–71; Henry G. Pearson, "Frederic Tudor, Ice King," *Proceedings of the Massachusetts Historical Society*, XCV, October 1933, pp. 169–215; Richard O. Cummings, *The American Ice Harvests: A Historical Study in Technology, 1800–1918*, Berkeley (University of California Press) 1949; Philip Chadwick Foster Smith, "Crystal Blocks of Yankee Coldness," *Essex Institute Historical Collections*, XCVII, July 1961, pp. 197–232; David G. Dickason, "The Nineteenth-Century Indo-American Ice Trade: An Hyperborean Epic," *Modern Asian Studies*, XXV, no. 1, 1991, pp. 53–89; Carl Seaburg and

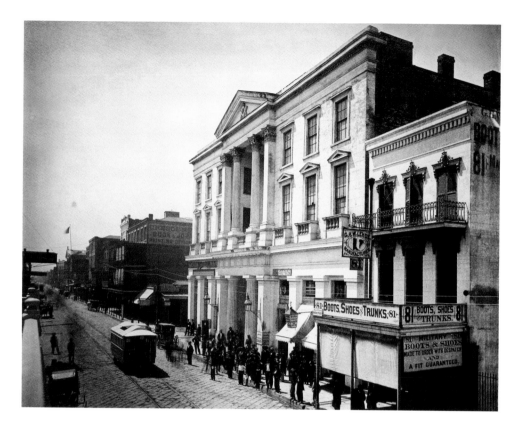

Stanley Paterson, *The Ice King: Frederic Tudor and His Circle*, Boston (Massachusetts Historical Society) 2003.
53. Dickason, *op. cit.*, pp. 55, 64.
54. Cummings, *op. cit.*, p. 141. See also Pearson, *op. cit.*, p. 193; Seaburg and Paterson, *op. cit.*, pp. 91–92.
55. Dickason, *op. cit.*, p. 53.
56. Although Tudor dominated southern trade, the business could be highly competitive, and he remained a keen competitor. In Mobile, Alabama, he was accused of price fixing for selling ice at a loss to drive prices down, which depleted his competitors' supplies and drove them out of business. He then raised prices by thirty percent. *Mobile Herald and Tribune*, August 14, 1844; *Mobile Advertiser*, August 13, 1844, in Tudor Ice Company Collection, Baker Library, Harvard Business School.
57. Tudor Ice Company Collection, *op. cit.*, Mss. 766, 1860–1902, I, Journal A, fol. 64–66; II, fol. 12; "Bills for Street and Sidewalk Paving, 1852–1877," III, fol. 288, January 1860, New Orleans Public Library, City Archives, Surveyor's Office Records, KG540.
58. "Editor's Cultivator," *Cultivator*, IX, no. 4, April 1852, p. 141.
59. Tudor Ice Company Collection, *op. cit.*, Mss. 754, 1860–1902, I, Journal A, fol. 337 (for September 1863).
60. See cat. 24.
61. "A Sight from the Attic: Construction of the Louisiana Ice Works," *Sunday Times*, April 7, 1867; Robert Somers, *The Southern States Since the War, 1870–1*, London, New York (Macmillan) 1871, p. 235. Lilienthal photographed the ice factory for *Jewell's Crescent City Illustrated* in 1872. See *Jewell's Crescent City Illustrated*, prospectus.
62. Somers, *op. cit.*
63. Oscar Edward Anderson, Jr., *Refrigeration in America: A History of a New Technology and Its Impact*, Princeton, NJ (Princeton University Press) 1953, p. 40, n. 14.

62
Masonic Hall St. Charles St
Temple Maconique Rue St Charles

At the corner of St. Charles and Perdido streets was a three-story stuccoed-brick building designed by James Gallier and built in 1845 for the Commercial Exchange, an organization formed to promote trade and mercantile interests.[1] It was the first commodities exchange established in the Second Municipality and represented the ascendancy of the Anglo-American business quarter above Canal Street. "[I]t is in the Second Municipality that the progress of the city in wealth and population is most conspicuous," the *Picayune* wrote.[2] The first purpose-built exchange, constructed ten years earlier on Royal Street in the Vieux Carré, had also been designed by Gallier, in partnership with James Dakin (and in large part established Gallier's early reputation), but it had by 1841 been converted to other uses.[3]

The Commercial Exchange featured trading and auction rooms on the ground level and, on the upper floors, a public lecture and exhibition hall, offices, and a reading room where merchants and ship captains could read the shipping news from around the world. Enframing the St. Charles Street entrance was a pedimented, recessed

portico of superimposed Orders, Corinthian above and Doric below, with fluted granite columns and gilded capitals. To maximize the leasable commercial frontage, Gallier flattened the portico and recessed it, creating an image of monumentality while adhering to the shallow setback of the block. The vertical elegance of the portico was echoed by the window bays; by spacing the windows closer vertically than horizontally, he gave the building an appearance of greater height. Gallier's proficient (if not always highly imaginative) adaptation of classical precedents (he had trained with the London classicists William Wilkins and John Gandy-Deering, both recognized scholars of the antique), his ease with projects on a monumental scale, and his skillful construction management resulted in many successful buildings for commercial and institutional clients in the 1830s and 1840s.[4] More than any other nineteenth-century architect, Gallier transformed the look and scale of the city. His impact is easily read here on St. Charles Street, where the grandly conceived Exchange sits beside a typical three-story, three-bay, galleried commercial building.

The Exchange failed in the early 1850s because New Orleans merchants, Gallier wrote, "could not be induced to assemble on change as they do in other cities."[5] In 1853, the Masonic Grand Lodge, with the backing of the banker James Robb, purchased the Exchange building for $55,000.[6] A renovation created a mirrored public ballroom on the upper floor and lodge rooms decorated by Alexander Boulet, a local scene-painter.[7] On the street front, the pediment was modified to carry the "hieroglyphical emblems" of the Masons. "The square and compasses, and the triangular seal of the Grand Lodge, with 'The All-Seeing Eye' in the centre, make a handsome display in their brilliant gilding," the *Picayune* reported, "and add much to the renewed beauty of the edifice."[8]

In 1861, after a fire damaged the interior, James Gallier, Jr. added a floor of lodge rooms above the ballroom.[9] With a variety of leasable commercial spaces, the Masonic Hall proved to be "one of the best locations for a retail store or auction mart in the city," and a significant source of income for the Masons.[10] Designed as an exchange, the building in the grandeur of its classical vocabulary was not inappropriate to an elite fraternity—"very large and influential in this city"—and even evoked the antiquity of freemasonry's origins, but seems too showy for the Masons' secret practices.[11]

In 1867, the Masons purchased an old Carrollton Railroad depot at Tivoli (Lee) Circle, and architect James Freret prepared a Gothic temple design for the site, but construction was suspended.[12] The Masons revived the project with a design competition that brought proposals from fifteen architects, among them S.B. Haggart, who eventually received the commission for a temple of Georgia granite estimated to cost $235,000.[13] In 1872, the Masons laid the cornerstone, but construction was stopped for lack of funds, and the granite pile at Tivoli Circle became a tourist curiosity.[14] It was not until 1889, when the postwar New Orleans economy was finally showing "signs of prosperity and revival," that the Masons renewed their campaign for a new temple—not at Tivoli Circle, which they abandoned, but at the St. Charles Street site they had occupied since 1853.[15] Rejecting a proposed renovation of the old Gallier building—it lacked an elevator and other modern conveniences that commercial tenants demanded, and the elegant classical portico was outmoded—the Masons demolished it in late 1890. In its place they erected a five-story brick-and-terracotta Gothic temple, designed by James Freret and built at a cost of $100,000.[16]

Lilienthal's deep perspective of St. Charles Street records the procession of ordinary commercial storefronts that give context to Gallier's imposing structure. A pole banner promotes the shirts of S.N. Moody, the city's largest retailer and a pioneer in outdoor advertising (cat. 21), and other signs advertise tailors, bootmakers, printers, machinists, and a notary. Among the Mason's tenants was Hugh McCloskey, an emigrant from Belfast who grew rich before the war from a soda and mead business, signposted here by a hanging lantern.[17] At the opposite corner of the hall, the auctioneers' signboard identifies one of the city's most prosperous antebellum slave markets, which had operated a "large, commodious and attractive salesroom, with spacious accommodations for slaves" in the old exchange room.[18] A Saturday auction there in 1860 offered "several slaves, a splendid sorrel trotter and two mares."[19]

Farther up St. Charles Street, the U.S. flag atop the City Hall (cat. 51) signifies a city that remained under federal military control, although civil government had recently been restored. In the foreground a streetcar is idled without traction, and a crowd of men on the *banquette*

appear captivated by Lilienthal's picture-taking. Large sidewalk gatherings there were not unusual, and had become something of a public nuisance—a provocation for "decent ladies or quiet men," as the *Crescent* put it. "Certain lewd fellows of the baser sort, recruited from the ranks of the gamblers, jockies, greeks, and other members of the 'dangerous classes' seem to have become possessed of the idea that this quarter is all their own, as they form groups in the centre of the *banquettes*."[20]

1. James Gallier, "Estimate for the Commercial Exchange, St. Charles St." (ms.), Southeastern Architectural Archive, Tulane University; Greenbury R. Stringer, V, no. 291, July 2, 1845, NONA; *Norman's New Orleans and Environs*, pp. 159–61; Gallier, *Autobiography*, p. 42. *Norman's* (p. 161) reported a construction cost of $90,000.
2. "New Orleans," *Picayune*, March 16, 1845.
3. The granite Merchants' Exchange, which featured a luxurious domed rotunda, was destroyed by fire in 1960. See *Norman's New Orleans and Environs*, p. 138; Gallier, *Autobiography*, pp. 24–25; Arthur Scully, Jr., *James Dakin, Architect: His Career in New York and the South*, Baton Rouge (Louisiana State University Press) 1973, pp. 44–45.
4. Offering his clients the services of designer and builder was apparently profitable for Gallier. After gaining a reputation locally, and with a sense of his own worth as a professional architect, he could command fees of 10 percent when 5 percent was common (even before the American Institute of Architects standard adopted in 1866). Within a short time in New Orleans he would seem to have fulfilled his ambition in taking up practice there after the "disagreeable work, and so badly rewarded," of "grinding out drawings" for New York builders. "Journal of Receipts and Expenditures, 1836–1852," V, fol. 25, November 30, 1850, New Orleans Public Library, City Archives, Second Municipality Comptroller's Office Records, CB440; Gallier, *Autobiography*, p. 20.
5. Gallier, *Autobiography*, p. 20.
6. *Gleason's Pictorial Drawing-Room Companion*, IV, no. 14, April 2, 1853; *Proceedings of the ... Grand Lodge of the ... State of Louisiana*, New Orleans (Crescent Office) 1853, pp. 66–69; "The New Masonic Hall," *Picayune*, March 24, 1853; *Proceedings of the ... Grand Lodge ... of the ... State of Louisiana*, New Orleans (Sherman & Wharton) 1854, p. 64; *Proceedings of the ... Grand Lodge of the State of Louisiana*, New Orleans (Sherman & Wharton) 1855, pp. 43–44, 48.
7. "New Masonic Lodge Room," *Picayune*, June 11, 1854.
8. "Architectural Transformation," *Picayune*, March 12, 1854. The drafting tools were a reference to the central legend of the Masons as successors of the architect of Solomon's Temple; the "Square teaches us to regulate our conduct ... [and] the Compass teaches us to limit our desires," a Masonic manual advised. The "All-Seeing Eye" was symbolic of the omniscience of the Almighty. See Thomas Smith Webb, *The Freemason's Monitor*, Boston (Brown, Taggard & Chase) 1859, p. 40.
9. "Fire at Masonic Hall," *Bee*, March 22, 1860; *Proceedings of the ... Grand Lodge ... of the State of Louisiana*, New Orleans (Bulletin Book and Job Office) 1861, pp. 31, 43–44, 48.
10. "Lower Story of the Masonic Hall for Lease," *Crescent*, July 6, 1866; William D. Moore, *Masonic Temples: Freemasonry, Ritual Architecture, and Masculine Archetypes*, Knoxville (University of Tennessee Press) 2006, pp. 124–29.

11. "Lower Story of the Masonic Hall for Lease," *op. cit.*
12. "Great Improvement," *Picayune*, March 30, 1867; "Local Intelligence," *Times*, May 28, 1867; "New Masonic Hall," *Crescent*, June 20, 1867; *Proceedings of the ... Grand Lodge ... of the State of Louisiana*, New Orleans (Isaac T. Hinton) 1868, pp. 10, 46–47. Freret's proposals of 1867 (and later) are in the Southeastern Architectural Archive, Tulane University.
13. Will Freret won the competition; Haggart, James Freret, and Lewis Reynolds also received premiums; *Proceedings of the Grand Lodge, State of Louisiana ...*, New Orleans (A.W. Hyatt) 1872, p. 126.
14. "The New Masonic Temple," *Picayune*, May 19, 1871; "The Masonic Temple," *Picayune*, January 14, 1872; "Masonic Jubilee," *Picayune*, February 16, 1872; "The New Masonic Temple," *Picayune*, February 16, 1872; *Laying of the Corner-Stone of the Masonic Temple, St. Charles Avenue ...*, New Orleans (A.W. Hyatt) 1872; *Jewell's Crescent City Illustrated*; *Proceedings of the Grand Lodge, 1872, op. cit.*, pp. 125–28; *Proceedings of the ... Grand Lodge of the State of Louisiana ...*, New Orleans (Clark & Hofeline) 1874, pp. 108–109; J. Curtis Waldo, *Visitor's Guide to New Orleans, November 1875*, New Orleans (J.C. Waldo) 1875, p. 118–19.
15. *Proceedings of the ... Grand Lodge of the State of Louisiana ...*, New Orleans (A.W. Hyatt) 1889, p. 15.
16. *Proceedings of the ... Grand Lodge of the State of Louisiana ...*, New Orleans (A.W. Hyatt) 1892, pp. 30–35, 68–69; *Proceedings of the M.W. Grand Lodge of the State of Louisiana ...*, New Orleans (A.W. Hyatt) 1893, pp. 3–4. The Freret building was, in turn, taken down in 1924–25 for a $2.5 million, nineteen-story speculative-office tower (then the city's tallest) built by the Masons, with a temple occupying the top floors. Designed by Sam Stone, Jr., in 1920, and completed in 1926, the temple was Stone's version of the skyscraper Gothic advanced by Cass Gilbert in the Woolworth Building of 1914. In 2001, Stone's building was renovated (at a cost of $34 million) for a 250-room hotel. "Masonic Temple Sold," *Daily States*, April 19, 1890; "The New Masonic Temple," *Picayune*, September 1, 1890; *Proceedings of the ... Grand Lodge, 1892, op. cit.* pp. 30–36; *Times-Picayune*, January 25, May 2, and November 19, 1920, and March 3, 1925; Moore, *op. cit.*, pp. 139–40. See also cats. 68 and 120.
17. *Proceedings of the ... Grand Lodge ... of the State of Louisiana*, New Orleans (Bouvain & Lewis) 1867, p. 34; *Jewell's Crescent City Illustrated*.
18. *Picayune*, February 11, 1860, cited by Frederic Bancroft, *Slave Trading in the Old South*, New York (Unger) 1959, p. 326.
19. *Ibid.*
20. "Town Talk," *Crescent*, April 5, 1866.

63 *overleaf*

Bank of New Orleans
Banque de la Nouvelle Orleans

The architect James Gallier, Jr., with his partner John Turpin, designed the Bank of New Orleans at the corner of St. Charles and Union streets, built in 1857.[1] The stuccoed-brick structure in a Renaissance palazzo style had a sculptural façade that expressed itself in weight and ornament. A base course and steps were of granite, and the ground floor was

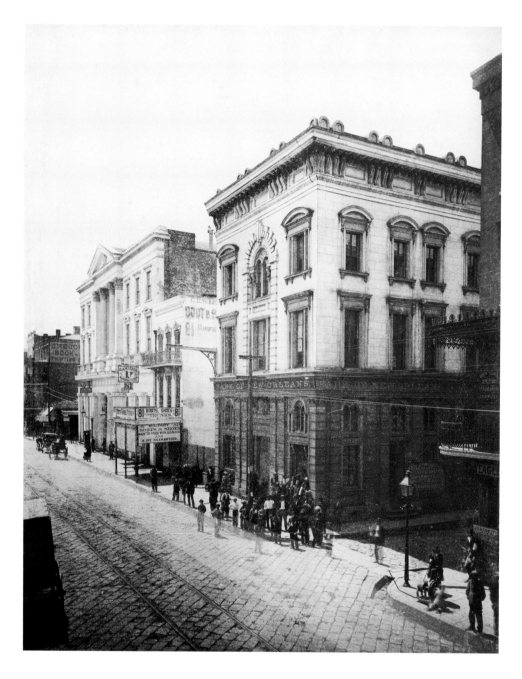

ornamented by rusticated pilasters with cast-iron capitals. Corinthian pillars framed the St. Charles Street entrance and over the door gilded figures represented Commerce, with a wheel of fortune, and Wealth, with a cornucopia. Pedimented windows with cast-iron hoods and sills appeared with round-arched bifore windows, and a cornice with large cast-iron consoles projected more than 3 feet (1 m) from the outside wall.

The sculptural opulence of the façade was stepped up even further in the elegant interior. An entrance vestibule with marble floors led to a 20-foot-high (6 m) banking room ornamented

with six cast-iron Corinthian pillars, each 14 inches (35.5 cm) square. Builders were instructed, without accompanying drawings, to ornament the interior rooms with "a complete entablature of the proper proportions of the Roman Corinthian order from the Temple of Jupiter Tonans at Rome"—a reference to the famous three-column fragment of the Temple of Vespasian excavated in the nineteenth century.[2]

The rusticated palace block was a centuries-old status symbol, and the bulky building and its expensive materials expressed a dominance of the street. Its rhetoric of costliness, massiveness, and strength was appropriate to a

successful antebellum business, and "a pretty sure indication of the prosperity of that bank," according to the *Picayune*.[3] Representing the new architecture of the fifties, Gallier's building was nearly side-by-side with one of his father's buildings of a decade earlier, the Masonic Hall (cat. 62). Wedged between the two Gallier buildings was an older retail building dwarfed by the taller, more massive and more detailed mid-century structures. The juxtaposition of modest and monumental was characteristic of the mix of scale and styles of commercial streets in nineteenth-century New Orleans.

The Bank of New Orleans was ruined by the war. Having suffered capital losses to the Confederate government, and with the establishment of a national banking system in 1863, seven banks closed, including the Bank of New Orleans.[4] Declaring insolvency, it listed its only assets as "Confederate notes on hand, or invested in cotton."[5] After the war, surviving banks "emerged underneath a sea of worthless confederate currency" to finance Reconstruction, but their available capital was insufficient.[6] In 1867, New Orleans's banks had capital of only $7.5 million, far less than the $20 million held before the war.[7] "In our city there appears to be a total abnegation of credit," the *Times* observed. "If there is not sufficient capital nor means in our city to grant the credit required, then business must go to other marts, where capital is in full supply."[8]

With credit nonexistent—devalued plantation properties were no longer sufficient security for loans—economic recovery depended on northern and foreign capital, but crop failures in 1866 and 1867 discouraged investors. It was a grim picture of collapsed prosperity, and revealing of the city's aspirations at the Exposition in Paris.

The Bank of New Orleans reorganized and reopened in early 1867, just before Lilienthal's photograph was made, but it went out of business once more a short time later. In 1868, the Louisiana State Lottery Company—said to be the largest gambling organization of the century—occupied the building, which Lilienthal photographed again for *Jewell's Crescent City Illustrated* in 1872.[9] It was demolished in the early 1920s for a ten-story office building.

Lilienthal's view takes in his own photography wagon, visible in shadow in the left foreground. A streetcar has ghosted the image, its bright white roof leaving a trace of light as it passed through the picture.

Commercial signs on storefronts and building walls advertise shoes, sewing machines, circular saws, and cotton gins. On the *banquette* two men operate a flywheel device, and a large street-corner gathering is deferential to Lilienthal's work.

1. Building contract, Walter Hicks Peters, XX, no. 470, December 26, 1856, NONA; "New Building for the Bank of New Orleans," *Picayune*, January 3, 1857. The Gallier & Turpin plans for the building are in the Southeastern Architectural Archive, Tulane University.
2. Building contract, *op. cit.*
3. "New Building for the Bank of New Orleans," *op. cit.*
4. On Reconstruction economics, see Larry Schweikart, *Banking and the American South from the Age of Jackson to Reconstruction*, Baton Rouge (Louisiana State University Press) 1987, pp. 238–39; Joe Gray Taylor, *Louisiana Reconstructed, 1863–1877*, Baton Rouge (Louisiana State University Press) 1974, pp. 347–48, 354, 400–401.
5. General Assembly of the State of Louisiana, *Report of the Committee on Banks and Banking, January 1866*, New Orleans (J.O. Nixon) 1866, p. 1.
6. Allan Nevins, *The Emergence of Modern America*, New York (Macmillan) 1955, p. 4.
7. *Gardner's New Orleans Directory for 1867*, p. 22.
8. "On Change," *Times*, September 8, 1866.
9. *Crescent*, January 7, 1867; *Jewell's Crescent City Illustrated*, prospectus. On the Louisiana Lottery, Andrew Morrison, *New Orleans and the New South*, New Orleans (L. Graham) 1888, pp. 78–79; T. Harry Williams, *P.G.T. Beauregard, Napoleon in Gray*, Baton Rouge (Louisiana State University Press) 1955, pp. 291–303. At the turn of the century the Gallier & Turpin building was again in use as a bank, the Bank of Commerce, and by 1903 it was occupied by the United Fruit Company. See George Englehardt, *The City of New Orleans: The Book of the Chamber of Commerce and Industry of Louisiana*, New Orleans (Geo. Englehardt) 1894, p. 50; *id.*, *New Orleans, Louisiana, The Crescent City*, New Orleans (Geo. Englehardt) 1903–1904, p. 80.

64 (overleaf)
St. Charles Hotel
Hotel St. Charles

For more than a century, the St. Charles Hotel was one of the finest hotels in America and one of the architectural sights of New Orleans. From 1838 to 1973, three hotels occupied a trapezoidal site on St. Charles Street between Gravier and Common streets. Lilienthal's view is of the second hotel, which was built from the ruins of the first, a Greek Revival masterpiece by James Gallier and Charles Dakin that was destroyed by fire in 1851.

Gallier and Dakin's St. Charles or Exchange Hotel, backed by financiers of the Anglo-American quarter and the Exchange Bank, was built in 1835–38 at a cost of $650,000

(figs. 26–28).[1] During a decade of seemingly limitless citybuilding, when New Orleans nearly tripled its population, the St. Charles embodied the city's aspirations as the "queen of cities" and the "rival of all the metropolises of the Union," especially New York and Boston.[2] With 350 rooms, the St. Charles was the largest hotel in the country, surpassing both the Astor House in New York (built at the same time as the St. Charles) and the Tremont in Boston (completed in 1830). The Tremont, which Nikolaus Pevsner called the "first American hotel built to be an architectural monument," was designed, like Astor House, by Isaiah Rogers and appears to have been Gallier and Dakin's model.[3]

"The St. Charles, chief hotel of the American quarter, covers the front of an entire square, and is built in a more showy style than any building in New York," one traveler observed; "the building is surmounted with a high, gracefully shaped dome, and a pretty cupola. The whole surface is of stucco, brilliantly white, and it can be seen at a great distance around."[4] It was the hotel's gilded dome, rising nearly 200 feet (61 m) and presenting a panoramic view from its observatory, that was the hotel's most admired feature, and inevitably recalled other famous domes.[5] "The St. Charles looks a little like St. Peter's at a distance," one visitor recounted, while a guidebook claimed that "[t]he effect of the dome upon the sight of the visitor, as he approaches the city, is similar to that of St. Paul's, London."[6] Design of the dome was attributed to Gallier's former partner (and Charles Dakin's brother), James Dakin.[7] Gallier himself complained that he received only $10,000—less than two percent of the construction cost—for his work on the St. Charles. "The amount of compensation was not nearly as much as it should have been," Gallier wrote in his *Autobiography*, "but I gained reputation by it, which brought in other business that paid better."[8]

On January 18, 1851, the St. Charles caught fire. "The flames are burning through the roof and protruding through the windows like the fiery tongues of serpents," the *Courier* reported. "The Cupola fell with a terrific crash carrying with it a flood of flames into the centre of the building … . The building is lost."[9] The destruction of the hotel was felt immediately. "This magnificent building was not only the pride of our citizens, from its architectural beauty, the vastness of its dimensions, and its high reputation," the *Picayune* wrote, "but had

grown into an almost indispensable part of the city itself."[10]

Stockholders organized a subscription drive to resurrect the hotel following a more modest plan, and architects Lewis Reynolds, James Gallier, Jr., Samuel Stewart, and George Purves submitted proposals.[11] Purves was hired as superintending architect, but the most important design ideas came from Isaiah Rogers, whose hotels in Boston and New York had inspired the first hotel. Visiting New Orleans in the winter of 1851 from Cincinnati, where he had taken up practice, Rogers consulted with Purves and prepared at least two plans before withdrawing from the project.[12] Rogers's plans were modified by the stockholders and in April Purves was reported to be "busily engaged preparing the specifications and working plans" for the new building. "Without admitting that we have less admiration for the beauty of architecture than others," the *Crescent* wrote, "we freely confess that we belong to the party who are content with a less expensive and imposing structure than the old … [where] too much comfort was sacrificed for outside show."[13] The showiest feature of all, the dome, was eliminated in the reconstruction plans.

Using the old foundations, and bricks salvaged from the ruins of the fire, the new St. Charles rose quickly. In August 1852, it reportedly appeared "very much like its former self with the whitening of its walls and the capping of its numerous columns in front." The following January the scaffolding was removed. The new hotel was described as having an "elaborate air of comfort and luxury" in the "classic modeling of its tasteful architecture." The construction cost of $300,000 was less than half that of its predecessor.[14]

Like most metropolitan hotels, the St. Charles served a large resident clientele, primarily single men and married couples, and hotel life was gender-segregated.[15] A men's dining room seated 500 and dazzled its diners with five immense chandeliers of 360 gaslights. The women's dining room seated 225, and there were additional private dining rooms and breakfast rooms. In the Ladies' Ordinary, resident women, freed from household concerns, "sewed, knitted, read, played piano or gossiped."[16] In the men's parlor, decorated with murals of Biblical subjects and furnished with morocco-covered sofas, "gouty old gentlemen with white cravats" would, one journalist wrote, "swelter out the long summer days, discuss politics and dream."[17]

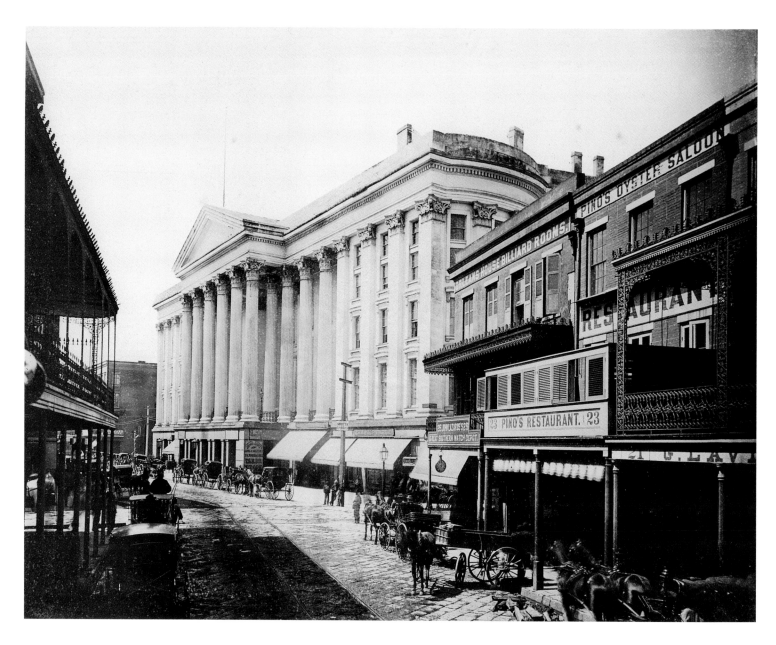

Guest rooms were carpeted and finished in black walnut. Speaking tubes and a telegraph enunciator relayed guests' needs to staff, and the building featured one of the earliest hotel elevators.[18] On the Common Street side was a marble-floored public bathhouse. Much of the real estate was taken up with service rooms, including kitchens, a bakery and confectionary, wine cellar, pantries, ice-closets, scullery, crockery room, washroom, and coal room. Steam pumps in the engine room filled five large iron tanks on the roof with 30,000 gallons (136,380 liters) of hot and cold water.

The new hotel quickly resumed its central role in the business and social life of the Anglo-American community above Canal Street. As

an offspring of American entrepreneurial enterprise, the rebuilt hotel was seen as the cornerstone of a continuing campaign to dislodge Creole commercial supremacy in the city. With all its amenities, the new St. Charles was no less a favorite with visitors than the old hotel, although Frederick Law Olmsted, visiting in the mid-1850s, thought otherwise: "I was landed before the great Grecian portico of the stupendous, ill-contrived and inconvenient St. Charles," he griped.[19]

The great columned rotunda, like the equivalent space in the St. Louis Hotel (cat. 14), served as an exchange, or auction market. It was "a scene of bustle and animation which can be compared to nothing but the Bourse at

Paris during the full tide of business," Charles Mackay observed in the *Illustrated London News*.[20] Slave auctions, like those at the St. Louis, were held there.[21] "Right there before your eyes, an auctioneer conducts a public sale of these human beings, like a bailiff's sale of goods and animals in Europe," one visitor wrote.[22] The auctions were serviced by infamous slave pens surrounding the hotel; in 1860 there were at least twenty-five in the vicinity.[23] A typical Gravier Street depot advertised that "a good stock of Negroes for sale will be constantly kept on hand, consisting of Field Hands, Mechanics, House Servants, Seamstresses, Nurses, Hair Dressers, &c."[24] An escaped slave recalled one of the depots opposite

the hotel as "a perfect Bedlam of despair":

> ... The pen would contain about five hundred, and was usually full. The men were separated from the women, and the children from both; but the youngest and handsomest females were set apart as the concubines of the masters Members of a family were of necessity separated, and would often see the last of one another in that dreadful show-room. The buying commenced at about ten in the morning, and lasted until one ... [and] the afternoon sale, which commenced at three, ended at six. This over, we had tea, and were then free to do what we liked in the pen until bed at ten.[25]

Following the federal capture of New Orleans, General Butler appropriated the St. Charles for his headquarters. As a Union regiment fortified the hotel with howitzers, an army band "played with fiery energy all the national airs from Yankee Doodle to the Star Spangled Banner."[26] Hundreds of soldiers were put up, including Captain Henry Scott from Massachusetts. "We are at last brought up in this great barn of a hotel," Scott wrote to his mother. "The bed bugs ate me half up last night and the mosquitoes got through a hole in the bar [and] tortured me."[27] Orleanian Clara Solomon's "heart sank" when she witnessed this spectacle of federal authority and the "desecration" of her beloved St. Charles by the Union soldiers. "It looks to be a perfect wreck," she wrote:

> They are loitering around it, lying down, playing cards, & their clothes hanging around. Oh! it was a loathsome sight ... as I gazed upon it tears voluntarily sufficed my eyes at the thought that one of our noblest institutions should be so disgraced as to be the abode of the invaders of our soil.[28]

As a famous destination for tourists and a local landmark, the St. Charles was also a frequent subject for photographers. Nearly all the many stereoviews and cartes de visite of the famous hotel published for the tourist trade were made from this vantage point near the corner of Common and St. Charles streets, where the shift in alignment of the street allowed photographers to capture the massive building in partial perspective. The first known outdoor photograph made in New Orleans, a daguerreotype by Thomas Easterly dating from

about 1845, is the only existing photograph of the first St. Charles Hotel (fig. 27). Easterly's elevated perspective takes in the dome of the building of 1838; Lilienthal's near-street-level perspective may have been made with the camera and tripod mounted on the roof of his photography wagon.

A fire destroyed the second St. Charles Hotel in 1894. It was replaced by a third hotel, designed by Thomas Sully—a seven-story, steel frame structure as luxurious as its predecessors, and which operated until 1973. Following demolition of the third, and last, hotel, Toronto developers raised on the site a pink-granite-faced, fifty-three-story office tower, which opened in 1985. The old hotel's rotunda was said to have inspired a balconied food court and retail arcade in the new tower, called Place St. Charles.[29]

In the foreground of Lilienthal's view, at left, is the iron gallery of Gallier and Turpin's J.W. Zacharie Building, a retail block built in 1855 on the site of another famous hotel, the Verandah, which had also been destroyed by fire.[30] Opposite is a watchmaker's shop, where a clock in the form of a pocket watch, suspended from the gallery, gives the photograph a vivid sense of particularity: it reads "10:02."

Also at this corner is Pino's Oyster Saloon and the Orleans House, two of St. Charles Street's many barrooms, known locally as "coffeehouses." St. Charles Street was "famous for its amusements, balcony serenades, cabstands and hotel arrivals," the *Crescent* wrote, and "one block upon either side in its busiest portion contains nothing but coffeehouses."[31] In a six-block stretch, no fewer than forty-five establishments sold liquor.[32] The easy availability of alcohol gave some visitors the impression of a city of drinking and drunkards—what Union chaplain and Methodist minister John Chandler Gregg called the "devotees of Bacchus." "Drunkenness abounds," Gregg proclaimed, "there are six hundred and thirty seven licensed groggeries," and even grocery stores sold alcohol. By Gregg's careful census, there were "eleven hundred and sixty five places where the public may purchase rum in New Orleans."[33] By Captain Henry Scott's count, "every third house" was a "drinking salon," and residents did "nothing but drink from morning till night." But he added: "I must confess that the great heat makes iced claret very nice."[34]

1. The hotel opened to guests in February 1837; *Niles Weekly Register*, LII, June 3, 1837, p. 224; *Gibson's Guide*, p. 141; *Norman's New Orleans and Environs*, p. 140; Arthur Scully, Jr., *James Dakin, Architect: His Career in New York and the South*, Baton Rouge (Louisiana State University Press) 1973, pp. 48–51; Mills Lane, *Architecture of the Old South: Louisiana*, New York (Abbeville Press) 1990, pp. 111–14. Gallier and Dakin's plans for the St. Charles are in the Southeastern Architectural Archive, Tulane University, the Louisiana State Museum and The Historic New Orleans Collection. Early documentation of the hotel can be found in St. Charles Hotel Papers, Manuscript Collection, Tulane University Library.
2. *Bee*, January 8, 1835; Jefferson Williamson, *The American Hotel*, New York (Arno Press) 1975, p. 97.
3. Nikolaus Pevsner, *A History of Building Types*, Princeton, NJ (Princeton University Press) 1997, p. 175–76; Lane, *op. cit.*, p. 111, noted the source of Gallier and Dakin's design in the illustrations of the Tremont, published in W.H. Eliot, *Description of the Tremont House*, Boston (n.p.) 1830.
4. Thomas Low Nichols, *Forty Years of American Life*, London (J. Maxwell) 1864, I, p. 184.
5. For discussion of this viewpoint, see p. 247.
6. *Norman's New Orleans and Environs*, p. 141; Lady Emmeline Stuart Wortley, *Travels in the United States, etc., during 1849 and 1850*, New York (Harper & Brothers) 1851, p. 122. For other comparisons, see the accounts cited by Scully, *op. cit.*, pp. 50 and 194, n. 14.
7. Scully, *op. cit.*, p. 51, discusses the attribution to James Dakin.
8. Gallier, *Autobiography*, p. 22.
9. "Burning of the St. Charles Hotel," *Courier*, January 18, 1851; "The St. Charles," *Orleanian*, January 21, 1851.
10. "Destruction of the St. Charles," *Picayune*, January 20, 1851.
11. *Picayune*, February 13 and 14, 1851; *Crescent*, January 23, February 15 and 17, 1851; *Weekly Picayune*, February 17, 1851. Reynolds prepared a pamphlet plan for a new hotel of 540 rooms on another site, *Remarks of the Architect Mr. L.E. Reynolds on Presenting a Plan for a New Hotel*, February 1851.
12. Isaiah Rogers, *Diaries*, February 14–March 14, 1851, Avery Library, Columbia University; *Picayune*, August 3, 1851. At least one nineteenth-century source attributes the design to Rogers: "The architect originally chosen was Rogers, the well known hotel builder of New York. He was compelled to abandon the task before its completion, and his plans were executed under the direction of George Purves, of New Orleans," *The Picayune's Guide to New Orleans*, New Orleans (Picayune) 1897, p. 77.
13. "St. Charles Hotel," *Crescent*, April 4, 1851; *Picayune*, August 4, 1851 ("The architect of the company is Mr. George Purves. The plan of the building is not that of any individual architect"). Further, on Purves's role, "The New St. Charles," *Crescent*, February 17, 1851; "St. Charles Hotel," *Picayune*, October 4, 1852; "The St. Charles Hotel," *Crescent*, January 21, 1853; "The New St. Charles Hotel," *Southern Ladies' Book*, I, no. 6, April 1853, p. 364 (from the *Picayune*).
14. *Delta*, June 13 and August 15, 1852; *Crescent*, January 21, 1853; *Picayune*, January 22, 1853.
15. On the nineteenth-century residential hotel, see Molly W. Berger, "The Rich Man's City Hotels and Mansions of Gilded Age New York," *Journal of Decorative and Propaganda Arts*, XXV, 2005, pp. 47–71.
16. Max Berger, *The British Traveller in America, 1836–1860*, New York (Columbia University Press) 1943, p. 81.
17. *Crescent*, January 21, 1853; "The New St. Charles Hotel," *Southern Ladies' Book*, *op. cit.*, p. 366.
18. *Otis Elevator Company: The First 100 Years*, New York (Otis Elevator Co.) 1953, p. 9, cited by Pevsner, *op. cit.*, p. 317, n. 179.

19. Frederick Law Olmsted, *A Journey in the Seaboard Slave States, with Remarks on their Economy*, New York (Dix & Edwards) 1856, p. 581.
20. Charles Mackay, *Life and Liberty in America: or, Sketches of a Tour in the United States and Canada in 1857–8*, New York (Harper & Brothers) 1859, p. 265.
21. John S. Kendall, "Shadow over the City," *Louisiana Historical Quarterly*, xxii, January 1939, p. 147.
22. Kalikst Wolski, *American Impressions*, Cheshire, Conn. (Cherry Hill Books) 1968, p. 127.
23. Frederic Bancroft, *Slave Trading in the Old South*, New York (Ungar) 1959, p. 319.
24. *Picayune*, January 1, 1860.
25. John Brown, *Slave Life in Georgia: A Narrative of the Life, Sufferings, and Escape of John Brown, a Fugitive Slave* [1855], ed. F.N. Boney, Savannah (Library of Georgia) 1991, pp. 94–100.
26. Benjamin F. Butler, *Private and Official Correspondence of Gen. Benjamin F. Butler During the Period of the Civil War*, Norwood, Mass. (Plimpton Press) 1917, I, p. 439.
27. Henry B. Scott to his mother, June 28, 1864, Henry B. Scott Papers, Massachusetts Historical Society.
28. Clara Solomon, *The Civil War Diary of Clara Solomon: Growing Up in New Orleans 1861–1862*, ed. Elliott Ashkenazi, Baton Rouge (Louisiana State University Press) 1995, pp. 355–56.
29. Sully's drawings for the third St. Charles (1896), with 400 rooms, are in the Southeastern Architectural Archive, Tulane University. Architect Emile Weil renovated the hotel in 1925, adding a 94-foot (29-m) stained-glass ceiling. The hotel was demolished in early 1974; *Times-Picayune*, February 17, 1974; *States-Item*, September 6, 1974. On Place St. Charles, see L. Stuart, "CBD's 53-story Place St. Charles Opens Wednesday," *Times-Picayune*, November 16, 1985; R. Green, "High Rise No Match for Hotel," *Times-Picayune*, December 7, 1985.
30. Gallier and Turpin's drawings for the Zacharie Building are in the Southeastern Architectural Archive, Tulane University. On the Verandah, by Dakin and Dakin, see Scully, *op. cit.*, pp. 52–55.
31. "The Streets of the City," *Crescent*, January 15, 1867.
32. Gerald M. Capers, "Confederates and Yankees in Occupied New Orleans, 1862–1865," *Journal of Southern History*, xxx, no. 4, November 1964, p. 421.
33. John Chandler Gregg, *Life in the Army, in the Departments of Virginia, and the Gulf, Including Observations in New Orleans*, Philadelphia (Perkinpine & Higgins) 1866, pp. 150–53. Gregg's count was probably accurate: *Gardner's New Orleans Directory for 1867* lists 605 "coffeehouses," as well as 105 wine and liquor merchants operating in the city.
34. Scott, *op. cit.*

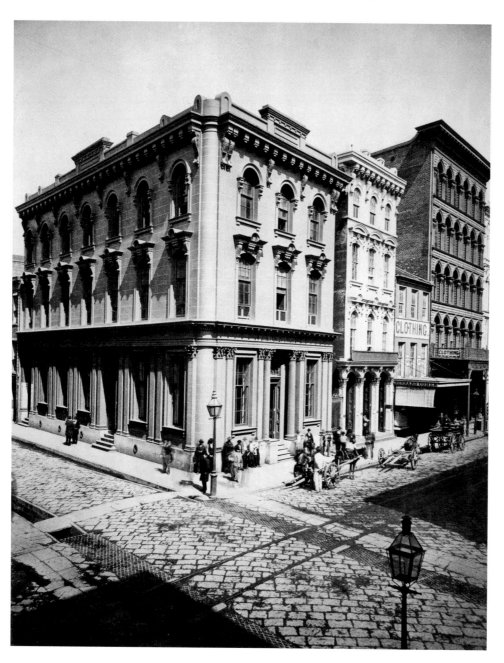

65

Canal Bank Cor. Camp & Gravier Sts
Banque du Canal Rues Gravier et Camp

The Canal Bank was an "improvement bank" organized in 1831 to finance the New Basin Canal (cat. 74). Its brick, granite, and cast-iron banking palace at Camp and Gravier streets was erected in 1858. Architect Lewis E. Reynolds, with James Gallier, Jr., and Richard Esterbrook, designed the bank, like Gallier's Bank of New Orleans the previous year (cat. 63), in an Italianate vocabulary that had long been associated with mercantile and banking success. The building solidly staked out a prime corner of the city's most important banking street with a mass and dignity that advertised the company's security in volatile times.[1]

The façade featured a base course of blue granite, paired Corinthian pilasters of cast iron, and deep cast-iron moldings. Windows on the upper floors had projecting cast-iron pediments with scrolled brackets, and similar brackets also supported a modillioned iron cornice above. The effect of size and grandeur in the modest building was enhanced by the deep relief and horizontal stress of pediments and cornices and the repetition of the pilasters across the façade. The iron and the plastered brick walls, scored to imitate stone courses, were painted dark brown.[2]

The interior banking room was elevated above the *banquette* and was accessed at the main Camp Street entrance by granite steps, which were flanked by fluted cast-iron columns. Inside were counters and desks for paying and receiving tellers, discount clerks, book-keepers and runners, and a cashier's room, plus two iron vaults. Luxuriously finished down to the last detail, the bank had fittings that included water

closets supplied with "the best hinged flaps of mahogany and brass."[3]

Next door to the Canal Bank was another banking house, the First National Bank. It had opened in January 1864, a symbol of "re-awakened commerce" for war-weary New Orleans.[4] Both bank buildings were demolished for the nine-story Canal-Louisiana Bank Building by Diboll and Owen, built in 1905–1907, now a hotel.[5] The three-story building dwarfed by its neighbors is the Bernard Cohen Clothing Store at 35 Camp Street, which was demolished in the late nineteenth century for the Teutonia Insurance Company Building.[6]

The five-story cast-iron Tulane Building at 31–33 Camp Street, seen at the right-hand edge of the photograph, was built in 1860–61 by the wealthy clothing merchant Paul Tulane (he endowed Tulane University). Designed by architect Henry Howard, the Tulane Building was fabricated by Daniel Badger's Architectural Iron Works of New York, and patterned after Badger's Cary Building on Chambers Street, New York, built four years earlier.[7] Both buildings were composed of four rows of keystoned, semi-circular arches, repeated twenty-four times, springing from entablatures above coupled Corinthian columns. The freestanding columns, deep window reveals, and heavy, projecting cornice gave the boldly modeled façade a dramatic effect of light and shade.[8]

The Tulane featured an interior light court, an ornamental iron spiral staircase, and Badger's rolling iron shutters on the exterior. During construction, before installation of the cast-iron front, the walls and framing timbers of the building collapsed and destroyed the two adjoining buildings, which were reduced to a "ghastly pile of bricks and timbers," the *Crescent* recounted.[9] The Tulane Building was rebuilt and in 1866 an elaborate iron balcony was added.[10]

"[B]uilt with all the modern improvements," the Tulane was among the most up-to-date commercial buildings in the city at the beginning of the war (especially compared to its Camp Street neighbors), and represented the height of fashion for cast-iron fronts.[11] In 1859, the *Crescent* noted the increased use of iron in building: "granite was the rage a few years since for store doors and window cornices, but now it is altogether iron. Not only iron basements, but whole iron fronts are

becoming fashionable."[12] The cast-iron façade, an assemblage of interchangeable, prefabricated components bolted together and attached to brick supporting walls, was an economical and efficient way to simulate the opulence and ornamental effects of stone construction (despite John Ruskin's admonition against such imitation), especially in a city with no native stone.[13] The fashion in iron fronts peaked locally with James Freret's Moresque Building on Lafayette Square, a splashy iron showpiece begun in 1860 but not completed until 1867 (cat. 120). The ornamental facility of iron construction for which the Moresque was a runaway demonstration was a "temptation too strong for designers, according to New Orleans architect Thomas K. Wharton. "These fronts are a great improvement in store building, but I fear will give rise to an incalculable amount of false ornamentation," he wrote.[14] By 1890, this type of construction was outmoded and many of New Orleans's iron buildings, including the Tulane, were demolished.[15]

The materials, cost, and scale of these buildings in Camp Street created an image of prosperity and modernity for this district of the city, enhanced by the city's campaign of street improvements before the war. The granite paving blocks that form the foreground mosaic of the photograph were laid in 1858–60, replacing "the old cobblestone nuisance" throughout the commercial district, often with the addition of new flagstone *banquettes*.[16] "We shall in a few years be able to point to the cleanest and most beautiful streets in the country," the *Evening Picayune* predicted in 1860.[17] The Union chaplain John Chandler Gregg found this claim to have been borne out at the end of the war, when he observed that New Orleans had the "best paved streets to be found on this continent."[18]

The "square block reform" of city streets had been promoted by associating the block pavements with the rout of filth and disease.[19] In fact, the granite was easier to clean than cobblestone, but the crevices between the blocks trapped horse manure and other filth. Cleanliness did improve in the commercial districts during the decade, but more from aggressive measures by the U.S. military, including the first citywide cleansing of the century, than from any sanitary benefit of new street pavements.[20] In 1865, Gregg found the streets "kept very clean, being swept and

washed every twenty-four hours, so that filth and garbage is not allowed to accumulate."[21] For a city long scorned for its dirt, disease, and disorder—one prewar visitor found the filth of New Orleans's streets "truly execrable"—it was a surprising claim.[22] The new sanitary conditions appeared to keep disease at bay; yellow fever did not return during the war. The city was, at least for Gregg, "unquestionably, at this time, the healthiest in the United States."[23] By 1867, however, New Orleans was "restored to its customary filthiness" and yellow fever returned, in the worst outbreak since 1853.[24]

1. Building contract, T. Guyol, XLI, no. 49, May 20, 1858, NONA, for plans by L.E. Reynolds, with "detail and working drawings to be made by Gallier and Esterbrook"; plans survive in the Southeastern Architectural Archive, Tulane University. Canal Bank had been established earlier at Gravier and Magazine streets in a building designed by Capt. Richard Delafield; Building contract, P. Cuvillier, I, no. 119, June 14, 1831, NONA. On the history of the bank, see Andrew Morrison, *New Orleans: Her Relations to the New South*, New Orleans (L. Graham) 1888, p. 51; *100 Years: The Canal Bank and Trust Company of New Orleans*, New Orleans (Canal Bank) 1931; Larry Schweikart, *Banking and the American South from the Age of Jackson to Reconstruction*, Baton Rouge (Louisiana State University Press) 1987, pp. 238–39.
2. *Times*, August 9, 1866; "Improvements and Buildings," *Times*, August 14, 1866.
3. Building contract, T. Guyol, *op. cit.*
4. "First National Bank of New Orleans," *Times*, January 13, 1864. A new building for the First National Bank was under construction at this time at Camp and Common. The bank relocated in August 1867, and the Louisiana State Bank occupied its old storefront at 37 Camp; *Picayune*, December 13, 1866; *Times*, January 1, 1867; "Camp Street," *Picayune*, August 31, 1867.
5. *Pen and Sunlight Sketches of Greater New Orleans*, New Orleans (American Illustrating Company) 19--, pp. 51, 81. Canal Bank moved to a new building designed by Emile Weil at Baronne and Common streets in 1927. In 1937, the bank was absorbed by the First National Bank of Commerce (later Bank One). This succession of corporate mergers ended with today's J.P. Morgan Chase & Co. In 2005, Chase disclosed its historical link with Canal Bank and that bank's antebellum slaveholding policy, and publicly apologized for it. Canal Bank had accepted slaves as collateral and owned slaves seized on defaulted loans; *Washington Post*, January 21, 2005.
6. *Times-Democrat*, July 4, 1890. S.B. Haggart remodeled the Cohen storefront for Cosmopolitan Bank in 1871; *New Orleans Architecture*, II, p. 214.
7. *Picayune*, June 9, 1861; Daniel Badger, *Illustrations of Iron Architecture, Made by the Architectural Iron Works of the City of New York*, New York (Baker & Godwin) 1865 [reprinted New York (Dover) 1981], plate VII. In the "Catalogue of the Principal Works," p. 25, Badger identifies the Cary Building as the pattern for the Tulane Building. Another Badger building modeled on the Cary Building, at 620 Broadway, known as the "Little Cary," was even closer to the New Orleans variant, with a narrower façade and string course that more closely matched the Tulane Building. The "Little Cary" was designed by John Snook in 1858. Both New

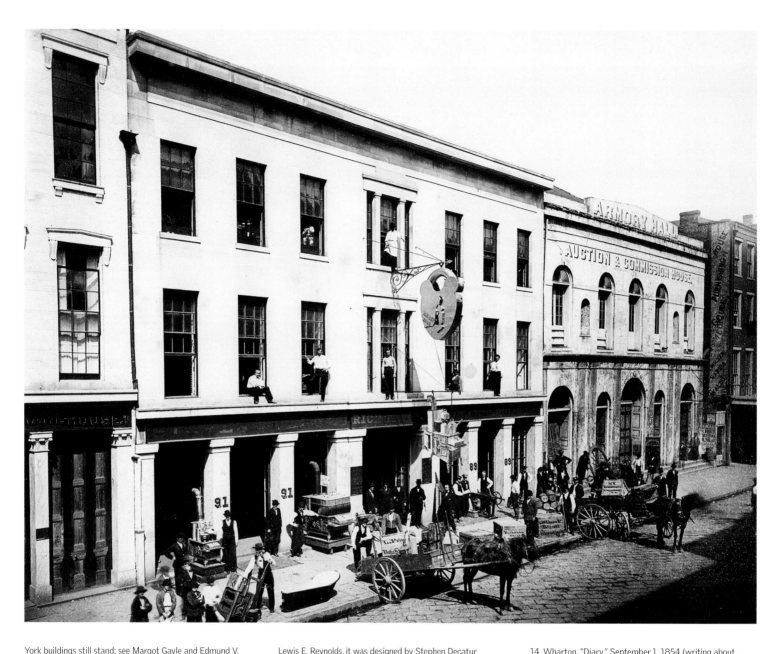

York buildings still stand; see Margot Gayle and Edmund V. Gillon, Jr., *Cast-Iron Architecture in New York: A Photographic Survey*, New York (Dover) 1974, pp. 150–51. On the pioneering work of Daniel Badger, see J. Leander Bishop, *A History of American Manufacturers from 1608 to 1860*, Philadelphia (Edward Young & Co.) 1868, pp. 204–207; Carol Gayle and Margot Gayle, *Cast-Iron Architecture in America: The Significance of James Bogardus*, New York (W.W. Norton & Co.) 1998, pp. 157–58.

8. The Tulane Building is engraved in Waldo, *Visitor's Guide* and *The Industries of New Orleans*, p. 83. Lilienthal photographed the Tulane Building for *Jewell's Crescent City Illustrated*, but the photograph was not selected to be engraved; see *Jewell's Crescent City Illustrated*, prospectus, fol. 61.

9. "Still Another Terrific Gale," *Crescent*, October 3, 1860.

10. *Times*, June 22, 1866.

11. *Picayune*, June 9, 1861, *op. cit*. The Story Building, located opposite the Tulane at Camp and Common streets, was the most admired of local cast-iron fronts. Always credited to Lewis E. Reynolds, it was designed by Stephen Decatur Button of Philadelphia (who had trained with New Orleans architect George Purves in New York), fabricated by Tiffany and Bottom in Trenton, NJ, and erected by Reynolds; Building contract, A. Mazareau, LIII, no. 90, February 10, 1859, NONA, cited by Mills Lane, *Architecture of the Old South: Louisiana*, New York (Abbeville Press) 1990, pp. 186 and 196, n. 33. On the Story, see "The Iron Palace," *Picayune*, May 22, 1859; "Building Improvements," *Crescent*, September 9, 1859; Griswold's *Guide*, p. 37; *New Orleans Architecture*, II, p. 102. Lilienthal photographed it for *Jewell's Crescent City Illustrated* in 1872 (see fig. 11); see *Jewell's Crescent City Illustrated*, prospectus.

12. "Building Improvements," *Crescent*, *op. cit*.

13. A sandstone was discovered in Catahoula Parish in early 1867, promoted as superior to northern stone (such as that from Illinois used for the Louisiana National Bank of 1866), and could be delivered, it was claimed, for half the cost; "Building Stone in Louisiana," *Picayune*, February 20, 1867.

14. Wharton, "Diary," September 1, 1854 (writing about 48 Camp Street).

15. The Tulane Building was pulled down in 1900 and replaced by a six-story office building designed by Andry and Bendernagle, which survives today; *New Orleans Architecture*, II, p. 113.

16. *Crescent*, September 12, 1859; "Local Improvements," *Picayune*, October 26, 1862. See also cat. 61.

17. "Banquettes," *Evening Picayune*, March 24, 1860.

18. John Chandler Gregg, *Life in the Army, in the Departments of Virginia, and the Gulf, Including Observations in New Orleans*, Philadelphia (Perkinpine & Higgins) 1866, p. 131.

19. "Local Improvements," *Picayune*, *op. cit*.

20. Later in the century, sanitarians and municipal engineers rejected block pavements in favor of smooth, easily cleaned asphalt, the new preferred road surface in the ongoing effort to rout urban epidemics; J.W. Howard, "Why Good Paving is Essential to the Success of a City," *Paving and Municipal Engineering*, X, 1896, pp. 305–308.

21. Gregg, *op. cit.*
22. Louis Fitzgerald Tasistro, *Random Shots and Southern Breezes*, New York (Harper & Brothers) 1842, I, p. 54.
23. Gregg, *op. cit.*
24. Joe Gray Taylor, *Louisiana Reconstructed, 1863–1877*, Baton Rouge (Louisiana State University Press) 1974, p. 7 (quotation); *Picayune*, September 6, 12, and 22, 1867; "The Yellow Fever in New Orleans," *Chicago Tribune*, August 14, 1867.

66
Stove Manufactory Camp St.
Manufactures de Fournaux

Lilienthal's view of this Camp Street commercial block between Poydras Street and Commercial Place is taken from opposite the Rice Bros. & Co. Stove Manufactory and the Armory Hall Auction and Commission House. Rice Brothers occupied two buildings at 89–93 Camp Street, renovated in early 1867, for its foundry and showroom, and hardware and tinware warehouse.[1] The buildings were typical of loft buildings of the antebellum New Orleans commercial district, with a granite pier-and-lintel shopfront, tall double-leaf doors that opened to the street, and large, six-pane-over-six-pane sash windows on the upper floors. Steam-powered hoists moved merchandise from floor to floor. The common brick exterior, often stuccoed, was here enhanced with a marble front. Similar granite post-and-lintel commercial buildings could be found in waterfront districts from Galveston to Halifax, and may have originated in Boston as early as 1810.[2]

Overhead, artful, pictorial signs advertise the foundry's keylocks and stoves. The spectacular commercial signs, of a type rarely documented for New Orleans, are similar to the traditional *enseigne* of Parisian shopfronts (which Atget later archived).[3] These trade emblems, often very large, functioned as advertisements for goods where they were manufactured or sold, as well as topographical markers mapping public space before consistent and comprehensible citywide street numbering existed.[4] Next door to the foundry sturdy letterforms in a bold grotesque enliven the Armory Hall shopfront. Signwriting like this, so prevalent in the nineteenth-century city, was often conceived as part of the architecture, and letterforms enhanced with shadowing and inlines added relief effects to the façade. Signs on building walls expressed a shared language of competitive commerce, as historian David Henkin has shown, and a "monumental

architecture of the written word."[5] Ghostly vestiges of these inventive signs survive on many older buildings today.

The Rice Brothers' foundry was an exceptional example of a successful postwar business. Established in 1848 with an investment of $15,000, the firm emerged from the war intact and by the late 1860s had an accumulated capital of nearly half a million dollars. The credit reporting agency R.G. Dun & Company noted in 1867 that Rice Brothers was still "one of the growing firms of this city" and, in the volatile postwar economy, an investment "safer than in any bank North or South."[6]

The neighboring Armory Hall, in 1867 occupied by an auction house, was formerly a theater. It had been the site of some of the city's greatest prewar entertainment spectacles, such as Beale's "Panopticon of India," which astonished audiences in 1860 with an animation of troops, ships, and scenery "so life-like as completely to delude the imagination."[7] Armory Hall was built in 1843 from the fire ruins of James Caldwell's American Theater, which had been the first building in the city to be lighted by gas.[8] When Armory Hall and the Rice Brothers' factory and warehouse were demolished in 1881, the buried retorts of Caldwell's gasworks were found.[9] Today the Pan American Life Center, built by Skidmore, Owings & Merrill in 1978, and the Intercontinental Hotel occupy the block.

In Lilienthal's view, the display of goods is a testimonial to the prosperity of the foundry. The entresol shopfront is opened to the street and the *banquette* has been claimed for the display of merchandise. Foundry men pose with samples of their best-selling Charter Oak Cooking Stove, burnished and glittering in the sunlight.[10] Other workers, possibly ironmolders from the foundry floor, pose at window ledges. A man with a handcart of barrels and another wheeling a stove pause for the portrait. A bathtub is exhibited on the *banquette* and drays stand by, loaded with crates of goods inscribed with their destinations: "Shreveport," "Brooklyn," and "Virginia." The men in sack suits and vests who claim the foundry entrance have a proprietary demeanor that suggests that they may be the owners, the Rice Brothers.

Lilienthal's shop portrait is not only an advertisement for the goods offered on the *banquette* but also a worker-centered composition ennobling manual labor. The foundry workers (undoubtedly compelled to

participate in the picture-making) are as much on exhibit as the stoves they built, in contrast to later nineteenth-century factory photographs, which rarely foreground workers.[11] Increasing industrialization in the postwar era challenged the traditional relationship of worker and craft, diminished workers' sense of identity with their trade, and put their jobs on the line, as foundries and other workshops replaced skilled tradesmen with unskilled machinists.[12] In later shop portraits, workers are either subordinated to the mechanics of production or absent altogether, while occupational portraiture, once an expression of artisan pride, nearly vanished from photographers' studios.[13] By the turn of the century, social standing was less likely to be measured by what one produced than by income and consumption, and personal identity was no longer tied to work alone. Labor itself came to be viewed increasingly as a commodity.[14]

This type of commercial portrait, unprecedented in New Orleans photography, came five years before local development of "booster" books—promotional directories of industry and commerce published by entrepreneurs (including photographers) or trade and fraternal organizations. In 1872, Lilienthal reprinted some of the Exposition photographs and made more than one hundred new views that were engraved in wood for *Jewell's Crescent City Illustrated*, the first commercial booster book published in New Orleans. The wood engravings in *Jewell's* formed the largest collection of commercial views of the city until the 1890s, when photographic booster books could be printed economically.[15] Early booster-book illustrations, however, were typically static logographs of business fronts, already in common use in advertising, rather than the animated shop portrait seen here.[16]

1. "The Fruits of Application and Industry," *Picayune*, January 5, 1867; Waldo, *Visitor's Guide*, pp. 118–19.
2. John M. Bryan has written that the Old Boston Customs House of 1810 by Uriah Cotting "introduced monolithic granite posts and lintels to commercial architecture," a means of construction made economically feasible by the "introduction of a new stone splitting technique and the completion of canals providing waterborne access to quarries"; John M. Bryan, *Robert Mills: America's First Architect*, New York (Princeton Architectural Press) 2001, p. 239; see also *id.*, "Boston's Granite Architecture, c. 1810–1860," PhD diss., Boston University, 1972, pp. 48–109.
3. Atget's album of old Paris signs and shopfronts, *Enseignes et vieilles boutiques de Paris*, dates from 1899–1911; see Molly Nesbit, *Atget's Seven Albums*, New Haven, Conn. (Yale University Press) 1992, pp. 181–87, 255–57, 381–96.

4. Richard Wrigley, "Between the Street and the Salon: Parisian Shop Signs and the Spaces of Professionalism in the Eighteenth and Early Nineteenth Centuries," *Oxford Art Journal*, XXI, no. 1, 1998, pp. 49–50 (I am grateful to Erika Naginski for this reference). See also David M. Henkin, *City Reading: Written Words and Public Spaces in Antebellum New York*, New York (Columbia University Press) 1999, pp. 40–41.

5. On architectural signage in the nineteenth-century cityscape, see Henkin, *op. cit.*, pp. 47–50.

6. *Louisiana*, II, pp. 148, 394, R.G. Dun & Co. Collection, Baker Library, Harvard Business School.

7. "The Panopticon," *Bee*, April 7, 16, 1860.

8. Caldwell's theater, built in 1823, burned in 1842. Building contract, H.B. Cenas, XXVIII, no. 221, November 16, 1843, NONA; "New American Theatre," *Picayune*, December 6, 1842; Noah M. Ludlow, *Dramatic Life as I Found It*, New York (Benjamin Blom) 1966 [first published St. Louis (G.I. Jones & Co.) 1880] pp. 248–50, 406. On Caldwell and gaslighting, see cat. 72.

9. "The Old Camp Street Theatre," *Picayune*, December 30, 1881. Rice Brothers opened a new building at the site in 1882. "Our New Store, Rice, Born & Co." (advertisement), *Times-Democrat*, September 1, 1882; *The Industries of New Orleans*; *New Orleans and the New South*, New Orleans (L. Graham; published with George W. Engelhardt) 1888, p. 94; George W. Engelhardt, *The City of New Orleans: The Book of the Chamber of Commerce and Industry of Louisiana* New Orleans (L. Graham) 1894, p. 123; Land, *Pen Illustrations*, p. 171. See also cats. 71–73.

10. "Rice Bros. & Co." (advertisement), *Times*, April 15, 1866.

11. See Richard Oestreicher, "From Artisan to Consumer: Images of Workers 1840–1920," *Journal of American Culture*, IV, no. 1, Spring 1981, pp. 5–56.

12. *Ibid.*, p. 60; W.J. Rorabaugh, *The Craft Apprentice: From Franklin to the Machine Age in America*, New York (Oxford University Press) 1986, pp. 131–33; Harry R. Rubenstein, "With

Hammer in Hand: Working-Class Occupational Portraits," in *American Artisans: Crafting Social Identity, 1750–1850*, ed. Howard B. Rock, Paul A. Gilje, and Robert Asher, Baltimore (Johns Hopkins University Press) 1995, p. 197.

13. Rubenstein, *op. cit.*, pp. 194–98; Rorabaugh, *op. cit.*; see also Brooks Johnson, "The Progress of Civilization: The American Occupational Daguerreotype," in *America and the Daguerreotype*, ed. John Wood, Iowa City (University of Iowa Press) 1991, pp. 109–17.

14. Oestreicher, *op. cit.*, p. 60; Rubenstein, *op. cit.*, p. 197.

15. *Jewell's Crescent City Illustrated*, prospectus (see discussion of Jewell's, pp. 15–16, and of the booster-book literature, pp. 290–91). After *Jewell's Crescent City Illustrated*, many booster books were published in New Orleans, especially by publishing entrepreneur J.C. Waldo. Throughout the 1870s and 1880s these books were illustrated with engraved views after photographs, some by Lilienthal. A.J. Hollander's *New Orleans of Today*, New Orleans (L. Graham) c. 1885, and Andrew Morrison's *New Orleans and the New South*, New Orleans (L. Graham) 1888, were still primarily illustrated by engravings but featured some photographic views. The photographic booster book was launched in New Orleans in the 1890s with three publications: Engelhardt, *op. cit.*; *The Resources and Attractions of Progressive New Orleans, the Great Metropolis of the South*, New Orleans (Young Men's Business League) 1895; *New Orleans Trade and Travel, Descriptive of the Productive and Commercial Ability, Financial and Trade Resources*, New Orleans (Travelers Protective Association) 1896. *New Orleans Through a Camera*, also published in the 1890s, was essentially a portfolio of the work of architect Thomas Sully. After the turn of the century there are numerous examples of the photographic booster book in New Orleans.

16. Two examples of an animated commercial portrait similar to Lilienthal's Rice Brothers view are a photograph, *c.* 1865, of Lower Hudson Street by Marcus Ormsbee in the New-York

Historical Society (Mary Black, *Old New York in Early Photographs*, New York [Dover] 1976, plate 60); and a slightly later view by an unknown photographer of the John J. McNutt Novelty Wood Works in the Society for the Preservation of New England Antiquities (OVP 84A, File 21). For New Orleans, Lilienthal's commercial portraits in the Paris portfolio are unusual, and the type is not often seen even in the later nineteenth century. Also of this type is a rare collection of commercial portraits in cyanotype by A.D. Hofeline and E.T. Adams entitled *Photographic Views of New Orleans*, published about 1887 (two copies are known, in the Louisiana Collection, Tulane University Library and The Historic New Orleans Collection).

67

Medical Colleges Common St.

École de Medecine Rue Common

Founded in 1834, the Medical College of Louisiana was located on Common Street, between Baronne and Dryades streets, near Charity Hospital.[1] In 1843, James H. Dakin designed the first college building, seen here as the west (left) wing of the Greek Revival campus.[2] In 1847, the Legislature merged the Medical College with the new University of Louisiana and appropriated funds for expansion. Dakin was again brought in, and his new design linked a set-back Corinthian temple form with a wing to the east that projected right up to the street line, nearly matching the elevation and footprint of the earlier Medical College west wing. The stately, symmetrical grouping, immediately successful, was one of Dakin's finest designs.

The medical school was the third largest in the country before the war.[3] Dr. Warren Stone, one of the founders, and Dr. Charles A. Luzenberg (cats. 22 and 46), lectured at the school, which was affiliated, like the New Orleans School of Medicine, with Charity Hospital. However, early academic standards were low: there were no entrance exams and anyone able to read and write could gain admission. Until 1879, classes lasted only four months, and the program only three years, with a one-year preceptorship.[4]

The school closed with the federal occupation of 1862, when Union troops seized the buildings for use as a hospital. In 1865–66, the Abraham Lincoln School for Freedmen occupied part of the medical buildings for the education of former slaves. In April 1866, *Harper's Weekly* reported that it was the largest freedmen's school in the country, with more than 800 pupils. *Harper's* published a wood engraving of

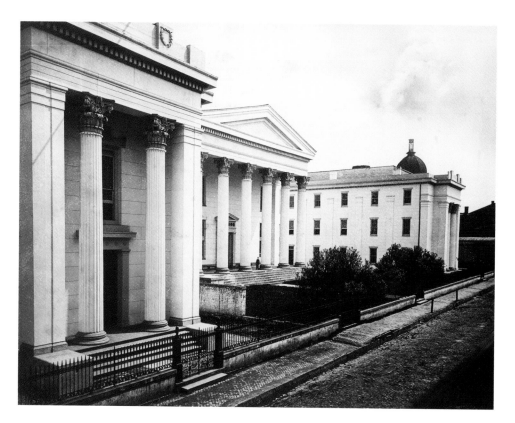

the school after a photograph by Lilienthal (fig. 42), one of his earliest outdoor photographs, taken not long after he had acquired a darkroom wagon.[5] The *Picayune* documented the picture-taking for *Harper's*:

> Lilienthal's "traveling photographic gallery," was brought into requisition yesterday evening to take a view of the building, now used as a colored school, corner of Dryades and Common streets, with the scholars and teachers all assembled on the outside. It was quite a scene, and the juveniles, some two hundred in number, seemed in high glee watching the proceeding.[6]

Lilienthal's Exposition photograph was made about a year later, when only the center building housed the Medical College (which reopened in late 1865).[7] The west wing of 1843, the original foundation, now held the Department of Law of the University of Louisiana, and the east wing was used for the Preparatory School of the University. In 1884, the Tulane University of Louisiana acquired the buildings, and the old Mechanics' Institute (cat. 68) nearby, as its first campus. In 1893, Tulane's medical school relocated to Canal Street and the academic departments occupied new buildings uptown at today's St. Charles Avenue campus. The Dakin building was pulled down in 1898.[8] The fourteen-story, international-style Shell Oil Building, completed in 1952, occupies the site today.[9]

1. On the history of the Medical College, see *Bee*, September 29, 1834; A.E. Fossier, "History of Medical Education in New Orleans," *Annals of Medical History*, VI, nos. 4–5, 1924, p. 14; Matas, *History of Medicine*, I, p. 249ff; John Salvaggio, *New Orleans' Charity Hospital*, Baton Rouge (Louisiana State University Press) 1992, pp. 68–70, 73, 86.
2. On Dakin's project, "The University of Louisiana," *Delta*, February 27, 1848; *Evening Picayune*, March 4, 1860; *Plan of the Organization, Ordinances and Officers of the American Medical Association, to which is Added a Brief Sketch of New Orleans*, New Orleans (American Medical Association) 1869, p. 43; Arthur Scully, Jr., *James Dakin, Architect: His Career in New York and the South*, Baton Rouge (Louisiana State University Press) 1973, pp. 106–107, 122–25.
3. Fossier, *op. cit.*, p. 33.
4. Salvaggio, *op. cit.*, p. 86.
5. "School for Freedmen," *Harper's Weekly*, X, no. 486, April 21, 1866, p. 241.
6. *Picayune*, January 31, 1866.
7. *Picayune*, October 5, 1865.
8. Scully, *op. cit.*, p. 125.
9. Now known as 925 Common Street, the office building, designed by August Perez & Associates, was converted to residential use in 2006.

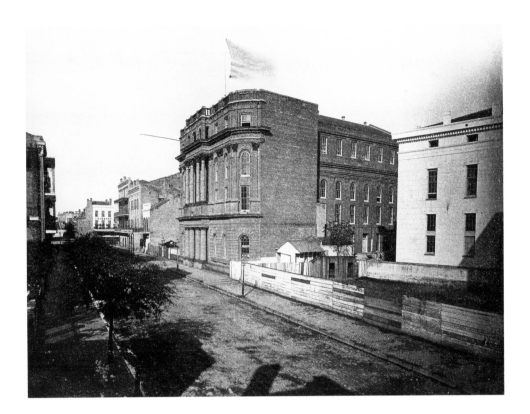

68
Mechanics' Institute
Institution Agricole Rue Dryades

Founded in 1850, the New Orleans Mechanics' Institute was chartered to provide education in "all branches of mechanical and agricultural sciences."[1] The State of Louisiana donated an old statehouse site on Dryades Street (University Place) between Canal and Common streets, adjacent to the University of Louisiana (see cat. 67), for a building "suitable for a library, lecture room, and cabinet of natural history and mechanical inventions."

The Mechanics' Institute Movement had its origin in Britain in the 1820s. The first institute was founded at the Edinburgh School of the Arts in 1821 with the aim of "providing education for mechanics in such branches of physical science as are of practical advantage in their several trades."[2] Glasgow followed in 1823, where George Birkbeck, a pioneer in adult education, organized free scientific lectures for mechanics.[3] A London institute was established in the same year "for the purpose of increasing the knowledge, refining the taste & eliciting the genius of the artisans of London."[4] From there, the institute movement spread quickly: within three years of the London foundation, 100 institutes were

operating in Britain, and by mid-century 700 had been established.[5]

In America, apprentices' libraries opened in Boston and New York by 1820, but the first true mechanics' institute, the Franklin Institute, was organized in Philadelphia in 1824, modeled on the Glasgow foundation. During the next few years, institutes were founded in Baltimore, Boston, New York, and Cincinnati.[6] By 1860, it was reported that "[e]very city of note in the United States has its Mechanics' Institute."[7]

The institutes developed out of a popular interest in scientific lecturing and the growth of philosophical societies, as well as broad movements of educational and social reform.[8] The movement acknowledged that mechanics required scientific knowledge to master the theoretical basis of their work, "rather than merely relying on tradition, training or intuition."[9] In workshops and factories transformed by new tools, processes, and materials, as historian Thomas Kelly has shown, there was an urgent need for mechanics "with at least elementary knowledge of scientific processes."[10] The institutes also worked toward resolution of labor conflicts that developed when mechanization displaced skilled labor.[11]

Mechanics' institutes played a pioneering role in the museum and library fields. Fundamental to all the institutes were a

reference and circulating library, reading room, and exhibition space, including some of the earliest public venues for photography.[12] Many public libraries, including New Orleans's, grew out of these early lending libraries. The institutes played an important role as well in the early development of the architectural profession by offering training in architectural drawing, modeling, design, and history.[13] At the Franklin Institute, instruction in architecture was offered from its founding, through lectures by William Strickland and a drawing program taught by John Haviland.[14] In New Orleans, an "Architectural School" operated at the Institute until 1875, and the Institute was supported by many of the city's most prominent builders and architects, including Lewis Reynolds, Charles Pride, Samuel Jamison, Henry Howard, and James Gallier, Jr.[15]

Construction began on the New Orleans Institute building, designed by R.P. Rice, in the fall of 1850.[16] The cornerstone was laid the following February, but the structure was not completed and dedicated until October 1853, after an outlay of $50,000.[17] The auditorium, "adapted to Musical and Oratorical entertainments," was the largest in the state.[18] A major part of the building was allocated to the Fisk Free Library, named after benefactor Abijah Fisk.[19]

In December 1854, the institute building was destroyed by fire.[20] Plans were made to rebuild, and later in the year the Institute hired James Gallier, Jr., to design the four-story plastered-brick building pictured here.[21] Gallier's design, "in the modern Italian style of architecture," featured a rusticated ground floor and a portico rising through three stories with Doric columns below and Composite columns above, and giant Composite pilasters that wrapped around the distinctive chamfered ends of the façade.[22] The building program included rooms for the Fisk Library, a lecture hall, meeting rooms and offices, and an auditorium and assembly room on the second floor, "to be finished in a very beautiful style with pilasters and rich panel work."[23] A large room on the third floor "for museum purposes" was "designed as a cabinet for the reception of models and inventions."[24] Construction of Gallier's building began in 1855, but only in October 1856 was the second story reached.[25] Six months later the building was reported to be "still in the rough brick-and-mortar stage."[26] Work progressed slowly as construction costs

escalated to an estimated $90,000.[27]

Gallier laid the cornerstone in April 1857. He dedicated the building to the "honor, distinction and wealth of hundreds of young mechanics who, but for this, would never attain to more than a mediocre position in their lives." Here the mechanic would be "initiated into the Temple of Science," Gallier declared. "They have done more for the world than all the professional men put together."[28] The president of the Institute, architect Thomas Murray, acknowledged the importance of mechanics' associations everywhere in "laying the foundation for the future success in life of the poor apprentice boy."[29]

Unfinished at the outbreak of the war, the Institute building was appropriated by the U.S. army as a military hospital in 1863.[30] In November 1865, it was designated as the state capitol, and work was resumed to complete it for government offices.[31] The Legislature occupied the building in the spring of 1866, sharing rooms with the Fisk Library and the institute, which continued to operate in the new statehouse.[32]

For many viewers in 1867 Lilienthal's photograph would have had grave associations with one of the most violent events of the Reconstruction era in the South. In July 1866, Radical Republicans organized at the Institute to reconvene the Constitutional Convention of 1864 in an effort to establish a new state government, give blacks the vote, and disenfranchise former Confederates. White opposition conspired with police to suppress the assembly of predominantly African American delegates and their supporters. As the assemblymen gathered on Dryades Street, police and firemen, supported by armed white citizens, were ready to act with "vigor and promptness" to suppress the convention.[33] "Fire-companies [had] prepared and armed themselves; the police were withdrawn from their posts, supplied with revolvers, and kept waiting at their station-houses until the signal ... was given," Harper's Weekly reported.[34] As black supporters demonstrated in support of the convention a large crowd of whites confronted them, and shots were fired. The "raging mob of rebel soldiers" was joined by the police, mainly ex-Confederate soldiers, who "rushed to the bloody work" of clearing the street and the Institute of delegates. Their advance recalled the skirmish tactics many of them had exercised on the battlefield.[35] "Finally

a crowd of policemen and citizens made a rush at the doors of the Convention chamber and broke them down," the Chicago Tribune recounted.[36]

Inside the hall were nearly one hundred unarmed conventioners. Rufus King Cutler (a New Orleans attorney who had been appointed to the U.S. Senate to fill a seat made vacant when Louisiana seceded) testified that while rioting broke out in the street conventioners "took their seats and remained quiet, awaiting the attack." Police entered the hall, Cutler related, and

> immediately commenced firing on those who were seated in the hall. No resistance was offered; though the police were requested not to fire, as we were unarmed.[37]

Cutler himself retreated to the top floor of the Institute, where he witnessed police confront a black man who had climbed the roof timbers to escape the gunfire. "He was shot, and fell to the floor, then stabbed, dragged to and rolled down the stairs," Cutler wrote.[38]

Edward Brooks, a correspondent for the New York Times, saw delegates who were attempting to flee the building

> shot as soon as they would show themselves [in the street]. I saw them beaten after they had fallen with clubs by the policemen, and I saw the policemen put revolvers to their heads and to their hearts, within a couple of inches, and fire into them.[39]

After the institute had been cleared, the British educator Henry Latham observed, "the victorious mob amused itself by murdering negroes up and down the city."[40] Some rioters did not stop at murder, as the Chicago Tribune reported:

> elegantly appearing persons [from the] aristocratic society of the city leap[t] upon the lifeless bodies of freshly murdered men as they lay on Canal street, within sight of the Clay statue, and crushed flesh and bones with their heels.[41]

When the rioting died down, and federal troops finally arrived to restore order, at least thirty-seven conventioners lay dead (only one white rioter was killed) and more than 200 delegates and bystanders, black and white, were injured. The victims were taken to the Marine Hospital (cat. 48), where Rufus Waples,

a former U.S. Attorney, was mortified by the sight of the wounded suffering from injuries inflicted by gunshots, knives, clubs, and axes.[42]

As many as 600 whites, many of them policemen, had engaged in what General Philip Sheridan, commander of federal troops in New Orleans, called "an absolute massacre." "The more information I obtain of the affair ...," Sheridan wrote to General U.S. Grant, "the more revolting it becomes." The police, Sheridan determined, had suppressed the convention "in a manner so unnecessary and atrocious as to compel me to say that it was murder."[43] The national press echoed Sheridan's view. "The riot, instigated and conducted by the police, was a downright massacre, and one of the most barbarous and fiendish ever recorded," one newspaper declared.[44] Many civilian participants, some dressed in Confederate gray and wearing white scarves or badges of fraternity, were, like most of the policemen, "former rebels or rebel sympathizers."[45] "It was a savage outbreak," Henry Latham wrote, "showing the bitterness with which some of the southerners regard the negro race as the chief cause of their misfortunes."[46] Rufus King Cutler concluded that the riot "centers in rebel hate."[47]

The violence appalled northerners and southerners alike. Justice Samuel Miller wrote that the riot confirmed that southern whites, with their "peculiar hatred" for blacks, were "men who seem incapable of forgiving or learning."[48] The *Picayune*, usually inimical toward the black community, revealed that the sight of the black delegates "mutilated and literally beaten to death as they sought to escape was one of the most horrid pictures it has been our ill fortune to witness."[49] To one war veteran, the "wholehearted slaughter" exceeded anything he had seen in battle.[50]

Although many believed that the mayor of New Orleans and its police chief, and others in local government, had planned the mayhem, a grand jury convened after the riot held the conventioners responsible, after depositions were taken only from the white participants, none of whom were charged.[51] "That any lives were lost is heartily to be regretted; but the guilt of causing that loss must chiefly lie at the door of those who attempted revolution that a few might govern the many," a prominent local journalist wrote. "That those who incited and began the fray suffered the most, was due to their non success."[52]

But the violence had profound repercussions in Washington, where the events in New Orleans helped galvanize opinion against President Andrew Johnson's Reconstruction policies and contributed to the first successful attempt to impeach a U.S. president.[53] "The country must look truth squarely in the face," *Harper's Weekly* wrote, "and the truth is that the party which ... planned and executed the fiendish slaughter in New Orleans, is the party with which the President and the Democratic party are allied."[54] In Congress, in early 1867, the committee reporting on the New Orleans riot (concluding that a police conspiracy had transpired) initiated a bill that provided for a new civil government in Louisiana, which disenfranchised former Confederates, and culminated in black suffrage. The Reconstruction Act of 1867 prohibited states from denying a citizen's right to vote "on account of race, color, or previous condition of servitude."[55] In New Orleans, less than a year after the riot, municipal changes struck at the heart of the Confederate fraternity implicated in the violence, when the city integrated the police force by hiring its first black policeman since 1830.[56]

By the end of the century, these gains against racial discrimination were reversed. Another Constitutional Convention convened at the Mechanics' Institute in 1898 was the triumph of what has been called the "white 'counter-revolution.'"[57] Revoking the political privileges blacks had gained during Reconstruction, the convention enacted measures that excluded most blacks from voting and sanctioned segregation —and, in one historian's words, "thoroughly prevented the Negro from sharing in the white man's civilization after 1898."[58] That the disenfranchisement of African Americans should be enacted in the building where three decades earlier a tragic bloodletting had helped move the city further toward racial equality was hardly lost on convention promoters:

It is quite fitting that the convention of 1898 should be held in the Mechanics' Institute, for it was here that the attempts of the radicals [were made] to utilize an old convention for the accomplishment of their diabolical purposes of engrafting the negro on the body politic.[59]

A few months after this photograph was made, workmen raised scaffolding to reface

and "granitize" the Institute with stucco. The city's black newspaper, the *Republican*, observed that although the building's appearance was renewed, "the scenes which occurred within it on the 30th of July last have gone into history and can never be changed or blotted out."[60]

1. Act of Donation, Act 270, General Assembly of the Senate and House of Representatives of the State of Louisiana, March 21, 1850, pp. 204–205. The parent organization was the New Orleans Mechanics' Society, a benevolent organization of tradesmen, organized in 1806; "Historical Sketch: The New Orleans Mechanics' Institute," *Picayune*, February 3, 1876. Prior to the donation of 1850, a trapezoidal site near the Levee at Canal and Tchoupitoulas streets was considered for the new building, and James Gallier (Sr.) prepared plans for a domed building containing exhibition, library, and "laboratory" spaces (drawings, including a site plan, are in the Southeastern Architectural Archive, Tulane University).
2. Thomas Kelly, "The Origin of Mechanics' Institutes," *British Journal of Educational Studies*, I, no. 1, November 1952, p. 25.
3. *Ibid.*, p. 22; Donald S. McPherson, "Mechanics' Institutes and the Pittsburgh Workingman, 1830–1840," *Western Pennsylvania Historical Magazine*, LVI, no. 2, 1973, p. 156.
4. Thomas Kelly, *George Birkbeck: Pioneer of Adult Education*, Liverpool (Liverpool University Press) 1957, p. 83; *id.*, "The Origin of Mechanics' Institutes," *op. cit.*, p. 26.
5. Michael D. Stephens and Gordon W. Roderick, "Science, the Working Classes and Mechanics' Institutes," *Annals of Science*, XXIX, no. 4, 1972, p. 353.
6. Charles Alpheus Bennett, *History of Manual and Industrial Education up to 1870*, Peoria, Ill. (Manual Arts Press) 1926, p. 325.
7. "Historical Sketch," *op. cit.*
8. Kelly, "The Origin of Mechanics' Institutes," *op. cit.*, pp. 17–20; Stephens and Roderick, *op. cit.*, p. 350; McPherson, *op. cit.*, p. 155. For a review of the literature on the Mechanics' Institute movement in Britain, see Ian Inkster, "The Social Context of an Educational Movement: A Revisionist Approach to the English Mechanics' Institutes, 1820–1850," *Oxford Review of Education*, II, no. 3, 1976, pp. 277–307.
9. Thomas R. Winpenny, "Those Who Attend Meetings Will be Excused from Paying Dues: The Lancaster Mechanics' Institute in Search of Mechanics," *Pennsylvania History*, LV, January 1988, p. 32.
10. Kelly, *op. cit.*, pp. 56–57.
11. Stephen P. Rice, "The Mechanics' Institute of the City of New-York and the Conception of Class Authority in Early Industrial America, 1830–1860," *New York History*, LXXXI, no. 3, July 2000, pp. 269–99.
12. Stephens and Roderick, *op. cit.*, p. 354; Mc Pherson, *op. cit.*, p. 156.
13. See Mary N. Woods, *From Craft to Profession: The Practice of Architecture in Nineteenth-Century America*, Berkeley (University of California Press) 1999, pp. 31, 58–60. It was recognized that instruction in drawing and modeling was also important for the mechanic who worked with machine tools, as "drawing and modeling more accurately reflected the language of the machine than the grammar of the text"; Edward W. Stevens, Jr., "Technology, Literacy, and Early Industrial Expansion in the United States," *History of*

Education Quarterly, XXX, no. 4, Winter 1990, p. 538.

14. Jeffrey A. Cohen, "Building a Discipline: Early Institutional Settings for Architectural Education in Philadelphia, 1804–1890, *Journal of the Society of Architectural Historians*, LIII, no. 2, June 1994, pp. 142–58.

15. "The Ceremony of Laying the Corner Stone of the Mechanics' Institute," February 22, 1851, Record Group 51, Louisiana State Museum; "Historical Sketch," *op. cit.*

16. "The Ceremony of Laying the Corner Stone of the Mechanics' Institute," *op. cit.*

17. "New Orleans As It Is To Be," *True Delta*, June 13, 1852; "Dedication of the Mechanics' Institute," *Picayune*, October 29, 1852; "Dedication of the Mechanics' Institute," *True Delta*, October 31, 1852.

18. *Picayune*, October 26, 1852.

19. The library originated with Fisk's bequest in 1847, and was opened to the public in 1853. Although mostly lost when the Institute burned, the Fisk Library was reestablished in the rebuilt Institute and later came under the control of the University of Louisiana (Tulane University after 1883), which occupied the building in the 1880s. In 1882, the library was reopened to the public with the acquisition of 1000 new books and the integration of collections with the university library. In 1895, the Fisk Library merged with the City Library that had been organized at City Hall. The "Fisk Free and Public Library," to be known within a few years as "New Orleans Public Library," was opened in 1897 in St. Patrick's Hall on Lafayette Square; see "Free Library," *Picayune*, November 6, 1853; "Fisk Free Library," *Picayune*, June 11, 1882; *Daily States*, August 31, 1901. See also cat. 51.

20. "Mechanics' Institute in Ruins," *Crescent*, December 27, 1854; "Burning of the Mechanics' Institute," *Picayune*, December 27, 1854; "The Fisk Free Library," *Picayune*, December 28, 1854; "From New Orleans," *New-York Daily Times*, January 20, 1855. Among tenants burned out was the photographer Giroux (first name unknown), who is documented in New Orleans until 1857.

21. "The New Orleans Mechanics' Society," *Picayune*, April 1, 1857.

22. Wallace Brice, *New Orleans Merchants' Diary and Guide for 1857 and 1858*, New Orleans (W. Brice) 1857.

23. *Picayune*, January 20, 1855; "The Mechanics' Institute," *Picayune*, November 22, 1855.

24. "The Mechanics' Institute," *op. cit.*

25. *Crescent*, October 21, 1856; *Jewell's Crescent City Illustrated.*

26. *Crescent*, March 16, 1857.

27. "The New Orleans Mechanics' Society," *Picayune*, April 1, 1857.

28. *Ibid.*

29. *Ibid.*

30. "New Orleans Post and General Index," *Indexes to Field Records of Hospitals, 1821–1912*, Records of the Adjutant General's Office, RG94, NARA; *Delta*, September 25, 1862; *Picayune*, February 4, 1876.

31. "The Capitol—The Executive Accepts the Mechanics' Institute as a Capitol," *Times*, November 15, 1865; "On the Move," *True Delta*, November 21, 1865.

32. *Crescent*, March 28, 1866; *Picayune*, March 29, 1866; *True Delta*, March 29, 1866; *Crescent*, May 17, 1866.

33. "Prompt Work," *Picayune*, September 5, 1866, cited by James G. Hollandsworth, *An Absolute Massacre: The New Orleans Race Riot of July 30, 1866*, Baton Rouge (Louisiana State University Press) 2001, p. 65.

34. "The Massacre at New Orleans," *Harper's Weekly*, p. 102.

35. *Ibid.*, p. 104; Joseph G. Dawson, III, Army Generals and

Reconstruction Louisiana, 1862–1877, Baton Rouge (Louisiana State University Press) 1982, pp. 39–40; Dennis C. Rousey, *Policing the Southern City: New Orleans, 1805–1889*, Baton Rouge (Louisiana State University Press) 1996, p. 115.

36. "The New Orleans Horror," *Chicago Tribune*, August 8, 1866.

37. *Report of the Select Committee on the New Orleans Riots*, House Report No. 16, 39th Congress, 2d sess., Washington, D.C. (Government Printing Office) 1867, p. 29.

38. *Ibid.*, p. 30.

39. Quoted in *ibid.*, p. 20.

40. Henry Latham, *Black and White: A Journal of a Three Months' Tour in the United States*, London (Macmillan) 1867, pp. 151–52.

41. "The New Orleans Horror," *Chicago Tribune*, *op. cit.*

42. *Report of the Select Committee*, *op. cit.*, p. 24.

43. Sheridan to General U.S. Grant, August 1, 1866, in Philip H. Sheridan, *Personal Memoirs*, New York (Charles L. Webster & Co.) 1888, II, pp. 235–36; Eric Foner, *Reconstruction: America's Unfinished Revolution, 1863–1877*, New York (Harper & Row) 1988, pp. 48–50, p. 263.

44. "The New Orleans Massacre ...," *Christian Advocate*, XLI, no. 33, August 16, 1866, p. 261.

45. *Report of the Select Committee*, *op. cit.*, pp. 32–33.

46. Latham, *op. cit.*

47. *Report of the Select Committee*, *op. cit.*, p. 31.

48. Foner, *op. cit.*, pp. 262–63.

49. *Picayune*, July 31, 1866, cited by Dan Carter, *When the War Was Over: The Failure of Self-Reconstruction in the South, 1865–1867*, Baton Rouge (Louisiana State University Press) 1985, p. 251, n. 41.

50. Foner, *op. cit.*, p. 263 and n. 62, citing a letter dated August 19, 1866.

51. Hollandsworth, *op. cit.*, p. 146.

52. *Gardner's New Orleans Directory for 1867*, p. 8.

53. *Ibid.*, pp. 148–50. Johnson's perceived accountability is discussed by Foner, *op. cit.*, pp. 263–64.

54. "The New Orleans Report," *Harper's Weekly*, X, no. 512, October 20, 1866, p. 658. *Harper's Weekly* published news of the riot and its repercussions for a nationwide readership throughout the summer and fall of 1866; see "The Massacre in New Orleans," X, no. 503, August 18, 1866; "The New Orleans Riot," X, no. 504, August 25, 1866; "After the Riot," X, no. 505, September 1, 1866; "The New Orleans Massacre," X, no. 506, September 8, 1866.

55. Foner, *op. cit.*, pp. 274–77.

56. Rousey, *op. cit.*, pp. 119–20.

57. Henry C. Dethloff and Robert R. Jones, "Race Relations in Louisiana, 1877–98," *Louisiana History*, IX, no. 4, Fall 1968, pp. 316–18.

58. *Ibid.*; Roger A. Fischer, *The Segregation Struggle in Louisiana, 1862–77*, Baton Rouge (Louisiana State University Press) 1974, p. 154; Hollandsworth, *op. cit.*, p. 150.

59. *The Convention of '98: A Complete Work on the Greatest Political Event in Louisiana's History*, New Orleans (William E. Myers) 1898, p. 11.

60. "Improvements in the Mechanics' Institute Building," *Republican*, July 28, 1867. A short time earlier, the *Crescent*, speaking for the white mercantile community, had already concluded that "the prejudices which may have existed against the Institute have entirely vanished ... this place has now regained its former and well-deserved popularity," *Crescent*, December 24, 1866.

69

Charity Hospital

Hopital de la Charitée

Charity, the municipal free hospital of New Orleans, was one of the largest hospitals in the country in the 1860s. The Common Street (Tulane Avenue) building, seen here, was the fifth in a succession of free hospitals that reached back to 1736, when the first hospital, called L'Hôpital des Pauvres de la Charité, was founded at Chartres and Bienville streets in the Vieux Carré.[1]

The Common Street building, designed by H. Hemphill and built in 1831–34 at the enormous cost of $150,000, occupied two blocks and housed forty-five wards. Having marked Palladian features, Charity was an ordered, symmetrical, three-story block of plastered brick topped by a cupola, with gabled wings, a pedimented central entrance, and semicircular windows below the gables. It was reportedly modeled on John Carr's General Infirmary at Leeds, England, but more closely resembled Boulton Mainwaring's London Hospital (1757), widely known through published plans.[2] Both Charity and the London hospital had similar pedimented center blocks of seven bays with end pavilions. Charity's Palladian front projected a prestigious image, but the building was a plain and rather ponderous mass that was relieved only by the portico and full-height Doric pilasters. It had the "heavy sombre appearance" that one critic observed made "a hospital resemble a prison or a place of punishment, and striking a repulsive awe in the sufferers who apply for relief."[3] To one antebellum visitor, Charity was "not a very beautiful building," but it had "a moral beauty of the highest order, ... [and] is probably one of the most efficient and useful charities in the country."[4]

The hospital underwent several building campaigns before the war. W.L. Atkinson designed a psychiatric wing, built by James Gallier, in 1841, and in 1847 Gallier designed an octagonal surgical theater with 600 seats, fronting on Gravier Street.[5] Four years later, Henry Howard prepared plans for an extensive renovation and expansion, but in 1854 the hospital was still in need of repairs and reported to be "in a dangerous state of dilapidation."[6] Shortly before the war James Gallier, Jr., and Richard Esterbrook added a two-story brick administration building with

cast-iron galleries flanking the main gate.[7] Other buildings contained lying-in and surgical wards for women, dissecting rooms, and a mortuary. A whitewashed brick wall enclosed the grounds, "while the front yard, filled as it is with beautiful flowers, shrubbery and trees," gave, according to one writer, an "air of seclusion and quiet beauty ... [that was] soothing and pleasant to the eyes of the suffering inmates."[8] A cupola provided ventilation to the wards and offered "a magnificent view of the city and environs."[9]

Charity was the "principal receptacle," *Niles Weekly Register* reported, "of the destitute multitudes who fall sick annually" in New Orleans—victims of epidemics, as well as immigrants and seamen who became ill in port.[10] "Hundreds land in our city in a sickly condition," the *Picayune* observed in 1840, "without any other means of recovering their health than what this institution affords them."[11] Charity's patients reportedly represented nearly "every nation under the sun, savage as well as civilized," and for many years the hospital's primary source of revenue was a tax on foreign passengers.[12] In a typical year in the decade before the war, only one-tenth of Charity's patients were American citizens, and only two percent came from Louisiana.[13] One visitor saw Charity as

> a sort of neutral ground, where a general "congress of nations" has been held Here have met the Hindoo and the Christian—the native of the sunny clime of Italy, and the denizen of the frozen regions of Russia— the simple sons of the Sandwich Islands, and the fiery Spaniard—men who have dwelt upon the Andes, and others who roamed the plains of Palestine! What strange tales could these old walls tell, if the power of language were vouchsafed to bricks and mortar![14]

The hospital's location near the medical colleges of the city offered students superior facilities for "the most interesting exemplifications of the theoretical teachings of the lecture-room," according to *Harper's Weekly* in 1859. "There is no better place in the country than New Orleans for young men who are studying to enter the medical profession."[15] One journalist observed that students had "no difficulty in obtaining dead and live subjects" for study, especially during epidemics, when hospital admissions could reach up to 15,000 patients a year.[16]

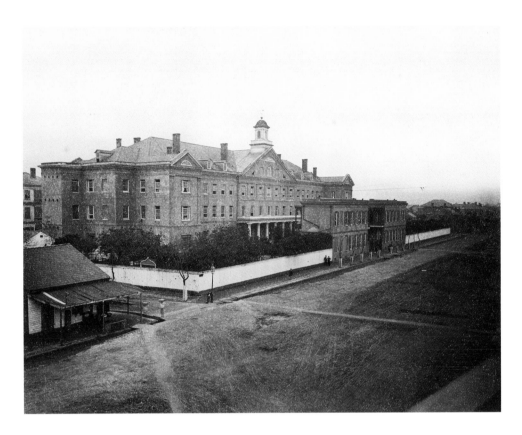

At the outbreak of the war, Charity had 1000 beds, more than the Hôtel Dieu in Paris. The hospital registered 23,000 wartime admissions from both Confederate and Union armies. U.S. General Benjamin Butler allocated staff to support the hospital, which was subsidized during the occupation.[17] "At present the hospital is semi-military," the *Times* wrote in 1864; "it is furnished, like the other military hospitals, with government rations and medicines."[18] Military control brought other enhancements. "Within the last year," the *Times* reported in 1865, "owing to the liberality of the national Government, the greatest improvements have been made. [Charity] has been partially painted, and the front colored in imitation of brownstone, which adds greatly to its appearance."[19]

The legacy of the war, however, was a growing number of indigents, including many former slaves, seeking care and shelter in the hospital. By 1879 the basic necessities for patients, including bedding and medicines, were "sadly deficient, or totally exhausted," as was Charity's financial credibility, which reportedly "could not be used for the purchase of a pound of flour or salt."[20] The hospital buildings, neglected after being removed from federal control, were "in a most dilapidated condition"

and sections of the walls and roof were in danger of collapse.[21] Finally, with an infusion of state funding and new management, the hospital was renovated and by the late 1880s it was admitting more patients than any other hospital in America.[22] The Charity buildings continued in use until 1936, when the Public Works Administration (PWA) razed what was then the oldest hospital building in continuous operation in the country for a twenty-story limestone tower designed by Weiss, Dreyfous & Seiferth.[23] In September 2005, floodwater damage from hurricane Katrina forced Charity to close after more than 250 years in existence. After the catastrophe, the hospital buildings were considered beyond repair, and demolition was planned, while hospital staff operated a community clinic in a vacated department store.[24] In the spring of 2007, the State of Louisiana, which had operated Charity, announced a $1 billion project to build a new facility at another location.[25]

Lilienthal's oblique rooftop perspective situates the hospital in its expansive setting beyond the commercial district of the city. A whitewashed brick wall that encloses the building partitions the frame and locates the vanishing point of the view, its brilliant white tone a striking contrast to the dark forms of

the trees and shrubs behind it. A dense, street-surface pattern of wagon rills marks the passage of time, as does the ghosted image of a man carrying a load on his head, possibly to the produce vendor at the street corner.

1. The architectural history of Charity has yet to be written. Sources for the history of the institution include: Charity Hospital Papers 1759–1938 and Kuntz Collection, Manuscripts Collection, Tulane University Library; *Courier*, October 16, 1832; "Historical Sketch of the Charity Hospital," *New-Orleans Medical Journal*, I, no. 1, May 1844, pp. 72–77; Stella O'Connor, "The Charity Hospital of Louisiana," *Louisiana Historical Quarterly*, XXXI, January 1948, pp. 52–53; Matas, *History of Medicine*, I, pp. 420–49, II, pp. 198–215; and John Salvaggio, *New Orleans' Charity Hospital: A Story of Physicians, Politics, and Poverty*, Baton Rouge (Louisiana State University Press) 1992.
2. "The Charity Hospital," *Picayune*, August 19, 1849, cites the Leeds hospital. On the London hospital, see Adrian Forty, "The Modern Hospital in England and France; The Social and Medical Uses of Architecture," in *Buildings and Society*, ed. Anthony D. King, London (Routledge & Kegan Paul) 1980, pp. 70–72; Christine Stevenson, *Medicine and Magnificence: British Hospital and Asylum Architecture*, 1660–1815, New Haven, Conn. (Yale University Press); London (Paul Mellon Centre for Studies in British Art) 2000, pp. 144–45.
3. *Gibson's Guide*, pp. 272–73; *Historical Epitome of the State of Louisiana*, New Orleans 1840, pp. 324–25; description in 1819 of St. Thomas Hospital, London, cited by Forty, *op. cit.*, p. 72, and Forty's own description of London Hospital, p. 71.
4. Charles A. Goodrich, *The Family Tourist: A Visit to the Principal Cities of the West Continent*, Hartford, Conn. (Case, Tiffany & Co.) 1848, p. 433.
5. Building contracts, William Christy, XLI, no. 45, January 12, 1841, NONA; LVI, no. 1, January 2, 1847; "New Lunatic Asylum," *Picayune*, June 26, 1841 (with attribution to Atkinson); "The Charity Hospital," *Picayune*, *op. cit.*; *Harper's Weekly*, III, no. 4, September 3, 1859; *Picayune*, March 12, 1863. A drawing by Atkinson for the asylum wing is in the Southeastern Architectural Archive, Tulane University.
6. *Report of the Joint Committee on Charitable Institutions*, New Orleans (Emile La Sere) 1854, p. 187.
7. *Report of the Board of Administrators of the Charity Hospital for 1853*, New Orleans (Emile La Sere) 1854, pp. 6–7; Building contract, J. Graham, XX, no. 5481, July 20, 1860, NONA.
8. *Picayune*, August 19, 1848.
9. *Historical Epitome of the State of Louisiana, op. cit.*, p. 325; *Picayune*, March 12, 1863.
10. *Niles Weekly Register*, LXV, November 11, 1843, p. 170.
11. "Charity Hospital," *Picayune*, December 15, 1840.
12. *Niles Weekly Register, op. cit.*
13. *Report of the Board of Administrators, op. cit.*, p. 11.
14. *Niles Weekly Register, op. cit.*
15. *Harper's Weekly, op. cit.*
16. *Plan of the Organization, Ordinances and Officers of the American Medical Association, to which is Added a Brief Sketch of New Orleans*, New Orleans (American Medical Association) 1869, pp. 46–47; James S. Zacharie, *New Orleans Guide*, New Orleans (F.F Hansell) 1903, p. 198.
17. James Parton, *General Butler in New Orleans*, New York (Mason Brothers) 1864, pp. 300–19; Benjamin F. Butler, *Private and Official Correspondence of Gen. Benjamin F. Butler During the Period of the Civil War*, Norwood, Mass.

(Plimpton Press) 1917, II, p. 242; Salvaggio, *op. cit.*, pp. 80–81.
18. "The Charity Hospital," *Times*, June 3, 1864.
19. "Charity Hospital," *Times*, June 26, 1865.
20. *Report of the Board of Administrators of the Charity Hospital for 1879*, cited by Harry F. Dowling, *City Hospitals: The Undercare of the Underprivileged*, Cambridge, Mass. (Harvard University Press) 1982, p. 34.
21. *Ibid.*
22. Henry C. Burdett, *Hospitals and Asylums of the World*, London (J. & A. Churchill; Whiting & Co.) 1891–93, III, pp. 716, 753–54.
23. *Morning Tribune*, October 23, 1936; *Times-Picayune*, June 24, 1937.
24. In October 2006, Charity was one of six hospitals, of nine acute-care facilities in New Orleans, that had not reopened. "The Battle of New Orleans's Medical Students," *Chronicle of Higher Education*, LIII, no. 10, October 27, 2006.
25. "Money Shift for Charity Planned," *Times-Picayune*, June 15, 2007.

70
School of Medicine
Ecole de Médecine Rue Common

The New Orleans School of Medicine at Common and Villere streets, designed by Will Freret and built by George Purves, opened in 1856.[1] It was described as "a handsome Roman building adapted to all the purposes of a medical education," but immediately proved to be insufficient, and the following year architects Henry Howard and Albert Diettel enlarged it.[2] The new four-story addition copied Freret's detailing but was awkwardly placed, and the resulting building was blockish and ungraceful.

The school housed two 300-seat lecture halls and one of the finest dissecting rooms in the country.[3] A famous museum of anatomy, built primarily with acquisitions from Paris, included more than "200 of the most valuable specimens from nature, all in most beautiful condition for the closest examination."[4] Before the war, the school was among the leading medical schools in the nation and a pioneer in clinical teaching. Faculty conducted students daily through the wards of its associated hospital, Charity (cat. 69), located across the street. The school established an early program for the study of the diseases of women and

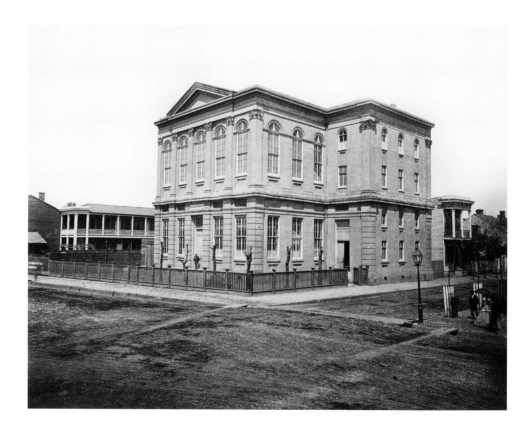

children, and opened a Free Dispensary, the first outpatient clinic in New Orleans.[5]

In 1861, with the outbreak of war, enrollment dropped from 236 students to 32, and the following year the school closed. It reopened on November 14, 1865, when inaugural lecturers spoke of Galen, Celsus, and the "sacred science of medicine," and recounted how the instruction of medicine had originated in Alexandria, Egypt, "in a latitude and soil similar to those of New Orleans."[6] They also spoke of the ravages of war and, that "great effort having failed," urged citizens "however much they might have suffered" to devote themselves to the peaceful pursuits of science.[7] But the pursuits of the school were short-lived. Failing to attract northern or even southern students in the numbers it had before the war, the school closed in April 1870. The building was demolished in the early 1890s when Charity Hospital took over the site.

As Lilienthal carried out his commission for 150 large-format views for the Paris Exposition, he simultaneously completed fifty stereoviews for his own studio trade. A comparison of the two formats can reveal different compositional strategies, although in many instances his large-format views also appear to function stereographically.[8] In the photograph of the School of Medicine, with its wide angle of view and expansive forespace, Lilienthal is concerned with how the building occupies space in the city, and its contextual relationship to nearby structures. His stereoview of the same subject (fig. 101), with its tight framing, seems a more successful representation of architectural volume, always a challenge for the photographer to resolve in the flat plane of the photograph.

1. Building contracts, J. Graham, X, no. 2238, May 3, July 31, November 29, 1856, NONA.
2. "City Improvements," *Crescent*, October 21, 1856.
3. "Editorial and Miscellaneous," *New Orleans Medical News and Hospital Gazette*, III, no. 10, December 1, 1856, pp. 620–21. On the history of the school, see Matas, *History of Medicine*, I, pp. 260ff.
4. "Editorial and Miscellaneous," *op. cit.*, p. 620.
5. "The Free Dispensary of the New Orleans School of Medicine," *New Orleans Medical News and Hospital Gazette*, III, no. 12, February 1, 1857, pp. 735–38.
6. "Medical," *Picayune*, November 11, 1865.
7. *Ibid.*
8. See pp. 260–65. Robert Taft, *Photography and the American Scene*, New York (Dover) 1964, p. 168 [reprint of 1938 edn.], discusses a stereographic method of composition.

71
Gas Works
Manufacture de Gaz Reservoirs

Rising above the gasworks of the New Orleans Gas Light Company, at Gravier and Locust streets, were three giant openwork gasholders. Described as "beautiful specimen[s] of iron casting," their trellis frames each carried an immense iron cylinder of coal gas, open at the bottom and inverted in a tank of water.[1] The cylinder was "moveable," William Matthews explained in his *Compendium of Gas-Lighting*, "and nicely suspended by means of weights and pulleys, which are so accurately adjusted as to allow it to ascend or descend in the water as the gas may be entering into it from the purifying apparatus, or passing out of it to the mains."[2] The chemist Samuel Hughes elaborated further:

> The mode in which the gas is stored in the gas-holder bears a very exact analogy to the mode of collecting and storing gas pursued by the chemist in the laboratory, where the jar to be filled is inverted over a trough containing water, and the gas admitted into it by a bent pipe passing up through the water … . The water is not displaced, but the gas-holder is raised by the gas flowing in.[3]

Vertical stanchions of cast iron affixed with sliding carriages guided the holder in its movement, and a heavy cast- or wrought-iron girder tied the stanchions together.[4] The guide-framing offered "the greatest field for the exercise of engineering skill," according to one nineteenth-century designer. The striking iron skeletons often exhibited a modern industrial aesthetic that contrasted sharply with their surroundings, and the ironwork was an opportunity for embellishment—although one gas pioneer advised against "all (so called) ornament, such as rosettes … fancy rings and devices … . All these things are out of place, and are totally useless."[5]

The gasholders were highly visible symbols of citybuilding and markers for a gas delivery network that was one of the oldest and largest in the country. New Orleans's gaslit streets were as modern as any streets anywhere—the city could boast of "more … gaslight by night than any city we know of," the *Crescent* wrote in 1866—a source of pride for city boosters and a measure of the city's commercial potential.[6] "The lamp post is an emblem of solidity," the *Times* observed in 1864. "Lamp posts are strictly a modern invention; so are a great many other things connected with light."[7]

While boosters promoted the local gas

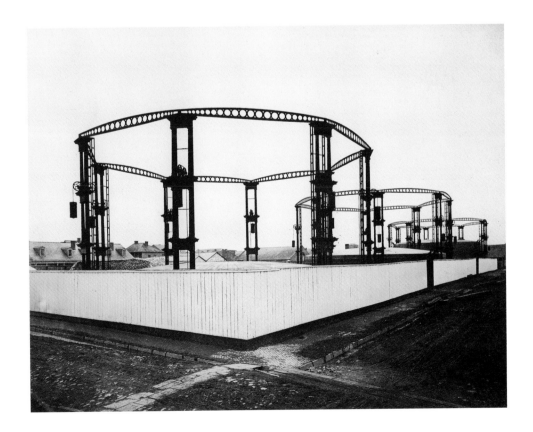

industry as evidence of the city's security and refinement—an image heightened by the classical language of the gasworks architecture—the gasholders also came to be symbolic of an urban peril. Immense storehouses of highly flammable gas, the holders were "capable of exploding with terrible force," a trade journal warned in 1865, so that those who lived nearby were "exposed to as serious consequences as if they were placed over a powder-magazine."[8] In the public mind, gas factories also became associated with "dirty processes and offensive odours," as one engineer wrote.[9] The stench of the lime used to purify gas was so foul that it drove business and residents away from gashouse districts.[10] By 1860, the New Orleans factory, once on the periphery of the city, was embedded in residential development near Charity Hospital, and in the press, the company attempted to relieve concerns about the hazards of its plant and the negative connotations of its product. A squib in the *Picayune* assured readers that the gasworks were in "perfect neatness and order":

> one would suppose [the works] would be a place of smoke and dust and sut [soot] and vallanous [villainous] odors. On the contrary, lady visitors may promenade the gas works, walk the fire rooms, the condensing rooms, the blacksmith shop ... examine the gasometers, the scales, the pipes, the steam engine, [and] the whole complicated apparatus of the place, and not soil a white satin slipper.[11]

As gasworks were increasingly perceived as detrimental to health and safety, the gasholders and their iron guide frames, often admired for their engineering elegance, came to be viewed as sinister.[12] Many guide frames were tarred over to prevent rust, only increasing the perception of unsightliness. Today these machines, which once towered over townscapes across America and Europe, are almost entirely vanished, their function long ago replaced by pipelines and industrial tank farms.[13] When disused, they were rarely considered worthy of preservation. London's Grecian St. Pancras gasholders are a notable survival, and other gasholders have been adapted to residential and commercial use, such as the Simmering district gasholders in Vienna or the South Boston gasholder house, now a hotel.[14]

Lilienthal included three views of the New

Orleans Gas Light Company in the Exposition portfolio (cats. 71–73), more than for any other site in the city. A potent emblem of industrial progress and citybuilding, or its hazards, the gasworks was also a compelling subject for photography. The "enormous furnaces, retorts, vats, cranes, and other immense machines present a spectacle to the curious," a local guidebook wrote, and Lilienthal, too, appears to have been fascinated by the distinctness and scale of these industrial structures.[15] His low vantage point frames the gasholders against the sky and suggests a visual contradiction: an enormous fabric of iron erected to contain an invisible gas.

1. "New Orleans Gas Works," *De Bow's Review*, IX (new series I), no. 2, August 1850, p. 250. On gasholder and guide-framing construction, see Samuel Hughes, *A Treatise on Gas-Works*, London (John Weale) 1853, pp. 193–229; Samuel Clegg, *A Practical Treatise on the Manufacture and Distribution of Coal-gas*, London (John Weale) 1859, pp. 241–63; "Apparatus for the Manufacture of Illuminating Gas," in *Appleton's Cyclopaedia of Applied Mechanics*, ed. Park Benjamin, New York (D. Appleton) 1881, I, pp. 900–27; Walter Ralph Herring, *The Construction of Gas Works*, London (Hazell, Watson, & Viney) 1893, pp. 257–81; F. Southwell Cripps, *The Guide-Framing of Gasholders,* London (Walter King) 1889; John Hornby, *A Text Book of Gas Manufacture for Students*, London (George Bell & Sons) 1900, pp. 139–52; Alwyne Meade, *Modern Gasworks Practice*, London (Benn Brothers) 1921, pp. 621–88; Oscar E. Norman, *The Romance of the Gas Industry*, Chicago (A.C. McClurg & Company) 1922, p. 79; W.B. Davidson, *Gas Manufacture*, London (Longmans, Green & Co.) 1923, pp. 245–56.
2. William Matthews, *Compendium of Gas-Lighting*, London (R. Hunter) 1827, p. 33.
3. Hughes, *op. cit.*, p. 195.
4. Herring, *op. cit.*, p. 271.
5. F. Southwell Cripps, *Gasholder and tank ... at the Sutton Gas-Works,* London (Walter King) 1898; Herring, *op. cit.*, p. 270; *Illustrated London News*, July 1, 1878, cited by Sarah Milan, "Reflecting the Gaselier: Understanding Victorian Responses to Domestic Gas Lighting," in *Domestic Space: Reading the Nineteenth-Century Interior*, ed. Inga Bryden and Janet Floyd, New York (Manchester University Press), p. 98.
6. *Crescent*, September 4, 1866.
7. "Lamp Post," *Times*, June 3, 1864.
8. *Journal of Gas Lighting, Water Supply and Sanitary Improvement*, November 14, 1865, cited by Wolfgang Schivelbusch, *Disenchanted Night: The Industrialization of Light in the Nineteenth Century*, Berkeley (University of California Press) 1988, pp. 34–35.
9. J.O.N. Rutter, *The Advantages of Gas in Private Houses*, London (Virtue Bros.) 1865, p. 30, cited by Sarah Milan, *op. cit.*, p. 99.
10. Denys Peter Myers, *Gaslighting in America: A Guide for Historic Preservation*, Washington, D.C. (U.S. Department of the Interior) 1978, p. 231.
11. "The Gas Works," *Picayune*, September 29, 1840.
12. On fear of gasworks and their hazards, see Schivelbusch, *op. cit.*, pp. 37–40, and Milan, *op. cit.*, pp. 98–99.
13. Nearly all American cities of even modest size had a gasworks by the late nineteenth century. Few of these

structures survive today. An inventory of 1984 recorded fifteen brick gasholders nationwide (in northern climates, the holders were often enclosed in a masonry structure to provide protection from ice and snow), and only one, in Concord, New Hampshire, completely intact; the number of exposed iron-frame gasholders existing was undocumented; William L. Taylor, "The Concord (New Hampshire) Gasholder: Last Intact Survivor from the Gas-Making Era," *IA: Journal of the Society for Industrial Archeology*, x, no. 1, 1984, pp. 1–16; Mary E. Pyne, "New England's Gasholder Houses," *IA: Journal of the Society for Industrial Archeology*, xv, no. 1, 1989, pp. 54–62.
14. The 100-foot-tall (30 m) St. Pancras gasholders (dating from the 1860s and later) are the subject of at least 140 photographs made by Bernd and Hilla Becher from the 1960s through the 1990s.
15. Griswold's *Guide*, p. 48.

72
Interior of Gas Works
Interieur d une Manufacture de Gaz

In the first decade of the nineteenth century, British inventor and showman Frederich Albert Winsor proved the effectiveness of a centralized coal-gas delivery system for street lighting, modeled on a typical city water supply network.[1] "The whole range of Pall Mall [in London] ... was lighted up by means of lamps, fed with gas instead of cotton and oil, ... in a style of much superior brilliancy," one observer wrote.[2] The spectacle of this new light of "peculiar softness and clearness ... with almost unvarying intensity" brought backers to Winsor's "stupendous scheme" to illuminate the streets of London, and in 1813 he built the first city gasworks.[3]

Acclaimed as "one of the greatest improvements of which modern times can boast," the coal-gas light created a sensation, and must have made an impression on a young British actor named James Henry Caldwell.[4] Following an early theatrical career as a "leading light comedian" on stages across England, Caldwell immigrated to Charleston in 1817 and two years later to New Orleans.[5] Almost immediately he began construction of a theater on Camp Street (cat. 66) and a coal-gas plant, the city's first, to service it. Recognizing the potential to secure a street-lighting monopoly, he organized public demonstrations of gaslight and in 1829 received a charter to illuminate city streets.[6] The New Orleans Gas Light and Banking Company factory began operating at Gravier and Perdido streets in 1834, using British gas delivery equipment and British technicians.[7] The gas Caldwell manufactured, he claimed, produced a light of "peculiar

brilliancy, softness, and unvarying intensity ... and comparative cheapness."[8] Within a year he had illuminated 900 gaslights along Canal, Chartres, and other commercial streets. With the new light, which "turned night into day," according to the *Bee*, "a person could see to read distinctly at 200 yards distance."[9]

One of America's greatest gaslight entrepreneurs, Caldwell established factories in Cincinnati, Memphis, and other cities, following his retirement from the stage in 1837.[10] He also sponsored aeronautics experiments, and was responsible for the first ascension in America of a balloon filled with illuminating gas (which gave aeronauts greater flight distances than hydrogen-filled balloons).[11] Caldwell's gaslight monopoly in New Orleans succeeded his death in 1863, and remained the sole provider of city street illumination until 1875, although the city more than once attempted to dodge the charter granted by the state legislature.[12] After the war the cost of imported Pennsylvania coal used in gas manufacture increased, as did labor costs, and in 1866 the New Orleans Gas Light Company raised prices for public gas service. In response, the city attempted to revoke its contract, characterizing the company as a "rapacious, grasping monopoly," and proposed to replace more than half the existing gaslights with petroleum lamps.[13] To ease public acceptance of the plan, the city announced extended coverage of street lighting throughout the city. Large areas of the city and suburbs remained in darkness in 1866, but fear of crime in those districts would not be ameliorated by dim oil lamps, which were only bright enough, it was said, "to make out how dark it really was."[14] "People have well nigh forgotten," the *Crescent* wrote, "that the days, perhaps we ought to say the nights, of oil-lamps were the nights of burglars and robbers ... we are to be transported back to that almost forgotten period when the flickering ray of the struggling oil-lamp used to serve the questionable purpose of making the darkness visible."[15] The city finally abandoned conversion plans when petroleum was found to have an even greater risk of explosion than coal gas. Expansion of gaslight service to outlying districts was also delayed in the controversy. "When two big corporations set by the ears," the *Times* observed, "the people are seriously inconvenienced. Such is the category of our poor benighted suburbans in regard to the stubborn contest which has so long engaged the

combative capacities of our City Government and the Gas Company of New Orleans."[16]

Gas street lighting in New Orleans reached a peak in 1873 with a network of 135 miles (217 km) of mains and 3500 lamps, but within a decade the city would make the transition from coal-gas to electric light.[17] Visitors to the Philadelphia Centennial Exposition of 1876 witnessed demonstrations of arc light, and by 1880 New York had installed arc lamps on Broadway.[18] New Orleans soon followed with arc lighting on Canal Street and on the batture. In 1882, Mark Twain found New Orleans "the best lighted city in the Union, electrically speaking," and *Harper's Weekly*, too, commented that it was "far ahead of most Northern cities in the use of electric light."[19] Lamps "suspended in rows from high poles" illuminated the wharves for around-the-clock stevedoring of ships.[20] Electric light demonstrations at the World's Industrial and Cotton Centennial Exposition of 1884–85 in New Orleans were called "sublime, beautiful and never to be forgotten," and the next year more than 600 arc lamps were in use along Chartres, Royal, and Canal streets.[21] A decade later electric lamps had replaced gaslights throughout the city.[22]

Lilienthal's two interior views of the gasworks yard (cats. 72 and 73) were made from a

factory roof at the corner of Magnolia and Perdido streets. Charity Hospital is visible in the distance, as are the towering guide frames of gasholders in the next block. In the foreground are two single-lift gasholders probably dating from the 1830s; the iron crank wheels of their manual pumps are visible.[23] Company offices, a lodge for the gateman and superintendent, and the purifying house enclose the yard.[24]

1. Dana Arnold, *Re-presenting the Metropolis: Architecture, Urban Experience and Social Life in London 1800–1840*, London (Ashgate) 2000, pp. 33–35. On Winsor, see "J.M.," "Historical Notes on Gas Illumination," *Science*, I, no. 23, December 4, 1880, p. 275–77; M.E. Falkus, "The Early Development of the British Gas Industry, 1790–1815," *Economic History Review*, ns. XXXV, no. 2, May 1982, p. 225ff; Wolfgang Schivelbusch, *Disenchanted Night: The Industrialization of Light in the Nineteenth Century*, Berkeley (University of California Press) 1988, pp. 25–27; Sarah Milan, "Reflecting the Gaselier: Understanding Victorian Responses to Domestic Gas Lighting," in *Domestic Space: Reading the Nineteenth-Century Interior*, ed. Inga Bryden and Janet Floyd, New York (Manchester University Press), pp. 94–96.
2. "From the Edinburgh Review," *Select Reviews, and Spirit of the Foreign Magazines*, II, August 1809, p. 102.
3. *Ibid.*, p. 101; "History of Gas-lighting," *Museum of Foreign Literature, Science, and Art*, LXVIII, February 1828, p. 269.
4. "On the Utility of Coal Gas Light," *Select Reviews, and Spirit of the Foreign Magazines*, V, January 1811, p. 66. On Caldwell, see "James H. Caldwell, Esq.," *Spirit of the Times*, VI, no. 40, November 19, 1836, p. 316, and VII, no. 9, April 15, 1837, p. 70; Noah M. Ludlow, *Dramatic Life as I Found It*, New York (Benjamin Blom) 1966 [first published St. Louis

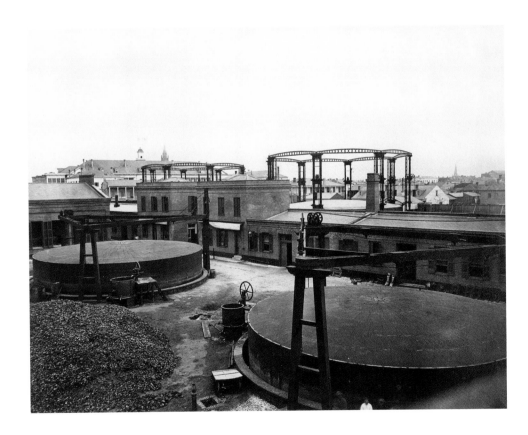

(G.I. Jones & Co.) 1880], pp. 140–43, 248–50, 403–408, 520–21, 562; Gerald Bordman and Thomas S. Hischak, *Oxford Companion to American Theatre*, New York (Oxford University Press) 2004, p. 107.

5. "James H. Caldwell, Esq.," *op. cit.*

6. Several cities in America had already built gasworks and installed gaslight systems for public streets, including Baltimore (the first) in 1817 and Boston in 1822. The New York Gas-Light Company, incorporated in 1823, laid its first gas pipes in 1825. J. Leander Bishop, *A History of American Manufactures from 1608 to 1860*, Philadelphia (Ed. Young & Co.) 1868, II, p. 93; Moses King, *King's Handbook of New York City*, Boston (Moses King) 1895, p. 185; Denys Peter Myers, *Gaslighting in America: A Guide for Historic Preservation*, Washington, D.C. (U.S. Department of the Interior) 1978, p. 265; Cecil D. Elliott, *Technics and Architecture*, Cambridge, Mass. (MIT Press) 1992, pp. 236–39.

7. *Argus*, May 4, 1833; "Lighting of the City," *A Digest of the Ordinances, Resolutions, By-Laws and Regulations of the Corporation of New-Orleans*, New Orleans (Gaston Brusle) 1836, p. 87. On the early history of gaslighting in New Orleans, see Hugh Mercer Blain, *A Near Century of Public Service in New Orleans*, New Orleans (New Orleans Public Service) 1927.

8. *Advertiser*, June 5, 1834.

9. *Bee*, August 6, 1834; *Advertiser*, November 11, 1834.

10. "James H. Caldwell, Esq.," *op. cit.*

11. Tom D. Crouch, *The Eagle Aloft: Two Centuries of the Balloon in America*, Washington, D.C. (Smithsonian Institution Press) 1983, p. 178.

12. "Inviolability of Corporate Charters," *Central Law Review*, XXII, no. 9, February 26, 1886, p. 204.

13. "The Light or Gas Question," *Times*, October 29, 1866.

14. Joachim Schlör, *Nights in the Big City: Paris, Berlin, London, 1840–1930*, trans. Pierre Gottfried Imhof and Dafydd Rees Roberts, London (Reaktion Books) 1998, p. 59.

15. "Gas and Oil," *Crescent*, January 18, 1866.

16. "The Light or Gas Question," *op. cit.*

17. *Jewell's Crescent City Illustrated*. On the development of electric lighting, see David Nye, *Electrifying America: Social Meanings of a New Technology*, Cambridge, Mass. (MIT Press) 1992, pp. 143–98.

18. John A. Jackle, *City Lights: Illuminating the American Night*, Baltimore (Johns Hopkins University Press) 2001, pp. 39–58; Schivelbusch, *op. cit.*, pp. 114–27; Harold L. Platt, *The Electric City: Energy and Growth of the Chicago Area, 1880–1930*, Chicago (University of Chicago Press) 1991, pp. 3–21.

19. Mark Twain, "Life on the Mississippi," in *Mississippi Writings*, Berkeley (University of California Press) 1982, p. 472; *id., Notebooks & Journals*, ed. F. Anderson, Berkeley (University of California Press) 1975, II, p. 553; *Harper's Weekly*, XXVII, no. 1367, March 3, 1883, cited by Bernard Lemann, "City Timescape, Shifting Scene," in *New Orleans Architecture*, II, p. 60.

20. *Harper's Weekly*, *op. cit.*

21. Alan A. Troy, *Louisiana Electric Utilities*, Baton Rouge (Louisiana Department of Natural Resources) 1994, I, p. 36; see also *Harper's Weekly*, XXIX, no. 1465, January 17, 1885, p. 40.

22. Jackle, *op. cit.*, p. 47.

23. Thomas S. Peckston, *Practical Treatise on Gas-lighting*, London (Herbert) 1841, p. 231.

24. "The Gas Works," *Picayune*, September 29, 1840; *Norman's New Orleans and Environs*, pp. 144–46; *Topographical View of the New Orleans Gas Light Company Works*, lithograph, 1865, Louisiana Collection, Tulane University Library; *Jewell's Crescent City Illustrated*.

73
Interior of Gas Works
Interieur d'une Manufacture de Gaz

In Lilienthal's view of the south yard of the gasworks, the flues of the gabled building mark the retorts, or ovens, where coal gas was produced. When baked at a very high heat, coal released gas and left a brittle and porous residue of coke. Purified with water and lime (produced from oyster shells), the gas was condensed and "scrubbed" to remove tar, oils, and other impurities, then pumped into gasholders for storage by steam-driven "exhausters." "Huge furnaces are day and night ... in an intense and perpetual glow," the *Picayune* wrote of the retort house, "[the] lime kilns are burning, and pyramids of coke are piling up."[1] The byproducts of this distillation process were marketable. Coke that was not used to fire the retorts was sold as a furnace and locomotive fuel, and tar was sold as a sealant to building and roofing companies located near the works.[2]

To the right of the retort house is the purifying house, and faintly visible rising above it is a fluted chimney, the engine-room stack, originally 107 feet (33 m) in height and described as "a chaste specimen of classical architecture."[3] James Gallier reported that he had designed the chimney (three previous chimneys had collapsed) on a costly pile foundation that was required by the swampy site.[4] Gallier also designed a three-story slave quarters fronting on Perdido Street (in 1860 the company owned fifty slaves, valued at $53,000).[5] The plant was surrounded by a 15-foot-high (4.5 m) wall with iron gates, an enclosure that was intended to confine slaves as well as to conceal the works from residents fearful about the hazards of gas manufacture.[6]

Adjoining the retort house, two rows of cast-iron columns supporting a roof frame have been erected. The tall, twin spars lashed together, hung with a pulley, and held in position with guy wires form a shear legs hoist used to raise roof timbers. Scattered around the site are ladders and wheelbarrows, and a supply of formwork is laid up in the yard. This is the only visible construction site in Lilienthal's portfolio, and the building frames and falsework make an intricate, engaging subject for photography. Apart from housing construction to provide for the postwar migration from rural areas into the city, major building projects were few at a time when shortages of materials and the high cost of skilled labor "retarded the progress of improvements."[7] "He must indeed be a bold and confident capitalist," the *Times* declared in

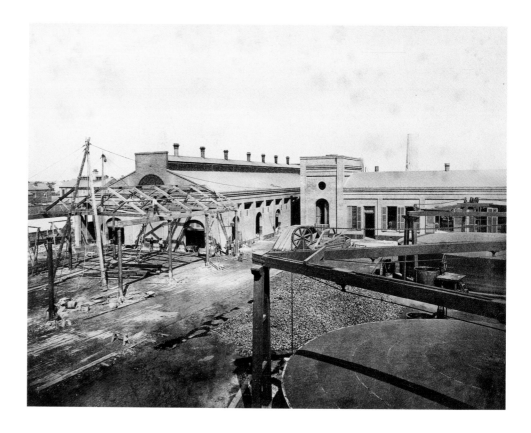

1866, "who enters largely into building and improvements at this juncture."[8]

1. "The Gas Works," *Picayune*, September 29, 1840.
2. On coal-gas manufacture, see cat. 71, n. 2, and LaVerne W. Spring, *Non-Technical Chats on Iron and Steel and Their Application to Modern Industry*, New York (Frederick A. Stokes Co.) 1917, pp. 41–47; R.A. Buchanan, *Industrial Archaeology in Britain*, New York (Penguin Books) 1982, pp. 336–40; M.E. Falkus, "The Early Development of the British Gas Industry, 1790 –1815," *Economic History Review*, ns. xxxv, no. 2, May 1982, p. 229; Margaret Hindle Hazen and Robert M. Hazen, *Keepers of the Flame: The Role of Fire in American Culture, 1775–1925*, Princeton, NJ (Princeton University Press) 1992, p. 201.
3. *Norman's New Orleans and Environs*, p. 145.
4. Gallier, *Autobiography*, pp. 34–35; Gallier's drawing for a Greek revival chimney enlivened with an Ionic colonnade at the base is in the Southeastern Architectural Archive, Tulane University. Other drawings by Gallier for the gasworks are in The Historic New Orleans Collection.
5. Building contract, XXXIII, no. 231, October 4, 1838, NONA; Robert S. Starobin, *Industrial Slavery in the Old South*, New York (Oxford University Press) 1970, p. 31; Harold Sinclair, *The Port of New Orleans*, Garden City, NY (Doubleday, Doran & Company) 1942, p. 191.
6. Starobin, *op. cit.*, p. 59.
7. *Times*, July 3, 1866; *Republican*, April 10, 1867.
8. *Times*, April 24, 1866.

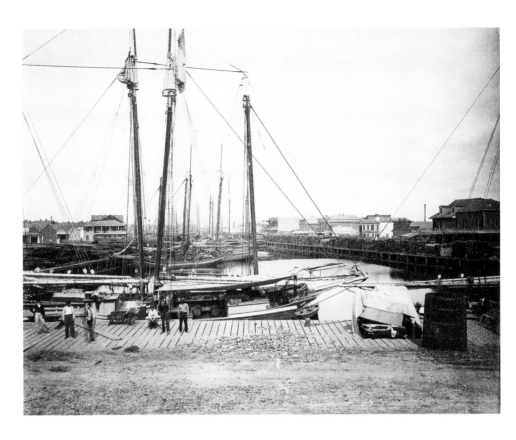

74
Head of New Basin
Quai du Bassin Neuf

In 1827, army engineers surveyed routes through New Orleans for a canal linking the Mississippi River with Lake Pontchartrain, a waterway proposed many times since the founding of New Orleans. Planners were encouraged by the success of the Erie Canal—the opening of which, two years earlier, had launched a canal-building craze—and promoted the waterway to supersede the thirty-year-old Carondelet Canal (cat. 23), through which navigation was difficult and slow.[1] As the commercial stature of New Orleans had increased, so had its strategic importance, and military planners, worried that the city was vulnerable to a foreign landing in the shallow waters of the Gulf Coast, saw the new canal as an aid to the deployment of naval ships and batteries in the event of an invasion. A proposed bypass channel, however, threatened to siphon goods handling away from city docks, and the land acquisition and system of locks required to build the new canal were costly and impractical. In the end, the military and commercial interests could not be reconciled.

The canal project gained renewed support in the business community of the Anglo-American

quarter above Canal Street, and in 1831 an improvement bank, the Canal and Banking Company (cat. 65), was incorporated to build it, with the backing of merchant–planter Maunsel White. Although army engineers had determined that the upper part of the city was "not susceptible of receiving the debouch of a canal," the Canal and Banking Company planned a route connecting the Anglo-American business center above Canal Street with the lake (not, however, connecting to the river), and engaged army Captain Richard Delafield as chief engineer.[2] To superintend construction, the company hired Simon Cameron, a Pennsylvania canal and railroad contractor who would later serve as President Lincoln's first Secretary of War, ambassador to Russia, and U.S. Senator.[3] Cameron observed that in New Orleans "nobody likes to work … all depend on the Negroes," but instead of relying on slave labor to build the canal, he brought 1200 workers to New Orleans from Philadelphia and maneuvered his own immigration scheme to recruit Irish laborers from abroad.[4]

Canallers dug 6 miles (10 km) of 6-foot-deep (1.8 m), 60-foot-wide (18 m) channel through dense cypress swamp with enormous difficulty and great loss of life.[5] "At the mercy of a hard contractor, who wrings his profits from their blood," Cameron's men, one witness wrote,

labored under an "insufferably fierce" sun, "wading amongst stumps of trees, mid-deep in black mud, clearing the spaces pumped out by powerful steam-engines; wheeling, digging, hewing, or bearing burdens it made one's shoulders ache to look upon."[6] Canallers slept in huts reportedly "laid down in the very swamp, on a foundation of newly felled trees." Under such conditions, few laborers could escape cholera and yellow fever. One newspaper reported 3000 deaths—another source doubled that number—but the pace of work continued despite the peril, and in 1834 the laborers rioted.[7] "They had the presumption to resort to force," *Niles Weekly Register* wrote, "such poor men, made mad by oppression at home—too often have to be brought to the necessity of submitting to the law in America."[8]

With the labor force restored, work resumed, and finally, after five years, the canal reached Lake Pontchartrain at New Lake End, where an entrance channel and harbor were built. A 25-foot-wide (7.5 m) turnpike laid opposite the canal's towpath, paved with oyster shells and said to be "as white, and almost as firm, as marble," was the best road in the city (cat. 34).[9] The new waterway cost $1.2 million to build, an almost unimaginable expense that was denounced in the local press: "the whole

concern," according to the *Bee*, "… [is] one of mismanagement, confusion and extravagance."[10] But whatever the canal's failures in design and construction—the undersized turning basin, in particular, was faulted as "one of the worst constructed … of its kind"—the waterway was a commercial triumph. In a short time, the New Basin became the "principal *entrepôt* for the coastal trade from Florida to Texas," transforming a district of the city poised for improvement.[11] "It has created a flourishing town, where, only a few years since, the gloomy swamp existed," the *Picayune* observed in 1852. "Rows of neat residences … paved streets, warehouses, and similar evidences of the increase and activity of a flourishing commerce extend in all directions from the unpoetical-looking reservoir of water."[12]

During the war, the New Basin was the site of an early experiment in submarining. In the summer of 1861, New Orleans machinists and Confederate privateers James McClintock and Baxter Watson, backed by attorney Horace L. Hunley, designed a 30-foot (9-m) cylindrical submersible torpedo boat called *Pioneer*.[13] Hand-powered by a crew of three, the submarine was built by the Leeds Foundry at Government Yard, New Basin, and floated there in February 1862. With the approach of federal troops in April 1862, *Pioneer* was scuttled in the New Basin, but it was soon recovered and documented by the U.S. military.[14] McClintock and partners fled to Mobile where they continued their experiments, and in 1863 their third submarine, known as the *H.L. Hunley*, was sent to Charleston to break the federal blockade. The *Hunley* sank twice before it engaged the enemy, killing Hunley himself, but in February 1864 the submarine destroyed a Union warship, and was then lost in Charleston Harbor (it was discovered and raised in 1995). The *Pioneer* lay on the bank of New Basin until it was scrapped in 1868.[15] Its creator, McClintock, not reconciled to the Confederate defeat, was said to "hate his countrymen, Americans," and in the early 1870s secretly offered his expertise in submersible warfare to the Royal Navy.[16] The Hunley experiment that began at New Basin, in the words of one naval historian, "demonstrated to the world the vast potential of the submersible vessel in future naval strategy."[17]

The New Basin was an important depot for New Orleans's building market, which was rapidly transforming "swamps to building lots" to provide housing for the postwar migration into the city from devastated rural regions of the South.[18] Schooners delivered rough lumber from the Pearl River, Pascagoula, and Jordan River sawmills in Mississippi to the New Basin lumber yards and sash factories. The Sanford and Black planing mill, located at Julia Street, is visible in Lilienthal's photograph. Revival of trade on the waterway was an early sign of postwar recovery: in late 1866, the New Basin was reported to be "crowded with steamboats and schooners," and the landings piled high with lumber.[19] In the photograph, schooners towed to the basin by mule teams lie alongside the wharf to discharge or take on cargo. There is a sense of abstract order in the rhythmic juxtaposition of spars, masts, and rigging silhouetted against the formless sky.

As schooner traffic increasingly gave way to steamers, the waterway was dredged and widened to accommodate the larger vessels, but engineering costs were high and competition from railroads diverted trade.[20] After the turn of the century canal traffic steadily declined as local railroads reached their greatest freight-handling capacity, and by the 1920s the New Basin was an obstacle to residential development, as well as to vehicular traffic.[21] Completion of a new industrial canal downriver in 1923 secured the waterway's obsolescence. The lower canal remained open until 1936, when the turning basin and waterway to Claiborne Avenue were filled in. The upper canal gave way in 1946–51 to interstate highway construction. Today a parking garage covers the turning basin site (in the vicinity of the Union passenger terminal), and Interstate 10 and West End Boulevard follow the former route of the canal. A small piece of the original canal survives at West End, where a modern Celtic cross commemorates the Irish laborers who died building the vanished waterway.

1. *Report, Plan, and Estimate, of a Canal, Destined to Connect the Mississippi with Lake Pontchartrain*, 19th Cong., 2d sess., H. Ex. Doc. 133, Washington, D.C., 1827, p. 16.
2. Delafield (1798–1873), who also designed the first Canal Bank (see p. 175, n. 1), had been posted to New Orleans in 1824 to supervise defenses at forts Jackson and Philip and improvements on the Mississippi River. He remained in New Orleans through July 1832. Letters Sent to Engineer's Offices, 1812–69, III, fol. 495, *passim*, and IV, fol. 266, *passim*, Records of the Office of the Chief of Engineers, RG77, NARA. Delafield would later superintend West Point (1838–45), command the fortification of New York harbor (1846–55), head a commission to report on the Crimean War in 1855, and serve as Chief of Engineers of the U.S. Army (as Major General, 1864–66); see *Biographical Register*, I,

pp. 180–86; Matthew Moten, *The Delafield Commission and the American Military Profession*, College Station (Texas A&M University Press) 2000, p. 89; and the finding aid to the Delafield family papers at Princeton University Library, online at libweb.princeton.edu/libraries/firestone/rbsc/aids/delafield.html (accessed March 2006).
3. Lee F. Crippen, *Simon Cameron: The Ante-Bellum Years*, Oxford, Oh. (Mississippi Valley Press) 1942. On Cameron, see *American National Biography*, New York (Oxford University Press) 1999, IV, pp. 259–60.
4. Crippen, *op. cit.*, p. 10. On the New Canal "swindle" and Cameron's "iniquitous conduct," see *United States Catholic Sentinel*, III, no. 19, February 3, 1832, p. 151.
5. Franz Anton Ritter von Gerstner, *Early American Railroads*, ed. Frederick C. Gamst, Stanford, Calif. (Stanford University Press) 1997, p. 746.
6. This and the quotations that follow are from Tyrone Power, *Impressions of America; During the Years of 1833, 1834, and 1835*, Philadelphia (Carey, Lee & Blanchard) 1836, II, pp. 150–51. "At such works all over this continent," Power observed (p. 151), "the Irish are the labourers chiefly employed, and the mortality amongst them is enormous." The Irish actor pleaded for "a little consideration" for his countrymen.
7. "The New Canal," *Times*, October 12, 1865; Gerstner, *op. cit.*
8. *Niles Weekly Register*, XLVI, April 5, 1834, p. 85.
9. "More Views in New Orleans," *Harper's Weekly*, V, no. 222, March 30, 1861, p. 196. Two horses could tow a 100-ton schooner over the 6-mile (10-km) route in three to four hours, for a toll of $37.50; Gerstner, *op. cit.*, p. 747.
10. *Bee*, April 18, 1836.
11. *Ibid.*; "New Orleans Canal," *Bee*, October 23, 1835.
12. "The Basins," *Picayune*, February 5, 1852.
13. Rich Wills, "The Confederate Privateer *Pioneer* and the Development of Confederate Submersible Watercraft," *INA Quarterly, Institute of Nautical Archaeology*, XXI, Spring/Summer 1994, pp. 12–19; *id.*, "The *H.L. Hunley* in Historical Context," history.navy.mil/branches/org12-76.htm (accessed March 2006); Mark K. Ragan, *The Hunley: Submarines, Sacrifice, & Success in the Civil War*, Charleston (Narwhal Press) 1995.
14. G.W. Baird, "Submarine Torpedo Boats," *Journal of American Society of Naval Engineers*, XIV, no. 3, 1902, pp. 845–55, cited by Ragan, *op. cit.*, p. 20.
15. *Picayune*, February 15, 1868, cited by Wills, "The *H.L. Hunley*," *op. cit.*, p. 7. A drawing by Ensign David M. Stauffer, in a sketchbook now on deposit in the Pierpont Morgan Library, New York (Gilder Lehman Collection, GLC7713), records the submarine on the bank of the canal in 1864; see Greg Lambousy, "Lost Drawings Identify the *Pioneer*," *Louisiana Cultural Vistas*, X, no. 3, Fall 1999, pp. 8–10. Another Civil War submersible of unknown origin pulled from the entrance to Bayou St. John in 1878 is exhibited today at the Louisiana State Museum.
16. Wills, "The *H.L. Hunley*," *op. cit.*, p. 4, citing documents in the Public Records Office, London.
17. *Ibid.*, p. 21.
18. *Times*, October 12, 1865.
19. "Trade of the New Basin," *Times*, December 13, 1866.
20. Louisiana House of Representatives, *Report of Committee of Public Works, Lands and Levees on Widening and Enlarging the New Canal and Basin, Session January 1867*, New Orleans (J.O. Nixon) 1867; *Proposals for Leasing the New Canal*, New Orleans (J.O. Nixon) 1867.
21. *Item-Tribune*, September 5, 1926.

Opposite *Carrollton* (cat. 104), detail.

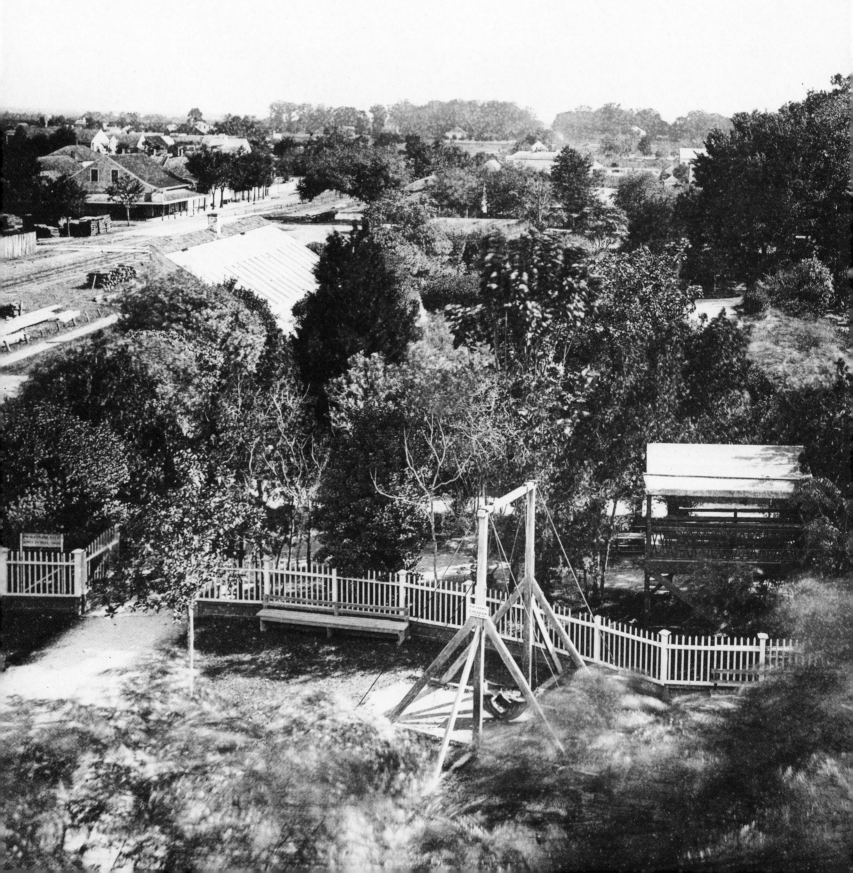

Tivoli Circle to the Fourth District and the Upriver Faubourgs

75
St Simeon's Select School
Couvent St. Simmons

In 1860, the Sisters of Charity of St. Vincent De Paul established St. Simeon's Select School for Young Ladies in the old Saulet plantation house on Annunciation Street, bounded by Melpomene, Constance, and Thalia streets, close by the river. The site's history reached back to the original colonial land grant to Jean Baptiste LeMoyne de Bienville, the founder of New Orleans, in 1719. Owned by the Jesuits from 1726, the property came into the Saulet family in 1763 following suppression of the Jesuits and sale of their properties. In 1810, as the city expanded upriver, the plantation was subdivided as the faubourg Saulet, according to a plan by Barthélémy Lafon.[1] Around 1832, François Saulet rebuilt an old family residence on the property, the house seen in the photograph.

The Saulet residence was a fine example of the galleried plantation-house form that had been in use in Louisiana since the mid-eighteenth century.[2] It was square in plan and surrounded by open galleries on two floors supported by giant Doric columns. Exterior openings were double French casement doors with round-arched transoms. The wide galleries opened the interior to cross-ventilation and provided shade and shelter from rain. A large central entrance hall was flanked by two square rooms with staircases and smaller rooms at the rear; the second floor had two symmetrical square rooms. The photograph is evidence that the ground-floor brick walls and square columns had been left unplastered and unpainted and the red brick exposed, in the fashion of the 1830s.[3]

Following the war, St. Simeon's enrolled 160 pupils under the instruction of eleven sisters.[4] An adjoining school, St. Vincent's Free School for Girls, enrolled another 200 students. The curriculum included French language studies, vocal and instrumental music, drawing, painting, "Florentine work," plain and ornamental needlework, and elocution.[5]

From 1871 to 1895, the sisters enlarged their campus with several buildings, including a brick schoolhouse and chapel, but enrollments declined after the turn of the century.[6] In 1912, St. Simeon's graduated its final class of six women.[7] The buildings continued in use as a parochial school and were finally sold by the Sisters of Charity in 1922 to a private psychiatric institution, St. Luke's Sanitarium. The Sisters of Mercy acquired the building in 1923 for use as a hospital, which they operated for thirty years. Abandoned in the early 1950s, the house became derelict and was damaged by fire. It was demolished in 1959 to make way for a supermarket.[8]

Tracks of the Annunciation Street line of the City Railroad, opened in 1866, can be seen in the lower right-hand corner of the photograph. Lilienthal's view is a portrait of order and conformity: the neatly trimmed, ornamented garden is confined by a sturdy fence of brick posts and iron pickets, painted white to contrast with the dark foliage and complement the gallery columns. Dressed in crisp, white crinoline, and tightly posed between the column bays, the pupils form a prim assembly on the gallery.

1. Samuel Wilson, Jr., "Early History of the Lower Garden District," *New Orleans Architecture*, I, pp. 20–21.
2. For a summary of the Louisiana plantation house, see Mills Lane, *Architecture of the Old South: Louisiana*, New York (Abbeville Press) 1990, pp. 54–81; and Barbara SoRelle Bacot, "The Plantation," in *Louisiana Buildings 1720–1940: The Historic American Buildings Survey*, ed. Jessie Poesch and Barbara SoRelle Bacot, Baton Rouge (Louisiana State University Press) 1997, pp. 95–125.
3. Wilson, *op. cit.*, p. 21. Views of the house in Charles A. de Armas, April 25, 1859, Plan Book 42, fol. 40, NONA, are reproduced by Wilson, who noted that the house was similar to Seven Oaks in Westwego, Louisiana, destroyed in 1977, and was possibly by the same unknown architect. See also the property survey, "Plan of 15 Desirable Lots of Ground Belonging to the Estate of the Late F. Saulet ... to be Sold at Public Auction on Tuesday 14th June 1859 ..." by N. Vignie, Kuntz Collection VIII, Printed and Visual Materials, Manuscripts Collection, Tulane University Library.
4. "Order of the Sisters of Charity in New Orleans," *Times*, September 10, 1866.
5. *Ibid.; New Orleans Catholic Directory*, New Orleans 1867.
6. W.J. Castell, XXIX, no. 5426, March 8, 1871, NONA; Proposal by A. Thiesen dated July 11, 1885, "to build a three-story Brick Building in accordance to plans and specifications as prepared by Albert Diettel & Son architects," Daughters of Charity of St. Vincent De Paul, West Central Province Archives, St. Louis, Missouri. Architects Diboll & Owen provided plans for a Romanesque brick chapel in 1895.
7. *Dixie Magazine*, June 10, 1962.
8. Mercy Hospital was relocated to North Jefferson Davis Parkway. "N.O. Area Will Lose Landmark," *Times-Picayune*, March 20, 1959.

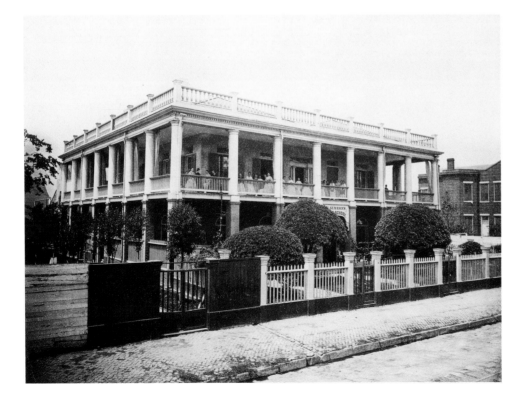

76
St. Paul's Church Camp St.
Eglise St. Paul Rue du Camp

St. Paul's Episcopal Church was built in 1853 at Camp and Bartholomew (Gaiennie) streets, in a mixed residential and commercial area that was dominated by carpenters' and coopers' shops, tinsmiths, foundries, and simple cottages. The architect was John Barnett, a native of Massachusetts who had arrived in

New Orleans around 1830.[1] Barnett was selected by the congregation—of the second oldest Episcopal parish in the city—on the merit of "a very beautiful plan" for a Gothic church, which was submitted in competition with other architects in late 1852.[2] According to the *Picayune*, Barnett designed "a beautifully proportioned structure ... the projecting flanks and buttresses, the rich foliated windows, and the crotcheted finials, will form a very beautiful and elegant *tout ensemble*."[3]

Builders Giraud and Lewis laid the foundation in May 1853 and the building was roofed over nine months later.[4] "The walls ... are now up and the roof is on," the *Picayune* reported in February 1854. "In architectural design this church is one of the handsomest, if not the very handsomest, edifice in New Orleans."[5]

St. Paul's was an asymmetrical brick block with a steeply pitched slate roof and three corner towers, the tallest of which, at 150 feet (46 m), was surmounted by a "graceful tapering spire" of terracotta. The church was accessed by balustraded granite steps "of very picturesque design." A quatrefoil gable window and a large triple lancet window lighted the west end. Tall, traceried lancet windows illuminated the nave and towers. The interior, "in the pure thirteenth-century style," had a "beautifully fretted" open timberwork ceiling. The double pointed arches framing the nave were supported by cast-iron trusses and quatrefoil columns with foliated capitals. All the ironwork was painted a striking indigo-blue, which contrasted beautifully with the varnished yellow-pine floors and pews, and the doors, window frames, and blinds of red cypress. The construction cost was $35,550.

The first service in the new church was held on Christmas Eve, 1854.[6] Architect Thomas K. Wharton reported the following May that the "perforated spire" of the large tower and two smaller towers, also designed to carry spires, had not been finished. Structural faults were revealed by a storm in February 1860, when Wharton found the church "leaking shockingly, especially in the Tower." Wharton was hired for repairs and modifications, including work on the nave, which enhanced the church's acoustics: "The noble organ rolled the finest volume of harmony thro' the Gothic aisles," he wrote. The spires were never completed.[7]

Federal troops under General Benjamin Butler closed St. Paul's during the war, charging the pastor Charles Goodrich with

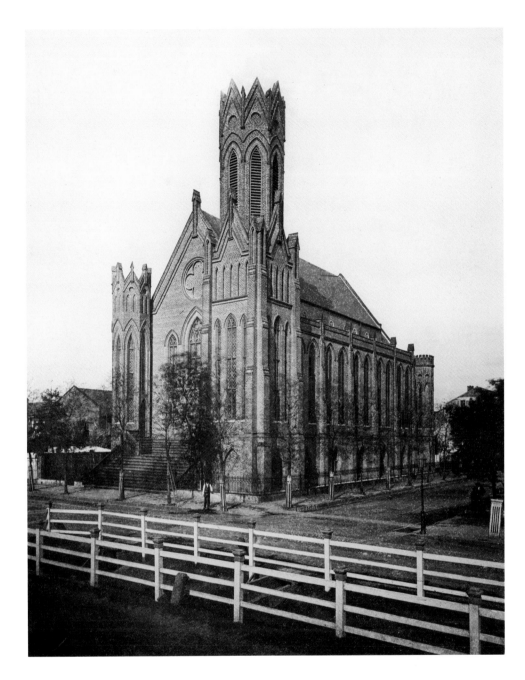

sedition. Although forbidden to offer prayers "for the success of rebel armies," Goodrich and other Episcopal pastors, defiant of the federal occupiers, continued to recite prayers for the Confederacy. With accusations that the clergy were "more mischievous in this city than they would be as soldiers in arms in the Confederate Service," Butler had Goodrich and two other pastors imprisoned in New York, and replaced them with Union army chaplains.[8] Three months later, Butler's successor, General Nathaniel Banks, released them from prison but would not permit them to disembark in New Orleans when they refused to take an oath of

allegiance to the federal government. Goodrich eventually returned to New Orleans after the war and revived the parish. St. Paul's was renovated and a new entry stair added before the church was re-consecrated in May 1870.[9]

St. Paul's was destroyed by fire in March 1891.[10] Its replacement, built in 1893 to a design by the McDonald Brothers of Louisville, was razed in 1958 to make way for an approach ramp (which was later removed) for a new highway bridge across the Mississippi. The congregation of St. Paul's relocated to Canal Boulevard where, at a cost of half a million dollars, it erected a new church that survives today.[11]

Among a small number of vertically framed views in the Exposition portfolio, the photograph of St. Paul's effectively conveys the form of the church by centering the tall corner tower. The foreground fence is a framing device to situate the building in depth, by which Lilienthal created a composition that could function stereographically. One of the earliest and largest publishers of stereoviews in New Orleans, Lilienthal was fluent in the visual syntax of stereoscopy, a compositional approach that can be found in his outdoor work in all formats.[12]

1. Building contract, Hilary B. Cenas, LVII, no. 693, May 7, 1853, NONA; *Picayune*, April 9, July 22, September 17, 1853, and January 14, 1854. Barnett's other church projects included the Coliseum Place Baptist Church, Camp and Terpsichore streets, 1855; and the Unitarian Church, St. Charles and Julia, 1853–55 (destroyed). His obituary appears in the *Picayune*, March 12, 1871.
2. "St. Paul's Church Vestry Minutes 1852–54," December 29, 1852, Louisiana Episcopal Diocese Papers, and "A Brief History of St. Paul's Church, New Orleans," McConnell Family Papers, Manuscripts Collection, Tulane University Library.
3. "New St. Paul's Church," *Picayune*, May 15, 1853, and for the description that follows.
4. "A New Church," *Picayune*, April 9, 1853; "St. Paul's Church Vestry Minutes 1852–54," *op. cit.*, February 27–28; "St. Paul's Church," *Picayune*, July 22, 1853; *Picayune*, September 17, 1853.
5. "New Churches," *Picayune*, February 23, 1854.
6. Edwin Belknap, *A History of St. Paul's Protestant Episcopal Church*, New Orleans 1926, p. 18.
7. Wharton, "Diary," May 24, 1855 (when he also sketched the church from Coliseum Place), December 24, 1856, February 21 and May 10, 1860, and journal entries throughout April 1860. Wharton was hired in 1856 to make modifications to the entrance. His renovation drawings, including an interior perspective of the nave and an entry elevation, are in The Historic New Orleans Collection and the Southeastern Architectural Archive, Tulane University.
8. Julia Huston Nguyen, "Keeping the Faith: The Political Significance of Religious Services in Civil War Louisiana," *Louisiana Historical Quarterly*, XLIV, no. 2, Spring 2003, pp. 169–170.
9. Belknap, *op. cit.*, p. 15.
10. "Desecrating Flames," *Picayune*, March 24, 1891; "St. Paul's Burned," *Times-Democrat*, March 24, 1891. A cabinet card of St. Paul's shortly after the fire, by an unknown photographer, is in the Southeastern Architectural Archive, Tulane University.
11. Belknap, *op. cit.*, pp. 27–28. On the demolition of the second St. Paul's, "Historic Church Going Down," *New Orleans States*, March 31, 1958.
12. Lilienthal simultaneously executed many, if not all, of the Exposition subjects in stereoscopy.

77

St. Mary's Convent & Church Drayades St.
Couvent Ste. Marie et Eglise Rue Drayades

In this view of the corner of Dryades and Calliope streets are three Dominican institutions serving a predominantly Irish neighborhood. The three-story galleried building, cloistered by a high brick wall, is the Dominican Convent of St. Mary, built in 1861. The church is St. John the Baptist, founded in 1851, and the gabled brick building at the corner of Clio Street is the St. John the Baptist Day School for Boys.

During the 1830s and 1840s, thousands of foreign-born, mostly Irish, immigrants arrived in the city.[1] Many of the Irish immigrants were commercial men associated with the new Anglo-American quarter, where the first Irish church, St. Patrick's, opened in 1838. Other Irish natives settled in the Creole faubourgs downriver, below Esplanade and in two areas of Lafayette City: below Magazine Street in what came to be called the "Irish Channel," and in the area above Tivoli (Lee) Circle, where this photograph was taken. More than 5000 Irish settled above Tivoli Circle in the 1830s during construction of the New Basin Canal (cat. 34), built by Irish labor. By mid-century all these neighborhoods required

national churches to serve foreign-born parishioners. St. John's was one of three Irish churches built in New Orleans between 1849 and 1858, with St. Peter and St. Paul in faubourg Marigny below Esplanade Street and St. Alphonsus (cat. 86) in the Irish Channel.

St. John's was a modest, frame church designed by the architects Theodore Giraud and Thomas Lewis. It was built for just $7200, including the interior furnishings of one hundred pews, two confessionals, a high-altar tabernacle, and two side altars.[2] A year after this view was made, a newspaper reported that the "old frame church disappeared suddenly and mysteriously" overnight and was moved to a site "more suitable to its modest pretensions," to make room for a new church building.[3] The new St. John's, designed by Albert Diettel and completed in 1871, was an imposing brick structure with a 125-foot (38-m) tower, built at a cost of more than $150,000.[4] The scale and cost of the church dwarfed the modest chapel built twenty years earlier and was an indication of the increase in prosperity and the assimilation of Irish immigrants over the course of two decades. The second church of St. John's remains in use today.

Shortly before the war, St. John's parish brought Dominican sisters from near Dublin to

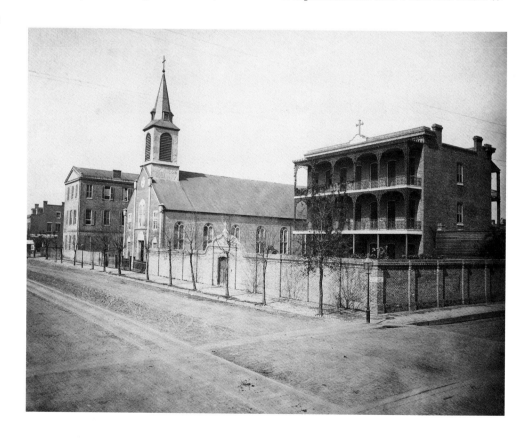

establish a convent and school for girls at Dryades Street. Irish-born Thomas Mulligan designed the new school and convent, which featured elaborate iron galleries, in 1861.[5] The school was used as a refuge for girls who had been displaced by the war. It soon became overcrowded, and in 1864 the sisters founded a convent and boarding school upriver in rural Greenville, near Carrollton.[6] The Dryades Street building remained in use by the Dominicans until 1956, when it was demolished for construction of a new Mississippi River bridge.[7]

1. Earl F. Niehaus, *The Irish in New Orleans 1800–1860*, Baton Rouge (Louisiana State University Press) 1965, pp. 23–26, 44–46.
2. Rev. Antoine Blanc to Council of Paris, Association for the Propagation of the Faith, October 19, 1849, Archdiocese of New Orleans; Building contract, O. de Armas, XLIX, no. 163, May 24, 1851, NONA; "Dedication of the New Catholic Church," *True Delta*, November 9, 1851; Roger Baudier, *St. John the Baptist Church, New Orleans: A Century of Catholic Parochial Service*, New Orleans 1952; Sisters of the Order of St. Dominic, *Congregatio Dominicana Sanctae Mariae, 1860–1960*, New Orleans (Dominican Sisters) 1960, pp. 30–33.
3. Baudier, *op. cit.*
4. The new St. John's was dedicated in January 1873; *Republican*, January 21, 1873.
5. "Interesting Ceremonies," *Delta*, June 26, 1861.
6. Architect William Fitzner designed the new convent and school, Greenville Hall, for St. Mary's Academy facing St. Charles Avenue in 1882; the sisters occupied it until 1984. It is now part of Loyola University.
7. "Historic School to Go for Approach" *States*, October 15, 1955; "Church a Lonely Sentinel," *Item*, February 23, 1957.

78
Public Schools Drayades St
Ecoles Publiques Rue Drayades

In Lilienthal's photograph of the corner of Dryades and Erato streets are two Greek Revival schoolhouses, the Webster School for girls and the Jefferson School for boys. The Jefferson School was built in 1850 to the design of architect Charles Pride, who was active in New Orleans from about 1845 until the war. In 1855, Irish-born Henry Howard was hired to design the Webster schoolhouse, modeled on the earlier building.

Pride's contract for the Jefferson School called for a two-story, galleried, wood-frame building in the Greek style, painted white with a slate roof, raised on 6-foot (1.8-m) brick piers.[1] For the Webster School, Howard specified a cypress- and yellow-pine-framed structure, also raised on brick piers and roofed with slate.[2]

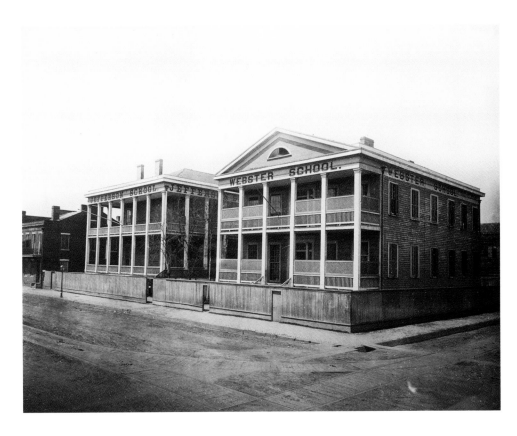

The galleries were to have "dressed wooden pilasters with moulded caps," and the entablature was to be carried around the entire building.[3]

The Jefferson and Webster schools were the pride of a public-school system that was said to be among the best in the South. New Orleans's public schools had long struggled financially and academically to meet standards in a city still strongly influenced by French Catholic institutions.[4] New Orleans had a long tradition of private and parochial education, and early attempts by the first Governor of Louisiana, William Claiborne, to create a public-school system were opposed by Creoles whose children were educated in the French language in Catholic schools, private academies, or at home. Visionary mercantile leaders, however, funded school programs for workers, purchased textbooks, recruited northern teachers, and hired Harvard-educated theologian John Angier Shaw to oversee a new public system.

The first tax-supported school opened in 1841. Representative of the waves of Irish and English immigrants that populated the city before mid-century, English prevailed over French in school administration and instruction, although French language instruction was commonplace in the old French districts below Canal Street. Superintendent Shaw reported in

1850 that "four large and commodious houses" had been built the previous year, adding to five already in use, but the need for school buildings was still acute.[5] With the death of John McDonough, Louisiana's largest landowner, who bequeathed funds for school construction, further expansion was assured.

The war shattered public education in New Orleans. Young male teachers were lost to the military and boys left school to find work to support their families when fathers and older brothers were mustered into service. During federal occupation in 1863, only 12,000 of 38,000 white children of school age attended the forty-four public schools in New Orleans, although many had been enrolled in the city's 140 private schools, some to avoid the "Yankee influence" of public instruction under federal guidance. Federal commissioners inspecting private schools found that nearly half the principals were, in their judgment, disloyal to the Union. In both public and private schools, Confederate history had been substituted for U.S. history, and refrains of "The Bonnie Blue Flag" and "Dixie," not "The Star-Spangled Banner," were heard in classrooms. U.S. General Benjamin Butler imposed measures to purge classrooms throughout the city of "rebel" sentiment by importing new curriculum materials and

implementing a unified program of English language instruction in all the schools.[6]

Mayor John Monroe reported in 1866 that the public schools were "in as good condition as could be expected after the lamentably inefficient administration of the three years of military rule."[7] During Reconstruction, the Federal Freedmen's Bureau established the first schools for African American children, and by 1867, it operated eleven schools in New Orleans with fourteen teachers and an enrollment of 469 pupils.[8] In late 1867, the city of New Orleans created a system of black schools, absorbing the Freedmen's Bureau facilities.[9]

The most consequential change of the century came to public education when the state constitutional convention of 1867–68 sanctioned desegregation in the public schools and ordered that no school could deny admission on account of race.[10] Although the measures were fully enacted only by a court ruling three years later, the city was now legally bound to educate black children. The result would be the most integrated public-school system in the country, but the compromise, with enrollments nearly double prewar levels, was severe overcrowding and faculty shortages.[11] A depleted municipal treasury could not support new faculty hires, new facilities, or even maintenance of existing buildings neglected during the war: one study estimated 2000 students were turned away because of a shortage of space and teachers.[12] Already during the 1866–67 school year, the Jefferson and Webster schools together admitted 1500 students and were reportedly "filled to overflowing during the whole session." The space shortage was so acute that more than one hundred pupils were assigned to one small classroom.[13]

1. Building contract, William Monaghan, October 14–19, 1850, NONA. By February of 1851, fences, privies, coal and wood houses were specified for the school; *Crescent*, February 13, 1851.
2. Building contract, with specifications signed by Henry Howard, P.E. Theard, April 27, 1855, NONA.
3. *Ibid.*
4. On the history of the public schools, see Donald E. DeVore and Joseph Logsdon, *Crescent City Schools: Public Education in New Orleans, 1841–1991*, Lafayette (Center for Louisiana Studies, University of Southwestern Louisiana) 1991.
5. John Angier Shaw, *Address Delivered Before the Public Schools of Municipality No. Two, City of New Orleans, February 22d, 1850*, New Orleans (Commercial Office) 1850, p. 1.
6. Elizabeth Joan Doyle, "Nurseries of Treason: Schools in Occupied New Orleans," *Journal of Southern History*, XXVI, no. 2, May 1960, pp. 163–66, 173.
7. "Mayor Monroe's Message," *Crescent*, October 3, 1866.
8. Charles W. Boothby, *Centennial Record of the Public Schools of the State of Louisiana, and especially of New Orleans*, New Orleans 1876, p. 23.
9. Roger A. Fischer, *The Segregation Struggle in Louisiana, 1862–77*, Urbana (University of Illinois Press) 1974, p. 45.
10. Louis R. Harlan, "Desegregation in New Orleans Public Schools During Reconstruction," *American Historical Review*, LXVII, no. 3, April 1962, p. 664.
11. *Crescent*, April 24, 1867; *Crescent*, May 11, 1867; Boothby, *op. cit.*, pp. 22–24; DeVore and Logsdon, *op. cit.*, pp. 40–68.
12. *Times*, October 16, 1866.
13. *Times*, June 26, 1867.

79

N. O. Jackson & Great N.R.R. Depot
Dépôt Central du Chemin de Fer du Nord

Organized in 1850 by prominent New Orleans financiers James Robb, Judah P. Benjamin, and John Slidell, the New Orleans, Jackson and Great Northern Railroad reached central Mississippi before the war. Built largely by slave labor, the railroad spanned the swamplands and floating prairies northwest of the city with 46 miles (74 km) of cribwork and bridges. Stations were built at 10-mile (16-km) intervals, opening large areas of northern Louisiana and Mississippi to settlement. North of Jackson, the railroad connected to lines in the upper South, finally bringing New Orleans into the national rail network. The road offered two trains daily connecting to New York, which could be reached in three days and sixteen hours for a fare, in 1861, of $48. The railroad was an important supply line for Mississippi cotton and for brick and lumber from the kilns and sawmills north of Lake Pontchartrain.[1]

The railroad's New Orleans terminal and shops were located near the New Basin Canal (cat. 34) in the block bounded by Locust (South Robertson), Magnolia, Calliope, and Clio streets.[2] Architect Thomas K. Wharton wrote in 1854 that the depot, "a temporary construction of wood," was located "quite in the swamp, on the last street opened in that direction."[3] But lumber yards and mills had located there near the railroad and the New Basin Canal, and in the later 1850s, building lots developed steadily in the vicinity.

During the war, the Jackson Railroad was the main route for troops and supplies sent from New Orleans to the Confederate camps and battle lines. With federal gunships offshore in late April 1862, the road carried thousands of evacuating troops and nearly anything that could be removed from the city for use at the front. Retreating Confederates cut the tracks behind them, and advancing federal forces tore up roadbeds, wrapped rails around tree trunks, wrecked cars, and burned bridges and depots. "The two belligerents vied with each other in their vandalic devastation of this splendid work," the *Picayune* wrote. "The tempest of war had swept this road, in all its whole length, into a mass of charred and rotten ruins."[4] Although it had been one of the best-equipped antebellum railroads in the South, at the end of the war the Jackson Railroad was "without means, with but a single locomotive, without depots or cars."[5] The company had accrued an enormous debt of unpaid interest on loans and had "a large lot of Confederate money on hand," the *Times* reported in 1865, "which, of course, is worthless."[6]

While wartime devastation underlies many of Lilienthal's photographs, several document postwar recovery. In late 1865, the Jackson Railroad hired ex-Confederate General P.G.T. Beauregard to rehabilitate the road. By 1867, it was back to half strength with twenty-five locomotives and dozens of new cars returned to service, stations along the line rebuilt, and new tracks laid.[7] "The trains are making regular trips and the earnings of the road are large," the credit agency R.G. Dun & Co. reported.[8] The railroad ran one passenger train a day to Canton, north of Jackson, Mississippi—a thirteen-hour trip covering 206 miles (331.5 km)—and offered daily excursions to the "piney woods and medicinal springs" above Lake Pontchartrain.[9]

Lilienthal's view encompasses the shops, offices, train sheds, and platforms of the railroad's New Canal terminal. The shops were "not so extensive as they were," the *Picayune* observed in 1867, "... owing to the wrecked condition in which the war left the road and its resources." Passenger wagons were built in the carpentry shops and foundry, which had "every facility for working iron into all sorts of shapes," using steam-powered machinery that once made Confederate arms.[10]

On the wide platform, which is mostly empty of goods, a man loading milled lumber on to a horse cart has paused in his work. Laborers pose for the camera beside a neat row of cotton bales and, in the distance, with a locomotive emerging from the shops. Rough-cut wood, probably fuel for locomotive boilers, is piled beside the tracks, and the signboard carries a notice to draymen.

By 1873, the Jackson Railroad provided direct service from New Orleans to Chicago.

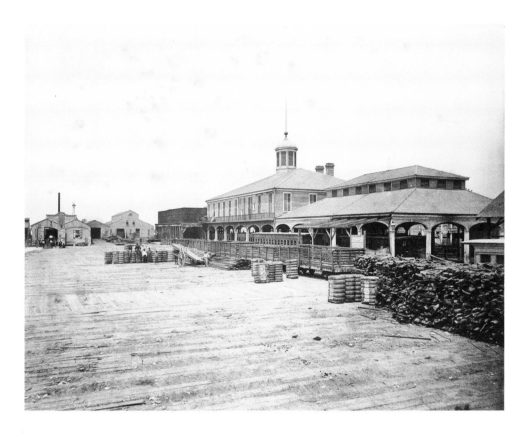

In the 1880s, the road was absorbed by the Illinois Central Railroad—the migration route, celebrated in folklore and popular song, for thousands of African Americans from the Mississippi cotton fields to the factories of the North. Passenger trains still serve New Orleans today using the old Jackson Railroad route.

1. *Gardner's New Orleans Directory for 1867*, p. 20; Thomas D. Clark, *A Pioneer Southern Railroad from New Orleans to Cairo*, Chapel Hill (University of North Carolina Press) 1936, pp. 55–82; Merl E. Reed, *New Orleans and the Railroads: The Struggle for Commercial Empire, 1830–1860*, Baton Rouge (Louisiana State University Press) 1966, pp. 88–107; Lawrence E. Estaville, Jr., "A Strategic Railroad: The New Orleans, Jackson and Great Northern in the Civil War," *Louisiana History*, XIV, no. 2, Spring 1973, pp. 117–36; Theodore Kornweibel, Jr., "Railroads and Slavery," *Railroad History*, Fall–Winter 2003, p. 55.
2. Legislature of the State of Louisiana, *Debates in the Senate, Session of 1853. Appendix. Report of the Joint Committee on the ... New Orleans, Jackson and Great Northern Railroads*, New Orleans (Emile La Sere) 1854, p. 14. *Atlas of the City of New Orleans, Louisiana, Based Upon Surveys Furnished by John F. Braun, Surveyor and Architect*, New Orleans (E. Robinson) 1883, 1st District, plate 4.
3. Wharton, "Diary," June 12, 1854.
4. "The Jackson Railroad," *Picayune*, May 9, 1866.
5. "The Jackson and Great Northern," *Times*, June 21, 1866; Estaville, *op. cit.*, p. 134.
6. "Jackson Railroad," *Times*, August 16, 1865. Estaville notes that when the road was returned to private ownership in June 1865, three stations remained standing, and of the
540 cars and forty-five locomotives the road owned before the war, only thirty-seven cars and four locomotives remained, all in damaged condition; Estaville, *op. cit.*, pp. 134–35.
7. *Twelfth Annual Report of the New Orleans, Jackson & Great Northern Railroad Company*, New Orleans (New Orleans Times) 1867, p. 3; T. Harry Williams, *P.G.T. Beauregard: Napoleon in Gray*, Baton Rouge (Louisiana State University Press) 1955, pp. 275–77.
8. *Louisiana*, XI, p. 151, R.G. Dun & Co. Collection, Baker Library, Harvard Business School.
9. "The Jackson Railroad," *Times*, September 16, 1866.
10. "Workshops of the Jackson Railroad," *Picayune*, July 28, 1867. Jay Dearborn Edwards recorded the shops of the Jackson Railroad in a salt print of the late 1850s, now in The Historic New Orleans Collection. Lilienthal photographed the Jackson Railroad offices at Lafayette Square, appropriated by federal troops, for the U.S. Quartermaster General in 1865 (see p. 44).

80 *overleaf*
Bennett & Lurges Foundry
Fonderie de Bennett et Lurges

The Bennett & Lurges foundry, located at Magnolia and Erato streets near the Jackson Railroad Depot, was the largest fabricator of architectural iron in the city.[1] During the 1850s, when commercial districts across the country took shape in cast iron, New Orleans also adopted the fashion. Benjamin Bennett (partnered with Luther Homes) was

manufacturing iron castings for buildings by 1853, when he supplied part of the gothic front of the Rice Amphitheater on St. Charles Street.[2] In 1857, Bennett & Lurges was reported to be "manufacturing all kinds of Architectural and Building Iron ... verandahs, railings, shutters, iron bridges, staircases, Store and House Fronts."[3] The foundry's ironwork included the Poydras Market expansion (cat. 60) and, on Canal Street, Will Freret's Merchant's Mutual Insurance Company and Frois Buildings.

In 1857, Bennett & Lurges began operating out of the Magnolia Street foundry, designed by Isaac H. Schubert. Two years later, the building was enlarged to produce iron for the City Water Works on the Levee at Canal Street, a *tour de force* of cast iron designed by W.H. Wells (and illustrated in Lilienthal's stereoview of the foot of Canal Street; see fig. 68).[4] It was the foundry's finest work: thirty-six iron columns supported arches decorated with Nereids, tritons, sea horses, Neptune with his trident, and, presiding over all, "a life-size representation of the old Mississippi god reclining on his urn," with an alligator. Never used as designed, it served as a charity free market for the distribution of food during the war and was later dismantled.[5]

Before the federal capture of New Orleans, Bennett & Lurges's operations were "directed to the preparations of the munitions of war," the *Delta* reported in March 1862; "now you will see in their extensive establishment any quantity of shot and shell."[6] The postwar economy did not generate orders for ironwork on the scale of the wartime armaments contracts, although Bennett & Lurges produced architectural ironwork for James Gallier, Jr., and Richard Esterbrook's Bank of America annex on Exchange Place in late 1866, and ornamental work to complete James Freret's Moresque Building on Lafayette Square in 1866–67 (cat. 120); it also fabricated the Iron Palace at the Mechanics' and Agriculture Fair of 1866.[7] The foundry produced iron rails for the City Railroad—a roadbed arcs through the center of the photograph—and wheels for the railroad's horsecars. In 1868, the Bennett & Lurges partnership dissolved, although the foundry continued to operate until 1899. The building was demolished in the 1930s.

Lilienthal's photograph is a stage-managed portrait of laborers posed with the tools of their trade. Foundry workers appear behind

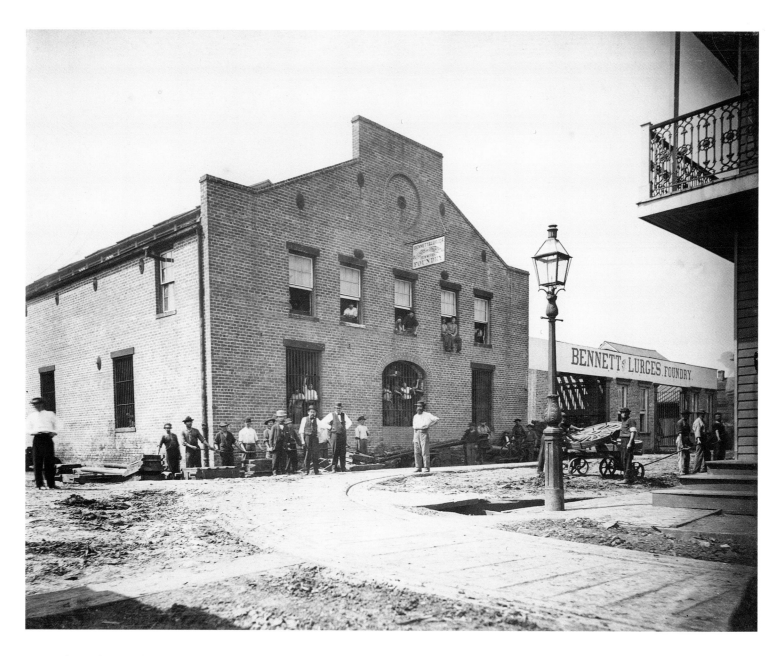

security bars (also a product of the foundry), while their coworkers outside pose with a dolly-load of lampposts and a cart of wagon wheels. The line of foundrymen who are grasping an iron link chain are displaying their role in the long tradition of chainmaking, a proud craft essential to a port and shipbuilding center where iron ships' cables and mooring chains were in constant demand.[8] The assembly is a reminder that the Civil War-era factory still relied primarily on traditional hand methods of production, and on human muscle.

Two men stand a little forward of the others: their bearing and dress signal authority and difference, and their proprietary status. One of these men is the owner, Francis Lurges,

who is recognizable from the portrait Lilienthal made of him as a member of the New Orleans city council (pp. 60–61). Lilienthal's conspicuous posing is central to his method of organizing the picture. Not only is he making skillful use of a vocabulary essential to his practice as a portrait photographer, but the human activity also narrates his portrait of industry and labor.

1. *Louisiana*, IX, p. 277, R.G. Dun & Co. Collection, Baker Library, Harvard Business School; "New Orleans Manufactures and Arts," *Times*, April 29, 1866; "The Last Day of the Fair," *Picayune*, November 28, 1866.
2. The building was designed by Isaac H. Schubert; "New Amphitheatre," *Picayune*, May 28, 1853. Homes and Bennett dissolved in late 1853; *Picayune*, October 4, 1853.
3. *Picayune*, July 15, 1857.

4. Building contract, W.L. Poole, August 7, 1857, NONA. The foundry had operated earlier in Circus Street under the name of Bennett & Co. The waterworks is illustrated in Lilienthal's stereoview of the foot of Canal Street, fig. 68.
5. "The Levee Water-Works," *Picayune*, December 14, 1859; "The Iron Buildings," *Crescent*, March 18, 1861; "Public Works," *Times*, September 27, 1866. The Water Works was pulled down in 1874; *New Orleans Architecture*, II, p. 18.
6. *Delta*, March 3, 1862, cited by Ann Masson and Lydia Schmalz, *Cast Iron in the Crescent City*, New Orleans (Gallier House) 1975, p. 4.
7. "New Orleans Manufactures and Arts," *op. cit.*; "The Last Day of the Fair," *op. cit.*
8. On the chainmaking craft, see Norman Wyler, *English Town Crafts*, Yorkshire (E.P. Publishing) 1975, pp. 100–102.

81
St Vincent Asylum Cor. Magazine and Race Sts.

Asile St. Vincent Rues du Magazine et Race

At the end of the war, the St. Vincent Orphan Asylum on Magazine Street, founded by the Sisters of Charity of St. Vincent De Paul in 1858, was in a "destitute condition." The *True Delta* wrote that the asylum received no aid whatsoever except army rations from occupying Union troops, "which, for babies, cannot be considered the most suitable food." The asylum was reportedly "dilapidated, gloomy, ill-ventilated and totally unfit" for the eighty infants and the six sisters who cared for them with "sublime self-abnegation."[1]

In 1864, the sisters began a building campaign to address the deficient conditions and the large numbers of children orphaned by the war. With $2000 raised in the city, including contributions from Union forces, the sisters hired the Irish-born architect Thomas Mulligan to design and build a new asylum, one of many under their supervision. In Mulligan's plan, a central core of common rooms and nurseries was flanked by twin dormitory wings in an H-shaped block.

Before construction could begin, the sisters had to pull down their old asylum. Despite the building's deteriorated condition, the *Picayune* noted its destruction with antiquarian resignation and the recognition that the city's antebellum building fabric (poorly maintained during the war) was another casualty of the conflict: "in these war times the spirit of innovation is dealing an occasional blow at the old landmarks of our city ... the old building at the corner of Orange and Magazine streets, so long known as the St. Vincent's Infant Orphan Asylum, has recently been torn down, and we understand a new edifice is soon to take its place, one more in accordance with the present day idea of architecture."[3]

Wartime shortages of lumber and other building supplies delayed construction of the building, which was not completed until late 1866, "owing to the scarcity of means."[4] In 1867, the asylum sheltered 160 children from four months to seven years of age, and the sisters soon expanded the building for the care of unwed mothers.[5] More than one hundred years later St. Vincent's still cared for needy mothers and children, but the state funding on which it depended ceased in 1986 and the asylum closed two years later.[6] The building is now a hotel.

1. "Sisters of Charity," *True Delta*, July 2, 1864.
2. *Picayune*, August 28, 1864.
3. *Crescent*, July 4, 1866 (quotation); "Grand Jurors of the Parish of Orleans," *Times*, April 17, 1864; *Picayune*, September 23, 1864; *Picayune*, November 24, 1864; *Times*, December 25, 1864; *Era*, December 27, 1864; "Building Improvements," *Picayune*, March 17, 1866; *Times*, April 8 and September 10, 1866.
4. Louisiana Legislature, Committee on Charitable Institutions, *Report of the Committee on Charitable Institutions ... January 1867*, New Orleans (J.O. Nixon) 1867, p. 4.
5. "Drop in State Aid to Close St. Vincent's," *Times-Picayune*, May 4, 1988.

82 *overleaf*
St. Ann's Asylum Prytania St.

Asile St. Anne Rue Prytania

In 1850, the Society for the Relief of Destitute Females and Their Helpless Children was organized to build an asylum where, according to its bylaws, "even a respectable or refined woman may be saved from ... want and suffering without incurring the loss of self respect." Essential to the Society's mission was a work program that would "insure a degree of independence" for impoverished women.[1] The Society's construction program attracted prestigious patrons including Swedish opera celebrity Jenny Lind and local banker James Robb. In a local gallery, Robb exhibited his prized acquisition, the *Greek Slave* by sculptor Hiram Powers, as a fundraiser for the asylum.[2] Robb's sculpture, now in the Corcoran Gallery, Washington, D.C., had toured the country in 1847–48 and was Powers's second of six versions of the statue, the most famous American sculpture of its time.[3]

But the primary patron for the building campaign was local surgeon Dr. William Mercer, who was reported to have a staggering annual income of $200,000, a quarter of which he distributed to charity. In the Society's project, he found a fitting memorial to his deceased only child, "an elegant, accomplished and intelligent young lady." Mercer donated land and $30,000 toward construction of the "stately and magnificent edifice ... named after her and called the 'St. Anna Asylum'."[4]

The asylum was incorporated in April 1853 and construction began on a three-story stuccoed brick building at Prytania and St. Mary streets in the suburb of Lafayette City, today's Lower Garden District.[5] The builders Little and Middlemiss received the contract, but the designer is not documented. With a projecting Doric temple front raised on heavy piers, and crowned by an observatory, the asylum was the "most handsome building in the

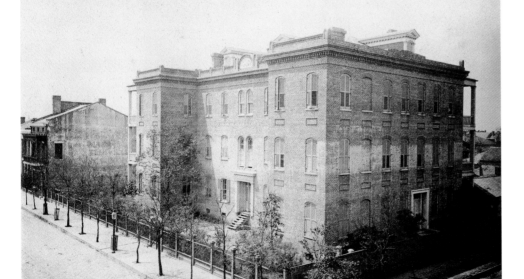

vicinity," according to architect Thomas K. Wharton, and an imposing presence in a district of low-rise row houses and small shops.[6] In material and scale, St. Anna's stood out from its neighbors; its scored plaster walls were designed to resemble stone in a suburb of modest frame buildings. The grounds of the asylum were laid out with "flower-starred gardens, velvety grass and fruit trees."[7]

St. Anna's, like many institutions in New Orleans, faced financial ruin in the postwar economy. Federal military authorities provided aid during the occupation of the city, but in 1867 the asylum had "no income from any source," according to a municipal study, and "42 inmates, mostly old and infirm, unable to work."[8] Always "bountifully supported before the war," it now had few patrons, and, with threat of closure, the asylum appealed for public assistance.[9] St. Anna's found the means to survive, and exists today as a home for the elderly. The building's exterior has remained largely unaltered through various twentieth-century renovations.

Lilienthal photographed the asylum obliquely from an elevated viewpoint at the corner of St. Andrew Street, a perspective that reveals the cubic volume of the building and its relationship to the Prytania Street corridor.

Scenographic choices such as this are ample evidence of Lilienthal's understanding of the scale and ambience of the city and of his craft as a viewmaker.

1. *Act of Incorporation and By-Laws of St. Anna's Asylum, New Orleans, April 29, 1853*, New Orleans (St. Anna's Asylum) 1953, "Preface." I am grateful to Jessie Poesch for providing a transcription of this pamphlet, and reference to the newspaper articles cited in n. 2 below.
2. "Powers' Greek Slave," *Picayune*, November 14, 1848. "The Greek Slave," *Commercial Times*, November 15, 1848.
3. Samuel A. Robertson and William H. Gerdts, "The Greek Slave," *Newark Museum Quarterly*, XVII, nos. 1–2, Winter–Spring 1965, pp. 1–32; Theodore E. Stebbins, *The Lure of Italy: American Artists and the Italian Experience, 1760–1914*, Boston (Museum of Fine Arts, H.N. Abrams) 1992, pp. 339–41. Symbolic of the atrocities of the Greek war for independence from Turkey, Powers's nude was also a thinly veiled reference to slavery in America; see Vivien M. Green, "Hiram Powers's Greek Slave: Emblem of Freedom," *American Art Journal*, Autumn 1982, pp. 32–33. The version of the *Greek Slave* that Powers sold to Robb was originally intended for an English collection. Robb was dissatisfied with the sculpture and sold the work to the Western Art Union in Cincinnati. William Watson Corcoran eventually acquired it; Robertson and Gerdts, *op. cit.*, pp. 15–16. The sculpture was the subject of an acrimonious exchange between Robb and Powers; Green, *op. cit.*, p. 32, n. 4. Another version of Powers's sculpture was exhibited in New Orleans in 1849 "for the benefit of the artist"; "Powers' Greek Slave," *Bee*, February 19, 1849.
4. "Dr. Wm. Newton Mercer," *American Farmer*, I, no. 3, September 1859, p. 68. Lilienthal's photograph is captioned incorrectly; see p. 57, n. 10.
5. Building contract, H.B. Cenas, LVII, no. 953, June 1, 1853, NONA; *Crescent*, March 10, 1860; *Picayune*, July 16, 1861; *Crescent*, July 4, 1866; *Crescent*, December 20, 1866; *Picayune*, February 13, 1867; *Crescent*, March 1, 1867; *Jewell's Crescent City Illustrated*; "St. Anna's Home," *Item-Tribune*, January 9, 1927.
6. Wharton, "Diary," February 3 and 19–20, 1857. Wharton supervised repairs to the building in 1857.
7. *Picayune*, February 1, 1892.
8. *Picayune*, May 21, 1867.
9. *Picayune*, April 17, 1868.

83 *opposite*
Private Residence
Résidence Particuliere

Lilienthal photographed nine private residences for the Paris portfolio, in four districts of the city: Canal Street in the commercial center; the faubourg St. Mary and Tivoli (Lee) Circle area; the Bayou St. John; and several locations in the Fourth, or Garden, District. The most luxurious Garden District residences, such as that of Arthur McGuirk at the corner of Jackson and St. Charles streets (pictured here), reflected the desire to live quietly, far from the congested commercial district, in spacious, airy houses on ample lots amid private gardens. Built for prosperous men of business, including many Anglo-American factors and commission merchants who rose to wealth in the decade before the war, the Garden District mansions were "magnificent," a European traveler observed, "[and] every house, it seemed to me, a palace."[1] The Union chaplain John Chandler Gregg noted that the houses were "set back from the street, with a large yard in front filled with charming flowers and refreshing shade trees. Some of these private residences occupy an entire square, and gave a beautiful variety with their luxuriant gardens, and embowered surroundings, resembling West Philadelphia for splendor and taste."[2]

McGuirk came to New Orleans from New Brunswick, Canada, before the war. Entering the cotton trade, he acquired wealth as a factor in the heady days of the market. The factors were "a class of men peculiar to the South," *New York Herald* correspondent Thomas Knox wrote in 1861.

> Whatever a planter needed, from a quire of paper to a steam-engine, he ordered his factor to purchase and forward In the happy days before the war, the factor's business was highly lucrative. The advances to the planters, before the maturity of the cotton crop, often

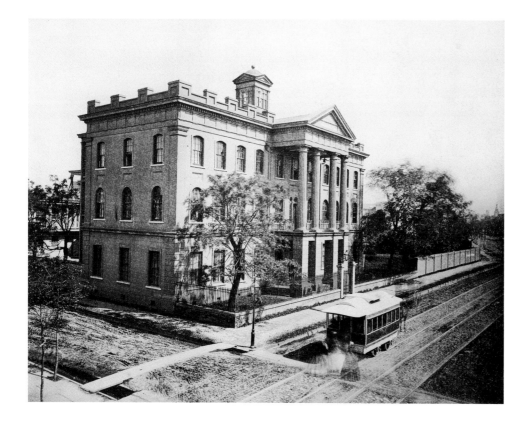

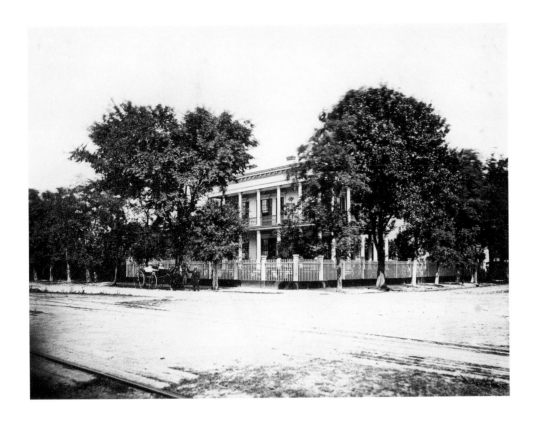

required a heavy capital, but the risk was not great. Nearly every planter was considerably indebted to his factor before his cotton went forward. In many cases the proceeds of the entire crop would but little more than cover the advances which had been made.[3]

In 1864, McGuirk purchased this house, which was built in the early 1850s.[4] After his death, the Harmony Club, an elite men's society, acquired the property, and in 1895 it demolished the residence for a marble-trimmed clubhouse.[5] That structure was in turn destroyed in 1963 for a twelve-story apartment building located there today.[6]

1. Kalikst Wolski, *American Impressions*, Cheshire, Conn. (Cherry Hill Books) 1968, p. 129. Wolski visited New Orleans between 1855 and 1860.
2. John Chandler Gregg, *Life in the Army, in the Departments of Virginia, and the Gulf, Including Observations in New Orleans*, Philadelphia (Perkinpine & Higgins) 1866, p. 133.
3. Thomas W. Knox, *Camp-Fire and Cotton-Field: Southern Adventures in Time of War*, New York (Blelock & Co.) 1865, p. 394–95.
4. Building contract, Hugh Madden, VI, no. 738, April 20, 1864, NONA.
5. Illustrated in *The Picayune Guide to New Orleans*, New Orleans (The Picayune) 1913, p. 95.
6. "Harmony Club's Purchase," *Daily States*, April 5, 1895; *The Israelites of Louisiana*, New Orleans (W.E. Myers) 1904, pp. 60–61; "Luxury Apartment Building to Rise on St. Charles Ave.," *Times–Picayune*, June 20, 1963; *States–Item*, July 13, 1963.

84 *overleaf*
Trinity Church Jackson St
Eglise de la Trinité Rue Jackson

The congregation of Trinity Episcopal Church in the City of Lafayette dated from 1847. By May 1851 the Trinity vestry recognized the need for a new church to replace a small frame chapel that was the congregation's first building, and requested plans from several architects. Without adopting any of the proposals, the vestry instructed the building committee to select a site and to raise a building fund. Two months later, the church purchased seven lots of ground fronting on Jackson Street, the preeminent residential street in the City of Lafayette, at the "bargain" price of $5000.[1]

In late 1851, Trinity's building committee approved plans by George Purves, a Scot who had worked in London with the Cubitt brothers (builders of much of Belgravia and Pimlico) and in New York, before setting up practice in New Orleans in 1847. When he received the commission for Trinity, Purves was already established as one of the city's most successful architects. His work included the Odd Fellows' Hall on Lafayette Square (cat. 50) and the St. Charles Hotel (cat. 64).[2]

Construction of the church began in early

1852. With the foundation complete, in April Purves requested payment to "carry up the walls and enclose the church," but the congregation was unable to meet expenses. A sale of pews and loans advanced by financier James Robb and others enabled work to proceed until the following spring, when funds were again depleted and workers were discharged.[3] The *True Delta* appealed to Trinity's neighbors to contribute liberally to bring the church to completion, "inasmuch as their property will be considerably enhanced in value by its completion." Despite a yellow-fever epidemic in the summer of 1853—the worst of the century in New Orleans—laborers returned to work, and soon the first services were held in the unfinished sanctuary.[4] Construction debts mounted, but in the spring of 1854 the church was structurally complete and ready to be "stuccoed and colored in imitation of brown freestone."[5]

Twin octagonal turrets, crowned by 75-foot (23-m) spires, framed an arcaded porch, and a finial-topped gable rested above a large, pointed arch window of stained glass.[6] Tall lancet windows lit the nave. Along the side walls, which were ornamented with banded brickwork, stepped buttresses rose to finials dressing up the roofline. Purves's design closely resembled Minard Lafever's First Baptist Church in New York (1841–42) and the Franklin Street church of 1844–47 in Baltimore by Robert Cary Long, Jr.[7] These designs, in turn, may have derived from illustrations in such handbooks as Thomas Hope's *An Historical Essay on Architecture* or Augustus Pugin's *Specimens of Gothic Architecture*, both fertile sources for American revival styles.[8]

Purves may have been familiar with Lafever's work in New York and may also have known Long's own writings on the Gothic, in which he wrote that the style was the only true expression of "a holy place" and "all that is good, lovely and reverent."[9] Purves would certainly have agreed with the importance of following the "ancient and established models" found in handbooks, but there were challenges for architects and their clients who sought appropriate Gothic examples for American cities.[10] Archaeologically and liturgically correct sources for Gothic church architecture worldwide were published in the middle of the nineteenth century by the *Ecclesiologist*, a propagator of the Gothic style. However, their

authors (English clerics) found it "not easy for ourselves to forward designs for town-churches to our Transatlantic brethren, because there are no old examples which we can recommend for direct imitation."[11] The American writer Theodore Dwight suggested that there was good reason that appropriate models could not be found for the Gothic in America: "There is not a feature in society here which bears the slightest affinity with it," he wrote in 1834.[12]

From 1855 to 1860, Trinity's rector was Leonidas Polk, who was one of the best-known Episcopal clergymen in the country and the founder, in 1860, of the University of the South.

Polk was a West Point graduate, but resigned his military commission and entered seminary. Following his ordination in 1838, he was appointed missionary bishop of the Southwest, and three years later he became the first bishop of Louisiana. When the war broke out, Polk took a commission as general in the Confederate army and was given command of the defense of the Mississippi River. In the last year of the war, the "Fighting Bishop of the Confederacy" was killed by a cannon shot at Pine Mountain, Georgia.[13]

Polk's successor as rector, John W. Beckwith, confronted a parish "broken in

fortune by the war." Although "the troubles of the times had scattered and impoverished the flock," Beckwith raised enough funds to release the church from debt. Finally, in March 1866, the building could be consecrated.[14] The growth of the congregation after the war brought another campaign to enlarge the church by extending the chancel.[15] Further alterations came in 1873, when architect Charles Hillger remodeled the front, removed the twin turrets, and plastered over the brickwork.[16] Later nineteenth-century additions and a reconstruction following hurricane damage in 1915 removed most of Purves's original structure. The church remains in use today.

The low sun of late afternoon has left an artifact of the photographer at work: the shadow of Lilienthal and his camera is visible at the lower right edge of the photograph. We are left to speculate whether this was an accident he retained in the final print, or a camera-conscious signature of his work.

1. For the building history recounted here, see *Record Book of Trinity Church*, 1851–1866, and *Minute Book*, Trinity Church Records, Manuscripts Collection, Tulane University Library.
2. Purves's later projects included Carondelet Street Methodist Church (cat. 55) and Lane Cotton Mill (cat. 100).
3. "Trinity Church," *True Delta*, May 29, 1853.
4. J.S. McFarlane, *A Review of the Yellow Fever*, New Orleans 1853.
5. *Picayune*, March 21, 1854; Building contract, Richard Brennan, V, no. 150, May 25, 1854, NONA.
6. The spires are recorded in a photograph, c. 1858–59, by Jay Dearborn Edwards of the vicinity of Camp and Forth streets (Southeastern Architectural Archive, Tulane University), and in a sketch by Thomas K. Wharton (Wharton, "Diary"). The towers became unstable and were removed in 1860 (*Record Book of Trinity Church, op. cit.*, 1860).
7. Wilbur H. Hunter, Jr., "Robert Cary Long, Jr., and the Battle of Styles," *Journal of the Society of Architectural Historians*, XVI, no. 1, March 1957, pp. 28–30; Phoebe Stanton, *The Gothic Revival & American Church Architecture: An Episode in Taste 1840–1856*, Baltimore (Johns Hopkins University Press) 1997, pp. 240–43; Mary Ellen Hayward and Frank R. Shivers, eds., *The Architecture of Baltimore: An Illustrated History*, Baltimore (Johns Hopkins University Press) 2004, pp. 113–14.
8. Thomas Hope, *An Historical Essay on Architecture*, London (John Murray) 1835–36; Augustus Pugin, *Specimens of Gothic Architecture*, London (Taylor) 1821; Hunter, *op. cit.*, p. 30, and Stanton, *op. cit.*, p. 241, identified Hope and Pugin as sources for Long's façade.
9. "Architectonics. No. 1. Gothic Church Architecture," *Literary World*, III, November 18, 1848, p. 833, cited by Stanton, *op. cit.*, p. 244, n. 39.
10. "The Fine Arts. Church Architecture," *Literary World*, III, October 14, 1848, p. 733, cited by Stanton, *op. cit.*, p. 243, n. 35.
11. *Ecclesiologist*, VIII, 1847, p. 70. Historian Michael Lewis has written that the *Ecclesiologist*'s forty years of articles on

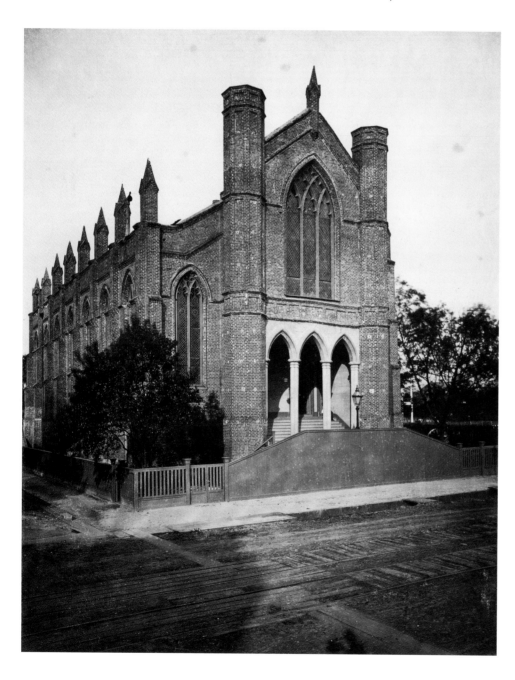

church design "forms the most sustained corpus of intelligent and savage architectural criticism in English literature"; Michael Lewis, *The Gothic Revival*, New York (Thames & Hudson) 2002, p. 92.

12. Theodore Dwight, *Things as They Are*, New York (Harper) 1834, cited by Jacob Landy, *The Architecture of Minard Lafever*, New York (Columbia University Press) 1970, p. 55.

13. *Biographical Register,* II, p. 391; *Dictionary of American Biography*, New York (Scribner's) 1935, XV, pp. 39–40; Richard L. Current, ed., *Encyclopedia of the Confederacy*, New York (Simon & Schuster) 1993, pp. 1227–28.

14. "Consecration of Trinity Church," *Times*, March 18, 1866; "Report of Rector John W. Beckwith to the State Convention, 1865," in *Trinity Church: One Hundred Years in New Orleans* (Trinity Church) 1948, p. 20.

15. *Record Book of Trinity Church, op. cit.*, July 13–14, 1866.

16. George W. Shinn, *King's Handbook of Notable Episcopal Churches in the United States*, Boston (Moses King) 1889, pp. 74–75 (noting Trinity's exceptional acoustics). Hillger's design, not Purves's, is discussed in Stanton, *op. cit.*, p. 221.

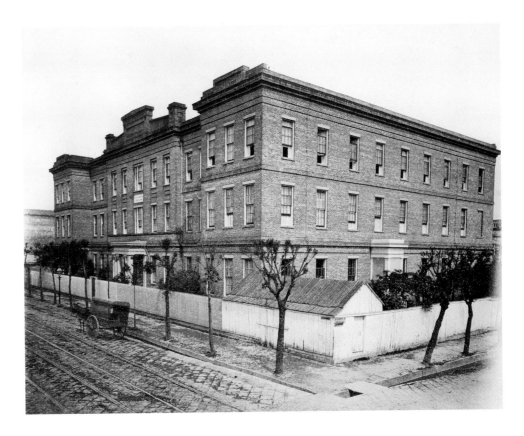

85
St Elizabeth Asylum Cor. Magazine & Josephine Sts.

Asile Ste. Elizabeth Rues Magazine et Josephine

The St. Elizabeth Asylum and House of Industry is one of five asylums photographed by Lilienthal for the Exposition portfolio. Vanished from the modern city, asylums were prevalent in nineteenth-century New Orleans, where frequent yellow-fever epidemics tore families apart and left many women and children homeless. The many charitable homes established in the wake of these epidemics made New Orleans, according to one historian, "one of the most institutionalized cities in the country in the care of dependent and neglected children."[1]

The Sisters of Charity of St. Vincent De Paul founded St. Elizabeth's Asylum for young women at Magazine and Josephine streets in 1855. Architect Henry Howard provided plans for a three-story brick building with two projecting wings, and the sisters found their principal donor in Dr. William Mercer, who had also supported St. Anna's Asylum (cat. 82).[2] In October 1856, according to the *Crescent*, St. Elizabeth's was "finished in the rough and occupied. The rooms are being plastered, and otherwise fitted up, at a slow rate. The building is large, well ventilated, and massive enough to stand through all time."[3] A year later, the asylum was still unfinished but housed eighty-three orphans, aged between ten and sixteen years. A legislative oversight committee applauded the work of the sisters: "Formerly,

these orphans were obliged to leave the Asylum at the age of twelve and fourteen years—the very period [when] they needed the most protection—and they were thus exposed to the most alarming dangers. This institution is designed to prevent such a necessity."[4]

According to its charter, St. Elizabeth's was established as a "house of industry" to train young women in the "useful employments of womanhood."[5] The Sisters of Charity were pioneers in the vocational training of women, and St. Elizabeth's was one of the earliest trade schools in the South. The author Anna Jameson, who campaigned for recognition of "the woman's privilege to share in the communion of labor at her own free choice," admired the work of the sisters and their efforts across the country to establish similar institutions, "which shall train [a woman] to do her work well."[6]

In 1867, after twelve years at St. Elizabeth's, the sisters, now with 140 residents under their care, began a search for a larger building.[7] Three years later, the asylum moved to another property belonging to the sisters, St. Joseph Academy on Napoleon Avenue, renaming it St. Elizabeth's (the building exists today as a private residence).[8] In 1874, the building in Lilienthal's view was demolished and replaced by a row of commercial buildings that still stand on Magazine Street.

1. Elizabeth Wisner, "The Howard Association of New Orleans," *Social Service Review*, XLI, no. 4, 1967, p. 417.

2. St. Elizabeth's was named after a Mercer daughter's name saint.

3. "City Improvements," *Crescent*, October 21, 1856.

4. "Report of the Committee on Charitable Institutions," in *Documents of the Second Session of the Third Legislature of the State of Louisiana, 1857*, New Orleans (John Claiborne) 1857, pp. 14–15.

5. Archdiocese of New Orleans, *Daughters of Charity, Board Minutes*, March 26, 1855; *Picayune*, April 24, 1862.

6. Anna Jameson, *Sisters of Charity, Catholic and Protestant and the Communion of Labor*, Boston (Ticknor & Fields) 1857, pp. 8, 32.

7. *Crescent*, March 1, 1867.

8. *Daughters of Charity, Board Minutes, op. cit.*, March 28, 1870.

St. Alphonse's Church

The Congregation of the Most Holy Redeemer, known as the Redemptorists, built three churches in New Orleans—all in the lower quarter of the old City of Lafayette, an area now known as the Irish Channel. The Redemptorists were a missionary order founded in Naples in the eighteenth century, and active in North America by 1832. In New Orleans, where they arrived around 1847, the order was dedicated to relief of the Irish and German poor and was enormously successful among the growing immigrant community of Lafayette City.[1]

Within a decade, an ambitious building campaign had begun, first with St. Alphonsus (named after the founder, Alphonsus Liguori), built in 1855–57 to serve the Irish and other English-speaking parishioners.[2] In the late 1850s, the Redemptorists also built St. Mary's Assumption (cat. 87), opposite St. Alphonsus, to serve the German community, and Notre Dame de Bon Secours on Jackson Street for their French-speaking parishioners. Three new churches built within three blocks of each other during the same decade transformed the district, and asserted the size and prominence of these immigrant communities in the commercial and social life of New Orleans at mid-century.

The Redemptorists hired the architect Louis L. Long of Baltimore to design St. Alphonsus. Prior to the war, Long had a brief but active career as a designer of ecclesiastical buildings, among them a project for the Baltimore Redemptorists.[3] In 1853, Long and his partner, Henry H. Pittar, designed the Jesuit Church of St. Ignatius in Baltimore, Long's most important commission.[4] He prepared designs for St. Alphonsus (with similarities to the earlier Jesuit church) under the direction of Thomas Luette, a Redemptorist brother who had been sent from Baltimore. Foundation work began in April 1855.[5] The cornerstone was laid in June, but construction was slow and the church was not opened for services until August 1857: "We had been engaged on the building over two years," a Redemptorist annalist wrote, "and it had now approached so far toward completion that the holy sacrifice of the mass could be offered up in it with all the proper respect and decorum."[6] The

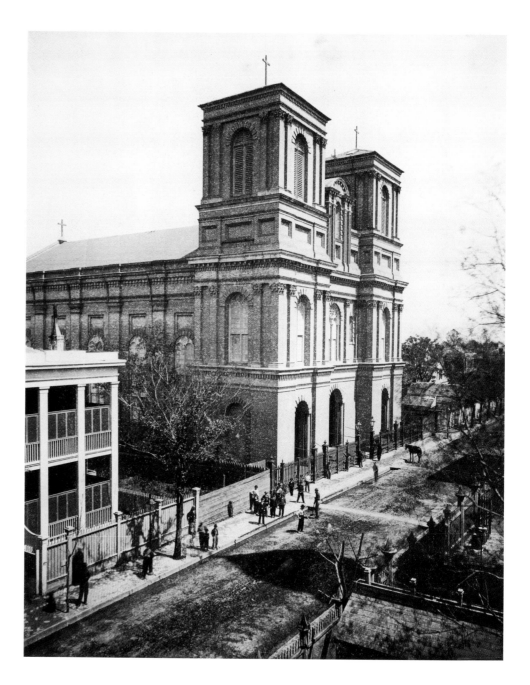

congregation, led by the Archbishop, joined in a procession from the old church on St. Andrew Street "to the splendid new building, which was surrounded by an immense concourse of people assembled to witness the ceremonies."[7] In September, St. Alphonsus was "lit up with gas for the first time," and in April 1858 the church was consecrated in a six-hour ceremony.[8]

Architect Thomas K. Wharton praised the "very superior" workmanship of the "best lake brick" at St. Alphonsus—as at St. Mary's, the brickwork was of a quality unusual at this time in New Orleans.[9] Local, soft brick was often plastered to insulate it from the weather, but

the discovery of good clays along the shores of Lake Pontchartrain and the Gulf of Mexico made production of hard brick feasible. Skilled German masons working in New Orleans from mid-century introduced new decorative brick forms that demonstrated the potential of the local brick—most successfully at the new Redemptorist churches.[10]

St. Alphonsus's square towers, decorated with inset panels, Corinthian pilasters, and round-arched bifora windows with glazed *oculi*, in a quattrocento manner, were to carry ornate spires, but the plan was never carried out.[11] Although Wharton approved of Long's design

("solid, massive and finely proportioned"), the towers were ponderous and the façade was an awkward composite of cubic forms that succeeded, above all, in being overscaled in the street.[12] Based on a vocabulary of Lombard brick architecture, St. Alphonsus also had elements of German Romanesque and the round-arched *Rundbogenstil* of the 1830s and 1840s—features that Long may have derived from contemporary handbooks.[13]

The 154 × 72-foot (47 × 22-m) nave, one of the largest in the city, remained undecorated until after the war. When most churches were struggling to reunify their congregations, replenish their treasuries, and finance repairs to buildings neglected during the war, the Redemptorists undertook an ambitious campaign to finish the interior. "St. Alphonsus ... is in the process of being made into one of the most magnificent temples of religion ... in the city," the *Times* announced in September 1866. Reportedly "the only church in the city clear of debt," St. Alphonsus was able to finance a sumptuous decorative program in the style of the German Rococo, "brilliantly pictured" by Dominique Canova, the nephew of the sculptor Antonio Canova.[14]

In the middle decades of the twentieth century, the Redemptorists' formerly Anglo-Irish constituency was transformed by suburban exodus and by an extensive federal housing project—built in 1937 and enlarged in 1952—covering 49 acres (19.8 ha) between St. Alphonsus and the river. The church has since been deconsecrated and reclaimed as an Irish heritage and community center.

Lilienthal's rooftop perspective is from a building attached to neighboring St. Mary's. In the lower left-hand corner of the photograph is the parish school of St. Alphonsus, which in 1867 was said to be the "finest schoolhouse in the city."[15] The 142-foot (43-m) spire of St. Mary's casts a long shadow across Constance Street.

1. B.J. Krieger, *Seventy-Five Years of Service*, New Orleans (Redemptorist Fathers) 1923.
2. "The Church: Order of the Redemptorists," *Times*, September 9, 1866.
3. Although almost nothing is known about Louis L. Long's life, more than two dozen projects, completed between 1855 and 1860, have been attributed to Long by the Baltimore Architecture Foundation's Historic Architects Roundtable, including sixteen projects for religious institutions. One project, a town house on Monument Street, Baltimore, is cited by Mary Ellen Hayward and Charles Belfoure, *The Baltimore Rowhouse*, New York (Princeton Architectural Press) 2001, p. 64 and

fig. 40, and in *The Architecture of Baltimore: An Illustrated History*, ed. Mary Ellen Hayward and Frank R. Shivers, Jr., Baltimore (Johns Hopkins University Press) 2004, p. 129. For the Redemptorists at Baltimore's St. Alphonsus, Long reportedly added the tower to Robert Cary Long, Jr.'s masterpiece of 1842–44; *Baltimore Sun*, October 15, 1855, cited in the archive of the Baltimore Historic Architects Roundtable.
4. *Metropolitan*, I, 1853, pp. 542–43.
5. A resemblance between the Baltimore church and St. Alphonsus was noted by Samuel Wilson, Jr., who suggested that a Redemptorist from New Orleans may have seen Long's plans when visiting Baltimore. The Baltimore church has a pedimented façade of very different design and no towers, but does bear some resemblance to St. Alphonsus in its interior arrangement and in side elevation. See Samuel Wilson, Jr., *The Church of St. Alphonsus*, New Orleans (Friends of St. Alphonsus) 1996, pp. 5–7.
6. *Annals of St. Alphonsus Parish* [ms.], Office of Provincial Records, Redemptorists, Denver Province, fols. 21, 24.
7. *Ibid.*, fol. 25.
8. *Ibid.*, fol. 30.
9. Wharton, "Diary," July 26, 1855, cited by Wilson, *op. cit.*, p. 7.
10. The distinctive brickwork of these churches was first noted by Griswold's *Guide* in 1873, p. 44, and taken up later by Nathaniel Curtis, *New Orleans: Its Old Houses, Shops and Public Buildings*, Philadelphia (J.B. Lippincott) 1933, pp. 238–40, and, much later, by Betsy Swanson, "Brick Churches in the Lower Garden District," *New Orleans Architecture*, I, pp. 59–61.
11. The side elevation of the church, signed by Long, recording one of the spires, survives in the Redemptorist archives, reproduced in Wilson, *op. cit.*, p. 6. A lithograph of 1882 by Thomas Fitzwilliam, illustrated by Wilson, *op. cit.*, pp. 31–32, shows the towers completed as designed by Long. A later guidebook publishes an altered photograph of the

church with different projected towers; see *The Creole Tourist's Guide and Sketch Book to the City of New Orleans*, New Orleans (Creole Publishing Co.) 1910–11, p. 55.
12. The appearance of the church was not improved by the addition of an entry porch in the late nineteenth century and by the loss of Corinthian capitals across the façade.
13. Thomas Hope, *An Historical Essay on Architecture*, London (John Murray) 1835, or William Whewell, *Architectural Notes on German Churches, with Remarks on the Origin of Gothic Architecture*, Cambridge, London (J. Smith for J. & J.J. Deighton) 1830, are popular examples.
14. "St. Alphonsus School," *Crescent*, July 28, 1867.
15. On Canova, see *Encyclopaedia of New Orleans Artists: 1718–1918*, New Orleans (The Historic New Orleans Collection) 1987, pp. 65–66; "Order of the Redemptorists," *Times*, September 9, 1866; "Interior of St. Alphonsus Church," *Times*, November 20, 1866, cited by Wilson, *op. cit.*, pp. 15–17.

87
St. Joseph's Church Josephine St.
Eglise St. Joseph Rue Josephine

Lilienthal's photograph, misidentified, is a view of the Redemptorist Church of St. Mary's Assumption, built in 1858–60 at Josephine and Constance streets.[1] The cornerstone ceremony for the church, which served the oldest German Catholic congregation in New Orleans, was laid on the same day in April 1858 as the consecration of nearby St. Alphonsus (cat. 86),

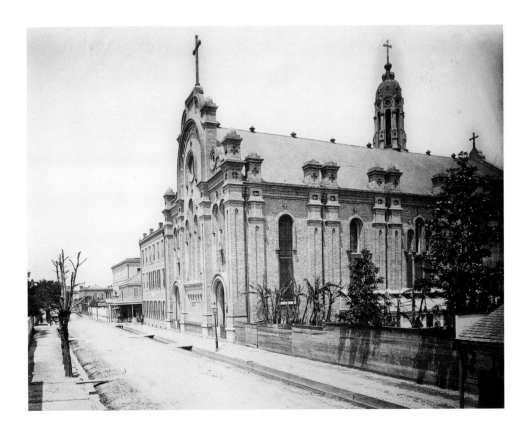

which was also a Redemptorist foundation.[2] The architect of St. Mary's is unknown, but may have been the young German émigré Albert Diettel.[3] The church was distinguished by a 142-foot (43-m) octagonal tower crowned by gilded segmental domes and by exterior walls of highly rhythmic brick patterns.

After the war, the pastor at St. Mary's was Francis Xavier Seelos, a German Redemptorist priest whose sermons, given in German, attracted large audiences. Seelos died serving yellow-fever victims in the epidemic of 1867. In the early 1870s, St. Mary's was finished with a high altar sent from Munich and a nave decoration in the style of the Bavarian Baroque. According to a local guidebook, it came "nearer to grandeur" than any other church interior in New Orleans.[4]

Although at the end of the nineteenth century the German-born population of New Orleans was less than half what it had been in 1860, the Redemptorists at St. Mary's continued to offer sermons in the German language until the United States entered World War I.[5] Extensively restored after hurricane damage in 1965, the church remains in use today.

1. Lilienthal's caption, which misidentifies the church, may refer to St. Joseph's German Asylum and Cemetery, which the Redemptorists of St. Mary's supervised.
2. *Annals of St. Alphonsus Parish*, Office of Provincial Records, Redemptorists, Denver Province, fol. 30.
3. On this attribution, see Hilary S. Irvin, "The Impact of German Immigration on New Orleans Architecture," *Louisiana History*, XXVII, no. 4, Fall 1986, p. 397.
4. Griswold's *Guide*, p. 44.
5. William Robinson Konrad, "The Diminishing Influences of German Culture in New Orleans Life Since 1865," *Louisiana Historical Quarterly*, XXIV, 1941, pp. 130, 138.

88
Synagogue Jackson St.
Cinagogue Rue Jackson

The Gates of Prayers congregation completed its new synagogue at Jackson and Chippewa streets in March 1867, just in time for Lilienthal to include the building in the Exposition portfolio.[1] The Orthodox congregation, who were mostly of German origin, had been organized in 1850, primarily for the welfare of victims of yellow fever, and acquired the site in Jefferson City in 1859. German-born architect William Thiel provided the design, but the war delayed the start of construction until 1865.[2]

Set back generously from the street, the façade was composed of two pairs of tall Doric pilasters, supporting a split entablature, and a broken pediment flanked by giant scrolls. Blind niches accented the wall between the pilasters. The synagogue was enclosed by a brick wall and an iron fence (complementing the iron stair rails). The ornate fence and the "plain but bold" façade, and the brick and iron used in construction, appear imposing in a block of modest frame houses.[3] In Lilienthal's framing, views into the domestic backlots, with their wooden sheds and picket fences, establish the hegemony of the synagogue.

Lilienthal's slightly off-axis framing of the building enhances the perception of volume and mass. The field of view is wide and deep enough to contextualize the building and record two artifacts of the city's networks of gaslights and street railways.

The Gates of Prayers congregation vacated the synagogue in 1920. Later occupants included a marine supply company, a judo school, a securities firm, and a tire shop.[4] About 1970 the property sold for $32,000, several thousand dollars less than its construction cost a century before. The building—the oldest synagogue structure in New Orleans—survives today, unoccupied and in blighted condition.

1. On the history of the congregation, now known as Gates of Prayer, with a synagogue in Metairie, Louisiana, see *Picayune*, January 26, 1865; *Times*, January 26, 1865; *Times*, June 23, 1865; *Crescent*, December 5, 1866; *Crescent*,

March 26, 1867; Nathaniel Share, "Gates of Prayer's First Century," *Centennial Volume, Congregation Gates of Prayer, January 13–15, 1950*, New Orleans 1950.

2. The foundation is reported in the *Picayune*, June 16, 1865; on consecration, see *Times*, April 5, 1867; *Crescent*, April 6, 1867; *Picayune*, April 6, 1867; *Occident*, xxv, no. 2, May 1867, p. 96.

3. "The Remaining Jewish Temple," *Times*, October 16, 1866.

4. "History or Nuisance," *Times-Picayune*, October 15, 1990.

89
Jewish Widows' & Orphans' Asylum
Asile des Vves et Orphelins Juifs

The Hebrew Benevolent Association established the Widows' and Orphans' Asylum to care for victims of New Orleans's desolating yellow-fever epidemic of 1853.[1] The cornerstone of the association's new building at Jackson and Chippewa streets was laid in August 1855, as another epidemic struck the city. It was reported to be a "heavy task" for the association to complete the building while caring for the victims of the latest outbreak, which, like previous epidemics, took a large toll among the immigrants of the Jewish community. "New Orleans is a great rendezvous of European immigrants, who, not having the means to remove, are compelled to remain in the place where they arrive," the Jewish monthly the *Occident* observed. "There now perish annually a large number of victims from the fever, and their helpless families are thrown upon the charities of the benevolent of New Orleans."[2]

The new asylum was dedicated in January 1856.[3] Designed by Will Freret, the building was described as "somewhat ornamental, but still entirely in keeping with the purpose proposed by the association, who have preferred expending the funds for the better accommodation of inmates, to exterior display."[4] The building's plan was subordinated to the need for fresh air to be circulated

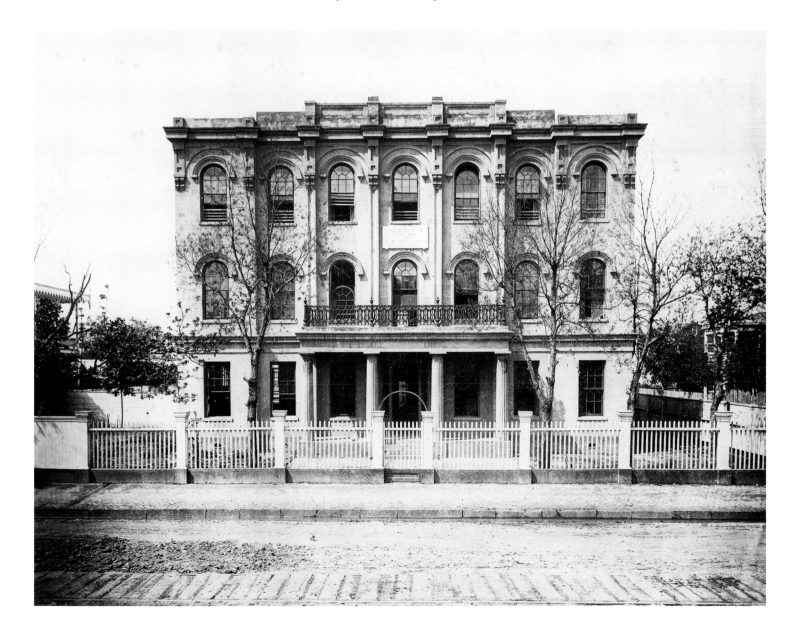

throughout the wards, in an expression of the ventilation mania of the period and the belief that fouled air was the basis of disease:

> it being the desire of the Committee to obtain a Building that would be as well ventilated as possible, great care was taken to make the Windows of a size considerably larger, than those generally used, and at the same time so placed as to allow of a thorough and free current of air. The passages are also wide, and intersect each other, thereby adding materially to the ventilation.[5]

During the first year of operation, the asylum provided for "six helpless widows" and thirty-two orphans.[6] Ten years later, at the time of Lilienthal's photograph, the "substantial, comfortable and airy" asylum housed fifty-two residents with "no sickness whatever."[7] An addition by Henry Howard in 1869 enlarged the building, which remained in use for another two decades. In 1887, Thomas Sully designed a new building for the association, in a French Renaissance style, at St. Charles and Jefferson streets, the site today of a Jewish community center.[8] The Jackson Street building was used as a public high school from 1885 until 1907, and later as a warehouse, until its demolition about 1960.

Lilienthal's typical approach to building views was an oblique perspective, as in the photograph of the synagogue on Jackson Street (cat. 88) or the view of St. Anna's Asylum (cat. 82), both of which reveal the mass and volume of the building and its scale by positioning it within the context of streets and neighboring structures. Here Lilienthal used a head-on, frontal approach in framing, similar to an architectural elevation or an advertising logograph. The result is a flattened image in which the building front, trees, and fence appear to be in the same plane. A successful elevation view such as this required precision in order to avoid perspective distortion from converging lines of the façade. Lilienthal positioned his camera so that it was centered directly on the building front, and obtained an absolute vertical position of the ground glass, probably with the aid of a plumb line, to achieve correct perpendiculars.

The photographic press of the period often warned practitioners against adopting this kind of frontal view. In selecting a vantage point for architectural subjects, the *Photographic Times* advised against placing the camera in

a position directly in front of the object you propose having as the main feature of your picture. Suppose there is a house in the country which you wish to photograph; fancy how badly your picture of it would look if you placed the camera exactly in front, so that no portion of it could be seen but the front; it would resemble an architect's drawing of the elevation, and would like such be lacking in perspective. Always, in such a case, choose a position to the one side or other ... by this means the piazza, the mouldings and trimmings, and all projecting points, will have relief, and not appear flat upon the face of the building.[9]

In fact, Lilienthal achieved a compelling picture by adopting the frontal view, which focuses our gaze on the pleasing rhythms of Freret's design.[10]

1. *Bee*, November 26, 1854; *Occident*, XII, no. 10, January 1855, pp. 527–29, XIII, no. 5, August 1855, p. 311, XV, no. 4, July 1857, pp. 190–95; *Picayune*, August 8 and 12, 1855; *Crescent*, October 21, 1856; Joseph Magner, *The Story of the Jewish Orphan's Home of New Orleans*, New Orleans (n.p.) 1905; Louisiana Historical Records Survey, *Inventory of the Church and Synagogue Archives of Louisiana*, Baton Rouge (Louisiana State University, Department of Archives) 1941, p. 92.
2. *Occident*, XIII, no. 7, October 1855, p. 370.
3. *Bee*, January 9, 1856; *Occident*, XIII, no. 11, February 1856, p. 560.
4. "Report of the Committee on Charitable Institutions," in *Documents of the Second Session of the Third Legislature of the State of Louisiana, 1857*, New Orleans (John Claiborne) 1857, p. 13.
5. *The Dedication of the Home for Jewish Widows and Orphans of New Orleans, January 8, 1856*, New Orleans (Sherman, Wharton & Co. Printers) 1856.
6. "Anniversary Celebration," *Picayune*, January 9, 1857.
7. *Crescent*, March 1, 1867; "Jewish Charities," *Picayune*, May 20, 1867.
8. Sully's drawings for the second Widows' and Orphans' Home (demolished in phases in the 1950s and 1960s) are in the Southeastern Architectural Archive, Tulane University. The community center, designed by Curtis and Davis, replaced the Sully building in 1965–66.
9. Charles Wager Hull, "Photography for the uninitiated, Letter No. IV," *Photographic Times*, I, 1871, pp. 132–35.
10. For a discussion of elevation and perspective views in architectural photography, see Cervin Robinson and Joel Herschman, *Architecture Transformed: A History of the Photography of Buildings from 1839 to the Present*, Cambridge, Mass. (MIT Press) 1988, pp. 4–18.

90
Groupe of N. O. Firemen
Groupe de Pompiers

This group portrait of Jefferson Steam Engine Company No. 22 and the portrait of the Chalmette Fire Company No. 23 (cat. 91) are documented in newspaper accounts prior to the Paris Exposition commission.[1] On November 18, 1866, during a reunion event in City Park, Lilienthal assembled these and three other fire companies and "daguerreotyped" them. "A separate picture was taken of each company," the *Crescent* reported; "together they present the faces of nearly a thousand active and exempt members of the fire department. The weather was favorable and the impressions taken were said to be very distinct."[2] The portrait-taking concluded with a clamorous procession through the streets of the city.

Jefferson No. 22, organized in 1845, was stationed at Tchoupitoulas Street, near Sorapuru Market. It was a volunteer company, as were all the city's fire brigades until 1891, when a salaried fire department was created. Volunteer firemen faced terrible hazards, often with inadequate and outdated equipment. Although unpaid, firemen found recompense in fraternity and in community esteem. Volunteers were excused from jury and militia duty, and their families benefited from company burial pensions. Community sponsors and company members, often men of wealth and position, financed the brigades and insurance companies supplied equipment in return for vigilance over insured properties.

While protecting life and property from fire, the fire companies also reinforced police actions; some were implicated in the Mechanics' Institute riot of July 1866 (cat. 68), and in other segregationist or anti-Republican rallies.[3] The *Tribune* claimed ex-Confederates evaded a government prohibition against rebel organizations by joining the ranks of firemen after the war. The Confederate fraternity transformed the fire companies, according to the *Tribune*, into "the last remnant of the rebel army, hostile to liberty, provided with arms and ready for mischief."[4]

Assembled around the company standard (a gonfalon), Jefferson No. 22 exhibits a military sense of polish and deportment. Several of the volunteers, veterans of ten or more years of service, wear uniforms bearing the insignia of the honorary Jefferson X Society. The children—one clasping hands with two adult

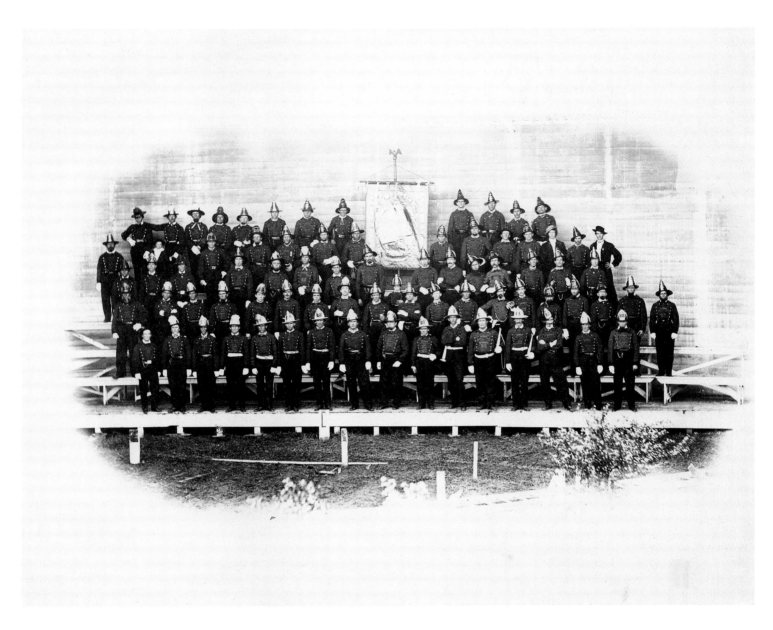

firemen (upper left), the other, apparently older, posing below the standard—are company mascots, possibly orphans supported by the brigade after rescue from fires.

1. "Fire Companies Daguerreotyped," *Crescent*, November 19, 1866; "Photographing the Firemen," *Times*, November 19, 1866; "Picture Taking," *Picayune*, November 19, 1866.
2. "Fire Companies Daguerreotyped," *op. cit*.
3. *History of the Fire Department of New Orleans*, ed. Thomas O'Connor, New Orleans (New Orleans Fire Department) 1895, p. 138; *Times*, February 19, 1867.
4. "The Firemen," *Tribune*, VI, no. 838, 1867.

91 *overleaf*
Groupe of N. O. Firemen
Groupe de Pompiers

Chalmette Fire Company No. 23 was located on Washington Street (Avenue), between Camp and Magazine streets, now the site of the New Orleans Fire Department Museum. This company was neither as large nor as financially secure as Jefferson No. 22, as is reflected in the informality of the group portrait. The company is seated, casually posed, without a standard or other regalia, but proudly displaying its horse-drawn J. Smith steam engine. Firemen pictured in civilian dress may be "exempt": injured or retired from duty and pensioned by the firemen's welfare association. The helmet

placed on the front riser is a tribute to a deceased member of the company, probably a volunteer recently killed in the line of duty.

Lilienthal "vignetted" his fire brigade negatives by burning out their edges, an effect that was popular in portrait photography of the 1860s. The technique enabled him to eliminate distracting foreground and background details.

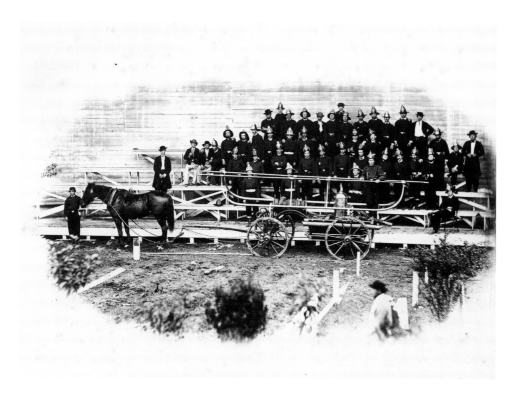

antebellum visitor observed. "... The yellow fever, the plague that returns annually, snatches up thousands and thousands, but more rush in and fill the deceased's places, for a while in life, then perhaps in their very same graves."[2]

In 1865, the *Times* described Lafayette No. 1 as "one of the most beautiful cemeteries" in the "City." The most superb exhibitions of sepulchral architecture to be found anywhere are seen here."[3] Gravesites were often elegant exhibitions, particularly on All Saints' Day, which was widely observed in New Orleans, especially in the Creole community. On November 1—not on November 2, "All Souls' Day," as was customary in other cities —freshly whitewashed tombs were "beautifully ornamented with wreaths of cypress and garlands of flowers."[4] Families reshelled plots, installed small altars, and attended the burial sites, sitting by on cast-iron benches to receive friends.

In the era before the development of City Park (cats. 40 and 41), the cemeteries in New Orleans were tranquil, park-like settings that were popular for family gatherings, not only those associated with rituals of bereavement and memorial. The solemnity and devotional symbolism of the cemeteries appealed to the sentiment of the period (many tombs were architecturally significant structures) and cemetery grounds were often the most attractive green spaces in the city. In 1867, the

92 *right*
Entrance to Lafayette Cemetery Washington Street
Entrence du Cimetiere Rue Washington

In 1833, the City of Lafayette established a municipal burial ground at Washington and Prytania streets, known as Lafayette Cemetery No. 1. Lilienthal's view is of the main entrance and central walkway off Washington Street looking toward Sixth Street, where a house and cistern are visible beyond the cemetery gate. Lafayette Cemetery was planned by Benjamin Buisson, a military surveyor trained under Napoléon. He laid out two wide, intersecting shell walks and a perimeter walk. Stately sepulchers, some enclosed by ornamental iron fences, lined these pedestrian streets, which were shaded by magnolia trees. Orderly rows of tombs filled interior plots.

Individual vaults, or "ovens," as they were called, were built in tiers lining the inner face of the cemetery's boundary walls. These less costly memorials, which could be cleaned of remains and reused, met a pressing need for burial space in the suburban community, where many German and Irish immigrants had settled before the war. Unacclimated to New Orleans, and living in densely populated riverfront districts where epidemics spread mercilessly, immigrants were "the principal victims of the

yellow fever," the physician Bennet Dowler noted in 1852. The foreign-born victims were typically poor and young; Dowler discovered that among the ages recorded on the vaults at Lafayette, none was older than 39.[1] "Everyone here—everyone—died in the prime of life," one

Republican observed that the city cemeteries were pleasant, quiet, and secluded retreats where "the grass is bright and green, the trees cast a grateful shade over the walks, the marble tombs gleam amid the foliage."[5] Some visitors, however, were overcome with melancholy, and found the sight of a cemetery less than agreeable: "The damp swamp of the unwholesome looking ground, the low, flat, gloomy inclosure, with its cold and sombre houses of death, and the carelessness and neglect visible ... made it a very mournful spectacle," one antebellum traveler observed.[6]

1. Bennet Dowler, "The Graveyards and Cemeteries of New-Orleans," *De Bow's Review*, XIII, no. 3, September 1852, pp. 310–13.
2. Friedrich Gerstäcker, *Gerstäcker's Louisiana: Fiction and Travel Sketches from Antebellum Times Through Reconstruction*, trans. and ed. Irene S. Di Maio, Baton Rouge (Louisiana State University Press) 2006, p. 61.
3. "All Saints' Day," *Times*, November 2, 1865.
4. "All Saints Day in New Orleans," *Niles Weekly Register*, LI, November 19, 1836, p. 182.
5. *Republican*, July 25, 1867.
6. Lady Emmeline Stuart Wortley, *Travels in the United States, etc., during 1849 and 1850*, New York (Harper & Brothers) 1851, p. 126.

93 *overleaf*
Depot of St Charles St. R. Road
Depot du chemin ferré Rue St. Charles

The St. Charles Street Railroad, organized during the war, began operation in 1866.[1] Mule- or horse-drawn cars ran on a 5-mile (8-km) route from St. Charles and Canal streets to the depot at the corner of Carondelet and Eighth streets, where the railroad's stables, car sheds, and shops for blacksmiths, carpenters, and harness-makers were located.[2]

In Lilienthal's deep perspective down the Carondelet Street corridor, a horseless car stands idle on the tracks outside the railroad's galleried, house-style terminal building. The coach is painted with a star, which identified cars open to black riders; those that were unmarked were reserved for whites. "Ever since the establishment of city railroads," the *Crescent* wrote in 1867, "... every third or fourth car has been a 'star car.' Stars were meant to designate such vehicles as the colored population were entitled to ride in. The slave had a right to a seat, with his or her market basket, his or her pickaninny, or his or her personal effects."[3] During the social upheaval

that followed the war, when, as historian Eric Foner has written, "a national principle of equality before the law" was defended for the first time, New Orleans was in the grip of a turbulent challenge to racial discrimination on streetcars, which would bring an end to the "star car" system.[4] The streetcar protest was one episode of many during Reconstruction that gave African Americans a role in public affairs," at a moment when the "old white elite was stripped of its accustomed political power."[5] As one New Orleans Creole observed: "There were many uproars and riots all over the city in those days of readjustment."[6]

In April 1867, a black man named William Nichols boarded a Canal Street car that did not display a painted star. When ordered off the car by the driver, Nichols refused and was arrested by police.[7] This was not the first incidence of public defiance of the star-car rule. Six months earlier a black federal soldier who boarded a white car drew a revolver when he was ordered off.[8] Following this event, the segregation rule was tightened up with respect to all passengers, both black and white (previously, whites had been permitted to board star cars as well as unmarked coaches). "The justice of the star system must be apparent," the *Times* wrote in 1866; "it is but fair that the star cars should be exclusively given up to the colored people, who are now, it is a fixed fact, a part of our population."[9]

At a police hearing, hundreds of blacks rallied to support Nichols against a "breach of the peace" charge, to which he responded with an affidavit of assault against the railroad for ejecting him—his sole intention, he later claimed, was to test the legality of the segregation rule.[10] Protests intensified in the days following the hearing. Blacks boarded and even seized possession of white cars and whites formed armed bands to enforce segregation, putting the city on the brink of widespread racial violence.[11] When 500 blacks gathered in Congo Square, the heart of the city's African American community, Mayor Edward Heath appealed to the protesters to disperse. He reminded the crowd of the "terrible results which grew out of the riot of the 30th of July"—the notorious melee at the Mechanics' Institute nine months earlier, when blacks had been massacred by rioting whites (cat. 68).[12] The mayor and railroad executives then approached General Philip Sheridan to request that troops be brought in to enforce order. "The

vexed question in the city at this moment is: have the colored population a right to ride indiscriminately in the street cars, whether those cars have the distinguishing star on them or not?" the *Crescent* wrote on May 5.[13] Two days later the *Picayune* warned: "The matter of the colored people riding in the city cars has begun to assume a serious phase."[14]

The federal military had issued orders at the end of the war forbidding "regulations that discriminate against negroes by reason of color, or their former condition of slavery." Sheridan, whose black troops were caught up in the protest, finally intervened, and on May 7, 1867, railroad owners abolished the star-car system.[15] The chief of police, in what the *Crescent* called "one of the most suggestive and significant documents that have ever been issued in this community," warned whites to "have no interference with negroes riding in cars of any kind. No passenger has a right to eject any other passenger, no matter what his color."[16]

Although the railroad anticipated a reduction in white ridership following its decision, little changed, and segregation of the cars continued to be observed by most passengers, black and white, until all the stars had been painted over. "Our people" the *Crescent* wrote, speaking for moderate whites, "have the facility of adapting themselves to every change forced upon them, however distasteful, uncalled for and irritating it may be."[17] The Republican *Tribune* urged blacks, who had come to recognize that they could bring about social change through public protest, to move on to even greater challenges, and called for the integration of the public schools.[18] The *Picayune*, the most extreme of segregationist newspapers, saw the star-car protest as "simply the introductory step to more radical innovations, which must materially alter our whole social fabric."[19] The paper was certainly correct in foretelling further changes, for African Americans would soon cast ballots and hold high office in city and state government. The landmark Louisiana constitution of 1868 provided for desegregated schools and prohibited racial discrimination in public places—advances that would be overturned, however, in the years following the end of Reconstruction.[20] Although Reconstruction gave African Americans a "real measure of political power" for the first time, as Eric Foner has observed, the end of Reconstruction thrust former slaves "into a no-man's land between

slavery and freedom that made a mockery of the ideal of equal citizenship."[21]

Laws later enacted throughout the South restored racial segregation to schools and to public transport. In 1890, the Louisiana legislature passed a bill requiring separate railroad coaches for black passengers, but the law was soon challenged, in an episode recalling the "Star Car" protest of 1867. When a black man named Homer Plessy, in defiance of the law, boarded a white coach on a New Orleans train, he was removed and arrested.[22] "We of the South who know the fallacy and danger of race equality, who have insisted on a separation of the races in church, hotel, car, saloon, and theater," the *Times-Democrat* editorialized, "... are heartily opposed to any arrangement encouraging this equality, which gives negroes false ideas and dangerous beliefs."[23] Plessy, who was found guilty in a New Orleans court, appealed the decision, and in 1896 the Supreme Court heard the case. In its famous decision *Plessy v. Ferguson*, the Court upheld the legality of segregated accommodations and laid the legal foundation for the doctrine of "separate but equal."[24]

In 1902, a "Jim Crow" law requiring separate streetcars for blacks and whites went into effect in New Orleans. Although railroads could seat blacks in the rear of the coaches, separated from whites by wire or wood screens—"as if they were wild or obnoxious animals," one observer wrote—the law essentially returned public transport to the "Star Car" conditions of 1867. Streetcars in New Orleans would remain segregated for another half-century.[25]

1. *Louisiana*, XII, p. 189, R.G. Dun & Co. Collection, Baker Library, Harvard Business School; Building contract, Andrew Hero, March 2, 1866, NONA; *St. Charles Street Railroad Charter, By-Laws, Contracts* [New Orleans 1866]; "The St. Charles Street Railroad," *Picayune*, January 31, 1862; "The St. Charles Street Railroad," *Times*, August 2, 1866; "St. Charles Street Railroad," *Picayune*, December 14, 1866.
2. "The St. Charles Street Railroad," *Times, op. cit.*
3. "The City Cars," *Crescent*, May 5, 1867.
4. Eric Foner, "Slavery, the Civil War, and Reconstruction," in *The New American History*, ed. Eric Foner, Philadelphia (Temple University Press) 1997, p. 88.
5. *Ibid.*, pp. 87–88.
6. Céline Frémaux Garcia, *Céline: Remembering Louisiana, 1850–1871*, Athens (University of Georgia Press) 1987, p. 202.
7. "The Negroes and the City Cars," *Crescent*, May 1, 1867. On

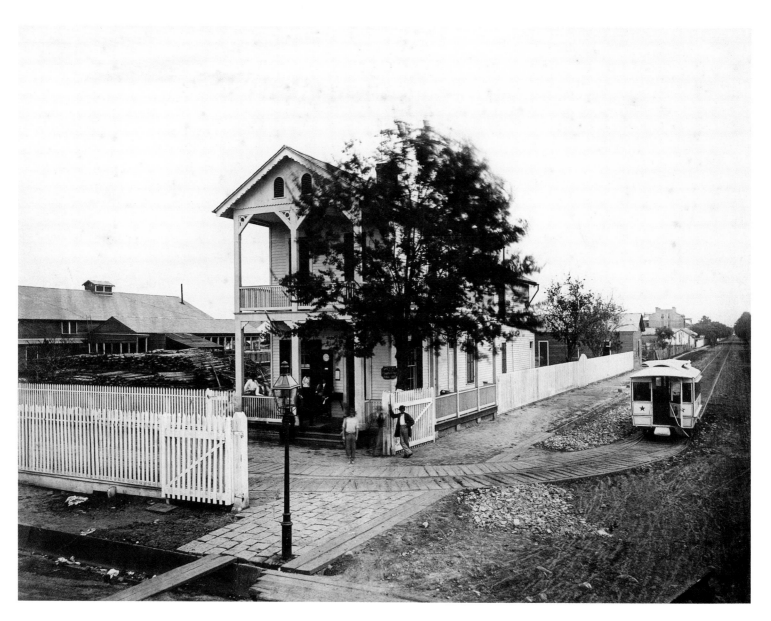

the star-car protest, see Roger A. Fischer, "A Pioneer Protest: The New Orleans Street-Car Controversy of 1867," *Journal of Negro History*, VI, Fall 1965, pp. 219–33; and *id., The Segregation Struggle in Louisiana, 1867–77*, Urbana (University of Illinois Press) 1974, pp. 30–41.

8. Even earlier, in 1864, U.S. General Nathaniel Banks had intervened in the city railroads' segregation policy on behalf of his black troops. The outcome, that black soldiers could ride in any car, was invalidated by a local court; Fischer, *The Segregation Struggle, op. cit.*, pp. 31–32.

9. "The Star Car Rule Works Both Ways," *Times*, October 15, 1866.

10. Fischer, *The Segregation Struggle, op. cit.*, p. 33, n. 24.

11. *Ibid.*, p. 33–37.

12. *Picayune*, May 7, 1867, cited by Fischer, "A Pioneer Protest," *op. cit.*, p. 230.

13. "The City Cars," *Crescent*, May 5, 1867.

14. *Picayune*, May 7, 1867.

15. General E.R.S. Canby in August 1865, quoted by Fischer, "A Pioneer Protest," *op. cit.*, p. 221; Joseph G. Dawson, III, *Army Generals and Reconstruction Louisiana, 1862–1877*, Baton Rouge (Louisiana State University Press) 1982, p. 51. Fischer, *The Segregation Struggle, op. cit.*, p. 38, minimized Sheridan's role in influencing the change.

16. "The Public Excitement on the Star Car Question," *Crescent*, May 7, 1867.

17. "The Effect of the Abolishing of Star Cars on Receipts," *Crescent*, May 24, 1867.

18. "The Public Schools," *Tribune*, May 9, 1867; Fischer, *The Segregation Struggle, op. cit.*, pp. 40–41.

19. *Picayune*, May 7, 1867, cited by Fischer, "A Pioneer Protest," *op. cit.*, p. 230.

20. Joe Gray Taylor, *Louisiana Reconstructed, 1863–1877*, Baton Rouge (Louisiana State University Press) 1974, pp. 151–55; Dale A. Somers, "Black and White in New Orleans: A Study in Urban Race Relations, 1865–1900," *Journal of Southern History*, XL, no. 1, February 1974, pp. 23–24.

21. Foner, *op. cit.*, pp. 85, 89.

22. Henry C. Dethloff and Robert R. Jones, "Race Relations in Louisiana, 1877–98," *Louisiana History*, IX, no. 4, Fall 1968, p. 316; Somers, *op. cit.*, p. 38; Fischer, *The Segregation Struggle, op. cit.*, pp. 152–55.

23. Quoted by Somers, *op. cit.*, p. 42.

24. Eric Foner and Olivia Mahoney, *America's Reconstruction: People and Politics after the Civil War*, Baton Rouge (Louisiana State University Press) 1997, p. 134.

25. A.R. Holcombe, "The Separate Street-Car Law in New Orleans," *Outlook*, LXXII, no. 13, November 29, 1902, pp. 746–47; Dethloff and Jones, *op. cit.*, p. 318; Fischer, *The Segregation Struggle, op. cit.*, pp. 153–55.

94
Private Residence
Residence Particulière

The press announcement of Lilienthal's completed portfolio in May 1867 identified "two excellent pictures of Mr. Bridge's flower-wreathed cottage, corner of Prytania and Eighth streets."[1] The house portraits (cats. 94 and 95) recorded—and celebrated—the Fourth District estate, built by Edward Bridge, a

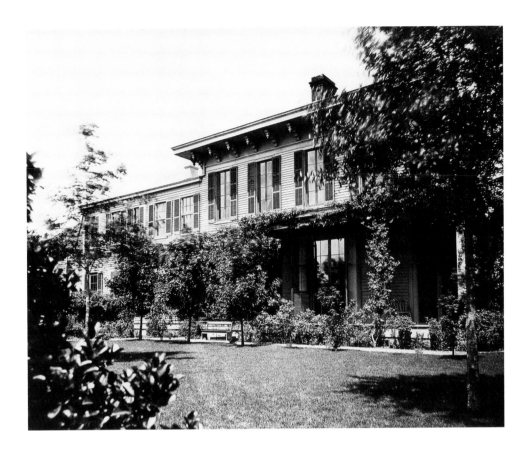

commission merchant who bought and sold goods and provided other business services to planters.[2] In the flourishing prewar plantation economy, many commission merchants were among the wealthiest men in New Orleans.

Bridge survived in business despite the crushing impact of the war on agriculture in Louisiana and the port trade in New Orleans. Commerce had "fallen off fearfully" in New Orleans, a Union soldier observed: "industry has been crippled, business broken up and agricultural improvements almost entirely suspended."[3] Although the port trade in 1867 had "not yet returned to its old channels," the *Commercial Bulletin* wrote, some aspects of city life were "slowly recovering from the effects of the war."[4] But New Orleans would never fully recover its antebellum commercial supremacy. Trade at the port of New Orleans in the five years before the war had surpassed that at all other ports in the country, including New York. But from 1865 to 1869, New Orleans cleared less than twenty percent of its antebellum tonnage, and the port slipped to fourth in the country.[5]

1. "New Orleans and Vicinity at the Paris Exposition," *Crescent*, May 26, 1867.

2. *Picayune*, November 19, 1876.

3. William Kingsford, *Impressions of the West and South During a Six Weeks' Holiday*, Toronto (A.H. Armour & Co.) 1858, p. 53; John Chandler Gregg, *Life in the Army in the Departments of Virginia, and the Gulf*, Philadelphia (Perkinpine & Higgins) 1866, pp. 128, 134.

4. "Annual Review of the New Orleans Market For the Year 1867," *Commercial Bulletin*, August 31, 1867.

5. Measured in ships' tonnage; the total number of vessels was down by seventy-five percent; *Causes of the Reduction of American Tonnage*, Washington, D.C. (Government Printing Office) 1870, pp. 262–67.

95 *overleaf*
Private Residence
Maison Particuliere

The uptown Fourth District, formerly the City of Lafayette, developed before the war as a garden suburb, where substantial lot-sizes allowed construction on a large scale.[1] Growth of this Garden District was organized about the major streets, St. Charles and Prytania, and the New Orleans and Carrollton Railroad, which passed through it. The City Railroad later brought streetcar service, providing convenient access to downtown business quarters. The Italian traveler Giulio Adamoli observed in 1867 that in the Garden District, "wealthy American residents retire to domestic

pleasures after their fatiguing business on Carondelet Street."[2] Recognized for its "breadth of flowered grounds and a wealth of arboreal shade and grateful odors," the neighborhood offered "all the quieter delights of a country home," as well as proximity to the conveniences and pleasures of the city.[3] "New York may have its Central Park, Paris its Bois de Boulogne, London its Hyde Park," the *Picayune* wrote in 1867, "but we of New Orleans boast our Garden District. Here may be seen on every side elegant residences, the homes of our merchant princes, each with its carefully tended garden, where bloom in tropical profusion the flowers and plants of almost every clime."[4]

1. On the growth of the Garden District, see S. Frederick Starr, *Southern Comfort: The Garden District of New Orleans*, New York (Princeton Architectural Press) 1998.
2. Giulio Adamoli, "New Orleans in 1867," *Louisiana Historical Quarterly*, VI, 1923, p. 276.
3. Griswold's *Guide*, p. 45.
4. "The Garden District," *Picayune*, May 7, 1867.

96 *opposite*
Brick yard
Manufacture de Briques

"The Hoffman kiln was photographed yesterday by Lilienthal for the Paris Exposition, and will doubtless attract much attention from its novelty," the *Picayune* reported on April 7, 1867.[1] The kiln's novelty derived from its circular form, and it was in fact much better known in Europe than in America. Patented by engineer Friedrich Hoffman of Berlin in 1859, it was first put into production in Germany, but was not introduced into the United States until 1866.[2] In March 1867, the New Orleans Manufacturing and Building Company began

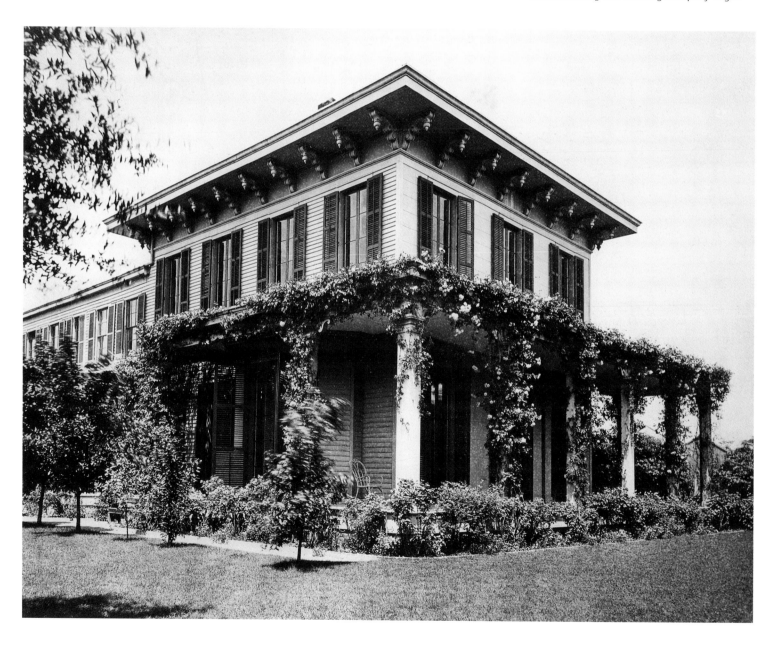

operating a Hoffman-patent kiln at its brickyard in lower Jefferson City, on the batture at Peniston and Levee (North Peters) streets.[3] The brickyard was located in a district that was once part of the Avart and Delachaise plantations, where kilns had operated since colonial times.[4]

The Hoffman kiln's ring-shaped chamber was divided into twelve or more ovens where bricks were fired. The ovens, according to one description, "instead of being superimposed, are placed side by side, [and] the heated gases, instead of rising vertically, [are] led from one oven to the next by the draught of the chimney."[5] Mechanized rotation of brick around the kiln allowed coal fires to burn continuously and conserved fuel by reducing waste heat and costly rekindling. The inventor claimed a two-thirds saving in coal using this continuous-firing method, compared to conventional kilns, as well as a more consistent quality of brick. By 1867, these claims seem to have been borne out, with more than 400 Hoffman kilns in operation in Germany, thirty in England, and twelve in America. A medal at the Paris Exposition acknowledged the Hoffman kiln's worldwide success.[6]

The Hoffman and other mechanized kilns industrialized the brick-making process, moving producers away from small kiln operations where skilled laborers molded bricks by hand. Machine-made bricks were generally more consistent in shape and color, with sharp edges and smooth surfaces, and industrialization made possible an extremely dense and uniform pressed brick for façade construction.[7] Soon after opening, the Hoffman kiln was "on the high road to prosperity," the *Picayune* reported, with orders for more than 2 million bricks and production at 60,000 bricks per day.[8] The kiln's operating costs were only $5 per thousand bricks in a market where bricks sold for $18–20 per thousand.[9] Local boosters praised the kiln as a new industrial enterprise that would reduce the city's dependence on import markets.[10] Builders in New Orleans had long imported brick from northern producers in preference to a soft, local brick that weathered poorly in the damp climate.[11]

Designed to maximize production through continuous operation, the kiln was never allowed to go out, and could be made profitable only as long as the demand for brick remained strong. But during a downturned economy the efficiency of the Hoffman kiln overstocked the

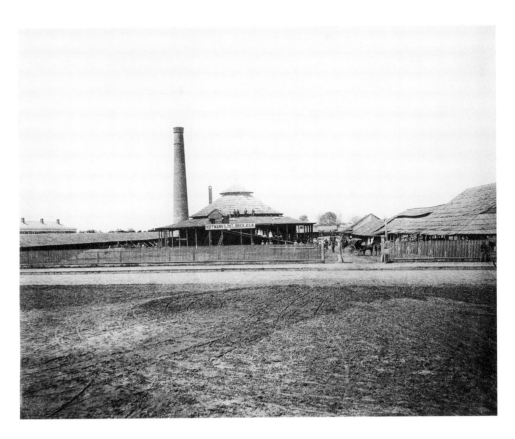

market. "The main difficulty about the use of the Hoffman kiln is its enormous productiveness," the *American Architect and Building News* wrote.[12] In 1874, with the postwar spike in the construction market over, the kiln failed, and the New Orleans Manufacturing and Building Company dissolved.[13] New Orleans architect James Freret reported that the kiln had been abandoned "on account of the necessity to keep it in blast constantly to its maximum supply, without regard to demand."[14] Under new ownership, the Hoffman kiln was returned to operation periodically until about 1884, when it was demolished.[15] Although many Hoffman kilns remained in use worldwide—mainly in Britain—until well into the twentieth century, few of the distinctive structures survive intact.[16]

In Lilienthal's photograph, the chimney of the kiln is a towering marker, rising as high as a church steeple, on the flat expanse of mud levee. The relentlessly flat topography of New Orleans at the river is suggested by the level shell road and picket fence that neatly bisect the view. By centering the kiln in the frame, Lilienthal diminished the assembly of participants, probably company stockholders and managers and their families, brought together to celebrate the new business (in which Lilienthal himself was a major investor).[17] Posed on the

roof, along a ramp, and in the brickyard, they are all too distant to make out. The view is enlivened not by these static, far-off figures but by the dynamic intersecting tracks of wagon wheels furrowed in the mud levee.

1. *Picayune*, April 7, 1867.
2. On the Hoffman kiln, see Frederick A.P. Barnard, "Machinery and Processes of the Industrial Arts," in *Reports of the United States Commissioners to the Paris Universal Exposition, 1867*, ed. William P. Blake, Washington, D.C. (Government Printing Office) 1868–70, III, pp. 357–59; Charles T. Davis, *A Practical Treatise on the Manufacture of Bricks, Tiles, Terra-Cotta, Etc.*, Philadelphia (Henry Carey Baird & Company) 1889, pp. 242–43, 266–71; Q.A. Gillmore, *A Practical Treatise on Coignet-Béton*, New York (Van Nostrand) 1871, pp. 68–73; W. Michaëlis, *Die Hydraulischen Mörtel*, Leipzig (Von Quandt & Handel) 1869, pp. 128–30. The kiln is referenced in two recent building technology surveys: Cecil D. Elliott, *Technics and Architecture: The Development of Materials and Systems for Buildings*, Cambridge, Mass. (MIT Press) 1992, p. 43; and Tom F. Peters, *Building in the Nineteenth Century*, Cambridge, Mass. (MIT Press) 1996, p. 430.
3. The New Orleans kiln was constructed and operated under the supervision of German engineer G.L. Dethlef, and received extensive coverage in the local press: "New Manufacturing Company," *Crescent*, March 8, 1867; "Vast Brickmaking Establishment," *Picayune*, March 8, 1867; "Brick Making," *Republican*, April 26, 1867; "The New Process of Making Brick," *Times*, May 9, 1867. Articles of incorporation were published in the *Crescent*, March 19, 1867.
4. Early brickworks are identified on Charles F. Zimpel's *Topographical Map of New Orleans and Its Vicinity* of 1834.

On the Delachaise and Avart family brick-making business, see *New Orleans Architecture*, VII, p. 39. From the earliest settlement of New Orleans, materials for brick manufacture were readily available locally: batture sand and clay; oyster or clam shells gathered from Indian middens for producing the lime required for mortar; and the Mississippi River for transport. The earliest known brickworks dated from 1725 at the Bayou St. John (Bayou Road) and produced bricks primarily for use in building foundations (there was no local stone), or as infill between wall timbers.

5. "Building Materials of Clay," *American Architectural Building News*, XV, no. 436, May 3, 1884, p. 207.
6. Barnard, *op. cit.*, pp. 357–59.
7. Carl R. Lounsbury, "The Wild Melody of Steam: The Mechanization of the Manufacture of Building Materials, 1850–1890," in *Architects and Builders in North Carolina: A History of the Practice of Building*, Chapel Hill (University of North Carolina Press) 1990, pp. 231–35.
8. *Picayune*, March 31 and April 21, 1867.
9. *Picayune*, April 7, 1867.
10. *Ibid.*; *Crescent*, March 8, 1867; *Times*, April 7, 1867.
11. Better clays for harder brick were already being pulled from the ground along the Gulf Coast east of New Orleans before the war. On brick-making in New Orleans, see James S. Janssen, *Building New Orleans: The Engineer's Role*, New Orleans (W.S. Nelson) 1987, pp. 67–71 (see also cat. 86).
12. "Building Materials of Clay," *American Architect and Building News*, XV, no. 436, May 3, 1884, p. 207.
13. *Deutsche Zeitung*, October 23, 1874.
14. *American Architect and Building News*, XIX, February 13, 1886, p. 83. The economics of the Hoffman kiln had been called into question earlier in "Communications," *American Architect and Building News*, XIX, January 9, 1886, p. 48.
15. "Communications," *op. cit.* The kiln was operated in the

1870s by the Delachaise Brickworks, the name under which the previous owners reorganized.
16. An Australian Hoffman kiln still in use in 1995 is described in Iain Stuart, "The History and Archaeology of the Hoffman Brick and Tile Company, Melbourne, Australia," *Industrial Archaeology Review*, XVII, Spring 1995, pp. 129–44. Several Hoffman kilns were in use in Canada into the 1960s; see T. Ritchie, "A History of the Tunnel Kiln and other Kilns for Burning Brick," *Association of Preservation Technology Journal*, XII, 1980, pp. 47–61. A drawing by an unknown engineer of another circular brick kiln in New Orleans is in The Historic New Orleans Collection (1990.61.2), dated to the 1880s. The drawing gives the location of this kiln as St. Peter and Rocheblave streets on the Old Basin Canal. If it was built it had already been taken down by 1896, the date of the first Sanborn Atlas issued for this district, which does not record the structure.
17. Lilienthal later served as treasurer and president of the company, which was described as being made up of New Orleans's "most enterprising citizens," *Picayune*, April 12, 1867.

97
St. Vincent's Academy
Academie de St. Vincent

In 1860, the Christian Brothers opened a four-year preparatory school for boys, St. Vincent's Academy, at Lawrence Square in Jefferson City.[1] The academy advertised that its location, six blocks from the river, was "unsurpassed by any other in the State for its healthy and salubrious location, as well as the beauty of its site."[2]

The academy offered supervision that was, the brothers claimed, "firm and unyielding, but kind and persuasive," and every pupil was "required to maintain the bearing and habits of a gentleman." While the academy gave special attention to the instruction of Catholic children, all denominations were admitted, and the brothers claimed that the students' "religious opinions are not interfered with." The school offered a bilingual curriculum in French and English, including "intellectual and practical" arithmetic, cyphering, geography, sacred history, declamation, and music, as well as specialized instruction in the use of globes, "mixed and pure mensuration," surveying, painting in watercolors, perspective drawing, and architecture.[3]

The Sisters of Charity of St. Vincent De Paul acquired St. Vincent's in 1878 and hired architects Albert Diettel and William Fitzner for expansion projects in 1887 and 1890.[4] The building remained in use until 1966, when it was demolished. St. Stephen's Elementary School occupies the site today.[5]

1. *The Centenary History of the Priests of the Congregation of the Mission, 1849–1949*, New Orleans (St. Stephen Parish) 1949, pp. 44–48. The architect of St. Vincent's is unknown. I would like to thank the Rev. Louis J. Derbes, C.M., archivist for the Vincentian Fathers and Brothers, Perryville, Missouri, and Sr. Genevieve Keusenkothen, archivist for the Daughters of Charity of St. Vincent De Paul, St. Louis, for their assistance.
2. "St. Vincent's Academy" (advertisement), *Times*, September 21, 1864.
3. "St. Vincent's Academy," *Carrollton Times*, September 10 and October 22, 1864.
4. Building contract (for a two-story north wing), Albert Thiesen, builder, December 23, 1887, notary J.J. Woulfe; Building contract (addition and renovation), February 1890, Edward Murray, builder, Sister M. De Sales, witnessed by William Fitzner; and payment records in Archives of the Marillac Provincialate, Daughters of Charity of St. Vincent De Paul, St. Louis, Missouri. A south wing was added in 1896–97. In 1908, the name St Vincent's was changed to St. Stephen's Parochial School for Boys and Girls; *The Centenary History*, *op. cit.*, p. 48. On its later history, see *ibid.*, pp. 44–48; *St. Stephen's Golden Jubilee, 1849–1899*, New Orleans 1899.
5. *States-Item*, November 14, 1959; *Clarion Herald*, May 26, 1966; *Times-Picayune*, August 22, 1966.

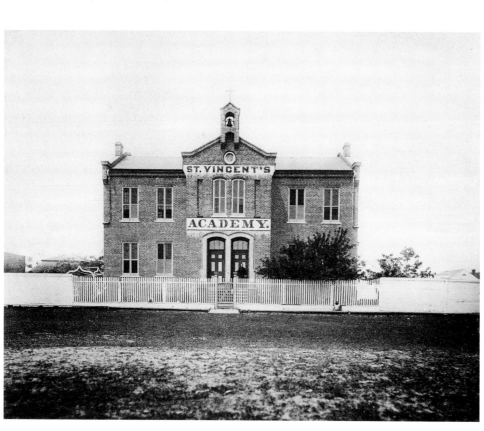

98
Carrollton Depot
Depot de Carrollton

The New Orleans and Carrollton Railroad, organized in 1833, began as a horsecar line serving St. Charles Street between Canal and Jackson streets.[1] Within a few years the railroad introduced steam locomotives manufactured in England and eventually the line linked the new town of Carrollton with New Orleans, a distance of about 5 miles (8 km). The *Bee* wrote that the railroad passed through "an ancient forest of live oaks ... one of the very few of its kind now remaining in the south."[2]

The Carrollton Railroad and its land-development strategies (the head of the railroad was Laurent Millaudon, one of the largest landowners in the state) brought about the transformation of the outlying woodlands and agricultural properties into residential subdivisions and the growth of the Garden District as a streetcar suburb. The *Times* observed in 1867 that where the railroad was now "flanked by houses in the whole course ... there remains not a single characteristic of the former waste of wilderness through which the route was originally laid."[3] But to residents of the newly populated districts, and riders alike, the screeching, smoky locomotives were objectionable and a hazard: sparks from their stacks ignited fires along the tracks and there was an ever-present threat of explosion. "Oh what dreadful noises these horrid steam whistles make! So shrill and loud and terrific," one passenger exclaimed.[4] In early 1867, the railroad caved in to public opinion and returned the old horsecar service along settled areas of the route.[5] "Passengers will be relieved from the smoke, the ear-piercing whistle, and the tolling of that bell," the *Crescent* predicted, "which now make a trip to or from Carrollton so harrowing to the feelings of a nervous person."[6]

During peak hours, trains ran every five minutes from Baronne and Canal streets to Carrollton.[7] The railroad opened several branch lines and operated major depots at Baronne Street, Tivoli (Lee) Circle (demolished in the spring of 1867), at the Carrollton terminus of the line (with a hotel and pleasure garden adjacent [cat. 104]), and at Napoleon Avenue in Jefferson City, where the line changed from steam locomotives to horse traction for passage through built-up districts. The location of Lilienthal's view is unidentified, but appears to record this

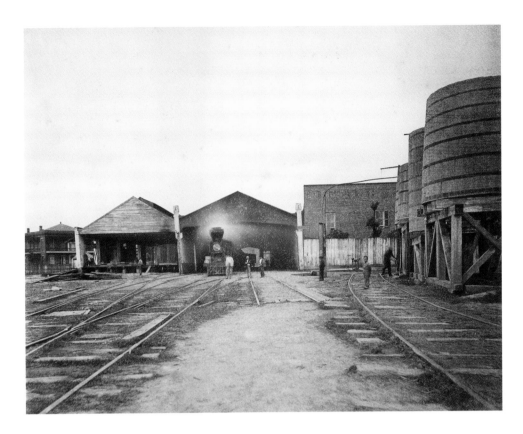

"halfway station" at Napoleon Avenue, where new facilities were put into use in 1867.[8] Lilienthal published additional views in stereo of the Napoleon Avenue depot at about this time.

In the early 1870s, the Carrollton Railroad was an important innovator in the development of a fireless locomotive powered by an ammonia engine—another effort by the railroad to eliminate the problem of smoke and fire in populated areas.[9] The invention, by Emile Lamm, fascinated Edgar Degas during his residence in New Orleans in 1872–73. "A person here called Lamm has invented an instrument said to be rather ingenious," he wrote, "which sets buses in motion at the tip of the town by means of steam with which it supplies itself."[10] The ammonia-powered locomotives were in use only a short time, but were reintroduced before the railroad began electrification in 1893.[11] Electric cars operated along the old Carrollton Railroad right of way for more than a hundred years, until hurricane Katrina in 2005, when service was suspended owing to damage to cars and tracks.

1. On the history of the New Orleans and Carrollton Railroad, see Walter Prichard, ed., "A Forgotten Louisiana Engineer: G.W.R. Bayley and His 'History of the Railroads of Louisiana,'" *Louisiana Historical Quarterly*, xxx, no. 4, October 1947, pp. 1065–85; E. Harper Charlton, *Street Railways of New*

Orleans: Interurbans Special No. 17, Los Angeles (I.L. Swett) 1955; Louis C. Hennick and E. Harper Charlton, *The Streetcars of New Orleans*, New Orleans (A.F. Laborde & Sons) 1965; Merl E. Reed, *New Orleans and the Railroads: The Struggle for Commercial Empire, 1830–1860*, Baton Rouge (Louisiana State University Press) 1966, pp. 38–40, 44–45; James L. Guilbeau, *The St. Charles Street Car or the New Orleans and Carrollton Rail Road*, New Orleans (Louisiana Landmarks Society) 1992; Franz Anton Ritter von Gerstner, *Early American Railroads*, ed. Frederick C. Gamst, Stanford, Calif. (Stanford University Press) 1997, pp. 753–74.
2. "Carrollton," *Bee*, September 28, 1835.
3. *Times*, April 26, 1867.
4. Joseph Holt Ingraham, *The Sunny South; Or, The Southerner at Home*, Philadelphia (G.G. Evans) 1860, p. 328.
5. "New Orleans and Carrollton Railroad," *Times*, July 10, 1866; *Carrollton Times*, May 29, 1867; "The Carrollton Railroad," *Crescent*, May 29, 1867.
6. "The New Orleans and Carrollton Railroad," *Crescent*, April 17, 1867.
7. "The Horse Cars to Carrollton," *Times*, May 28, 1867.
8. *Crescent*, April 13, 1866; "The New Orleans and Carrollton Railroad," *Crescent*, April 17, 1867. I am grateful to James Guilbeau for his help in identifying this view.
9. "Ammonia Engine for Street Cars," *Scientific American*, xxv, no. 19, November 4, 1871, pp. 290–92; P.G.T. Beauregard, *Report on the Practicality and Economy of Ammoniacal Gas as Motive Power for Street Cars*, New Orleans (L. Graham) 1871; Anthony J. Bianculli, *Trains and Technology: The American Railroad in the Nineteenth Century*, Newark (University of Delaware Press) 2001, I, pp. 172–73.
10. Christopher Benfey, *Degas in New Orleans*, Berkeley (University of California Press) 1997, pp. 86–87 and 274, n. 11.
11. "The Ammonia Motor," *Picayune*, April 30, 1893.

Residence of J.Q.A. Fellows
Residence de J.Q.A. Fellows

In 1860, Jefferson City was a small, upriver municipality with a population of 4500, of which at least three-quarters were foreign-born. It was a district of vegetable and dairy farms, tanneries, soapmakers, and other small factories —and eighty-four slaughterhouses.[1] Real-estate acquisition there, especially of properties adjacent to the New Orleans and Carrollton Railroad, which traversed the village, brought wealth to residents who built handsome houses along the major avenues St. Charles and Napoleon, served by the railroad. Among the most admired of the Jefferson City residences was this garden estate built in 1847 by John Calhoun on St. Charles between Jena and Cadiz streets.[2] Calhoun's real-estate ventures, including his house (which he furnished at the extravagant sum of $8000), bankrupted him, and in 1851 Samuel J. Peters, one of New Orleans's business elite, purchased the property from Calhoun's creditors.

The main house of the Calhoun–Peters estate was a raised, five-bay, center-hall Greek Revival mansion with a colonnaded porch, dormers, and a cupola. The entrance was framed by paired Corinthian columns and pilasters. Plastered brick walls, scored to resemble stone, were decorated with carved friezes above tall, shuttered windows. Across the front were four fluted columns with Tower of the Winds capitals, 15 feet (4.5 m) high, set within pillars and joined by an elaborate iron railing. The roof was ornamented with elaborate acroteria in a scroll pattern. The residence had four bedrooms and a kitchen wing with slave quarters above, and a coach house and stables behind. Adjacent to the main house Peters added a second brick house with five more bedrooms. The estate was, at the time, rural and semi-agricultural, with an open pasture and fruit orchard.

The architect of the Calhoun–Peters house is unknown. It was a strong interpretation of the Greek forms for which New Orleans had a particular affinity, generally favoring them over other revival styles, as a local architect later recalled:

> For all buildings but the few very best, the carpenter architects hit upon the idea that the Grecian temple ... [was] the most perfect

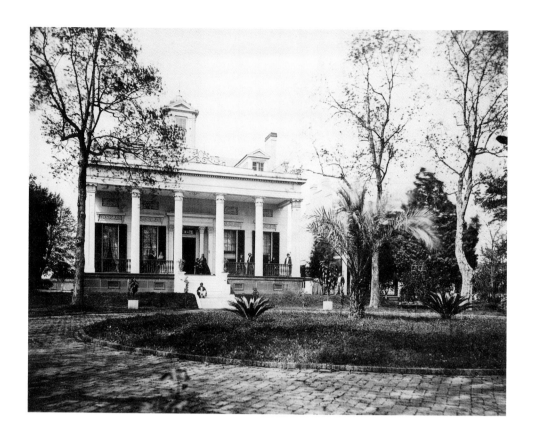

type for everything in the architectural line Not being able to carry out the Grecian ideas in marble, however, they built of wood and painted it white. So the Grecian temple style became all the rage here This style of architecture was particularly easy to build, for the rules and dimensions are all laid down in the books.[3]

Not all observers, however, agreed that the style was suitable for residences. "We abhor Grecian architecture for private dwellings," Henry Ward Beecher wrote in 1855:

> It is cheerless, pretentious, frigid. Those cold long-legged columns, holding up a useless pediment that shelters nothing and shades nothing, reminds one of certain useless men in society, for ever occupied with maintaining their dignity, which means their perpendicularity. In spite of Mr. Ruskin, we do like Grecian architecture in well-placed public buildings. But it gives us a shiver to see dwellings so stiff and stately.[4]

Before the war the Calhoun–Peters house changed hands again, and in 1864 John Quincy Adams Fellows acquired the property.[5] Fellows was a judge, a Jefferson City alderman, and a "well known Union man" who had been an

unsuccessful candidate for governor in the election of February 1864.[6] His opponents, Benjamin Flanders, a Radical Unionist, and Michael Hahn, a moderate, were both former United States Congressmen who supported emancipation and who saw the war as, in the words of historian Eric Foner, "a genuine revolution that offered the opportunity to overthrow a reactionary and aristocratic ruling class."[7] Fellows, on the other hand, represented Conservative Unionists—anti-secessionist and anti-abolitionist—who sought to maintain the ruling planter elite and obtain compensation for lost slaves. Fellows and Flanders lost to the German-born Hahn, who received the backing of President Lincoln and General Nathaniel Banks, the military overseer of New Orleans.[8]

It was probably Fellows who landscaped the Jefferson City estate, laying out gardens, shell walks, arbors with marble benches, and plantings of live oak, cedar, magnolia, and tallow trees. A six-room gardener's cottage and greenhouse on the Cadiz Street side may have been added at this time, as well as a brick-paved carriage drive, seen in the photograph, which terminated in a circle planted with palms.[9]

Fellows was bankrupted in 1878 by a judgment against him in a lawsuit, and the following year the seized property was again

sold at a sheriff's auction. In 1887, the Academy of the Sacred Heart, a Catholic teaching order, acquired the property and demolished the buildings for a school, built in 1900–06, that occupies the site on St. Charles Avenue today.[10]

At least three generations of the Fellows family, and their servants, appear to have posed for the photograph. Lilienthal also used his stereo camera to record the house a short time after (or perhaps before) this large-plate view was made (fig. 90).

1. *New Orleans Architecture*, VII, p. 33.
2. "Up at Jefferson City," *Picayune*, December 14, 1866. The chronology here follows the documented history in Sally K. Reeves, *Legacy of a Century: Academy of the Sacred Heart in New Orleans*, New Orleans (Walsworth Press) 1987, pp. 67–70.
3. "Modern Architecture," *Picayune*, July 14, 1884.
4. Henry Ward Beecher, *Star Papers: Experiences of Art and Nature*, New York (J.C. Derby) 1855, p. 291.
5. Sale recorded by A. Barnett, June 17, 1864, NONA, cited by Reeves, *op. cit.*, p. 188, n. 16.
6. *Removal of City Council of New Orleans*, 40th Cong., 2d sess., H. Ex. Doc. 209, Washington, D.C., 1868, p. 14.
7. Eric Foner, *Reconstruction: America's Unfinished Revolution, 1863–1877*, New York (Harper & Row) 1988, pp. 48–50, p. 46. On the election of 1864, see also Joe Gray Taylor, *Louisiana Reconstructed, 1863–1877*, Baton Rouge (Louisiana State University Press) 1974, pp. 27–32.
8. *Deutsche Zeitung*, February 14, 1864. Hahn's engraved victory portrait appeared in *Harper's Weekly*, March 26, 1864, after a photograph by Lilienthal.
9. A survey of 1876, published by Reeves, *op. cit.*, p. 70, documents the improvements.
10. Reeves, *op. cit.*; *New Orleans Architecture*, VII, p. 163.

100
Lane's Cotton Mills
Manufacteure de Cotton

The Lane Cotton Mill at Tchoupitoulas and Valence streets in Jefferson City opened in 1856 for the manufacture of rope. George Purves designed the three-story brick mill with an octagonal entry, attached engine house, cistern, and warehouse. The building was located at a remote site near the river because of community restrictions on factory operations in settled areas, an effort to control pollutants thrown off during the milling process. Shortly before the war, Lafayette Napoleon Lane purchased the mill and began manufacturing cotton yarn.[1]

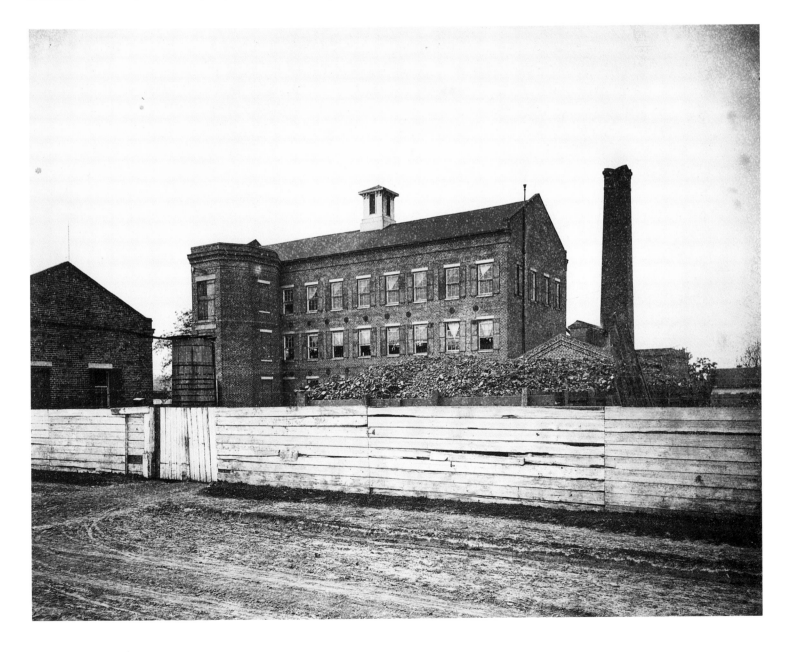

Closed by federal troops during the occupation, the mill reopened in 1866, when Lane advertised yarn of a "quality put up by me prior to the war, which excelled any ever offered in this market."[2] It was New Orleans's only cotton mill, but was financially unsuccessful under Lane's management, and within five years his "effort of Southern enterprise" had failed. With the backing of New York industrialists, a new owner eventually revived the business, and by the turn of the century the mill had expanded to 50,000 spindles, from 1500 during the 1860s.[3]

The mill's later success generated the urban development of a large area of lower Jefferson City, including mill-sponsored worker housing along Valence Street and retail businesses established to serve millworkers. But in the mid-1950s the mill's most important product, denim, sold poorly and the mill again became unprofitable. In 1957, after one hundred years of operation, and with a workforce of 1200, the mill closed down.[4] Later nineteenth-century buildings of the mill complex survive today, although Purves's original building, seen in Lilienthal's photograph, has been demolished.

Carding machinery is visible through the open, second-story windows. The tall stack marks the steam-powered engine, fueled by the wood that is piled high behind a whitewashed board fence that partitions the view. Lilienthal often brought fences and walls into his views to create distinct foreground and background planes. In a photograph of the Lane Mills taken five years later for *Jewell's Crescent City Illustrated*, he took a very different, elevated vantage point (fig. 13), where the building is brought into prominence and the cluttering elements of the industrial site are diminished.

1. "New Orleans Manufactures and Arts," *Times*, December 28, 1865; Griswold's *Guide*, p. 34; *New Orleans Architecture*, VII, pp. 173–74.
2. "The Lane Cotton Mills" (advertisement), *Crescent*, September 6, 1866; 'Lane Cotton Mills' (advertisement), *Commercial Advertiser*, January 11, 1867.
3. *Jewell's Crescent City Illustrated*; "Lane Cotton Mills," *Martin Behrman Administration Biography 1904–1916*, New Orleans (J.J. Weihing Printing Co.) 1917, p. 107; Andrew Morrison, *New Orleans and the New South*, New Orleans (L. Graham) 1888, n.p.; "Lehman, Stern & Co.," *Picayune*, September 2, 1889; "Capital and Industry," *Picayune*, September 15, 1889; 'New Orleans as a Site for Cotton Mills,' *Manufacturers' Record*, XXIX, July 17, 1896, p. 37.
4. *Times-Picayune*, July 16, 1957; *States*, July 16, 1957; *Item*, July 16, 1957.

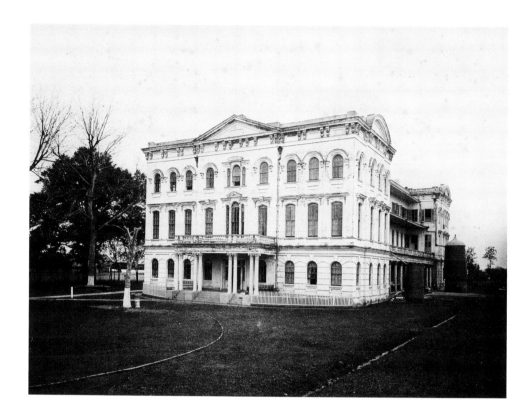

101
Poydras Asylum Jefferson City
Asile Poydras Citée de Jefferson

Founded in 1816, the Poydras Female Orphan Asylum was a pioneering institution for the care of orphans, and one of the city's first charities.[1] Julien Poydras, a successful planter, provided for the asylum's first home at St. Charles and Julia streets.[2] Poydras was a native of Brittany and one of the most influential men of his time: co-founder of Louisiana's first bank, territorial representative to Congress, and president of the Constitutional Convention that granted statehood to Louisiana in 1812. His patronage guaranteed the early success of the asylum, which admitted girls aged six to twelve for an average of two to three years. The children were "instructed in good morals and behavior, and in all such knowledge as shall tend to make them useful members of society."[3]

Prior to the establishment of the Poydras home, "charitable institutions based upon the principle of voluntary association were unknown in New Orleans," the *Picayune* wrote in 1858, although conventual orphan care had already been provided by the Ursuline nuns.[4] Orphan asylums became common throughout the country only after 1830—one historian recorded just fifteen privately sponsored orphan asylums established between 1800 and 1830, when orphan care remained largely the responsibility of relatives, friends, and neighbors.[5] In New Orleans, the Poydras Asylum and later homes cared for children orphaned by the city's many nineteenth-century epidemics, or others who were destitute, some of whom were the sons or daughters of immigrants who arrived at the port with no means. Although New Orleans subsidized asylums from 1824, the city was without a public almshouse or a system of public welfare until the 1850s.[6]

Overcrowded in its deteriorated downtown building, the Poydras home in the early 1850s planned a new building campaign in Jefferson City. The site selected was the old Ricker plantation, "a most charming spot" of "rustic beauty" shaded by live oaks.[7] There were few structures in the area, and even by 1867, only fifty-three households could be counted there, most of them impoverished.

The building committee received plans from several architects, including Lewis Reynolds and Will Freret. On the recommendation that Reynolds was an "architect of great talent and ability" who would execute his plan with "fidelity," the committee adopted his proposal.[8] His three-story stuccoed brick building featured granite steps and sills, a portico of cast-iron

Corinthian columns on granite bases, bracketed window caps, a cornice supported by heavy consoles, and a roofline that was "broken," the *Picayune* wrote, "by a judicious combination of circular and angular forms." With the "highest regard" for "comfort ... neatness, vastness, massiveness and beauty," the newspaper continued, the Poydras Asylum would "find no equal in the South."[9]

The building's first floor housed a spacious entry hall and central dining room, flanked by a waiting room, porter's room, and housekeepers' dining room. The kitchen, laundry, and bathing rooms, "with a separate spigot for every child," were located at the rear.[10] On the second story were an infirmary and dispensary, classrooms, and meeting rooms. The third floor accommodated the sleeping wards.

Reynolds designed an elaborate ventilation system to circulate outside air in the belief that "children can sleep in moderate currents of air without danger" of sickness.[11] In providing for the exchange of fresh air, his plan was typical of ward design of the period, governed by environmental or miasmic theories and the belief that stale air caused illness.[12] Although realization of Reynolds's design put the asylum heavily in debt, as construction costs topped $75,000, the building was completed in early 1858. In February, "the orphans took possession of its spacious apartments."[13]

The war left many single mothers with little opportunity for employment, unable to receive public assistance at home and with little ability to provide for the care of their children. Poydras and other asylums, with curtailed private charity, struggled to take up the increased need for orphanages. Antebellum state and municipal budgets had provided modest subsidies to aid the private asylums, but treasuries were now exhausted. In 1865, the *Times* reported that municipal funds were so much depleted that the city could no longer "keep up the old paltry stipend of fourteen dollars a year for the orphan."[14]

The need for orphan care declined during the twentieth century, and by the late 1950s there were only fourteen girls in the asylum's care. In 1958, the orphanage closed and the building was renovated as a home for elderly women. The renovation removed two floors of the building, and later expansions, the largest in the late 1990s, further modified the original structure.[15]

The Poydras view provides evidence of Lilienthal's choices as a viewmaker. The openness of the sparsely settled district of Jefferson City, where he was not restricted by a dense fabric of streets and buildings in placing his camera, allowed a range of framing options, and here Lilienthal chose a perspective view that best conveyed the proportions and scale of the building in its expansive suburban site.

1. The asylum was chartered on January 16, 1817. On the institutional history, see Poydras Home Papers, Manuscripts Collection, Tulane University Library, especially "Specifications of the Poydras Female Orphan Assylum [*sic*]," May 8, 1855; Lilian Fortier Zeringer, *The History of the Poydras Home*, New Orleans (Poydras Home) 1977. On charitable care of orphans in New Orleans and the Poydras Asylum, see Priscilla Ferguson Clement, "Children and Charity: Orphanages in New Orleans, 1817–1914," *Louisiana History*, XXVII, Fall 1986, pp. 337–51.
2. *Norman's New Orleans and Environs*, pp. 113–14.
3. *The New-Orleans Directory and Register*, New Orleans (J.A. Paxton) 1822, p. 15.
4. *Picayune*, April 25, 1858.
5. David J. Rothman, *The Discovery of the Asylum: Social Order and Disorder in the New Republic*, Boston (Little, Brown & Co.) 1971, pp. 206–207.
6. Clement, *op. cit.*, p. 342, points out that most asylums did not accept black orphans, who were expected (by whites) to be cared for by families within the black community; Elizabeth Wisner, "The Howard Association of New Orleans," *Social Service Review*, XLI, no. 4, 1967, p. 415.
7. "Charities of New Orleans," *Picayune*, February 14, 1858. On the development of the Ricker property, Rickerville, and Jefferson City, see Sally K. Reeves, "The Founding Families and Political Economy, 1850–1870," in *New Orleans Architecture*, VIII, pp. 26–49.
8. Letter of May 8, 1855, from Mrs. J.A. Adams in Poydras Home Papers, *op. cit.*
9. "Charities of New Orleans," *op. cit.*; "Specifications," *op. cit.*
10. "Charities of New Orleans," *op. cit.*
11. "Specifications," *op. cit.*, p. 12.
12. Robert Bruegmann, "Central Heating and Forced Ventilation: Origins and Effects on Architectural Design," *Journal of the Society of Architectural Historians*, XXXVII, no. 3, October 1978, pp. 143–60; Jeanne Kisacky, "Restructuring Isolation: Hospital Architecture, Medicine, and Disease Prevention," *Bulletin of the History of Medicine*, LXXIX, no. 1, 2005, pp. 1–49. See also cat. 102.
13. "Charities of New Orleans," *op. cit.*
14. "Municipal and Judicial Intelligence," *Times*, November 21, 1865.
15. "Poydras Home Being Changed," *Times-Picayune*, March 17, 1959; Diane Farrell, "Old Home Gets a New Job," *Dixie Magazine*, February 14, 1960, pp. 10–11; *Times-Picayune*, September 19, 1976; "Facelift for a New Orleans Grande Dame," *Times-Picayune*, March 28, 1996.

102 *overleaf*
U. S. Sedgwick's Hospital in Greenville
Hopital Sedgwicks a Greenville

Built in 1864, Sedgwick Hospital was one of 200 general hospitals established across the country by the U.S. military during the war. The 1000-bed hospital was designed under the supervision of U.S. army captain Henry L. Jones and followed a pavilion plan that was adopted for military hospitals nationwide. Built on a large scale, Sedgwick was a temporary structure intended to meet the immediate crisis of caring for the casualties of war.[1]

The rural site selected for the hospital covered 30 acres (12 ha) of old plantation land in Greenville, below Carrollton. The owner of the property was the Marquis Louis Foucher, a resident of Paris, whose ancestors had settled there in the eighteenth century.[2] "[A]dmirably adapted for the location of a Hospital," Captain Jones wrote, the Foucher property was "surrounded with large Live Oaks and Pecan Trees bordering the Avenues of approach ... and an abundance of the best arable land for garden purposes or for pasturage." Fronting on the Mississippi River "at the river's highest water mark," the site was regarded as safe from overflows.[3]

The hospital plan was a panopticon of sixteen detached pavilions (four were never completed) connected by a 1000-foot (305-m) circular corridor, roofed with open sides, and a tramway for transporting supplies. Pavilions were built of upright battens on piers raised 3 feet (1 m) off the ground, with shingled roofs open at the ridge for ventilation. The one-story pavilions were 175 feet (53 m) long by 25 feet (7.6 m) wide, with the exception of the administration building, seen here, which was two stories on a smaller footprint. An inner circle of four buildings housed a guard's quarters, knapsack room, kitchen, and dining rooms. At the center of the inner circle was a brick cistern, 50 feet (15 m) in diameter and built partially underground, holding 150,000 gallons (570,000 liters) of rainwater for drinking and cooking. Water for surgical and sanitary uses was pumped directly from the river (where city sewerage and slaughterhouse refuse was dumped daily) and piped to all the buildings. At the end of each ward were brick-vaulted water closets and washrooms. Detached buildings included a laundry, bakery, chapel, dead house, blacksmith, stables, and a gasworks, also photographed by Lilienthal (cat. 103). A large post garden was laid out at one corner of the site, and a picket fence enclosed the grounds, which were accessible from Tchoupitoulas and Magazine streets by shelled service roads.[4] The Greenville U.S. Cavalry stables and an artillery camp were located nearby.[5]

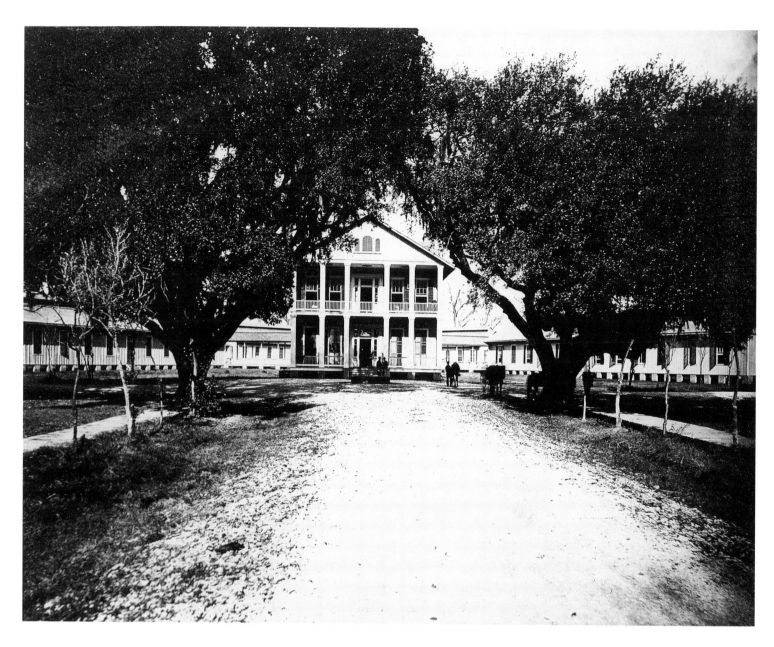

Early in the war, the U.S. military relied almost exclusively on confiscated buildings, usually hotels, for use as general hospitals.[6] These buildings rarely functioned well in their new role, and the U.S. Sanitary Commission advocated construction of pavilion-plan hospitals to replace them.[7] The pavilion hospital plan probably originated in France in the early 1820s and had been used successfully by the British army in the Crimean War in 1855, when Isambard Kingdom Brunel designed a temporary, prefabricated pavilion hospital in Renkioi, Turkey, which has been called one of "the two most significant industrial buildings of the nineteenth century."[8] The basic concepts underlying Brunel's pavilion hospital were those

later adopted by the U.S. military: a structure composed of separate, self-contained pavilions, well-ventilated, and united by covered passages.[9] Adoption of the pavilion plan was supported by the view, promulgated by miasmatists, that "poisons" and effluvia accumulated in hospital wards and caused illness. According to Florence Nightingale, the most influential miasmatist, the "exhalations" of the sick were "always highly morbid and dangerous" and had to be "instantly and perpetually carried off by ventilation." To deprive the sick of pure air "is nothing but manslaughter under the garb of benevolence," she stated.[10] Sedgwick's "arrangements for ventilation" were, according to its designer, "perfect"—the raised, narrow-

windowed pavilions with ridge ventilation above allowed air to circulate around the structure, similar to a field tent.[11]

The first pavilion hospital built by the U.S. military was at Poolesville, Maryland, 36 miles (58 km) from Washington, in October 1861.[12] Three years later the army issued regulations that all general hospitals were to be constructed according to the pavilion plan. Sedgwick was already under construction when the orders were issued, but later hospitals were built under the regulations.[13]

The first Surgeon General, John Woodworth, predicted in 1873 that the "old magnificent hospitals, built as monuments for all time" would be "abandoned for the simple pavilion."[14] Use of

the plan was widespread in the United States, but most of the pavilion hospitals built by the military, including Sedgwick, were of temporary construction and designed to last only between ten and fifteen years—or until "accumulated miasmas rendered them unsafe."[15]

"Arranged on a most extensive scale" and built at a cost of $500,000, Sedgwick was the largest new building project of the Civil War era in New Orleans.[16] "It can hardly be supposed that while the country is engaged as it is in this fierce struggle between the sections, that much time can be given to building edifices," the *Times* wrote. Building projects were generally inconceivable during the war owing to the high cost of building materials or even the "utter impossibility of obtaining essential things used in construction."[17] Most construction during the war years was for temporary military facilities and public-works projects: swamp drainage, street grading, new roads, rail lines, canals, and wharves. "It is not often in the history of mankind," the *Times* observed, "that we find a conquered city thus improved with useful and permanent works by the conquerors."[18] The projects improved not only the supply and movement of troops and military goods but also the general health of the city, and gave work to the unemployed. "About two thousand laborers have been employed in cleaning the streets and making city improvements," Marion Southwood wrote, "and this feeds perhaps ten thousand people."[19]

After the war, Sedgwick was refitted as an epidemic quarantine facility with equipment from the abandoned U.S. Marine Hospital (cat. 48).[20] In 1870, following the sale of the Foucher property, the hospital—adjudged to be "of little value"—was closed and demolished.[21] The city made plans to develop the Foucher tract as a park, but the land remained unimproved until the World's Industrial and Cotton Centennial Exposition in 1884–85, when temporary exhibition buildings were built over 245 acres (99 ha).[22] In 1897, the city finally began construction of Audubon Park on the old Foucher tract, designed by the successors of Frederick Law Olmsted.[23]

Lilienthal made this view of Sedgwick and the hospital's gasworks in late 1865, as part of a series of eighteen photographs of military installations in New Orleans for the U.S. Quartermaster General. He reprinted four negatives from the Quartermaster commission for the Exposition portfolio, including the two

views of Sedgwick, as well as two of Jackson Barracks downriver (cats. 116 and 117).[24]

1. "Plan of the Sedgwick Hospital, Greenville, Near New Orleans, La.," General Correspondence, Letters Received, New Orleans Marine Hospital, Records of the Public Buildings Service, RG121, NARA; Henry L. Jones to W.D. Stewart, MD, Special Agent, Treasury Dept., and Medical Inspector USMHS, February 20, 1869, Letters Sent, Correspondence of the Marine Hospital Service, Records of the Public Health Service, RG90, NARA; *Times*, June 27, 1864; "On the General Hospitals," *The Medical and Surgical History of the War of the Rebellion*, Washington, D.C. (Government Printing Office) 1870–88, VI, pp. 946–49; Henry C. Burdett, *Hospitals and Asylums of the World*, London (J. & A. Churchill; Whiting & Co.) 1891–93, III, pp. 750–51.
2. *Letter of the Secretary of the Treasury*, 41st Cong., 2d sess., S. Ex. Doc. 69, Washington, D.C. (Government Printing Office) 1870. The hospital was named for U.S. Major General John Sedgwick (1813–1864), who was killed at the battle of Spotsylvania. On the Foucher Plantation, see Hilary Somerville Irvin, "The Foucher Tract," and Samuel Wilson, Jr., "The Uptown Faubourgs," in *New Orleans Architecture*, VIII, pp. 30–33, 39–41. Wilson reproduces Lilienthal's photograph, unattributed and reversed.
3. Henry L. Jones to W.D. Stewart, *op. cit.*
4. "Report of Buildings Owned by the U.S. Government, 1865," Consolidated Correspondence File 1794–1915, Records of the Office of the Quartermaster General, RG92, NARA; "Sedgwick Hospital, & other buildings – La.," Map 107G, Sheet 5, Post and Reservations, Records of the Office of the Quartermaster General, RG92, NARA; Col. S.B. Holabird, Chief Quartermaster, Dept. of the Gulf, June 3, 1865, in *War of the Rebellion: Official Records of the Union and Confederate Armies*, Washington, D.C. (Government Printing Office) 1894–1922, ser. L, XLVIII, pt. II, p. 744. See also William H. Williams, "The History of Carrollton," *Louisiana Historical Quarterly*, XXII, no. 1, January 1939, pp. 187–90.
5. "The Cavalry Stables at Greenville," *Crescent*, December 12, 1866. Sixteen stables for 3000 horses, built during the war on the Millaudon estate, were demolished in the summer of 1866, then partially rebuilt in early 1867. The 9th Regiment of U.S. Cavalry, an African American unit, was assembled there in 1866–67. Lilienthal photographed the stables in 1865.
6. In New Orleans, even a cotton press was used. The Southern Cotton Press, the hotels St. James, St. Louis, and St. Charles, the Belleville foundry, and the University of Louisiana buildings were all used as general hospitals; "New Orleans Post and General Index," Indexes to Field Records of Hospitals, 1821–1912, Records of the Adjutant General, RG94, NARA.
7. See *A Report to the Secretary of War of the Operations of the Sanitary Commission and Upon the Sanitary Condition of the Volunteer Army ... Sanitary Commission Report No. 40, December, 1861*, Washington, D.C. (McGill & Witherow) 1861, pp. 64–65; Thomas W. Evans, *La Commission Sanitaire des États-Unis*, Paris (E. Dentu) 1865, plate 1.
8. Eric Kently, "A Turkish Prefab: The Renkioi Hospital," in *Isambard Kingdom Brunel: Recent Works*, London (Design Museum) 2000, p. 74.
9. David Toppin, "The British Hospital at Renkioi, 1855," *Arup Journal*, XVI, no. 2, July 1981, pp. 3–5; C.P. Silver, "Brunel's Crimean War Hospital—Renkioi Revisited," *Journal of Medical Biography*, VI, 1998, pp. 234–39.
10. Cited by John D. Thompson and Grace Goldin, *The Hospital: A Social and Architectural History*, New Haven, Conn. (Yale University Press) 1975, p. 159. See also Jeanne Kisacky,

"Restructuring Isolation: Hospital Architecture, Medicine, and Disease Prevention," *Bulletin of the History of Medicine*, LXXIX, no. 1, 2005, pp. 4–6; Adrian Forty, "The Modern Hospital in England and France; The Social and Medical Uses of Architecture," in *Buildings and Society*, ed. Anthony D. King, London (Routledge & Kegan Paul) 1980, pp. 78–90.
11. Henry L. Jones to W.D. Stewart, *op. cit.*
12. Army surgeon A.B. Crosby claimed to be the designer of the Poolesville hospital, "the first complete military hospital on the modern 'pavilion plan,' that was built during the war of the Rebellion"; J. Whitney Barstow, "Obituary Notice of A.B. Crosby ...," *Transactions of the New Hampshire Medical Society*, 1878, pp. 161–62.
13. "War Department Circular, July 20, 1864," in *The Medical and Surgical History of the War of the Rebellion, op. cit.*, VI, pp. 943–45. John McArthur, Jr.'s Mower U.S.A. General Hospital in Philadelphia of 1862, built on a much larger scale, had radiating wood pavilions similar to Sedgwick; on Mower, see Lawrence Woodhouse, "John McArthur, Jr. (1823–1890)," *Journal of the Society of Architectural Historians*, XXVII, no. 4, December 1969, pp. 277–78. Lincoln Hospital, Washington, D.C., was even closer to the Sedgwick plan, with similar covered corridors, wards raised on brick piers, and detached buildings for staff quarters and services; see Burdett, *op. cit.*, III, pp. 752–53; and Thompson and Goldin, *op. cit.*, p. 174.
14. *Annual Report of the Supervising Surgeon of the Marine-Hospital Service of the United States for the Fiscal Year 1873*, Washington, D.C. (Government Printing Office) 1873, p. 49.
15. *Ibid.*
16. "Improvements in New Orleans," *Times*, June 27, 1864. Cost cited in "Location and Value of Government Property In and Around New Orleans," *Times*, October 12, 1866.
17. "Improvements in New Orleans," *op. cit.*
18. *Ibid.*
19. *Beauty and Booty*, p. 60.
20. General Philip Sheridan to W.P. Kellogg, Collector, June 25, 1866, Letters Sent, Correspondence of the Marine Hospital Service, Records of the Public Health Service, RG90, NARA.
21. "New Orleans Post and General Index," *op. cit.*; James H. Casey, Collector of Customs, to Secretary George S. Boutwell, March 14, 1870, Letters Received, New Orleans Marine Hospital, Records of the Public Buildings Service, RG121, NARA.
22. John Smith Kendall, *A History of New Orleans*, Chicago and New York (Lewis Publishing Company) 1922, p. 460.
23. Irvin, *op. cit.*, pp. 41–53.
24. See p. 44 for a discussion of Lilienthal's work for the U.S. Quartermaster General, now in the National Archives, Washington, D.C. Lilienthal completed other views of Sedgwick for this commission, as well as views of the Small Pox Hospital operated by the Corps d'Afrique at Poydras and Clara streets, and the Greenville cavalry post (see n. 5 above), not included in the Paris portfolio.

103 *overleaf*
Gas works of Sedgwick's Hospital
Manufacture de Gaz de l'Hopital Sedgwicks'

The rural site of Sedgwick Hospital, on high ground at the river's edge, was described as "one of the most desirable spots in the State."[1] The flat plain of the river basin is evident in this view of the hospital's gas plant. Visible to the left is part of the stately *allée* of oaks that marked

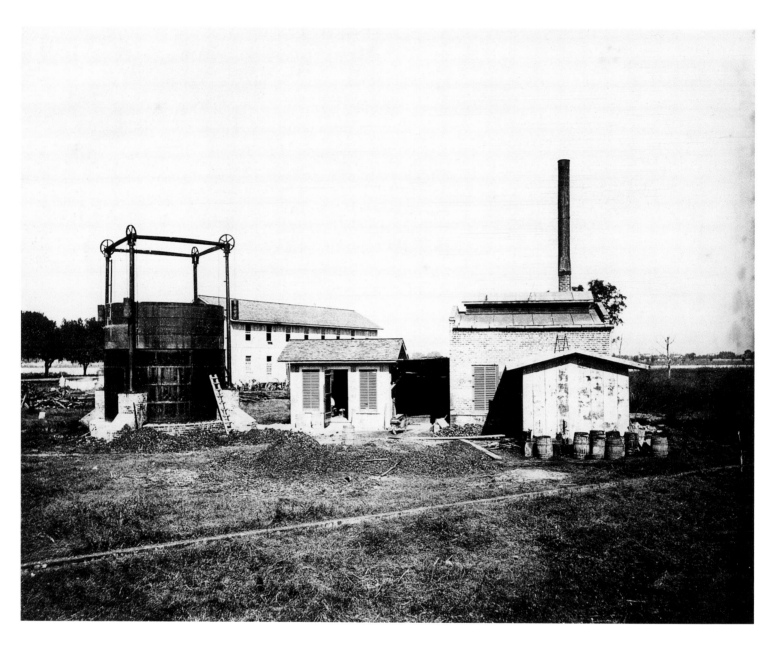

the entrance to the old Foucher plantation. At the horizon is the river levee. The location of the hospital, 5 miles (8 km) above New Orleans, far beyond the reach of city gas mains, required a self-sufficient gas supply. Because of the ever-present danger of explosion, the gasholder, retort house, and other structures of the gasworks were placed at a safe distance from the wards.

Behind the gasholder are a service building, a parked dray, and a line of laundry set out to dry. The photograph records buildings that appear to be "put up without order or symmetry, just as present need dictates," as one observer described another nineteenth-century industrial landscape.[2] Here, the array of structures, woodpiles, coal heaps, ladders, and

barrels, and the diagonal boundary score make an engaging composition, while documenting coal-gas manufacture in New Orleans.

1. Henry L. Jones to W.D. Stewart, MD, Special Agent, Treasury Dept., and Medical Inspector USMHS, February 20, 1869, Letters Sent, Correspondence of the Marine Hospital Service, Records of the Public Health Service, RG90, NARA. Lilienthal made this view, and its companion photograph of the hospital's administration building (no. 102), in late 1865, for the U.S. Quartermaster General, part of a photographic survey of military installations nationwide (see p. 44).
2. Carl Gustav Carus, *Denkwürdigkeiten aus Europa*, ed. Manfred Schlösser Hamburg, 1963, on the Thames River industrial landscape, cited by Wolfgang Schivelbusch, *Disenchanted Night*, Berkeley (University of California Press) 1988, p. 34.

104 *opposite*
Carrollton
Carrollton

"Carrollton is one of the suburban offshoots of New Orleans and contains some two thousand inhabitants, mostly of the poorer classes, and of Germanic lineage," author John William De Forest observed in 1867. [1] The town was not yet forty years old. In 1831, the New Orleans Canal and Banking Company and financiers, including John Slidell and Laurent Millaudon, purchased Jean Baptiste McCarty's sugar plantation, which had been a concession from the Spanish crown in 1795, located 5 miles (8 km) from New Orleans. Backers hired

German-born surveyor Charles F. Zimpel to plat a new town there.[2] Residential development was assured with the building of the New Orleans and Carrollton Railroad, which provided service from Tivoli (Lee) Circle in New Orleans to Carrollton, following the path of today's St. Charles Avenue streetcar line (no. 98).

To promote tourism, the railroad built the Carrollton Hotel in 1835 on a site near the river, adjacent to their depot. The hotel and nearby pavilions featured a shooting gallery, bowling green, cricket club, ten-pin alleys, billiard room, ice-cream parlor, and rooftop belvedere. "We ascended to the observatory," a visitor wrote, "and were much pleased at the view presented of the Mississippi in its winding course."[3] The hotel's prime attraction was the 4-acre (1.6-ha) Carrollton Gardens, a "miniature Eden" designed by Charles Haaff and Frances Schuler.[4] Plantings included chinaberry, pecan, and banana trees and, according to the English-born architect Thomas K. Wharton, who visited the "far-famed" gardens in 1854, "lovely alleys of Cape jessamines, and the white bell flowered Yucca."[5] Bowers, alcoves, shell paths, fountains, and other ornaments made the gardens a restful retreat.[6]

The hotel and gardens were popular destinations, especially for visiting planters and their families "unwilling to traverse the city in the summer months," and for day-trippers from the city seeking the "quiet and rural air" of Carrollton."[7] The "pure, bracing air, the shady groves, green fields and calm, tranquil bayous" of the village were a "peaceful" respite, the *Crescent* wrote in 1867, "for men who plod and plod away their lives among the brick walls of the city."[8]

Lilienthal's bird's-eye view from the rooftop observatory of the hotel captures at a glance the topography of Carrollton. "The only raised ground is the levee," De Forest wrote of the terrain there, "[and] the only grand feature of the landscape is the Mississippi; all the rest is greenery, cypress groves, orange thickets, flowers, or bare flatness."[9] As a landscape view, the photograph was technically demanding. The indeterminate mass of the trees is evidence of the difficulty of the wet-collodion process, which needed, according to one photographer, "so long an exposure [to bring out sufficient detail] that the foliage is but seldom motionless."[10] Another challenge for Lilienthal was to master the extremes of light and shade in the bright, sunlit patches of ground and the dark, shadowy mass of the trees. "The great difficulty which the landscape photographer has to combat," the critic and photographic chemist Carey Lea wrote, "is the unsatisfactory rendering of deeply shaded foliage in the presence of well-lighted objects, such as light buildings, light-colored stones, and rocks in direct sunlight, &c."[11]

In the foreground of Lilienthal's view is one of Carrollton Gardens' popular swings, reserved here, according to the sign, "for ladies and children only." In the distance are the double tracks of the New Orleans and Carrollton Railroad.[12] Construction of a protection levee at Carrollton in 1892–93 required the destruction of a large part of the business center, including the railroad hotel and garden, "which have a fame," the *New York Times* noted, "... extend[ing] far beyond the state."[13] Five months after it was completed, the new 16-foot-high (5 m) levee prevented the Mississippi from inundating Carrollton when an older levee collapsed.[14]

1. John William De Forest, *Miss Ravenel's Conversion, from Secession to Loyalty*, ed. Gordon S. Haight, New York (Rinehart & Co.) 1955, p. 192. De Forest's novel is based on his observations as a Union army officer in New Orleans.
2. Charles F. Zimpel, *Topographical Map of New Orleans and Its Vicinity*, 1834; William H. Williams, "The History of Carrollton," *Louisiana Historical Quarterly*, XXII, no. 1, January 1939, pp. 187–91 (Williams's text dates from 1876). Carrollton was named, according to conflicting local accounts, for either U.S. General William Carroll, whose militia camped there in 1815 prior to engaging British troops at the Battle of New Orleans, or Charles Carroll of Maryland, the last surviving signer of the Declaration of Independence, who died in 1832.
3. "Carrollton," *Bee*, September 28, 1835; "Carrollton Hotel," *Bee*, October 8, 1835; "Carrollton Hotel" (advertisement), *Picayune*, September 25, 1849.
4. *Picayune*, June 9, 1840.
5. Wharton, "Diary," May 2, 1854.
6. "Plan of 140 Lots of Ground situated in Carrollton," C. Herman, May 4, 1844, NONA (I would like to thank Sally Reeves for her assistance with this document). Williams, *op. cit.*, p. 211.
7. "Jefferson and Lake Pontchartrain Railway," *Picayune*, April 10, 1853; "Carrollton Hotel," *Crescent*, April 4, 1866; *Picayune*, October 31, 1866; "Sunday Trip to Carrollton," *Picayune*, April 10, 1867.
8. *"City Sketches—Number Five,"* *Crescent*, February 24, 1867.
9. De Forest, *op. cit.*
10. H.E. Hoelke, "Landscape Photography in Germany," *Philadelphia Photographer*, IV, no. 47, November 1867, p. 347.
11. M. Carey Lea, "Various Photographic Remarks," *Philadelphia Photographer*, IV, no. 47, November 1867, p. 340.
12. "For a New Levee," *New York Times*, September 4, 1891. The hotel and gardens are illustrated in three wood engravings in Waldo, *Visitor's Guide*, pp. 24–25.
13. "For a New Levee," *op. cit.*
14. "Saved from Inundation," *New York Times*, July 5, 1893.

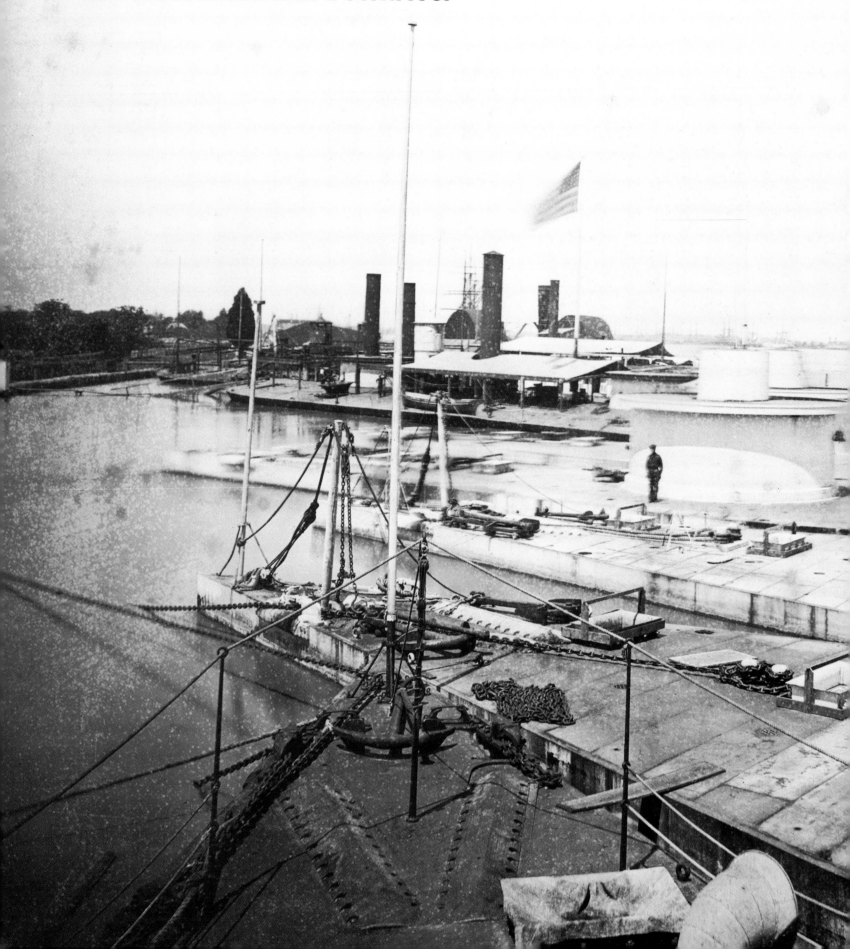

105
Belleville Iron Works Algiers
Fonderie Belleville Algiers

The Belleville Ironworks covered a 4-acre (1.6-ha) site in the Belleville district of Algiers, opposite New Orleans on the West Bank of the river. Built in 1847–53 by the industrialist John P. Whitney and partners, the foundry, at 80,000 square feet (7400 sq. m) was a large, castellated block with battlemented corner towers.[1] The structure was admired locally as a counterpart of the Castle of Caernarfon in Wales—a model chosen, it was said, as an "embodiment of architectural strength" appropriate to an iron foundry.[2] But the foundry was as likely to have been a response to a local landmark, the Gothic Marine Hospital of 1837–48, also on the West Bank.[3] Belleville was expensive to build: the roof alone, made from English slate, was said to have cost $100,000.

Belleville manufactured architectural iron and steamboat, plantation, and railroad machinery before the war. With as many as 800 workers, it was one of the city's largest employers. Twice ruined by fire and rebuilt, it allegedly stored munitions and manufactured boilers for Confederate gunships early in the war.[4] During the federal occupation, troops appropriated the building for a quarters, hospital, and prison, and by late 1865 it was a ruin.[5] "Weeds and dank grass grow in the ample court yard, the damp wind stirs through the broken windows and desertion chills the surroundings," the *Times* wrote. "Four years of war can accomplish more than four hundred of peace."[6] The image of desolation recalls a Union soldier's observation in 1865 that in towns all over the South "grass is actually growing on their paved streets and places of former prosperity in business."[7]

Although Belleville was seen as a "monument of the ravages made by war," and to the lost fortunes of an industry that New Orleans now relinquished to manufacturing cities of the North, the foundry had, in fact, failed several times, and its history was more accurately one of bankruptcy and sheriff's auctions than "prosperity in business."[8] After one closure in 1851, Belleville was "painful to behold," according to the *Orleanian*: a "lonely and deserted pile, of massive buildings, on the erection of which so large an amount was expended" (words that might also have scripted a postwar lamentation on the foundry's ruins).[9] Belleville was perhaps the most conspicuous example of New Orleans's inability to establish a strong manufacturing sector to complement its role as a major commodities trader, wholesaler, and handler of goods.

Lilienthal positioned his camera far enough from the building that it does not immediately appear to be closed and vacant. But closer examination reveals signs admonishing vandals and billposters, and other evidence of abandonment. In the context of the Exposition, Lilienthal's view of an unoccupied industrial building might have been read as an appeal to the entrepreneur, a position that had been adopted by the *Times* in 1865: "Fill up this temple of the useful arts—let the bell in its skeleton belfry once more call the mechanics to their work ... let its walls once more re-echo to the blast of furnace and the roar of machinery; rebuild the deserted Belleville Iron Works."[10]

In the early 1870s, investors did attempt to restore the building to use by adapting it to the milling of cotton seed—an industry, ultimately a failure, that was based on agricultural byproducts of the region.[11] In 1883, lightning ignited storage tanks of oil, which exploded, destroying the mill. It was never rebuilt.[12] Railroad switching yards later took over the site, which was eventually cleared to make way for a public playground, which is located there today.

1. Site acquisition, A.C. Ainsworth, V, no. 285, June 18, 1847, NONA; *Courier*, September 4, 1849.
2. "The Belleville Iron Works," *Times*, December 31, 1865.
3. On the Marine Hospital, derived from a design by Robert Mills, see cat. 48. The hospital may have inspired another immense Gothic structure also on the West Bank, known as Harvey's Castle, built the same year as Belleville. See Betsy Swanson, *Historic Jefferson Parish from Shore to Shore*, Gretna, La. (Pelican) 1975, pp. 86–87. James Dakin's Gothic state capitol in Baton Rouge was also underway at this time (1847–50).
4. "Belleville Iron Works for Sale," *Picayune*, June 21, 1861; Greg Lambousy, "John Hughes, Algiers' Shipbuilder," *Algerine*, XVI, September 2004, pp. 6–8.
5. "New Orleans Post and General Index," *Indexes to Field Records of Hospitals, 1821–1912*, Records of the Adjutant General, RG94, NARA.
6. "The Belleville Iron Works," *op. cit.*
7. John Chandler Gregg, *Life in the Army, in the Departments of Virginia, and the Gulf, Including Observations in New Orleans*, Philadelphia (Perkinpine & Higgins) 1866, p. 133.
8. *Louisiana*, X, p. 234, R.G. Dun & Co. Collection, Baker Library, Harvard Business School; *Orleanian*, January 24, 1851; *Picayune*, September 14, 1854; *Picayune*, July 22, 1858; *Delta*, January 11, 1859; *Sunday Delta*, January 22, 1860; "The Belleville Iron Works at Algiers," *Times*, January 24, 1867.
9. *Orleanian*, January 24, 1851.
10. "The Belleville Iron Works," *op. cit.*
11. Property sale, J. Bendernagel, IV, nos. 111–12, July 9, 1877, NONA; "Cotton Seed Oil Works," *Jewell's Crescent City Illustrated*.
12. "A Million Dollar Fire," *Picayune*, June 26, 1883.

Opposite *U. S. Monitors* (cat. 111), detail.

106
Dry Dock
Dock Flottant a Algiers

The village of Algiers, on the West Bank of the Mississippi River, opposite New Orleans, was the site of the city's shipyards. The batture there was open to private ownership, and dry-dock industries flourished after the 1820s, when the city of New Orleans prohibited shipbuilding at the Levee.[1] "Algiers is the great work-shop of New Orleans for the building and repairing of vessels," *Norman's New Orleans and Environs* observed in 1845. "It has its dry docks, and other facilities for the most extensive operations. In business times, it presents a scene of activity that is seldom observed in any other part of these regions, and reminds one of the bustling and enterprise of the North."[2] A visitor after the war found the dry docks recovering some of their antebellum bustle, while Algiers' many grogshops offered a diversion from the toil of the docks: "Quite a number of persons were engaged in caulking boats, while an equal number were engaged in the less praiseworthy avocation of uncorking bottles," he observed.[3]

Visible in Lilienthal's photograph is the 200-foot (61-m), steam-driven Good Intent dry dock, built on the Tchefuncte River near Madisonville, Louisiana. The Good Intent was put into operation in May 1866 at Delaronde Street above the West Bank landing of the Canal Street ferry.[4] A bark, possibly a coffee clipper, is docked for repairs and work is already underway, with one spar removed and laid against the bowsprit, supported by a barrel. Square-rigged, wooden sailing ships such as this were out of date in 1867. Costly to build, as accessible timber supplies became increasingly depleted, they were also expensive to operate, with large crews required to maintain them at a time when laborers were being increasingly lured to industrial jobs on shore.

1. Melissa M. Green and Sally K. Reeves, *Archaeological Testing of Quarters A (16OR137) at the Naval Support Activity, West Bank Facility, Algiers, Orleans Parish, Louisiana*, Plano, Tex. (Geo-Marine) 1996, p. 194.
2. *Norman's New Orleans and Environs*, p. 194.
3. "Over the River," *Times*, March 6, 1865.
4. *Times*, August 12, 1866; *Jewell's Crescent City Illustrated*.

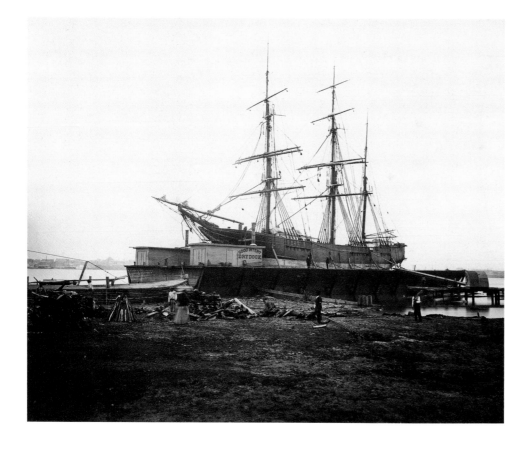

107
Dry Dock
Dock Flottant

Floating dry docks were first put into successful commercial use in 1827 at the St. Lawrence River shipyards in Quebec. "They have here a floating dock to repair the ships in," a Quebec shipping clerk reported; "[it is] a very clever invention: they sail into it, as a foot goes into a shoe: when the gate is shut, and water pumped out, then they are left dry to be examined."[1] Within a decade the first floating docks arrived at the Algiers shipyards, opposite New Orleans.[2] They were less expensive than fixed masonry or iron docks, which required costly excavations, especially where the soil was not well suited to substantial dock construction, as in the Algiers basin.[3]

The Ocean dry dock, seen here, was launched in October 1866 at the foot of Bartholomew (Bermuda) Street, near the landing of the Second District ferry (cat. 4).[4] The builders T. and C. Mackie and Junior Follette floated the dock for owner Seymour Field in just six weeks— "demonstrative," the *Times* wrote, "of the enterprise of Algiers."[5] Steam-powered, with a length of 225 feet (69 m) and a breadth of 64 feet (19 m), the dock was "capable of giving full accommodation to a vessel of fourteen and a half draft," and could raise 1500 tons. "The frame is strong knit, is well skewered and anchored, in short, is firm on its pins."[6]

The Ocean is servicing the iron sidewheel steamer *Lilian*, one of the most famous Confederate commerce raiders of the war.[7] Built in early 1864 on the River Clyde in Scotland, for a Georgia company engaged in running the Union blockade, the *Lilian* was described as a "light draught, gossamer craft" and one of the "fleetest and most beautiful of the blockade-defying vessels."[8] She had a forward deck shaped like a turtle back to navigate turbulent waters, and a sharp bow that "seemed to cleave the waves like a razor."[9] By raising a great head of steam from her large boilers, the 225-foot (68.5 m), 427-ton vessel was capable of "flying through the water at a speed which defied pursuit." And she was stealth: she "went through the gloaming like a ghost," one witness wrote.[10]

The *Lilian* ran the Union blockade at Wilmington, North Carolina, five times. During one of many pursuits, a Union gunboat fired 140 rounds at her, but she escaped by running into shallow water.[11] On her sixth attempt at the blockade, on August 24, 1864, the *Lilian* set

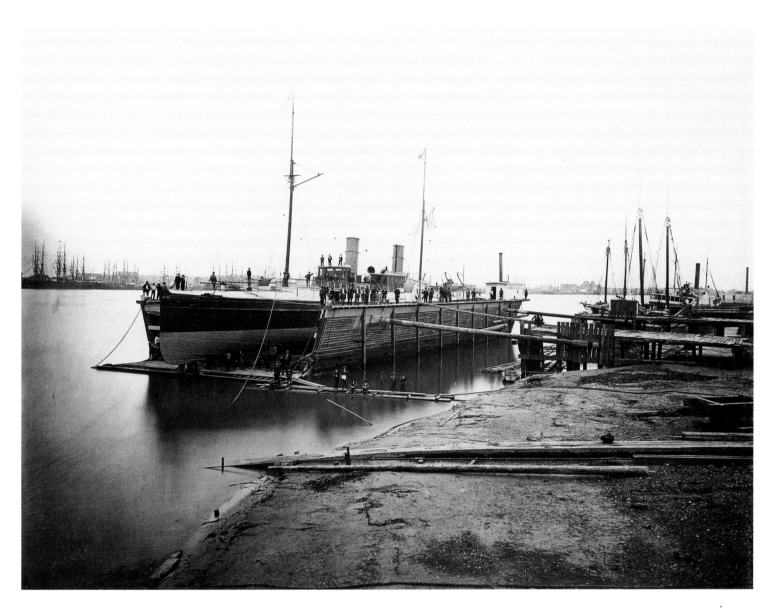

out for Bermuda with a load of 640 bales of cotton and $34,000 in Confederate bonds. Witnesses reported that they "saw the Yankees throw several rockets, then saw the flashes and heard the reports of fifteen guns" off Cape Fear, and the *Lilian* was taken.[12] Now in Union hands, the *Lilian* was one of about fifty Confederate blockade runners captured or destroyed off Wilmington in the preceding twelve months.[13] The relentless efforts of the commerce raiders, as one Cape Fear pilot wrote, had "helped keep the hopes of the Confederacy alive during the last years of the Civil War."[14]

"The prize is a splendid iron side-wheel steamer," the *New York Times* wrote of the *Lilian*'s capture and exhibition at the Philadelphia Navy Yard. "She ... looks like a fast sailer, as she is represented to be."[15] Refitted and

commissioned by the U.S. Navy, the *Lilian* returned to Cape Fear as a Union blockader. After the war she was sold and put to sea as a merchant vessel. In 1870, the Spanish government purchased the *Lilian*, but after a few months in service as a gunboat, she was lost.[16]

With his camera positioned on a nearby wharf, Lilienthal has organized a tableau of more than fifty workmen, crew, and visitors on the dock and the ship's deck. On the gangplank, a ghosted trio of men appear more spectral than their own shadows, which are caught on the water's surface. Two women in hoop skirts stand amidships.[17]

Lilienthal's high vantage point and wide angle of view brings the mud flat into prominence in the foreground, diminishes the mass of the ship, and emphasizes the vast

reach of river and shore. View lenses such as the wide-angle Globe, patented in 1862, or the rectilinear wide-angle by Dallmeyer were available in New Orleans after the war, but it is not known what lens Lilienthal used.[18] The dark area at the perimeter of this print, possibly caused by internal reflection in the lens, is evidence of the limited light-gathering power of his optics.

1. Eileen Reid Marcil, "Wooden Floating Docks in the Port of Quebec from 1827 Until the 1930s," *Mariner's Mirror*, LXXXI, no. 4, November 1995, p. 448.
2. William H. Seymour, *The Story of Algiers*, Gretna, La. (Pelican Press) 1971 [1896], p. 63.
3. "Floating Dry Docks," 30th Cong., 1st sess., H. Ex. Doc. 11, Washington, D.C. (Government Printing Office) 1847; Charles H. Wigram, "On a Project for a Floating Dock," *Transactions of the Institution of Naval Architects*, X, 1869, pp. 26–29; Seymour, *op. cit.*, lists the Ocean as the sixteenth dry dock

established at Algiers. It was still operating in 1896, at opposite Patterson between Valette and Belleville streets; David L. Fritz and Sally K. Reeves, *Algiers Point: Historical Ambience and Property Analysis of Squares Ten, Thirteen, and Twenty*, Denver (National Park Service) 1984, pp. 17–18.

4. *Jewell's Crescent City Illustrated* (Lilienthal photographed the Ocean dock again for Jewell's, see *Jewell's Crescent City Illustrated*, prospectus); Fritz and Reeves, *op. cit.*, p. 17.

5. "The Ocean Dry Dock," *Times*, October 18, 1866.

6. *Ibid.*

7. "Steamers," in *American Lloyd's Register of American and Foreign Shipping*, New York (J.W. Pratt & Co.) 1867, p. 19; Stephen R. Wise, *Lifeline of the Confederacy: Blockade Running During the Civil War*, Columbia (University of South Carolina Press) 1988, p. 309. On blockade running, see Warren F. Spencer, *The Confederate Navy in Europe*, Tuscaloosa (University of Alabama Press) 1983, pp. 192–93; Robert M. Browning, Jr., *Success Is All That Was Expected: The South Atlantic Blockading Squadron During the Civil War*, Washington, D.C. (Brassey's, Inc.) 2002, pp. 73–77, 104–10, 285–90.

8. "Running the Blockade into the Port of Wilmington, North Carolina," *Illustrated London News*, XLV, no. 1268, July 16, 1864, p. 70, reprinted as "Blockade Running," *New York Times*, July 18, 1864.

9. Hamilton Cochran, *Blockade Runners of the Confederacy*, Tuscaloosa (University of Alabama Press) 2005, p. 268, quoting the London *Times* correspondent Francis C. Lawley.

10. "Running the Blockade," *op. cit.*

11. James Morris Morgan, *Recollections of a Rebel Reefer*, Boston and New York (Houghton Mifflin) 1917, pp. 190–96.

12. Mary J. White, *Diary*, August 2, 1864–June 7, 1865, entry for August 24, 1864, United Daughters of the Confederacy, Richmond, Virginia, cited by Jim McNeil, *Masters of the Shoals: Tales of the Cape Fear Pilots Who Ran the Union Blockade*, Cambridge, Mass. (Da Capo Press) 2003, p. 115; "Arrival of a Prize Steamer at Philadelphia," *New York Times*, September 4, 1864; *Official Records of the Union and Confederate Navies in the War of the Rebellion*, ser. I, X: *North Atlantic Blockading Squadron*, Washington, D.C. (Government Printing Office) 1900, pp. 388–95; James Sprunt, *Tales of the Cape Fear Blockade*, ed. Cornelius M.D. Thomas, Wilmington, NC (Charles Towne Preservation Trust) 1960, pp. 122–23; Wise, *op. cit.*, pp. 159–61.

13. *Official Records*, *op. cit.*, p. 504.

14. McNeil, *op. cit.*, p. 510.

15. "Arrival of a Prize Steamer at Philadelphia," *op. cit.*

16. "From Georgia," *New York Times*, January 31, 1865; *Dictionary of American Fighting Ships*, Washington, D.C. (Navy Department) 1969, IV, p. 113; Wise, *op. cit.*, p. 309. The *Lilian* was privately owned when Lilienthal photographed her.

17. On posing figures outdoors, see Susan Danly, "The Landscape Photographs of Alexander Gardner and Andrew Joseph Russell," PhD diss., Brown University, 1983, p. 56; Peter Palmquist, "Carleton E. Watkins at Work," *History of Photography*, VI, 1982, pp. 292–325.

18. Désiré Van Monckhoven, *Photographic Optics*, London (R. Hardwicke) 1867 [reprinted New York (Arno Press) 1979, pp. 100, 152–53]; John M. Blake, "Means of Equalizing Exposure with Wide-Angle Lenses," *Philadelphia Photographer*, V, 1868, pp. 411–14; H. Vogel, "German Correspondence," *Philadelphia Photographer*, IV, 1867, p. 329; Rudolf Kingslake, "Optics Design in Photography," *Image*, XXV, no. 3–4, September–December 1982, pp. 38–56.

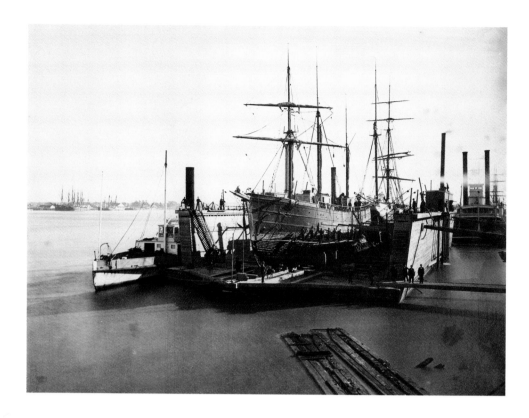

108
Floating Dock
Dock Flottant du Mississipi

Upon the approach of the federal fleet to New Orleans in April 1862, residents of Algiers reportedly sank the Mississippi River dry docks to keep them from falling into Union hands, leaving the West Bank, according to one observer, "as bare as a plucked turkey."[1] After the war a gradual revitalization of the port generated a demand for new maritime facilities, of which the dry docks were among the largest investments of capital and labor.[2] In the spring of 1867, eight new dry docks operated in Algiers, supplying work for residents and contributing to a sharp increase in land values on the West Bank. Many of these docks were steam-powered, buoyant docks, which lifted ships above water level by emptying water-filled compartments. With their associated mills and blacksmiths' shops, the dry docks typically employed one hundred or more carpenters, caulkers, riggers, and other tradesmen and laborers in the repair and outfitting of vessels.[3]

The ship that is docked for repair was powered by wind or steam and may have serviced either domestic coastal runs or the overseas trade. Workers have torn away the

ship's damaged hull for replacement. Moored behind the dock is an old schooner-rigged cargo vessel, and positioned alongside is the towboat *Camelia*. A paddle steamer is anchored alongshore. In this picture of sail and steam, the tall masts and stacks tower above the relentlessly flat, riparian landscape. With no natural promontory available onshore, Lilienthal's elevated viewpoint was probably obtained from a neighboring dock.

1. *Picayune*, January 16, 1866.
2. "Algiers: The Vote to Incorporation," *Crescent*, December 18, 1866.
3. "A Glance at New Orleans Manufactures and Arts: The Southern Dock," *Times*, December 31, 1865.

109
U. S. Man of War
Aviso a Vapeur des Etats Unis

At the outbreak of the war, how the conflict might begin to play out at sea was far from certain. The U.S. Navy had only fifty-one serviceable vessels in commission; the Confederacy had none.[1] In April 1861, President Lincoln ordered the navy, with its meager fleet, to implement a blockade of shipping along 3000 miles (4800 km) of coastline. For the Union, the blockade was an attempt to isolate the South economically, and it proved to be a significant factor in winning the war.[2] In response, the strategy of the Confederacy, as one naval historian has written, was to "break, discredit or circumvent" the blockade, and maintain an economic lifeline of southern cotton, sugar, and tobacco exports, as well as imports of foreign arms and other manufactured goods.[3] Because the South did not have sufficient industry to supply its war machine, supplies run through the blockade from Europe were essential to the conduct of Confederate armies in the field.[4]

There were huge profits to be made, at great risk, sending ships out from Britain and France to Nassau, Bermuda, and Havana, and from there to run the blockade into Confederate ports. Wilmington, North Carolina, and Charleston, South Carolina, the ports closest to the Confederate troops in the field, saw the most activity, but at New Orleans, too, 300 ships ran the blockade in the ten months before federal occupation in April 1862.[5] Although vessels broke the blockade, by one calculation, 5400 times, and their crews were glorified by southern press, the blockade successfully impeded the supply of war material and led to the surrender of the main Confederate army in Virginia.[6]

The urgent need for vessels for use as runners and blockaders initiated a shipbuilding frenzy in America and abroad. By the end of the war, the U.S. Navy had 690 vessels in service, most assigned to the North and South Atlantic Blockading squadrons (the navy would not be as large again until World War II).[7] The Confederacy and its contractors looked to Britain and France to supply ships and, often, their crews—more than one hundred British merchant ships have been estimated to be involved in blockade running.[8] Any kind of vessel could be put to sea as a commerce raider, but during the war a new type of ship designed for speed and stealth, with powerful engines and large cargo capacity, emerged (the *Lilian*, for example, cat. 107). One seaman described the typical blockade runner as

a long low rakish-looking lead-colored steamer with short masts, and a convex forecastle deck extending nearly as far aft as the waist, and placed there to enable the steamer to be forced through and not over a heavy head sea. These were genuine blockade-runners, built for speed; and some of them survived all the desperate hazards of the war.[9]

The runners were capable of operating on sail or steam; the sails were deployed in the open ocean far from coaling stations to conserve fuel.[10] Powerful engines gave the runners speed to outrun blockaders, and their light draft and maneuverability gave them an advantage in shallow coastal waters. On the open sea, however, they relied on stealth. The masts and spars were hinged so that they could be lowered to avoid detection, and other tactics included covering the ship's paddle wheels with canvas to muffle the noise, and, for fuel, using Welsh coal, which would burn without the heavy black smoke of anthracite.[11]

Lilienthal's "Man of War," unidentified, is evidently the gunboat *Mahaska*—a 228-foot (69-m) side-wheel "double-ender" built in Portsmouth, New Hampshire, in 1861 and stationed at Algiers during the winter of 1867.[12]

Double-enders were light-draft ships designed for shallow waters. Both ends were fitted with a rudder (their stem and stern were often identical), which allowed the vessels to steam in either direction, a tactical advantage in rivers and harbors.[13] The navy built thirty-nine gunboats of this type during the war for support, reconnaissance, and blockade duties.[14]

The *Mahaska* was assigned to the South Atlantic Blockading Squadron, and saw action in the blockade of Charleston in 1863, as well as the St. John's River in Florida.[15] Double-enders were usually thought to have poor sea-keeping qualities, but the *Mahaska* "behaved well generally," according to her captain in the Florida expedition. "Being a double-ender, with a steering apparatus specially adapted to river service and deeply laden with her armaments and stores, I was agreeably surprised to find her a fair sea vessel," he wrote.[16]

Although Lilienthal's view appears to overcome the technical challenge of photographing a moving vessel, the warship is actually anchored at mid-stream—there is no bow wave and the anchor chain is faintly visible. Photographed from the shore, the swift river current is a milky blur, reflecting the masts and stack of the ship.

1. Donald L. Canney, *Lincoln's Navy: The Ships, Men and Organization, 1861–65*, Annapolis, Md. (Naval Institute Press) 1998, pp. 17, 81.

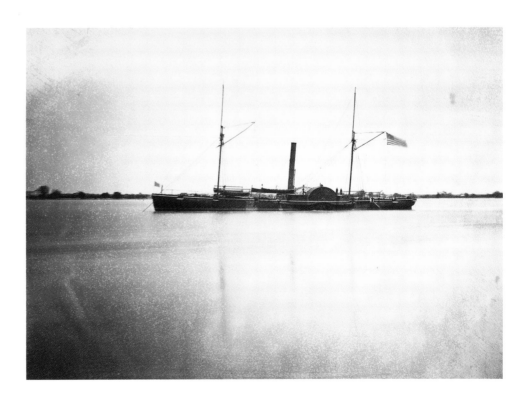

overtake turbulent freshets in the river and to clear the sediment, continuously deposited in the passes, that could shoal sailing ships or steamers. Enormous power was required to drag loaded ships through the mud bars and to pilot the swift waters of the river.

Lilienthal photographed the Vulcan from the West Bank of the river. On the opposite bank, visible just above the prow of the boat, is the massive ruin of the Touro Almshouse, which was destroyed by fire in 1865 (cat. 123).

1. "The Steam Tug Vulcan," *Picayune*, September 9, 1865.
2. Charles R. Schultz, ed., "New Orleans in December 1861," *Louisiana History*, IX, Winter 1968, pp. 53–61.

111
U. S. Monitors
Moniteurs des Etats Unis

Lying at anchor at the Algiers navy yard on the West Bank of the river was a fleet of shallow-draft, ironclad warships known as monitors.[1] Built for the U.S. Navy during the war, the monitors were ordered to New Orleans in May 1866 for defense of the Gulf Coast, and moored in fresh water to minimize corrosion of their iron hulls.[2]

Described by Nathaniel Hawthorne as "ugly, questionable, suspicious, evidently mischievous," the monitors were, according to their inventor, John Ericsson, "not ships, but floating fighting machines."[3] The "unique raft-like structure supporting a turret," as one historian has described it, was part submarine, with a crew of eighty or more quartered below the water line.[4] Its armor plate was 3–5 inches (8–13 cm) thick: "a storm of cannon-shot damages them no more than a handful of dried peas," Hawthorne wrote.[5]

The first monitor-type vessel and namesake of the fleet, the USS *Monitor*, was built under Ericsson's supervision at Greenpoint, New York, and launched in January 1862.[6] Two months later, off Hampton Roads, Virginia, the *Monitor* stopped a rampage by the Confederate ironclad *Virginia*.[7] Although the battle was a stalemate, it played a decisive role in the war, signaling the end of, in Herman Melville's words, "navies old and oaken," and the arrival of steam-powered armored fleets.[8] The *Monitor* brought a new kind of mechanized warfare that removed men, protected by layers of armor, from the direct experience of battle, as David Mindell has shown,

2. On the blockade, see Warren F. Spencer, *The Confederate Navy in Europe*, Tuscaloosa (University of Alabama Press) 1983, pp. 192–93; Stephen R. Wise, *Lifeline of the Confederacy: Blockade Running During the Civil War*, Columbia (University of South Carolina Press) 1988, pp. 3, 25; David G. Surdam, *Northern Naval Superiority and the Economics of the American Civil War*, Columbia (University of South Carolina Press) 2001; Robert M. Browning, Jr., *Success Is All That Was Expected: The South Atlantic Blockading Squadron During the Civil War*, Washington, D.C. (Brassey's, Inc.) 2002, pp. 1–5; Rodman L. Underwood, *The Union Blockade of Texas During the Civil War*, Jefferson, NC (McFarland & Company) 2003, p. 50; Hamilton Cochran, *Blockade Runners of the Confederacy*, Tuscaloosa (University of Alabama Press) 2005, p. 8.
3. William N. Still, Jr., "Technology Afloat," in William N. Still, Jr., John M. Taylor, and Norman C. Delaney, *Raiders & Blockaders: The American Civil War Afloat*, Washington, D.C. (Brassey's, Inc.) 1998, p. 44.
4. Wise, *op. cit.*, p. 4.
5. Surdam, *op. cit.*, p. 170.
6. By comparison, about 2000 ships entered the port of New Orleans alone annually before the war; *ibid.*, p. 5; Wise, *op. cit.*, pp. 3–4. See the romanticized accounts of blockade running given by Captain James Sprunt in *Chronicles of the Cape Fear River*, Raleigh, NC (Edwards & Broughton) 1914, and *id.*, *Tales of the Cape Fear Blockade*, ed. Cornelius M.D. Thomas, Wilmington, NC (Charles Towne Preservation Trust) 1960.
7. Canney, *op. cit.*, p. 81.
8. Spencer, *op. cit.*, p. 193. For a British ship captain's account of running the blockade, see Hobart Pasha, *Sketches from My Life*, New York (D. Appleton & Company) 1887, pp. 87–102.
9. Captain J. Wilkinson, *The Narrative of a Blockade Runner*, cited by Underwood, *op. cit.*, p. 55; Cochran, *op. cit.*, p. 7. ; see also Browning, *op. cit.*, p. 286.
10. Underwood, *op. cit.*, p. 55.
11. Browning, *op. cit.*, p. 286.
12. K. Jack Bauer and Stephen S. Roberts, *Register of Ships in the U.S. Navy 1775–1900: Major Combatants*, New York (Greenwood Press) 1991, p. 79; Donald L. Canney, *The Old Steam Navy*, Annapolis, Md. (Naval Institute Press) 1993, II, p. 110; see also cat. 111, n. 31. The *Mahaska* was pictured in *Harper's Weekly*, VI, no. 286, June 21, 1862, p. 390; VI, no. 287, June 28, 1862, p. 411; VI, no. 291, July 26, 1862, p. 470; VI, no. 295, August 23, 1862, p. 540. She was decommissioned in New Orleans in 1868.
13. Frank M. Bennett, *The Steam Navy of the United States*, Pittsburgh (Warren & Company), 1897, I, pp. 221–29, 357, 395; Roger Chesneau and Eugene M. Kolesnik, eds., *Conway's All the World's Fighting Ships 1860–1905*, New York (Mayflower) 1979, p. 131; Canney, *The Old Steam Navy*, *op. cit.*, II, pp. 109–20; Still, *op. cit.*, p. 44.
14. Canney, *The Old Steam Navy*, *op. cit.*, II, p. 110.
15. Browning, *op. cit.*, p. 236; U.S. Navy, Naval History Center, *Dictionary of American Naval Fighting Ships*, online at history.navy.mil/danfs (accessed March 2007).
16. Edward K. Rawson and Robert Wood, eds., *Official Records of the Union and Confederate Navies in the War of the Rebellion*, Washington, D.C. (Government Printing Office) 1895–1921, ser. I, XVII, p. 806.

110
Tow Boat
Remorqueur du Mississippi

The Drummond, Doig & Company foundry (cat. 8) commissioned the 56-ton, 85-foot (26-m) steam tug *Vulcan* just after the war from the shipyard of J.O.McLean of Algiers.[1] Mississippi River tow-boats like the *Vulcan* were "of great power" and "larger than any used for the same purpose in any other place," as one sailor observed.[2] The tugs were built to

and "redefined the relationship between people and machines in war."[9] In the iron vessel, in this new war of machines, as one sailor observed, "there isn't danger enough to give us glory."[10]

The Hampton Roads engagement secured the *Monitor*'s fame as "the best known warship in American history" and launched a "monitor mania" in the North.[11] "The furor in favor of the monitor style of war vessels became overwhelming, and the Government could scarcely find contractors fast enough to supply the orders for them," the *New York Times* wrote; "... it may well be doubted if any considerable number would have been built, but for the *éclat* created by that memorable contest."[12] The U.S. navy built sixty monitor-type vessels during the war (thirty-seven were commissioned).[13] The cost of building and maintaining the monitor fleet was $200 million, or $2 million per gun, the *New York Times* calculated: "we believe that no other branch of the service can compare with this extravagance."[14]

In a war that saw "unprecedented use of industrial techniques and resources for military operations," ironclads, and the monitor-type vessels in particular, according to one account, "appeared as novel experiments."[15] In this proving ground for new ships and weapons, the monitor incorporated several innovations that predated the war: iron cladding, steam propulsion, the screw propeller, and advanced ordnance. Steam propulsion, already widely adopted for warships, "changed the whole nature of maritime strategy," historian William N. Still, Jr., has observed—a strategy that was no longer dependent on the wind, but now relied on accessibility to coaling stations.[16] The screw propeller eliminated exposed paddle wheels (which were vulnerable to enemy fire) and put engines below the water line, an advantage dramatically exploited in the monitors' design.[17] The monitors' Dahlgren guns fired exploding shells (rather than solid shot) that brought unprecedented fire-power, highly destructive to conventional wooden ships.[18]

Of the monitors' 250 patentable inventions, at least forty were contained in the vessel's steam-powered, revolving gun turret, which has been called "the most successful innovation in nautical warfare of the century."[19] The original Ericsson turret was improved by ironclad builder and engineer James B. Eads (better known today as a designer of bridges).[20] The Eads turret weighed 120 tons and was shielded

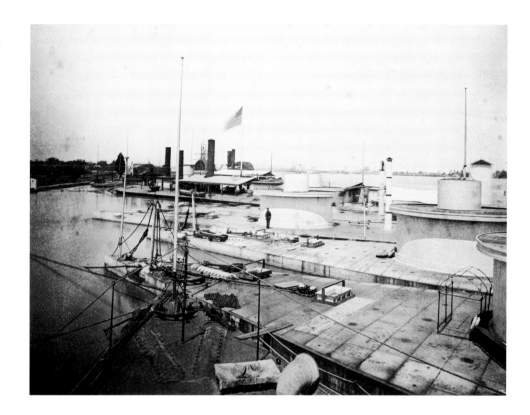

by iron plate as thick as 11 inches (28 cm). Mounted on a steam-powered lift, it was armed below deck and was capable of firing a 180-pound (82-kg) solid iron shot in any direction without the necessity of maneuvering the ship.[21] "Think of monster guns," the *Picayune* wrote, "whose gaping mouths measure diametrically fifteen inches, looking through a solid wall of iron."[22]

Although the most technologically advanced vessels afloat, the monitors had serious—sometimes fatal—drawbacks. Crew comfort and safety were dangerously compromised in what came to be called an "iron coffin." The low freeboard of the vessel meant that the deck was frequently awash, forcing the crew to remain below for long periods of time. A unique ventilation system developed for the monitors often failed to deliver fresh air or clear the air of fumes from the engine room, and in summer the temperature below deck could reach 150°F (65°C).[23] "Think of the sanitary prospects of eighty or a hundred men shut up in a submerged iron encasement, with only about sixty-five cubic feet of air-space to each person," a medical journal wrote in 1864. "Add to this the inevitable humidity and the excessive heat and darkness of the Monitors, and you have the elemental and *inevitable* causes of a fearfully high invalid-rate."[24]

It was not long before the vessels proved they were "not well endowed with sea-keeping qualities."[25] The original *Monitor*, "unable to ride out a moderate gale at sea," went down in December 1862 with all hands on board.[26] Slow sailing, with guns that required as long as eight minutes to load, the monitors were essentially floating batteries that were best suited to harbor and coastal defense and were unfit for the primary mission of the navy— pursuit of blockade runners—or for any offensive operation.[27] They "failed to fulfill the mission," historian Frank M. Bennett wrote in 1897, "and never rendered any service of value to the government."[28] Official naval reports recorded "every form of disparagement of these vessels, except the profanity they evoked from officers and men," another historian wrote.[29] One sailor declared, "They might as well send a lot of men to sea in a wash tub."[30]

In the winter of 1867, three Milwaukee-class double-turreted river monitors and five Canonicus-class single-turreted coastal monitors were stationed at Algiers.[31] The "nest of iron monsters" evoked curiosity, fascination, and some misgivings from Orleanians, many aware of the monitors' legendary wartime feats against the Confederacy. Visitors, among them "several parties of ladies," were carried by ferry to the Algiers station, where they marveled at the

"immense shells and wounds made in the sides of the vessels"—one was an "immense hole" in the hull of the monitor *Winnebago*, "made by a glancing shot from Fort Morgan in Mobile bay."[32] The *Times* reported that "everything is in perfect condition, and it would not take long to put them in fighting trim if an enemy was about."[33]

The indomitable monitors would hardly seem to be suitable messengers of peace, but in New Orleans after the war they were seen as momentary symbols of sectional reconciliation.[34] In February 1867, a steam launch carried 300 guests from Canal Street to the monitors' anchorage for a naval ball aboard ship. "The officers of the Iron-clad fleet will entertain their friends this evening, on board of their vessels, in a manner seldom witnessed in our waters," the *Times* reported.

> One of the grim war monsters has been turned into a huge ballroom, canvassed over, and most profusely decorated with flags of all nations [and] lighted with several hundred wax candles The vessel is shorn of all her warlike proportions, and now looks like an Oriental saloon."[35]

The balls produced "a better feeling" between "the enemy" and residents of the occupied city, one journalist proclaimed.[36] "The feeling that existed between the North and South is gradually dying away, and those that took a most prominent part in the late civil war, are now the first to extend the hand of friendship and good will."[37]

Despite the millions of dollars expended on construction of the monitors, the program was abandoned after the war. The vessels were called "amazing specimens of constructional stupidity," and a government study concluded that they were "failures as originally designed and constructed."[38] As America turned from internal conflict to warlike complications overseas, the vessels were considered "not capable of encountering ships now afloat in Europe" and "worthless" for defense.[39] "As to our keeping an immense fleet, every ship of which eats up as much as it is worth every few years," one journal editorialized, "merely that we may be in condition to bully or browbeat our neighbors ... this is a course ... that will be very likely to secure us a good thrashing from some quarter, some time."[40]

In 1866–68, the navy sold off many of the monitors at Algiers station.[41] Two were purchased by the Peruvian navy, "entirely refitted

... and made as sea-worthy as such monsters can be," the *New York Times* reported.[42] In late 1868, the vessels sailed from Algiers for Peru with an American crew and Peruvian captain, towed by two steamships. The voyage around Cape Horn required six months at sea, with stops at coaling stations every six days.[43]

Still an inspiring spectacle of naval might, the remaining "double-barreled thunderbolts" dropped anchor at the foot of Canal Street in September 1874 during the White League rebellion, an armed insurrection by white-supremacists against the federally supported Reconstruction government.[44] Ironically, when the monitors, which had "been lying down idly in the river for many years," were finally called to service, only a few were still stationed at Algiers; most had been sold at auction two days before the insurrection to McKay shipyards in Boston and other northern industrialists, apparently for use in a Cuban filibuster.[45] The sale price of an average of $8500 was a small fraction of the vessels' construction cost of half a million dollars or more apiece eight or ten years earlier. All the monitors in the U.S. navy were eventually broken up or sold, the last in 1908.[46] Income from the sales, as has been shown, was applied to help recoup losses from profiteering scandals associated with fraudulent wartime contracts to build the monitors. "There have been the grossest abuses practiced in this business of iron-clad vessels," one Congressman declared.[47]

Lilienthal's photograph of these fascinating warships undoubtedly held special interest for a European audience at the Exposition. France had launched the world's first seagoing ironclad, the *Gloire*, in 1859, and there was great interest in the American ironclads abroad, as one observer wrote: "this question of armored vessels seems to be preoccupying one after the other of all the governments of Europe."[48] The *Monitor* experiment held symbolic value as an example of American innovation, and Napoléon III, in particular, recognized its importance.[49] Receiving reports of the Hampton Roads engagement, the emperor ordered modernization of the French fleet, reportedly announcing that "it is now settled that there is no navy in the world that can make head against ironclad boats."[50]

In 1863, shipyards in Bordeaux and Nantes outfitted warships for the Confederate navy, including two ironclad batteries designed for use in the Mississippi River.[51] The emperor,

however, observing France's declared neutrality in the American conflict, would not permit the new Confederate ships to sail. The efforts of the special commissioner of the Confederacy in France, John Slidell of Louisiana, and other Confederate agents to persuade Napoléon III directly to aid the South, which he seemed inclined to support, failed. John Bigelow, the U.S. minister to the imperial court, wrote that the French-built ships "would have enabled its commander to strike severe and telling blows upon the Northern seaboard."[52]

Lilienthal mounted his tripod and camera on the deck of an ironclad steamer moored with the monitors; its bow is visible in the foreground. Four monitors can be seen here, and the geometry of deck plates, bowstaffs, turrets, and chimneys forms a striking composition. In the far distance, the massive side wheels of an ironclad ram and the tall masts of a sailing ship are visible. A spectral United States flag flies above a construction barge, and a lone sentry stands on the deck of one of the monitors, its foredeck ghosted by the vessel's drift.[53]

1. "A Nest of Iron Monsters," *Picayune*, August 27, 1867.
2. "An Iron Clad Fleet," *Times*, July 23, 1866; "The Iron-Clad Fleet," *Times*, May 20, 1868.
3. Nathaniel Hawthorne, "Chiefly About War Matters by a Peaceable Man," *Atlantic Monthly*, July 1862, p. 58, cited by David A. Mindell, *War, Technology, and Experience Aboard the USS Monitor*, Baltimore (Johns Hopkins University Press) 2000, p. 84; Ericsson quoted in *ibid.*, p. 121.
4. William N. Still, Jr., "The Historical Importance of the USS Monitor," in William N. Still, Jr., John M. Taylor, and Norman C. Delaney, *Raiders & Blockaders: The American Civil War Afloat*, Washington, D.C. (Brassey's, Inc.) 1998, pp. 13, 18.
5. Hawthorne, *op. cit.*, cited by Mindell, *op. cit.*, p. 63.
6. Donald L. Canney, *The Old Steam Navy*, Annapolis, Md. (Naval Institute Press) 1993, II, pp. 25–30; *id.*, *Lincoln's Navy: The Ships, Men and Organization, 1861–65*, Annapolis, Md. (Naval Institute Press) 1998, pp. 83–86; Mindell, *op. cit.* pp. 43–48; William H. Roberts, *The U.S. Navy and Industrial Mobilization*, Baltimore (Johns Hopkins University Press) 2002, p. 4.
7. "The Blockade Disturbed," *Picayune*, March 11, 1862. The CSS *Virginia* is often referred to by its former name, the USS *Merrimack*.
8. Mindell, *op. cit.*, pp. 6, 125.
9. *Ibid.*, p. 7.
10. *Ibid.*, p. 2.
11. Still, "The Historical Importance," *op. cit.*, p. 20.
12. "The Monitors and their Armaments," *New York Times*, July 26, 1867.
13. Canney, *The Old Steam Navy*, *op. cit.*, II, p. 75.
14. *Ibid.*; "The Monitors and their Armaments," *op. cit.*
15. Mindell, *op. cit.*, p. 4.
16. William N. Still, Jr., "Technology Afloat," in William N. Still, Jr., John M. Taylor, and Norman C. Delaney, *Raiders & Blockaders: The American Civil War Afloat*, Washington, D.C. (Brassey's, Inc.) 1998, p. 51.

17. Mindell, *op. cit.*, pp. 18–19.

18. Still, "Technology Afloat," *op. cit.*, p. 38; Mindell, *op. cit.*, p. 119.

19. James Phinney Baxter, *The Introduction of the Ironclad Warship*, Cambridge, Mass. (Harvard University Press) 1933, p. 181; Still, "Technology Afloat," *op. cit.*, pp. 18–19.

20. Canney, *The Old Steam Navy, op. cit.*, II, pp. 114–16.

21. Still, "Technology Afloat," *op. cit.*, p. 43.

22. "A Nest of Iron Monsters," *op. cit.*

23. Mindell, *op. cit.*, pp. 65–66.

24. "The Ventilation of the Iron-Clads," *Sanitary Commission Bulletin*, I, no. 7, February 1, 1864, p. 215.

25. Baxter, *op. cit.*, p. 304; Still, "Technology Afloat," *op. cit.*, p. 43.

26. "The Monitors and their Armaments," *op. cit.* The USS *Monitor* was recovered off Cape Hatteras, North Carolina, in 2002; see "Saving the Ship that Revolutionized War at Sea," *New York Times*, December 2, 1997; "Retrieval Efforts Aim to Bring Ironclad Monitor Back to Life," *New York Times*, July 30, 2002.

27. Still, "Technology Afloat," *op. cit.*, p. 43.

28. Frank M. Bennett, *The Steam Navy of the United States*, Pittsburgh (Warren & Company) 1897, I, pp. 392–95 (see also I, pp. 483–93).

29. Francis Trevelyan Miller, *The Photographic History of the Civil War*, New York (Review of Reviews Co.) 1912, III, p. 177.

30. Canney, *The Old Steam Navy, op. cit.*, II, p. 755.

31. At Algiers station in early 1867 were three Milwaukee-class double-turreted river monitors (*Kickapoo, Winnebago, Chickasaw*) and five Canonicus-class single-turreted coastal monitors (*Manhattan, Manayunk, Catawba, Tippecanoe, Oneota*). Four of these monitors were commissioned after the war (all of the Canonicus class, except the *Manhattan*). The *Kickapoo* saw no action in the war, but the *Manhattan, Winnebago,* and *Chickasaw* participated in the battle of Mobile Bay, where the *Winnebago* took nineteen hits. At Mobile Bay, the *Manhattan* captured the Confederate ram CSS *Tennessee*, which was also stationed at Algiers (the *Tennessee* was the largest vessel built by the Confederacy—it took on the entire Union fleet at Mobile—and may be the ram visible in the distance in Lilienthal's view). Also at Algiers were the CSS *Nashville*, another captured ram, the Union ram *Osage*, and the gunboat *Mahaska* (see cat. 109). The monitors *Catawba* and *Oneota* were sold to Peru in 1868 (see n. 41); the *Kickapoo* and *Chickasaw* were sold in 1874; the *Tippecanoe* and *Manayunk* in 1899; and the *Manhattan* in 1902. The *Chickasaw* existed until 1944 as a river ferry, one of the last surviving Civil War monitors. "An Iron Clad Fleet," *Times, op. cit*; "The Iron Clad Fleet," *Crescent*, February 26, 1867; "The Iron-Clad Fleet," *Times, op. cit.*; *Official Records of the Union and Confederate Navies in the War of the Rebellion*, Edward K. Rawson and Robert Wood, eds., Washington, D.C. (Government Printing Office) 1895–1921, ser. 1, II, p. 376; XV, pp. 127, 1092; XXII, pp. 106–107, 191–93, 231, 252; XXIII, pp. 224, 381; XXVI, p. 579; XXVII, pp. 277, 290; ser. 2, I, pp. 121, 165; Frank M. Bennett, *The Steam Navy of the United States*, Pittsburgh (Warren & Company) 1897, I, pp. 440–41; Canney, *The Old Steam Navy, op. cit.*, II, pp. 84–88, 114–18, 138; *id., Lincoln's Navy, op. cit.*, pp. 18–19, 81, 91–93.

32. "The Iron Clad Fleet," *Crescent, op. cit.*; "A Nest of Iron Monsters," *op. cit.*

33. "An Iron Clad Fleet," *Times, op. cit.*

34. "The Iron Clads," *Times*, February 2, 1867.

35. "Ball of the Iron-Clad Fleet," *Times*, February 1, 1867.

36. "Ball of the Iron-Clad Fleet," *Times, op. cit.*

37. "The Iron-Clad Fleet," *Times, op. cit.* Only a few months later a yellow-fever epidemic, the first since the outbreak of the war, hit hard at the Algiers station, afflicting sixty-five crew and ten officers. The illness spread quickly in the sailors' close quarters below deck, and mortality was high; "The Fever in New-Orleans," *New York Times*, August 31, 1867; "Sickness on the Ironclads," *Picayune*, September 3, 1867.

38. U.S. Congress, Joint Committee on the Conduct of the War, *Light-Draught Monitors*, December 15, 1864, Washington, D.C. (Government Printing Office) 1864, p. 11; "The Proposed Iron-Clad Trade," *New York Times*, January 11, 1868.

39. "The Monitors and their Armaments," *New York Times, op. cit.*

40. "What Need of Our Iron-Clads Now," *Advocate of Peace*, March–April 1868, p. 41.

41. "Important Sale of U.S. Iron-Clads," *Picayune*, March 13 and 28, 1866; "The Ironclads," *New York Times*, June 9, 1867; "The Proposed Iron-Clad Trade," *New York Times*, January 11, 1868; "The Peruvian Iron-Clads," *Picayune*, June 7, 1868; "Sale of the Iron-Clads," 40th Cong., 2d sess., H. Rep. No. 64, June 19, 1868, Washington, D.C. (Government Printing Office) 1868; "The Monitors at New-Orleans," *New York Times*, September 1, 1869; George Paloczi-Horvath, *From Monitor to Missile Boat: Coast Defense Ships and Coastal Defense since 1860*, Annapolis, Md. (Naval Institute Press) 1996, "Appendix A."

42. "The Peruvian Iron-Clads," *New York Times*, December 11, 1868.

43. "The Attempted Breach of the Neutrality Laws," *New York Times*, June 10, 1868.

44. "Affairs in Louisiana," *New York Times*, September 19, 1874.

45. "Monitors Sold at New-Orleans," *New York Times*, September 17, 1874.

46. Bennett, *op. cit.*, II, pp. 627–32; Canney, *The Old Steam Navy, op. cit.*, II, pp. 137–39.

47. Roberts, *op. cit.*, p. 180.

48. Lynn M. Case and Warren F. Spencer, *The United States and France: Civil War Diplomacy*, Philadelphia (University of Pennsylvania Press) 1970, p. 268.

49. Still, "The Historical Importance," *op. cit.*, p. 17.

50. Case and Spencer, *op. cit.*, p. 267.

51. James D. Bulloch, *The Secret Service of the Confederate States in Europe; or, How the Confederate Cruisers Were Equipped*, New York (Modern Library) 2001 [orig. published in 1884], pp. 331–54.

52. *Ibid.*, p. 344.

53. Lilienthal published a stereoview of a river monitor in 1866 or 1867 (in the collection of Mr. and Mrs. Eugene Groves). A Samuel T. Blessing stereoview, "Monitors at the Levee," is in the Louisiana Collection, New Orleans Public Library.

112 *overleaf*
Urselines Convent
Convent des Urselines

The Ursulines was one of the most influential women's religious organizations in seventeenth- and early eighteenth-century France, and played a major role in the settlement of the French colony of New Orleans.[1] In 1727, a mission of the Ursulines of Rouen established a community of laywomen in New Orleans with "a special zeal for visiting the sick, the relief of the poor and the instruction of their children and their slaves."[2] Many of the confrères were wives and daughters of slaveholding planters, and their work in the education and conversion of slaves to Christianity had an enormous impact on the local black community. As historian Emily Clark has shown, the Ursulines succeeded in raising the literacy of New Orleans women, both black and white, to levels that were among the highest in colonial America.[3]

The Ursulines' community was cloistered initially in a house in the Vieux Carré, and from 1734 in a convent designed by Alexandre De Batz near the Levee.[4] After only a decade this convent was obsolete, and François Broutin provided plans for a new building, completed in 1750, which still stands on Chartres Street.[5] When street construction in the Vieux Carré encroached upon their convent, the Ursulines made plans to move 2 miles (3 km) downriver to an old plantation property they had acquired.[6] In 1823–24, the builders Claude Gurlie and Joseph Guillot erected a new convent in the Third District, photographed here, on Dauphine Street at the Levee.

The Dauphine Street convent was originally a two-story brick building with wide galleries and a low-pitched, hipped roof. An attic level and a baroque clock tower were added later.[7] Wings extending back from the main block formed a cloister and in 1830 Gurlie and Guillot built a chapel, visible to the far right in the photograph; its baroque pediment was a mid-century addition. A hipped-roof house in the foreground survived from the early plantation and probably served as an orphanage.[8] A porter's lodge is to the far left and the gardens are visible just beyond the fence. Upon moving to the new convent in 1824 one of the Ursulines described it as "beautiful for this country" and the grounds, planted with stands of oak, cedar, pecan, and magnolia, as "very salubrious, where we can walk and breathe with ease."[9] Author Joseph Holt Ingraham, admitted to the grounds in the 1830s, wrote that the convent was "a very large and handsome two story edifice, with a high Spanish roof, heavy cornices, deep windows, half concealed by the foliage of orange and lemon trees, and stuccoed, in imitation of rough white marble."[10]

Lilienthal's riverside view of the convent and the river underscores its seclusion, detached from the city and the river by the tall plank fence that bisects the photograph. Encroachment of the river and decaying levees forced abandonment of the convent in 1912, when the Ursulines moved far uptown to State

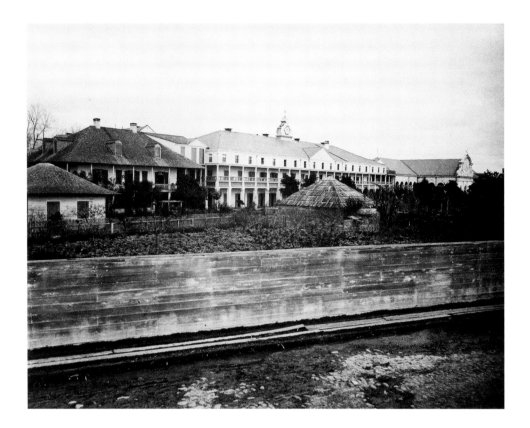

The Louisiana Sugar Refinery was located at
Reynes Street and the Levee, near the U.S.
Hospital and Barracks (cats. 114–17). It was
built in 1831–32 by Norbert Soulié and Edmond
Rillieux, both free men of color, for owners
Edmond J. Forstall and John George, a British
sugar refiner.[1] The cost of building and outfitting
the refinery was $370,000, an enormous sum
at the time (Charity Hospital [cat. 69], begun
the same year, was built for $150,000). In the
1830s, the refinery produced 12 million pounds
(5.5 million kg) of "the best loaf sugar" annually,
as well as molasses and rum. It was reported
to be the "most extensive and complete
establishment of the kind in the whole world,"
shipping refined sugar throughout the country
and to Europe and Mexico.[2]

An innovator in refining technology, the
Louisiana Sugar Refinery was probably one
of the earliest factories in America to utilize a
vacuum evaporation technique (in which closed
retorts replaced open kettles) invented by
British chemist Edward Charles Howard—a
technology George probably brought with him
from London.[3] In 1833, Forstall hired Norbert
Rillieux (builder Edmond Rillieux's older
brother) as head engineer for the plant. Rillieux,
a free black born in New Orleans and educated
in Paris, was an engineering instructor at the
Paris École Centrale, where he researched
the application of steam power to sugar
manufacture. On his return to New Orleans he
began to develop an evaporation technique,
apparently derived from Howard's methods,
of boiling cane juice in vacuum pans using the
steam from one pan to heat another, greatly
reducing fuel consumption. In 1843, Rillieux
patented the method, described by one
historian as "the premier engineering
achievement in nineteenth-century sugar
technology."[4] Widely adopted in the decade
before the war, Rillieux's patent has been
generally credited with modernizing the industry.

One of New Orleans's largest industrial
plants, the refinery was also among the city's
largest antebellum slaveholders. "The work is
done chiefly through the instrumentality of
negroes," the *Bee* observed in 1836, "under the
superintendence of a gentleman who knows
how to value and use negro labor."[5] In 1850,
the refinery had a workforce of about one

Street. Six years later, the old convent was
destroyed for construction of the Industrial
Canal (the waterway that breached its
embankment and flooded the adjacent Lower
Ninth Ward after hurricane Katrina in 2005).
The lost convent was extensively documented
in photographs by an Ursuline, Marie Fourant,
Mother Marie de la St. Croix, who produced
large-format views of the Ursuline buildings from
about 1888 until 1912. Her photographs were
exhibited at the St. Louis World's Fair of 1904
and survive in several New Orleans collections.[11]

The Ursuline Convent is, with Charity
Hospital (cat. 69), the oldest institution
documented in the Lilienthal portfolio. The
continuity of both institutions was interrupted
tragically by hurricane Katrina, when Charity
was forced to close, apparently permanently,
owing to floodwater damage, and the Ursulines
were compelled to abandon their convent for
the first time in 278 years.

1. Emily Clark, "By All the Conduct of Their Lives:
A Laywomen's Confraternity in New Orleans, 1740–1744,"
William and Mary Quarterly, 3d ser., CIV, no. 4, October 1997,
pp. 769–94; *ead.*, "The Ursulines: New Perspectives on 275
Years in New Orleans," *Historic New Orleans Collection
Quarterly*, XX, no. 3, Summer 2002, pp. 2–5. Also on the
history of the Ursulines, see *The Ursulines in Louisiana,
1727–1824*, New Orleans (Hyman Smith) 1886; Sister Jane
Frances Heaney, *A Century of Pioneering: A History of the
Ursuline Nuns in New Orleans, 1727–1827*, New Orleans
(Ursuline Sisters) 1993.
2. *Premier Registre of the Confraternity*, dated to 1739–44
by Clark, *op. cit.*, p. 778.
3. *Ibid.*
4. Samuel Wilson, Jr., "An Architectural History of the Royal
Hospital and the Ursuline Convent of New Orleans," in
The Architecture of Colonial Louisiana, edited by Jean M.
Farnsworth and Ann M. Masson, Lafayette (Center for
Louisiana Studies, University of Southwestern Louisiana)
1987, pp. 161–220. The De Batz drawings are in the
National Archives, Paris; see also *id.*, "Louisiana Drawings by
Alexandre De Batz," in *The Architecture of Colonial Louisiana*,
op. cit., pp. 261–74.
5. The Chartres Street convent is today the only building in
New Orleans to survive from the French colonial period.
6. *Norman's New Orleans and Environs*, p. 104; Henry
Churchill Semple, *The Ursulines in New Orleans and Our Lady
of Prompt Succor: A Record of Two Centuries, 1727–1925*,
New York (P.J. Kennedy & Sons) 1925, p. 87.
7. Wilson, "An Architectural History," *op. cit.*, pp. 201–202.
8. A similar hipped-roof structure used by the nuns as
a chaplain's residence also survived from the Duplessis
plantation. Located directly in front of the chapel, it is not
visible in the photograph. See Wilson, "An Architectural
History," *op. cit.*, p. 203.
9. Heaney, *op. cit.*, p. 277.
10. Joseph Holt Ingraham, *The South-west, by a Yankee*, New
York (Harper & Brothers) 1835, I, p. 193.
11. Mother St. Croix's photographs, as large as 14 × 17 inches
(35.6 × 43.2 cm), are in the Louisiana State Museum, the
Southeastern Architectural Archive, Tulane University, and
the Ursuline Convent Archives and Museum. See the exhibition
catalog by Tina Freeman, *The Photographs of Mother
St. Croix*, New Orleans (New Orleans Museum of Art) 1983.

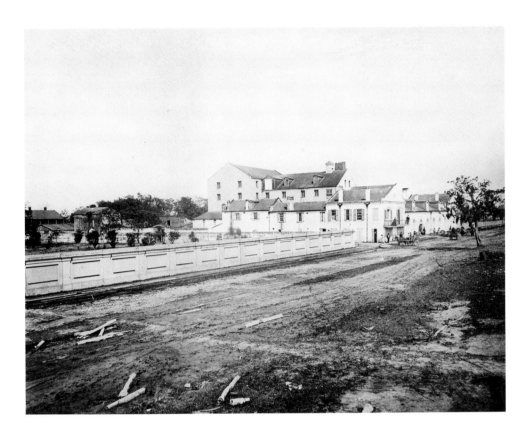

hundred slaves, comparable to the largest cotton presses but fewer than the Pontchartrain and Jackson railroads, which were the largest urban slaveholders.[6]

Driven by a robust sugar market, the refinery was at first a commercial success, but by 1867 it was in financial ruin—a casualty of the collapse of sugar production in Louisiana during the war. Soon after this photograph was made, the parish sheriff seized the property and put it up for auction "with all the machinery and fixtures attached."[7]

The sugar industry had been Louisiana's most important antebellum industry, but the war left sugar houses everywhere "neglected and weed covered," if not plundered or burned by invading federal troops.[8] The "tide of conquest and the devastation of defeat," the *Times* wrote in 1866, "destroyed sugar manufacture to such a wide extent that Louisiana to this day does not produce enough sugar for home consumption [and] does not yield sufficient to satisfy the demand of our refineries."[9] With the decline of Louisiana sugar, imported Cuban sugar seized the market and reportedly "filled the sugar bowls of all classes," even in the South.[10] Cuban cane could grow to full maturity in frost-free soils, producing sugar of higher quality than Louisiana cane, which had a shorter growing season.

Cash-poor and much of their capital lost, and with a scarcity of credit to bring sugar to market, the sugar producers' future lay not in the great broadland plantations of the antebellum era, cultivated by slave labor, but in small farms. "No more shall the old time sugar planter ... witness the labor of his hundred hands," the *Times* predicted in 1866; "... the whole system has changed ... in which plantation sugar making finds no place."[11]

Lilienthal's elevated viewpoint takes in a large extent of the "irregular pile" of refinery buildings, with their many chimneys and dormers, and the broad levee, but the workers and carriages assembled for the camera are too distant to make out.[12] Lilienthal often partitions the frame with a strong diagonal—here a wall enclosing a vegetable farm opposite the refinery—enhancing the perception of depth in the photograph.[13] The main subject in this view appears to be the expansive, unimproved, cane-strewn levee that defines the industrial waterfront of New Orleans.

Lilienthal's view is the photographic equivalent of a lithographed view of the refinery published thirty years earlier in a popular guidebook, *Gibson's Guide*, which also emphasizes the factory's relationship to the Levee.[14]

1. Edmond J. Forstall and John George, "Refined Sugar," *Niles Weekly Register*, XLII, April 21, 1832, p. 149; "[Forstall & Co.]," *Niles Weekly Register*, XLVI, May 10, 1834, p. 174; *Advertiser*, May 27, 1834; *Gibson's Guide*, pp. 318–19; *Bee*, April 2, 1836; *American Farmer*, ser. IV, XII, 1856, pp. 131–32; Victor S. Clark, *History of Manufactures in the United States*, New York (Peter Smith) 1949, I, p. 491. The works can be seen clearly in Charles F. Zimpel, *Topographical Map of New Orleans and Its Vicinity*, 1834, and a lithograph plan for a property auction in October 1869, *Plan of 87 Squares and Parts of Squares ... in the Third District*, New Orleans (J. Manouvrier) 1869, p. 1. Soulié trained as an architect with Henry Latrobe in 1811–17, when Latrobe was working in New Orleans. Soulié and Rillieux were cousins, and the refinery venture was backed by Vincent Rillieux, Edmond's father, a cotton factor and press owner. Edmond left New Orleans abruptly during construction of the refinery, and Soulié also left the city, relocating to Paris, in 1833; see Christopher Benfey, *Degas in New Orleans*, Berkeley (University of California Press) 1997, pp. 24–29, 128, 135.
2. "[Forstall & Co.]," *Niles Weekly Register, op. cit.*; *Gibson's Guide*, pp. 318–19; *Bee, op. cit.* Henry Howard designed an addition to the Refinery in the 1850s.
3. *Gibson's Guide*, pp. 318–19; J.S. Buckingham, *The Slave States of America*, London (Fisher, Son & Co.) 1842, I, p. 338; Frederick Kurzer, "The Life and Work of Edward Charles Howard, FRS," *Annals of Science*, LVI, 1999, pp. 133–37. The Howard vacuum pan was also adopted in 1832 by planter Thomas Morgan at Orange Grove plantation (cat. 118); see John Alfred Heitmann, *The Modernization of the Louisiana Sugar Industry, 1830–1910*, Baton Rouge (Louisiana State University Press) 1987, p. 33.
4. Heitmann, *op. cit.*, p. 17 (quotation), and further, on Rillieux, pp. 16, 37–39. See also J.P. Benjamin, "Louisiana Sugar," *De Bow's Review*, II, no. 5, November 1846, p. 344; N. Rillieux, "Sugar Making in Louisiana," *Commercial Review of the South and West*, V, no. 3, March 1848, pp. 285–90; "Norbert Rillieux," *Louisiana Planter and Sugar Manufacturer*, XIII, 1894, pp. 285, 333; Clement Eaton, *The Growth of Southern Civilization, 1790–1860*, New York (Harper & Brothers) 1961, p. 134; and Benfey, *op. cit.*, pp. 29, 125–33, who cites George P. Meade, "A Negro Scientist of Slavery Days," *Scientific Monthly*, LXII, 1946, pp. 317–26.
5. *Bee, op. cit.*
6. Robert S. Starobin, *Industrial Slavery in the Old South*, New York (Oxford University Press) 1970, pp. 19–22, 28, 128.
7. "Sheriff's Sale of Fine Property," *Picayune*, April 6, 1867. Local competition for a share of the diminished crop was undoubtedly a factor in the sale. Large industrial refineries operating in 1866 included the Crescent City Refinery at Julia and Tchoupitoulas streets, the Goodale Steam Refinery at New Levee (South Peters) and Girod streets, the Hanna Refinery at Magazine and Girod streets, and the Battle Ground Refinery downriver; *Times*, April 20, 1866.
8. *De Bow's Review*, IV, no. 3, September 1867, p. 238; Charles P. Roland, *Louisiana Sugar Plantations During the Civil War*, Baton Rouge (Louisiana State University Press) 1997, pp. 65–71.
9. "A Glance at New Orleans Manufactures and Arts: Sugar Making in Louisiana," *Times*, January 9, 1866.
10. *Ibid.*
11. *Ibid.*
12. *Gibson's Guide*, pp. 318–19. The refinery was situated in the vicinity of Camp Dupré, a stronghold against British troops in the battle of New Orleans in 1815. French colonial structures were still standing there in the 1860s; one of these may be the galleried structure visible at the left edge

of the photograph. See "The Environs of New Orleans,"
Crescent, May 3 and 29, 1866.
13. Compare the use of this partitioning device in the views
of the Vicksburg Cotton Press, Charity Hospital, and Lane
Cotton Mill (cats. 10, 69, and 100).
14. On the precedents for Lilienthal's topography of New
Orleans, see "Introduction," pp. 28–31.

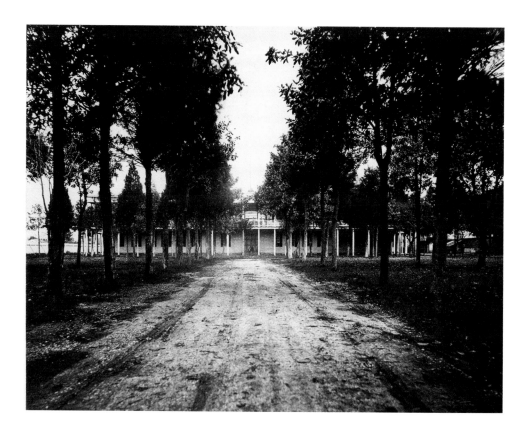

114
Entrance of U. S. Hospital
Entreé de l'Hopital Militaire

The U.S. Military Hospital, located 3 miles
(4.8 km) below the city on a riverfront site, had
its origin in the American war with Mexico of
1846–48, a conflict that arose over the
annexation of Texas and territorial interests of
the U.S. in northern Mexico. The Mexican War
positioned New Orleans, the largest city west
of the Alleghenies, and the gateway to Texas,
as "the grand military depot of a vast section of
the country."[1] "The city of New Orleans had
been our channel and *entrepôt* for everything,
going and returning," Walt Whitman, who
worked for a local newspaper during the war,
later wrote.[2] Outgoing were troops, including
local volunteer militia, outfitted in New Orleans,
and returning were thousands of casualties
who had been evacuated from Vera Cruz by
ship. Malaria and other diseases were so
widespread among the troops in Mexico that in
early 1848 over a quarter of the American
soldiers were ill. Those who survived the arduous
journey to New Orleans arrived at facilities that
were ill-equipped to care for them.[3]

In March 1848, Secretary of War W.S.
Marcy ordered Surgeon General Thomas
Lawson to New Orleans to purchase ground
and supervise the erection of a hospital to
accommodate the large number of sick and
wounded soldiers arriving there.[4] Years earlier,
as a young field officer leading troops through
the Louisiana backswamps, Lawson had
witnessed appalling mortality when his soldiers
were removed to the "very incommodious and
in every respect very objectionable" military
hospital at New Orleans.[5] Lawson was now
finally authorized to address the critical need
for a new facility, which he designed in
collaboration with an architect named Elrey
and builder W.P. Kelsey. The hospital opened in
March 1849.

As with the adjacent garrison, Jackson
Barracks (cats. 116 and 117), the hospital's
downriver site was "almost impracticable"

to reach in wet weather, and far from the
center of the city.[6] But the hospital was a
salubrious retreat, its spacious and "thickly
shaded" grounds laid out with, as one visitor
observed, "every variety of flower and shrub
and tree which will flourish in the soil and
climate of Louisiana."[7] With the "appearance of
a paradise more than a hospital," according to
the *Crescent*, the building was "almost
tempting enough to swell unduly the sick list."[8]

In Lilienthal's photograph, the entrance
pavilion is framed by an *allée* of trees at the
approach to the grounds. Although the view
provides little information about the buildings,
it nevertheless gives a powerful impression of
the wooded, riverine setting.

1. "The United States Military Hospital," *Picayune*,
December 7, 1848.
2. Walt Whitman, "New Orleans in 1848," *Picayune*,
January 25, 1887, reprinted in Floyd Stovall, ed., *The
Collected Writings of Walt Whitman: Prose Works 1892*,
New York (New York University Press) 1964, II, pp. 604–10.
3. Mary C. Gillett, *The Army Medical Department, 1818–1865*,
Washington, D.C. (Center for Military History) 1987, pp. 122–23.
4. W.S. Marcy to General George M. Brooke, U.S. Army,
March 31, 1848, Letters Sent by the Secretary of War
William Marcy to General Officers in the Field During the
Mexican War, 1847–48, I, fol. 38, Records of the Office of
the Secretary of War, RG107, NARA.
5. Thomas Lawson to Surgeon General Joseph Lowell, July 1,
1822, Letters Sent by Surgeon Thomas Lawson, Central
Office Records of the Individual Medical Officers, Records of
the Surgeon General, RG112, NARA.
6. "New Marine Hospital," *True Delta*, May 25, 1854.
7. "An Excursion to the U.S. Barracks," *Picayune*, March 3,
1849; United States Surgeon General's Office, *A Report on
Barracks and Hospitals with Descriptions of Military Posts*,
Washington, D.C. (Government Printing Office) 1870, p. 164.
For another description of the gardens, see Ferencz Aurelius
Pulszky, *White, Red, Black: Sketches of Society in the United
States*, New York (J.S. Redfield) 1853, II, p. 100.
8. "An Excursion to the U.S. Barracks," *op. cit.*; "United States
Hospital," *Crescent*, March 6, 1849.

115
Interior of U. S. Hospital
Interieur de l'Hopital Militaire

The U.S. Hospital site was a narrow wedge of land covering about 20 acres (8 ha), fronting on the river and extending back to Good Children Street and the Mexican Gulf Railroad at Gentilly Ridge.[1] The quaggy swampland was cleared and drained for building in the spring of 1848, and by December, four two-story ward buildings, two service buildings, and eight cypress cisterns had been erected.[2] The hospital buildings were "constructed on the very best plan to secure light and ventilation" to the wards, which opened on to broad, encircling galleries that captured river breezes and provided shelter from the sun and rain.[3] A center courtyard was "tastefully laid out in serpentine walks" and thickly shelled, with a "white and frosty appearance," according to one visitor, forming a striking contrast to the green turf. The hospital campus was, the *Crescent* wrote, "one of the most delightful prospects on the river."[4]

The final building to be completed in early 1849 was the centerpiece of the campus: a domed, octagonal dispensary of "architectural pretensions" originally designed as a surgical theater.[5] This rotunda, 27 feet (8 m) in diameter, had a spiral stair that ascended to a cupola from which the visitor could "take a survey of the surrounding country." It may have been modeled on James Gallier's new operating theater for Charity Hospital, opened in 1847.[6] The composition of the campus—a centrally placed domed building bounded by ward buildings in a courtyard that was open at one end—was similar to the celebrated plan of Union College, Schenectady, by Joseph Jacques Ramée (1813), and may have been derived from it.[7]

Completed after the end of the Mexican conflict, the wooden buildings, erected quickly and of poor construction, were ill-suited to the damp climate. After having been in use for barely a year, the hospital was reported to be "in a condition of rapid decay," and a short time later a visitor found "only a few invalids there."[8] Military inspectors were called in and reported badly leaking roofs—"water percolated through both ceilings and floors," they noted, and the construction was "very defective". The city laid a new plank road and opened an omnibus line to the hospital, helping to mitigate the great distance from the city that was the greatest

drawback of the site, but the military made few improvements.[9] During the 1850s, the army proposed that the hospital be put to use as an asylum for "impaired and broken" soldiers who "need a long interval of repose," but inspectors now found the facility in "such a dilapidated condition as to render it uninhabitable."[10]

Despite its condition, the hospital was occupied by the Marine Hospital Service until the Confederate Army seized the campus in 1861 (cat. 117).[11] Returned to use as a military hospital during the war, by the early 1870s the buildings were largely abandoned and their demolition was recommended.[12] Removal did not begin until the early 1880s, and in 1890 a new post hospital was erected.[13] In the mid-1930s, Works Progress Administration housing covered most of the hospital site. Following hurricane Katrina in 2005, the Louisiana National Guard, owner of the property, announced plans to demolish flood-damaged housing there as part of its base renovations.[14]

1. Sale of Property, May 19, 1848, L. Badins to U.S. of America, C.O.B. 44, pp. 579–80, NONA.
2. "The United States Military Hospital," *Picayune*, December 7, 1848.
3. "An Excursion to the U.S. Barracks," *Picayune*, March 3, 1849; "New Marine Hospital," *True Delta*, May 25, 1854.
4. "United States Hospital," *Crescent*, March 6, 1849.

5. "The United States Military Hospital," *op. cit.*
6. *Ibid*. See cat. 69.
7. On Union College, Paul V. Turner, *Joseph Ramée: International Architect of the Revolutionary Era*, New York (Cambridge University Press) 1996, pp. 189–216 and 331, n. 85.
8. "Report of the Board of Survey on U.S. Barracks, October 16, 1849," Consolidated Correspondence File, 1794–1915, Records of the Office of the Quartermaster General, RG92, NARA; Ferencz Aurelius Pulszky, *White, Red, Black: Sketches of Society in the United States*, New York (J.S. Redfield) 1853, II, p. 100.
9. J. Ross Browne, Special Agent of the Treasury Department, to Secretary James Guthrie, May 18, 1854, General Correspondence, Letters Received, New Orleans Marine Hospital, Records of the Public Buildings Service, RG121, NARA; Dr. Mercier, Chief Surgeon, New Orleans Marine Hospital, to Secretary James Guthrie, March 27, 1854, General Correspondence, Letters Received, New Orleans Marine Hospital, Records of the Public Buildings Service, RG121, NARA.
10. "The United States Military Hospital," *op. cit.*; Surgeon General Lawson to Major General D.E. Twiggs, February 19 and March 19, 1851, Letters and Endorsements Sent, April 1818–October 1889, XX, fols. 391, 428, Central Office Correspondence, 1818–1946, Records of the Surgeon General, RG112, NARA; Collector of Customs F.H. Hatch to Treasury Secretary Howell Cobb, May 30, 1858, Letters Sent, Correspondence of the Marine Hospital Service, Records of the Public Health Service, RG90, NARA.
11. "New Marine Hospital," *True Delta*, May 25, 1854; William E. Rooney, "The First 'Incident' of Secession: Seizure of the New Orleans Marine Hospital," *Louisiana Historical Quarterly*, XI, March 1983, pp. 135–42; *War of the Rebellion: Official Records of the Union and Confederate Armies*, Washington, D.C. (Government Printing Office), 1894–1922, ser. I, LIII, p. 611.
12. "List of Buildings Used for Government Purposes at the

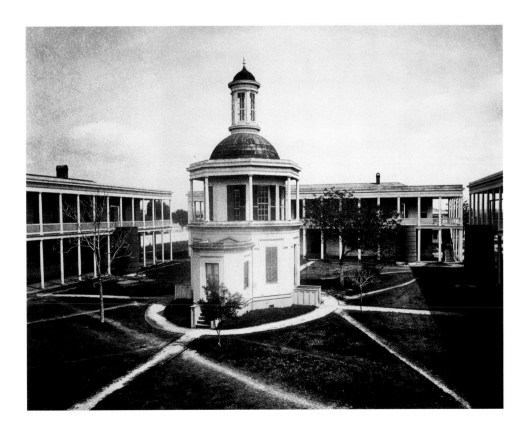

Post of Jackson Barracks, La," January 15, 1873, Miscellaneous Records, Records of U.S. Army Continental Commands, 1821–1920, RG393, NARA; U.S. Surgeon General's Office, *A Report on the Hygiene of the United States Army, with Descriptions of Military Posts*, Washington, D.C. (Government Printing Office) 1875, pp. 137–38, 164–65.

13. "Registers of Construction and Repair to Post Hospitals and Other Medical Facilities, 1875–1917," II, fol. 191, Central Office Records Relating to Hospitals 1861–1927, Records of the Surgeon General, RG112, NARA.

14. Lilienthal made a view similar to this, but with a low, ground-level perspective, for the U.S. Quartermaster General in 1865, print no. 165-C-884, Quartermaster Views, NARA (see p. 52, n. 53).

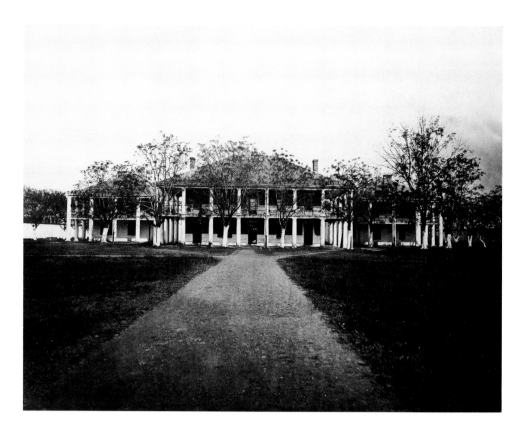

116
Interior of U. S. Barracks
Interieur de la Caserne

New Orleans had been fortified for nearly a century by French and Spanish troops when the United States acquired the Louisiana territories in 1803, and for another fifteen years the U.S. military occupied old colonial garrisons in and around the city. After the last of these forts was sold in 1818, the military leased buildings in the Vieux Carré, but high rents and the temptations the city offered to young soldiers led to proposals for a new garrison outside the center.[1] In July 1832, Congress authorized funds to purchase a site and erect a new barracks.[2] Planners sought a location that allowed for an expansive campus and parade ground, yet within an hour's march of any district of the city, as concern rose to protect the city "against any attempt at rebellion that might be made by the colored population."[3] Rejecting sites near Lake Pontchartrain, in 1833 the federal government purchased the Livaudais plantation on the river about 3 miles (5 km) below the city.[4] The 87-acre (35-ha) wedge of land—900 feet (274 m) deep but with only 360 feet (110 m) of river frontage—was typical of the long, narrow agricultural lots demarcated in French colonial times up- and downriver from New Orleans.

In designing the new barracks, the military's primary concern was to moderate the deleterious effects of the Louisiana climate and the threat of "local diseases." U.S. Surgeon General Thomas Lawson supplied the plan, with Lieutenant Frederick Wilkinson, a West Point-trained engineer who later designed Cypress Grove Cemetery (cat. 38) and Poydras Market (cat. 60).[5] Lawson and Wilkinson organized fifteen Greek revival buildings around an open parade ground, and enclosed the garrison with a high brick wall commanded by four corner towers with rifle slots and cannon parapets, much like a frontier fortress. The buildings' walls were 22 inches (56 cm) thick, and adequate, Wilkinson wrote, to "serve as a citadel for the reception and safety of the families of the citizens in case of an insurrection or other casualty"—confirming the continuing fear, rarely substantiated, of a slave rebellion.[6] The spacious campus situated close to the river was believed to "be well adapted to this unhealthy climate," and the exposure to river breezes was thought to diminish the persistent peril of cholera and yellow fever. As "attention should be paid to the appearance of a military work in the immediate vicinity of one of our greatest cities," the barracks plans called for brick construction trimmed with granite and no wood except for interior framing, in the "same manner of the best buildings in New Orleans."[7]

Construction began in February 1834 under the supervision of Assistant Quartermaster Major Isaac Clark, and it became Clark's toilsome duty to inform Washington of constant work delays and cost overruns.[8] Local brick, when available, was expensive, carpentry estimates were "far short of the actual cost," and granite shipments from New England were often held up or lost at sea. Frequent heavy rains also slowed construction, and part of the workforce of 150 men had to be quartered and kept on expenses as they waited out the storms or struggled to work in flooded conditions.[9] When yellow fever appeared in late 1834, Clark feared the threat of an epidemic at the remote location would "deter Mechanics from coming to this country."[10] Skilled workers were difficult to bring to the site, not because of the fear of sickness, but because they could find plentiful employment in the city during the building boom of the mid-1830s in New Orleans.

Added to the cost overruns and delays was construction of fifteen cypress cisterns, omitted in the original plan, to capture rainwater for cooking and drinking. The designers felt the river would provide all the water required at the post but, as Clark observed, the Mississippi was "more than half the year too muddy for any purpose" and, worse, contained "the whole filth of the City."[11] In January 1836, Clark wrote to Washington, "I regret that I cannot report the Barracks complete. I have made every exertion possible. Still [there] is much yet to be done."[12] Finally, in the fall of the same year, Clark was able to report that the buildings had been finished.

After barely a decade of use, extensive

repairs to the barracks became necessary.[13] Although the campus plan was generally admired, the project came to be regarded by many critics as a costly failure, particularly in the choice of a site far from town. "The idea of building barracks at a point below the city four or five miles from the centre of its business," the *True Delta* wrote in 1854, "and at all times most difficult of access, was one government agents and contractors alone could entertain." The newspaper editorialized on the "unfortunate fatality attending Federal governmental undertakings at this city."[14]

In July 1866, criticism of the remote site was borne out. Federal troops garrisoned at the barracks were called out to deter violence at the Mechanics' Institute on Dryades Street (cat. 68), where a mob of former Confederates was known to be planning to intercede forcibly in a constitutional convention being held there. With a violent outbreak imminent, soldiers from the 1st U.S. Infantry, a detachment of 708 men, were summoned by messenger from the barracks, transported by steam ferry, and led across town to the Institute. In the four hours required for the troops to reach the scene, the mayhem there had run its course and several dozen conventioneers lay dead.[15]

1. Quartermaster General Thomas S. Jesup to Secretary of War James Barbour, January 22 and March 24, 1828, in *American State Papers: Military Affairs*, III, nos. 367, 384, Washington, D.C. (Gales & Seaton) 1832–61.
2. "Measures Taken for the Purchase of a Site and Erection of Barracks at New Orleans," in *ibid.*, V, no. 549.
3. Letters of Governor A.B. Roman, New Orleans, May 12, 13, 1833, in Field Records of Hospitals, 1821–1912, Records of the Adjutant General's Office, RG94, NARA; U.S. Surgeon General's Office, Circular No. 4, *A Report on Barracks and Hospitals with Descriptions of Military Posts*, Washington, D.C. (Government Printing Office) 1870, pp. 162–65, reprinted (without citation) in *Architectural Art and Its Allies*, VI, no. 5, November 1910, pp. 5–6.
4. Letter of A. Drane to Quartermaster General, October 22, 1833, and "A Sketch Plan of the Faubourg Livaudais" executed by B. Buisson, March 1832, in Field Records of Hospitals, 1821–1912, *op. cit.*; Building contract, William Christy, XVI, no. 145, December 14, 1833, NONA.
5. George W. Allen, Capt. 4th Infantry, to Quartermaster General Thomas S. Jesup, April 12, 1833, Consolidated Correspondence File, 1794–1915, Records of the Office of the Quartermaster General, RG92, NARA. Wilkinson, a native of Poughkeepsie, New York, arrived in New Orleans in 1831 from West Point, and resigned from the army four years later to practice as a civil engineer, surveyor, and architect in New Orleans. On Wilkinson, see *Picayune*, December 22, 1838; *Gibson's Guide*, p. iv; *Picayune*, November 24 and December 11, 1840; *Picayune*, March 24, 1841 (obituary); *Biographical Register*, I, pp. 494–95.
6. *Gibson's Guide*, p. 327, reprinted in *New-Orleans Directory*

for 1842, New Orleans (Pitts & Clarke) 1842, p. 62. Wilkinson collaborated with Gibson on the guidebook of 1838 and probably authored the Barracks account, one of the most detailed in the book, which was written as the old colonial garrison in the city was being demolished. On the fear among whites of a slave insurrection, and the few real rebellions that did occur, see Peter Kochin, *American Slavery, 1619–1877*, New York (Hill & Wang) 2003, pp. 155–56.
7. Letter of Major Isaac Clark to Quartermaster Jesup, March 18, 1833, Field Records of Hospitals, 1821–1912, *op. cit.*
8. *Ibid.*, February 24, 1834.
9. *Ibid.*, February 27, 1834.
10. *Ibid.*, November 17, 1834.
11. *Ibid.*, November 11 and December 14, 1835.
12. *Ibid.*, January 10, 1836.
13. "Report of the Board of Survey on U.S. Barracks," Consolidated Correspondence File, 1794–1915, Records of the Office of the Quartermaster General, RG92, NARA.
14. "The Marine Hospital," *True Delta*, May 24, 1854.
15. James G. Hollandsworth, *An Absolute Massacre: The New Orleans Race Riot of July 30, 1866*, Baton Rouge (Louisiana State University Press) 2001, p. 95.

117 *overleaf*
Interior of Entrance to U. S. Barracks
Interieur de l'Entreé de la Caserne

In January 1861, the Louisiana militia seized the U.S. Barracks, then occupied as a marine hospital, in the first military act of Louisiana secession.[1] "I took possession of these barracks in the name of the State of Louisiana," the commander of the militia wrote to the federal agent in New Orleans. "As these quarters will be required for the Louisiana troops now being enlisted, I have to request that you will immediately remove those patients who are convalescent; and, as soon as in the opinion of the resident surgeon, it may be practicable and humane, those also who are now confined to these beds."[2] When news of the seizure was received in the North, the expulsion of sick and injured patients was reported as a barbarous act—the "most unfeeling outrage which has yet been perpetrated by the Disunionists," the *New York Times* exclaimed.[3] Secretary of the Treasury John Dix denounced the seizure as a "violation of the usage of humanity" that had maintained respect for "edifices dedicated to the care and comfort of the sick," even in the bloodiest conflicts.[4]

As the country moved rapidly toward civil war, the Barracks incident was soon overshadowed by even more consequential acts. The assault on the hospital, as Simon Cameron, the Secretary of War, later indicated to President Lincoln, "was only wanting to complete the [Confederates'] catalog of

crime."[5] Federal forces reclaimed the barracks for use as a hospital during the occupation of New Orleans, and, in 1866, renamed the garrison for Andrew Jackson in recognition of his victorious confrontation with British forces at nearby Chalmette in 1815.[6]

Pictured here is the headquarters building of the garrison. "The quarters of the commandant occupy the middle of the front, those of the Staff and Company Officers on either flank," the designer of the barracks, Frederick Wilkinson, wrote. "The companies are quartered in a hollow square, which is thrown back far enough to give space for a large and handsome parade ground."[7] Lilienthal's view is from the parade ground looking toward the levee of the river, which is visible through the sally port. The two-story brick-and-granite troop quarters, like the other officers' quarters facing the grounds, had a kitchen and dining room on the ground floor and living and sleeping rooms above, lighted and ventilated by the casement doors favored by local Creole builders. The doors opened directly on to a spacious veranda that captured the river breezes. The lower floor was built into the perimeter fortifications about 40 yards (37 m) from a wharf used for landing supplies and moving troops between the barracks and the U.S. forts St. Philip and Jackson downriver. Under the exterior staircase a few representatives of the largely invisible detachment defer to Lilienthal's camera.

In 1912, the river broke through the levee and damaged the forward perimeter of the campus, including this building, which was demolished. Infantry battalions trained at the barracks during World War I, and in the 1930s the Works Progress Administration restored the dilapidated post for the Louisiana National Guard.[8] In 2005, Jackson Barracks was still in use by the Guard, which staged troops there for the war in Iraq. During the levee breaches that followed hurricane Katrina, the 100-acre (40-ha) base flooded, damaging the antebellum buildings. The State of Louisiana announced a $210 million restoration project ($12 million for the historic garrison) in July 2006. A year later, a heliport was under construction near the site of this photograph.[9]

Lilienthal's two views of the barracks date from late 1865 and were part of a photographic survey of military installations in New Orleans commissioned by the U.S. Quartermaster General. Lilienthal reprinted

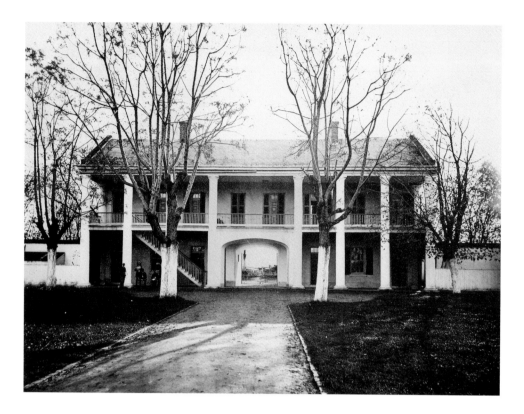

the two barracks views and two views of Sedgwick military hospital (cats. 102 and 103) for the Exposition portfolio.[10] In 1866–67, he published stereoviews of the garrison (including fig. 94) and in 1872 he made an unusual view of the barracks levee for *Jewell's Crescent City Illustrated*.

1. William E. Rooney, "The First 'Incident' of Secession: Seizure of the New Orleans Marine Hospital," *Louisiana Historical Quarterly*, XI, March 1983, pp. 135–42.
2. Captain C.M. Bradford to F.H. Hatch, Collector of Customs, January 13, 1861, Letters Sent, Correspondence of the Marine Hospital Service, Records of the Public Health Service, RG90, NARA; *War of the Rebellion: Official Records of the Union and Confederate Armies*, Washington, D.C. (Government Printing Office), 1894–1922, ser. I, LIII, p. 611.
3. *New York Times*, January 28, 1861.
4. Rooney, *op. cit.*, pp. 138–40.
5. Cameron to Lincoln, July 1, 1861, in *War of the Rebellion, op. cit.*, ser. III, I, p. 302, cited by Rooney, *op. cit.*, p. 142, n. 29.
6. "Registers of Army Hospitals and their Staffs, 1861–70," Central Office Records Relating to Hospitals 1861–1927, Records of the Surgeon General, RG112, NARA.
7. *Gibson's Guide*, pp. 327–28, partially written by Wilkinson; see p. 289. A description of the barracks is found in War Department, Quartermaster General's Office, *Outline Description of U.S. Military Posts and Stations in the Year 1871*, Washington, D.C. (Government Printing Office) 1872, p. 46.
8. "New Bricks but Century-Old Architecture," *Times-Picayune*, July 12, 1936.
9. "Jackson Barracks will be Restored," *Times-Picayune*, July 6, 2006.
10. See discussion of the Quartermaster series, p. 44.

118 *opposite*
Sugar Plantation
Plantation Sucricère

Although Lilienthal did not identify the location of this view, the Gothic forms of the house, visible through the trees, suggest that it is the "field of cane at Orange Grove plantation" listed in the *Crescent*'s inventory of the Exposition photographs.[1] Built for Thomas Asheton Morgan of Philadelphia in 1847–49, from the design of Philadelphia architect William L. Johnston, Orange Grove may have been the earliest Gothic Revival house in Louisiana.[2] The plantation of nearly 3000 acres (1215 ha) was 15 miles (24 km) downriver from New Orleans in Braithwaite, Plaquemines Parish.[3]

In the photograph, roofs of the nucleated plantation outbuildings and the square chimney of the sugar mill are visible. "Every sugar plantation is a little village in itself," the Scottish journalist Robert Somers wrote after the war. "The planter's mansion—sometimes elegant, always comfortable, seated amidst bright green orange groves ... is flanked by rows of negro frame-cottages ... while close at hand is the sugar factory, with its great square chimney-stalk, broad shingled roof, and numerous outworks."[4] The old slave cabins, called "quarters," were arranged in orderly

ranks like urban factory housing, and were typically two-room frame dwellings with porches, wood-shingled roofs, and unfinished interior walls.[5] The cabins were provided by the planter, although after the war some sharecropping freedmen leased quarters.[6]

Orange Grove had been a large antebellum slaveholder; in 1860, a total of 231 slaves were housed in ninety-seven cabins there.[7] This was about double the average slave-labor force for sugar parish plantations at that time, but to have 400 slaves or more was not uncommon— one sugar producer, John Burnside, owned 940 slaves.[8] Sugar was profitably produced only on a large scale (unlike cotton) and its cultivation was limited to a small elite of planters who could manage the major capital investment required.[9] Many slave-owning sugar planters were among the wealthiest men in the country.

The robust prewar sugar market encouraged investors to acquire large land holdings for the cultivation of cane, often in excess of 1000 acres (400 ha). The vast plantation properties impressed visitors, none more than the federal soldiers who came to seize the territory. John Chipman Gray of Massachusetts, viewing the plantations from a transport on the river, was "perfectly astonished at them, never having seen agriculture on so enormous a scale."[10] Another Massachusetts native, Henry Scott, also marveled at the size of the plantations and their sugar mills, which he found "as large as New England factories and built in the most approved style of brick and iron."[11]

The war brought the destruction of sugar culture in South Louisiana, with vast plantations ruined and abandoned. When General Benjamin Butler's invading army entered the country, the English traveler Henry Latham wrote:

they emancipated all the slaves, and took away all the cattle, annihilating all the plantation labour at a blow. The whole sugar crop ... was entirely lost The whole system of credit collapsed, the banks [were] all broke, and the factors' capital was swallowed up.[12]

To one planter, the "days of darkness and gloom" after the war brought "nothing but despondency with regard to the future. Our beautiful Parish is laid waste & is likely to become a desert ... ," he wrote. "Such is war, civil war."[13] *De Bow's Review* reported the loss of nearly 1000 Louisiana sugar plantations and $69 million in capital.[14] "Nearly all the former rich sugar estates ... [are] in a condition of utter dilapidation," James

D.B. De Bow wrote in 1867. "Some have been sold under the auctioneer's hammer that have not brought the actual cash value of the still useful bricks."[15] The sugar crop of 1867 came in at only a small fraction of the prewar harvest—38,000 hogsheads compared to 460,000 in 1861;[16] Latham found that sugar cultivation was "almost at a standstill." Ruined planters, he reported, were "selling for 15 and 20 dollars an acre lands which before the war would have fetched 100 and 120 dollars."[17] Another English visitor arriving in New Orleans by river steamer in 1867 discovered that the plantation lands were

> very different now to what was formerly the case ... the land on each side of the river seemed deserted. From one place we brought sixty mules and other plant connected with the cultivation of the plantation, the working of that estate being given up, as hundreds of others were besides. Many were the instances of ruined homesteads ruthlessly shelled or plundered by the federals.[18]

Some planters had destroyed their crops to keep them from the hands of federal forces, and had torn up their household to keep goods from confiscation or to supply Confederates in the field. "I drew up the tack from every carpet at Arlington [plantation]," a planter's wife wrote;

> all were made into blankets and promptly sent to the front. ... When the Federals, after an exciting siege, captured New Orleans, very little was left in the houses on the river that could be made available for the use of the army."[19]

Many sugar planters blamed emancipation for the collapse of their fortune and way of life, while for freedmen who remained with their former owners as wage-earners, plantation life was often little changed. The freedmen "do not seem to be very well satisfied and contented, oweing [sic] to their exaggerated and wrong ideas of freedom," a federal inspector for the Freedmen's Bureau observed in 1866. Another inspector wrote that freedmen did not "give the same amount of labor that they did under the lash, nor can it be expected."[20] From the perspective of a Scottish traveler, the "old and bad system" of slavery had been abolished, but the freedmen had "yet to grope in the dark for the elements of a new and a better life."[21]

Restructuring the plantation economy based on a free wage-earning labor pool was one of the great challenges of Reconstruction. The transition

largely failed and landowners looked to Europe to provide labor and capital that, De Bow wrote, "cannot be furnished at the South."[22] Without immigration and outside investment, in De Bow's words, there could be "no just hope of restoring the culture."[23] Louisiana saw the Paris Exposition as an opportunity to further this goal by marketing labor opportunities to a European audience. An "influx of immigrants and capital," local boosters claimed, would "inaugurate a new system of labor, and thus retrieve lost fortunes and advantages."[24]

Orange Grove's postwar fate seems to have played out as the commissioners would have intended. After the war, "the finest sugar works and dwelling house in the State" was put up for lease "with all the stock on it."[25] A Swiss entrepreneur and experimental balloonist named Louis Fasnacht purchased the plantation and in April 1867, around the time this photograph was made, 450 acres (182 ha) of sugar were under cultivation, plus an equal number of acres of corn for the laborers' consumption. Fasnacht employed 87 contract hands and 137 freedmen, but almost half the former slaves were reported to be "aged and helpless."[26]

Apart from illustrating the major industry of Louisiana, Lilienthal's plantation view carried specific meaning for an audience at the Paris Exposition, where worldwide agricultural

production was exhibited, cataloged, judged, and honored. Louisiana triumphed at the Exposition, receiving more medals for its sugar, cotton, and other agricultural exhibits than any state except New York. "The products of Louisiana have been crowned with high acknowledgements from the 'Imperial Jury,'" the Exposition Commissioner Edward Gottheil announced. "Do you not think Louisianians have cause to rejoice over this brilliant success!"[27]

1. "New Orleans and Vicinity at the Paris Exposition," *Crescent*, May 26, 1867.
2. Johnston's plan and front elevation for Orange Grove survive in the Louisiana State Museum collection, and are reproduced in Mills Lane, *Architecture of the Old South: Louisiana*, New York (Abbeville Press) 1990, pp. 162–63. On Johnston (c. 1811–c. 1849), see George B. Tatum, "William L. Johnston," in *Macmillan Encyclopedia of Architects*, New York (Free Press) 1982, II, pp. 502–503; Roger W. Moss and Sandra L. Tatman, *Biographical Dictionary of Philadelphia Architects, 1700–1930*, Boston (G.K. Hall) 1985, pp. 422–23; Leland M. Roth, "William L. Johnston," in *Grove Dictionary of Art*, New York (Macmillan) 1996, XVII, p. 626. On Orange Grove, see "Orange Grove Diary," Manuscripts Collection, Tulane University Library; William R. Cullison, III, "Orange Grove: The Design and Construction of an Ante-bellum, Neo-Gothic Plantation House," MA diss., Tulane University, 1969. The plantation, later known as Braithwaite, was acquired by the Southern Pacific Railway in the 1960s. Although ruined, the house was saved from demolition, but burned in 1982.
3. Lilienthal published at least three other views of Orange Grove in stereo format; examples are in The Historic New Orleans Collection (1988.134.22, captioned as "Fastnacht

residence," and 1996.43.1) and the Southeastern Architectural Archive, Tulane University; see fig. 95.

4. Robert Somers, *The Southern States Since the War, 1870–71*, London and New York (Macmillan) 1871, p. 217.

5. Barbara SoRelle Bacot, "The Plantation," in *Louisiana Buildings, 1720–1940: The Historic American Buildings Survey*, ed. J. Poesch and B.S. Bacot, Baton Rouge (Louisiana State University Press) 1997, pp. 125–32; John B. Rehder, *Delta Sugar: Louisiana's Vanishing Plantation Landscape*, Baltimore (Johns Hopkins University Press) 1999, pp. 115–22.

6. Eric Foner, *Reconstruction: America's Unfinished Revolution, 1863–1877*, New York (Harper & Row) 1988, pp. 48–50, p. 172.

7. Joseph Karl Menn, *The Large Slaveholders of Louisiana—1860*, New Orleans (Pelican Publishing Co.) 1964, pp. 309–11.

8. *Ibid.*, pp. 99–107.

9. Peyton McCrary, *Abraham Lincoln and Reconstruction: The Louisiana Experiment*, Princeton, NJ (Princeton University Press) 1978, pp. 19–65; see also "History of the Sugar Cane in Louisiana," *Crescent*, January 28, 1851; "The Sugar-Fields of Louisiana," *Southern Bivouac*, II, no. 1, June 1886, pp. 1–18; Charles P. Roland, *Louisiana Sugar Plantations During the Civil War*, Baton Rouge (Louisiana State University Press) 1997. See also Richard J. Follett, *The Sugar Masters: Planters and Slaves in Louisiana's Cane World*, Baton Rouge (Louisiana State University Press) 2005. For a contemporary description of the sugar harvest, see Somers, *op. cit.*, pp. 220–22.

10. John Chipman Gray, *War Letters, 1862–1865*, Boston (Massachusetts Historical Society) 1927, p. 356.

11. Henry B. Scott to his mother, June 28, 1864, Henry B. Scott Papers, 1861–66, Mss. N-891, Massachusetts Historical Society.

12. Henry Latham, *Black and White: A Journal of a Three Months' Tour in the United States*, London (Macmillan) 1867, p. 177.

13. William T. Palfrey, *Diary*, January 22, 1863, and March 16, 1864, Hill Library, Louisiana State University, cited by Roland, *op. cit.*, p. 127.

14. "Progress of Sugar Culture," *De Bow's Review*, IV, no. 3, September 1867, pp. 238–40.

15. "The South, Its Situation and Resources," *ibid.*, p. 446.

16. Joe Gray Taylor, *Louisiana Reconstructed, 1863–1877*, Baton Rouge (Louisiana State University Press) 1974, p. 370. On the destruction of the sugar industry, see Roland, *op. cit.*, pp. 57–74; Latham, *op. cit.*, p. 170.

17. Latham, *op. cit.*, p. 170.

18. Henry Deedes, *Sketches of the South and West; Or, Ten Months' Residence in the United States*, Edinburgh and London (William Blackwood & Sons) 1869, p. 110.

19. Eliza McHatton-Ripley, *From Flag to Flag: A Woman's Adventures and Experiences in the South During the War*, New York (D. Appleton & Co.) 1889, p. 18.

20. Captain Charles W. Gardiner, Agent, to Brigadier Colonel J. Grigg, Inspector General, January 31, 1866, Plantation Inspection Reports, Office of the Assistant Commissioner, Louisiana, Records of the Bureau of Refugees, Freedmen and Abandoned Lands, RG105, NARA; Report of J.D. Rich, Assistant Inspector of the Parish of St. Charles, January 31, 1866, Plantation Inspection Reports, *op. cit.*

21. Somers, *op. cit.*, p. 222.

22. "Progress of Sugar Culture," *op. cit.*, p. 238.

23. *Ibid.*

24. *Report of Edward Gottheil*, p. 4.

25. "Plantation to Lease," *Times*, January 14, 1866.

26. Report of Ira D. McClary, Inspector, September 30, 1866; Report of Lieutenant B.M. Clark, Inspector, April 30, 1867; Plantation Inspection Reports, *op. cit.*

27. "Interesting Letter from Paris," *Picayune*, August 18, 1867.

119
Crevasse on the Mississippi
Crevasse du Mississippi

The Mississippi River was New Orleans's opportunity for trade and profit, but it also kept the city perpetually on the brink of annihilation. The "resistless volume of water," as one visitor described it, could breach its levee and inundate the city's streets and houses or the rich plantation land in the parishes—and it did this regularly.[1]

New Orleans had raised its first artificial defenses against the river, on the rise of the natural levee, soon after the founding of the city in 1718. A century later, levees stretched from New Orleans to Baton Rouge (and beyond) on both sides of the river.[2] The city had levees under its jurisdiction, sometimes under multiple authorities, but rural parishes depended on the vigilance and resources of individual landowners to maintain them. The system was far from secure and breaks, or "crevasses," occurred frequently. In 1849, the famous Sauvé crevasse sent 4 feet (1.2 m) of water into the heart of New Orleans, sparing the wealthier neighborhoods but inundating the poor districts built on low ground, and forcing thousands of residents from their homes. "All the efforts of our scientific engineers and practical mechanics have proved unavailing to stop the irruption," the *Picayune* wrote. "May our citizens, in their foresight and their intelligence, devise some means of raising an insuperable barrier to another inundation."[3]

In the river parishes, a crevasse could destroy valuable crops and "with terrible rapidity ... plunge a settlement into ruin."[4] One antebellum visitor described the ensuing peril:

> At first the breach may not be larger than a stream of water from a hose, and can easily be stopped with cotton-bales, or bags of earth, if at once applied. But when at night one of these ... [crevasses] begins to form unseen by any watchful eye, it rapidly enlarges ... and in an hour plunges a roaring cataract twenty yards wide, rushing like a mill race, and deluging road, gardens, fields, and pastures.[5]

Slave labor would often be used to shore up levees and to battle a crevasse, but planters often feared an uprising of slaves even more than the destructive force of the river. "So fearful were all planters ... of negro assemblages, so apprehensive lest they communicate from plantation to plantation, and a stray spark enkindle the fires of sedition and rebellion," planter Eliza McHatton-Ripley recalled, that they refused to send slaves to repair a crevasse. Ripley described her own experience with a breach that could not be stopped: "It is a fearful sight to see the relentless flood plowing by ... leaving a wide ravine with a rush of roaring water that poured millions of gallons a minute, plowing a deep canal through roads and fields, spreading and widening over the rear swamps in its destructive errand."[6] Another planter, after failing to stop a crevasse, observed: "we are now experiencing some of the delights of living in a country whose normal condition is under water."[7]

Widespread destruction and neglect during the war left the levee system in ruin. The "immense levees, once of such grandeur to attract foreign visitors," now allowed waters to rampage through fields miles outside the river's course.[8] In early 1867, the *Times* reported that the "planters to whom the erection and repair of our levees were formerly entrusted have been so impoverished by the war that they are wholly incapable of performing that work any longer ... while the imminent danger of a desolating overflow stares [them] in the face."[9] The state attempted to sell bonds in the North for levee repairs, but failed, and turned for aid to Congress, which did not act.

In the early spring of 1867, more than a dozen levee breaks occurred above New Orleans. "A large extent of our most fertile lands have been submerged," the Governor announced, as residents of the flood zone appealed to authorities for urgent assistance: "Not only desolation and destruction of property, but death marches along in the track of the swiftly overwhelming flood," they wrote. "Now—today—is the time for measures of relief to be put in operation, for tomorrow will be too late."[10]

But help did not come swiftly, and thousands were driven from their homes. "It is to be regretted that the request for assistance did not elicit a speedier response, for had immediate measures been taken, much misery might have been relieved," the *Crescent* wrote (in words that now recall the Katrina catastrophe of 2005). "Such misfortunes would be enough to ... weaken the resolution of the most persevering community in the world."[11] The resolution of many, including the southern propagandist James D.B. De Bow, did appear to

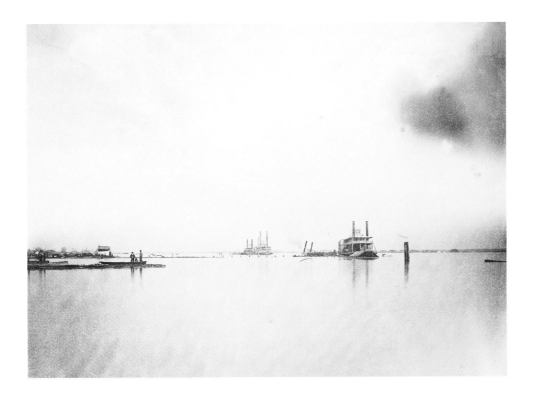

1. Lady Emmeline Stuart Wortley, *Travels in the United States, etc., during 1849 and 1850*, New York (Harper & Brothers) 1851, pp. 115, 124; Henry Latham, *Black and White: A Journal of a Three Months' Tour in the United States*, London (Macmillan) 1867, pp. 148–49.

2. Peirce F. Lewis, *New Orleans: The Making of an Urban Landscape*, Cambridge, Mass. (Ballinger) 1976, pp. 22–27; Donald W. Davis, "Historical Perspective on Crevasses, Levees, and the Mississippi River," in *Transforming New Orleans and Its Environs: Centuries of Change*, ed. Craig E. Colten, Pittsburgh (University of Pittsburgh Press) 2000, pp. 84–106; Craig E. Colten, *An Unnatural Metropolis: Wresting New Orleans from Nature*, Baton Rouge (Louisiana State University Press) 2005, pp. 19–32.

3. "A Glimpse from the Cupola of the St. Charles," *Picayune*, July 3, 1849.

4. "Disasters of the Overflow," *Crescent*, April 14, 1867; "The Suddenness of a Crevasse," *Crescent*, April 18, 1867.

5. Joseph Holt Ingraham, *The Sunny South; Or, The Southerner at Home*, Philadelphia (G.G. Evans) 1860, p. 325.

6. Eliza McHatton-Ripley, *From Flag to Flag: A Woman's Adventures and Experiences in the South During the War*, New York (D. Appleton & Co.) 1889, pp. 19–20.

7. Edward J. Noyes to his father, Routhwood [Plantation], May 9, 1866, Noyes Family Papers, 1687–1949, Ms N-607, Massachusetts Historical Society.

8. *Remarks of Mr. Perkins, of Louisiana, in the House of Representatives*, Tuesday, May 3, 1864, Richmond, Virginia, 1864, p. 4.

9. *Times*, January 7, 1867.

10. J. Madison Wells, *Message of the Governor of Louisiana to the General Assembly, Commencing January 28, 1867*, New Orleans (J.O. Nixon) 1867, p. 1; "Disasters of the Overflow," *op. cit.*

11. "Disasters of the Overflow," *op. cit.*

12. "The South: Its Situation and Resources," *De Bow's Review*, IV, no. 5, November 1867, p. 446.

13. *Times*, May 24, 1867.

14. "Our Levees," *Times*, January 7, 1867.

be shaken by the "calamitous destruction": "All hail," DeBow wrote, "... to the strong emigrant from our midst, resolved to look out for more secure homes than the ruined, God-forsaken, abodes in the Delta alluvions now afford."[12]

The location of the crevasse that Lilienthal recorded is unidentified, but it appears treacherous, having already claimed a submerged steamboat. The inundation is probably at its peak, and only the distant thin line of ground marks the normal course of the Mississippi opposite the breach. As only water and sky fill the frame, the viewer senses the peril, and is drawn into the threat by the near-water-level position of the camera and the lone witnesses in a rowboat. Dark patches that appear to be menacing stormclouds are artifacts of Lilienthal's lens, an accident that only heightens the mood of endangerment. It is a startling depiction of the hazards of the river and the fragility of New Orleans's infrastructure that imperfectly kept the potent forces of nature at bay, and seems far removed from the idealized imagery that characterized most urban views, and much of Lilienthal's portfolio. For an explanation we might look to the pictorial potential of the subject and the fascination with an event of such gravity in the life of the city. Or, we could attribute the image to Lilienthal's taxonomic, itemized approach to his subject matter in this municipally sponsored

work, similar to the scientific scrutiny that characterized government-sponsored photographic surveys of the West.

In the end, it may indeed be boosterism of a specific kind that played a role in Lilienthal's choice of subject. The *Times* suggested in May 1867 that a photograph of a crevasse exhibited at Paris "would express louder than any tongue the peculiar position of our people."[13] Boosters had already declared that the future prosperity of New Orleans depended on a sound levee system, and called for a company to be organized that would "secure Northern or foreign capital to put the levees in efficient condition."[14] In the context of the Exposition portfolio, Lilienthal's view appears to be an appeal for such outside investment.

"To Scan the Crescent City Broadly": Lilienthal's Panoramas of New Orleans

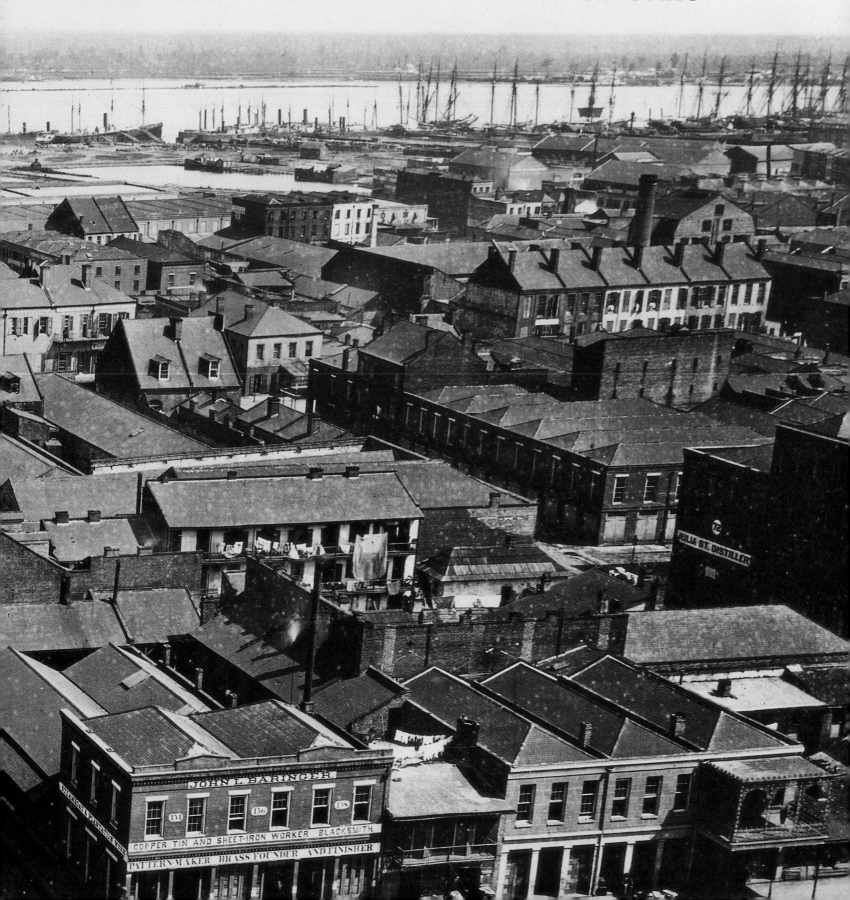

"For how many centuries has this city existed?" the foreign visitor naturally wonders, quickly surveying with astonishment the wealth and splendor spread out before him. "How much time did it take to build up this seven-mile-long sea of houses, these enormous warehouses, these wharfs and levees?" His astonishment increases when he hears of the fantastic speed with which the city literally arose from the mud and swamp.[1]

Before the war, New Orleans's epic progress—it was the fastest-growing large city in America for nearly three decades[2]—was perceived as a triumph over vast wetlands and, to a degree, over the Mississippi River itself, which was always poised to deliver destruction as well as profit to the city.[3] The improbable rise of New Orleans, as witnessed by the German author Friedrich Gerstäcker's "foreign visitor," from "mud and swamp" to commercial supremacy, was accompanied by the inevitable risks that attended citybuilding in an inhospitable setting. "I really, at the view of it, felt quite a shock at the idea of living in such a place," one visitor exclaimed; "the whole city is exposed to imminent danger."[4] Scores of northerners and Europeans were prepared to accept the peril of the water-bound site for the opportunities it afforded and, like the young architect James Gallier, "run the hazard of New Orleans."[5] The antebellum city, as geographer Peirce Lewis has written, "gained a reputation not merely as a city in the wilderness, but as a beacon which shone with special brilliance, and a prize most eagerly to be sought."[6]

The desire to witness New Orleans's astonishing success was expressed in the pursuit of the panorama—an encompassing view obtained from an elevated vantage point where the visitor, like Gerstäcker's observer, could survey the city "spread out before him." "It would be wise in travellers to make it their first business in a foreign city to climb the loftiest point they can reach, so as to have the scene they are to explore laid out as in a living map before them," British author Harriet Martineau advised.[7] The writer herself ascended rooftop stations at Charity Hospital (cat. 69) and a cotton press, where the view commanded the "many windings of the

Fig. 51 *View South toward Magazine and Julia Streets, and the Mississippi River* (fig. 59), detail.

majestic river, and the point where it seems to lose itself in the distant forest."[8] Another visitor, the eminent Scottish geologist Charles Lyell, writing in 1849, noted the city's "constant gain of land" reclaimed for building blocks: "If a traveller has expected, on first obtaining an extensive view of the environs of the city, to see an unsightly swamp, with scarcely any objects to relieve the monotony of the flat plain save the winding river and a few lakes, he will be agreeably disappointed."[9]

To obtain a panoramic view of this transfigured landscape, in a place where there was no natural promontory, architects and builders provided observatories on increasingly taller structures.[10] One such "elevated station," at Bishop's Hotel, was recommended in 1835 by author Joseph Holt Ingraham to "every stranger, on his arrival at New-Orleans." From this "eminence," he wrote, the visitor would "receive his first general impression ... a fine panoramic view of the whole city, with its sombre towers, flat roofs, long, dark, narrow streets, distant marshes, and the majestic Mississippi."[11]

The dome of St. Charles Hotel (figs. 26–28) replaced Bishop's Hotel as the preferred observatory when it opened in 1837. The colonnade of the 200-foot-high (61 m) dome formed "a beautiful gallery eleven feet wide," from which the city could be comprehended "at one view," according to the *Picayune*:[12]

> The eye of the man who ascends the dome can see our entire city, with its crowded churches and church spires, its brick buildings, splendid private palaces, and antique Spanish built houses.[13]

The journalist Abraham Oakey Hall described New Orleans as "perpetually upon exhibition" when viewed from this vantage point. "I have often seen a stranger from the interior wilds gazing upon ... [this panorama] with astonishment and admiration; and perhaps with awe," he remarked. "These dissolving views have been seen for years, and will be seen for years to come."[14] Travel and guidebook writers publicized the hotel's observatory and advised "all persons wishing to scan the Crescent City broadly" to ascend the dome for a "panorama," Benjamin Norman wrote, "at once magnificent and surprising."[15]

Those who sought the ultimate panoramic experience and a "beautiful bird's eye view" could secure passage in a balloon piloted by a

touring aeronaut. The celebrated balloonists Eugène Godard (later appointed to the court of Napoléon III) and Alexander Morat made frequent ascensions from Jackson Square in the 1850s—at least once astride a "team of young alligators" that, it was suggested, "were never so high before."[16]

By mid-century, a local tradition was established of lithographed views from these elevated perspectives.[17] One such view, lithographed by Bernhard Dondorf of Düsseldorf in 1850, was engraved by William Cooke and published as *Souvenir de la Nouvelle-Orléans* with a decorative border of building vignettes. Captioned in French, it was the kind of souvenir sheet a recent immigrant might have sent to family or friends overseas (fig. 52).[18] But the most accomplished of the early elevated print perspectives of the city was a colored lithograph by John William Hill and Benjamin Franklin Smith, Jr., *New Orleans from St. Patrick's Church* (fig. 53), which was published in 1852 with a second view, *New Orleans from the Lower Cotton Press*. The Hill–Smith works were large—26 × 41 inches (66 × 104 cm)—and, according to the *Picayune*, "entailed much labor on the projectors."[19] One critic wrote that they were "the only just and accurate views we have ever seen of our Port Together, they afford a full picture of the city."[20] Encompassing the city in a visually spectacular way, the Hill–Smith prints documented New Orleans's triumph over the wetlands, rendered by the viewmakers as an hospitable greenbelt beyond neatly ordered housing blocks. Beautifully serving the purposes of civic boosterism, they were flattering portraits of urban progress.[21]

For photographers, with their unwieldy equipment and fiddly chemistry, a rooftop vantage point presented difficulties, but like viewmakers in other media, they recorded the cityscape from elevated stations. The pioneer photographer James Maguire (credited with introducing paper photography to New Orleans) ascended to the St. Charles's observatory to record the destructive floodwaters that followed a breach in the levee, the Sauvé crevasse, in 1849. Maguire reportedly made only one plate from this viewpoint, the earliest documented bird's-eye photograph of the city.[22]

New Orleans photographers were producing rooftop perspectives routinely by the late 1850s. When the Custom House (cat. 19) walls

Fig. 52 Bernhard Dondorf, lithographer, William Cooke, engraver, *Souvenir de la Nouvelle-Orléans*, lithograph, 1850.

rose to a height of 100 feet (30 m), the "noble views" from the top of the unfinished structure "surprised and delighted" visitors.[23] The vantage point attracted photographers for a perspective on the river landings, always a compelling subject. The city's first successful view photographer, Jay Dearborn Edwards, included a levee view made from the Custom House among a series of salt prints of the city and environs he published in 1858–60 (see p. 31),[24] and Samuel T. Blessing and the partnership of McPherson and Oliver also published carte-de-visite rooftop perspectives from various vantage points (fig. 54).[25] However, each of these views was an isolated image and not linked to a continuous panorama from a fixed viewpoint.

Lilienthal's Stereoscopic Panorama of 1866

In the late winter of 1866, Theodore Lilienthal completed the earliest surviving photographic panorama of New Orleans, in twelve sections and in stereo format.[26] The vantage point was the 185-foot (56-m) bell tower of St. Patrick's Church (completed in 1841) on Camp Street. Already fixed in the iconography of the city by the Hill–Smith lithograph, this viewpoint, although difficult to reach, was recommended by a popular guidebook of 1866 as the "best point from which to obtain a view of the city and its environs."[27] It was also the best viewpoint on the municipal center at Lafayette Square and the "cluster of fine buildings, public and private," that surrounded the square.[28]

Always a "practical photographer" in close touch with the marketplace, Lilienthal anticipated demand for the views and the need to protect images that were difficult and expensive to produce. In April 1866, he

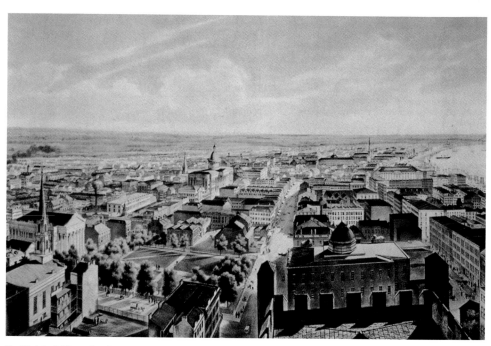

Fig. 53 John William Hill and Benjamin Franklin Smith, Jr., *New Orleans from St. Patrick's Church*, 1852. Printed by Francis Michelin & Geo. E. Leefe, New York. Published by Smith Brothers, New York. [Drawn in 1850.] Manuscript Collection, Tulane University Library.

deposited for copyright "Twelve Photographs representing 'Birds eye views of the City of New Orleans taken from the Steeple of St Patrick Church.'"[29] A few weeks later, he copyrighted another panorama, made from an unidentified location, and soon began advertising "bird-eye views and other stereoscopic views of the city of New Orleans, on exhibition and for sale" at his Poydras Street gallery.[30] Only five frames of Lilienthal's

twelve-part stereo panorama from St. Patrick's are known today (figs. 55–59), but the positioning of the surviving images is evidence of a continuous, 360-degree panoramic series.

By encompassing the city in its entirety, closing it in for the viewer, panoramas like this were one of the most successful means, as Peter Hales has suggested, that photographers had to "civilize the city and make it comprehensible."[31] Lilienthal's progression of rooftops disappearing

Fig. 55 Theodore Lilienthal, *View West toward Unitarian Church and Julia Street*, half stereoview detail, 1866. Louisiana State Museum.

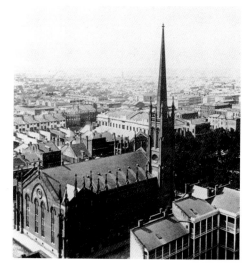

Fig. 56 Theodore Lilienthal, *View North toward First Presbyterian Church, Lafayette Square*, half stereoview detail, 1866. The Historic New Orleans Collection.

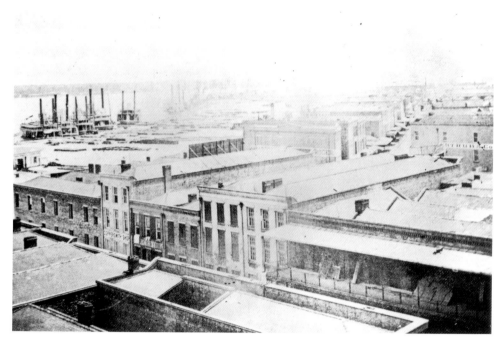

Fig. 54 Samuel T. Blessing, *Bird's Eye View toward Customhouse Street and the Levee*, carte de visite, c. 1865–66. Charles East Papers, Hill Memorial Library Special Collections, Louisiana State University.

into the distance documents the city's triumph over the wilderness, and the density, even chaotic jumble, of buildings, streets, and wharves gives an impression, at a glance, of the commercial vigor of the port. The "disciplined and detailed systematicity that was impossible on the ground" made this kind of virtual tour of the city, as Derek Gregory has written, often superior to "being there," and so credible a means of representing the city that travelers

often sought vantage points that provided a heightened sense of reality familiar from photographic panoramas.[32] The perception that the panorama represented the city more truthfully than conventional photography made it an ideal propaganda tool for city boosters.[33]

Panoramic photography required agility and skill, and a strenuous working day high above ground. Lilienthal had to work as quickly as possible in order to minimize changes in

lighting and weather conditions that could spoil the continuity of his series. Despite the effort and expense involved in executing the work, the panorama had a shorter life than many of his views, and had to be updated regularly to represent cityscape changes.

Lilienthal's Panoramas for *La Nouvelle Orléans et ses environs*

In the spring of 1867, Lilienthal again ascended St. Patrick's steeple, this time hoisting his heavy view camera and large glass plates to the roof of the tower to execute a second panoramic series, a year after his stereograph panorama. It was another pioneering panorama, the first for New Orleans in large format. Three segments of this series survive in the Exposition portfolio (cats. 120–22). Also sent to Paris were at least two views of the Ninth Ward, Third District, taken from the roof of the Marianite Academy (cats. 123 and 124)—possibly sections of another full panorama, now lost.[34]

From the steeple of St. Patrick's the city could be viewed, unobstructed, in a full circle: northwest from Lafayette Square to the Bayou St. John, the backswamps, and Lake Pontchartrain beyond; northeast toward the Vieux Carré; east toward Algiers and the West Bank; and, finally, toward the southwest and uptown beyond Tivoli (Lee) Circle, to the fashionable residential neighborhoods of the Garden District and faubourg Jefferson City. The meandering river lined with miles of wharves

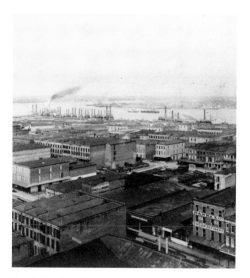

Fig. 57 Theodore Lilienthal, *View North toward Lafayette Square and Moresque Building*, half stereoview detail, 1866. Louisiana State Museum.

Fig. 58 Theodore Lilienthal, *View Northeast toward Poydras and Magazine Streets, and the Mississippi River*, half stereoview detail, 1866. Collection of Joshua Paillet, The Gallery for Fine Photography.

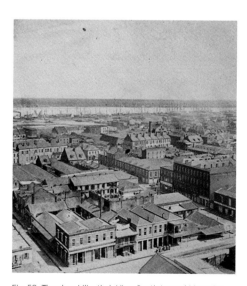

Fig. 59 Theodore Lilienthal, *View South toward Magazine and Julia Streets, and the Mississippi River*, half stereoview detail, 1866. Collection of Joshua Paillet, The Gallery for Fine Photography.

and landings curved around the uptown districts in a great crescent, visible on the horizon looking east, south, or west from St. Patrick's. Lilienthal's views encompass most of the Anglo-American quarter, the First District from Canal Street to Tivoli Circle and Coliseum Square uptown.

In its broad sweep, the panorama provides an overall impression of the scale and ambience of the city, and how urban space was used. The patchwork pattern of streets and rooftops and variety of building forms, stretching from the river to the backswamps and far uptown, are presented "flattened out like the skin of an animal."[35] The accidental elements—a plume of smoke from a steamer negotiating its mooring, a ghosted flag, a horsecar discharging riders, the untidy backlots and hanging lines of laundry— give the views an almost disquieting immediacy.

Few commercial or residential structures exceeded four or five stories in New Orleans until the elevator office buildings of the 1880s and later (although New Orleans introduced the elevator early, for example at the St. Charles Hotel and Marine Hospital, it was slow to build high). Blocks of low-rise, mixed-use buildings are punctuated here and there by tall church spires that give direction to pedestrians and draw attention to their sanctuaries. Lilienthal's panoramas record a range of tonal variation, from the dark brick buildings to gleaming marble and white-painted stucco fronts, suggesting the color palette of the nineteenth-century city.[36]

120
Birds eye view of 1st Dist.
Panorama du Primier district

The first of three surviving segments of Lilienthal's panorama of 1867 from St. Patrick's Church is a view of Lafayette Square looking northwest in the direction of the Bayou St. John, City Park, and Lake Pontchartrain. In the far distance, the succession of rooftops and church steeples dissolves into the utterly flat backswamp at the rear of the city. The streets of the Vieux Carré are visible at the upper right. Two gleaming-white pedimented buildings in the Greek style stand out in the middle distance along St. Charles Street: James Gallier's Masonic Hall and, beyond, the St. Charles Hotel (cats. 61, 62, and 64). The hotel represents a dramatic shift in scale in the context of the three- or four-story brick row buildings characteristic of the district. Visible at Canal Street is the tall Gothic spire of Second

Christ Church designed by Gallier and Thomas K. Wharton and built in 1856. To the left of this church is the broad dome of the Jesuit Church of the Immaculate Conception, on Baronne Street, built in 1857. At the near end of St. Charles Street, Gallier's porticoed City Hall (cat. 51) faces Lafayette Square. Above this former seat of the secessionist government of Louisiana now flies a United States flag.

"Lafayette Square, with its wide, smooth lawn and fringe of green, leafy verdure, forms a very picturesque and appropriate frontispiece to the Municipal Hall," the *Picayune* wrote in 1851.[37] Planted with sycamores and traversed by shell walks, the square was "one of the most attractive features of the city to every stranger," and was the heart of a fashionable and prosperous quarter known for nearly twenty years (1836–53) as the Second Municipality, when the city was divided into three independently governed districts.[38] The quarter had its origin in French colonial settlement. New Orleans's founder, Jean Baptiste LeMoyne de Bienville, and the Jesuits, until their suppression in 1763, operated plantations there.[39] Acquired by the Gravier family, the agricultural properties were subdivided for development in 1788 following a fire that devastated most of the Vieux Carré. By laying out Magazine, Girod, Julia, and other streets the faubourg St. Mary was born, with a public square, later named Lafayette, at its center. The suburb developed rapidly after the purchase of Louisiana by the United States in 1803, with an influx of emigrants from the northeastern states and the British Isles.

In the foreground of Lilienthal's view, at the corner of Camp and South streets, is the Florance House hotel. Its magnificent cast-iron galleries were fabricated in 1854 at the height of the fashion for open ironwork to embellish houses and commercial buildings. Next door is the Alfred Penn residence, designed by Will Freret and built in 1856–57, also with iron galleries facing Lafayette Square.[40] The tapering Gothic steeple marks the First Presbyterian Church, designed by Henry Howard, built by George Purves (also in 1856–57), and described as the "most classically beautiful edifice in the city."[41] Its spire, ornamented with cast-iron windows and finial, was the tallest in New Orleans. The pastor there, Reverend Benjamin Palmer, was a popular preacher whose fiery sermons fueled secessionist fervor. First Presbyterian was

destroyed by a hurricane in 1915 but rebuilt, only to be demolished in 1938, with the adjacent Penn residence and Florance House, for a federal office building that faces the square today.

On the north side of the square is one of the city's great Civil War-era building projects, the Moresque Building. Described by its architect, James Freret, as "one of the many schemes spoiled by the war," the building was eventually completed in 1867, an event that was seen as a rare triumph of the city's postwar convalescence.[42] In early 1860, Freret, apprenticed to his cousin, Will Freret, prepared plans for a five-story building in several styles for John Barelli, a commission merchant.[43] Barelli approved Freret's Moorish design of cast iron on a granite base, and fabrication of the ornate ironwork began in June 1860 at the Jones McElvain foundry in Holly Springs, Mississippi. With the outbreak of war, material costs rose, especially for iron and plate glass to glaze the building's "numberless windows," but construction continued despite the interruption of trade.[44] In August 1861, as construction proceeded, the *Picayune* observed:

> our population has not lost a particle of confidence in the prosperity of the Southern metropolis. While in New York nearly half of the stores are shut up, and the handsomest dwellings advertised to let, here we go on building, to be ready when business revives."[45]

But within months this rallying optimism gave way to disillusionment. The ironwork was incomplete when the Holly Springs foundry was converted to ordnance manufacture, and with the Union occupation of New Orleans, construction was halted. Federal authorities seized the building for back taxes and its owner, "arrested in his splendid enterprise by misfortunes" of war, was forced to sell out at public auction.[46] At the end of the war the unfinished building was "one of the greatest nuisances and eyesores in the city," according to the *Times*: "devoured in rust, ... [it] stood like a great mausoleum, in which the hopes of its many builders were buried."[47] Half of the building's roof remained unfinished, the copper reputedly stolen by Union troops. To the *True Delta*, the "noble iron building" suggested the "ruin caused by the war, and we are anxious to get rid of such reminders."[48]

James Freret, who had left New Orleans in 1860 to study at the École des Beaux Arts in Paris, returned from Europe to enlist in the

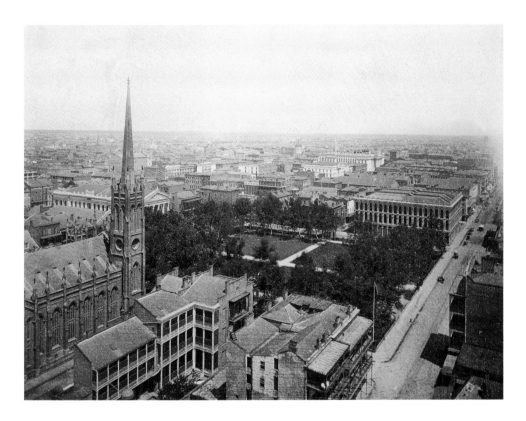

Building taken from Camp and Poydras streets, possibly similar to a stereoview Lilienthal published at the time (fig. 84).[62] His stereo bird's-eye view of Lafayette Square made in April 1866 (fig. 57) shows the Moresque's unfinished roof (which was completed in November of that year). The Paris bird's-eye of Lafayette Square, seen here, shows the old and new roof sections.[63]

On the Camp Street side of the square was another admired building, the Odd Fellows' Hall (fig. 25), destroyed by fire in 1866. The domed, four-story stuccoed brick-and-granite building was designed by George Purves and built in 1850–52.[64] It had been "the showiest building in the city," according to the *Picayune*, and rivaled "in elegance" Gallier's City Hall across the square.[65] The massive fire ruins, visible at the right-hand edge of the photograph, were a melancholy reminder of "the halcyon days of the past," when the building hosted balls, concerts, lectures, and exhibitions in frescoed rooms.[66] Orleanians saw the admired building suffer "three years of desecration" as a federal barracks before its destruction by fire. "[D]eplorably defaced and broken up," Odd Fellows' was "in a state of disrepair and filth impossible to describe," according to the *Bee*.[67]

Abandoned by federal troops, Odd Fellows' was repaired and refurbished for a brief return to "gayety and festivity" before the building was consumed by fire on July 4, 1866.[68] Plans to rebuild were immediate, and prominent architects, including James Gallier, Jr., prepared designs, but the Odd Fellows' treasury was depleted from the distribution of war relief to fraternity families after the war.[69] "A large number of the members," the *Times* reported,

> entered the ranks of the army, many, alas! never to return ... and as their funds grew less, and sources of revenue more and more crippled, the claims for relief and assistance swelled rapidly in numbers and urgency. Troubles increased with the duration of the war, as family after family was robbed of its chief stay and support and mourning widows and orphans became more numerous.[70]

The Odd Fellows never rebuilt, but remodeled the old Benjamin Story residence a few doors down on Camp Street as their fraternal hall.[71] In 1874, James Freret's St. Patrick's Hall was built on the old Odd Fellows' site (from 1897 the city library).[72] Freret's building was itself demolished in 1914 for Hale and Rogers's U.S. Post Office building, now a federal courthouse.

Confederate army, and was wounded at the battle of Port Hudson, Louisiana. Taken prisoner and paroled, he convalesced at home in New Orleans, and gradually resumed his practice. Taking up completion of the Moresque for a new owner, crockery and housewares merchant John Gauche, Freret prepared a "showy plan" that included a 220-room hotel in a failed attempt to promote the project to a northern investor.[49] For Gauche, Freret enlarged the ground-floor showroom and construction began again in late December 1865. The Mississippi fabricators of the Moresque's cast iron had not survived the war, so local founders Bennett & Lurges (cat. 80) completed the work.[50] In February 1866, the building was "being completed as rapidly as the busy hands of workmen can finish it."[51] The entire city seemed to follow the progress of the project, which was viewed as symbolic of postwar recovery.

In December 1866, as construction costs topped $350,000, the Moresque was structurally complete, and was fitted up with gaslight.[52] The building opened with a benefit "Confederate Fair" to aid disabled soldiers, war widows and orphans.[53] The interior spaces, finally completed in the spring and summer of 1867, were "got up in the most tasteful and elegant manner," with millwork of Louisiana cypress and frescoes "by the best artists in the city."[54]

On its completion the Moresque was called "the most perfect specimen of Arabesque architecture in the U.S."[55] Fantastic Moorish arcades framed large plate-glass windows for the display of merchandise. The modular cast-iron construction allowed for less wall mass and more glass, and gave the building a "light and airy appearance."[56] Painted bright white with dark-brown trim, the Moresque was brilliantly illuminated at night—"a scene of gorgeous beauty," the *Picayune* wrote—and the display of goods, "tastefully arranged in the immense windows," attracted window-shoppers to Lafayette Square.[57]

"It is said by the lovers of architectural beauty that the Moresque Building has no equal on the American continent," the author of a New Orleans guidebook stated.[58] For thirty years the building was one of the sights of the city. But in April 1897, electric sparks ignited a storeroom of furnishings and the building went up in flames.[59] The iron exterior walls contained the blaze "like a huge furnace," generating one of the hottest fires in local memory.[60] Only two giant iron columns remained standing after the flames were extinguished, adding a "picturesqueness to the desolate scene that kodak fiends are taking advantage of," the *Daily States* reported.[61]

The Exposition portfolio reportedly included another view, now lost, of the Moresque

This and two other twentieth-century federal office buildings today dominate Lafayette Square, the city government having vacated Gallier's City Hall in the 1960s. Once the seat of Confederate authority in the largest city of the Confederacy, the square is today the primary site of the federal government in Louisiana.

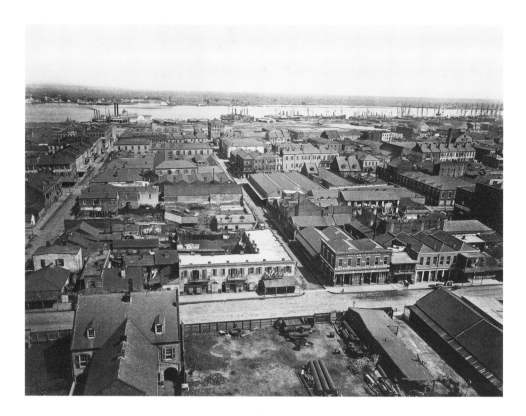

121
Bird's eye View of 1st Dist.
Panorama du 1ᵉʳ District

East and southeast of St. Patrick's Church, from Magazine Street (in the foreground) to the Levee, was the warehousing and industrial area of the batture. Streets that terminate at the Levee—Girod (left), Notre Dame, and Julia (right)—and those parallel to the river beyond Magazine, developed from the old faubourg St. Mary with access to shipping and the profits of the river trade. Activity in this waterfront district commenced with the river, where the wharves and landings handled more than 3000 ships a year before the war. Here, the sidewheeler *Magnolia* and other packet boats line the wharves of the Louisville, Cincinnati, and St. Louis steamboat landings. Farther upriver a long line of cargo schooners ride at anchor. The landings appear much as an antebellum visitor described them, "looming like an interminable row of lofty pines bereft of their foliage."[73]

It was at the batture that provisions dealers and grain merchants warehoused their goods. New Orleans was the distribution center for "the multitude of things which come pouring out of that wonderful cornucopia, the Valley of the Mississippi," *Beadle's Monthly* observed in 1867, and many of these cargoes were stevedored to and from the warehouses of the faubourg St. Mary.[74] The handling and export of goods made commission merchants, factors, ship captains, and others associated with the port rich before the war.

Coopers, ironmongers, tinsmiths, carpenters, and other trades had workshops there, often with residences nearby, and storefront grocers, druggists, and barkeeps served residents of the district. "This belt of land," the *Times* wrote in 1866,

> that extends for the length of a mile and a half, has absorbed unto itself all the residences that at one time were built by the retiring merchants of a quarter of a century ago, and in these houses live the

operatives, instead of the wealthy merchants who first built them. Small groceries are sprinkled throughout, and in the midst of this region coffee houses are thick upon the levee front, where workmen get their grog.[75]

From mid-century, this vast area of valuable batture was increasingly used for warehousing and industrial use, displacing the residences, retail stores, and workshops typical of the early development of the faubourg.[76]

Lilienthal's roofscape is a view into the untidy backlots of the batture, and is filled with engrossing detail. Iron boilers lie in a foundry yard in the foreground, a wagon factory and cooperage bridge the lots between Notre Dame and Girod streets, and a brass foundry fronts on Notre Dame opposite the wagon works. The Magazine Street workshop of John L. Baringer—"Copper Tin and Sheet Iron Worker, Blacksmith, Pattern Maker, Brass Founder and Finisher"—is typical of the commercial buildings of the riverfront district, its ground floor with glazed folding doors opened directly on to the street for ease of hauling and displaying wares. Often these shopfronts were constructed of brick with granite piers and lintels—the "Boston granite style" characteristic of waterfront commercial districts from Halifax to Galveston (see cat. 66).

The *Delta* predicted in 1862 that the granite style first adopted in New Orleans in the 1820s, and used for some thirty buildings planned or recently constructed along the waterfront, would bring "a complete metamorphosis" in the appearance of the batture. "A stranger, arriving by the river, will not recognize it as the Crescent City he has heretofore seen in daguerreotypes and lithographs," the *Delta* predicted.[77]

There is little sign of activity here in sun-bleached, dusty, treeless streets that appear desolate in the midday glare. A pedestrian is visible on the *banquette*, far along on Girod Street, but the druggist and the bookseller on Foucher Street and the other shops are quiet, as is the Levee. A cooper at work in his shop yard, a dray parked on Magazine Street, and lines of laundry slung out across rooftops are occasional signs of life. A plume of smoke rises from a packet negotiating the landing near the *Magnolia*, a steamer that served the Vicksburg, Mississippi, trade.

Along Girod and Tchoupitoulas streets are compact rows of brick buildings on narrow lots with party walls (extended above the roofline to contain fires) and ground-floor shopfronts, typical of American row houses built in the faubourg St. Mary before the war. The buildings had granite or iron piers and lintels with simple detailing, and were constructed of Baltimore, Philadelphia, or

Lake Pontchartrain red brick, often painted red, with shutters painted green. After mid-century, cast-iron detailing was typically applied. "A greater desire for ornamentation is visible, both in residences and places of business, than existed in former days," the *True Delta* observed in 1862.[78] The storefront repetition of piers and lintels and uniform openings gave a pleasing rhythm and scale to many batture streets.[79] A few remaining wooden structures were mostly sheds and lean-tos, although older building types survived. At the corner of Magazine and Girod streets a cottage with a French roof-form has been adapted to commercial use, with the addition of a metal overhang—a variation of the Creole *abat-vents*, or projecting roof, that shielded pedestrians from glare and rain.[80] One of the rooftops at the riverfront is the Drummond, Doig & Company foundry at Front and Notre Dame streets, photographed by Lilienthal for the Exposition (cat. 8).

Near the right-hand edge of the photograph is the Great Western Warehouse, built in 1861, and beyond, partially hidden behind a block of row houses, is the Crescent City Sugar Refinery, its gambrel roof and tall stack rising above the neighboring buildings.[81] The proximity of old housing blocks to refineries and mills was typical of this quarter, which was reclaimed from agricultural land, but the industries were a menace to the health of residents. The greatest hazard may have been the Julia Street Distillery, opposite the Great Western Warehouse; it was reported in 1866 to be emptying its "lees, foul stews, and swills" into a nearby canal.[82] The *Republican* complained that the distillery was "constantly sending offal along the gutters ... to the disgust and destruction of all the inhabitants."[83] This was a peril known, however, in different forms throughout New Orleans, where piles of refuse could be found "even in some of the handsomest streets." Most of the city's waste, "the contents of privies, the refuse of slaughterhouses, and similar accumulating filth," was, according to the *Republican*, "sunk in the river by means of flatboats" between midnight and daybreak.[84]

After the war, with river commerce greatly fallen off, this warehouse district was devitalized, and owners of batture properties had difficulty leasing buildings. Reporting the sale of batture land in 1866, the *Bee* observed:

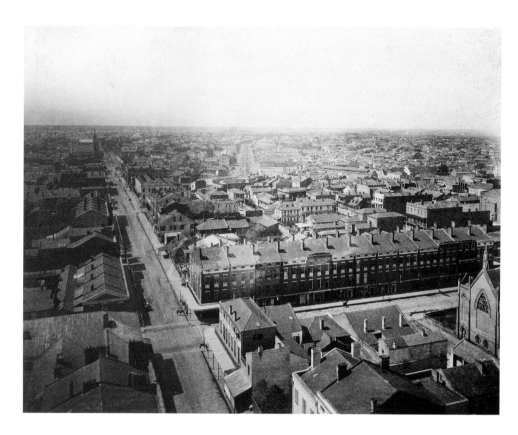

New Orleans does not have always an extended commerce to cover these vast tracts of land and to fill large buildings ... constructed on the batture lands People just do not use these ... brick "hangars" [We now] have eight successive streets without occupants ... at least forty uninhabited blocks.[85]

The *Times* proposed that the vacant warehouses be converted into residential units for the "mechanical and laboring people."[86] But building costs were so inflated, with materials scarce and labor expensive, that "some owners of property seem disposed to let go to decay," the *Times* reported. "[M]echanics are receiving enormous prices; four and five dollars per day for carpenters and bricklayers frightens property holders. We have never known so many buildings requiring repairs as at this present time. This arises from the limited repairs for four years past."[87]

Revival of the warehouse district came only with the growth of rail traffic in the later nineteenth century, bringing expanded freight-handling facilities to the Levee and industrial growth to the quarter. During the first half of the twentieth century, pier terminals covered the riverfront, but with containerization and

the opening of deep-water port facilities downriver in the 1960s and 1970s, most of the transfer and storage of goods moved away from the area, and again the warehouse district declined. The river landings were cleared for construction of the Louisiana World Exposition of 1984. Commercial and residential development followed the fair and brought destruction as well as renovation and restoration of old commercial buildings, as industrial loft living became fashionable. Today, this view would be dominated by a sprawling riverfront convention center, the hotels built to service the convention trade, and two twentieth-century bridges carrying highway traffic across the river to the West Bank.

122
Birds' eye View of 1st Dist.
Panorama du 1ᵉʳ District

The third panoramic section from St. Patrick's Church is a view uptown in a southwesterly direction toward Tivoli (Lee) Circle, following the Camp Street corridor, which intersects Julia Street in the foreground. The river is visible as a thin line near the horizon. St. Charles Street cuts a wide path uptown in the center of the view. Just entering the frame

in the lower right is the Gothic Congregationalist Unitarian Church of the Messiah (the Strangers' Church), designed on an octagonal plan by John Barnett and built in 1853–55. The pastor there before the war was Theodore Clapp, "long regarded as one of the foremost pulpit orators in America," the *New York Times* wrote at his death in 1866.[88]

On the uptown side of Julia Street is an orderly row of thirteen identical three-bay, side-hall town houses known as Julia Row, probably designed by Alexander T. Wood and built on speculation by the New Orleans Building Company in 1832–33.[89] The federal-style row house introduced there, complete with a service alley, was more characteristic of Philadelphia than of Creole New Orleans, and reflected the "malady," one Orleanian proclaimed, "of building private residences like 'fiddlers all in a row.'"[90] The "American fashion" of the faubourg impressed visitors, however: "nothing in ... [its] appearance [is] different from an Atlantic town," one observed.[91] Julia Row was home of the "leading social element of the American colony," according to one antebellum resident.[92] Architect H.H. Richardson, born on a Louisiana sugar plantation, lived in a row house there from 1838 until the mid-1840s.[93] A lease advertisement in 1867 for 152 Julia Street provides a description of the town-house amenities at Julia Row:

> Three-story and attic brick dwelling, with three-story brick back buildings, containing wide hall and two large parlors on [the] first floor, wide hall and three large bed-rooms on each [of] the second, third, and fourth floors. The back buildings contain kitchen, china closet, two other rooms, and a wood house on the first floor, and seven bed-rooms, bath-room, water closets, etc. on the second and third floors, or about twenty-one rooms in all. The house has gas and bells throughout, marble mantels, etc. The yard is flagged, and has a large cistern, hydrant, and a well.[94]

After the middle of the nineteenth century, affluent Americans settled increasingly farther uptown, where lot sizes allowed house construction on a larger scale, and in June 1866 the *Bee* reported declining property values in the American quarter, while other districts uptown were improving.[95] Uptown beyond Julia Street, the street grid appears in the photograph as a dense jumble of frame houses. There were few green spaces and no streets canopied with trees so characteristic of uptown New Orleans today. In the upper left of the view, Camp Street widens into Coliseum Square, beyond which Prytania Street intersects and forms a triangular lot fronting on the New Orleans Female Orphan Asylum.[96] A trio of Gothic church towers is visible here. St. Paul's Episcopal Church of 1853 (cat. 76) is on the left side of Camp Street. Beyond is the Coliseum Square Baptist Church of 1855—its graceful spire was described as "one of the first seen by the traveler as he approaches the city by the river."[97] Behind the asylum at Camp and Erato streets is the tower of St. Theresa's Church, built in 1848–49.[98]

Tivoli Circle, just above the center of the photograph, was an artifact of an early town-planning scheme. Languedoc-born surveyor and engineer Barthélémy Lafon subdivided the old Duplesis-Delord-Sarpy plantation adjoining the faubourg St. Mary (an area now known as the Lower Garden District) in 1807. Lafon planned for this site a water park that he called Place du Tivoli, with a canal connecting to the river, but only a carriage circle was built. Once intended as a grand gesture of citybuilding, Lafon's circle was neglected and its wartime use as a Union encampment left it ruined. After the war, circus shows and theater troupes performed there, but the square was blighted and barren, scorned for its "woe-begone-ness" and the "signs of so much poverty which that public place so roundly offers to the passer-by."[99]

Uptown from Tivoli Circle, Lafon laid out a grid of streets, named for the gods and muses of antiquity, and bisected by an avenue called the "Cours des Naiades" after the river nymphs (later renamed St. Charles Street). The street names "in what may be called the Olympian portion" of the city delighted visitors, none more than the New Yorker Abraham Oakey Hall.[100] "The Muses and the Graces contributed their refinement to the swamp infested districts of the Faubourg St. Marie," Hall wrote in *The Manhattaner in New Orleans*; "... what would you say to Nayades and Dryades and Bacchus-street ... which run into Felicity-road, and are intersected by Calliope and Clio and Erato and Thalia-streets?"[101]

Facing Tivoli Circle to the west is the depot and train shed of the New Orleans and Carrollton Railroad, demolished in the late spring of 1867 for a proposed Masonic Hall.[102] Gentrification of the neighborhood was predicted, with the demolition of other "wretched and unsightly buildings on both sides of the old Tivoli Walk."[103] The *Picayune* saw "no reason why this Tivoli Circle vicinity should not, [as] soon as the new Masonic Hall is built, blossom in to ice cream gardens and break out in retail stores."[104] Construction of the new hall was delayed, however, and the Masons eventually abandoned the site. Improvements were made to the circle only after it was selected for a memorial to Confederate General Robert E. Lee, which was completed in 1884.[105]

123
Birds eye view of 3rd Dist.
Panorama du Troisieme district

Lilienthal completed at least two sections of a panorama (this view and cat. 124) from the observatory of the Academy of the Marianite Sisters of the Holy Cross, located in the Ninth Ward of the Third District, below the Vieux Carré. The Marianite Academy faced Rampart Street between Congress and Elmira (Gallier) streets, and was backed by Good Children (St. Claude) Avenue. Lilienthal's view is toward the river, which makes a turn in the direction of the Vieux Carré at the upper right of the photograph. Elmira is the diagonal street that leads from the right foreground to the river, where tall masts of sailing ships are visible. Wharves and landings covered the riverfront from about Piety Street to well upriver beyond the Vieux Carré.

The Marianite sisters were a teaching congregation founded in France in 1841 and established in New Orleans in 1848; by the early 1850s, they were working among the poor immigrant families of the Third District.[106] On May 3, 1862, two days after federal troops took possession of the city, the sisters laid the foundation stone for their three-story brick school, and construction continued intermittently during the occupation.[107] The Academy was dedicated in 1865. It was still in use by the sisters in 2005 when it was damaged by the floodwaters of hurricane Katrina, which inundated the Ninth Ward and most of the Third District.

At the Levee between Piety and Desire streets is the fire ruin of the Touro Almshouse (also visible in cat. 110). Financed from a bequest of Judah Touro and by R.D. Shepherd, his executor,

the public asylum was organized to provide for "one of the greatest wants of New Orleans," a refuge for the "swarms of mendicants" on city streets.[108] After a study committee urged trustees to select a riverfront site that would provide "fresh air and an abundance of water," Shepherd purchased batture property in the Third District.[109] A national design competition in 1858 netted at least thirteen "striking" plans, the majority from northern architects, and included a proposal "in a very graceful Gothic style" by local architect Will Freret, drawn by James Freret.[110] Freret's plan, accepted by the trustees, gave "extraordinary evidences of talent, judgment and architectural art, in the young author," then twenty-two years old.[111]

Freret's winning design was a three-story brick building, 290 feet wide and 72 feet deep (88 × 22 m), with a galleried center dormitory and two wings containing staff quarters and a hospital. Ornamented with corner towers, turrets, and cast-iron detailing, the building was designed, the *Bee* wrote, in a "grand architectural harmony" of "three Gothic styles of different ages": the "pure old Gothic" of the street façade, the "altered Gothic of the 14th and 15th centuries" for the remainder of the center building, and "the latest Gothic style, known as the Elizabethan," for the wings.[112] A two-story dining hall and kitchen was connected to the center building, and outbuildings included a gasworks, laundry, dairy, bakery, workshops, and an engine house (to supply steam pump river water to the buildings).[113] A 100-foot (30-m) forecourt was "handsomely laid off in parterres, with fountains, lodges, etc." and surrounded by a tall brick wall. The construction cost was estimated at $150,000.[114] It would, the *Crescent* predicted, "be by far the largest and most splendid of all the public buildings of New Orleans."[115]

Construction of the almshouse began in October 1859. The following spring, the first story of the center building and the kitchen had been raised, but progress slowed as supplies of brick became difficult to obtain.[116] With the outbreak of war in 1861, work stopped, leaving a roofless, timber-framed shell of brick walls.[117] "Though unfinished, it was one of the most impressive and elegant buildings in the South," the *Picayune* declared. The *New York Times* echoed the claim: "architecturally, [it] could compare favorably with any [building] in the city."[118]

In early 1864, the Corps d'Afrique, an African American unit of the U.S. army, took

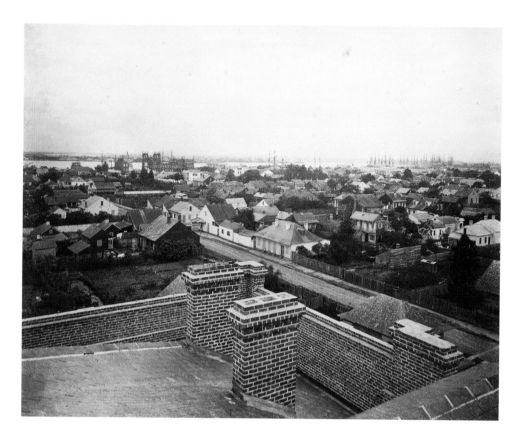

possession of the building as a recruiting depot and barracks, and expended $50,000 on a build-out to accommodate 2000 soldiers.[119] On September 1, 1865, a faulty flue from a cookstove ignited the rafters, and "one of the noblest charities in the South [was] reduced to ashes," the *Daily Southern Star* reported.[120] Although an investigation attributed the fire to the "gross carelessness" of the federal soldiers, attempts by the trustees to hold the government accountable failed, as did a reconstruction campaign.[121] Salvageable material was "shamelessly and fraudulently appropriated" by city officials, according to one report, but for years the charred brick walls remained—a conspicuous symbol, as one observer wrote, of the "gloom and ruin" of the war.[122]

124 *overleaf*
Birds' eye View of 4th Dist.
Panorama du 4ᵐᵉ District

Although Lilienthal's caption refers to the uptown district above Felicity Street known as the Garden District, the vantage point, like that of the preceding photograph, is the Academy of the Marianite Sisters in the Third District. The view looks northeast across the sparsely settled Ninth Ward, in the direction of Gentilly Road and

the Bayou Sauvage (where today the Industrial Canal and the container terminals of the port of New Orleans are located). Bisecting the photograph in the middle distance are Good Children (St. Claude) Avenue and the tracks of the Mexican Gulf Railroad. Congress Street, with drainage canals on either side, leads away from the Academy, meeting the Claiborne Canal in the far distance.

The Ninth Ward was formed out of the old eighteenth-century faubourgs Montreuil and Carraby, and the properties of the Macarty and Duralde families, and was known in the 1840s as Washington.[123] In the 1850s, an "industrial class of people," predominantly Irish and German immigrants, settled its "delightful and sanitary grounds," large areas of which had been recently drained but where city improvements were reportedly still "very limited."[124] Extension of the City Railroad during the next decade brought the Ninth Ward into a citywide network of horsecar lines, and by 1866 most of the district was subdivided. Yet building was sporadic and diverse: identifiable in the photograph are Creole and American cottages, two bay shotgun cottages, and Greek-revival and colonial-style raised plantation houses. But most prevalent here is small-scale agriculture—garden lots trimmed

with picket fences, small farms and dairies, turnip fields, and pastureland. A visitor in late 1866 described streets that still presented "quite a barn-yard appearance."[125]

Long, straight streets, fencerows, and ranks of trees trace the boundaries of the old colonial plantations—narrow strips of land, or *arpents,* characteristic of early French settlement up and down the river. Properties laid out in this way, offering the most fertile land with easy access to water transport, maximized premium river frontage, as the English lawyer Henry Latham observed in 1867:

> Each bank of the Mississippi, and each bank of each bayou, is cleared of forest to the depth of from a mile to a mile and a half from the riverbank ... and these strips of land are divided, at right angles to the river, into plantations; so that each plantation has a river frontage, and the great white houses of the planters stand facing the river about 300 yards back from the bank.[126]

The uncultivated long lots that marked the edge of development of the district are visible in the far right distance. Some of these properties had been developed for the Ursuline nuns, the New Orleans Sugar Refinery, and the United States Hospital and Barracks, also subjects of Lilienthal's Exposition photographs.

This area of this view was one of the hardest hit in the city during the Katrina catastrophe in 2005. The hurricane's storm surge from the Gulf of Mexico was funneled, via the Mississippi River Gulf Outlet (known as the "hurricane superhighway"), into the Industrial Canal, which borders this district.[127] The storm waters breached the flood walls of the canal, inundating the Ninth Ward.[128]

Located well below sea level, this area of the city had historically experienced chronic flooding.[129] In the mid-nineteenth century, it was "constantly subject to overflows" from the Mississippi, as the city surveyor, Louis H. Pilié, noted in 1854. Pilié was alarmed at the city's failure, after the poorly maintained levees had "occasioned so much injury" in the Ninth Ward, to allocate the funds necessary to keep them in repair.[130] His successor, the federally appointed T.B. Thorpe, also warned of the "dangerous condition" of the infrastructure. The "Mississippi has threatened and still threatens to overwhelm the lower part of the City," he declared in 1863. "The danger [is] becoming imminent."[131] But the wartime city council, with many pressing

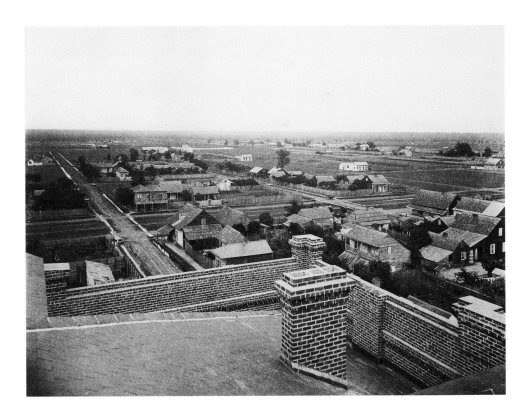

issues on its agenda, continued to be indifferent to the plight of the district. "[M]y books will in the future show that the impending destruction hanging over the Lower part of the City has been intelligently and constantly brought before the proper authorities," Thorpe wrote.[132] Toward the end of the century, city surveyor B.M. Harrod predicted that if the neglected levees crevassed, "the destruction of life and property would extend throughout the entire city." Again, the city could not provide funds for levee improvements, nor could the state, and no further appropriations could be obtained from Congress.[133]

Although the inundation of the Ninth Ward following hurricane Katrina had many precedents (most recently in the floods of 1978, 1983, and 1995), the devastation of 2005 exceeded all earlier events. Exposed by the catastrophe, the poverty and desperation of Ninth Ward residents became a metaphor for government indifference and the topographics of race that compelled poor and working-class black Orleanians to live in ecologically marginal areas of the city.[134] "Obviously the Ninth Ward is just going to have to be bulldozed," one resident remarked. "There's nothing left to salvage."[135]

1. Friedrich Gerstäcker, *Gerstäcker's Louisiana: Fiction and Travel Sketches from Antebellum Times Through Reconstruction,* trans. and ed. Irene S. Di Maio, Baton Rouge (Louisiana State University Press) 2006, p. 54. The passage, from 1847 to 1848, appears in *Mississippi-Bilder: Licht- und Schattensteiten Transatlantischen Lebens* (1847–48), published in Friedrich Gerstäcker, *Gesammelte Schriften,* Jena, Germany (Costenoble) 1872, pp. 617–31.

2. Peirce F. Lewis, *New Orleans: The Making of an Urban Landscape,* Cambridge, Mass. (Ballinger) 1976, p. 37.

3. Between 1810 and 1840, New Orleans was the fastest-growing city in America; *The Seventh Census of the United States: 1850,* Washington, D.C. (Robert Armstrong) 1853, p. lii.

4. Louis Fitzgerald Tasistro, *Random Shots and Southern Breezes,* New York (Harper & Brothers) 1842, I, p. 56.

5. Gallier, *Autobiography,* p. 21.

6. Lewis, *op. cit.,* p. 30.

7. Harriet Martineau, *Retrospect of Western Travel,* London (Saunders & Otley) 1838, II, p. 71.

8. *Ibid.,* p. 126; the cotton press referred to is not identified, but several presses had viewing cupolas: *Gibson's Guide* recommended the cupola of the Orleans Cotton Press on New Levee (South Peters) Street, from which "a fine view may be had of the Port of the Crescent City" (p. 319), and a Hill–Smith lithograph of 1850 was made from the "Lower Cotton Press" (see n. 19 below).

9. Charles Lyell, *A Second Visit to the United States of North America,* London (John Murray) 1849, II, p. 132.

10. Observatories and viewing belvederes topped many local buildings. Those photographed by Lilienthal with prominent viewing rooms included: the Girod House on St. Louis Street, the S.N. Moody House on Canal Street, Evariste Blanc House on Bayou St. John, Dan Hickock's Restaurant on the New Basin Canal, Charity Hospital, St Anna's Asylum on Prytania Street, the Fellows Residence in Jefferson City, the Carrollton Hotel, the U.S. Hospital, and the Marianite Academy, from which Lilienthal made a partial panorama (see cats. 14, 21, 30, 33, 69, 82, 99, 104, 114, and 123). Lilienthal's other rooftop views in 1866 included a view from the cupola of Poydras Market and

the set of Fairgrounds views—"two or three bird's eye views of the entire grounds, taken from the place of Mr. Luling, adjoining" (*Crescent*, December 1, 1866). Two sequential stereoviews (figs. 63 and 65), one nearly duplicating an Exposition view (cat. 26), may have been part of a panorama of the Bayou St. John and the lakefront completed at this time.

11. Joseph Holt Ingraham, *The South-West, by a Yankee*, New York (Harper & Brothers) 1835, I, pp. 183–84. Bishop's Hotel was built by Charles Zimpel at Camp and Common streets in 1831 (it was renovated in 1873 as the City Hotel).

12. *Gibson's Guide*, p. 333.

13. *Picayune*, May 24, 1839.

14. Abraham Oakey Hall, *The Manhattaner in New Orleans, or, Phases of "Crescent City" Life*, New York (J.S. Redfield); New Orleans (J.C. Morgan) 1851, p. 26. Hall's text dates from 1846–47, before destruction of the first St. Charles Hotel.

15. "Our Levee," *Picayune*, April 11, 1841; *Norman's New Orleans and Environs*, pp. 69, 141, which essentially copies *Gibson's Guide* of 1838, p. 333. The St. Charles Hotel burned down in 1851 and was rebuilt without the dome; see cat. 64.

16. *Picayune*, February 9, 1858, cited by Joseph Jenkins Cornish, *The Air Arm of the Confederacy*, Richmond, Va. (Richmond Civil War Centennial Committee) 1963, p. 14; "Congo Square—Mr. Eugene Godard" (advertisement), *Picayune*, January 10, 1855; "The Balloon Ascension," *Picayune*, January 17, 1855; "Place d'Armes ... Ascension of E. Godard" (advertisement), *Picayune*, February 9, 1855; "Aerial Navigation and Grand Balloon Ascension at Place d'Armes" (advertisement), *Picayune*, November 20, 1857. No early aerial photographs of New Orleans are known but Nadar's ballooning experiments in Paris were reported by a *Picayune* correspondent in 1863; "From Paris," *Picayune*, September 17, 1863.

17. Printed bird's-eye views of New Orleans dated from at least 1803, the year of the Louisiana Purchase, when J.L. Boqueta de Woiseri published the aquatint *View of New Orleans from the Plantation of Marigny*, probably to celebrate the American acquisition of New Orleans from France. On the print tradition of bird's-eye views, see Susan Gross, *Toward an Urban View: The Nineteenth-Century American City in Prints*, New Haven, Conn. (Yale University Art Gallery) 1989, p. 18; Ann Payne, *Views of the Past*, London (British Library) 1987, pp. 11ff; and John W. Reps, *Cities on Stone: Nineteenth-Century Lithograph Images of the Urban West*, Fort Worth, Tex. (Amon Carter Museum) 1976; id., *Views and Viewmakers of Urban America*, Columbia (University of Missouri Press) 1984; id., *Cities of the Mississippi: Nineteenth Century Images of Urban Development*, Columbia (University of Missouri Press) 1994, especially pp. 8, 18, 103, 111–13; id., *Historic Lithographs of North American Cities*, New York (Princeton Architectural Press) 1998.

18. On Dondorf, see Ulrich Thieme and Felix Becker, *Allgemeines Lexikon der bildenden Künstler*, Leipzig (W. Engelmann; E.A. Seemann) 1907–50, IX, p. 437; Gloria Gilda Deák, *Picturing America, 1497–1899*, Princeton, N.J. (Princeton University Press) 1988, I, pp. 413–14. On Cooke, Michael Bryan, *Bryan's Dictionary of Painters and Engravers*, London (G. Bell) 1903–1905, I, "Cooke." Examples of Cooke's steel engraving of New Orleans are in the Southeastern Architectural Archive, Tulane University; Louisiana State Museum; New York Public Library; and, together with a similar Cooke engraving of New York, in the Bildarchiv Preussischer Kulturbesitz, Berlin. Schwarz issued many versions in different formats of the Dondorf lithograph over many years.

19. "View of New Orleans—We have received from Messrs. Smith, Bros. & Co., a colored engraving representing a view of New Orleans, taken from the tower of St. Patrick's Church and looking northward. It was undertaken two years ago, and has

entailed much labor on the projectors. The large size of the picture, the faithful manner in which every object has been delineated, and the superior style of the execution, render this view one of the best of the kind ever brought to completion in this country"; *Picayune*, April 27, 1852. *New Orleans from the Lower Cotton Press* is illustrated in John W. Reps, *Cities of the Mississippi: Nineteenth-Century Images of Urban Development*, Columbia (University of Missouri Press) 1994, p. 116. Hill was an innovative topographic artist who had published bird's-eye views of New York from the steeple of St. Paul's Church (a few years before the New Orleans view) and a bird's-eye from Brooklyn Heights (about 1836); Deák, *op. cit.*, I, pp. 311–12, 391–92, II, pp. 463, 578. Smith specialized in city views published in partnership with three brothers in Boston and New York from about 1848 to 1857; Reps, *Cities on Stone, op. cit.*, pp. 9–10; and id., *Views and Viewmakers, op. cit.*, pp. 206–208.

20. *Delta*, June 3, 1852, cited by Reps, *Cities of the Mississippi, op. cit.*, p. 43, n. 11.

21. Peter Bacon Hales, *Silver Cities: The Photography of American Urbanization, 1839–1915*, Philadelphia (Temple University Press) 1984, p. 73. Two years after the publication of the Hill–Smith lithographs, a 2700-square-foot (250 sq. m) painted panorama from St. Patrick's by Pietro Ghaldi was installed in an octagonal theater erected at St. Charles and Poydras streets; "Panorama of New Orleans," *Picayune*, March 14, 1854.

22. *Picayune*, May 30, 1849.

23. Wharton, "Diary," March 10, 1856. Earlier, in his entry for February 3, 1854, Wharton remarked that the "city and Levee views ... from the top of the walls add a new and interesting feature."

24. Illustrated in Samuel Wilson, Jr., *The Vieux Carre Historic District Demonstration Study*, New Orleans (Bureau of Governmental Research) 1968, p. 83. Edwards is documented in St. Louis in 1857, and was active in New Orleans 1858/59 to 1862; "Jay Dearborn Edwards," in Peter E. Palmquist and Thomas R. Kailbourn, *Pioneer Photographers from the Mississippi to the Continental Divide: A Biographical Dictionary, 1840–1865*, Stanford, Calif. (Stanford University Press) 2004, pp. 230–31.

25. McPherson and Oliver cartes-de-visite of New Orleans streets and buildings are in the Marshall Durham Photograph Album, Mss. 3241, Louisiana and Lower Mississippi Valley Collections, Louisiana State University Libraries. An early Blessing carte-de-visite rooftop view is in an unprocessed collection in the Hill Library, Louisiana State University.

26. In the history of panoramic photography, Lilienthal's work falls in the first decade of stereograph panoramas of American cities. See David Harris and Eric Sandweiss, *Eadweard Muybridge and the Photographic Panorama of San Francisco, 1850–1880*, Montreal (Canadian Centre for Architecture) 1993.

27. Edward H. Hall, *Appleton's Hand-book of American Travel: The Southern Tour*, New York (D. Appleton) 1866, p. 107.

28. "Lafayette Square," *Picayune*, December 14, 1851.

29. Lilienthal deposited for copyright the twelve bird's-eye views on April 13, 1866. Library of Congress, Copyright Records, Eastern District, Louisiana, August 1863–June 1870 (see p. 273).

30. Copyright deposit of May 2, 1866. Library of Congress. Copyright Records, Eastern District, Louisiana, August 1863–June 1870 (see p. 273); *Times* (advertisement), June 14, 1866.

31. Hales, *op. cit.* Martha Sandweiss has shown that panoramas celebrating urban progress were sequential and "transformed photography into a narrative medium" in which the differences in the shadows, pedestrians, horses, and

vehicles suggested movement and passage of time; Martha A. Sandweiss, "Undecisive Moments," in *Photography in Nineteenth Century America, 1839–1900*, ed. Martha A. Sandweiss, Fort Worth, Tex. (Amon Carter Museum) 1991, p. 113. The source for this narrative function can be found in the nineteenth-century fascination for cosmoramas, panopticons, dioramas, and painted panoramas, like New Orleans's Armory Hall exhibition of "Harrington's Panorama of the Russian War" in 1856 (*True Delta*, February 25, 1856) or "Harding's Panorama of Commander Perry's Expedition" in 1857 (*Sunday Delta*, June 7, 1857). Historian Tom Kailbourn has recorded more than a dozen major panoramas exhibited in New Orleans in the 1850s, a fascination supplemented and partly supplanted by stereoview mania.

32. Derek Gregory, "Emperors of the Gaze: Photographic Practices and Productions of Space in Egypt, 1839–1914," in *Picturing Place: Photography and the Geographical Imagination*, ed. Joan M. Schwartz and James R. Ryan, London and New York (I.B. Tauris) 2003, p. 208; Dana Arnold, "The View from St. Paul's," in *Re-presenting the Metropolis: Architecture, Urban Experience and Social Life in London, 1800–1840*, London (Ashgate) 2000, pp. 1–24; Glen E. Holt, "Chicago Through the Camera Lens: An Essay on Photography as History," *Chicago History*, I, no. 3, Spring 1971, p. 159; Nancy Armstrong, "City Things: Photography and the Urbanization Process," in Diana Fuss, *Human, All Too Human*, New York, London (Routledge) 1996, pp. 106–107. Deborah Bright has suggested that a "dramatically distanced and kinesthetically alienated view of the city" characterized Civil War-era photography. Deborah Bright, "Souvenirs of Progress: The Second Empire Landscapes," in *Image and Enterprise: The Photographs of Adolphe Braun*, New York (Thames & Hudson) 2000, p. 102.

33. Jill Delaney, "Truth Be Told: The Photographic Panorama and the Canadian City," conference paper, Society for the Study of Architecture in Canada, Halifax, NS, May 1999. See also Hales, *op. cit.*, pp. 73–88.

34. The inventory of *La Nouvelle Orléans et ses environs* (*Crescent*, March 1, 1867) refers only to "Birds-eye views of New Orleans," and the partial inventory published at completion (*Crescent*, May 26, 1867) lists a "Bird's-eye view from St. Patrick's of the city, levee, Algiers, and the crescent bend in the Mississippi." This later reference may describe a view taken in a more easterly direction (compare fig. 58), or may simply have been intended to refer to several "views." No mention is made in any of the published reports of the Marianite Academy views. The Exposition portfolio also included two other rooftop views, the bird's-eye view from the Carrollton Hotel observatory (cat. 104) and the lost view inventoried as "Jackson Square and steamship landing from the Cathedral" (*Crescent*, May 26, 1867). Five years after *La Nouvelle Orléans et ses environs*, Lilienthal again updated the St. Patrick's panorama, in both stereo and large-plate formats, for *Jewell's Crescent City Illustrated*. One updated segment of the St. Patrick's bird's-eye is a stereoview toward the new Southwestern Exposition Building, built in 1872 (examples are in the collections of Mystic Seaport Library, Mystic, Connecticut; Visual Studies Workshop Research Center, Rochester, New York; and the Louisiana State Museum, New Orleans, 1979.120.061). Two or three years after Lilienthal's stereo panorama of 1866, Samuel T. Blessing published a set of eight bird's-eyes in stereo format advertised as "a Panorama of the whole City ... Taken from St. Patrick's Church Spire." Blessing's framing differed slightly from Lilienthal's, so presumably avoided infringement of Lilienthal's copyright.

35. Rebecca Solnit, *River of Shadows: Eadweard Muybridge and the Technological Wild West*, New York (Viking) 2003,

p. 160.

36. Colorwash drawings advertising auction sales of property commissioned by the city from 1802 through 1918, now deposited in the Orleans Parish Notarial Archive, document the colors of nineteenth-century New Orleans with unusual detail. See Sally K. Reeves, "The Plan Book Drawings of the New Orleans Notarial Archives: Legal Background and Artistic Development," *Proceedings of the American Antiquarian Society*, CIV, pt. 1, 1995, pp. 105–25. For a discussion of colorism and urban ambience as revealed in nineteenth-century photography, see Diane Favro, "Capturing the Past: Experiencing the Ancient City through Historical Photographs," *Visual Resources*, VIII, 1992, pp. 355–62.

37. "Lafayette Square," *Picayune*, December 14, 1851.

38. "The Ruins of the Late Fires," *Evening Picayune*, February 9, 1867.

39. The divisions are seen clearly on Henry Moellhausen's city plan of 1845, *Norman's Plan of New Orleans & Environs,* which accompanied *Norman's New Orleans and Environs*. On the history of the quarter, see Samuel Wilson, Jr., "Early History of Faubourg St. Mary," in *New Orleans Architecture*, II, pp. 3–48.

40. Building contract, G. Rareshide, May 1, 1856, NONA.

41. *Crescent*, March 16, 1857, cited by Samuel Wilson, Jr., *The First Presbyterian Church of New Orleans*, New Orleans (Louisiana Landmarks Society) 1988, p. 33.

42. James Freret, "The Moresque Building," n.d., transcription in James Freret Collection, Southeastern Architectural Archive, Tulane University.

43. Building contracts, D.T. Ricardo, LXXVII, nos. 46, 246, March 5, 1860, and June 14, 1861; J. Graham, XXII, no. 4998, November 15, 1861; LXXX, no. 747, December 12, 1865, NONA. "A New and Elegant Building," *Picayune*, January 25, 1860; Freret, *op. cit.* A hotel was proposed for the Moresque site before Barelli located his retail and wholesale stores there; "Lafayette Square and its Improvements," *Picayune*, August 2, 1857. Freret revived the hotel project after the war for John Gauche and George Moore.

44. See "Numberless windows," *Crescent*, July 28, 1867; "The City," *Picayune*, August 21, 1861.

45. "The City," *op. cit.*; see also *True Delta*, March 7, 1862.

46. "The Barelli Buildings," *True Delta*, November 15, 1865.

47. "The Moorish Building," *Times*, October 29, 1865; *Tribune*, November 15, 1865; "Sale of the Moresque Buildings," *Picayune*, November 16, 1865; *Times*, December 9, 1866.

48. "The Moresque Buildings," *True Delta*, January 12, 1866.

49. Freret, *op. cit*; Freret returned from Paris in 1862: "I ran the blockade at Charleston, received a commission of List [Lt.] of Engineers, went through the siege of Port Hudson and was paroled and sent home on a litter after the surrender of that place in July 1865." A similar biographical account appears in *Jewell's Crescent City Illustrated*. Contract for completion of the Moresque, New Orleans Mortgage Board, 80/747, December 12, 1865.

50. "New Orleans Manufactures and Arts," *Times*, April 29, 1866.

51. *Daily Southern Star*, February 1, 1866; also *Crescent*, January 31, 1866; *Picayune*, February 6, 1866.

52. "Doors of the Moresque Building Open," *Times*, December 9, 1866. The roof was completed in November; *Times*, November 13, 1866. A stereoview by Samuel T. Blessing ("Views of New Orleans No. 405, Camp Street from Lafayette Square to Canal Street") shows "John Gauche's new Iron Building" (the Moresque) from a second-story balcony near St. Patrick's Church. Also visible in the foreground are the fire ruins of Odd Fellows' Hall (Louisiana State Museum 1979.120.110).

53. "The Bazaar at the Moresque Building," *Picayune*, December 11, 1866. Giulio Adamoli witnessed the fair on March 1, 1867: "Just now it is occupied by a charity bazaar for the benefit of ex-Confederate soldiers"; "New Orleans in 1867," *Louisiana Historical Quarterly*, VI, 1923, p. 272. More Moresque benefit balls followed in early 1867 before the commercial spaces were fully occupied; *Picayune*, February 7, 1867; *Times*, March 24, 1867.

54. "Improvements in the City," *Picayune*, April 9, 1867; "The Gauche Building," *Times*, July 27, 1867; *Crescent*, July 28, 1867.

55. *Times*, January 8, 1867; *Crescent*, July 28, 1867.

56. *Picayune*, October 24, 1867.

57. Quotation from *Picayune*, October 24, 1867. See also *Times,* April 13, 1866; *Crescent,* April 3, 1867.

58. *The Picayune Guide Book of New Orleans*, New Orleans (The Picayune) 1895.

59. "Fire Sweeps a Historic Square," *Picayune*, April 16, 1897; "After the Fire," *Daily States*, April 16, 1897.

60. "Fire Sweeps a Historic Square," *op. cit.*

61. "After the Fire," *op. cit.* The Moresque was one of the most-photographed buildings in the city and appeared in many view books, even after its destruction. Among the best views are a cyanotype by E.T. Adams, published in *Photographic Album of the City of New Orleans, Comprising the Principal Business Houses and Views of the City*, New Orleans (Hofeline & Adams) 1887, reprinted as a "Postmortem" in Henry E. Chambers, *Hansell's Photographic Glimpses of New Orleans*, New Orleans (F.F. Hansell & Bro.) 1908; and an albumen print contemporary with Lilienthal's by an unknown photographer in the collection of the Royal Institute of British Architects (now transferred to the Victoria and Albert Museum), London, reproduced in Robert Elwall, *Building With Light*, London and New York (Merrell) 2004, p. 75. The Metropolitan Bank Building (Diboll, Owen & Goldstein) was built at the corner of Poydras and Camp streets in 1909, but most of the block remained vacant for twenty years after the Moresque fire. The Times-Picayune Building, "of steel and reinforced concrete, fireproof throughout," designed by Moise Goldstein, finally replaced Freret's building in 1919–20 (*Times-Picayune*, July 11, 1919). An office tower, the Poydras Center, in turn replaced the Times-Picayune Building in 1981.

62. A view of the Moresque Building is listed in the *Crescent* inventory of March 1867 ("The Portfolio," *Crescent*, March 1, 1867). The completed portfolio was reported to contain a view of the "Moresque Building from corner of Camp and Poydras streets," "New Orleans and Vicinity at the Paris Exposition," *Crescent*, May 26, 1867.

63. Lilienthal photographed the Moresque Building again in 1872 for *Jewell's Crescent City Illustrated*, which published a wood engraving (probably by J.W. Orr) after Lilienthal's photograph.

64. "The Odd Fellows' Hall," *Picayune*, February 17, 1852. Purves competed with five other architects for the commission. On the hall: Building contract, William Shannon, November 15, 1851, NONA; "Elevation of Odd Fellows' Hall," Map 107G, Sheet 6, RG92, Post and Reservations, Records of the Office of the Quartermaster General, NARA; *Courier*, August 18, 1849; "The Odd Fellows' Hall," *Delta*, December 23, 1849, with a wood engraving by Shields and Collins; *Picayune*, October 15, 1852; "Dedication of Odd Fellows' Hall," *Crescent*, November 23, 1852; *Delta*, November 23, 1852; Wallace A. Brice, *New Orleans Merchants' Diary and Guide, for 1857 and 1858*, New Orleans (E.C. Wharton) 1857; John G. Dunlap, *History of the Independent Order of Odd-Fellows of Louisiana*, New Orleans (L. Graham) 1877, pp. 16–18. The new hall is prominent in the Hill–Smith bird's-eye view, drawn during construction probably from Purves's elevations (fig. 53).

65. "The Odd Fellows' Hall," *Picayune*, February 17, 1852.

66. "The Ruins of the Late Fires," *Evening Picayune*, February 9, 1867.

67. "Odd Fellows' Hall," *Bee*, December 4, 1865. Lilienthal photographed the building in 1865 for the U.S. Quartermaster General (see p. 44).

68. "Odd Fellows' Hall," *Times*, November 14, 1865; "Odd Fellows' Hall in Ashes," *Crescent*, July 6, 1866; *Gardner's New Orleans Directory for 1867*, p. 6.

69. The call for proposals was issued in July 1866; "Odd Fellows' Hall," *Crescent*, July 7, 1866; "Plans for Rebuilding Odd Fellows' Hall," *Times*, July 10, 1866; "To Architects," *Crescent,* July 11, 1866; "The New Odd Fellows' Hall," *Times*, September 8, 1866. A contemporary photographic copy of Gallier's proposal, publicly exhibited in early 1867, is in the Southeastern Architectural Archive, Tulane University.

70. *Times*, April 27, 1866.

71. The building located at North and Camp streets had been photographed by Lilienthal in 1865, when it was occupied by the U.S. Quartermaster General (see p. 44). Built by the Merchant's Bank, it was occupied by the Jackson Railroad when U.S. troops took possession. "Report of Buildings Owned by the U.S. Government, 1865," Consolidated Correspondence File 1794–1915, Office of the Quartermaster General, RG92, NARA. The renovation was designed by William Thiel (architect of the Jackson Street Synagogue, cat. 88). *Picayune*, December 10, 1867; "Odd Fellows Ceremonies: Laying of the Cornerstone of the New Hall," *Picayune,* February 5, 1868; "Odd Fellows' Hall," *Picayune*, May 19 and 26, 1868.

72. Drawings by James Freret for St. Patrick's Hall are in the collection of the Royal Institute of British Architects (now transferred to the Victoria and Albert Museum), London, and the Southeastern Architectural Archive, Tulane University. On St. Patrick's, see "St. Patrick's Hall," *Morning Star and Catholic Messenger*, March 8, 1874; "Celebration of St. Patrick's Day," *Republican*, March 18, 1874.

73. John C. Reid, *Reid's Tramp*, Selma, Ala. (John Hardy & Co.) 1858, p. 17.

74. *Beadle's Monthly*, May 1867, p. 391.

75. "The Houses We Live In," *Times*, September 6, 1866.

76. *Bee*, June 11, 1866.

77. "New Orleans—As It Is to Be," *Delta*, June 20, 1862.

78. "The City," *True Delta*, March 7, 1862.

79. *New Orleans Architecture*, II, pp. 95–100.

80. The corner buildings at Girod and Magazine streets appear here just as they did in a notarial act drawing of 1859 of the properties; Charles A. de Armas, XLIII, no. 58, February 7, 1859, NONA, illustrated in *New Orleans Architecture*, II, p. 84.

81. The warehouse was rebuilt in 1887 by Thomas Sully; Sully's building is a children's museum today. Lilienthal photographed the refinery for *Jewell's Crescent City Illustrated*, although the photograph was not engraved in the published edition. See *Jewell's Crescent City Illustrated*, prospectus, fol. 238.

82. *Times*, August 11, 1866.

83. "Clean up the City," *Republican*, April 24, 1867.

84. *Ibid.*

85. "The Batture," *Bee*, June 11, 1866.

86. "On Change," *Times*, October 9, 1866.

87. *Ibid.*

88. "The Late Rev. Theodore Clapp," *New York Times*, May 21, 1866. On Clapp's church, see Building contract, William Shannon, July 8, 1853, NONA; "A New Church," *Picayune*, June 22, 1853; "Dr Clapp's Church," *Picayune*, August 6, 1853; John F.C. Waldo, *Historical Sketch of the First Unitarian Church of New Orleans, La.*, New Orleans (A.W. Hyatt) 1907. On Clapp,

see John Duffy, ed., *Parson Clapp of the Strangers' Church of New Orleans*, Baton Rouge (Louisiana State University Press) 1957. Lilienthal photographed Clapp's church for *Jewell's* in 1872; *Jewell's Crescent City Illustrated,* prospectus, fol. 11. The church was demolished around 1901.

89. Julia Row has also been attributed to James H. Dakin. Building contract, William Christy, May 15, 1833, NONA; *New Orleans Architecture*, II, pp. 174–75. Wood was architect of the Custom House, see cat. 19.

90. "Letter from New Orleans," *Picayune*, May 1, 1853.

91. Charles A. Goodrich, *The Family Tourist: A Visit to the Principal Cities of the West Continent*, Hartford, Conn. (Case, Tiffany & Co.) 1848, p. 432.

92. Eliza Ripley, *Social Life in Old New Orleans*, New York (D. Appleton) 1912, cited in *New Orleans Architecture*, II, p. 17.

93. James F. O'Gorman, *Living Architecture: A Biography of H.H. Richardson*, New York (Simon & Schuster) 1997, pp. 34–35.

94. "Dwelling House in the Julia Street Row" (advertisement), *Picayune*, May 16, 1867.

95. *Bee*, June 11, 1866.

96. Coliseum Square is described by *Jewell's Crescent City Illustrated* as "a long, irregular triangle, having Race street for its base ... planted with shade trees Many fine buildings surround this Park." The Female Orphan Asylum was built in 1839 and demolished in 1966; Dennis E. Hayden was the architect. Today Margaret Place at Camp and Clio streets, laid out in the 1880s, survives there in the shadow of the elevated Pontchartrain–West Bank Expressway crossing the river. On the asylum, see *Norman's New Orleans and Environs*, pp. 110–12; and *Orphans' Flower Carnival*, New Orleans (H.C. Welch) 1900, with a photograph of the asylum by E.J. Bellocq.

97. *Jewell's Crescent City Illustrated*.

98. The architect for the Coliseum Square Baptist Church was John Barnett, with reconstruction of the tower in 1855 by Thomas K. Wharton, Richard Esterbrook, and Lewis Reynolds; Barnett was also architect for St. Paul's, which was destroyed by fire in 1891 (cat. 76). T.E. Giraud designed St. Theresa's, demolished in 1966. The Baptist Church building survived at 1376 Camp Street until June 21, 2006, when it was destroyed by fire.

99. "Tivoli Circle," *Picayune*, December 25, 1853; "The Academy in Tivoli Circle," *Picayune*, July 28, 1865; "Tivoli Circle," *Picayune*, January 7, 1866.

100. "The Names of Our Streets," *Crescent*, December 2, 1866.

101. Abraham Oakey Hall, *The Manhattaner in New Orleans, or, Phases of "Crescent City" Life*, New York (J.S. Redfield); New Orleans (J.C. Morgan) 1851, pp. 37–38. See also James S. Zacharie, "New Orleans, its Old Streets and Places," *Publications of the Louisiana Historical Society*, II, no. 3, February 1900, pp. 74–75.

102. "The Horse Cars to Carrollton," *Times*, May 28, 1867, refers to the station as "undergoing rapid demolition [I]n a few more days the whole will be razed to the ground." The railroad's Tivoli Circle properties are documented in "Sale of Choice Improved and Vacant Real Estate in the First District ... for account of The New Orleans and Carrollton Railroad Company, by J.B. Walton & Deslonde ... Wednesday, January 24, 1866," Manuscript Collection, Tulane University Library. On the Masonic Hall proposed for this site, see cat. 62.

103. *Picayune*, May 28, 1867.

104. *Ibid.*

105. The Masons eventually remained at their old site at St. Charles and Perdido streets; see cat. 62. The Lee Monument Association, formed the year of Lee's death (1870) with representation from the former Confederate states, attempted to erect monuments all over the South, but succeeded only in Virginia and Louisiana. See Herman Hathaway, "The United Confederate Veterans in Louisiana," *Louisiana History*, XVI, Winter 1975, p. 7.

106. On the history of the Marianites in New Orleans, see *Marianite Centennial in Louisiana, 1848–1948*, New Orleans (Provincial House, Holy Angels Academy) 1948.

107. *New Orleans Architecture*, IV, p. 162.

108. "An Alms House," *Picayune*, December 18, 1851; "The Touro Almshouse," *Delta*, January 14, 1859; "The Touro Almshouse," *Crescent*, January 21, 1859; "The Touro Almshouse at New Orleans," *Chicago Press and Tribune*, February 10, 1859. On the Touro bequest, see Julianna Liles Boudreaux, "New Orleans—'A Rich Harvest of Good Works' and Judah Touro," in *New Orleans and Urban Louisiana*, ed. Samuel C. Shepherd, Jr., The Louisiana Purchase Bicentennial Series in Louisiana History, XVI, A, Lafayette (The Center for Louisiana Studies) 2005, pp. 556–59.

109. "Extract from a Report of a Committee ... Appointed to Select a Site for Touro Alms House, May 1, 1855," Letters Received, New Orleans Marine Hospital, Records of the Public Buildings Service, RG121, NARA; "The Touro Almshouse at New Orleans," *Chicago Press and Tribune*, February 10, 1859.

110. "The Touro Almshouse," *Delta, op. cit.*; "Touro Almshouse," *Picayune*, January 19, 1859; "The Touro Alms-House," *Delta*, January 22, 1859; "To Builders" (advertisement), *Delta*, February 1, 1859; *Letter from the Secretary of War, communicating ... information in relation to the Touro Hospital, New Orleans, February 13, 1872*, 42d Cong., 2d sess., S. Ex. Doc. 30, Washington, D.C. (Government Printing Office) 1872, p. 10. Thomas K. Wharton's "Diary" (May 1, 1858) refers to his work on plans for the almshouse, and Thomas Murray apparently also prepared plans shortly after almshouse trustees acquired the site (Southeastern Architectural Archive, Tulane University; illustrated in Mills Lane, *Architecture of the Old South: Louisiana*, New York, Abbeville Press, 1990, p. 194, where they are identified as being for the First U.S. Marine Hospital). On questions this project raised about the monetary value of competitive drawings, see "Liabilities of Express Carriers," *New York Times*, December 23, 1859, and the commentary on a suit by one of the almshouse submitters in "The Architect, Owner and Builder Before the Law, V," *American Architect and Building News*, XXXIII, no. 815, August 8, 1891, p. 79.

111. "The Touro Almshouse," *Delta*, January 14, 1859.

112. "The Touro Almshouse," *Bee*, May 28, 1860.

113. *Ibid.*

114. "The Touro Almshouse," *Crescent, op. cit.*

115. Quoted in "The Touro Alms-House," *Delta, op. cit.*

116. "The Touro Almshouse," *Bee, op. cit.*; "Touro Alms House," *Picayune*, December 6, 1860.

117. "The Negro Soldiers' Home," *True Delta*, August 3, 1864.

118. "The Touro Hospital," *Picayune*, September 5, 1865; "A Demand on the Government," *New York Times*, September 6, 1877.

119. "The Negro Soldiers' Home," *op. cit.*; *Times*, June 18, 1865; *Letter from the Secretary of War, op. cit.*, p. 2. The Corps d'Afrique was formed in early 1863; see "Department of the Gulf," *New York Times*, January 11, 1864. In 1864, New Orleans photographer William Guay completed a series of views of the interior of the building, while it was occupied by the Corps d'Afrique, for engravings in a New York newspaper.

120. *Daily Southern Star*, September 3, 1865; "The Touro Hospital," *Picayune, op. cit.*; "The Burning of the Touro Building," *Picayune*, September 6, 1865; "The Touro Asylum," *Picayune*, September 9, 1865; "The Recent Destruction of the Touro Almshouse by Fire," *Daily Southern Star*, October 5, 1865; "Burning of the Touro Building," *Picayune*, October 6, 1865; "The Destroyed Touro Almshouse," *Times*, October 6, 1865; "Where the Ruined Touro Almshouse Casts its Shadow," *Times*, July 30, 1866; *Letter from the Secretary of War, op. cit.*, pp. 1–16; *Jewell's Crescent City Illustrated*.

121. *Letter from the Secretary of War, op. cit.* In the late nineteenth century, Congress allocated $21,000 to the almshouse trustees (the city had claimed nearly $300,000). In 1882, an almshouse was built on Daneel Street, far uptown from the original Touro site, financed largely by a gambling tax. It was later named for Touro and the mayor, Joseph Shakespeare, who built it. In 1931, the Touro–Shakespeare Almshouse relocated to Algiers, where it operates today; see John Smith Kendall, *History of New Orleans*, New Orleans (Lewis Publishing Company) 1922, p. 246.

122. "A Noble Charity Defeated," *Chicago Tribune*, March 1, 1872; "Gloom and Ruin," *Times*, December 28, 1865.

123. Samuel Wilson, Jr., "Early History," *New Orleans Architecture*, IV, pp. 20–22.

124. "The Proposed Shell-Road," *Orleanian*, January 26, 1857; "The Horse Cars," *Crescent*, March 31, 1857.

125. "Down to the Third District," *Picayune*, December 18, 1866.

126. Henry Latham, *Black and White: A Journal of a Three Months' Tour in the United States*, London (Macmillan) 1867, pp. 164–65.

127. The Industrial Canal and Inner Harbor (now the Inner Harbor Navigation Canal), designed in part by Henry Goldmark, who engineered the gates of the Panama Canal, was built in 1918–22 to carry ocean-going vessels between the lake and the river, and to provide fixed-level waterfront sites for shipbuilding and for other maritime industrial development that could not be located on the river. See Thomas E. Dabney, *The Industrial Canal and Inner Harbor of New Orleans*, New Orleans (Board of Commissioners, Port of New Orleans) 1921.

128. For a chronology of the Katrina catastrophe, see Elizabeth Kolbert, "Watermark: Can Southern Louisiana be Saved?," *New Yorker*, LXXXII, no. 2, February 27, 2006, pp. 46–57.

129. See Craig E. Cotten, *An Unnatural Metropolis: Wresting New Orleans from Nature*, Baton Rouge (Louisiana State University Press) 2005, pp. 154–55.

130. Louis H. Pilié to the Common Council, April 15 and September 24, 1854, "Outgoing Correspondence, 1853–1863," I, fol. 54, New Orleans Public Library, City Archives, Surveyor's Office Records, 1833–1890, KG511.

131. T.B. Thorpe, City Surveyor, to Acting Mayor Capt. James F. Miller, February 10, 1863, "Outgoing Correspondence, 1853–1863," II, Surveyor's Office Records, *op. cit.*

132. *Id.*, to Acting Mayor Col. Henry C. Deming, January 15, 1863, "Outgoing Correspondence, 1853–1863," II, Surveyor's Office Records, *op. cit.*

133. "New-Orleans Threatened," *New York Times*, August 23, 1891.

134. Rachel Breunlin and Helen A. Regis, "Putting the Ninth Ward on the Map: Race, Place, and Transformation in Desire, New Orleans," *American Anthropologist*, CVIII, no. 4, December 2006, p. 748.

135. *Ibid.*, p. 746.

"New Orleans in Miniature": Lilienthal as a Stereo Photographer

Stereoscopy created a sensation when the technology arrived in New Orleans in the decade before the Civil War.[1] The *Bee* predicted in 1853 that "the day must soon come when nearly all important photographic pictures of landscapes, monuments, portraits, &c., will be practiced double."[2] Although New Orleans daguerreians were producing stereo images by 1853, it was the inexpensive card stereograph—two nearly identical albumen prints mounted side by side on cardboard—that launched the stereoviewing craze. Introduced in America in 1854, three years after the first stereoscope viewing devices were marketed in Britain, card stereographs were available in New Orleans by 1858. Prior to the war, New Orleans studios sold inventories of the London Stereoscopic Company, Edward and H.T. Anthony, D. Appleton Company, and other publishers of card views, and local photographers began issuing stereoviews of the city, among them Jay Dearborn Edwards and James Bailey.[3] Few of these early, prewar stereoviews are known to survive (fig. 62).

The "wonderfully beautiful revelation of the stereoscope" was the medium's seemingly magical, strange, and even (to some contemporary observers) immoral illusionism.[4] "The result is to throw the two pictures into one, which is seen standing out in the centre in all the beauty and perfection of the most finished *bas-relief*," the *Bee* wrote.[5] Photographers looked for a new compositional strategy to achieve the illusion of relief and, when successful, created an effect of recession and deep perspective that could be startling, as Oliver Wendell Holmes, who helped popularize the new medium, described it:

> The first effect of looking at a good photograph through the stereoscope is a surprise no painting ever produced. The mind feels its way into the very depths of the picture. The scraggy branches of a tree in the foreground run out at us as if they would scratch our eyes out.[6]

This new perception of space transported the observer, as historian Anne McCauley has written, "into deep imaginary spaces [that] made older visual illusionism seem quaint."[7] New Orleans

Fig. 60 *Lafayette Square Under Snow*, negative exposed January 1866. Collection of Joshua Paillet, The Gallery for Fine Photography.

Fig. 61 *Mississippi River near Carrollton*. Louisiana State Museum, 1979.120.045.

Fig. 62 James Bailey, "Canal St. Showing New Custom House, New Orleans, Novr. 18, 1860," stereoview, salt print. Collection of Mr. and Mrs. Eugene Groves.

architect Thomas K. Wharton discovered for himself the "virtualness" of the new medium in 1858. Stereoscopy "reproduce[d nature] more exquisitely than ... any other contrivance of art," he observed after purchasing a stereoscope and a set of views of his native England at a local shop.

> You are brought face to face with the reality, no painted shew but genuine air-encircled masses, the splendid alcoves of Elgin, the ivys of Kenilworth, the glorious trees over the old bridge at Warwick Castle, and the simple farm yard scene at Tintern Abbey are all apparently real, real. The last is beyond all description charming. No need hardly to travel, with such an instrument as this at home.[8]

As Wharton noted, views of every imaginable destination were available as souvenirs or as a substitute for the tourist experience. "Do you travel?" the *Philadelphia Photographer* asked in 1867,

> Then you will find photographers everywhere, and you may gather, as you go along, stereographs of the points of greatest interest, and bring them home to refresh your memory Are you not a tourist? Then you may make collections of stereographs and journey all over the world and *under* it, without the time, expense and inconvenience of travel."[9]

Lilienthal's earliest known work in stereo format dates from January 1866: a card stereoview of Lafayette Square taken during one of New Orleans's rare snowfalls (fig. 60). Lilienthal could publish outdoor stereoviews on a

large scale only with the availability of a mobile darkroom, which he owned by late 1865. In the summer of 1866, he was advertising "stereoscopic views of the city of New Orleans, on exhibition and for sale" at his 131 Poydras Street gallery (fig. 112).[10] Later in the year, he received a silver medal for the "best series of stereoscopic views" at the Mechanics' and Agricultural Fair, the highest local recognition of his accomplishment as a view photographer.[11]

The fair medals led directly to Lilienthal's commission for the Exposition portfolio, *La Nouvelle Orléans et ses environs*, three months later.[12] While carrying out the Exposition campaign he also produced fifty stereoviews.[13] This working method in dual formats was often used in survey work by wet-plate photographers, who were motivated by the greater marketability of the card format.[14] There is no evidence that Lilienthal exhibited stereoviews at the Paris Exposition, but he did prepare a "series of views of the city" in a "stereoscopic portfolio" for exhibition locally in May 1867, two weeks before the Exposition portfolio was shipped to Paris. "Taken together they are New Orleans in miniature," the *Times* declared.[15]

Over the next decade, Lilienthal published dozens of stereoview compositions. His competitors, notably Samuel Blessing, W.H. Leeson, and James McPherson, also maintained large stereoview inventories. Photography dealer H. Miller and other local retailers offered card stereographs from various publishers, and Edward and H.T. Anthony in New York licensed views from New Orleans photographers for sale

nationwide.[16] Inexpensive stereocards flooded the market; in 1867, Lilienthal sold twelve stereoviews for $4 to $5, and the following year he reduced the price to $3.[17] The low cost of stereoviews and other popular wet-plate formats—cartes de visite and tintypes—of the Civil War era brought "a portable Picture Gallery within the reach of persons of the most moderate means," as one southern journalist remarked, and allowed many to own photographic images for the first time.[18]

By the late 1870s, with stereoscopy still the dominant medium for local views, Lilienthal had industrialized stereocard production. In his Canal Street studio he employed as many as forty operatives and other workers, who exposed and printed negatives, trimmed and mounted prints, labeled mounts, and filled orders.[19] A Lilienthal backstamp catalog of the late 1880s includes views reprinted from negatives exposed in the 1860s, with varying card backs (fig. 64). As well as the standard inventory of building and street views, Lilienthal published card views of commemorative sites (Chalmette battlefield), disasters (floods and

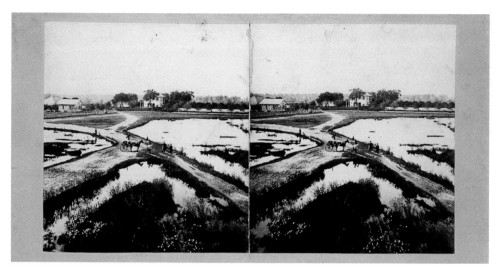

Fig. 63 *Entrance to the Bayou St. John*, negative exposed 1867. The Historic New Orleans Collection, 1988.132.14.

steamship explosions), field laborers and sharecroppers' cabins, festivals (Mardi Gras and firemen's parades), curiosities (alligators and century plants), and composition stereos of a wide variety of theatrical or genre subjects.

A comparison of Lilienthal's stereoview of the School of Medicine on Common Street (fig. 101) with the Paris version of the same subject (cat. 70) reveals his different methods of organizing space in the two formats. The close framing of the stereoview conveys the full cubic mass of the building; the wide angle of the Exposition view contextualizes the building and reveals the geometry of the street. *Sheep Grazing Near Carrollton* (fig. 104), which has no corresponding Paris view, functions stereographically in an orderly recession of

planes. The foreground ravine in deep shadow appears to fall off the edge of the photograph when viewed through the stereoscope, and in the middle ground the sheep grazing in bright sunlight stand out in strong relief against the dark field of grass. The screen of trees and fence row define the horizon and the perimeter of the photograph and appear cut away from the blank sky that fills half the image. What appears to be an unaccomplished photograph without the aid of the stereoscope is in fact a well-resolved stereoview, in which Lilienthal has chosen the subject, the framing, and the light to maximize perspective illusion.[20]

The dramatic effect of perspective recession sought by stereo photographers can also be seen in many of Lilienthal's large-plate views,

Fig. 64 *List of New Orleans Views, Photographed and Published by Theo. Lilienthal, New Orleans*, stereoview backstamp, *c.* 1888–90. Louisiana State Museum.

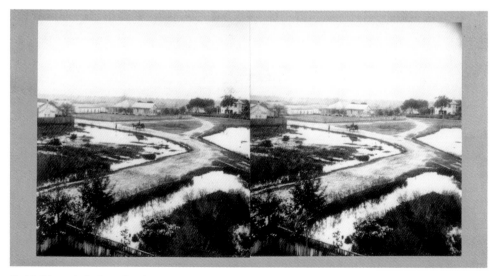

Fig. 65 *Entrance to the Bayou St. John*, negative exposed 1867. The Historic New Orleans Collection, 1996.43.3.

Fig. 66 *Levee, View from Canal Street toward French Market*. Collection of Joshua Paillet, The Gallery for Fine Photography.

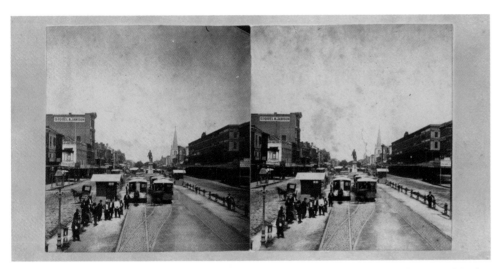

Fig. 67 *Canal Street toward Touro Building and Clay Statue* (photography studios of William Washburn and Louis Isaac Prince), negative exposed 1866/67. Collection of Joshua Paillet, The Gallery for Fine Photography.

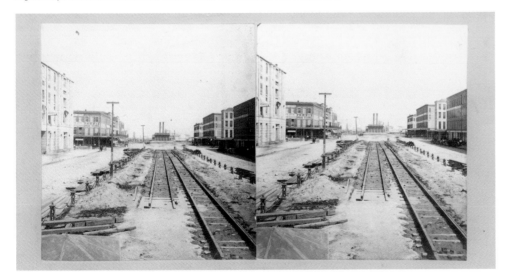

Fig. 68 *Canal Street from Magazine Street toward Water Works, with Construction of City Railroad*, negative exposed 1866. Collection of Joshua Paillet, The Gallery for Fine Photography.

with their ample foregrounds and formal devices characteristic of stereoscopy. His large-plate views required longer exposures than the stereoviews, and compared to the large view camera, the twin-lens stereo camera's shorter focal length and faster lenses recorded motion more effectively. The stereo camera was also smaller and lighter and easier to manipulate, allowing a greater range of subject matter. The type of stereo camera Lilienthal was using in 1867 is not documented, but a stereoscopic camera he was using five years later is recorded in one of his photographs (fig. 10).[21]

Illustrated here is a selection from Lilienthal's earliest stereoviews, published from 1866 through the early 1870s, with negatives exposed for most views in 1866–67. At least eight of the stereoviews reproduced here were made concurrently with the Exposition views:[22] *St. Charles Hotel* (fig. 88; cat. 64); *French Opera House* (fig. 86; cat. 16); *Medical Colleges* (fig. 87; cat. 67); *Masonic Hall* (fig. 97; cat. 62); *Carrollton Gardens* (fig. 92; cat. 104); *Entrance to Bayou St. John* (fig. 63; cat. 26; possibly one half of a partial panorama with fig. 65); and the Fellows Residence (fig. 90; cat. 99). Other views appear to be closely associated in time with the Exposition portfolio: *City Park* (fig. 93) with cat. 40; a view of a cane plantation (fig. 95) with *Sugar Plantation* (cat. 118); and a view of the steamer *Great Republic* (fig. 76). This last and a second stereoview of the same subject appear to have been taken on different days during the steamer's three-day anchorage at New Orleans (see cat. 6). The stereoview of the corner of Carondelet and Poydras streets (fig. 99) appears nearly identical in framing to the Paris view (cat. 53), but was made some time during the preceding year.[23]

All stereoviews reproduced here are albumen prints mounted on bristol board measuring approximately 3.4 × 6.9 inches (8.6 × 17.6 cm).

1. On the development of stereoscopy, see the essays in R. Reynaud, C. Tambrun, and K. Timby, eds., *Paris in 3D: From Stereoscopy to Virtual Reality, 1850–2000*, Musée Carnavalet, London (Booth-Clibborn) 2000, especially Denis Pellerin, "The Origins and Development of Stereoscopy," pp. 43–48. See also Robert Taft, *Photography and the American Scene: A Social History, 1839–1889*, New York (Macmillan) 1938, [reprinted New York (Dover) 1964], pp. 167–85; Edward Earle, ed., *Points of View: The Stereograph in America: A Cultural History*, Rochester, NY (Visual Studies Workshop Press) 1979; Robert J. Silverman, "The Stereoscope and Photographic Depiction in the 19th Century," *Technology and Culture*, xxxiv, no. 4, October 1993, pp. 729–56; William C. Darrah, *The World of Stereographs*, Nashville, Tenn. (Land Yacht Press) 1997 [reprint of 1977 edn.].

Fig. 69 *Lake Pontchartrain.* Collection of Joshua Paillet, The Gallery for Fine Photography.

Fig. 70 *Woodyard on the Mississippi River.* Collection of Joshua Paillet, The Gallery for Fine Photography.

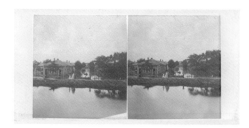

Fig. 71 *Flood Scene.* Louisiana State Museum 1979.120.71.

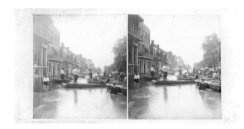

Fig. 72 *Flood Scene.* Collection of Joshua Paillet, The Gallery for Fine Photography, New Orleans.

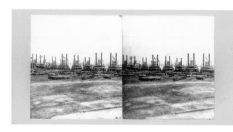

Fig. 73 *Steamboat Landing.* Collection of Joshua Paillet, The Gallery for Fine Photography, New Orleans.

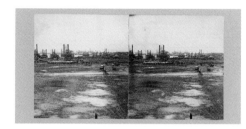

Fig. 74 *Steamboat Landing,* card mount dated 1868. Collection of Joshua Paillet, The Gallery for Fine Photography.

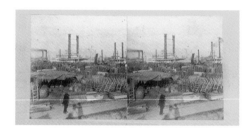

Fig. 75 *Steamboat Landing* (with photographer's shadow). Collection of Joshua Paillet, The Gallery for Fine Photography.

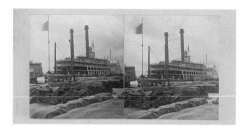

Fig. 76 *Steamer Great Republic,* negative exposed 1867. Louisiana State Museum 1979.120.065.

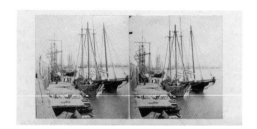

Fig. 77 *Wharf Scene.* Collection of Joshua Paillet, The Gallery for Fine Photography.

Fig. 78 *Canal Street, View from Levee.* The Historic New Orleans Collection, 1988.134.4.

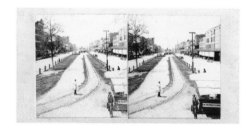

Fig. 79 *Canal Street at New Levee Street, toward Clay Statue.* Collection of Joshua Paillet, The Gallery for Fine Photography.

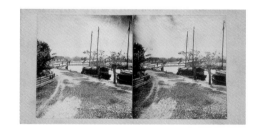

Fig. 80 *Bayou St. John.* The Historic New Orleans Collection, 1988.134.6.

Fig. 81 *Jackson Square.* Collection of Joshua Paillet, The Gallery for Fine Photography.

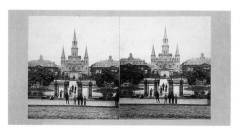

Fig. 82 *Jackson Square.* The Historic New Orleans Collection, 1988.134.13.

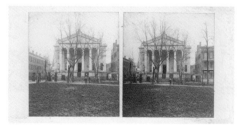

Fig. 83 *City Hall, Lafayette Square.* Collection of Joshua Paillet, The Gallery for Fine Photography.

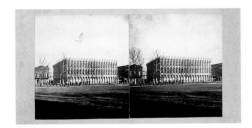

Fig. 84 *Moresque Building from Lafayette Square*. The Historic New Orleans Collection, 1988.134.12.

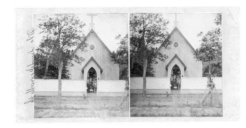

Fig. 85 *St. Mark's Church*. Collection of Joshua Paillet, The Gallery for Fine Photography, New Orleans.

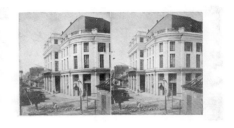

Fig. 86 *French Opera House, Bourbon and Toulouse Streets*, negative exposed 1867. Collection of Joshua Paillet, The Gallery for Fine Photography, New Orleans.

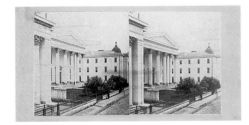

Fig. 87 *Medical Colleges, Common Street*. Louisiana State Museum, 1979.120.029.

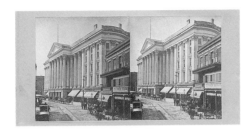

Fig. 88 *St. Charles Hotel, St. Charles Street*. Louisiana State Museum, 1979.120.021.

Fig. 89 *Cypress Grove Cemetery*. Collection of Joshua Paillet, The Gallery for Fine Photography.

Fig. 90 *Residence of J.Q.A. Fellows, St. Charles Street, City of Lafayette*, negative exposed 1867. Louisiana State Museum, 1979.120.055.

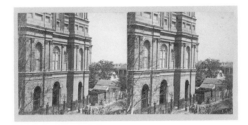

Fig. 91 *St. Alphonsus Church, Constance Street*. Louisiana State Museum, 1979.120.057.

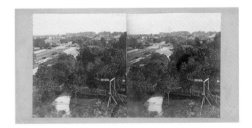

Fig. 92 *Carrollton Gardens*, negative exposed 1867. Louisiana State Museum, 1979.120.048.

Fig. 93 *City Park*. Louisiana State Museum 1979.120.031.

Fig. 94 *U.S. Barracks, Sally Port*. Collection of Mr. and Mrs. Eugene Groves.

Fig. 95 *Orange Grove Plantation, Braithwaite, Louisiana*. The Historic New Orleans Collection, 1988.134.22.

Fig. 96 *Canal Street, Clay Statue*. Collection of Mr. and Mrs. Eugene Groves.

Fig. 97 *Masonic Hall, St. Charles Street*. Louisiana State Museum, 1979.120.053.

Fig. 98 *Fairgrounds Bell Tower*, card mount dated 1866. Collection of Mr. and Mrs. Eugene Groves.

2. "The Stereoscope," *Bee,* May 20, 1853; reprinted in *True Delta,* May 23, 1853. The article originally appeared in the *Baltimore American.*

3. James Bailey, born in Ireland around 1820, was active in Plaquemine, Louisiana, by early 1861. See George Esker III, "James Bailey: An Obscure Louisiana Photographer and His Confederate Photographic Legacy," *Military Images,* May–June 1998, pp. 12–13. I would like to thank Eugene Groves for this reference.

4. "Stereoscopic Pictures," *Southern Cultivator,* XVII, no. 9, September 1860, p. 280. The "virtualness" made stereoscopy an effective and popular medium for erotic imagery, providing justification for some observers that stereoscopy was immoral; Anne McCauley, "Realism and its Detractors," in *Paris in 3D, op. cit.,* p. 27.

5. "The Stereoscope," *op. cit.*

6. Oliver Wendell Holmes, "The Stereoscope and the Stereograph," *Atlantic Monthly,* June 1859, p. 744, cited by Nanette Sexton, "Watkin's Style and Technique," *California History,* LVII, no. 3, Fall 1978, pp. 247 and 270, n. 57.

7. McCauley, *op. cit.,* p. 26. Stereoviewing has been seen by some modern historians as pre-cinematic: viewing that unfolded over time as the observer was drawn into the perspective of the picture and encouraged to scan the image. The startling detail revealed by the illusion potentially engaged the viewer for longer periods of time than ordinary photographs.

8. Wharton, "Diary," March 24, 27, 1858, and later journal entries including April 10, 1860, when Wharton praises the work of "a stereoscopist named 'Thompson,'" probably James Thompson, of Niagara Falls.

9. "Stereographs," *Philadelphia Photographer,* IV, October 1867, pp. 332–33.

10. *Times* (advertisement), June 14, 1866. Lilienthal's earliest documented outdoor work was a view of the St. James Hotel and a series of views of military installations for the U.S. Quartermaster General, completed in November 1865; "Photograph of the St. James Hotel," *Times,* November 20, 1865; *True Delta,* November 29, 1865 (see p. 44).

11. *Picayune,* December 2, 1866; *Crescent,* December 9, 1866; *Report of the First Grand Fair of the Mechanics' and Agricultural Fair Association of Louisiana,* New Orleans (Commercial Bulletin) 1867. The *Crescent* announced Lilienthal's fair series in "Scenes from the Fair Grounds," *Crescent,* December 1, 1866, where the photographs, including panoramic views from the Luling residence, were described as "arranged for stereoscopic view." The Fairgrounds Bell Tower is dated 1866 on the card mount.

12. *Picayune,* December 2, 1866; *Crescent,* December 9, 1866; *Report of the First Grand Fair of the Mechanics' and Agricultural Fair Association of Louisiana, op. cit.*

13. In May, Lilienthal was reputed to have "just completed one hundred and fifty photographic and fifty stereoscopic views of this city and vicinity, which are very creditable to that artist"; "New Orleans and Vicinity at the Paris Exposition," *Crescent,* May 26, 1867.

14. Lilienthal's contemporary, Carleton Watkins, often photographed the same subject in stereo and large-plate negatives, "with an eye to the different markets to which these might appeal"; Douglas R. Nickel in *Carleton Watkins: the Art of Perception,* San Francisco (San Francisco Museum of Modern Art) 1999, p. 35, n. 39; see also Peter Palmquist, "Carleton E. Watkins at Work," *History of Photography,* VI, no. 4, October 1982, pp. 291–325.

15. *Times,* May 21, 1867.

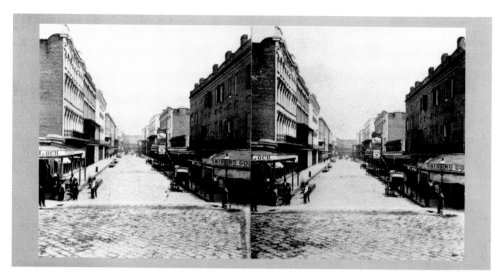

Fig. 99 *Carondelet Street from Poydras Street toward Canal Street.* The Historic New Orleans Collection, 1988.134.10.

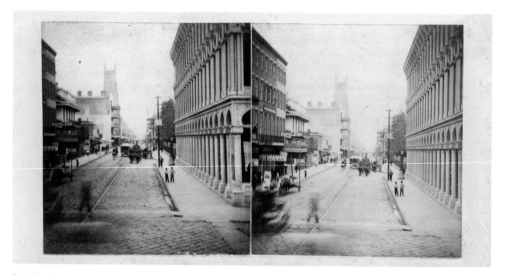

Fig. 100 *Camp Street from Poydras Street* (at Moresque Building). Collection of Joshua Paillet, The Gallery for Fine Photography.

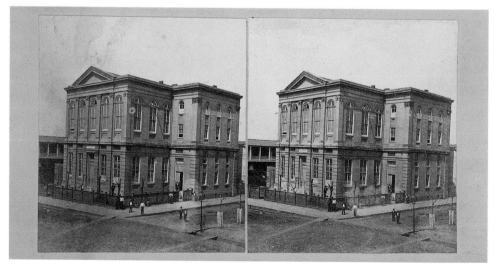

Fig. 101 *School of Medicine, Common Street.* Louisiana State Museum, 1979.120.020.

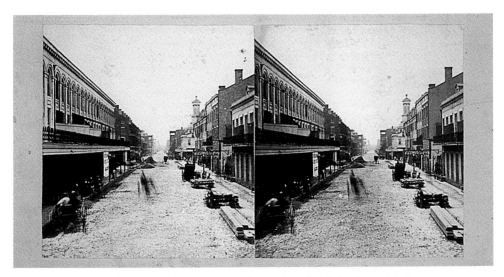

Fig. 102 *Carondelet Street from Poydras Street toward Methodist Church.* The Historic New Orleans Collection, 1977.143.9.

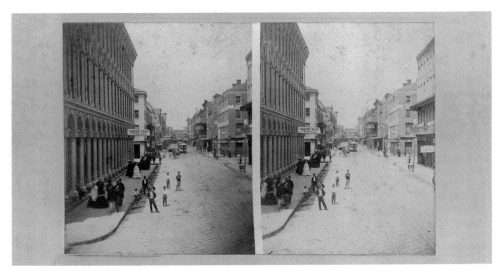

Fig. 103 *Camp Street from Lafayette Street* (at Moresque Building), negative exposed December 1866. Collection of Joshua Paillet, The Gallery for Fine Photography.

Fig. 104 *Sheep Grazing Near Carrollton.* The Historic New Orleans Collection, 1988.134.7.

16. *Picayune*, July 14, 1867; "Photographic Views in City and Suburbs," *Picayune*, May 17, 1868.

17. As a member of the Photographic Society of New Orleans in 1867, Lilienthal advocated higher prices for stereocards and other formats. "With the current rates one can neither deliver good work nor make a living," the Society declared, and established prices for all work, including stereocards. The Society also entreated its members "not to underbid each other's prices" (*Deutsche Zeitung*, November 6, 1867), but six months later Lilienthal did just that, advertising in May 1868 that "to meet the views of the public during the summer season" he was lowering his price of stereocards by $1 per dozen (*Times*, May 3, 1868). On the stereoview trade in general, see Howard S. Becker, "Stereographs: Local, National, and International Art Worlds," in *Points of View*, *op. cit.*, pp. 88–96.

18. "Stereoscopic Pictures," *op. cit.*

19. *Deposition of Theodore Lilienthal.* A production worker could finish an average of fifty to sixty mounts per day; see Becker, *op. cit.*, p. 92. Although one of the large local publishers of stereoviews, Lilienthal's production could not equal the output of a more heavily capitalized firm such as the Kilburn Brothers in New Hampshire, who already in the 1860s, using a mechanized belt-driven exposure machine, could publish 3000 cards per day, and more than 1 million cards per year.

20. Taft, *op. cit.*, p. 168, discusses the method of composition of stereographic views.

21. Lilienthal's stereo cameras may have had a movable front lens panel and swing back that made it possible to control perspective distortion, see T. Sutton, "The Stereoscopic Camera," *Humphrey's Journal*, XII, 1861, pp. 374–77, cited in Palmquist, *op. cit.*, p. 301.

22. The *Crescent* reported on May 26, 1867, that "Mr. Lilienthal has just completed one hundred and fifty photographic and fifty stereoscopic views of this city and vicinity, which are very creditable to that artist."

23. Other stereoviews may correspond to views lost from the original Exposition portfolio. Of the 150 views reportedly sent by Lilienthal to Paris, 126 survive today; twenty-four photographs are lost. The *Crescent*'s inventory of March 1, 1867, of the portfolio refers to several views not among the surviving photographs, and two of these subjects are represented in stereoviews from the 1860s: the Moresque Building (fig. 84), and the sawmill and woodyard at the levee (fig. 70).

Chronology of Lilienthal's Studio Locations

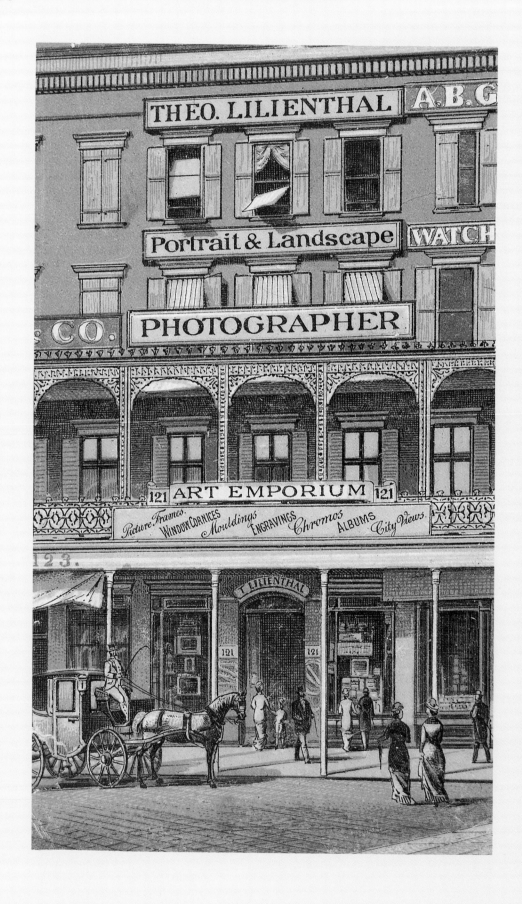

1854
121 Poydras Street
Waldo, *Visitor's Guide*.

1856 (July)
257 Tchoupitoulas Street at St. Mary's Market
Deutsche Zeitung, July 23, 1856.

1856 (October)
132 Poydras Street, "E.W. Mealy & Th. J. Lilienthal Daguerreotype and Ambrotype Saloon"
Deutsche Zeitung, October 8 and 30, 1856. E.W. Mealy was probably the daguerreian and ambrotypist W.E. Mealy, documented in New Orleans from 1856 to 1861 and in 1866.

1856 (November)
132 Poydras Street, "Theodor[e] Lilienthal Daguerreotype and Ambrotype Saloon"
Deutsche Zeitung, November 26, 1856; *A. Mygatt & Co.'s New Orleans Business Directory*, New Orleans (A. Mygatt & Co.) 1857.

1857 (June)
corner Baronne and Poydras streets, "Th. Lilienthal and Joseph Kaiser"
Wallace A. Brice, *New Orleans Merchants' Diary and Guide for 1857 and 1858*, New Orleans (E.C. Wharton) 1857; *Deutsche Zeitung*, June 13–early October 1857; on October 10, 1857, Kaiser advertised on his own as successor to the partnership (he is not documented after 1858). After this dissolution, Lilienthal does not advertise in the *Deutsche Zeitung* until March 1860. His studio location during the period October 10, 1857–March 1, 1860 is undocumented.

1860 (March)–1861
106 Poydras Street, "Fahrenberg & Lilienthal's Picture Gallery"
Deutsche Zeitung, March 1, 1860–February 28, 1861; *Crescent*, July 15, 1861.
J.R. Hoening, a Düsseldorf portrait painter, shared Lilienthal's studio in March 1860. In June 1860, Lilienthal partnered with German-born Albert Clement Fahrenberg, a daguerreian, ambrotypist, and portrait painter who had worked in New York and Louisville

Fig. 105 *Lilienthal's Art Emporium, Touro Buildings, 121 Canal Street*, lithograph, c. 1880–81. Southeastern Architectural Archive, Tulane University.

before arriving in New Orleans in 1859/60 (he was working in Mexico by 1863 and, from 1870, in Texas).

1863 (May)
347 Hercules Street
Internal Revenue Assessment Lists for Louisiana, 1863–66, Louisiana, Dist. 1, Division 4 [New Orleans], May 18, 1863, RG58, Records of the Internal Revenue Service, NARA.

1863 (June)–1864 (April)
102 Poydras Street
Bee, June 4, 1863; cartes de visite backstamps during war years. Copyright records and Internal Revenue records also document this address.

1865–75
131 Poydras Street
Harper's Weekly, IX, no. 433, April 15, 1865, p. 1; *Gardner's New Orleans Directory for 1866*; *Graham's Crescent City Directory for 1867*, New Orleans (L. Graham) 1867; *Deutsche Zeitung*, March 24, 1866; *Almanach de la Louisiane*, New Orleans (F. Bouvain) 1867.

1875–86
121 Canal Street, Touro Buildings, and 34 Chartres Street
J. Curtis Waldo, *Visitor's Guide to New Orleans, November 1875*, New Orleans (J.C. Waldo) 1875 (advertisement). In 1882, Lilienthal partnered at this address with **Samuel Anderson**, one of the city's most successful photographers from the late 1850s to 1884 (and thereafter in Houston). By early 1884, Lilienthal operated a frame factory at 34 Chartres Street, which was damaged by fire in April 1884. In the summer of 1884, he reopened the Chartres Street factory as the **Crescent City Photographic Supply House**, and by 1886 he had moved his studio there and closed the Canal Street location. *Philadelphia Photographer*, August 1884.

1886–87
32 and 34 Chartres Street
New Orleans city directories, cabinet card backstamps, and newspaper advertisements document this and later studio locations.

1888–90
137 Canal Street, Touro Buildings
Various partnerships are recorded at this address, including **Lilienthal and Burrell**

and **Lilienthal and Company** (T. Lilienthal, C. Giese, I. Benjamin). On February 18, 1890, fire destroyed Lilienthal's studio and much of the Touro block.

1890–early 1894
109 Canal Street at Exchange Place
Lilienthal, ill with Bright's Disease, sold out in early 1894, and moved to Minneapolis, Minnesota, with his second wife and two children. He died there on November 29, 1894, and was buried in Lakewood Cemetery.

On Lilienthal's partners Mealy, Fahrenberg, and Anderson, see Smith and Tucker; and Peter E. Palmquist and Thomas R. Kailbourn, *Pioneer Photographers from the Mississippi to the Continental Divide: A Biographical Dictionary, 1840–1865*, Stanford, Calif. (Stanford University Press) 2004.

Appendix of Sources

Lilienthal's Early Career, 1856–67

Deutsche Zeitung, July 23, 1856 (advertisement, translated from the German; fig. 107).

Daguerreotypes! Daguerreotypes! No. 257 Tchoupitoulas Street, at St. Mary's Market. I respectfully call to the attention of an esteemed German audience that I make daguerreotypes from 50 cents up and in any other size, in fine cases. N.B. Ill or dead persons in their own homes, at the lowest prices. Theodor[e] J. Lilienthal

Sunday Delta, October 25, 1856 (advertisement).

DAGUERREOTYPES. Complete in large size Cases for 50 cents. The undersigned inform their friends and the public in general that they have removed to No. 132 Poydras street and are prepared to work at reduced prices. Don't forget, 132, third gallery from St. Charles street. MEALY & LILIENTHAL.

Deutsche Zeitung, October 8 and 30, 1856 (advertisement, translated from the German).

E.W. Mealy & Th. J. Lilienthal Daguerreotype and Ambrotype Saloon No. 132 Poydras Street. We respectfully announce to an esteemed audience that we make photographs [*Lichtbilder*] of every kind, of the best quality and at the least expensive price. Pictures to be shipped overseas are prepared in a special manner, and their permanence is guaranteed. Prices vary, from 50 cents up, in altogether tidy cases. Please note, No. 132 Poydras Street.

Deutsche Zeitung, June 13, 1857 (advertisement, translated from the German; fig. 108).

Business Relocation of Theodor[e] Lilienthal's Daguerreotype and Ambrotype Salon. Because my clients often found the light at my former studio (132 Poydras Street) too blinding, I have felt it necessary to relocate my salon to the corner of Baronne and Poydras, where I work with northern light, which is, as is well known, not at all blinding to the eye and which makes it possible only to take really good pictures. I have installed as my partner Mr. Joseph Kaiser, who has learned the trade from me. N.B. Guaranteed good portraits, which correspond in every respect

with the wishes of my audience, or no payment. Th. Lilienthal & J. Kaiser.

Deutsche Zeitung, March 1, 1860 (advertisement, translated from the German).

Theodor[e] Lilienthal's studio for photographs, daguerreotypes, ambrotypes and portraits in oil, water color, ink, etc. No. 106 Poydras Street, between St. Charles and Camp. The smallest picture of deceased persons is sufficient to make from it a portrait perfectly alike in any size and genre. Careful preparation and packing of portraits for overseas shipment. Only perfectly good work, or no claim to payment will be made. Mr. J.R. Hoening, a portrait painter of the Düsseldorf School, has opened his studio with me.

Fig. 107 Advertisement for Lilienthal's daguerreotype studio, 257 Tchoupitoulas Street, St. Mary's Market, 1856. *Deutsche Zeitung*, July 23, 1856.

Deutsche Zeitung, June 29, 1860 (advertisement, translated from the German).

Ivorytype, a new invention. Fahrenberg & Lilienthal's Picture Gallery No. 106 Poydras Street, between St. Charles and Camp. We take the liberty to recommend to our esteemed audience our picture gallery, which is well furnished with all the latest improvements of photography, and we particularly call attention to the invention mentioned above. The ivorytype, a picture that in beauty and fine detail surpasses everything that has so far been accomplished in this line of work. Considering our countrymen's good taste or understanding of art, we believe it is superfluous to elevate these pictures with praise any further, and entertain the hope that we will be honored by numerous visits. Ambrotypes, photographs, etc., portraits of all kinds, from the smallest miniature to lifesize, in oil, water color, pastel, etc. are made to complete satisfaction. Albert Fahrenberg, portrait painter[;] Theodor[e] Lilienthal, photographist [a similar advertisement

appears in *Deutsche Zeitung*, July 28, 1860, for Lilienthal without Fahrenberg].

Deutsche Zeitung, February 28, 1861 (advertisement, translated from the German; fig. 109).

Large Photographs only a Dollar. Duplicates 50 Cents. I wish to inform my clients that, because of a beneficial change in my locale, I am able to offer photographs of the finest quality at the lowest prices. Since my work has been so favorably received, I will respond by lowering prices considerably and offering for 1 dollar photographs that until now cost 10 dollars. I employ the best German artists, so I can produce portraits of any size, in oil, pastel, chalk, and water color, to your complete satisfaction, or else I will make no demand. Please visit my studio and convince yourself. Theodore Lilienthal 106 Poydras St. next to *Deutsche Zeitung* Office.

Crescent, July 15, 1861.

We are indebted to Mr. Lilienthal, photographist, No. 106 Poydras street, for a photographic full length likeness of the late Lieutenant Colonel Charles D. Dreux, the picture representing him in his uniform as he left here—Captain of the 1st company of Orleans cadets.

Bee, June 4, 1863 (advertisement, translated from the French).

Photography. Mr. Lilienthal, of 102 Poydras Street, between Camp and St. Charles, is one of the most skillful and conscientious artists our city possesses. Following the advances in photography step by step, he

Fig. 108 Advertisement for relocation of Lilienthal & Kaiser's Daguerreotype and Ambrotype Salon, 132 Poydras Street, 1857. *Deutsche Zeitung*, June 13, 1857.

Fig. 106 "T. Lilienthal & Co. Portraits," backstamp, cabinet card, 1888–89. Louisiana Collection, Tulane University Library.

271

puts them to best use, and does not allow himself to fall behind his colleagues, as is sufficiently attested to by the beautiful prints of which his gallery consists. We add that despite his talent and his determination to deliver no portrait with which he is not completely satisfied, Mr. Lilienthal, by reason of these unhappy times, asks only a modest fee of his clients.

Library of Congress. *Copyright Records, Eastern District, Louisiana, August 1863–June 1870.*
U. S. Dist[rict] Court, E[astern] D[istrict] of L[ouisian]a … 15th day of September 1863, T. Lilienthal of this City hath deposited in this Office, the photographic portraits of Major Genl Banks, Major Genl U.S. Grant[,] Adjutant Genl Thomas of the United States Armies & of Major Genl Gardner of the Confederate States Army.

Picayune, September 20, 1863 (advertisement).
Photographical. ARTISTS are respectfully informed that LILIENTHAL has entered his application for the Copyright (according to act of Congress) of his PHOTOGRAPHS of Major Generals BANKS and GRANT, of the Federal Army, and Major General GARDNER, of the Confederate Army, after the full approval of the Generals and their friends. This notice is to warn against trespass upon the author's rights.

Library of Congress. *Copyright Records, Eastern District, Louisiana, August 1863–June 1870*
United States Dist[rict] Court, East[ern] Dist[rict] of Louisiana … T. Lilienthal hath this day deposited in the Clerk's office of this

Court 4 photographs representing Major Genl ERS Canby in 4 different attitudes & 3 photographs representing Major General F Steele in 3 different attitudes … . March 9, 1865.

Times, November 20, 1865.
PHOTOGRAPH OF THE ST. JAMES HOTEL
We were shown yesterday a very fine photograph of the St. James Hotel, bringing out in bold relief the striking features of the building, with its wide verandah, etc. The picture was taken by Mr. T. Lilienthal, No. 131 Poydras street, and reflects much credit upon his abilities as a photographer.

True Delta, November 29, 1865.
We yesterday saw the photographer Lilienthal out with his big wagon, endeavoring to "commemorate on paste-board" the appearance of the Chief Quartermaster's office, opposite Lafayette Square. He is ordered, we learn, to take pictures of all the buildings used and occupied by the officers of the Department of Louisiana, and a copy of each is to be forwarded to Washington.

Library of Congress. *Copyright Records, Eastern District, Louisiana, August 1863–June 1870*
United States of America, Eastern District of Louisiana … T. Lilienthal Esq. has this day deposited in the Clerk's office of this Court a certain photograph … entitled "Mississippi Mission Conference of the M. E. Church" … Dec 27th 1865.

Picayune, January 31, 1866.
A PICTUR[E]. Lilienthal's "traveling photographic gallery" was brought into requisition yesterday evening to take a view of the building, now used as a colored school, corner of Dryades and Common streets, with the scholars and teachers all assembled on the outside. It was quite a scene, and the juveniles, some two hundred in number, seemed in high glee watching the proceeding.

Deutsche Zeitung, March 24, 1866, and May 10, 1866 (advertisement, translated from the German).
Theodore Lilienthal's Photographic Establishment 131 Poydras, near Camp St. opposite the iron building. Porcelain pictures, miniatures for medallions, broaches, etc., as well as larger ones for frames and every kind of painting are made in the most tasteful and solid manner at my studio. By means of most perfect equipment, the most beautiful paintings are made accurately, in oil or in pastel, on canvas or on paper, or in aquarell, Indian Ink, etc., in photography in every size. Popular *Carte de Visite* either of life or copied from an old picture, even if it is almost destroyed, or any work at all in this field is carried out with utmost care, which translates into longevity, something that is missing from pictures made quickly and with cheap materials. I call to your special attention that I have completely outfitted a wagon in order to photograph, out of studio, ill or dead persons, buildings, or views of New Orleans at any time of the day. On Sundays, the studio closes at 2 p.m. Theodor[e] Lilienthal.

Library of Congress. *Copyright Records, Eastern District, Louisiana, August 1863–June 1870*

United States of America, Eastern District of Louisiana, Clerk's Office ... Theo. Lilienthal has this day deposited in the clerk's office of this court Twelve Photographs representing "Birds eye views of the City of New Orleans taken from the Steeple of St Patrick Church" & marked respectively No2x, No6, No7x, No8x, No10x, No11x, No16, No17, No19x, No20, No21, No25x ... New Orleans, April 13th 1866.

Times, May 1, 1866.

We had the pleasure of seeing yesterday a most interesting and striking lifelike picture of the members of the Methodist Conference which has been in session in the city for some time past. The picture is a large size photograph, taken by Mr. Theo. Lilienthal, the well known photographist, No. 131 Poydras street. The grouping is admirably arranged, and those who have seen the picture will agree with us that it is admirably perfect in details. Mr. Lilienthal has been at great expense to arrange and build a permanent amphitheatre, at the City Park House, for the purpose of taking extended groups, many occasions arising which render this a most laudable and worthy enterprise. His pictures need only to be seen to be appreciated, and we wish him that success which his ability and enterprise so eminently deserve.

Crescent, May 1, 1866.

Mr. Theo. Lilienthal, the well known artist at 131 Poydras street, exhibited to us yesterday a photograph he had taken of the members of the General Conference now in session here. Mr. Lilienthal took advantage of their attendance at the pic-nic at City Park, on Saturday last, and, according to his request, they ranged themselves in a position to have the picture taken, the bishops in the foreground and the other members in the rear. The faces are small, but remarkably clear, distinct, and faithful to the originals; and Mr. Lilienthal has reason to be proud, as no doubt he is, of this piece of work. Many copies of it have been ordered, and it will be a pleasant thing for the reverend gentlemen to show to their friends at home and retain as a souvenir of a most interesting occasion.

Fig. 111 Lilienthal's 131 Poydras Street studio, stereoview backstamp, *c.* 1866–72. Louisiana State Museum, 1979.120.57.

Library of Congress. *Copyright Records, Eastern District, Louisiana, August 1863–June 1870*.

United States of America, Eastern District of Louisiana, Clerk's Office ... Theo. Lilienthal has this day deposited in the Clerk's office of this Court two certain photographs representing respectively 1– "Bishops of the Methodist Episcopal church, South" 2– "The General conference of the Methodist Episcopal Church, South" & 12 photographs representing bird's eye views of the City of New Orleans, marked respectively No 46, No 49, No 50, 51, 53, 55, 56, 58, 59, 60, 61, 78 ... Clerk's office, N. Orleans, May 2nd, 1866.

Times, June 14, 1866 (advertisement; fig. 112).

ATTENTION! ATTENTION! BIRD-EYE VIEWS, and other STEREOSCOPIC VIEWS of the CITY OF NEW ORLEANS, on exhibition and for sale at LILIENTHAL'S PHOTOGRAPHING GALLERY, 131 POYDRAS STREET, near Camp. COPYRIGHT SECURED ON ALL VIEWS. I am the only Photographer in the city who is at any time prepared to do out-door work, such as Photographing deceased persons, and taking Views in general, having a traveling apparatus attached to my establishment. Prices of Cartes de Visite reduced to $3 per dozen. All other Photographing work in proportion; and only the best artists are employed and the purest of materials used. My desire, by reducing my prices, is not to obtain any more customers, but only to compete with the prices of others. T. LILIENTHAL, 131 Poydras street, New Orleans.

Times, July 15, 1866.

Lilienthal's operator and portable apparatus were engaged Friday in photographing the Louisiana University building on Common street. They will make a fine picture, we should judge.

Crescent, November 19, 1866.

FIRE COMPANIES DAGUERREOTYPED. Yesterday, Mr. Lilienthal having had a stand erected in front of the City Park, took daguerreotype pictures of the following fire companies: "Jefferson No. 22, Perseverance No. 13, Louisiana Hose, Home Hook and Ladder No. 1, Orleans No. 21, Hook and Ladder No. 3, Chalmette No. 23." A separate picture was taken of each company, and, together they present the faces of nearly a thousand active and exempt members of the fire department. The weather was favorable and the impressions taken were said to be very distinct. The pictures are to be exhibited at the fair which opens to-morrow. Creole No. 9 and Philadelphia No. 14 were on the ground but Mr. Lilienthal had not time to take them.

Times, November 19, 1866.

PHOTOGRAPHING THE FIREMEN. A number of organizations of the Fire Department, in response to the invitation of Mr. Lilienthal, yesterday visited the Fair Grounds, for the purpose of having photographs taken of their several companies. First on the ground was Perseverance, No. 13, with their engine and two horses, "Happy Jim" and "Fox" ... Orleans, No. 21, accompanied them, the two companies marching in procession, headed by a fine band. Hope

Fig. 112 Advertisement for Lilienthal's Photographic Gallery, 131 Poydras Street, 1866. *Times*, June 14, 1866.

Hook and Ladder No. 3, Home Hook and Ladder No. 1, of Jefferson City, Chalmette No. 23, Louisiana Hose and Jefferson Engine No. 22, were also among those to answer the call. Philadelphia No. 14, and Creole No. 9, were on the ground, but owing to the great amount of work Mr. Lilienthal had on his hands, it was too dark to take a good picture before their turn came. Perseverance No. 13, and Orleans No. 21, were taken singly and together. They afterwards repaired to the city Park, Where a mighty bowl of champagne punch was provided. The several processions afterwards marched through the principal streets.

Times, November 28, 1866.
One of the finest displays of the photographic likenesses, pictures, paintings, etc. in the building [of the 1866 Mechanics' and Agricultural Fair], is made by Lilienthal, whose gallery is on Poydras street, near Camp. Many of the likenesses of groups on a large scale were admirably finished, and the general arrangement and variety of the attractions in Mr. Lilienthal's space do equal credit to his judgement and enterprise.

Times, November 28, 1866.
LILIENTHAL'S PHOTOGRAPH GALLERY, NO. 131 POYDRAS STREET, NEAR CAMP STREET. It is unnecessary for us to say more than we have heretofore expressed, in our opinion, of the neatness of execution of Mr. Lilienthal's pictures. Suffice it to say that the committee at the late State fair awarded him a gold medal, diploma, three silver medals and a premium of thirty dollars for the best and most imposing display of photographic likenesses, etc. We advise all desiring a true likeness to go to the

fashionable resort of Mr. Lilienthal, where they will have satisfaction guaranteed them, both as to price and quality.

Crescent, December 1, 1866.
SCENES FROM THE FAIR GROUNDS. Lilienthal, the well-known photographer, on Poydras Street, appreciating, with the eye of an artist, the many beautiful combinations of art and nature offered during the recent exhibition, has taken a series of photographs introducing the various and attractive scenes of the occasion. We had the best recommendation we can give when we say that on seeing them we found ourselves involuntarily pulling out our pencil and note-book to report the same.

The photographs, which are arranged for stereoscopic view, embrace the bell tower, the display of iron architecture by Armstrong, the Southern soap factory, the machine works, the Fair-ground Crescent and St. James, and two or three birds-eye views of the entire grounds, taken from the place of Mr. Luling, adjoining. By all those desirous of preserving the pleasant memories of the occasion these photographs will be valid.

Times, December 31, 1866 (advertisement).
LILIENTHAL'S PHOTOGRAPHIC GALLERY. Gold Medals and Diplomas—Three Silver Medals, $30, Awarded at the Louisiana State Fair, 1866, to THEODORE LILIENTHAL, Photographer and Proprietor of the Gallery of Fine Arts, 131 Poydras street, between Camp and St. Charles. N.B. MR. H. BYRD, Painter Artist, who received the Medal at the first Louisiana State Fair in 1859, for the best Oil Painting on Canvas, has charge of the Studio in this establishment. All work guaranteed or no charge.

Deutsche Zeitung, January 1, 1867 (advertisement, translated from the German; fig. 113).
Theodor[e] Lilienthal's Photographic Establishment. 131 Poydras Street, near Camp, opposite Moresque Hall. Due to the late arrival of a shipment of albums of the latest fashion imported directly from Paris, I see myself compelled to sell same albums in a clearance sale, at purchase price I always employ the best artists in my studio ... [and] because I transfer the

drawing to the canvas by means of instruments, I am in a position to achieve the unsurpassable in oil painting—the smallest, most imperfect picture of deceased persons is sufficient to produce a life-size picture. I am also the only photographer in this city who is completely equipped to photograph, upon the shortest notice, ill and dead persons in their homes, as well as views of buildings, monuments, etc., etc.

Picayune, January 5, 1867.
PHOTOGRAPHING THE INTERIOR OF A CHURCH. Lilienthal, the clever photographer of Poydras street, was engaged this morning taking views of the interior of the First Presbyterian Church, Rev. Dr. Palmer's, opposite Lafayette Square, to fill an order. The interior of this church, though finished without any great attempt at display, is very rich and chaste, and will doubtless make a pretty picture when photographed.

Fig. 113 Advertisement for Lilienthal's "Photographic Establishment," 131 Poydras Street, 1867. *Deutsche Zeitung*, January 1, 1867.

La Nouvelle Orléans et ses environs:
Lilienthal's Photographic Campaign for the
Paris Exposition of 1867

New Orleans Public Library, Louisiana Division, City Archives, Minutes and Proceedings of the Board of Assistant Aldermen, X, March 19, 1866–August 28, 1868, folios unnumbered. Entry dated January 9, 1867.

To the Honorable Board of Assistant Aldermen: Gentlemen: Inclosed [*sic*] is a communication from the Committee appointed to represent Louisiana at the coming World's Exposition at Paris. It is submitted for such consideration and action as you may think proper. Respectfully, John T. Monroe, Mayor NEW ORLEANS, Jan. 9, 1867.

To the Honorable the Mayor and City Council of the City of New Orleans

Gentlemen—The undersigned, commissioners appointed to represent the State of Louisiana at the approaching World's Exposition, to be held at Paris, entertaining a deep interest, not only in the representation of its rich and varied sources of wealth, whether mineral, agricultural, or industrial, but also in every contingent action which may tend to promote a cordial and friendly feeling between our country and that nation, to which, in our memorable struggle for independence, we incurred a debt of lasting gratitude, would respectfully suggest the following action: That under your authority and supervision, a portfolio be prepared containing stereoscopic views of the city of New Orleans and its environs, illustrating the principal streets, squares, public buildings, levee, river, etc. The volume to contain the photograph, with the autograph of his honor the mayor, and each member of the City Council, to be dedicated in an appropriate address in the French language to the emperor of the French after the exposition.

As this work is designed to illustrate the chief center of the Southern and Western trade of the United States, and to be dedicated to the head of a great nation with whose people and associations the State of Louisiana is identified by the bonds of history, language, and commercial interest, we respectfully suggest that it should be designed and executed in the most artistic style, and regardless of the cost. We would furthermore suggest that the work should

embrace letters of invitation to the capitalist, the artist, the artisan and the mechanic and laborer to adopt the city of New Orleans or the State of Louisiana their home. Impressed with the vast importance of such action in the advancement of our general interest, we submit the same to your consideration, and remain, gentlemen, with great respect, your most obedient servants. W.S. PIKE, President[,] ED. GOTTHIEL [GOTTHEIL,] J.B. PRICE

Picayune, January 11, 1867.

STEREOSCOPIC VIEWS OF NEW ORLEANS FOR THE PARIS EXPOSITION. The commissioners appointed to represent the State of Louisiana at the Paris Exposition have requested the authorities of our city to have stereoscopic views of the public buildings, principal streets and levee of New Orleans taken, to be presented, with photographs of the Mayor and Common Council, to the Emperor of the French.

The views of the city, particularly those of the Levee, would doubtless be quite interesting to those visitor's [*sic*] at the World's Fair, who have not had an opportunity of dropping in upon us, while not a few would also be gratified in seeing what our city fathers look like. It is proposed that an appropriate address shall accompany the views, showing that New Orleans offers large inducements as a residence and place of business for artists, artisans, capitalists, etc.

The Board of Assistant Aldermen, to whom the communication of the commissioners was transmitted by the Mayor, at their meeting last evening appointed a special committee of four of its members to confer with the commissioners on the subject.

Crescent, January 12, 1867.

The commissioners appointed to represent the State of Louisiana in the great Paris Exposition held a meeting last evening …. Mr. Gottheil then presented the following memorial, addressed to the New Orleans Chamber of Commerce … NEW ORLEANS, Jan. 11, 1867. Chas. Briggs, Esq., President Chamber of Commerce: Sir—We would respectfully suggest the propriety of the Chamber of Commerce of New Orleans forwarding to the Paris Exposition, samples of all the agricultural products grown in Louisiana, and sold in the New Orleans

Fig. 114 Lilienthal, "Series of Stereoscopic Views of New Orleans and Vicinity," stereoview backstamp, *c.* 1871–75. Collection of Mr. and Mrs. Eugene Groves.

market …. The object of this communication is to present to the eyes of visitors to the Paris Exposition, specimens of the … produce in our market, and to better advertise New Orleans and Louisiana to the world. We want population and must employ every particular mode of attracting it to our rich and productive State …. Signed: Wm. S. Pike, president; Edward Gottheil, vice president; Jas. R. Currell, secretary; T. Anfoux, S.N. Moody, Rufus Dolbear, R.H. Cuney, B.W. Warner, J.W. Goslee, W.P. Coleman, Alfred Dufilho, J.B. Price, L.G. De Lisle, Jas. Davidson, Thomas Murray. … The following memorial, to the governor of the State, was next adopted … NEW ORLEANS, Jan. 9, 1867. To His Excellency J. Madison Wells, Governor of Louisiana: Sir—The undersigned commissioners, appointed to represent the State of Louisiana at the approaching world's exposition, to be held in the city of Paris, would respectfully suggest that you request

Fig. 115 Advertisement for Lilienthal's Photographic Gallery, 121 Canal Street, 1875. J.C. Waldo, *Visitor's Guide to New Orleans, November, 1875*, New Orleans (J.C. Waldo) 1875.

the State legislature to prepare a general letter of invitation, addressed to the capitalist, the artisan, mechanic, and laborer of Europe, tendering the welcome and hospitality of our State and people, and enumerating the rare advantages possessed, and benefits to be enjoyed by the adoption of our State as their future home.

The intimate relations of interest and good will which link the people of Louisiana with all Europe through the medium of the above stated elements of successful action, should be placed before the view of that class of Europeans who are seeking homes in America. We would suggest that ten thousand copies of the letter of invitation, in the French and German languages, be printed and distributed through such agency as you may elect …. Mr. Gottheil announced that the State of Louisiana would be represented in the exposition by fifty exhibitors. The goods of twenty-four of these have already been sent, and the rest are being forwarded as rapidly as possible …. No more articles of bulk can be received, and very few even of small bulk can be found room for as the imperial catalogue is already made up …. Mr. Murray made some interesting remarks in regard to a portable

Fig. 116 Advertisement for Lilienthal's Photographic Establishment, 131 Poydras Street, 1871. *Fifth Grand Fair of the 1871 Mechanics' and Agricultural Fair Association*, New Orleans (Weed & Kelly) 1871.

cottage, to be made from the different specimens of wood growing in Louisiana, and forwarded for exhibition, promising samples of cedar, elm, white-oak, magnolia, black walnut, cypress, yellow pine and red cedar …. Messrs. Murray and Gottheil were appointed to superintend the construction of the portable house.

Crescent, January 16, 1867 (advertisement). THE PARIS EXPOSITION. An appeal to the Ladies of Louisiana. The Board of Commissioners to the Paris Universal Exposition, while they feel proud of the contributions offered for exhibition, regret that no specimens of Needle work have been furnished them. They are confident, however, that the fair women of the State could have competed successfully with those of any nation. The Commissioners have decided to forward to Paris for exhibition, a portable cottage, composed of the various beautiful woods in which our forests abound. For the external decoration of this cottage they require a number of State and National flags. [Notice also *Picayune*, January 16, 1867.]

Picayune, January 30, 1867.
The City Council: Board of Aldermen … Mr. Clarke offered a resolution appropriating $2000 for the purpose of preparing a portfolio of photographic views of the city of New Orleans, to be presented to the Emperor of the French, the work to be performed under the supervision of the Joint Committee of the Council upon the Paris Exposition. Mr. Stith was opposed, upon the ground that the cost would, in the end, amount to a great deal more money than the resolution called for …. Mr. Whitney opposed the appropriation, as he could not see what good could result from it. Upon motion of Mr. Stith the resolution was laid over.

Message of the Governor of Louisiana to the General Assembly, Commencing January 28, 1867, New Orleans (J.O. Nixon) 1867, pp. 10–11.
THE GREAT PARIS EXPOSITION. Through the exertions of commissioners appointed by me on the part of the State, and particularly by the indefatigable zeal and industry of Mr. Edward Gotthiel [Gottheil], a laudable feeling of pride has been stimulated among our people to see our State represented at

the great world's exhibition. Samples of our great staples—specimens of nearly every product of our soil as well as articles of mechanism, have gone forward, and will attest to Europe, more powerful than language, that Louisiana is the Indies of America in her natural gifts. It has been suggested that the interests of the State would be further advanced, through the medium of this great exhibition and assemblage from all parts of the habitable globe, for the Legislature to prepare an address, to be disseminated by the commissioners, tendering a general invitation and welcome to our State and people to the capitalist, the artisan, mechanic, and laborers of Europe, and enumerating the rare advantages possessed and benefits to be enjoyed by the adoption of our State as their future home.

New Orleans Public Library, Louisiana Division, City Archives, Minutes and Proceedings of the Board of Aldermen, VII, fol. 489, February 8, 1867.
Resolved—that the sum of two thousand dollars ($2000) be, and the sum is hereby appropriated for the purpose of preparing a portfolio of views of the City of New Orleans and under the joint supervision of the Joint Committees on the Universal Exposition in Paris to be sent to the Emperor of the French.

Bee, February 13, 1867 (city council proceedings, Board of Assistant Aldermen).
The resolution of the upper Board appropriating $2000 for a port folio of

Fig. 117 Advertisement for Lilienthal's Art Gallery, 121 Canal Street, 1878. *Bee*, June 16, 1878.

views of New Orleans to be presented to the Emperor of France, at the Paris Exposition, passed its first reading, but the Board refused to suspend the rules to put it on its final passage.

Crescent, February 16, 1867 (city council proceedings, Board of Assistant Aldermen).
The resolution from above for sending photographic pictures to Paris was now called up. Mr. Prague thought $100 would be a more appropriate sum than $2000. He could not see the use of honoring the Emperor of the French with either pictures of the city or of the members of the Boards. A violent discussion here ensued, in which more than half a dozen members attempted to speak at once. Mr. Prague moved to adjourn. The motion was carried.

Picayune, February 22, 1867.
PORTABLE COTTAGE FOR THE PARIS EXPOSITION. A short time since, we noticed the fact that Messrs. Thomas Murray and Edward Gottheil [Gottheil] had been selected by their co-commissioners to Paris to have constructed for exhibition at the great Exposition, a portable cottage, to be designed with a view of introducing into its construction as great a variety of the native growth of Louisiana as could be obtained in the short time allotted for the work. We take pleasure in announcing that the cottage has been finished, and will be sent forward to New York for shipment to Europe by steamer, to-morrow morning. Some eight or ten kinds of wood have been used in constructing this cottage, which is a very beautiful piece of work, both in point of design and artistic finish, and reflects great

Fig. 118 Advertisement for Lilienthal's Art Gallery, 121 Canal Street, 1877. J.C. Waldo, *The Roll of Honor: Roster of Citizen Soldiery Who Saved Louisiana*, New Orleans (J.C. Waldo) [1877].

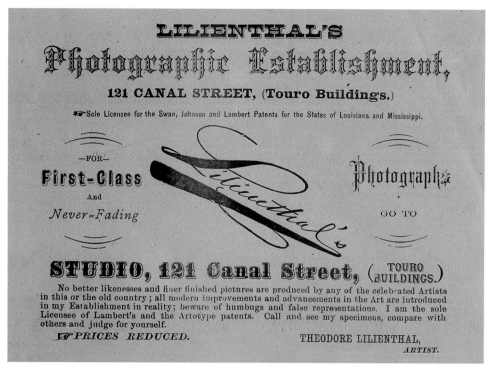

Fig. 119 Advertisement for Lilienthal's Photographic Establishment, 121 Canal Street, 1879. J.C. Waldo, *Illustrated Visitor's Guide to New Orleans*, New Orleans (J.C. Waldo) 1879.

credit upon the architect and builder. A portico in front of the cottage, supported by plain and fluted columns of oak, cedar, cypress, and yellow pine, and the floor of which is laid with alternate planks of red cedar and cypress, gives quite a happy effect to the miniature building. Not a particle of paint has been used, the wood in every instance being varnished instead, so as to bring out the true colors. The tympanum of the portico is enriched with the coat of arms of the State of Louisiana, a pelican feeding her young, elaborately carved in walnut.

The cottage has a single room, twenty-two feet in length by fifteen feet in width, with a height of fifteen feet, which is intended for a reading room, where will be kept the files of the leading American journals, particularly those of our city, with a register book presented by Messrs. Bloomfield, Steel, & Co., Camp street, for the use of all Louisianians arriving in Paris. A handsome set of flags has been presented to the commissioners, to be placed upon the outside of the cottage—one the state flag of Louisiana, and the other the national colors. The state flag is superbly embroidered in gold, and will be perhaps as rich a piece of work, of its kind, as any sent

from this side of the water to the Exposition. An appeal has been made by the commissioners to our ladies for other flags to decorate the reading room and we have reason to believe that quite a number of handsome banners and streamers will be sent forward for that purpose. Messrs. Murray & Gotthiel [Gottheil] deserve a great deal of praise for the construction of this handsome specimen of Louisiana handicraft.

New Orleans Public Library, Louisiana Division, City Archives, Minutes and Proceedings of the Board of Assistant Aldermen, X, March 19, 1866–August 28, 1868, fols. 30–31, February 26, 1867.

Mr. Higenbotham [Higgenbotham] called up the following resolution for adoption on second reading which was adopted by the following vote ... Resolved—that the sum of two thousand dollars ($2000) be and the sum is hereby appropriated for the purpose of preparing a portfolio of views of the City of New Orleans and under the supervision of the joint committee on the universal exposition in Paris. It to be sent to the Emperor of the French. Mr. Prague having voted in the affirmative gave notice that he would move a reconsideration at the next regular session.

Crescent, February 27, 1867.
Board of Assistant Aldermen ...
Mr. Higginbotham [Higgenbotham] called up for a second reading the resolution appropriating $2000 for a portfolio for the Paris exposition. Mr. Prague amended by moving that the $2000 be devoted to some charitable object in this city. What was the good of sending a gilt-edged portfolio to the Emperor Napoleon, who is sitting in purple and fine linen, while children and women here at home are crying for bread? The resolution, upon a second reading, was concurred in by a vote of 9 to 4. Mr. Prague motioned a reconsideration at the next meeting.

Deutsche Zeitung, February 27, 1867 (translated from the German).
City Council Board of Assist. Aldermen. A motion to appropriate $2000 for the compilation of a photographic album of views of Louisiana for the Paris Exposition was approved.

Crescent, February 28, 1867.
THE PORTFOLIO OF VIEWS FOR THE PARIS EXPOSITION. The Board of Assistant Aldermen at their meeting last evening concurred in the resolution of the upper board, appropriating the sum of $2000 for the purchase of a series of views of different scenes of interest in and about the city, together with photographs of the legislative and municipal bodies. All these are to be forwarded to the world's exposition in the city of Paris, at the close of which they will be presented to the French emperor. We understand that Mr. Lilienthal, the photographer on Poydras street, will be selected as the artist for carrying out this design.

Times, February 28, 1867.
THE PORTFOLIO. We hope that in photographing the buildings and public places of the city for presentation to the Industrial Exposition of Paris, under the resolution adopted by the Board of Assistant Aldermen, on Tuesday evening, it will not be forgotten to include the old building at the corner of Chartres and St. Louis, which was built by Nicholas Girod and tendered to Napoleon the first, as his residence, in the event of escape from St. Helena, to effect

which escape a plot had been laid in this city, and money subscribed. This old building will attract the attention of no one passing along the street, but in its day it was regarded a grand and palatial edifice.

Crescent, March 1, 1867.

THE PORTFOLIO. We have been furnished by Mr. Lilienthal, the artist, with the following list of the views, which are to be taken in this city and vicinity, as material to the portfolio to the Paris exposition. The selections are good ones, and embrace every prominent feature of interest. Mr. Lilienthal has already been at work for several days in the matter, and promises to collect a series of pictures not only useful for the specified purpose, but well worthy of purchase by all of our citizens: Birds-eye views of New Orleans, public squares, Fair Ground, Custom House, Mint, Barracks, United States Depository, United States Marine Hospital, banks, theaters and Opera House, churches of all denominations, synagogues, asylums, hospitals, public schools, City Hall, hotels, Mechanics' Institute, Masonic halls, markets, cotton presses, city cars stopping places and stables, railroad depots with trains, Moresque Building, principle [sic] streets, manufactories, foundries, refineries, breweries, engine houses, engines and engine companies, field and monument of Chalmette, ships of war, ferry-boats, floating docks, saw-mills and brick-yards, race course, new and old basin, Lake Pontchartrain, Bayou St. John, Fort St. John, water-works, gas-works, Parish Prison, grave yards, shell road, new Merchants' Exchange, Medical Colleges, private residences, sugar plantations and sugar fields, views of Carrollton, Algiers, Gretna, Jefferson, views of levee, river, and shipping, east and west.

Deutsche Zeitung, March 1, 1867 (translated from the German).

The album of photographic views to be sent to the Paris Exposition, for which $2000 is to be expended in accordance with the city council resolution of two days ago, will be made by Mr. Th. Lilienthal, No. 131 Poydras Street. Although we do not approve the matter from the standpoint of the costs which will thus accrue to the city, in selecting the aforementioned artist,

however, the city council has made an excellent choice that we must applaud. In fact, Mr. Lilienthal's studio has gained increasing popularity because in photographing scenery and social events he has acquired a reputation of taking the most naturally accurate views.

Crescent, April 6, 1867.

PHOTOGRAPHS OF THE GREAT REPUBLIC. Mr. Theodore Lilienthal, the photographer, succeeded, on Thursday, in taking excellent pictures of the interior and exterior of the monster steamboat Great Republic. These will be included among the views to be forwarded in the portfolio to the Paris Exposition, and will give to those who have never seen our river boats, a thorough idea of the floating palaces which ply upon our inland streams.

Picayune, May 22, 1867.

PHOTOGRAPHIC ALDERMANIC ALBUM FOR THE PARIS EXPOSITION. The good artist, whether he be a painter or a photographist,

LILIENTHAL'S
Art Emporium
121 CANAL STREET,
(Touro Buildings.)
Use Elevator to Photograph Gallery.
PHOTOGRAPHS OF ALL DESCRIPTIONS MADE SUPERIOR IN FINISH TO ANY OTHER PHOTOGRAPHER IN THIS CITY. COMPETITION IN PRICES OUTDONE.
My Frame, Moulding and Art Picture Department, in charge of Mr. F. WAGNER, offers to the public inducements worthy their consideration.
Goods of all kinds appertaining to the business are in stock in such quantities that every lady will find it to her interest to examine the same before purchasing elsewhere.
THEO. LILIENTHAL,
PROPRIETOR.
8.27.6.19

Fig. 120 Advertisement for Lilienthal's Art Emporium, 121 Canal Street, 1881. *New Orleans Price Current*, February 19, 1881.

in exercising his art, always chooses a good subject. The fame of many an artist has been achieved as much by the judgement he has displayed in the selection of a subject, as by the touch—the finish of his pencil. Mr. Lilienthal, an accomplished photographist of this city, has been for some time engaged in taking photographic views of various portions of our city, intending to make up an album of pictures to send to the Exposition at Paris. This will certainly be a handsome contribution of art to the Great Exhibition.

Mr. Lilienthal, with the judgement of a true artist, concluded that his album of pictures would be incomplete, unless he made contributions to it other than views of the different localities of the Crescent City. He felt that there would be something wanting, and his artistic instinct was not long in finding out what it was. In taking pictures of different portions of such a city, he very naturally concluded that there must be in it what are known as Aldermen. In sooth, a fair presumption, if not strictly a logical conclusion! The absence of the pictures of the members of the Common Council, was the *hiatus* of his album for the Paris Exposition. Consequently, being too much of the artist to send his album to such a place as Paris with such an aperture in it, he has invited the members of both Boards of the Common Council to visit his gallery with the view of having the aperture closed. The members of the Council have accepted the invitation in the most cordial manner, and are to have the *camera lucida* or the *camera obscura*, we don't know which, leveled at them, and thus become immortal—and go to Paris besides.

We feel confident of one thing, and that is, the picture gallery of the Exposition in France will not be able to furnish a finer presentation of aldermanic health, or the faces of cleverer or more paternal fathers. We wish the vessel, which will be cargoed with the album thus completed, a safe voyage across the broad Atlantic to *la belle* France.

Deutsche Zeitung, May 23, 1867 (translated from the German).

WORTH SEEING. Yesterday, we had the opportunity to view, in the company of several city fathers, the photographs of the city of New Orleans which Mr. Theo. Lilienthal, 131 Poydras Street, has made for

Fig. 121 Advertisement for Lilienthal's Art Gallery, 121 Canal Street, 1881. *Picayune*, November 24, 1881.

the World Exposition in Paris, and in our own judgment and that of these aldermen we can assure [our readers] that these photographs taken by Mr. Lilienthal will be applauded not only by the many Americans visiting Paris, but will be of interest to anyone whose relatives and friends live here, and must make a favorable impression on the viewer regarding the upswing of New Orleans.

The execution of the numerous views leaves nothing at all to be desired concerning sharpness of expression and naturalness of the image. Mr. Lilienthal intends to make duplicates of these views and to exhibit those for sale. This album for the Exposition will be a piece of work of which Mr. L. and N.O. can be proud and which can give our friends in Europe a correct idea of the size and importance of New Orleans and the numerous places worth seeing in this city, and will therefore create a very favorable impression concerning our conditions.

On the occasion of our visit we saw a number of oil paintings which show prominent persons of the city of New Orleans, partly finished, partly in progress, and we must attest Mr. Lilienthal that his oil paintings compare well with the work of the best portrait painters of European cities.

Among other pictures we saw a portrait in oil of ex mayor Monroe, which is, as they say a speaking likeness. Those who want to be photographed or painted in oil should look at the photographs and portraits exhibited at Mr. Lilienthal's studio.

Times, May 23, 1867.

Petitions ... A letter from Mr. Theo Lilienthal, photographist, inviting the Aldermen to come to his office to be photographed for the Paris Exposition was ... accepted.

Times, May 24, 1867.

THE LILIENTHAL VIEWS. One hundred and fifty views of the principal objects of public interest in the city have been taken by Lilienthal and are now ready for the Paris Exposition. The views are all as eloquent as a photograph can be, and are cast in a style of great nicety and finish. Some of them are particularly chaste, in the fact that passers by are taken while in the act of making a step. An Orleanian in Paris would at a glimpse of this series of pictures recognize the main features of New Orleans. But the series are [*sic*] not so many as are required. The river front of the city, with its peculiar crescent shape, fringed with the masts of vessels and chimneys of steamships is not there. There is no view of a Louisiana crevasse which would express louder than any tongue the peculiar position of our people. There is no view of an old plantation as a memento of what has been. Among the manufactories not a single newspaper office is pictured. But even with these things missing the collection may be pronounced the most complete of the kind ever arranged in this city. As an enterprising gentleman who desires to do something more and make better use of his art than taking a picture of the human face, Mr. Lilienthal deserves the success to which he aspires and to which his ambition leads him.

Crescent, May 26, 1867.

NEW ORLEANS AND VICINITY AT THE PARIS EXPOSITION. Mr. Lilienthal has just completed one-hundred and fifty photographic and fifty stereoscopic views of this city and vicinity, which are very creditable to the artist. These views have been ordered by the State for the great

Paris exhibition, whither they will be taken by Mr. S.N. Moody, who will be off in a few days for that attractive spectacle. Our public buildings, squares, statues and our great levee, with its wealth of produce, and fleet of steamers, steamships and sailing craft, have merited prominence, while our handsome residences have not been overlooked, and we were gratified to observe in the series two excellent pictures of Mr. Bridge's flower-wreathed cottage, corner of Prytania and Eighth streets. Among other attractive views are the following: "Canal street from Bourbon to the river," Moresque Building from corner of Camp and Poydras streets," "Jackson Square and steamship landing from the Cathedral," "Bird's-eye view from St. Patrick's of the city, levee, Algiers, and the crescent bend in the Mississippi," "University of Louisiana," "Cotton Region of Carondelet street," where the bulls and bears most do congregate, "Dan Hickock's restaurant," and "Boudro's[,]" the floating palace "Great Republic," "A meet at the Metairie Race Course, 1867," "Field of cane, and sugar house on Orange Grove plantation," "A crevasse on the Mississippi," and the "Half Way House." Mr. L. retains the negatives of all these views, and will print copies for all who may desire them.

Times, May 29, 1867.

OUR CITY TAKEN. The following from a cartman is not so bad: NEW ORLEANS, May 28, 1867. To the Editor of the N. O. Times—I perceive in the columns of your paper that the honorable City Council have consented to sit with our distinguished artist, Mr. Lilienthal, and have their photographs taken; also, in another article, that Mr. Lilienthal has about 150 different views of the city and its environs, all of which are to be sent to the Paris Exposition. This is well and commendable indeed, but as the Emperor takes such a deep interest in the streets and thoroughfares of the City of Paris, and particularly those leading to the interior, by which the people receive their marketing and other supplies so requisite in a large city; and thinking that our Council and Street Commissioner, and City Surveyor, and the Chairman of the Streets and Landings should point the Emperor with pride to the great march of improvement

here in this city over European cities, and let the people of the Old World behold these wonders, I would hence suggest that the Hon. Mayor and Council, and other savants connected with the same, should invite Mr. Lilienthal to take views of ... some of those beautiful subterranean caverns filled with water, which may be found about and near the tobacco warehouse on Levee street ... [and] by all means let the Emperor be instructed by seeing the views of our superior thoroughfares, that he may thus improve the streets of Paris. CARTMAN.

Controller's Report Embracing a Detailed Statement of Receipts and Expenditures of the City of New Orleans from January 1st, 1867, to June 30th, 1867, New Orleans (New Orleans Times Book and Job Office) 1867, p. 90.
Expenditures of City of New Orleans Contingency Fund, June 4, 1867, Warrant No. 850: T. Lilienthal, for Portfolio of Photographic Views of the City, for Paris Exposition.

Crescent, June 7, 1867.
MOODY ON A EUROPEAN TRIP. Moody the monarch whose linen and cambric fabrics fill the palatial establishment at the corner of Canal and Royal, departs to-morrow from among us to mingle a while with other potentates, who are now figuring at the great Paris exposition ... he carries with him the numerous views of New Orleans taken by Lilienthal, views which present the city in a hundred different aspects, and will be accredited with a letter from Mayor Heath, presenting him to the illustrious Louis Napoleon as the greatest shirt maker and the most appreciative admirer of art on the American continent.

Times, June 9, 1867.
THE LETTER WHICH ACCOMPANIES THE PHOTOGRAPHIC VIEWS. The following is the letter which has been drafted to accompany the portfolio of views to the Paris Exposition. It will be presented to the Emperor Napoleon: STATE OF LOUISIANA, MAYORALTY OF NEW ORLEANS, City Hall, June 8, 1867. To His Imperial Majesty the Emperor of the French: Sire—By the direction of the honorable City Council of New Orleans, I, as Mayor of the corporation, beg leave to accompany the presentation of certain

memorials of our city, with the expression of high respect entertained for your majesty and the great French nation, by the authorities and peoples of this city, which owes its foundation to French enterprise.
We presume to believe that the sovereign of the countrymen of the chivalric and devoted Bienville cannot but be interested in the fortunes of the city which he established a century and a half ago on the banks of the "great Father of Rivers," in the midst of the swamps rescued from annual overflow by the energy of himself and his compatriots. To the fostering care of France and the devotion and endurance of her colonists, the success and prosperity of this settlement in its infancy, and for a long period of its struggling youth and manhood were mainly due. When your great predecessor determined to cede this territory to the United States, he displayed alike his wisdom and philanthropy. He knew that the rights of the Frenchmen, who had under his protection and encouragement of their government, fixed their fortunes and homes

in the territory, would be amply secured by the new power to which the colony was transferred. The guarantees of the treaty of cession of 1803 have been faithfully observed by the United States. The natives of France have enjoyed here all the rights and privileges of American citizens. Their original settlers and their descendants have become identified with their fellow-countrymen of different races. No prejudices have under the beneficent influence of our republican institutions obtained any permanent hold upon the minds of the diverse races who make up our composite population. None of these have exercised a larger or more beneficial influence on the habits, tastes, and many of the social ideas of our community than the French founders of this city.
Especially has this been so in regard to the ornamental arts, and the elegancies and comforts of social life. To the wisdom of your jurists, to that admirable code in the compilation of which your illustrious uncle bore so useful a part, we are indebted for

Fig. 122 Advertisement for Lilienthal's 121 Canal Street studio, 1882. J.C. Waldo, *History of the Carnival in New Orleans from 1857 to 1882*, New Orleans (L. Graham) 1882.

the jurisprudence which governs their conduct and protects their rights in all their civil relations. Under these favorable circumstances the city of Bienville has greatly prospered, and become the fifth in population, and the second in commerce on the continent. Its immense geographical and commercial advantages are fully comprehended by your majesty. Recent political changes, by giving new vigor and variety to the pursuits of our people, will greatly increase the prosperity and activity. These changes will add new attractions to our city for the skilled labor, the cultivated science and art, the enlightened enterprise, and the various fabrics of the nations of the Old World, and especially of France. To promote this purpose we look for great aid to the Exposition which your majesty has wisely originated, and is so energetically directing to so many noble ends. A deep interest is felt by our people in the success and brilliant triumph of this Exposition of arts and products of all nations. We have sent many of our most esteemed citizens to bear personal testimony, and faithfully report the result of this Exposition.

In further testimony of our interest in this noble institution, and of our high respect for you as the ruler of the ancient mother of our State and city, we beg your acceptance of [the] accompanying photographic views of notable localities of our city, of our principal public buildings and industrial establishments, with portraits of the members of our municipal government. And with our sincere wishes for your majesty's long and peaceful government, and for your success in your high mission as the promoter of peace and the arts and sciences of civilization, I beg to subscribe myself.

Your majesty's very obedient servant,
E. HEATH, Mayor[,] Geo T. Childs, Secretary

Deutsche Zeitung, June 9, 1867 (translated from the German).
THE ALBUM FOR THE PARIS WORLD EXHIBITION. The splendid album of views of the city of New Orleans and surrounding area was sent to his Majesty Emperor Napoléon III by Mayor Heath yesterday. On this occasion, Mayor Heath wrote a rather long letter to the Emperor in which he touches on the colonization

Fig. 123 Advertisement for Lilienthal's Photographic Establishment, 121 Canal Street, 1883. *Picayune*, March 2, 1883.

of Louisiana by the French, the cessation of the French province to the U.S., and the increase, growth, and commercial flowering of the city, and expresses his hope that the ties between the inhabitants of New Orleans and Louisiana and their countrymen in France remain close and that these photographs may give the visitors of the Exposition a better idea of the size and importance of the place of residence of their local relatives.

Commercial Bulletin, June 10, 1867.
COL. MOODY OFF FOR PARIS. Our readers doubtless have not forgotten that our friend Col. Moody, the great Canal street dealer in furnishing goods was appointed one of the representatives from this state to the World Fair at Paris, and will also remember his exertions towards having the products of this state represented at the great Exposition. It may therefore be interesting for them to learn that his departure—which has been delayed on account of the dilatoriness of the operator who was preparing the photographic views of the city New Orleans for the Emperor Napoleon of which Moody is to be the custodian—will take place this afternoon, and that he will bear the above mentioned views, which have

all been finished and which will reflect credit upon our photographists.

Crescent, August 4, 1867.
LETTER FROM PARIS. ... Paris, July 14, 1867. In the grounds of the exhibition there is to be seen a pretty, simple cottage, made of Louisiana cypress. It is left in the natural color of the wood, finely polished; and with its little portico, its wide door, its three cheerful windows, it breathes of "home," until the heart melts with its own sweet memories. This little cottage is erected in the garden, among the roses, the pinks and the heliotropes and mignonette, and on its facade is written in gilt letters, "Maison portative de la Louisiane." On the walls hang several colored prints, engravings, drawings, etc., of Louisiana scenery. Over the mantel-piece hangs a large engraving of New Orleans, with its steamboats, its wharf, its familiar steeples, and a thousand minute objects so well recognized by those who belong to that dear city On a table, in the center of the room, there are two specimens of cotton, which have now each a gold medal. Next is a little heap of salt, with a card—"D.D. Avery, mention honorable"; then come the syrup and the sugar, and the Louisiana moss pressed into a miniature bale—each object having attached its prize—some the silver medal, some the bronze, others the honorable mention, etc. This spot has become a sort of shrine for the Louisiana people in Paris. They go there and write their names in a huge book, quite large enough to contain the name of every inhabitant of the State. They sit on the little piazza and imagine themselves at home. A patriotic lady was heard to exclaim, the other day, while seated in the cottage: "If my cruel fate have decreed that I shall end my days in a foreign land, I would like my coffin made from a piece of this cypress."

Crescent, August 4, 1867 (correspondence of A. Head).
A. HEAD AS A PARIS-ITE. PARIS, July 16, 1867 ... The last time I wrote you I mentioned "The Louisiana Cottage!" This is a live little affair and "it is not a dye!" Gotthiel [Gottheil] ... has received his photographs for exhibition in it, prior to their being presented to the Emperor, Mister Napoleon, with the accompanying letter of Mayor

Heath, whom I only know by having read of him. The photos represent all portions of the city of New Orleans, and some of the rich, plantation scenery of Louisiana. They make a fine appearance in "the cottage!"

Paris, Archives Nationales, F12 3095, Class 9: Edward Gottheil, Louisiana Commissioner to the Paris Exposition, to Jurors of the Exposition

Paris, August 2, 1867.

Sir—In my capacity as Commissioner in Chief of the State of Louisiana, I have the honor of submitting to your judgment my claim for reconsideration in favor of some of my exhibitors who have not been honored with a visit by the examination jury of the Exposition.

1st, the portable house built in New Orleans (of cypress wood)

2nd, the photographs presented to the Emperor Napoleon III by the City of New Orleans, made by Mr. Lilienthal.

3rd, the products of Mr. S. Moody, the most noted shirt-maker of the Southern States, employing 500 workers.

With the hope that all will be made right according to my request, Edward Gottheil [annotation apparently in the hand of Alphonse Davanne, juror and Secretary of Exposition Class 9 photographic entries: "saw the proofs of Mr. Lilienthal too late to be able to rank them, they were at the binders'. One could only have given a bronze medal at most if there had been time to do so."]

Paris, Archives Nationales, F12 3095, Class 9: Edward Gottheil, Louisiana Commissioner to the Paris Exposition, to Frédéric Le Play, Director of Exhibitions.

Paris, August 7, 1867

Mr. Le Play

Counselor of the State

[President of the Imperial Commission]

17 Rue St. Dominique St. Germain

Sir—The undersigned, Mr. Edward Gottheil, commissioner in chief of the State of Louisiana and delegate of the City of New Orleans; and Mr. Col. Lemat, commissioner of the same state:

Being charged with presenting to the Emperor Napoleon III an address and important documents offered by the City of New Orleans. With the honor of soliciting from your benevolence a few moments of regard ...

Edward Gottheil

Col. Lemat [Jean Alexander François LeMat]

Crescent, August 11, 1867.

A. HEAD AS A PARIS-ITE. PARIS, July 22, 1867 ... the cottage is now finished, and I send you a photo of it ... Frenchmen and other "foreigners" appear to be in doubt as to whether the "Louisiana Cottage" is the private residence of a planter, or his office on a plantation, or a common Louisiana city or country residence, or "negro quarters!" They can't seem to understand that it is constructed merely to show the Louisiana cypress and that its interior contains the native products of our good State that are the chief staples of wealth, comfort and happiness in the world!

Picayune, August 18, 1867.

INTERESTING LETTER FROM PARIS. The Exposition. The following is a portion of a very interesting letter from Paris, descriptive of some of the beauties and magnificence of the art displays in the exposition, written to a lady of this city, by Mr. Edward Gotthiel [Gottheil], who is a commissioner from Louisiana. This letter will repay perusal, and we commend it specially to our lady readers: Paris, August, 1867 ... After much difficulty and outlay of money to complete the cottage, it now stands here at Champ de Mars, the great pride of all Louisianians in Paris, and receives the admiration of all visitors. The frame building in itself is not receiving itself exclusively the general approbation; its handsome interior decoration got up in every way in an appropriate style, is coming in for a large share of praise; all the furniture is of oak, the sideboard is covered with crystal vases containing samples of all our sugars and syrup; upon the center table are large crystal cylinders, covering cotton, wool, tobacco, salt, etc., etc.; upon the bureau is spread an elegantly bound register, in which all Louisiana visitors are daily inscribing their names (this, in itself, is original at the Champ de Mars): from the center of the ceiling is suspended a piece of bark of a tree, out of which Louisiana evergreens, ivy and other plants are growing most luxuriably; the walls with original square paintings, representing views of Louisiana and the flowers of our state; then two beautiful flags donated by the gallant Mrs. Collins,

are displayed from the ceiling, which add nationality to the tout ensemble of which all is Louisiana. Then these decorations are not all that gives the great interest to the cottage. The products of Louisiana have been crowned with high acknowledgments from the "impartial Jury"; they have received two gold, four silver, three bronze medals and five honorable mentions The New Orleans photographs arrived a few days ago, and are much admired. Every Louisianian recognizes some familiar spot, and all give great credit to Mr. Lilienthal, the artist. The ladies, in particular, are delighted with them, and have proposed to write a complimentary letter to Mr. Lilienthal. The presentation of the photos to the emperor is postponed for the present, from necessity—the court being in mourning for the death of Maximilian, all such matters are deferred.

Crescent, September 13, 1867.

LETTER FROM PARIS. Paris, August 23, 1867. It was my fortune a day or two since to receive an invitation to pay a visit to the Louisiana Lodge, situated in the grounds of the exhibition. The lodge is made of Louisiana cypress, and was made in New Orleans, brought to this country and put together. There is not a nail in the entire building, and it can be raised and taken down in an hour's time.

L'exposition universelle de 1867 illustrée. Publication internationale autorisée par la Commission impériale. Sommaire de la 41e Livraison, Du 23 septembre 1867. V. La maison portative de la Louisiane, Paris (Administration) 1868 [translated from the French].

THE PORTABLE HOUSE OF LOUISIANA. The emigrant ... needed a shelter that would withstand the demands of the climate and that could be easily transported. These needs inspired the idea to build portable, wooden houses. A model of one of these dwellings can be visited in Le parc du Champ de Mars. The leaflet handed out inside the house shows us that, owing to its elegance, the house is superior to all others. Without fully adopting the builder's opinion, we admit that it looks quite lovely. Its light weight is a characteristic that cannot be challenged. Built entirely of cypress wood, a very light wood that grows abundantly in

Louisiana, the house weighs only two and a half tons. Its different parts can be assembled with screws. Therefore only a few hours are needed for the builder to set up his house once he has chosen the place where he wants to stay. Even if he wants to build a larger house, the cypress house can serve as his lodging during the time required to build another house.

Crescent, September 19, 1867.

A STROLL IN THE EXPOSITION—THE LOUISIANA COTTAGE [from the *Paris Moniteur Universel*]. Among the edifices which encircle the palace of the Champ de Mars, in such variety and number, is one distinguished from the rest by its originality and usefulness. We mean the portable cottage from Louisiana, belonging to the department of the United States. This little house is situated alongside the English lighthouse; it is constructed entirely of cypress, and has no paint, but simply a light coating of varnish, to keep the dust off. The appearance of this edifice (which is intended for the use of immigrants), is that of a cottage, greater in length than in breadth, of a convenient height, and containing only one room, which is reached from the outside by three steps. The walls within, just like the outside, are plain cypress, of a yellowish-red. A good sized window stands opposite the door, which has two shutters; there is also a window on either side. The roof is of cypress planks, and has the shape of a half-opened book. Four posts support a shed, which protect the doorway from sun and rain. The walls are adorned with several paintings, one of which represents the city of New Orleans. The articles exhibited in the cottage are of an exceedingly valuable quality … . This very handsome edifice reached its present locality all ready to be put up. It takes six hours to raise it and two to take it down. It contains neither nails nor pegs; all the timbers are screwed and jointed with grooves and tongues. Two flags, which cost 4000 francs, were spread over the center of the room. These were sent by the clubs of New Orleans. The one is blue, with a picture in the middle, and is the flag of Louisiana; the other red, white, and blue, the national colors of the Americans.

Times, December 3, 1867.

PARIS, August 20, 1867. To Mr. Theo. Lilienthal: We, the ladies of New Orleans, now sojourning in Paris, desire to offer these lines as a tribute of admiration and thanks —admiration for the masterly execution of the Photographic views of New Orleans, destined as a Royal present—and thanks for the sweet memories of home which fill the heart while gazing upon these scenes of our youth.

Report of Edward Gottheil, Chief Commissioner and General Agent from the State of Louisiana to the Paris Universal Exposition of 1867, Made to the Governor and General Assembly, Session of 1868, New Orleans (A.L. Lee) 1868 (excerpt).

The Emperor Napoleon III … proposed to gather from all sections of the civilized world specimens of the sciences and the arts, and the products of the soil, as now practiced and produced, for the well being of its inhabitants … . Louisiana … heard the invitation, and notwithstanding that she had so recently emerged from a protracted war with all her energies prostrated, thought this a fitting opportunity of showing to an intelligent world her unbounded resources, the productiveness of her soil and her commercial facilities. She hoped to show, too, that by an influx of immigrants and capital into her borders she could inaugurate a new system of labor, and thus retrieve lost fortunes and advantages, and finally make New Orleans the great metropolis which nature destined her to be … for the purpose of further advertising the city of New Orleans, and to convey an idea to those unacquainted with the internal appearance of the Southern Metropolis, the city authorities, upon the suggestion of our co-Commissioner, J.B. Price, were induced to send a large number of photographic views of our principal private and public buildings, together with street and levee scenes, the surroundings of the city and Lake Pontchartrain. Combined with this mode of benefiting our State, the city authorities contemplated to manifest to the author of so vast an enterprise their appreciation, and thought the Exposition a fitting occasion for renewing, and if it were possible, strengthening that sympathy which, for the most natural reasons, had always existed between the people of the French Empire

and the inhabitants of Louisiana. They therefore requested the Chief Commissioner to present these photographs, at the close of the Exposition to his Imperial Majesty, Napoleon III. The evidence of appreciation with which this gift was received by the Emperor is well attested by his Majesty's autograph letter to Mayor Heath of New Orleans, and the contribution to the Public Library of his literary works, the "Life of Caesar." … The State of Louisiana, complying with the suggestion made by the Committee of the American division, caused a movable house to be constructed for the double purpose of exhibiting the building materials with which our forests teem, and of illustrating to the immigrant with what facility comfortable, yet movable, quarters can be procured previous to his final and permanent location. … I had the satisfaction, through the kind assistance of Mr. Mulat, United States Engineer of the American Section, of seeing the Louisiana movable cottage erected on the Champ de Mars, on the 15th of June. The contributions from Louisiana scattered through four groups, in fourteen classes, within the American Section. … I thought proper to concentrate in this Louisiana cottage specimens of all our produce, so as to show at one glance what our soil is capable of producing. For this purpose I fitted up the building as a special exhibition room of the State of Louisiana. The favorable impression this little building made upon the millions of visitors who examined it, will be readily seen from the description given in the "Illustrated Exposition" of July, 1867, published by authority of the Imperial Commission, and the award given by the International Jury. … The absence of an address prepared by the Legislature, as recommended by Governor Wells, to be disseminated by the Commissioners, "tendering a general invitation and welcome of our State and people to the capitalist, the artisan, mechanic, and laborers of Europe, and enumerating the rare advantages possessed and benefits to be enjoyed by the adoption of our State as their future home," was greatly felt.

Crescent, January 21, 1868 (published in French in *Picayune*, January 21, 1868).

AN IMPERIAL LETTER. "Palace of the Tuileries" 30th of December, 1867. Monsieur the Mayor—I have received the photographic views of New Orleans which you have had the kindness to send me in the name of the City Council. It was with very strong interest that I passed in review the monuments and the various localities of a city which clings to France in so many remembrances and so many sympathies. You have partly retained our laws, our customs, and our language, and I entertain hopes that the links will be made stronger by commercial intercourse. I should be happy, if the Universal exposition, in which you have taken a distinguished part, has contributed to increase our business relations. Be pleased, sir, together with your honorable colleagues of council, who have sent me their likenesses, and whose acquaintances I am delighted to have made, to accept my sincere thanks, and the assurance of my best wishes. "NAPOLÉON".

Times, May 3, 1868 (fig. 124).

No photographer in the city has received more tokens of appreciation than Mr. Theo. Lilienthal. Wherever he entered into competition he has been victorious. The various fairs held in this city have acknowledged his superiority by the award of medals and prizes, and we read in the report of Hon. N.M. Beckwith of the Paris exhibition, that he has achieved still another triumph, one of the prize medals having been awarded him. Mr. Lilienthal merits all the patronage he has received, as well on account of his personal merits as his artistic ability.

Times, May 16, 1868.

It is with feelings of profound gratitude and pride that the public will read the telegraphic announcement that the Imperial present to the city of New Orleans has reached the state department at Washington. New Orleans may now congratulate itself upon a novelty it has discovered—a new use for its Aldermen. They are no longer to be considered only serviceable in awarding disinterested contracts and legislating unselfishly in relation to city finances. That they are

Fig. 124 Advertisement for Lilienthal's 131 Poydras Street studio, 1868. *Times*, May 3, 1868.

useful in other ways as a source of revenue is now apparent. The very sight of their photographs by Napoleon III revealed to his envious soul such a constellation of legislative intellect and sublime patriotism that he hastened to honor it by presenting immediately to the August body a copy of his "History of the Caesars," bound, it is supposed, in ornamental calf. Of course the idea that the Emperor even intimated the faintest shadow of irony in the gift is not to be entertained for a moment …. Now, as we deem it important that some record of the prompting cause should be preserved in the city library along with the volumes themselves, we propose that they be rebound with copies of the same photographs, so that the ancient and modern Romans may go down to posterity side by side.

Picayune, Late May/June, 1868 [clipping from S.N. Moody family scrapbook in the possession of Alicia Heard, New Orleans].

To the Editors of the *Picayune*. Sirs— Enclosed you will find extracts from a letter to "Bella" from Mr. E. Gottheil, Louisiana Commissioner to Paris Exposition, dated Washington, May 11, 1868: The State flag of Louisiana floats in triumph in the Hall of Representatives at the Capitol; not brought there with drum and fife and glittering bayonets, but waved there by soft breezes of peace! A messenger of returning prosperity … The imperial gift, of which I am the bearer (The "History of Caesar" by Napoleon III) is at the "White House." The President having signified a desire for its perusal, I could not do otherwise than to send them there. When the President returns them, Mr. Haswell will place them in the glass case in which the medals are exhibited for the inspection of Senators, members of Congress and the public at large.

New Orleans Public Library, City Archives, Office of the Mayor Records, AA510, Messages of the Mayor to the General Council.

MAYORALTY OF NEW ORLEANS, City Hall, 7th day of July 1868.

To the Honorable, The Common Council. Gentlemen, I have the honor to inform you that the Emperor of the French, Napoleon III, has, through Mr. Gotthiel [Gottheil], Commissioner to the Paris Exposition, presented to the City of New Orleans, his History of Julius Caesar. This celebrated work, in two volumes, imperial edition, was formally placed in my hands, as the representative of the City, at the public distribution of Exposition Medals at the Varieties Theatre, the 15th Ultimo. It is a token of the good will which the Emperor bears to our City founded by Bienville, and so long nourished and protected by the French Kings and his illustrious Uncle, Napoleon I. The boldness, clearness, and beauty of the typography of this imperial edition make it a model of the "art preservative of art." All the maps illustrating the campaigns of the great Roman are both accurate and finely limned; while the portrait of Caesar, a precise copy of the celebrated statue which has transmitted his features to posterity, is remarkable alike for its fidelity & exquisite finish. I understand that but few copies of the imperial edition have been printed for distribution, and hence this gift to the City of New Orleans has a pleasing and unusual significance. It deserves some appropriate Official notice at the hands of the Common Council, so that the gift may be placed among the Archives of the City and the present government shall bear testimony of the good will entertained by our people for one, who has not only trod the Soil of New Orleans in the days of his adversity, but sends her this token of his remembrance in the proudest days of his prosperity. Very Respectfully, John R. Conway, Mayor.

Bibliographic Essay

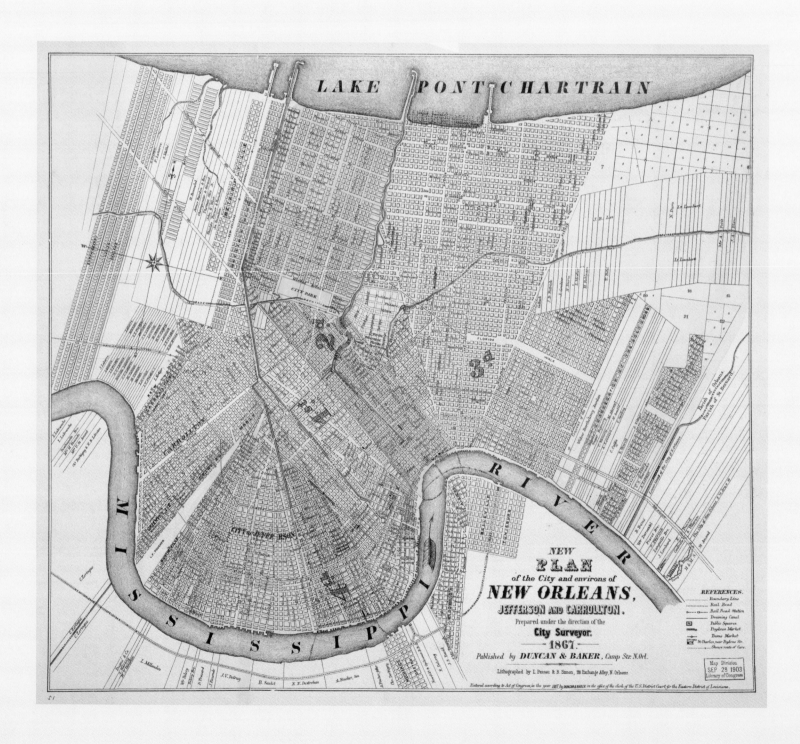

Mapping New Orleans in the 1860s

Two maps from the period of Lilienthal's photographs are illustrated here. *Approaches to New Orleans*, or "Banks's Map" (fig. 126), was prepared for General Nathaniel Banks by surveyor Henry L. Abbot in 1863 during the federal occupation of New Orleans (published in United States War Department, *Atlas to Accompany the Official Records of the Union and Confederate Armies ...*, Washington, D.C., Government Printing Office, 1891–95). This map derived, as the legend indicates, from Charles F. Zimpel's *Topographical Map of New Orleans and Its Vicinity* of 1834, which was unsurpassed in breadth and scale of all the early maps of the city (Zimpel's map measured about 5 square feet/0.5 sq. m). Designed for military strategic purposes, "Banks's Map" emphasized the relationship of the built city to the backswamp (a defensive advantage and logistical impediment) and existing networks of waterways, turnpike roads, and railways. Cypress and swamp oak in the backswamp cleared recently are identified ("timber mostly felled") as areas for development and future expansion of the city. The West Bank is almost entirely prairie and swamp, with plantation properties and town settlements hugging the river and natural levees. The New Basin and the Old Basin/Bayou St. John waterways can be seen connecting Lake Pontchartrain with the commercial districts in the Anglo-American quarter above Tivoli (Lee) Circle and the Vieux Carré.

Pessou and Simon's *New Plan of the City and Environs of New Orleans, Jefferson and Carrollton* (fig. 125; lithographed in 1867 by Louis Lucien Pessou and Beneditz Simon) shows the undeveloped backswamp seen in "Banks's Map" as a grid of subdivided streets in the Second and Third districts. In reality, these districts were surveyed but mostly not opened in what was still largely undrained wetlands (locations of steam-powered draining machines are indicated). This fiction reflected the urgent need, after the war, to develop housing tracts to accommodate a large migration from rural regions into the city. "The city contains about one hundred and twenty squares between Poland and Toledano streets (from downriver to upriver), and nearly seventy between the river and lake," the *Crescent* wrote in 1867, "of the latter number, one-half—where the city is the widest—are adorned with houses,

while the balance are at present occupied by alligators and pirogue wood choppers, as tenants for the city which is to come after" ("The Streets of the City," *Crescent*, January 15, 1867).

The municipal districts are clearly delineated in the Pessou and Simon map: the First District, or Anglo-American quarter, above Canal Street, encompassing the riverfront warehousing district and the New Basin Canal; the Second District, including the Vieux Carré and Tremé quarters back to the Bayou St. John and Metairie Ridge; and the Third District, encompassing the old downriver faubourgs from Esplanade Street bordering the Vieux Carré to the St. Bernard Parish line, and traversed by the Bayou Sauvage and Gentilly Road. The Third District in 1867 included several plantation properties not yet subdivided as well as the Ursulines convent, sugar refinery, and U.S. Hospital and Barracks, all photographed by Lilienthal (cats. 112–17). Also delineated by Pessou and Simon is the Fourth, or Garden, District uptown, a wealthy quarter of substantial houses on large lots and generous greenery. Farther upriver are the faubourg of Jefferson City, annexed to New Orleans in 1870, and the smaller faubourgs of Rickerville, Hurstville, Bloomingdale, Burtheville, Friburg, Marly, and Greenville, formed in the 1830s. Farthest upriver is the suburb of Carrollton (cat. 104), annexed in 1874. Not subdivided upriver is land identified as the property of L.F. Foucher—plantation land leased to the U.S. Military (cat. 102) and developed thirty years later as Audubon Park and the campus of Tulane University. The upper part of the Second District above Metairie Road was later developed as Lakeview and a much-enlarged City Park (cats. 40 and 41). On the West Bank of the Mississippi are the dry docks and the village of Belleville that appear in Lilienthal's maritime and industrial views (cats. 105, 106, and 108).

For prewar maps, especially of the colonial period, the survey by Samuel Wilson, Jr., of the early cartographic history of New Orleans is the starting point (*The Vieux Carre New Orleans, Its Plan, Its Growth, Its Architecture. Historic District Demonstration Study*, New Orleans, City of New Orleans, 1968). *Charting Louisiana: Five Hundred Years of Maps*, published by The Historic New Orleans Collection in 2003, illustrates New Orleans city plans, as does John A. Mahé, II, in "Walking the Streets of New Orleans: Printed Maps and Street Scenes of New Orleans," in *Printmaking in New Orleans*, ed. Jessie Poesch, New Orleans (The Historic New Orleans Collection) 2006.

Atlases and Surveys

An important source for the identification of structures and for charting urban change is insurance cartography, the finest examples of which are the D.A. Sanborn & Co. atlases, first published for New Orleans in 1876. Sanborn, a Somerville, Massachusetts surveyor, began in 1867 to publish detailed maps of municipalities as an underwriting tool for the insurance industry. The early Sanborn editions were hand-colored lithographs (using waxpaper stencils and colored wash) issued on 21 × 25-inch (53 × 64-cm) sheets at a scale of 1 inch to 50 feet (2.5 cm to 15 m; later editions were reduced in scale). The large scale allowed building footprints and structural details to be presented comprehensibly, and the maps recorded building materials (keyed to a color chart), occupancy, and use. Issued by subscription, the maps were kept current by updates issued to subscribers as paste-down revisions or corrected pages. Sanborn atlases played a transformative role in citybuilding, as historian David Scobey noted: "They not only recorded the built environment but also reconstituted it into a notational field that was at once atomized, standardized, and potentially limitless ... [and] established the cognitive regime in which urban space could be treated as a commodity" (David M. Scobey, *Empire City: The Making and Meaning of the New York City Landscape*, Philadelphia, Temple University Press, 2002, p. 110).

The two-volume 1876 Sanborn Atlas for New Orleans mapped only the Vieux Carré and the business quarters of the city, omitting large areas uptown and downtown (this first edition is rare and is not found in recent Sanborn microfilm and online editions; a set is in the Southeastern Architectural Archive, Tulane University). Later nineteenth-century editions appeared in 1885 and 1895–96, the third edition covering nearly the entire city in four volumes. Sanborn published numerous editions in the twentieth century, although the latest issue, in 1994, is not color-keyed.

On the Sanborn atlases, their methods of production and use for urban and architectural history, several sources are valuable: Robert A. Sauder, "The Use of Sanborn Maps in Reconstructing 'Geographies of the Past,' Boston's Waterfront from 1867 to 1972," *Journal of Geography*, LXXIX, 1980, pp. 204–13; Walter W. Ristow's introduction to *Fire Insurance Maps in the Library of Congress. Plans of North American Cities and Towns Produced by the*

Sanborn Map Company, Washington, D.C. (Library of Congress) 1981; and Helena Wright, "Insurance Mapping and Industrial Archeology," *IA: The Journal of the Society for Industrial Archeology*, IX, 1983, pp. 1–18.

Nineteenth-century real-estate atlases are also useful for identifying structures and property owners. Surveyor and architect John F. Braun's *Plan Book of the Fourth District*, 1874, for the Garden District, and *Plan Book of the Third District*, 1877, for the city below the Vieux Carré, survey districts not covered by Sanborn until later in the century. The 1883 "Robinson Atlas" (*Atlas of the City of New Orleans*, New York, Elisha Robinson, 1883, online at notarialarchives.org/robinson/index.htm) was based in part on the earlier Braun survey of 1877. These atlases were printed at a scale of 1 inch to 200 feet (2.5 cm to 61 m) and many editions were hand-colored.

Newspapers

Newspaper digests of construction activity were published periodically under various titles: "Building Improvements" or "City Improvements" (*Crescent*); "Architecture in New Orleans" (*True Delta*); "New Orleans—As It Is To Be" (*Delta*); and "New Buildings in Our City" (*Republican*). From the 1870s through the 1890s, columns on building projects became increasingly comprehensive and a regular feature in several papers: "Hammer and Trowel," "Building in New Orleans," and "New Orleans Homes" (*Picayune*); "Brick(s) and Mortar" (*Picayune* and *Times-Democrat*); and "Going Ahead" (*Times-Democrat*). Some city directories also summarized building projects for the previous year; for example, *Gardner's New Orleans Directory* during the late 1860s.

During 1866 and early 1867, the *Crescent* published a series of topographies of the city entitled "Environs of New Orleans"—lengthy narratives of the settlement history and descriptions of prominent structures in the Bayou St. John, Carrollton, West Bank, and other suburban areas. A series of articles published daily by the *Times* between December 28, 1865, and January 10, 1866, under the byline "A Looker On" and entitled "A Glance at New Orleans Manufactures and Arts," provides useful descriptions of industrial buildings and commercial histories.

Although newspapers are not infrequently the only contemporary source for building histories, and provide important topographical narratives,

use of the highly partisan press for political and social commentary requires care. More than a dozen newspapers, each identified with a community constituency, served the city's population of nearly 200,000. During the early federal occupation of New Orleans, there was little diversity of published opinion on political matters. Union overseers suspended local newspapers for editorial breaches, jailed editors for criticism of federal policies, and replaced staff with northern editors and printers. General Benjamin Butler suspended six newspapers in 1862, including the *Commercial Bulletin*, *Bee*, *Picayune*, and *Price-Current*. The *Crescent*, which began publication in March 1848 as a "fearless, independent sheet" (*Brooklyn Daily Eagle*, March 14, 1848)—it had been owned by the filibusterer William Walker, and employed the young Walt Whitman as "exchange editor"—was strongly secessionist and was also shut down by Butler in 1862, but resumed publication in 1865. The bilingual French–English *Bee* was said by the *New York Sun* to "sting rather remorselessly" in time of war, when "it said its bitter things on the French side, and assumed a smiling countenance in the English columns" (*Bee*, October 31, 1866). The *True Delta* had opposed secession, but was nevertheless seized by Union forces briefly in May 1862 for refusing to publish occupation proclamations. The *True Delta* was purchased in early 1864 by Michael Hahn, a German-born attorney and abolitionist, who had been elected to the U.S. Congress during federal occupation in 1863 and then became Governor of Louisiana (when he sat for a portrait by Lilienthal for *Harper's Weekly*). In 1866, after adopting a Unionist position, the paper ceased publication. Northern editors in support of General Banks took charge of the pro-Union *Delta* in February 1863, renamed it the *Era*, achieved the largest circulation in the city, then closed the paper down altogether in 1865. The *Picayune*, the city's oldest daily, had supported the Confederacy and was anti-Republican after the war. The *Times* began publication as a radical Unionist paper during the occupation, backing General Benjamin Butler, and remained unsympathetic to the old planter aristocracy, but also became anti-Republican. The largest circulation dailies in 1867—the *Times*, *Bee*, *Crescent*, and *Picayune*—were conservative and often white-supremacist in outlook, fueling racial division during Reconstruction.

African Americans began to have a voice in the press during Reconstruction. The *Tribune*, a bilingual French–English newspaper published

between 1864 and 1870, was the first black daily in the country. The *Tribune* was edited by a white Belgian immigrant, Jean-Charles Houzeau, who had been associated with the pioneering African American paper in the city, and the first black newspaper in the South, the French-language *L'Union*, published twice weekly between 1862 and 1864 (also in English between 1863 and 1864). Following the Mechanics' Institute riot in July 1866 (cat. 68), the *Tribune*, described by a New York paper as "the only loyal daily newspaper in the city," was forced to close after its editors and printers were threatened (*Bee*, August 30, 1866). The *Republican*, published from 1867 as the "official journal" of the Reconstruction government of Louisiana, gave voice to the condition of freedmen.

New Orleans was a multilingual as well as multiracial city with large-circulation French- and German-language newspapers. For Lilienthal's practice, the German-language daily *Deutsche Zeitung*, published from May 1854 to 1899, is an important source (the newspaper survives today only in faint and incomplete microfilm copies). Another German daily, the *Morning Post*, began publication, by D.H. Lehmann & Co., in 1867, but no copies are known to exist. There were a number of antebellum French-language dailies and weeklies, including the bilingual *Louisiana Courier/Le Courrier de la Louisiane* (1807–59), continued by the *Courier/Le Courrier* (1859–60), which did not resume publication after the war. The French edition of the *Bee* was published with different content under the banner *L'Abeille de la Nouvelle-Orléans*.

On the New Orleans press during the Civil War era, see:

"Journalism in New Orleans," *Delta*, August 12, 1862

Richard H. Abbott, "Civil War Origins of the Southern Republican Press," *Civil War History*, XLIII, 1997, pp. 38–58

Gerald Capers, *Occupied City: New Orleans under the Federals, 1862–1865*, Lexington (University of Kentucky Press) 1965, pp. 176–90

William P. Connor, "Reconstruction Rebels: The New Orleans Tribune in Post-War Louisiana," *Louisiana History*, XXI, Spring 1980, pp. 159–81, reprinted in *Reconstructing Louisiana*, ed. Lawrence N. Powell, Louisiana Purchase Bicentennial Series in Louisiana History, VI, Lafayette (Center for Louisiana Studies) 2001, pp. 445ff

Fayette Copeland, "The New Orleans Press and Reconstruction," *Louisiana Historical Quarterly*, XXX, January 1947, pp. 149–337

Eric Foner, *Reconstruction: America's Unfinished Revolution, 1863–1877*, New York (Harper & Row) 1988, pp. 62–64

Jean-Charles Houzeau, *My Passage at the New Orleans Tribune: A Memoir of the Civil War Era*, ed. David C. Rankin, Baton Rouge (Louisiana State University Press) 1984

J.M. Laveque, "The Press," in *Standard History of New Orleans*, ed. Henry Rightor, Chicago (Lewis Publishing Co.) 1900, pp. 267–85

A census of nineteenth-century newspapers can be found in *The Louisiana Newspaper Project Printout*, Baton Rouge (Louisiana Newspaper Project, Louisiana State University Libraries) 2001. On the antebellum press (and many other aspects of life in the "Calcutta of America"), see the observations of Abraham Oakey Hall, New York attorney and journalist (and later mayor) who practiced law in New Orleans in the 1840s: *The Manhattaner in New Orleans, or, Phases of "Crescent City" Life*, New York (J.S. Redfield); New Orleans (J.C. Morgan) 1851, especially pp. 162–72. For another view of the antebellum press, see J.S. Buckingham, *The Slave States of America*, London (Fisher, Son & Co.) 1842, I, pp. 370–75.

Guidebooks

Guidebooks instruct the visitor and direct their gaze; with an emphasis on visual qualities, such books are an important source of evidence of the appearance of the lost nineteenth-century cityscape. The earliest guidebook cited here is Paxton's *New-Orleans Directory & Register*, New Orleans (J.A. Paxton) 1822, a standard topography of the city. But it is *Gibson's Guide* (1838) that is the most authoritative account of architecture for the first half of the century and the progenitor of later guidebooks, through *Jewell's Crescent City Illustrated* of 1873. Gibson's collaborator was the West Point-trained engineer and architect Lieutenant Frederick Wilkinson, and the guide records his experience with building projects in New Orleans, including the U.S. Barracks (cats. 116 and 117) and Cypress Grove Cemetery (cat. 38). Writing about the first St. Louis Hotel (cat. 14), Wilkinson observed compromises in the design (not his) to accommodate diverse functions and the will of the client: "The architecture of the building is neither so regular, nor so uniform as would under

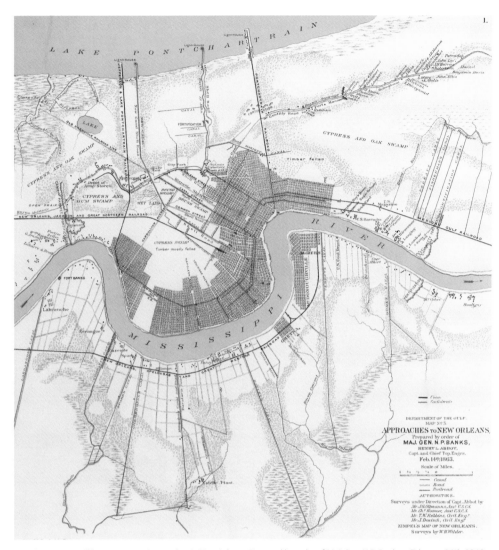

Fig. 126 Henry L. Abbot, surveyor, *Approaches to New Orleans, Prepared by order of Maj. Gen. N.P. Banks ... February 14th, 1863* ("Banks's Map"). Reprinted in United States War Department, *Atlas to Accompany the Official Records of the Union and Confederate Armies ...*, Washington, D.C. (Government Printing Office) 1891–95. Courtesy of Widener Library, Harvard University.

other circumstances have been the case. The architect is always, of course, bound to conform to the wishes of his employers" (p. 329). *Gibson's* was revised and republished as the *Historical Epitome of the State of Louisiana* in 1840, and again in Pitts's and Clarke's *New-Orleans Directory for 1842*. It was also the basis for the best-selling nineteenth-century guidebook to the city, *Norman's New Orleans and Environs* of 1845 (a facsimile is still in print today). *Norman's* copies the *Gibson's* building histories, often with additional observations or updates, and also marks the beginning of antiquarian interest in the Vieux Carré: "Innovation has now done her work, has absolutely trodden the city of the last century under her feet" (pp. 188–89). It was not until J.B. Bradford's *Stranger's Guide to the City of New Orleans*, Gretna, La. (Pelican)

1874, that the first true antiquarian text was published, a eulogy on the ruins of J.N.B. DePouilly's masterwork, the Citizen's Bank on Toulouse Street, by historian John Dimitry.

Apart from brief *City Directory* topographies, the first new guidebook after *Gibson's*, and the best architectural guide for the immediate postwar period, is the A.B. Griswold *Guidebook to New Orleans* of 1873, issued as a promotion by a local jeweler. Also published in 1873, *Jewell's Crescent City Illustrated* was a business directory and booster book, not a guidebook, but it does contain building histories, which are often reprints of entries from *Gibson's* and *Norman's*. All the early guidebooks, except Griswold's, were illustrated with lithographs or wood engravings of buildings, but as a view book for the period *Jewell's* is unsurpassed, with full-page wood

engravings by John William Orr of New York, one of the most prolific book illustrators of the period, after photographs by Lilienthal (see pp. 15–16). *Jewell's* was reprinted at least twice, unpaginated and with varying collations, and issued in a new expanded and paginated edition in late 1873 (page numbers are not given for *Jewell's* citations in the catalog). The *Jewell's* format of business profiles illustrated with wood engravings, portraits, and biographies of commercial and professional men (and one woman) adopted a format that became prevalent during the next two decades for booster books across the country.

In the later 1870s, the booster books of J.C. Waldo (*Visitor's Hand Book*, 1876; *Illustrated Visitor's Guide*, 1879; *Waldo's Gazetteer*, 1879) provide commercial and institutional histories, logographs of buildings, and biographies, including the first published biography of Lilienthal. The guidebooks of James S. Zacharie, president of the New Orleans Chamber of Commerce, and the guidebooks published by the *Picayune* offer the best accounts of architecture after *Jewell's*. Zacharie's *New Orleans Guide* (New Orleans, New Orleans News Co.) of 1885 was published for the World's Industrial and Cotton Exposition of 1884–85; later editions were published by F.F. Hansell in 1893, 1902, and 1903. Its derivatives, the *Picayune's Guide to New Orleans*, were published by Nicholson & Co. and by the *Picayune* in 1892, 1895, and 1897, and in later editions through 1913. The expanded 11th edition of 1913 is the best city guide issued before the *New Orleans City Guide* of 1938, the most authoritative modern guidebook to New Orleans, in the American Guide Series of the Federal Writers' Project (Boston, Houghton Mifflin).

City Directories

Business directories, including the Paxton's *New-Orleans Directory* of 1822 already cited, often incorporated guidebook sections, sometimes illustrated, and advertising inserts featured logographs of commercial buildings. Prominent city directory publishing houses in the 1860s (all directories were suspended during the war) were: Duncan & Co.; Charles Gardner; L. Graham; Palmer, Buchanan & Smith, publishers of the *Louisiana State Gazetteer*; and Denson & Nelson of St. Louis, publishers of the *New Orleans and Mississippi Valley Business Directory and River Guide*. Francis Bonvain's *Almanach de la Louisiane*

(1865–67) is a directory of businesses with a clientele in the French-speaking community. In the early 1870s, Richard Edwards, L. Soards & Company, Graham & Madden, and J.B. Bradford, publisher of the *Stranger's Guide to the City of New Orleans*, all issued city directories.

View Books and Booster Books

The record of New Orleans as it appeared in illustrated business directories, booster books, and view books is often the only surviving direct visual evidence of lost buildings. Booster books carried advertisements and promoted profiled businesses and, similar to Lilienthal's portfolio of views, presented the city as a marketplace worthy of investment and as a place of fine institutions and civic amenities. Toward the end of the century, as this promotional genre evolved, booster books appeared in many cities and were the entrepreneurial literature of citybuilding in the New South after the war.

Publisher John E. Land issued about a dozen booster-book titles for American cities in the 1880s, including Chicago, Charleston, St. Louis, Milwaukee, and New Orleans. Land's *Pen Illustrations* of 1882 is a compilation of descriptions of local subscriber-businesses (including Lilienthal and his brother Edward, a jeweler), illustrated by photoengravings.

Although development of the halftone process in the 1880s made it possible to print photographs with text on standard printing presses, most of the illustrated view books of the 1880s still featured woodcuts or wood engravings. Andrew Morrison was the compiler of two booster books of the 1880s, *The Industries of New Orleans*, New Orleans (J.M. Elstner) 1885, illustrated in the old manner of wood-engraved logographs, and *New Orleans and the New South*, New Orleans (L. Graham, published with George W. Engelhardt) 1888, a transitional work illustrated with old-style engravings as well as photoengravings, and photographs.

New Orleans of To-Day, published about 1885, featured numerous photographs of the buildings of architect Thomas Sully, who presumably subsidized the book as a promotional work (compiled by A.J. Hollander, published by L. Graham). *New Orleans Through a Camera* also featured photographs of Sully's work (Sully's photograph collection is in the Southeastern Architectural Archive, Tulane University). A fine compilation of cyanotypes of

commercial building fronts, with accompanying advertising pages, by photographer E.T. Adams was published as *Photographic Album of the City of New Orleans, Comprising the Principal Business Houses and Views of the City*, New Orleans (Hofeline & Adams) 1887. Copies are in The Historic New Orleans Collection and Special Collections of Tulane University Library.

The master of the booster-book genre for New Orleans after Edwin Jewell was subscription publisher George W. Engelhardt. His *City of New Orleans: The Book of the Chamber of Commerce and Industry of Louisiana*, New Orleans (L. Graham) 1894, is the best of all the photo-illustrated booster books, including building views by W.H. Burgess and portraits of New Orleans's business elite by William Washburn, with biographies and views of their residences. Engelhardt's *New Orleans, Louisiana, the Crescent City: The Book of the Picayune*, New Orleans (George W. Engelhardt) 1903–1904, includes both photographs and engravings of commercial buildings. Frank H. Tompkins, *Riparian Lands of the Mississippi River: Past-Present-Prospective*, Chicago (A.L. Swift & Co.) 1901, is a compilation of photographs by Wolff and Hathaway. Two booster books with building views were published after the turn of the century by commercial organizations, the Young Men's Business League (*The Resources and Attractions of Progressive New Orleans, the Great Metropolis of the South*, with photographs and copper etchings, some reprinted from *New Orleans and the New South*) and the Travelers Protective Association (*Trade and Travel, Descriptive of the Commercial Ability, Financial and Trade Resources, Year 1896*). Another early twentieth-century example of the genre is the New Orleans Association of Commerce, *New Orleans Merchants & Manufacturers Boosters Fourth Annual Trade Trip*, published in 1913.

Photographically illustrated view books published from the 1890s are useful sources for building and street views. Among the best of the type is *Art Work of New Orleans* (1895) by Chicago publisher W.H. Parish, who issued view books for Baltimore, St. Louis, New Haven, and many other localities in the 1890s. F.F. Hansell was a local publisher of view books at the turn of the century, including *New Orleans Illustrated in Photo Etching* (1892) and *Hansell's Photographic Glimpses of New Orleans* (1908)—with photographs by John N. Teunisson and others—an update of *Hansell's*

Guide to New Orleans, Historical-Descriptive (1903). Souvenir view books issued for expositions and fairs include the various Chellet view books of albertypes published by the Albertype Company, Brooklyn, in the 1890s. Finally, photographs of local religious houses by E.J. Bellocq, who is today the best known of all New Orleans photographers (for his Storyville portraits), illustrate the *Orphans' Flower Carnival Souvenir Program*, New Orleans (H.C. Welch) 1900. Other examples of Bellocq's view work can be found in *Book of the Bankers of Louisiana*, Baton Rouge (Louisiana Bankers Association) 1903.

Travel Literature

Antebellum travelers were attracted to the vibrant and prosperous port city and left accounts of local culture, social life, and architecture (often biased, however, with a preference for the exceptional over the commonplace). The following prewar accounts, among others, are cited in the text:

Henry Ashworth, *A Tour in the United States, Cuba, and Canada*, London (A.W. Bennett) 1861

Francis Baily, *Journal of a Tour in Unsettled Parts of North America in 1796 & 1797*, ed. Jack D.L. Holmes, Carbondale (Southern Illinois University) 1969

Barbara Leigh Smith Bodichon, *An American Diary, 1857–8*, ed. Joseph W. Reed, Jr., London (Routledge & Kegan Paul) 1972

J.S. Buckingham, *The Slave States of America*, London (Fisher, Son & Co.) 1842, 2 vols.

Friedrich Gerstäcker, *Gerstäcker's Louisiana: Fiction and Travel Sketches from Antebellum Times Through Reconstruction*, trans. and ed. Irene S. Di Maio, Baton Rouge (Louisiana State University Press) 2006 (in New Orleans 1847–48 and 1867)

Charles A. Goodrich, *The Family Tourist: A Visit to the Principal Cities of the West Continent*, Hartford, Conn. (Case, Tiffany & Co.) 1848

Abraham Oakey Hall, *The Manhattaner in New Orleans, or, Phases of "Crescent City" Life*, New York (J.S. Redfield); New Orleans (J.C. Morgan) 1851

Henri Herz, *My Travels in America*, Madison (State Historical Society of Wisconsin) 1963, translation of *Mes voyages en Amérique*, Paris (Achille Faure) 1866, a travel account of the 1840s

Matilda Charlotte Houstoun, *Hesperos; Or, Travels in the West*, London (J.W. Parker) 1850

Joseph Holt Ingraham, *The South-West, by a Yankee*, New York (Harper & Brothers) 1835, 2 vols.

——*The Sunny South; Or, The Southerner at Home*, Philadelphia (G.G. Evans) 1860

William Kingsford, *Impressions of the West and South During a Six Weeks' Holiday*, Toronto (A.H. Armour & Co.) 1858

James Logan, *Notes of a Journey through Canada, the United States of America, and the West Indies*, Edinburgh (Fraser & Co.) 1838

Charles Lyell, *A Second Visit to the United States of North America*, London (John Murray) 1849, 2 vols.

Charles Mackay, *Life and Liberty in America: or, Sketches of a Tour in the United States and Canada in 1857–8*, New York (Harper & Brothers) 1859

J. Milton Mackie, *From Cape Cod to Dixie and the Tropics*, New York (G.P. Putnam) 1864 (a record of travels before the war)

Henry A. Murray, *Lands of the Slave and the Free*, London (G. Routledge & Co.) 1857

Thomas Low Nichols, *Forty Years of American Life, 1821–1861*, London (J. Maxwell) 1864, 2 vols.

John W. Oldmixon, *Transatlantic Wanderings: Or, a Last Look at the United States*, London and New York (G. Routledge & Co.) 1855

Frederick Law Olmsted, *A Journey in the Seaboard Slave States, with Remarks on their Economy*, New York (Dix & Edwards) 1856

Tyrone Power, *Impressions of America: During the Years 1833, 1834, and 1835*, Philadelphia (Carey, Lea & Blanchard) 1836

Ferencz Aurelius Pulszky, *White, Red, Black: Sketches of Society in the United States*, New York (J.S. Redfield) 1853, 2 vols.

Salomon de Rothschild, *A Casual View of America: The Home Letters of Salomon de Rothschild, 1859–1861*, trans. and ed. Sigmund Diamond, Stanford, Calif. (Stanford University Press) 1962

Charles R. Schultz, ed., "New Orleans in December 1861," *Louisiana History,* IX, Winter 1968, pp. 53–61 (manuscript journal of a Maine seaman in the Mystic Seaport Library, Mystic, Conn.)

Lady Emmeline Stuart Wortley, *Travels in the United States, etc., during 1849 and 1850*, New York (Harper & Brothers) 1851

Edward Sullivan, *Rambles and Scrambles in North and South America*, London (R. Bentley) 1852

Louis Fitzgerald Tasistro, *Random Shots and Southern Breezes*, New York (Harper & Brothers) 1842, 3 vols.

Henry Benjamin Whipple, *Bishop Whipple's Southern Diary, 1843–1844*, ed. Lester B. Shippee, Minneapolis (University of Minnesota Press) 1937

Kalikst Wolski, *American Impressions*, Cheshire, Conn. (Cherry Hill Books) 1968 (in New Orleans 1855–60)

During the Civil War (and Reconstruction) era, foreign travelers, northern journalists, clergymen, federal soldiers, and others recorded their impressions of the occupied city. Cited in the text are the following:

Giulio Adamoli, "New Orleans in 1867," *Louisiana Historical Quarterly*, VI, 1923, pp. 271–79; translated from Luigi Adamoli, "Lettere a mio Padre dall'America (1866–1867)," *Nuova Antologia Revista de Lettere, Scienze ed Arti*, LVII, fasc. 1196, January 16, 1922, pp. 120–33, 221–34

Benjamin F. Butler, *Butler's Book: Autobiography and Personal Reminiscences*, Boston (A.M. Thayer) 1892

——, *Private and Official Correspondence of Gen. Benjamin F. Butler During the Period of the Civil War*, Norwood, Mass. (Plimpton Press) 1917, 5 vols.

W.C. Corsan, *Two Months in the Confederate States, Including a Visit to New Orleans ... by an English Merchant*, London (Richard Bentley) 1863 (new edition, ed. Benjamin H. Trask, Baton Rouge, Louisiana State University Press, 1996)

John William De Forest, *A Volunteer's Adventures: A Union Captain's Record of the Civil War*, ed. James H. Croushore, New Haven, Conn. (Yale University Press) 1946

——, *Miss Ravenel's Conversion, from Secession to Loyalty*, ed. Gordon S. Haight, New York (Rinehart & Co.) 1955 (A writer living in Charleston, De Forest fled to New Haven at the outbreak of the war and formed a Union company for the Louisiana campaign. His novel, based on his impressions of New Orleans during the federal occupation, was first published in 1867.)

Henry Deedes, *Sketches of the South and West; or, Ten Months' Residence in the United States*, Edinburgh and London (W. Blackwood & Sons) 1869

Thomas Cooper DeLeon, *Four Years in Rebel Capitals: An Inside View of Life in the Southern Confederacy, from Birth to Death*, Mobile, Ala. (Gossip Printing Co.) 1890 (military tour in 1861–65)

Sarah A. Dorsey, *Recollections of Henry Watkins Allen, Brigadier-General Confederate States Army, Ex-Governor of Louisiana*, New York (M. Doolady) and New Orleans (J.A. Gresham) 1867

Frances Fearn, ed., *Diary of a Refugee*, New York (Moffat, Yard & Company) 1910 (Journal of a planter's wife during federal occupation.)

Céline Frémaux Garcia, *Céline: Remembering Louisiana, 1850–1871*, Athens (University of Georgia Press) 1987

John Chandler Gregg, *Life in the Army, in the Departments of Virginia, and the Gulf, Including Observations in New Orleans*, Philadelphia (Perkinpine & Higgins) 1866

George H. Hepworth, *The Whip, Hoe, and Sword: Or, the Gulf-Department in '63*, Boston (Walker, Wise, & Co.) 1864

Thomas W. Knox, *Camp-Fire and Cotton-Field: Southern Adventures in Time of War*, New York (Blelock & Co.) 1865

Henry Latham, *Black and White: A Journal of a Three Months' Tour in the United States*, London (Macmillan) 1867.

J. Mead, "Memory Types of New Orleans," in *Leaves of Thought*, Cincinnati (Robert Clarke) 1868

Charles O. Musser, *Soldier Boy: The Civil War Letters of Charles O. Musser, 29th Iowa*, ed. Barry Popchock, Iowa City (University of Iowa Press) 1995

Whitelaw Reid, *After the War: A Tour of the Southern States, 1865–1866*, ed. C. Vann Woodward, New York (Harper & Row) 1965

Albert D. Richardson, *The Secret Service, the Field, the Dungeon, and the Escape*, Hartford, Conn. (American Publishing Co.) 1865

Eliza McHatton-Ripley, *From Flag to Flag: A Woman's Adventures and Experiences in the South During the War*, New York (D. Appleton and Co.) 1889

William Howard Russell, *My Diary North and South*, Boston (T.O.H.P. Burnham) 1863 (Abridged edition, ed. Fletcher Pratt, New York, Harper & Brothers, 1954; Russell was correspondent for the London *Times*.)

——, *William Howard Russell's Civil War: Private Diary and Letters, 1861–1862*, ed. Martin Crawford, Athens (University of Georgia Press) 1992

Philip H. Sheridan, *Personal Memoirs*, New York (Charles L. Webster & Co.) 1888, 2 vols.

Robert Somers, *The Southern States Since the War*, New York (Macmillan) 1871

Marion Southwood, *Beauty and Booty: The Watchword of New Orleans*, New York (M. Doolady) 1867

John Townsend Trowbridge, *The South, a Tour of Its Battle-fields and Ruined Cities, A Journey through the Desolated States*, Hartford, Conn. (L. Stebbins) 1866

——, *A Picture of the Desolated States; and the Work of Restoration, 1865–1868*, Hartford, Conn. (L. Stebbins) 1868

Lawrence Van Alstyne, *Diary of an Enlisted Man*, New Haven, Conn. (Tuttle, Morehouse & Taylor) 1910 (diary of a twenty-four-year-old Hudson Valley soldier in 1862–64)

For a bibliography of Civil War-era travel accounts, see E. Merton Coulter, *Travels in the Confederate States*, Baton Rouge (Louisiana State University Press) 1948 [reprinted 1994].

A record of family life in New Orleans during the war is Clara Solomon, *The Civil War Diary of Clara Solomon: Growing Up in New Orleans 1861–1862*, ed. Elliott Ashkenazi, Baton Rouge (Louisiana State University Press) 1995. Solomon was Lilienthal's sister-in-law.

Architecture

Two first-hand accounts of building projects and practice by nineteenth-century New Orleans architects James Gallier (1798–1866) and Thomas K. Wharton (1814–1862) are cited in the catalog. James Gallier's *Autobiography,* published in Paris in 1864, two years before his death, describes his training with William Wilkins, the London classicist; early work in London, New York, and Mobile; and several major projects in antebellum New Orleans, including the City Hall (cat. 51) and the St. Charles Hotel (cat. 64). Many pages are devoted to his overseas travels, and, overall, the *Autobiography* is a disappointing record of practice for an architect at the head of his profession. With his eyesight failing, Gallier retired in 1850 and his son, James, Jr., continued the practice with partners John

Turpin (1849–58) and Richard Esterbrook (1849–68). The elder Gallier died in a steamship accident in 1866; James, Jr., outlived him by only two years (on Gallier's *Autobiography*, see L. Koenigsberg, "Life Writing: First American Biographers of Architects and Their Works," in *Studies in the History of Art*, xxxv, 1990, pp. 41–58).

The journal of English-born New Orleans architect Thomas K. Wharton is the most detailed source for building projects in the city during the period 1853 to 1862. Wharton held federal positions at the Custom House (cat. 19) and the Marine Hospital (cat. 48), and maintained his own practice, consulting on buildings designed by other architects and frequently critiquing their work in his journal. The manuscript, in seven volumes, is now in the New York Public Library; four volumes and a sketchbook contain his pen-and-ink drawings. An abridged, annotated transcription has been published as *Queen of the South: New Orleans 1853–1862: The Journal of Thomas K. Wharton*, New Orleans (The Historic New Orleans Collection) and New York (New York Public Library) 1999. The transcription omits some New Orleans entries and all entries prior to his arrival in New Orleans. Citations here are to the New York Public Library manuscript by date of entry.

The most comprehensive reference for local architectural history is the *New Orleans Architecture* series, published from 1971 under the sponsorship of Friends of the Cabildo. The volumes are inventories of standing historic structures by district with brief building histories and introductory essays on urban development, architectural styles, building types, and other topics. The initial volumes were published to focus public attention on the preservation of historic structures in neighborhoods targeted for development or urban renewal, or threatened by neglect, beginning with the most endangered, the Lower Garden District (the district's nineteenth-century industrial architecture is still threatened today by convention-center expansion and commercial development of the riverfront). The seven volumes to date in this series, now edited by Robert Cangelosi, Jr., are fundamental to building research.

The best introduction to architecture and urbanism in New Orleans are the essays by architectural historian Bernard Lemann for the *New Orleans Architecture* series—"Lower Garden District Types and Styles" (vol. I); "City

Timescape: The Shifting Scene" (vol. II); "The Uptown Experience" (vol. VII)—and Lemann's preamble to a preservation history, *The Vieux Carré: A General Statement*, New Orleans (Tulane School of Architecture) 1966. Before Lemann, Nathaniel Cortland Curtis, a practicing architect and teacher, laid the foundation of modern architectural history in New Orleans in a series of articles for *Architectural Record* and *AIA Journal* from 1918 through the 1920s (later excerpted in *New Orleans: Its Old Houses, Shops and Public Buildings,* Philadelphia, J.B. Lippincott, 1933). Trained at Columbia University, Curtis taught at the Tulane School of Architecture for more than twenty years (he was head of the School from 1912 to 1917). His work was an early and always reasoned call for preservation.

Columbia University historian, architect, and Avery Librarian, Talbot Hamlin, in his influential *Greek Revival Architecture in America*, New York (Oxford University Press) 1944, devoted many pages to buildings in New Orleans and brought local history into the art-historical mainstream. Hamlin drew from the Historic American Buildings Survey research and photography by New Orleans architect Richard Koch. Groundbreaking work was undertaken on the French and Spanish colonial periods by the preservation architect Samuel Wilson, Jr., in essays, newspaper articles, and pamphlet building histories published between the 1940s and the 1980s, many of which were reprinted in *The Architecture of Colonial Louisiana: Collected Essays of Samuel Wilson, Jr., F.A.I.A.*, Lafayette (Center for Louisiana Studies, University of Southwestern Louisiana) 1987. Wilson's essay "Early History of Faubourg St. Mary" (*New Orleans Architecture*, II, pp. 3–48) is an introduction to nineteenth-century building types and styles. Malcolm Heard's *French Quarter Manual*, New Orleans (Tulane School of Architecture) 1997, is a taxonomy of Vieux Carré architecture illustrated with historic photographs from New Orleans collections. Betsy Swanson's *Historic Jefferson Parish from Shore to Shore,* Gretna, La. (Pelican) 1975, is a study of the physical geography, archaeology, and architecture of the parish that included Carrollton and areas of what is now uptown New Orleans. An authoritative source for the art of colonial and antebellum Louisiana is Jessie Poesch, *The Art of the Old South: Painting, Sculpture, Architecture & the Products of Craftsmen, 1560–1860*, New York (Knopf) 1983; it also provides a survey of New Orleans architecture. Mills Lane, *Architecture of the Old South: Louisiana*, New York (Abbeville Press) 1990, based on documentary research by Ann Masson and Jonathan Fricker, is the best overview of nineteenth-century architecture in New Orleans. S. Frederick Starr, *Southern Comfort: The Garden District of New Orleans*, New York (Princeton Architectural Press) 1998, is particularly useful (especially chapter 5) for observations and documentation on the respective roles of architects and builders during this period. The pages on New Orleans in Karen Kingsley's *Louisiana* guide in the *Buildings of the United States* series of the Society of Architectural Historians, New York (Oxford University Press) 2003, provides an overview and inventory of extant historic architecture, with brief building histories and an introductory survey. The model for the SAH guides, the American Guide Series of the Federal Writers' Project (the New Orleans volume is referenced above), although now dated, remains a good place to begin building research for many cities. Publication of the Historic American Buildings Survey (HABS) for Louisiana, *Louisiana Buildings 1720–1940*, edited by Jessie Poesch and Barbara S. Bacot, Baton Rouge (Louisiana State University Press) 1997, catalogs the historic structures surveyed by HABS from 1934 to the present, illustrated with HABS photographs, and introduced by contextual essays on historical periods of Louisiana architecture.

Evidence of how much architectural history has yet to be written for New Orleans is the existence of only one monograph on a New Orleans architect of the nineteenth century, published thirty-five years ago: Arthur Scully, Jr., *James Dakin, Architect: His Career in New York and the South*, Baton Rouge (Louisiana State University Press) 1973. Gallier, Sr., James Freret, and Thomas Sully all had careers of national prominence, but nevertheless lack monographs, although large archives of their work survive in New Orleans collections. William Brand, Joseph and Louis H. Pilié, J.N.B. DePouilly, Will Freret, George Purves, Lewis Reynolds, Thomas Murray, Thomas Mulligan, John Barnett, James Gallier, Jr., and Henry Howard were important local architects both before and after the war; all need further study. Historians have begun to piece together the careers of some of these figures. A monograph on Henry Howard by Victor McGee (a Howard descendant) and photographer Robert S. Brantley is now in press, and this author's study of the career of James Freret is also in preparation. Other research remains unpublished on James Gallier, Sr. (by William Cullison) and J.N.B. DePouilly (by Ann Masson). New Orleans architectural graphics and office practice for this period is surveyed by James F. O'Gorman in an essay introducing the catalog, compiled with this author, *Drawn from History: New Orleans Architectural Graphics 1820–1900*, also forthcoming.

Photography in New Orleans
Margaret Denton Smith and Mary Louise Tucker surveyed early New Orleans photography in *Photography in New Orleans: The Early Years, 1840–1865*, Baton Rouge (Louisiana State University Press) 1982. The book, now out of print, remains a basic reference, although its "Biographical Checklist" of photographers has now been superseded by the encyclopedic *Pioneer Photographers from the Mississippi River to the Continental Divide: A Biographical Dictionary 1839–1865*, Stanford, Calif. (Stanford University Press) 2004, by Thomas R. Kailbourn and the late Peter E. Palmquist. Overall, in the vast modern literature on Civil War-era photography, New Orleans has been largely overlooked.

Compilations of Civil War photography contain views of New Orleans published during this period. Carl Moneyhon and Bobby Roberts's *Portraits of Conflict: A Photographic History of Louisiana in the Civil War*, Fayetteville (University of Arkansas Press) 1990, includes mainly portraits of soldiers but also New Orleans city views and photographs of military installations. Other compilations, by the National Historical Society, William C. Davis, ed., *Touched by Fire*, New York (Black Dog & Leventhal) 1997, and *The Image of War 1861–1865*, New York (Doubleday & Co.) 1981 (with an essay on New Orleans photographer Jay Dearborn Edwards by Leslie D. Jensen), are good sourcebooks for Civil War-era images, and follow the fundamental work of this type, Francis Trevelyan Miller's *The Photographic History of the Civil War* (10 vols.), New York (Review of Reviews) 1911 [reprinted New York (Thomas Yoseloff) 1957].

Nineteenth-Century New Orleans
The best introduction to New Orleans and one of the best books on any American city is by geographer Peirce F. Lewis, *New Orleans: Making of an Urban Landscape*, Cambridge, Mass. (Ballinger) 1976. Revised editions were

published by the University of Virginia Press in 2003 and 2006; citations here are to the first edition. A number of studies of New Orleans of the Civil War and Reconstruction eras, listed here, were important in the preparation of this book. Eric Arnesen, *Waterfront Workers of New Orleans: Race, Class, and Politics, 1863–1923*, New York (Oxford University Press) 1991; Elliott Ashkenazi, *The Business of Jews in Louisiana, 1840–1875*, Tuscaloosa (University of Alabama Press) 1988; Gerald Capers, *Occupied City: New Orleans under the Federals, 1862–1865,* Lexington (University of Kentucky Press) 1965; Joseph G. Dawson, III, *Army Generals and Reconstruction Louisiana, 1862–1877*, Baton Rouge (Louisiana State University Press) 1982; Roger A. Fischer, *The Segregation Struggle in Louisiana, 1862–77*, Baton Rouge (Louisiana State University Press) 1974; James G. Hollandsworth, *An Absolute Massacre: The New Orleans Race Riot of July 30, 1866*, Baton Rouge (Louisiana State University Press) 2001; Lawrence Lee Hewitt and Arthur W. Bergeron, Jr., eds., *Louisianians in the Civil War*, Columbia (University of Missouri Press) 2002; Lawrence N. Powell, ed., *Reconstructing Louisiana*, Louisiana Purchase Bicentennial Series in Louisiana History, VI, Lafayette (Center for Louisiana Studies) 2001 (many articles on Louisiana history cited here have now been republished in this exemplary series); Peyton McCrary, *Abraham Lincoln and Reconstruction: The Louisiana Experiment*, Princeton, NJ (Princeton University Press) 1978; Mary P. Ryan, *Civic Wars: Democracy and Public Life in the American City During the Nineteenth Century*, Berkeley (University of California Press) 1997 (a study of urban public space and the politics of race in New Orleans, New York, and San Francisco during the 1850s and 1860s); Dennis C. Rousey, *Policing the Southern City: New Orleans, 1805–1889*, Baton Rouge (Louisiana State University Press) 1996; Charles P. Roland, *Louisiana Sugar Plantations During the Civil War*, Baton Rouge (Louisiana State University Press) 1997; and Joe Gray Taylor, *Louisiana Reconstructed, 1863–1877*, Baton Rouge (Louisiana State University Press) 1974. Two recent works on New Orleans's environmental history provide a compelling context for understanding the evolution of the city: Craig E. Colten, *An Unnatural Metropolis: Wresting New Orleans from Nature*, Baton Rouge (Louisiana State University Press) 2005; and Ari Kelman, *A River and Its City: The Nature of Landscape in New Orleans*, Berkeley (University of California Press) 2003.

Of special importance for the many medical subjects was Matas's *History of Medicine* of 1958–62, and for the many railroad subjects, the well-documented history of Merl E. Reed, *New Orleans and the Railroads: The Struggle for Commercial Empire, 1830–1860*, Baton Rouge (Louisiana State University Press) 1966. Other works of local history—for example, many congregational histories—will be found cited in the catalog entries.

For an overview of the Reconstruction period, I have relied especially on David W. Blight, *Race and Reunion: The Civil War in American Memory*, Cambridge, Mass. (Harvard University Press) 2001; Don Doyle, *New Men, New Cities, New South: Atlanta, Nashville, Charleston, Mobile, 1860–1910*, Chapel Hill (University of North Carolina Press) 1990; and Eric Foner's *Reconstruction: America's Unfinished Revolution, 1863–1877, op. cit.*

Web Resources

When research for this book began more than a decade ago, historical resources available online were limited, but in recent years much has changed, and web access to archival and photographic collections and the content of journals as well as books has transformed research. The availability of a wide range of early American periodicals electronically (through ProQuest and other vendors) as well as entire runs of some metropolitan newspapers are significant resources. Photographic collections are increasingly accessible online, including archives of early New Orleans photography. The website of the Louisiana State Museum (lsm.crt.state.la.us) features digital scans of many of Lilienthal's stereoviews, as well as those of Samuel Blessing and other local photographers, from its extensive collection of topographic views. An example of the progress of online access to archive and manuscript collections is the New Orleans Public Library Louisiana Division Special Collections website (nutrias.org/~nopl/spec), which provides detailed finding aids for the city archives, including records of the mayoralty, city council, and municipal offices, as well as online exhibitions of manuscripts and historical photography; this site must now be the first stop for anyone researching the history of nineteenth-century New Orleans.

The Paris *Exposition Universelle* of 1867

References cited for the history of the 1867 Exposition include the manuscript records in the Archives Nationales, Paris, F12 3095, Class 9, and the following contemporary published sources:

William P. Blake, ed., *Reports of the United States Commissioners to the Paris Universal Exposition, 1867,* Washington, D.C. (Government Printing Office) 1868–70, 6 vols.

Michel Chevalier, ed., *Rapports du Jury International*, Paris (P. Dupont) 1868, 13 vols.

Commission Impériale, Exposition Universelle de 1867, *Complete Official Catalogue, English Version,* London and Paris (J.M. Johnson & Sons) 1867

——, *Rapport sur l'exposition universelle de 1867 à Paris: précis des opérations et listes des collaborateurs avec un appendice des documents officiels et le plan de l'exposition*, Paris (Imprimerie Impériale) 1869

L'Exposition universelle de 1867 illustrée. Publication internationale autorisée par la Commission impériale, Paris (Administration) 1868

Grand Album de l'Exposition Universelle de 1867, Paris (Michel Lévy Frères) 1868

"The Great Show at Paris," in *Harper's New Monthly Magazine*, xxxv, no. 205, June 1867, pp. 238–53; no. 205, November 1867, pp. 777–92

Message from the President of the United States Transmitting a Report from the Secretary of State Concerning the Universal Exposition to be Held at Paris in the Year 1867, Washington, D.C. [1865]

Henry Morford, *Paris in '67, Or, the Great Exposition*, New York (G.W. Carleton) 1867

Official Catalogue of the Products of the United States of America Exhibited at Paris, 1867, Paris (A. Chaix & Cie) 1867

John Parker Reynolds, *State of Illinois and the Universal Exposition of 1867 at Paris, France*, Springfield, Ill. (State Journal Printing Office) 1868

Eugene Rimmel, *Recollections of the Paris Exhibition of 1867*, Philadelphia (J.B. Lippincott) 1867

G.A. Sala, *Notes and Sketches of the Paris Exposition*, London (Tinsley Bros.) 1868.

James M. Usher, *Paris Universal Exposition; 1867*, Boston (Nation Office) 1868

On Louisiana participation in the Exposition exclusively, the primary sources are:

Raoul Ferrère, "La maison portative de la Louisiane," *L'Exposition universelle de 1867 illustrée,* September 23, 1867, pp. 170–72

Edward L. Gottheil, *Report of Edward Gottheil, Chief Commissioner and General Agent from the State of Louisiana to the Paris Universal Exposition of 1867, Made to the Governor and General Assembly, Session of 1868*, New Orleans (A.L. Lee) 1868

J. Madison Wells, *Message of the Governor of Louisiana to the General Assembly, Held in the City of New Orleans, Commencing January 28, 1867*, New Orleans (J.O. Nixon) 1867.

Recent studies of the Exposition include:

Arthur Chandler, "Paris 1867, Exposition Universelle," in *Historical Dictionary of World's Fairs and Expositions, 1851–1988*, ed. John E. Findling, New York (Greenwood) 1990, pp. 33–43

Peter Greenhalgh, *Ephemeral Vistas: The Expositions Universelles, Great Exhibitions and World's Fairs, 1851–1939*, Manchester, England (Manchester University Press) 1988

"International Expositions," in *Historical Dictionary of the French Second Empire, 1852–1870*, ed. William E. Echard, Westport, Conn. (Greenwood Press) 1985, pp. 312–15

Matthew Truesdell, *Spectacular Politics: Louis-Napoleon Bonaparte and the Fête Impériale, 1849–1870*, New York (Oxford University Press) 1997, pp. 101–20

Pieter van Wesemael, *Architecture of Instruction and Delight: A Socio-Historical Analysis of World Exhibitions as a Didactic Phenomenon*, Rotterdam (010 Publishers) 2001, pp. 218–330

Photograph Sources
Bibliothèque Nationale, Paris
George Eastman House, Rochester, New York
Mr. and Mrs. Eugene Groves, Baton Rouge
Hill Memorial Library, Louisiana State
 University, Baton Rouge
The Historic New Orleans Collection
Library of Congress, Washington, D.C.
Louisiana State Museum, New Orleans
Massachusetts Historical Society, Boston
Missouri Historical Society, St. Louis
Museum of the Confederacy, Richmond
Napoleon Museum, Arenenberg, Switzerland
National Archives and Records Administration,
 Still Pictures Branch, College Park, Maryland

New Orleans Notarial Archive
Joshua Paillet, The Gallery for Fine
 Photography, New Orleans
Southeastern Architectural Archive,
 Tulane University, New Orleans
Tulane University Library, New Orleans
Virginia Historical Society, Richmond
Widener Library, Harvard University

Manuscript Sources (abbreviations noted)
Archdiocese of New Orleans

——, Daughters of Charity Board Minutes

——, St. John the Baptist Parish Records

Archives Nationales, Paris. Records of the Paris Exposition of 1867

Avery Library, Columbia University, Isaiah Rogers Diaries

Baker Library, Harvard Business School, Boston

——, R.G. Dun & Co. Collection

——, Tudor Ice Company Records

Baltimore Historic Architects Roundtable, Archive

The Historic New Orleans Collection, Vieux Carré Survey

Library of Congress, Washington, D.C.

——, Copyright Records, Eastern District, Louisiana, August 1863 to June 1870

——, Geography and Map Division, New Orleans Maps

Louisiana State Museum, New Orleans, Collection and Correspondence files

Louisiana State University, Baton Rouge, Hill Memorial Library, Louisiana and Lower Mississippi Valley Collection, Manuscript 4526, Jewell & Prescott, *The Crescent City Illustrated*, prospectus, 1872

Marillac Provincialate, Daughters of Charity of St. Vincent De Paul, St. Louis, Missouri, Records of St. Vincent's Academy

Massachusetts Historical Society, Boston, William H. Gardiner Papers, James Miller Diary, Noyes Family Papers, John Carver Palfrey Papers, Henry B. Scott Papers

National Archives and Records Administration, College Park, Maryland (NARA)

——, RG90, Records of the Public Health Service

——, RG121, Records of the Public Buildings Service

——, Still Pictures Branch, RG92, Records of

the Office of the Quartermaster General

——, Cartographic Division, RG92, Records of the Office of the Quartermaster General

National Archives and Records Administration, Washington, D.C. (NARA)

——, RG26, Records of the U.S. Lighthouse Service (U.S. Lighthouse Board and Bureau), U.S. Coast Guard

——, RG46, Records of the U.S. Senate

——, RG56, General Records of the Department of the Treasury

——, RG58, Records of the Internal Revenue Service

——, RG77, Records of the Office of the Chief of Engineers

——, RG92, Records of the Office of the Quartermaster General

——, RG94, Records of the Adjutant General

——, RG105, Records of the Bureau of Refugees, Freedmen, and Abandoned Lands

——, RG107, Records of the Office of the Secretary of War

——, RG112, Records of the Surgeon General

——, RG393, Records of U.S. Army Continental Commands, 1821–1920

National Archives and Records Administration, Fort Worth, Tex. (NARA)

——, RG21, Records of the U.S. Fifth Circuit Court for the Eastern District of Louisiana

——, RG58, Records of the Internal Revenue Service, Assessment Lists for Louisiana

National Library of Medicine, *Register of Permits to Enter the Marine Hospital at New Orleans*, 1870–1887

New Orleans Notarial Archives, New Orleans (NONA), Acts of Notaries (Building Contracts)

New Orleans Public Library, Louisiana Division, City Archives

——, Comptroller's Office Records

——, Records of the Civil District Court for the Parish of Orleans

——, Minutes and Proceedings of the Board of Aldermen; Minutes and Proceedings of the Board of Assistant Aldermen

——, Records of the Administrations of the Mayors of New Orleans

——, Receipts and Expenditures of the City Council

——, Surveyor's Office Records

New York Public Library, Manuscripts Division, Thomas K. Wharton, "Diaries and Sketchbook, 1830–62"

Office of the Mayor, Messages of the Mayor to the General Council

Redemptorist Archives, Denver Province, Records of St. Alphonsus Parish, New Orleans

Tulane University, Howard-Tilton Memorial Library Special Collections, New Orleans

——, Manuscripts Collection, Charity Hospital Papers; Kuntz Collection; Louisiana Episcopal Diocese Papers; Louisiana Historical Association Collection; McConnell Family Papers; New Orleans Camera Club Records; New Orleans City Papers; Pontchartrain Railroad Series; Poydras Home Papers; Roberts & Co. Papers; St. Charles Hotel Papers; Trinity Church Records; Urquhart Collection; William Cressey Account Book

——, Southeastern Architectural Archive, James Freret Collection; Labrot Collection of the James Galliers; Photographic Collections; Records of the City Engineer; Vieux Carré Survey

University of New Orleans, Louisiana and Special Collections Department, Earl K. Long Library

——, Records of the Civil District Court for the Parish of Orleans

——, Records of the Supreme Court of Louisiana

Newspapers
Asmonean
Atlanta Constitution
Baltimore American
Baltimore Sun
Brooklyn Daily Eagle
Chicago Daily Tribune; Chicago Press and Tribune; Chicago Tribune
Cincinnati Commercial
Concordia Intelligencer (Louisiana)
Louisville Daily Democrat (Kentucky)
Harper's Weekly
Houston Daily Post
Louisiana Gazette
Memphis Appeal
Minneapolis Tribune
Mobile Herald and Tribune (Alabama)
Mobile Advertiser (Alabama)
New York Herald
New York Sun
New York Times
New York Tribune
Niles Weekly Register

Pall Mall Budget
Paris Moniteur Universel
Philadelphia Evening Argus
Pittsburgh Gazette
United States Weekly Telegraph
Washington National Intelligencer
Washington Post; Washington Post-Union
Wheeling Daily Intelligencer (West Virginia)

The following New Orleans newspapers, with full or variant titles and known publishing runs given, are cited in the text:

Advertiser (*Louisiana Advertiser*, 1820–42)
Argus (*New-Orleans Argus*, 1827–34)
Bee (*New-Orleans Bee, New Orleans Daily Bee*, 1830–72)
Carrollton Star (1851–56)
Carrollton Times (1863–70)
Commercial Bulletin (*New-Orleans Commercial Bulletin*, 1832–71)
Commercial Times (*New-Orleans Commercial Times*, 1845–49)
Courier (*Louisiana Courier/Le Courrier de la Louisiane*, 1807–59; continued by the *Courier/Le Courrier*, 1859–60)
Crescent (*Daily Crescent*, 1848–51; *New Orleans Daily Crescent*, 1851–66; *New Orleans Crescent*, 1866–69)
Daily Southern Star (1865–66)
Daily States (1880–1918)
Delta (*Daily Delta*, 1845–53; *New Orleans Daily Delta*, 1853–57; *Daily Delta*, 1857–63)
Democrat (*New Orleans Democrat*, 1880–81)
Deutsche Zeitung (*Tägliche Deutsche Zeitung*, 1854–72, 1877–89; *New Orleans Tägliche Deutsche Zeitung*, 1872–77; *New Orleans Deutsche Zeitung*, 1889–99)
Era (*Daily Era*, 1863–65)
Evening Crescent (1866–67)
Evening Picayune (1848–84)
Item (*New Orleans Item*, 1902–58)
Item-Tribune (Sunday, 1924–41)
Jewish Ledger (1895–1963)
Morning Star and Catholic Messenger (1868–80)
Morning Tribune (1924–37)
Orleanian (*Daily Orleanian*, 1847–58)
Picayune (1837–1914)
Price-Current (*New-Orleans Price-Current and Commercial Intelligencer*, 1822–82)
Republican (*New Orleans Republican*, 1867–78)
States (*New Orleans States*, 1918–58)
States-Item (*New Orleans States and Item*, 1958–60; *New Orleans States-Item*, 1960–70; *States-Item*, 1970–80)

Sunday Delta (1855–63)
Times (*New-Orleans Times*, 1863–81)
Times-Democrat (1881–1914)
Times-Picayune (1914–80, 1986–; *Times-Picayune/States-Item*, 1980–86)
Times-Picayune New Orleans States (Sunday, 1933–58)
Tribune (*New Orleans Tribune*, 1864–70)
True Delta (*Daily True Delta*, 1849–66)
Weekly Courier (1858–59)
Weekly Delta (*New Orleans Weekly Delta*, 1845–63)

Other weekly editions published by local dailies but not listed here are also cited in the text.

Abbreviations of Frequently Cited Sources

Beauty and Booty—Marion Southwood, *Beauty and Booty: The Watchword of New Orleans*, New York (M. Doolady) 1867

Biographical Survey—George W. Cullum, *Biographical Register of the Officers and Graduates of the U.S. Military Academy at West Point, Boston*, New York (Houghton Mifflin) 1891

Deposition of Theodore Lilienthal—RG21, Records of the U.S. Fifth Circuit Court for the Eastern District of Louisiana, Case 8959, Lilienthal v. Washburn, NARA, Fort Worth, Tex.

Gallier, *Autobiography*—James Gallier, *Autobiography of James Gallier, Architect*, Paris (E. Brière) 1864

Gardner's New Orleans Directory for 1867—Charles Gardner, *Gardner's New Orleans Directory for 1867*, New Orleans (Charles Gardner) 1867 (the Gardner city directory was published annually 1858–61 and 1866–69)

Gibson's Guide—J. Gibson, *Gibson's Guide and Directory of the State of Louisiana, and the Cities of New Orleans & Lafayette*, New Orleans (J. Gibson) 1838

Griswold's Guide—A.B. Griswold & Co., *Guide Book to New Orleans and Vicinity*, Philadelphia (Rowley & Chew) 1873

The Industries of New Orleans—Andrew Morrison, compiler, *The Industries of New Orleans* (J.M. Elstner) 1885

Jewell's Crescent City Illustrated—Edwin L. Jewell, *Jewell's Crescent City Illustrated*, New Orleans (E.L. Jewell) 1873 (various printings and collations; not paginated until expanded edn., late 1873)

Jewell's Crescent City Illustrated, prospectus—Louisiana State University, Baton Rouge, Hill Memorial Library, Louisiana and Lower Mississippi Valley Collection. Manuscript 4526, Jewell & Prescott, *The Crescent City Illustrated*, prospectus, 1872

Land, *Pen Illustrations*—John E. Land, *Pen Illustrations of New Orleans, 1881–82, Trade, Commerce and Manufactures*, New Orleans (John E. Land) 1882

Matas, *History of Medicine*—Rudolph Matas, *History of Medicine in Louisiana*, ed. John Duffy, Baton Rouge (Louisiana State University Press), 1958–62, 2 vols.

New Orleans Architecture—*New Orleans Architecture,* compiled and edited by Robert J. Cangelosi, Jr., Mary Louise Christovich, Pat Holden, Sally Kittredge Reeves, Dorothy G. Schlesinger, Betsy Swanson, Roulhac Toledano *et al.*, New Orleans (Friends of the Cabildo); Gretna, La. (Pelican) 1971– (8 vols. to date)

Norman's New Orleans and Environs—Benjamin Moore Norman, *Norman's New Orleans and Environs; Containing a Brief Historical Sketch of the Territory and State of Louisiana and the City of New Orleans*, New Orleans (B.M. Norman) 1845

Occident—*Occident and American Jewish Advocate*, 1843–69

Report of Edward Gottheil—Edward L. Gottheil, *Report of Edward Gottheil, Chief Commissioner and General Agent from the State of Louisiana to the Paris Universal Exposition of 1867, Made to the Governor and General Assembly, Session of 1868*, New Orleans (A.L. Lee) 1868

Smith and Tucker—Margaret Denton Smith and Mary Louise Tucker, *Photography in New Orleans: The Early Years, 1840–1865*, Baton Rouge (Louisiana State University Press) 1982

Vieux Carré Survey—*Vieux Carré Survey,* compiled by the Tulane School of Architecture and Augmented by The Historic New Orleans Collection, 1981 (archived at the Southeastern Architectural Archive, Tulane University, and The Historic New Orleans Collection)

Waldo, *Visitor's Guide*—J. Curtis Waldo, *Illustrated Visitor's Guide to New Orleans*, New Orleans (J.C. Waldo, Southern Publishing and Advertising House) 1879

Wharton, "Diary"—New York Public Library, Manuscripts Division, Mss. ZZ-293, Thomas K. Wharton, "Diaries and Sketchbook, 1830–62"

Acknowledgments

This book originated with a project to exhibit Theodore Lilienthal's *La Nouvelle Orléans et ses environs* in New Orleans in the autumn of 2000. Entitled *Lost New Orleans: Photographs by Theodore Lilienthal for Emperor Napoleon III*, the exhibition was organized by the Southeastern Architectural Archive at Tulane University, of which I was head, for Tulane's Newcomb Art Gallery and the New Orleans Museum of Art. Two years later I came to MIT, where this book took on a very different life, and largely took shape, but much of my indebtedness for the privilege of publishing Lilienthal's work has remained with that original project, with Tulane, and with many supporters and collaborators in New Orleans.

John Geiser, Honorary Swiss Consul in New Orleans and one of the most perceptive advocates for the study and preservation of New Orleans architecture, officially and personally promoted this project from the beginning; without his interest and generous support neither the exhibition nor the book would have been realized. A grant from James Lamantia, as holder of the Richard Koch Chair in the School of Architecture at Tulane, helped realize the exhibition and preliminary research on the photographs. Erik Neil, former director of the Newcomb Art Gallery, provided support for the exhibition, as did Don Gatzke, Philip Leinbach, and Lance Query at Tulane. Wilbur Meneray, as head of Tulane's Special Collections, facilitated the project from its inception. John Bullard, director, and Steve Maklansky, curator, at the New Orleans Museum of Art were helpful collaborators.

Grants from Pro Helvetia, the Swiss Arts Council; the Grace Slack McNeil Program in the History of American Art at Wellesley College; the Louisiana Endowment for the Humanities/National Endowment for the Humanities; and the Canton of Thurgau/Napoleon Museum brought this book to press. I would like to acknowledge in particular Marianna Erni at Pro Helvetia and Alice Friedman at Wellesley for their interest and support. A sabbatical from Tulane in 2001 enabled me to carry out research in Washington archives and libraries, and travel grants from Pro Helvetia and the Swiss-American Cultural Exchange Council supported my research in Switzerland.

Hans Peter Mathis, former director of the Napoleon Museum in Arenenberg, Switzerland, not only recognized the significance of the Lilienthal photographs in his custody but also enabled and actively promoted their exhibition and publication. I am most grateful to Hans Peter, and to Erika Schoberth, for assisting my research in Arenenberg, in what must be one of the most alluring settings anywhere to do research. Hanna Widrig, former cultural officer at the Swiss Embassy in Washington; Christoph Eggenberger, now at the Zentralbibliothek, Zürich; Alfons Müggler, former Swiss Consul in Houston; and Dominik Gügel, the current director of the Napoleon Museum, also generously assisted my research. All embraced this project and, I am very pleased to say, became friends during the course of it. David Gubler in Märstetten prepared the superb copy photography.

Many readers and colleagues made valuable contributions to the book. For their close reading of the manuscript and many helpful comments, I am grateful to Mary Daniels, Mary Woods, and Jessie Poesch—my thanks to Jessie, too, for her advice and her early and continuing support of the manuscript's publication. Karen Kingsley and Erik Neil also commented on an early draft, as did Sally Reeves, who as archivist of the Notarial Archives generously shared her encyclopedic knowledge of New Orleans buildings. Tom Kailbourn and the late Peter Palmquist provided guidance and freely shared information from their astonishing research files on western and southern photographers, most of which has now been published. Kurt Forster, Peter Hales, and Anne McCauley, in a program of lectures Richard Tuttle and I organized at Tulane, all helped shape my thinking about Lilienthal, as did co-participants, too numerous to thank individually, at a conference on Photography and the City at University College, Dublin in 2006. I benefited from discussions about New Orleans architecture with Mac Heard, whose own study of Vieux Carré architecture appeared shortly before his untimely death in 2001, and with Bernard Lemann, Jim O'Gorman, Betsy Swanson, Dell Upton, and Ellen Weiss. I am especially grateful to François Brunet of the University of Paris, with whom I have had many discussions about Civil War era photography and the Paris Exposition of 1867, for his contributions, including research in the Paris archives.

I am indebted to the staff, interns and volunteers of the Southeastern Architectural

Archive, particularly Laura Cochrane (for her continuing assistance after leaving Tulane) and the other Richard Koch interns, Kathryn Alexander, Olivia Fagerberg, and Johee Lee; and Deena Bedigian, Dayna Castenedo, Estella Chung, Loretta Clark, Kathy Falwell, Heather Fielding, Elizabeth Glenn, Doris Ann Gorman, Jane Himel, Andrew McKernon, June Norman, Susan Saward, Margaret Scheurerman, Taylor Webb, Kevin Williams, Albert Wolf, Jr., and Ann Woodruff.

Many others aided my work. Eugene Groves and Joshua Paillet (and his assistants Jenifer Freidman and Caroline Cotten) generously allowed me access to their collections and prepared scans. Jennifer Tran helped prepare the map, Rakia Faber assisted with the manuscript, and Louise James, Francine Judd, and Mike Smith contributed photography and scans. Dietmar Felber, Samuel Lasman, and Scott Powers provided translations. Daniel Abramson, Lydia Breen, Dan Brown, Robbie Cangelosi, Jr., Jeffrey Cohen, Kathleen Colongne, Michael Crosby, Oliver Dabezies, Jr., Jill Delaney, Catherine De Lorenzo, Dorothy Dawes, Vais Favrot, Rene Freret, Ben Fuller, James Guilbeau, Alan Hardin, Donald Hawkins, Alicia Heard, Betty Hendrickson, Kevin Herridge, Ann Howell, Aline Freret Kasischke, John Klingman, Alison McQueen, Will Morgan, Erika Naginski, Sara Wermiel, Maunsel White, and Bob Whitman all provided assistance. In Minneapolis, Alan Lathrop, Dennis McGrath, and Zella Mirick helped unravel the mystery of Lilienthal's last months there. John H. White gave expert answers to my railroad questions.

The sleuthing required to assemble the fragments of Lilienthal's life and work and compile the commentaries on his photographs indebted me to many curators, archivists and librarians. In particular, I would like to thank Nick Natanson (National Archives, College Park); Cindy Smolovik and Barbara Rust (National Archives, Fort Worth); Wayne Everard and Irene Wainwright (New Orleans Public Library); Monte G. Kniffen (Redemptorists Archive, Denver); Shannon Glasheen, Nathaniel Heller, Claudia Kheel-Cox, Greg Lambousy and James F. Sefcik (Louisiana State Museum); John Lawrence and John Magill (The Historic New Orleans Collection); Janice Madhu and Rachel Stuhlman (George Eastman House); Sally Pierce and Catharina Slautterback (Boston Athenaeum); Sharon Frost (New York Public Library); Florence Jumonville and Marie Windell (University of New Orleans Library); Dorothy Dawes (Dominican Archives, New Orleans); Elaine Smith, Judy Bolton, and Mark Martin (Hill Library, Louisiana State University); Catherine Kahn (Touro Archives, New Orleans); Valerie Miller (Library Company of Philadelphia); Sr. Genevieve Keusenkothen (Archives of Marillac Provincialate, Daughters of Charity of St. Vincent DePaul, St.Louis); Joan Caldwell and Eric Wedig (Tulane University Library); Ann Wakefield (New Orleans Notarial Archives); Kurt Hasselbalch (MIT Museum); James T. Wollon, Jr. (Baltimore Historic Architects Roundtable); Rev. Louis J. Derbes (Archives of the Vincentian Fathers and Brothers, Perryville, Mo.), and Carolle Morini (Massachusetts Historical Society). I also acknowledge the assistance provided by the staffs of Rotch and Hayden Libraries at MIT; Sterling Library at Yale University; and the Widener, Lamont, Loeb and Baker Libraries at Harvard University.

I wrote most this book after coming to MIT in 2002, and it is a pleasure to acknowledge my colleagues at the MIT Museum, particularly John Durant and Mary Leen, for their support. I owe a special debt of gratitude to Leslie Myers, who encouraged this work in innumerable ways; no one was more interested in seeing me complete it. For skillfully shepherding this project to print, my thanks to my editors Rosanna Fairhead and Helen Miles, and, also at Merrell, to Julian Honer and Hugh Merrell, not least for enjoyable hours at the Boot & Flogger in Southwark.

Gary A. Van Zante
September 2007

Index

Page numbers in *italic* refer to the illustrations

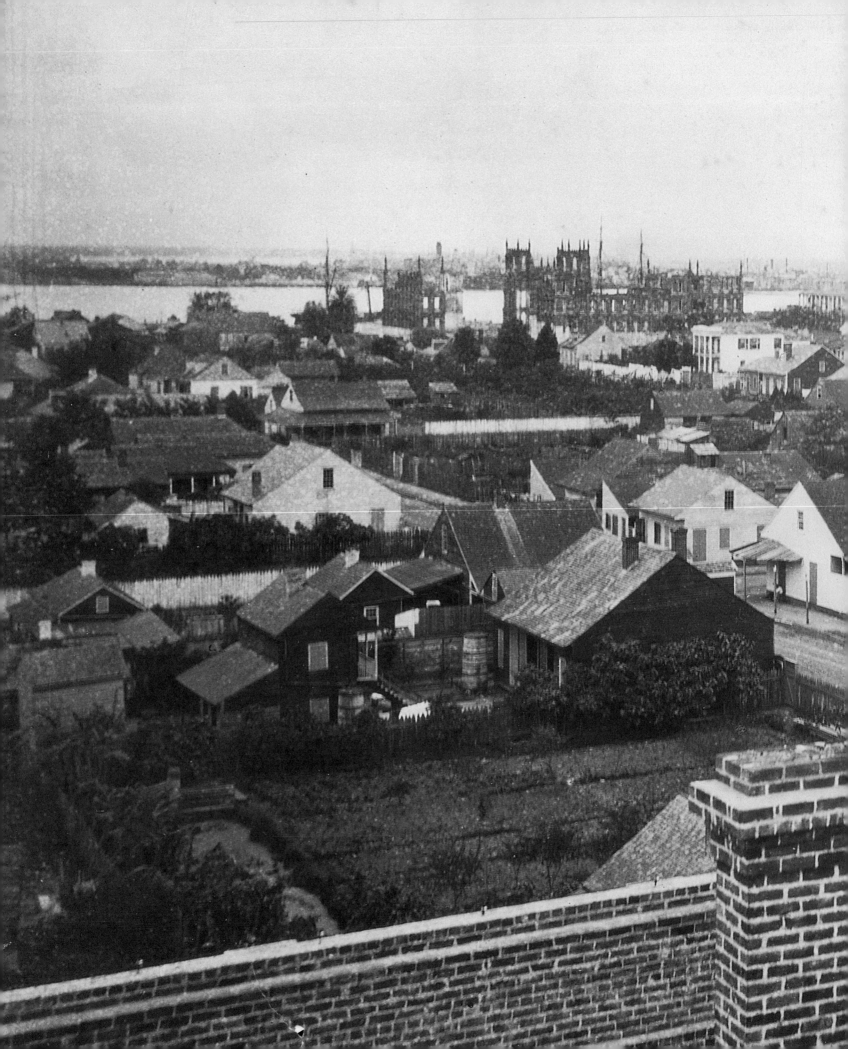